MASTERPIECES OF IVORY

FROM THE WALTERS ART GALLERY

MASTERPIECES OF IVORY

FROM THE WALTERS ART GALLERY

by Richard H. Randall, Jr.

with texts by Diana Buitron

Jeanny Vorys Canby

William R. Johnston

Andrew Oliver, Jr.

Christian Theuerkauff

HUDSON HILLS PRESS, *New York*

in Association with the Walters Art Gallery, Baltimore

FIRST EDITION

©1985 by the Walters Art Gallery

Published in the United States by Hudson Hills Press, Inc., Suite 301,
220 Fifth Avenue, New York, NY 10001.

Distributed in the United States by Viking Penguin Inc.
Distributed in Canada by Irwin Publishing Inc.
Distributed in Japan by Yohan (Western Publications Distribution Agency).

Editor and Publisher: Paul Anbinder
Designer: Philip Grushkin
Composition: U.S. Lithograph Inc.
Manufactured in Japan by Toppan Printing Company

Library of Congress Cataloguing in Publication Data

Walters Art Gallery.
 Masterpieces of ivory from the Walters Art Gallery.

 Bibliography: p.
 Includes index.
 1. Ivories—Maryland—Baltimore—Catalogues.
2. Walters Art Gallery—Catalogues. I. Randall,
Richard H. II. Title.
NK5810.B3W34 1985 730'.074'01526 85-14312
ISBN 0-933920-42-3 (alk. paper)

CONTENTS

LIST OF COLORPLATES

Chapter 4. Later Roman and Egyptian Ivories

Chapter 5. Consular Diptychs

Chapter 6. Middle and Late Byzantine Ivories

Chapter 7. Islamic Ivories

Chapter 8. Early Medieval Ivories

Chapter 9. Gothic Ivories

Chapter 10. Renaissance and Baroque Ivories

Chapter 11. Later Ivories

PREFACE

As a collector of ivory in all its forms, from the beginning of its use about 8000 B.C. to his own day, Henry Walters had few peers. His interest in the small and the beautiful, which led him to collect small sculpture, fine ceramics, goldsmith's work, and enamels, found a major outlet in the field of ivories.

His earliest purchases in the area of ivory were an unusual series of contemporary works. Between 1893 and 1895 he purchased two Augustin-Jean Moreau-Vauthier figures (cat. nos. 440 and 441) from the artist's widow, and a Clovis Delacour female figure (cat. no. 443) in 1896. In 1900 he added works by Antonin Mercié (cat. no. 444) and Louis-Ernest Barrias (cat. no. 445). At the St. Louis World's Fair of 1904, he bought two superb pieces of René Lalique jewelry with major ivory segments (cat. nos. 447 and 448).

Early in his collecting career, Walters also pursued exotic examples, such as the delicately pierced candle shades from Dieppe (cat. nos. 426 and 427) and the tusk from the Congo with scenes of African life (cat. no. 482) bought from Tiffany & Company in 1910.

A few classical pieces came with the collection of Dom Marcello Massarenti, purchased by Walters in 1903, and he added two fine Roman examples at the Michel Boy sale in Paris in 1905. He purchased his first medieval ivories in a sale in Paris in 1901, and he took the opportunity of buying a number of unusual ivories from the Octave Homberg Collection in 1908.

Walters' preferred method of collecting was to purchase individual pieces of ivory from numerous different sources. In fact, many Parisians, the story goes, thought Walters had something wrong with his left hand, because he so often kept it in his pocket. When asked about this, the well-known dealer Jacques Seligmann explained: "There is nothing wrong with Mr. Walters' hand. He is merely playing with the last object he bought."

In addition to the medieval field, Walters maintained a lifelong interest in Egyptian ivories; he collected the largest number of pieces in these two areas in the 1920s. He frequently bought his Egyptian and Near Eastern material from Dikran Kelekian in Paris, and his eighteenth-century material from Jacques Seligmann in Paris and New York; the nineteenth-century material came from many sources, with most of the exotic from Tiffany & Company. In the medieval field, which was his major interest for more than thirty years, he purchased from George Harding in London, Henry Daguerre and Léon Gruel in Paris, as well as scattered dealers in Italy, Germany, and New York. Out of the total collection of 24,000 items Walters left to the city of Baltimore in 1931, 1,150 were ivories.

Henry Walters' taste was catholic and, to his credit, he sought things for the most part undervalued or not yet collected by others. His very select group of fifteenth-century European ivories, for example, reflects his interest in an area that is even now, more than fifty years after his death, relatively ignored. Walters sought ivories from Hellenistic and Coptic Egypt to complement his jewelry, silver, enamel, and textile holdings. Two of the Coptic pieces are among the most famous in the collection and are of great historical value. The Coptic ivory statuette of the Virgin and Child (cat. no. 180), a work of the late ninth or early tenth century, represents the "Eleousa," or Virgin of Tenderness, type, in which a touching familial bond between the two figures is made evident through pose and gesture. The Walters Eleousa is the earliest surviving example of this imagery, later to become essential to medieval and Renaissance artists. The second Egyptian example of great fame is the wonderful wood and bone casket or box, undoubtedly for secular use, from the fourth to fifth century A.D. (cat. no. 135). Its importance lies in the fact that its bone and wax inlay panels are the best ensemble to have been preserved from such a box, a luxury object of a type that must have existed in profusion in the Egypt of later antiquity.

Walters' Cretan chryselephantine snake goddess (cat. no. 56), his Gothic Arthurian romance casket (cat. no. 324), and his orchid hair comb by Lalique (cat. no. 448) are also among the highlights of the collection. He sought, too, the great carvers of the Baroque, an era that was generally ignored in his collecting days, and purchased a signed Cleopatra by Adam Lenckhardt (cat. no. 374), a

sleeping child by the Flemish sculptor Artus Quellinus (cat. no. 377), and a figure of a son of Laocoön by the Master of the Furies (cat. no. 375).

Few areas failed to attract Walters' attention; works from the colonial centers of Goa and the Philippines took their places beside ivories from Egypt, Rome, medieval Europe, Russia, Byzantium, and the Islamic world. He did not need to collect in the Oriental area because his father, William T. Walters, had by 1886 collected both Chinese works and Japanese netsuke (more than four hundred of them). An exhibition of the netsuke was presented at the Walters Art Gallery in 1978.

The present catalogue of the Walters collection of ivories has been the work of Jeanny Vorys Canby in the Egyptian area and the Ancient Near East; Diana Buitron and Andrew Oliver, who have studied the ivories of Greece, Crete, Etruria, and Rome; and William R. Johnston, who has contributed much new knowledge in the area of eighteenth- and nineteenth-century works. The medieval collection, which makes up more than half of the objects in the catalogue, occupied a number of years of study, largely supported by the National Endowment for the Arts. In 1978, I was able to bring together curators from the medieval collections of the Metropolitan Museum, the British Museum, and the Louvre for conferences in Baltimore and New York. This group studied the Gothic ivories in the Metropolitan and the Walters; the following year they continued their studies in Europe—at the British Museum and the Victoria and Albert Museum in London, and at the Musée de Cluny and the Louvre in Paris. This experience and the exchange of information and photographs that followed contributed to the solution of many problems that exist in the field of Gothic ivories. My special thanks go to Danielle Gaborit-Chopin of the Louvre, Neil Stratford of the British Museum, and Charles Little of the Metropolitan Museum. Their differing backgrounds—and differences of opinion—set the stage for some new directions in research.

The Walters was handicapped by the lack of a curator in the Baroque field, but was fortunate to be able to avail itself of the knowledge and advice of Dr. Christian Theuerkauff of the Staatliche Museen, Berlin. Dr. Margarita-Mercedes Estella Marcos of the Instituto de Don Juan de Valencia offered expertise on the Spanish and Portuguese colonial material. Pierre Bazin of the Dieppe Museum and Robert Tschoudoujney of Paris offered their deep understanding of eighteenth- and nineteenth-century French ivories.

Many students contributed to the project; Clare Rose and Sally Rowan provided research assistance regarding Byzantine ivories, while Bernard Barryte, during his term as curatorial intern at the Walters, explored portions of the eighteenth- and nineteenth-century collection. Caroline Smitter undertook research on Roman ivories, and Linda Sirkis is responsible for the excellent line drawings of a number of pieces.

Consultants and friends all over the world have contributed to various entries in the catalogue. I would especially like to thank François Avril, John Beckwith, Peter Lasko, Sir John Pope-Hennessy, Robin Sand, Hanns Swarzenski, Paul Williamson, and David Wright. The entire manuscript was typed and ordered by Catalina Davis. Angeline Polites edited the text.

Of major importance is the color photography by Harry Connolly, staff photographer at the Walters during the preparation of this volume. He is also responsible for a small percentage of the black-and-white photographs of objects that had been cleaned in the laboratory or where conservation changed the appearance of an object. The majority of the black-and-white photographs are the work of Miss Sherley Hobbs, staff photographer for the preceding twenty-five years. Every object in the catalogue was examined in the laboratory, under the direction of Mrs. Terry Weisser, and many were cleaned, strengthened, or repaired.

The form of the book and the richness of its color illustrations are the result of the efforts of Paul Anbinder and Hudson Hills Press. One hopes that the Neoclassical view of ivory as a medium illustrated only in black and white will be definitively altered by this publication. The beautiful color range of the material—equated to warm flesh tones by the Greeks, but actually ranging from soft whites through many shaded tones of sand and yellow to brown—can be easily appreciated from the colorplates.

Funding for the project was graciously provided by the Trustees of the Walters Art Gallery, twenty-six friends of the Gallery, and the Women's Committee, and through grants from the National Endowment for the Arts. The Endowment funded the original international conference in 1978, and provided a research grant for the catalogue in 1981–1982 and a partial publication grant in 1983. The Walters Art Gallery is deeply grateful for the continued support and encouragement of the NEA, without which this project could never have been brought to fruition.

RICHARD H. RANDALL, JR.
Curator of Medieval Art, Arms, and Armor

MASTERPIECES OF IVORY

FROM THE WALTERS ART GALLERY

1 Ivory

by Richard H. Randall, Jr.

THROUGHOUT HISTORY ivory has been considered a beautiful and rare substance, fit for kings and gods. In the Bible it is equated to the precious and the exotic: "Once in three years came the navy of Tharshish, bringing gold, and silver, ivory, and apes, and peacocks" (1 Kings 10:22). Many a monarch was said to have sat on a throne of ivory, Solomon being among the first (1 Kings 10:18); and such a seventeenth-century ivory throne, that of the kings of Denmark, still reposes in Rosenborg Castle, Copenhagen.

By "ivory" one generally refers to the tusk of the elephant, which to this day remains the largest source of the substance. The African elephant's tusks are the largest, sometimes reaching over eight feet in length and weighing as much as from 150 to 200 pounds. As the base of a mature tusk often exceeds six inches in diameter, objects of large dimensions can be created, such as the volute of a bishop's crozier (cat. no. 260; see colorplate 1).

Other types of ivory exist, however, and the second largest source is the fossil tusks of the mammoths of the Asian steppes, which have been found in huge numbers under the snows of Siberia. The material is often in perfect condition and can be worked as easily as elephant ivory (cat. no. 493; figure 1).

A number of other creatures produce useful ivory, including the hippopotamus, which has large incisor teeth (see figurines, chapter 2, cat. nos. 1 and 2); the walrus with its two tusks (cat. no. 254); the warthog and related members of the boar family; the dugong, a type of sea cow of the Pacific Ocean; and the sperm whale with its rows of six-inch teeth. The narwhal grows a single large tusk of pure ivory up to seven feet in length, though it is small in diameter. More often preserved as a curiosity, the narwhal's tusk has passed for the horn of the unicorn.

Many alternative substances, mainly horn and bone, have been used as substitutes for ivory and are often polished to imitate the more costly material. The bill of the exotic hornbill of India and Borneo is called ivory and has been carved by the Japanese (figure 2). The Embriachi workshop of Venice substituted cow bone for ivory and

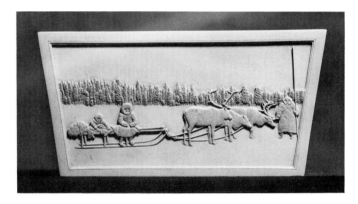

Figure 1 (cat. no. 493). Paperweight showing an eskimo sled, mammoth ivory, Russian, late 19th century. This is one of many small plaques carved by Russian villagers who had discovered fossil mammoth tusks under the melting ice in Siberia. The supply of the material is one of the largest sources of ivory in the world.

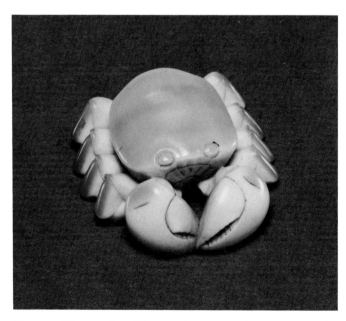

Figure 2. Netsuke, hornbill ivory, Japanese, 19th century, signed "Jugyoku." This netsuke in the shape of a crab is cleverly carved so that its shell shows the red exterior of the mass of "ivory" that crowns the bill of the hornbill of Borneo and India. Walters Art Gallery (71.851).

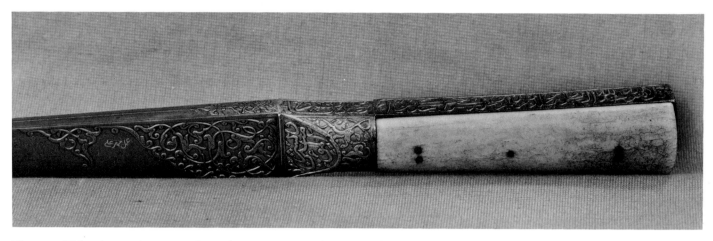

Figure 3. Walrus ivory grip on carved iron dagger, Persian, 17th century. The granular ivory of the walrus was popular in Persia for sword hilts and dagger grips. It was imported first from the Vikings in the tenth century, and continued to be used through the nineteenth century. Walters Art Gallery (51.43).

polished it to a high gloss in the fifteenth century (cat. no. 355); a great Spanish ivory depicting the Adoration of the Kings, now in the Victoria and Albert Museum, was made from polished whalebone in the late eleventh century.

English, German, and Scandinavian ivories of the Middle Ages are largely of walrus ivory, which was the available material, as seen in a twelfth-century draughtsman (cat. no. 256). Walrus ivory from Iceland was shipped to Persia from very early times and by the seventeenth century had become the normal material for dagger and sword grips among the Turks and Persians (figure 3). The Vikings employed whalebone for various types of artifacts, including the "ironing board" found in a female grave of the eighth to ninth century (figure 4). Most of the work found in the Pacific islands is either from dugong ivory or whale tooth, as in a New Zealand amulet (figure 5). Many articles from Siberia were naturally produced from mammoth tusks, including the village souvenir (cat. no. 493) and a fine cup with royal portraits (cat. no. 488). The early Egyptians relied heavily on the tusk of the hippopotamus, though elephant ivory was readily available from the Sudan. Some of the earliest figures in the collection dating from the fourth millennium B.C. are carved from hippopotamus teeth (cat. no. 1).

Since African elephants are wild, the ivory had to be obtained by hunting the great herds of elephants. Much elephant ivory was collected and saved by the people of the interior as bullion, however, and the ivory bought by traders in the nineteenth and twentieth centuries was often quite ancient in actual fact. The people of Benin, in particular, saved and revered tusks as part of their royal treasure. For centuries, Asian elephants have been domesticated, and the ivory in this area of the world comes from elephants that have died a natural death. Because there are so many elephants, the supply is considerable.

Many "ivory" buttons are actually made of vegetable ivory from South America. This material, which was used throughout the world for small work in the nineteenth and twentieth centuries, is the nut of the tagua palm. When cured it is a yellowish-white color and can be dyed easily.

The horns of many types of deer were used from earliest times throughout the world to make tools, combs,

Figure 4. Board with monster heads, whalebone, Viking, late 8th–late 9th century. A number of boards nearly identical to this one have been excavated from the graves of wealthy Viking women. These boards have been associated with domestic life, although their function is unknown. One board was found with a glass ball for smoothing linen; they have thus been called "ironing boards" in the literature. It is more likely, however, that they were trenchers or serving dishes of some kind, used in rich households. Walters Art Gallery (71.1169).

Figure 5. Amulet, sperm whale tooth, New Zealand (Maori), 19th century. The carving shows masks and small animals together with a larger creature, perhaps a whale, devouring human beings. The tooth was cut in half so that two carvings could be produced, and the finished work has been dyed. Walters Art Gallery (71.252).

sculpture, and inlay. The earliest example in the Walters Collection is a flint pick made of elk antler found in a cave site in France, near Châlons-sur-Marne (figure 6), and dating from about 8000–3000 B.C. in the Neolithic period. Stag antler and cow horn were frequently used in imitation of ivory for inlay on furniture, musical instruments, or weapons; these substitutes are often indistinguishable from the real material. A German priming flask illustrates this very well (cat. no. 449; figure 7).

When these various substances are examined scientifically, however, they can be easily distinguished from one another: the horns are actually a hair product, while ivory is always a tooth. Ivory is extremely even in texture and has virtually no graininess, making it a fine material for the sculptor's chisel. Horn is a much softer substance; when cut into thin strips, it can be dipped into boiling water to give it a texture like spaghetti; thus it can be easily inlaid in delicate scrolls or other forms. Since all these materials have been used interchangeably at different periods, many horn and bone pieces are illustrated here together with their ivory counterparts. In a Renaissance crossbow, ivory, bone, cow horn, and staghorn are all employed in the inlay (see figure 51). In a Russian miniature desk of the nineteenth century, from Archangel (cat. no. 491), walrus ivory and bone, both white and stained, are used together.

The trade in ivory is mentioned in the Bible in the books of Kings and Ezekiel and is implied by archaeological finds. The route in ancient times was very much the same as that of the present day. In Ezekiel it is said of the Mediterranean port of Tyre that the men of Dedan, on the Red Sea, "brought thee for a present horns of ivory . . ." Ezek. 27:15). Aden, at the mouth of the Red Sea, was the most active trading center in the material when Marco Polo wrote his account of his travels in the thirteenth century. The ivory came from East Africa to the island of Zanzibar, the largest market in the world, and then to Aden and up the Red Sea to Egypt and

overland to the Mediterranean. Thus it must have come to the Assyrians, who decorated their palaces and furniture with ivory, and to the Greeks, whose giant chryselephantine statues at Athens and Olympia contained large quantities of ivory. The same basic route was followed in the nineteenth and twentieth centuries; the ivory went from Zanzibar by ship through the Suez Canal and on to the markets of London and Antwerp for distribution.

It is difficult to estimate the amount of ivory that was used in the ancient civilizations because so much has been lost. It is clear, however, from the excavations of the Assyrian palaces at Nimrud in Iraq that palace walls and furniture were inlaid with finely carved ivory, just as the literary references tell us. The Bible speaks harshly of "beds of ivory," which were equated with unnecessary wealth. Such beds have survived, a fine Roman example being on view in the Metropolitan Museum. Our greatest knowledge of the variety of uses for ivory comes from Egypt, where, because of climatic conditions, thousands of examples of both bone and ivory have survived (cat. no. 157; see colorplate 46). The range of uses included theater tickets, dolls, furniture, jewelry, needles, amulets, statues, toilet boxes, and handles for mirrors and weapons. The Greeks and Romans also used both materials as inlay; often bone and ivory are seen in the same piece.

In the early Middle Ages, ivory seems to have been a highly revered material and was used sparingly for important commissions, for example, the covers of imperial manuscripts and presentation diptychs. During the Byzantine and Romanesque periods its use gradually expanded to include great altar frontals composed of many panels and bishops' thrones covered with ivory plaques in great profusion.

A cultural explosion in the use of ivory occurred in Gothic France from the middle of the thirteenth to the end of the fourteenth century, in which time ivory had become the primary material for objects of fashion. Every type of utensil for secular or religious life was made of the substance, and croziers, scepters, boxes, mirror cases, combs, and statues were produced in great variety. The

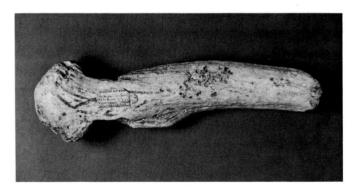

Figure 6. Flint-mining pick or garden tool, elk antler, French, Neolithic period, 8000–3000 B.C. The pick was found in the nineteenth century at Jacquesson, near Châlons-sur-Marne, along with flint and other contemporary implements. Walters Art Gallery (71.1164).

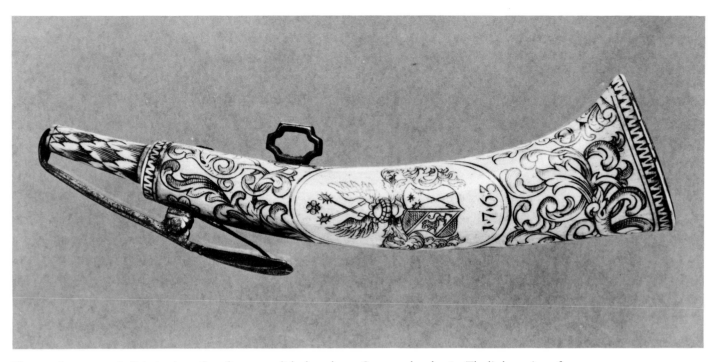

Figure 7 (cat. no. 449). Priming horn for a firearm, polished staghorn, German, dated 1763. The little section of staghorn has been hollowed out and given a high polish, then engraved and the design filled with blacking. It is decorated with the coat of arms of the owner, the date, and scrolling leaves.

industry was centered in Paris and, through the medium of ivories, the French Gothic style was disseminated far and wide. The great sculptor Giovanni Pisano used a French ivory as a model for his large Madonna and Child of 1299 in the Cathedral of Pisa, and artists throughout Europe followed the taste of Paris, imitating both the subjects and technique of Parisian ivories. The question of the source of this sudden abundance of ivory has been little investigated, partly because records of trade in ivory do not exist. The material had to pass through the territories of the Mamluk Dynasty in Egypt, which completely dominated the African coast along the Mediterranean during this period. The Mamluks were both seafarers and great traders, and it is apparent that they sold ivory in exchange for European gold and goods. Whether the ivory was usually carried to France in Arab vessels or Venetian ones is still unclear, but Alexandria and Tunis were the most probable ports for ivory shipment. A rare entry on the subject in the Datini papers in Venice shows the purchase of nine pounds of ivory on 22 September 1401. It was acquired by a Venetian at Alexandria and shipped in a Venetian vessel that was carrying cotton, pepper, and other spices.[1]

With the rise of the Ottoman Turks, who began their conquests in the thirteenth century and eventually defeated the Mamluks in 1517, the trade in ivory diminished. The Ottomans, who were not a maritime people, evidently did not encourage such trade, and, by the early fifteenth century, ivory had practically disappeared from the European scene to be replaced by bone for the duration of the century. Finally, in the sixteenth century, the material virtually vanished as a medium for works of art.

The use of ivory was revived in the seventeenth century by Baroque artists in both Italy and Germany, and in the eighteenth century it continued to be employed for many purposes, including snuffboxes, portrait sculpture, and knife handles. By the nineteenth century, most ivory was used not for works of art but for billiard balls, piano keys, knife handles, and mirror- and brush-backs. Only fine, large tusks could be used for billiard balls, which were made mostly in London; the fragments that were left over were resold for other uses. In the nineteenth century the trade in ivory was enormous, with one thousand tons each reaching the ports of Antwerp and London every year. India and other Eastern countries, like Japan, used considerable quantities of ivory for furniture inlay, small carvings, and netsuke, uses that continue to this day.

In the modern world, plastic has been substituted in the manufacture of piano keys and buttons, stainless steel has become universal for knife handles, and billiard balls are made of composition material. Today, while countries have outlawed the use of ivory to protect the elephant, a certain quantity of this beautiful material still reaches the market and is used in traditional ways in India and other parts of Asia.

NOTE

1. E. Ashtor, *Studies on the Levantine Trade in the Middle Ages*, London, 1978, 582.

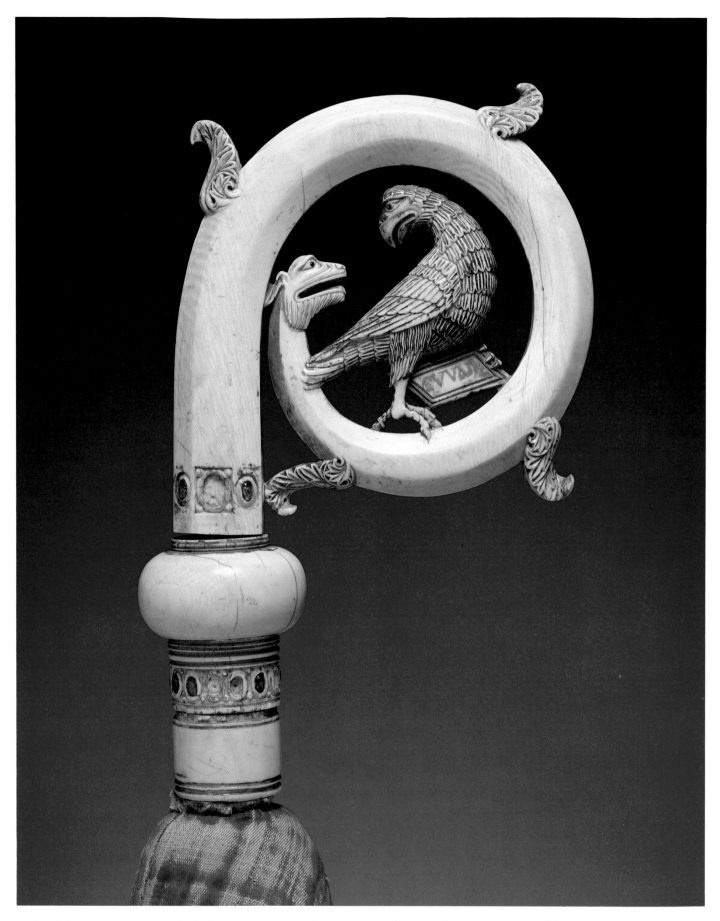

Colorplate I (cat. no. 260). Eagle of Saint John, head of an ivory crozier, Italian(?), 13th century. Because of the large scale of elephant tusks, an object such as this bishop's crozier, 6⅛ inches wide at the greatest width, could be achieved from solid ivory.

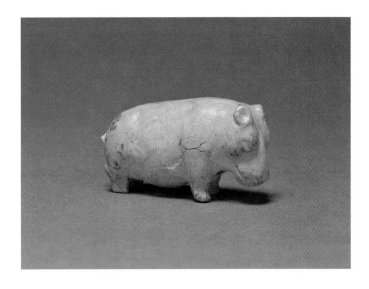

Colorplate 2 (cat. no. 18). Figurine of a hippopotamus, hippopotamus ivory, Egyptian, mid-5th millennium B.C. This extraordinary piece, which is less than two inches long, manages to convey the heaviness and power of the beast from whose tusks most Egyptian ivories were made.

Colorplate 3 (cat. no. 2). "Concubine" figurine, hippopotamus ivory, Egyptian, Middle Kingdom, 2040–1786 B.C. The figure is nude except for a belt and necklace. A headdress would have been attached.

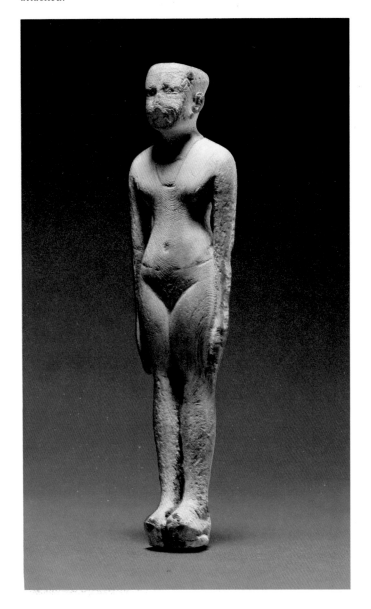

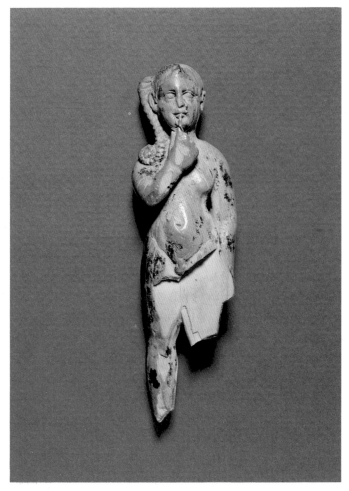

Colorplate 4 (cat. no. 9). Figurine of Horus-the-Child, hippopotamus ivory, Egyptian, Ptolemaic period, 4th–1st century B.C. The statuette, which represents the god Horus-the-Child, called Harpocrates by the Greeks, shows the persistence of Egyptian style even under Greek influence, betrayed here in the eyes and hair.

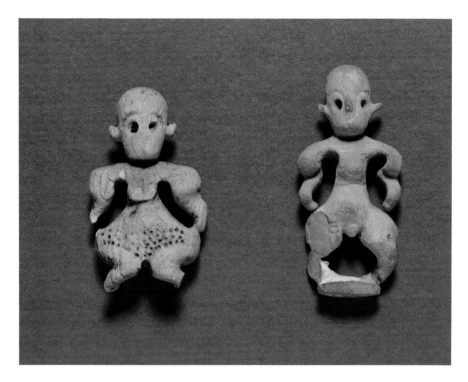

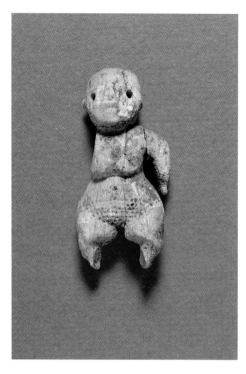

Colorplate 5 (cat. nos. 12 and 13). Figurines of dwarfs, hippopotamus ivory, Egyptian, Predynastic period, mid-4th millennium B.C. The amusing couple reflects the Egyptians' fondness for dwarfs and Pygmies.

Colorplate 6 (cat. no. 14). Figurine of female dwarf, hippopotamus ivory, Egyptian, Predynastic period, mid-4th millennium B.C. Only the head of this female dwarf is stylized in this typical representation of a favorite subject of the period.

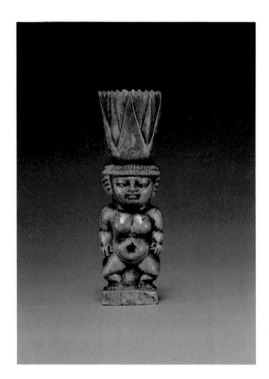

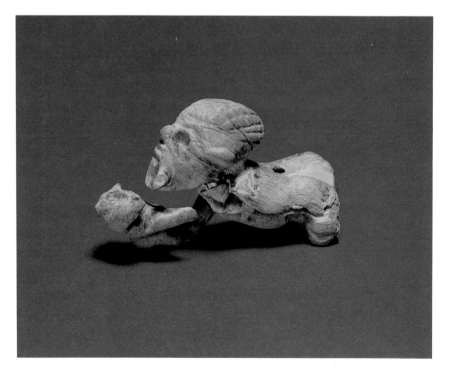

Colorplate 7 (cat. no. 17). Figurine of female dwarf, bone, Egyptian, Predynastic period, mid-4th millennium B.C.(?) This elegantly carved figure of a dwarf carries a large lotus blossom on her head, inside of which the calyx of the flower is represented.

Colorplate 8 (cat. no. 15). Figurine of male dwarf and child, hippopotamus ivory, Egyptian, Predynastic period, mid-4th millennium B.C. This representation of a dwarf on hands and knees playing with a baby is unique. The well-executed piece shows the Egyptian artist freed of the usual conventions governing images of human figures.

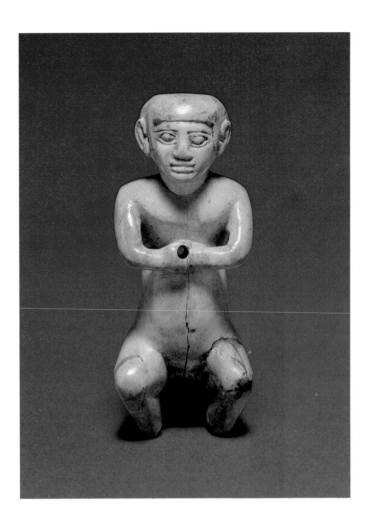

Colorplate 9 (cat. no. 16). Mechanical toy(?), hippopotamus ivory, Egyptian, Old Kingdom, 2680–2258 B.C.(?) The figure of a dwarf with legs bent as if dancing may have been part of a mechanical toy such as the one illustrated in figure 11.

Colorplate 10 (cat. no. 32). Ointment box, hippopotamus and elephant ivory and bone, Egyptian, New Kingdom, 1580–1085 B.C. This very typical and popular container had the wings doweled on so that they could open to expose a pocket for cosmetics.

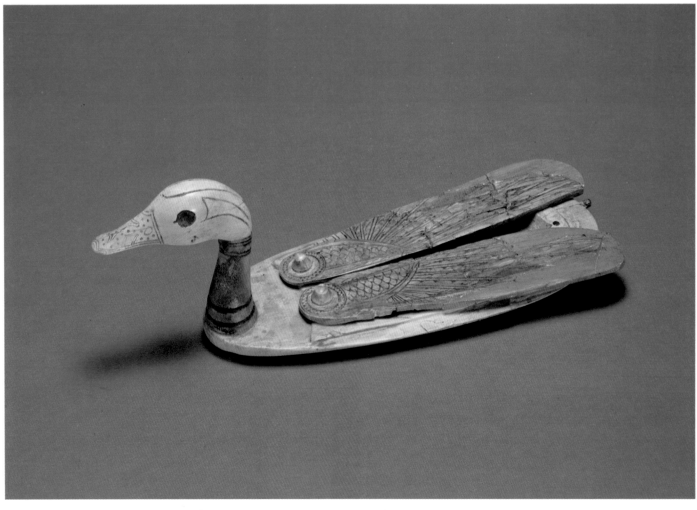

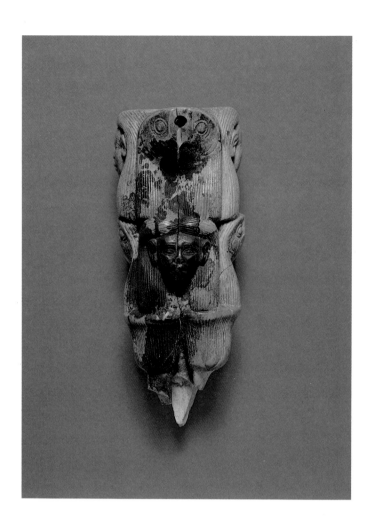

Colorplate 11 (cat. no. 37). Mirror handle, hippopotamus ivory, Egyptian, date unknown. This complex design of heads set on freestanding papyrus stalks is very unusual. The falcon represents the great god Horus.

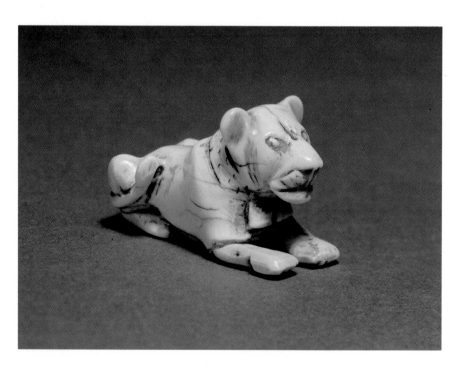

Colorplate 12 (cat. no. 20). Game piece, hippopotamus ivory, Egyptian, 1st Dynasty, 3200–2980 B.C. One of a set of three lions and three lionesses used in a game played on a round board with a coiled serpent on it. Representations of the game board and pieces are found in tombs of the period.

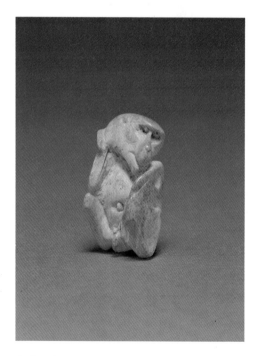

Colorplate 13 (cat. no. 25). Game piece, bone, Egyptian, 900–700 B.C. The piece has been carved very cleverly to look like a knucklebone that has been turned into a seated monkey.

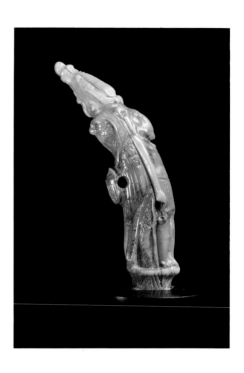

Colorplate 14 (cat. no. 45). Amulet, canine tooth, Egyptian, Merotic, 9th century B.C.(?) The finely executed pendant intertwines a variety of magical figures to protect the wearer.

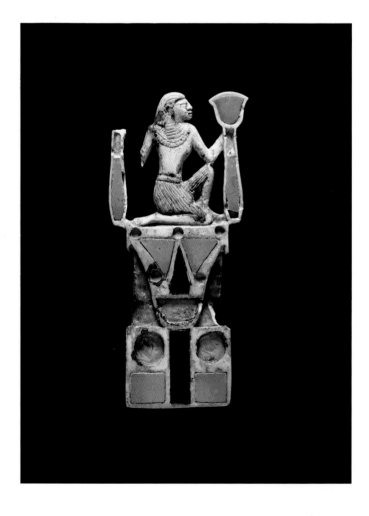

Colorplate 15 (cat. no. 39). Plaque, hippopotamus ivory(?), blue faience and black semiglassy faience, Egyptian, date unknown. The delicate human figure is carved on both sides of this thin plaque.

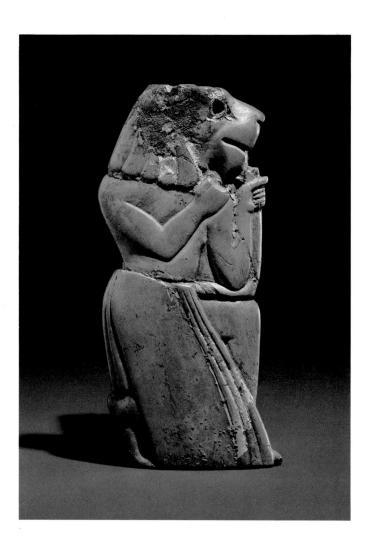

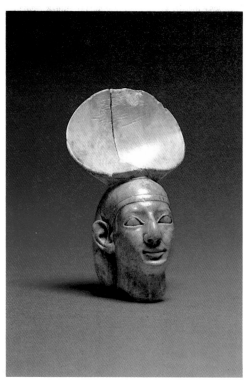

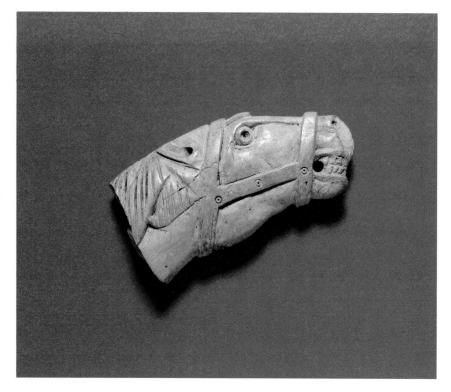

Colorplate 16. Plaque, ivory and gold, Hittite, c. 19th century B.C. This example of the earliest ivories from Anatolia (Turkey) represents a local adaptation of the Egyptian lion-headed deity. The Metropolitan Museum of Art, New York, Gift of Mrs. George D. Pratt in memory of George D. Pratt, 1936.

Colorplate 17 (cat. no. 35). Tip of a horn vessel, hippopotamus ivory, Egyptian, New Kingdom, 1580–1085 B.C. This exquisite representation of a Syrian type was used as the tip of a horn-shaped vessel for ointment.

Colorplate 18 (cat. no. 54). Horse head, hippopotamus ivory handle of a knife or implement, Parthian, 2nd–3rd century A.D. The horse's head was often employed as the terminal of the grip of a small knife or dagger worn in the belt. The tradition extended from Assyrian times to the modern era, and is seen in many jade and ivory dagger grips made in Mughal India in the seventeenth and eighteenth centuries.

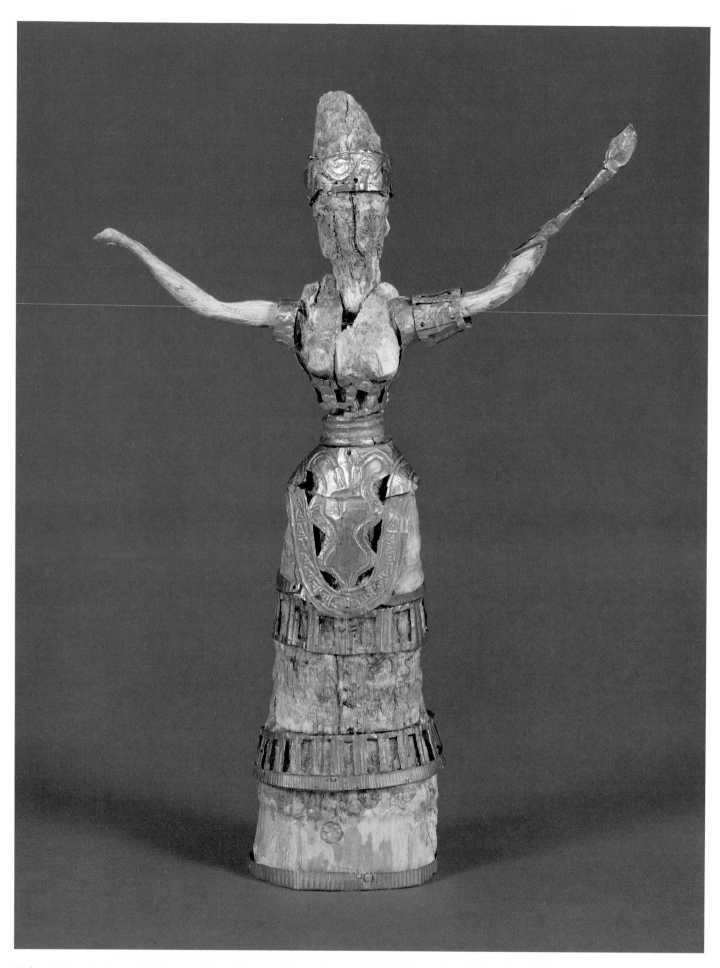

Colorplate 19 (cat. no. 56). Statuette of a goddess or priestess, ivory and gold, Cretan, Late Minoan I period, 16th century B.C. The figure raises her arms—one is now missing—which were once entwined with snakes, symbols of her holy office. Similar figures in faience were found in the excavations of the Palace of Knossos in Crete.

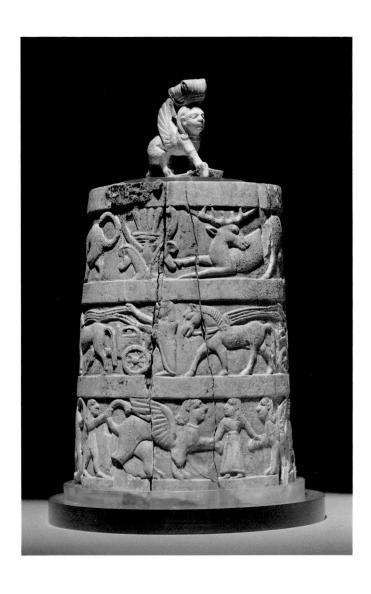

Colorplate 20 (cat. no. 57). Pyxis (cylindrical box), ivory, Etruscan, 650–625 B.C. The box is carved from the hollow end of an elephant's tusk and was used in daily life for precious objects of the boudoir like jewelry or scent. Personal possessions recovered from tombs are among the most numerous ivories surviving from antiquity.

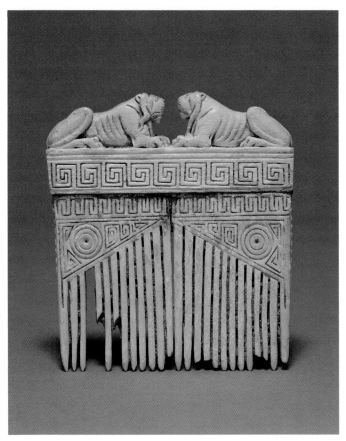

Colorplate 21 (cat. no. 58). Comb, bone, Etruscan, after 500 B.C. The comb is ornamented with lions, animals that were probably never seen by the Etruscan who owned it. Like the related fantastic beasts— griffins, sphinxes, sirens—they recall the exotic Eastern lands that spawned them.

Colorplate 22 (cat. no. 60). Bust of Alexander the Great, ivory, Greek, late 4th–3rd century B.C. The personality of Alexander, as represented by the great artists of the day, became a powerful image in the Hellenistic period and inspired a host of smaller representations in the decorative arts. This example once ornamented a couch.

Colorplate 23 (cat. no. 61). Furniture inlay with satyr's head, ivory, Greek, Hellenistic period, 2nd century B.C. Ivory-inlaid couches, admired by classical writers, scorned by Early Christian moralists, were a sign and symbol of luxury in the ancient Greek and Roman worlds.

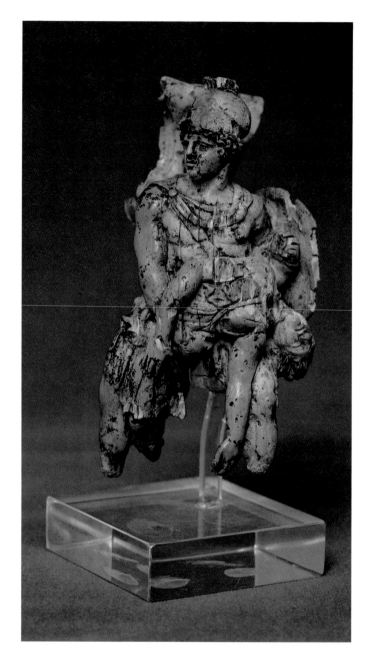

Colorplate 24. Furniture decoration with Achilles and Penthesilea, ivory, Greek, 1st century B.C. The Greek hero of the Trojan War Achilles supports the dying Amazon queen Penthesilea in a miniature sculpture modeled after a large-scale work of art. Nelson-Atkins Museum of Art, Kansas City, Missouri, Nelson Fund.

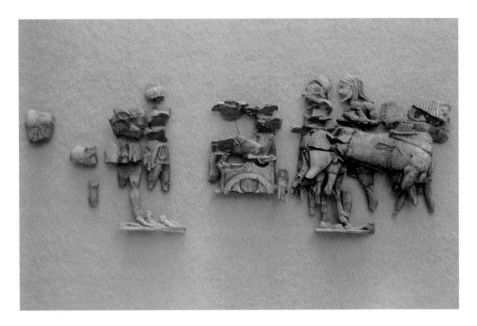

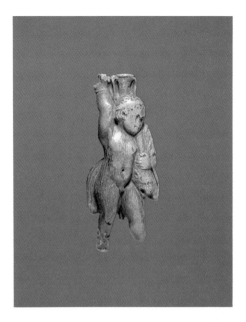

Colorplate 25. Relief from a box found at Delphi with the departure of a warrior by chariot, ivory, Greek, 6th century B.C. Ivory reliefs with narrative or mythological subjects recall Pausanias' description of the famous chest of the Cypselid kings of Corinth. Delphi Archaeological Museum (Excavations of the French School).

Colorplate 26 (cat. no. 64). Eros as the child Herakles, ivory statuette, Greek, Hellenistic period, 3rd–2nd century B.C. Ivory sculpture in the round is rare in the Hellenistic period, and while this figure was made to be attached to a piece of furniture or a box, it is treated in three dimensions. The fine modeling and attention to detail are noteworthy. Eros is wearing the lion's skin, symbol of Herakles, and is carrying an amphora on his shoulders.

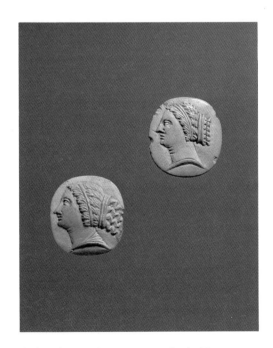

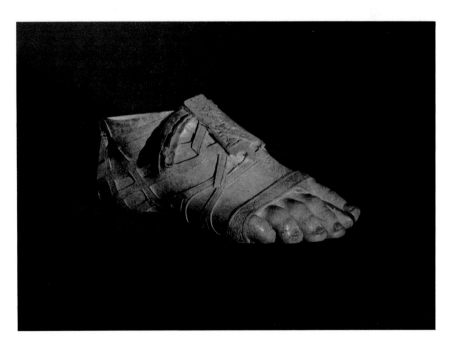

Colorplate 27 (cat. nos. 62 and 63). Two rings, bone, Greek, Hellenistic period, 3rd century B.C. Profile images of the queens of Egypt, here perhaps Arsinoë III, demonstrate the allegiance of the wearer to the royal family.

Colorplate 28. Sandaled foot, ivory, Roman, 1st century. This half-life-size representation of a sandaled foot probably came from a statue of a god or ruler whose face, hands, and feet were rendered naturalistically in ivory. The clasp on the sandal shows a personification of the Nile, a river god seated on a sphinx. The Metropolitan Museum of Art, New York, Gift of John Marshall (25.78.43).

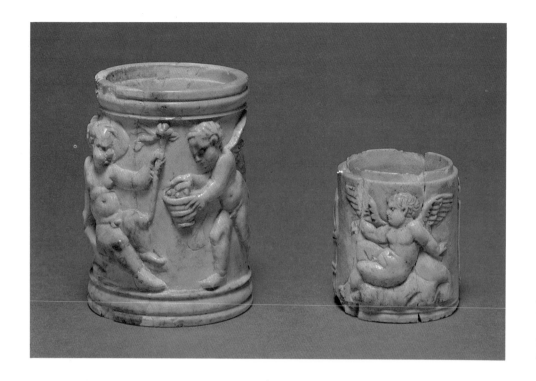

Colorplate 29 (cat. nos. 71 and 72). Pyxides with Erotes, bone, Roman, 1st century. Similar boxes have been found at Pompeii and elsewhere around the Mediterranean.

Colorplate 30 (cat. no. 75). Panel from a box with cupids, ivory, Roman, 2nd–3rd century. The subject matter and style of this relief, made in a Western workshop, recall large-scale sculpture.

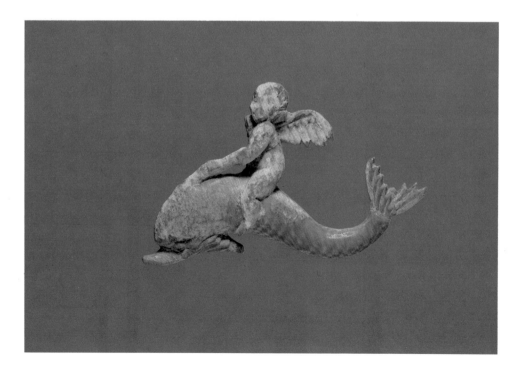

Colorplate 31 (cat. no. 81). Eros on a dolphin, ivory appliqué, Roman, 1st–2nd century. A favorite subject of both the Greek and Roman worlds, Eros riding the dolphin is rendered with great delicacy. As there are no signs of holes for attachment, it must have been glued to a surface as decoration.

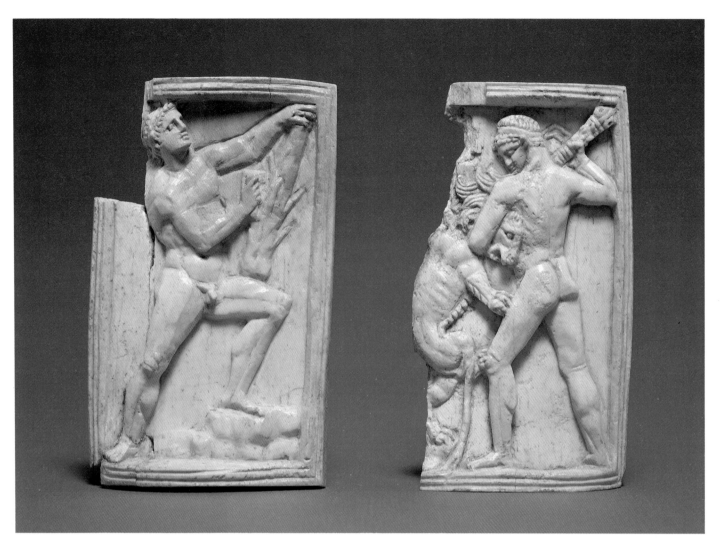

Colorplate 32 (cat. nos. 83 and 84). Scenes of the life of Herakles, bone, Roman, 4th century. The plaques are rare in showing that a box was decorated with a number of sequential scenes of the life of Herakles. The first shows the hero fashioning his club from an olive branch, and the second is his combat with the Nemean Lion.

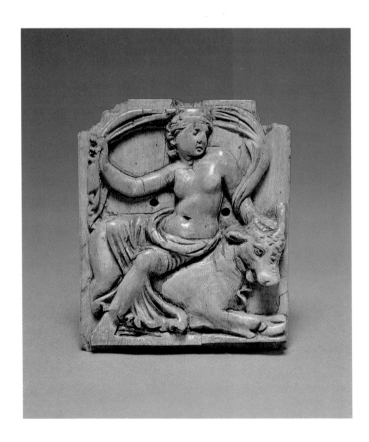

Colorplate 33 (cat. no. 90). Plaque from a box with Europa on the bull, ivory, Roman, 3rd–4th century. Zeus, in the guise of a white bull, abducts Europa, the daughter of the king of Crete, and swims across the sea with her.

Colorplate 34 (cat. no. 91). Plaque from a box with triumphant soldier, ivory, Roman, 4th–5th century. Carved in shallower relief and in a totally different style from the inlays in catalogue nos. 82, 87, and 90, this one shows a warrior standing in front of a trophy of shields.

Colorplate 35 (cat. no. 87). Plaque from a box with Achilles in his tent, bone, Roman, 4th century. Episodes from Greek mythology were a favorite subject for the decoration of Roman boxes.

Colorplate 36 (cat. no. 88). Artemis and Apollo, bone plaque, Roman, 4th century. Artemis, dressed in hunting attire of a short chiton and boots, is seated with Apollo under a grape arbor. Her hound lies between them. The frame and format suggest that this was an inlay for a box or piece of furniture.

Colorplate 37 (cat. no. 82). Box plaque with soldier, bone, Roman, 3rd–4th century A.D. or possibly 1st century B.C. The soldier poses in armorial majesty, wearing a plumed helmet, tunic, and breastplate.

Colorplate 38 (cat. no. 103). Knife handle with boy, ivory, Roman, from Egypt, 2nd–4th century. Carved in the round and attractive from all sides, this handle, perhaps from a fruit knife, is in the form of a little boy clutching a large bunch of grapes.

Colorplate 39. Two horse trappings, bone (cat. no. 106) and ivory (cat. no. 105), Roman, 1st–2nd century. Trappings such as these could have served as ornaments on leather bridles. One (cat. no. 105) shows a lion's face, the other (cat. no. 106) a portrait of Herakles or Alexander the Great in the guise of Herakles.

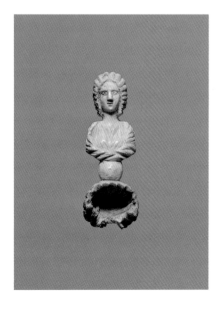

Colorplate 40 (cat. no. 107). Bust of a woman, bone pin, Roman, late 2nd–3rd century. Pins for garments and for hairdressing were often made of ivory or bone. This example can be dated by the female hairstyle, which is that associated with Julia Domna, wife of the emperor Septimius Severus.

2 Ancient Egypt and the Near East

by Jeanny Vorys Canby

IVORY CARVING was indigenous to Egypt. Elephants and hippopotamuses inhabited the Nile Valley in ancient times and early man used the tusks of these animals, as he used bone and shell, for essential tools like fishhooks and spears.[1] When the Egyptians began to decorate their possessions around the middle of the fifth millennium B.C., the special qualities of ivory soon became apparent and objects in this medium are among the earliest Egyptian works of art to survive. The development of many of the basic principles of Egyptian art can be traced in these prehistoric ivories. Human heads were at first added to the tips of tusk pendants, turning them into monklike figures.[2] From these, primitive but lively figurines evolved into formal statuettes displaying the stiff frontality that was to characterize all subsequent Egyptian sculpture (cat. no. 1).[3] Knives and combs were decorated by placing a single figure of a Nile animal on the handle;[4] later, rows of carefully observed animals in relief were used, forming a virtual catalogue of local fauna (figure 8). More complex narrative hunt scenes followed, succeeded finally by symbolic representations of historical episodes.[5] The tradition of ivory carving was highly developed in Egypt before the advent of written history, around 3200 B.C., and was to have a long history there. As life became more complex and comfortable over the centuries, ivory came to be used in a variety of ways to embellish the elegant objects in demand. But in the course of the 1st Dynasty, in about 3000 B.C., ivory served practical purposes. It was used, for example, as a vehicle for writing: small ivory labels with incised or painted inscriptions are the most important extant source of written history for these early times.[6]

Elephants are believed to have retired to the south of Egypt proper by the late fourth millennium B.C.,[7] after which time tusks had to be imported from this region. For this reason, although they are shown in rows of local fauna on prehistoric Egyptian ivories, elephants never became an important subject in Egyptian art or a part of Egyptian animal symbolism. The hippopotamus, however, whose tusks were extensively used for ivory carving,

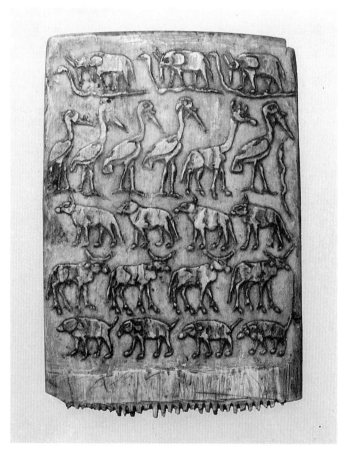

Figure 8. Comb, ivory, Egyptian, Late Predynastic period, 4th millennium B.C. The rows of local animals include elephants, which disappeared from Egypt after this period. The Metropolitan Museum of Art, New York, Theodore M. Davis Collection, bequest of Theodore M. Davis, 1915.

had a long and important career in Egyptian art. This impressive and dangerous animal, which moves swiftly despite its size, continued to inhabit the Nile River, the center of Egyptian life. Artists frequently represented it, always with great respect. A tiny representation in the Walters Art Gallery (cat. no. 18; see colorplate 2) probably dates to the mid-fifth millennium B.C.,[8] the earliest

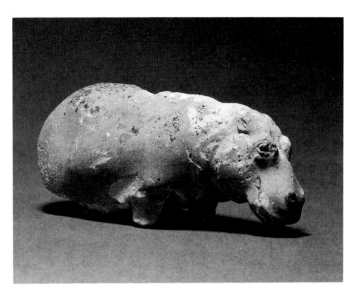

Figure 9. Figurine, limestone, Egyptian, Middle Kingdom, 2040–1786 B.C. This hippopotamus is a fine example of small representations of the animal typical in this period. Walters Art Gallery (22.138).

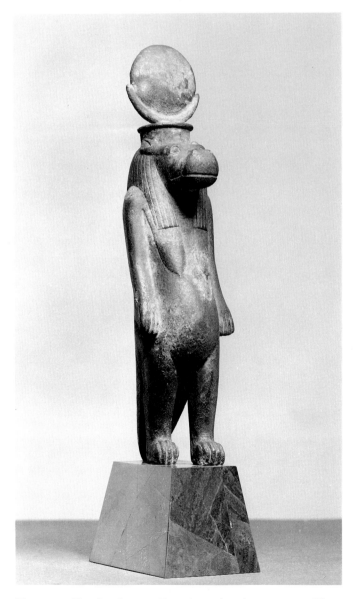

Figure 10. Figurine, bronze, Egyptian, 7th–4th century B.C. The figure represents the hippopotamus goddess Tweret, patroness of the home and women in childbirth. Walters Art Gallery (54.2067).

period of Egyptian ivory carving. The short feet, heavy body, and bulging eyes reflect careful observation of the subject. Even on this scale the artist has taken pains to suggest the beast's great power. Masterful representations continued to be made in Egypt in later periods (figure 9). The hippopotamus also had a place in religion in Egypt: the goddess Tweret could take the form of a hippopotamus. Patroness of the home and of women in childbirth, she is shown standing upright with pendulous breasts and crocodile tail (figure 10 and cat. no. 47).

Since we know from pieces such as the hippopotamus represented in colorplate 2 (cat. no. 18; see also cat. no. 20) that the artists of this early period had the capacity to capture natural forms, the stylization of contemporary human figures is striking. Figurines of nude, often steatopygous, women occur in almost all early cultures. They are usually thought to represent a mother goddess, connected in some way to fertility cults. In the same period in which the hippopotamus was made, a slender version of the figurine type[9] was created in Egypt, one which continued to appear in later prehistoric times (see cat. no. 1). Although well shaped, these figurines are stiff and frontal, with round eyes and ears that protrude unnaturally. For magical or religious reasons the carver seems to have been reluctant to treat the human figure with the same naturalism with which he treated animals, a dichotomy that endured in Egyptian art.

The "fertility" figures of primitive times reappear, somewhat surprisingly, in the sophisticated, highly civilized Middle Kingdom (2040–1786 B.C.). Within the long-established canon for such figures the Egyptian ivory carver made many charming individualized pieces (for example, cat. no. 2; see colorplate 3). Although many believe that they represent concubines,[10] it has also been argued[11] that the figures were included in tombs for ritual purposes to serve as one of several means to revive the dead person's physical, in this case procreative, powers in the next world. This theory would relate the figures to the cult of the god of the dead, Osiris, who fathered a child posthumously, as well as to magic rites intended to assure the continuation of the family line.

Small-scale statues, in which the spirit of the deceased could live eternally, were occasionally made of ivory. The elegantly dressed Middle Kingdom man (cat. no. 8), shown in the prime of youth, is a good example of the type. Ivory figurines of deities were also sometimes made (cat. no. 9; see colorplate 4).

Figures of dwarfs were occasionally excepted from the rigid canons governing the representation of the human figure. In prehistoric times they appear in ivory with characteristic short, misshapen limbs carefully rendered in stylized fashion (cat. nos. 12 and 13; see colorplate 5). Other dwarfs in the same period are more naturalistically rendered, for example the plump woman (cat. no. 14; see colorplate 6). Here stylization is limited to the head where tiny round eyes were once inlaid.[12] The exquisite little figure of a female dwarf (cat. no. 17; see colorplate 7) is unusual and probably dates from the fourth

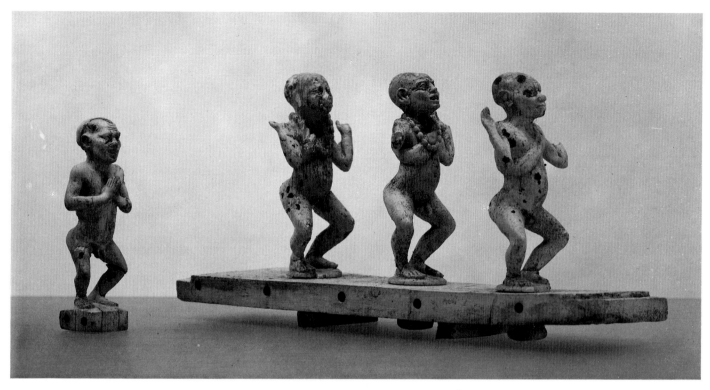

Figure 11. Mechanical toy, ivory, Egyptian, 12th Dynasty, 1991–1786 B.C. This toy, in which the Pygmies could be twisted as if dancing, was found in a tomb at Lisht, and is now in the Metropolitan Museum of Art. Three other pieces are in the Cairo Museum.

millennium B.C. The remarkable figurine of a dwarf sprawled on the ground balancing a baby (cat. no. 15; see colorplate 8), thought to date from the Prehistoric period, shows none of the restraints that usually governed Egyptian sculpture. The complexity of the pose, the distorted shape of the dwarf, and the soft forms of the child are freely and realistically handled. By contrast, a dwarf, possibly of the Old Kingdom (2680–2258 B.C.; cat. no. 16; see colorplate 9), which is probably part of a mechanical toy (see, for example, figure 11), is treated more formally. He has the typical bland, cheerful face of contemporary sculpture. There are a number of ancient Egyptian representations of dwarfs, who are known to have danced in religious ceremonies.[13] Tomb statues of dwarfs from the Old Kingdom,[14] one with a normal-sized wife, suggest that some of them were members of the Egyptian upper class.

In the hot, dry climate of ancient Egypt moisturizing ointments and eye shadow were real necessities to protect from the glare of the sun. Containers for these preparations are found from the earliest times. The little bone spoon (cat. no. 27) may have been an applicator for kohl (eye shadow), which was kept in tiny ivory imitations of everyday vessels,[15] such as catalogue nos. 29 and 30. The Egyptian craftsman's designs for ointment containers are wonderfully imaginative.[16] The wings of the duck of the New Kingdom (1580–1085 B.C.; cat. no. 32; see colorplate 10), seen skimming along the surface, separate to expose a hollow for the cosmetics. Heavy jars carried on the shoulders of Syrian tribute bearers were similarly scooped out to hold cosmetics (cat. no. 31). Boxes were made

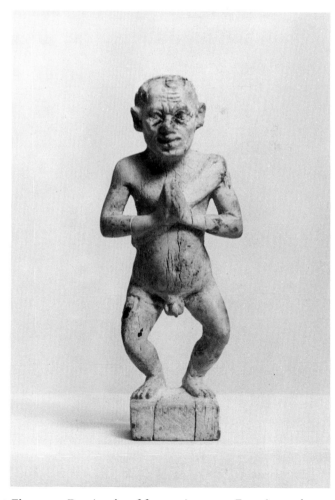

Figure 12. Dancing dwarf from an ivory toy, Egyptian, 12th Dynasty, 1991–1786 B.C. The Metropolitan Museum of Art, New York, Museum Excavations 1933–1934, Rogers Fund, 1934.

that could hold several different types of kohl at once (cat. no. 36).

Cosmetics used to improve the appearance were applied with the aid of mirrors. Many mirrors—and illustrations of mirrors—have been found from ancient Egyptian times.[17] The round reflecting surface of the mirror was normally bronze, more rarely silver, and the handles often ivory. The handles were frequently carved in the shape of nude girls (cat. no. 38), although it was not unusual for them to display more complex designs. Catalogue no. 37 (see colorplate 11), for example, places alternating heads of the sky god Horus and the goddess Hathor (patroness of cosmetic arts) on papyrus fronds whose slender stalks form the handle proper.

Among the age-old uses of ivory is the making of game pieces. Many of the Egyptian games were played with small figures of animals, such as the lioness (cat. no. 20; see colorplate 12) and the dog (cat. no. 21). One piece for a game of knucklebones is cleverly carved as a seated monkey (cat. no. 25; see colorplate 13).

Ivory was also used to inlay jewelry and to make small-figured pendants. The apotropaic amulet (cat. no. 45; see colorplate 14), in which myriad animal forms are combined to ward off evil, is a masterpiece. Ivory was extensively used for inlays in cabinetmaking, where the color could be contrasted with that of other materials. Occasionally ivory was inlaid with other substances, as catalogue no. 39 (see colorplate 15) well illustrates.

While most Egyptian ivory objects are designed to disguise the hippopotamus-tusk shape, some peculiarly Egyptian types retain it, as if to remind the user of the animal that provided the ivory. An example is the pair of clappers made of a tusk split down the middle (cat. nos. 46a, b). The clappers are carved to suggest human arms; on the end of one outside surface a right hand is carved, on the other, a left hand. They were clapped together during songs and dances;[18] modern experiments have shown that ivory can withstand such use.[19] The curve dictated by the natural shape of the tusk, although not much resembling a human arm, is retained even in clappers made of other materials. This suggests that the connection between the instrument and the hippopotamus may have had some profound significance. Magic knives of the Middle Kingdom (cat. no. 47; figure 13) also retain the curve of the hippopotamus tusk. They probably derive from real knives of earlier times.[20] The hippopotamus goddess Tweret mentioned above (see figure 10) appears on these knives together with other imaginary hybrid creatures to protect the owner from a variety of dangers. The worn points of these knives suggest that they were used to draw magic circles around areas in need of protection. Retaining the tusk shape may have increased the potency of the object.

Near-Eastern Ivories

The highly developed tradition of ivory carving in Egypt had a great influence on the rest of the ancient world. The Near East was to be the home of several important ivory carving schools which occur only sporadically, which is puzzling since some evidence indicates that elephants roamed the upper and middle Euphrates River area of north Syria until the eighth century B.C. Ancient Egyptian texts of the fifteenth century B.C. tell

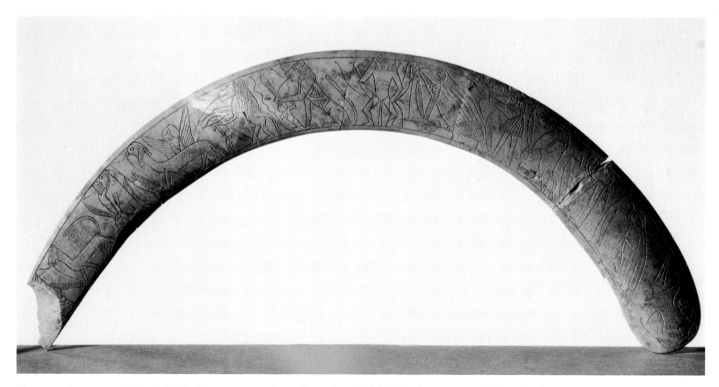

Figure 13 (cat. no. 47). Magic knife, hippopotamus ivory, Egyptian, Middle Kingdom, 2040–1786 B.C. Such knives with a host of strange beings and gods were used to protect various parts of the home.

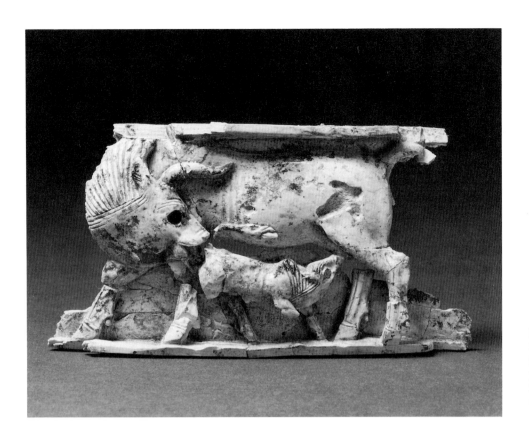

Figure 14. Cow and calf, ivory, north Syrian, 8th century B.C. One of the ivories found in the great Assyrian palaces at Nimrud, it was probably a furniture inlay, and was originally covered with gold. Walters Art Gallery (71.1170).

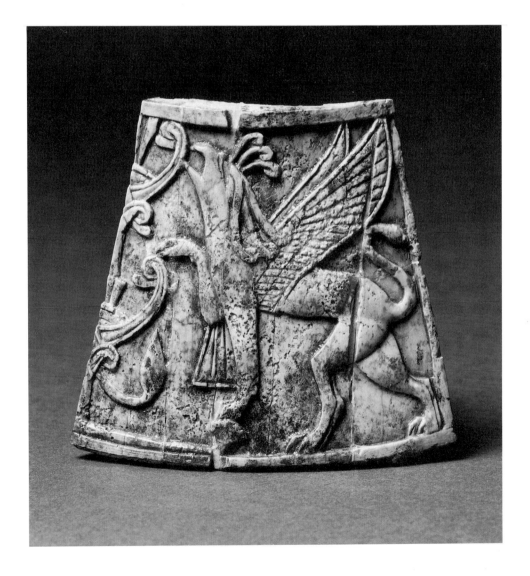

Figure 15. Griffin and sacred tree, ivory plaque, north Syrian, 8th century B.C. A furniture inlay from the site of Nimrud with the subject that was so often represented in large-scale stone sculpture. Walters Art Gallery (71.1171).

of the Egyptian pharaoh, Thutmose III, hunting a herd of 120 elephants near Aleppo. Tomb paintings of the same period show Syrians bringing elephants as gifts to the Egyptian ruler. There are records that the Assyrian kings Tiglath-pileser I in the eleventh century B.C. and Ashurnasirpal II in the ninth hunted elephants in this same area.[21] These kings regularly received tusks and hides as well as elephants as tribute from Syria. Yet ancient texts inform us[22] that the Sumerians of Mesopotamia (modern Iraq), who had been in contact with Syria from very early times, received ivory and ivory objects (combs, breastplates, boxes, inlaid pieces of furniture, and spoons) in the late third millennium B.C. from another source: the island of Dilmun (modern Bahrain) in the Persian Gulf. Dilmun's source for tusks may have been Egypt, but it could also have been India.[23] Indus Valley objects, among which are seals with an elephant design, were found in Mesopotamia in levels of even earlier periods (twenty-fourth–twenty-third centuries B.C.),[24] showing that India and Mesopotamia were already in indirect contact at that time. If elephants (thought to be a subspecies of Indian elephant) were indigenous to the Near East, it is difficult to understand why ivory was used only infrequently there. One recent theory attempts to explain the conflicting evidence by suggesting that the elephants were not native to the Near East but were imported periodically in herds from India.[25] Expert reexamination of ivory objects from early excavations may eventually reveal the sources of the material used in the Near East. All that can be said now is that the existence of elephants in north Syria apparently did not foster a strong tradition of ivory carving in the Near East.

Extensive ivory carving is not attested in the Near East until after the fifteenth century B.C., which, significantly, is precisely when Egypt extended her empire into Syria. Most earlier ivories also come from periods when contact with Egypt is probable. Excavations of ivory carvers' workshops at Abu Matar and Safadi near Beersheba in Palestine have produced a spectacular group of ivory figures dating to 3500 B.C.[26] These wonderfully stylized human figures have eyes carved out for inlay and holes made for the attachment of hair and beards. They strongly resemble, although they are not identical to, the somewhat earlier Predynastic[27] figures from Egypt, such as catalogue no. 1. This Palestinian workshop, however, appears to have had no successors.[28] Only a few ivories dating to the later third millennium B.C. have been found at Sumerian centers: at Mari on the middle Euphrates, Assur[29] on the upper Tigris, and Kish on the lower Tigris.[30] The Walters ivory plaque (cat. no. 48) may be of the third millennium B.C. If it is, it would provide extremely important additional evidence for the use of ivory at this time. A brilliant ivory tradition appeared in Anatolia (modern Turkey) in the early second millennium B.C.[31] and continued to the fall of the Hittite Empire (c. 1200 B.C.). In its later phase it became entirely Hittite in style; in its initial stages, motifs such as sphinxes and lion-headed demons

(a variation of the Egyptian goddess Sakhmet)[32] clearly indicate significant Egyptian influence (see colorplate 16).

In the Late Bronze Age (sixteenth–twelfth centuries B.C.) Egyptian ivories and other luxuries were exported to the Near East.[33] Cosmetic containers almost identical to the Egyptian duck (cat. no. 32; see colorplate 10) have been found at Megiddo[34] in Palestine, at Minet-el-Beida, a port on the north Syrian coast,[35] and at Atchana farther inland.[36] Local ivory carving began to develop. Artists copied and adapted Egyptian motifs, adding iconographical elements from their own repertoires. In Assyria,[37] as in Anatolia, a more independent school developed. The international character of the age makes some ivories difficult to classify. The exquisitely carved Walters head (cat. no. 35; see colorplate 17) is probably an Egyptian representation of a Syrian. The unusual band on the back of the wig, however, if taken as a misunderstanding of the Egyptian headdress, could mean that the piece is an exceptionally fine Syrian copy of an Egyptian type of object. Excavations have shown that ivory was widely used. This is particularly evident from the investigation of the palace of Ugarit in north Syria where furniture with ivory inlay was found in situ.[38] These developments form the background of the Near Eastern schools that were to proliferate in the Iron Age.

King Solomon's ivory throne,[39] Ahab's "house of ivory,"[40] and the city of Tyre's "decks" inlaid with ivory[41] have been known for millennia from Old Testament references, but it is only since the middle of the last century that we have been able to imagine their appearance. With Sir Austen Henry Layard's discoveries in the 1840s in the huge Assyrian palaces of Nimrud (ancient Calah) of rooms full of ivory inlays for furniture, horse trappings, and a variety of other objects, it became clear why biblical writers used such images as metaphors for luxury. These pieces display a rich variety of exotic motifs drawn from Egyptian and local traditions. The style was originally attributed to the Phoenicians, whose traders were known to have transferred Oriental motifs to Greece. However, Richard Barnett's[42] close study of the ivories brought from Nimrud to the British Museum in the nineteenth century suggests the existence of various schools of carving. New excavations at Nimrud[43] and elsewhere, and further differentiation of stylistic groups,[44] have led to the conclusion that at this time most of the major cultural centers of the Near East had their own styles of ivory carving. Far to the west a Phrygian school of carving has been discovered in central Turkey.[45] To the east yet another has been located in the powerful ancient kingdom of Urartu (Armenia).[46] Here composite statues of the local god made of bronze, gold, and ivory were popular (for example, cat. no. 53). Egyptian influences finally dwindled in these distant schools where ivory carving became infused with vigorous local elements. Whatever foreign motifs do exist were now primarily derived from the great centers of Assyria.

1. W. Hayes, *Most Ancient Egypt*, ed. K. C. Seele, Chicago, 1964, 110–111.

2. See Staatliche Museen, Berlin, *Ägyptisches Museum, Berlin*, 1967, figs. 38, 61.

3. Capart, *Primitive Art in Egypt*, 159, fig. 122; Emery, *Archaic Egypt*, pl. 30b; from Abydos in the British Museum, see W. M. Petrie, *Abydos, Part II, 1903*, Egypt Exploration Fund Memoir, XXIV, London, 1903, pl. 13.

4. *PKG* XIII, pls. 198a,b.

5. E.g., *PKG* XIII, pls. 206a, b, 210a, b; H. J. Kantor in *ibid.*, fig. 22 (246), fig. 24 (248); Emery, *Archaic Egypt*, pl. 1a.

6. Emery, *Archaic Egypt*, 44 ff., 59, 86, 194, 230; see Staatliche Museen, Berlin, *Ägyptisches Museum, Berlin*, 1967, nos. 161, 164–166.

7. *Scepter I*, 16, 226.

8. See the very close excavated example *PKG* XIII, pl. 189, from Mostagedda, Badarian culture (in the British Museum).

9. See *PKG* XIII, pl. 192b, from Badari, in the British Museum.

10. These did exist, even in the monogamous world of ancient Egypt. See *Scepter I*, 219; see also J. H. Breasted, Jr., *Egyptian Servant Statues*, Bollingen Series, XIII, Washington, D.C., 1948, 93–97.

11. Ch. Desroches-Noblecourt, "'Concubines du mort' et mères de famille au Moyen Empire, à propos d'une supplique pour une naissance," *Bulletin de l'institut français d'archéologie orientale*, LIII, 1953, 7–47.

12. For another example, see *PKG* XIII, pl. 193b, and Ucko.

13. See *Scepter I*, 129, and A. Lansing in *BMMA* Egyptian Supplements, Nov. 1934, 33 ff.

14. C. Aldred, *Old Kingdom Art in Ancient Egypt*, London, 1949, 37, pls. 52 and 53 (from Cairo Museum).

15. See Emery, *Archaic Egypt*, 208, no. 2, fig. 122; 217, no. 29, fig. 125, for shapes in other media.

16. See Vandier, d'Abbadie.

17. C. Lilyquist, *Ancient Egyptian Mirrors from the Earliest Times through the Middle Kingdom*, Münchner Ägyptologische Studien, XXVII, 1979.

18. See C. Ziegler, in *Egypt's Golden Age: The Art of Living in the New Kingdom, 1558–1085 B.C.*, Museum of Fine Arts, Boston, 1982, 261–262.

19. C. Ziegler, *Catalogue des instruments de musique égyptiens*, Musée du Louvre, Département des antiquités égyptiennes, Paris, 1979, 19.

20. *Scepter I*, 248–249; G. Steindorff, "The Magic Knives of Ancient Egypt," *JWAG*, IX, 1946, 41–107.

21. *Nimrud Ivories*, 163–168.

22. A. L. Oppenheim, "The Seafaring Merchants of Ur," *Journal of the American Oriental Society*, LXXIV, 1954, 11–12.

23. C. C. Lamberg-Karlovsky, "Dilmun: Gateway to Immortality," *Journal of Near Eastern Studies*, XLI, 1982, 44–50, esp. 45, n. 3; *idem*, "Trade Mechanisms in Indus-Mesopotamian Interrelations," *Journal of the American Oriental Society*, XCII, 1973, 222–230.

24. From Akkadian levels at Tell Asmar, see H. Frankfurt, "Tell Asmar Kafaje and Khorsabad, Second Preliminary Report of the Iraq Expedition," *Oriental Institute Communications*, XVI, 1933, 48 ff., figs. 32 and 33.

25. D. Collon, "Ivory," *Iraq*, XXXIX, 1977, 219–222.

26. *PKG* XIII, color pls. 21 and 22; pls. 122, 125, 125a, c; J. Perrot, "Statuettes en ivoire et autres objets en ivoire et en os provenant des gisements préhistoriques de la région de Beersheba," *Syria*, XXXVI, 1959, 8–19; *idem*, "Les ivoires de la campagne à Safadi près de Beersheba," *Eretz Israel*, VII, 1963, 92–93.

27. See *PKG* XIII, pls. 192a, b, 195a, b, Negada I culture 4200–3600 B.C.

28. Except for a small group of bulls' heads, see H. Liebowitz, "The Impact of Sumerian Art on the Art of Palestine and Syria," *The Legacy of Sumer*, ed. D. Schmandt-Besserat (Biblioteca Mesopotamia, IV, ed. G. Buccellati), Malibu, 1976, 89–90, and fig. 1, p. 163, and simple geometric inlays; see *idem*, "Bone and Ivory Inlay from Syria and Palestine," *Israel Exploration Journal*, XXVII, 1977, 89–97.

29. A. Parrot, *Le "Trésor" d'Ur*, Mission archéologique de Mari, IV, Paris, 1968, 18–22, pls. 7a, 8; *idem*, *Le temple d'Ishtar*, Mission archélogique de Mari, I, Paris, 1956, Chapter 4; *idem*, "Les fouilles de Mari douzième campagne, Automne 1961," *Syria*, XXXIX, 1962, 163–169, esp. 169 and pl. 11:2; W. Andrae, *Die Archaischen Ischtar-Tempel in Assur*, Wissenschaftliche Veröffentlichungen der Deutschen Orient-Gesellschaft, XXXIX, Leipzig, 1922, pl. 29a, 55–58. An ivory figurine very Egyptianizing in style has recently been found in levels of the Akkadian period, late third millennium B.C., at Tell Braq in northern Syria, D. Oates, "Excavations at Tell Braq, 1978–1981," *Iraq*, XLIV, 1982, 195, pl. 11.

30. For Kish ivories, see P. R. S. Morey, "Reconsideration of Excavations on Tell Ingharra," 1923–33, *Iraq*, XXIII, 1966, 30; and *idem*, "Cemetery A at Kish, Grave Groups Chronology," *Iraq*, XXXII, 1970, pl. 17, who dates them to the Akkadian period.

31. Especially from Acem Hüyük, see P. Harper, "Dating a Group of Ivories from Anatolia," *The Connoisseur*, Nov. 1969, 156–162; N. Özgüç, "Excavations at Acemhuyok," *Anadolu*, X, Ankara, 1966, pls. 19 and 20, 21:1, 28:2; see also K. Bittel, *Die Hethiter, Die Kunst Anatoliens vom Ende des 3. bis zum Anfang des 1. Jahrtausends vor Christus*, Universum der Kunst, Munich, 1976, figs. 44 and 45, 47, from Acem Hüyük; and figs. 33, 46 for other early ivories; for later Hittite ivories, figs. 174, 187, 248. See also H. G. Güterbock, "Ivory in Hittite Texts," *Anadolu*, XV, 1971, 1–7.

32. See, in particular, Harper, *op. cit.* (n. 31), 157, fig. 3, lower left.

33. A convenient corpus of these ivories, although somewhat out of date, is by C. Decamps de Mertzenfeld, *Inventaire commenté des ivoires phéniciens et apparentés decoverts dans le Proche-Orient*, 2 vols., Paris, 1954, to be used with H. Kantor, "Syro-Palestinian Ivories," *Journal of Near Eastern Studies*, XV, 1956, 153–175; see also G. Loud, *The Megiddo Ivories*, Oriental Institute Publications, LII, 1939.

34. Loud, *op. cit.* (n. 33), pls. 12, 30 (no. 157), 31, 45 (nos. 202–209).

35. *Syria*, XIII, 1932, pls 9:2, 7:2.

36. L. Woolley, *Alalakh, An Account of the Excavations at Tell Atchana in the Hatay*, 1937–1949, Oxford, 1955, 289, pl. 71.

37. W. Andrae, *Das Wiedererstandene Assur*, Leipzig, 1938, pl. 54; A. Haller, *Die Gräber und Grüfte von Assur*, Wissenschaftliche Veröffentlichungen der Deutschen Orient-Gesellschaft, LXV, 135–139, pls. 29, 39 a–c.

38. C. F. A. Schaeffer *et al.*, *Ugaritica IV*, Mission de Ras Shamra, XV, Paris 1962, 30, fig. 22; head, 34–36, figs. 24–26; *idem*, *Syria*, XXXI, 1954, 12, pl. 7.

39. I Kings 10:18.

40. I Kings 22:39.

41. Ezekiel 27:6.

42. *Nimrud Ivories*; see now *idem*, Ancient Ivories in the Middle East, *Qedem*, Monographs of the Institute of Archaeology, Hebrew University of Jerusalem, XIV, 1982 (not available at time of writing).

43. M. E. L. Mallowan, *Nimrud and Its Remains*, 2 vols., New York, 1966; J. J. Orchard, *Equestrian Bridle-Harness Ornaments*, Ivories from Nimrud, 1949–1963, I:2, London, 1967, eds. M. E. L. Mallowan and D. J. Wiseman; M. E. L. Mallowan and L. G. Davies, *Ivories in Assyrian Style*, Ivories from Nimrud, 1949–1963, II, London, 1970; M. E. L. Mallowan and G. Herrmann, *Furniture from SW-7 Fort Shalmaneser*, Ivories from Nimrud, 1949–1963, III, London, 1974.

44. Particularly by I. J. Winter, "Phoenician and North Syrian Ivory Carving in Historical Context: Questions of Style and Attribution, *Iraq*, XXXVIII, 1976, 1–22; *idem*, "Carved Ivory Furniture Panels from Nimrud: A Coherent Subgroup of the North Syrian Style," *Metropolitan Museum Journal*, XI, 1976, 25–54; *idem*, "Is There a South Syrian School of Ivory Carving in the Early First Millennium B.C.?," *Iraq*, XLIII, 1981, 101–130.

45. See Smithsonian Institution, *Art Treasures of Turkey*, Washington, D.C., 1966, figs. 90a–b, 91.

46. *Nimrud Ivories*, pls. 128–131, and *idem*, "The British Museum Excavations at Toprak-Kale," *Iraq*, XII, 1950, 1–43; M. van Loon, *Urartian Art, Its Distinctive Traits in the Light of New Excavations*, Publications of the Nederlands Historisch-Archaologisch Instituut, Istanbul, XX, Leiden, 1966, 131–136; T. Özgüç, *Altin Tepe II, Tombs, Storehouse and Ivories*, Ankara, 1969, 78–93, pls. 32–52.

Catalogue, Ancient Egypt and the Near East

1. FEMALE

Hippopotamus ivory figurine. Egyptian,
Predynastic period, mid-4th millennium B.C.

A female figure stands stiffly, the shaved head slightly raised. The shoulders droop and the hands dangle, the fingers indicated by simple grooves. Large oval depressions indicate the eyes; the top left eyelid is shown. She has a ledgelike left ear, full breasts, and slender hips with well-shaped buttocks. Incised holes mark the pubic triangle and navel.

There are many old breaks and repairs and a light area in line over the left arm and thorax. The lower legs have been broken off.

H: 2¼″ (5.7cm) 71.535

HISTORY: Old label on sticker, 3604; MacGregor Collection, lot 712; purchased from Dikran Kelekian, Paris, 1923.

BIB.: Steindorff, no. 1, pl. 1; Smith, *AAE*, 14, pl. 1a; Ucko, 230, no. 21.

2. "CONCUBINE"

Hippopotamus ivory figurine. Egyptian, Middle
Kingdom, 2040–1786 B.C.

This figure of a girl is nude except for an incised belt and long pendant necklace tied in back. The ears are well shaped, and the incised and modeled eyes have dark pupils. The lower part of the face is chipped off. The figure has broad shoulders, large feet, and a flat chest. The top and back of the head are flat. There are dowel holes for the attachment of a headdress: one at each temple, two on top of the head, and another in back that is filled with dark material. The pubic triangle is marked by incised dots and a line.

H: 5″ (12.7cm) 71.517

HISTORY: Purchased in 1925.

See also colorplate 3

3. "CONCUBINE"

Ivory figurine. Egyptian, early 18th Dynasty(?)

This well-carved figure represents a nude girl wearing an elaborate wig. The hair is pulled across the forehead. Two twisted locks hang in front of the shoulders, and two thick tapering locks, which end in large curls, fall in back. The eyes are heavy lidded. Circular grooves mark the nipples and navel, and there is a ridge under the breasts. There is a groove down the back and under the buttocks. The knees are particularly well modeled. Unfortunately, the surface is flaking.

The face and proportions of the figure resemble those of Ahhotep of the 17th Dynasty, c. 1560 B.C., in the Louvre (*PKG* 15, pl. 172; Vandier, *Manuel*, III, 294).

H: 4⅞″ (11.8cm) 71.505

HISTORY: Purchased before 1930.

4. "CONCUBINE"

Hippopotamus ivory figurine. Egyptian, Middle
Kingdom, 2040–1786 B.C.

A slender girl is represented nude except for a bead necklace, arm rings, and an elaborate wig that ends in curls at the shoulders. Holes on the front, back, and top of the curls, across the top of the head, and down the back of the head were probably used for inlay or for the attachment of hair. The fingernails are indicated on the well-shaped hands. The back of the figure is flat. As is often the case with figures, the lower legs are intentionally cut off.

H: 2¾″ (7.0cm) 71.522

HISTORY: Purchased in 1930.

5. "CONCUBINE"

Bone figurine. Egyptian, Middle Kingdom,
2040–1786 B.C.

This standing nude female figure has sloping shoulders, full low breasts, a large deep navel, and long arms and legs. There is no indication of fingers. The head and feet have been broken off.

H: 2¼″ (5.7cm) × TH: 1¼″ (3.2cm) 71.36

HISTORY: Old label: "I siècle avant J. C."; collection of Grand Duke Nicolas Michaelovitch, St. Petersburg, until 1919; purchased from Léon Gruel, Paris, before 1930.

6. "CONCUBINE"

Bone figurine. Egyptian, Middle Kingdom,
2040–1786 B.C.

This standing female figure has high breasts, a long torso, and very large hands with fingers marked by grooves. There is an indentation at the navel and at the top of the buttocks, and there are traces of gold leaf on the upper right leg, left breast, and right arm. The head and feet are missing.

H: 2¹⁵⁄₁₆″ (6.8cm) × TH: ¼″ (0.6cm) 71.35

HISTORY: Purchased from Léon Gruel, Paris, before 1930.

7. "CONCUBINE"

Bone figurine. Egyptian, Ptolemaic period,
4th–1st century B.C.

This very common type of figurine with a high, wide wig appears to be a late version of the "concubine" figure. For a close, excavated parallel, see W. M. F. Petrie, *Tanis*, II, Egyptian Exploration Fund, Memoir 4, London, 1888, pl. 7 (c. 230 B.C.).

H: 3⅛″ (8.3cm) 71.521

HISTORY: Old number "29"; label: "small ivory figure epoc Ptolemaic"; purchased from Dikran Kelekian, Paris, before 1931.

8. STANDING MALE

Ivory figurine. Egyptian, Middle Kingdom,
11th Dynasty, 2040–1991 B.C.

This standing male figure, with a short torso and very long limbs, holds his left arm across his chest; his right arm is placed over the front edge of a long stiff kilt worn below the navel. The piece is carefully modeled, with the toes and fingers clearly marked. The figure style and costume are closely paralleled in a smaller ivory figurine in the Louvre, which, however, wears a wig (E 14701, Vandier, *Manuel*, III, pl. 57:7, labeled 11th Dynasty). A smaller, more primitive version of the type was found in an eleventh-Dynasty tomb at Nag'el Der (see A. B. Elasser and V. M. Frederickson, *Ancient Egypt*, the Robert H. Lowie Museum of Anthropology, University of California at Berkeley, Mar.–Oct. 1966, 59).

The piece has flaked extensively since it was published by Steindorff.

H: 8⅜″ (21.3cm) 71.509

HISTORY: Purchased from Maurice Nahman, Paris, 1930.

BIB.: Steindorff, no. 46; Vandier, *Manuel*, III, 228–249; Smith, *AAE*, 184, fig. 177.

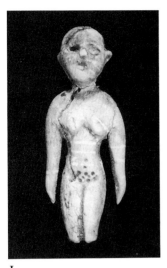

1

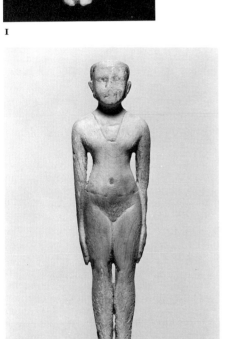

2

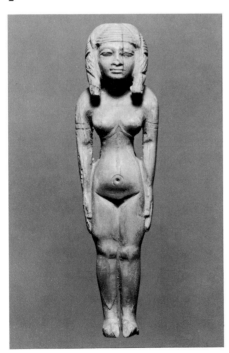

3

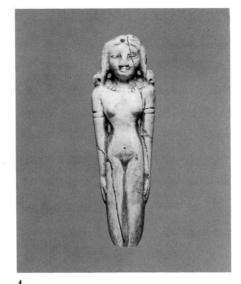

4

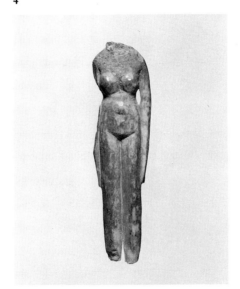

5

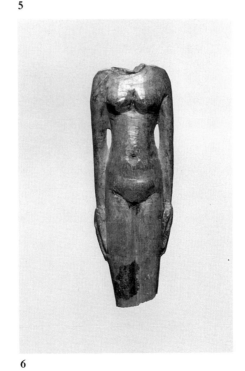

6

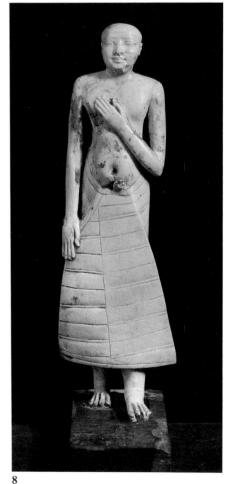

7

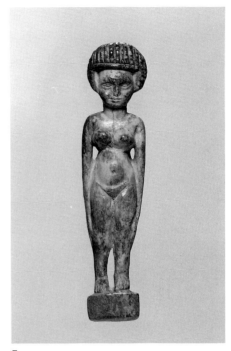

8

9. HORUS-THE-CHILD

Hippopotamus ivory figurine. Egyptian, Ptolemaic period, 4th–1st century B.C.

This finely modeled figure of the young god Horus-the-Child (called Harpocrates by the Greeks) shows him, as usual, sucking his finger. He wears the typical juvenile sidelock, but also has short curly hair, indicated by fine incised lines. The deep-set eyes reveal the influence of Greek art on late representations of this well-known Egyptian god.

For the hairdo in portraits of Ptolemy V, 204–180 B.C., cf. H. Kyrieleis, *Bildnisse der Ptolemaer*, Deutsches Archäologisches Institut, Archäologische Forschung 2, Berlin, 1975, 54, pls. 41 and 42.

The legs and left arm are damaged.

H: 3⅝" (9.2cm) 71.506

HISTORY: Purchased from Dikran Kelekian, Paris, 1923; said to be "22nd Dynasty, found near Alexandria"; on same base as catalogue nos. 10 and 11.

BIB.: Steindorff, no. 437.

See also colorplate 4

10. HORUS-THE-CHILD

Hippopotamus ivory figurine. Egyptian, Ptolemaic period, 4th–1st century B.C.

Horus-the-Child (see cat. nos. 9 and 11) is shown here seated on a low-back throne. At his right shoulder, there is a dowel hole for attaching the arm, now missing.

The head, lower left arm, and left thigh and upper leg are broken. The surface is rough and unpolished.

H: 2¼" (5.8cm) × TH: 1⅝" (4.2cm) 71.502

HISTORY: Purchased from Dikran Kelekian, Paris, 1923; on same base as catalogue nos. 9 and 11.

11. HORUS-THE-CHILD

Bone amulet. Egyptian, Ptolemaic period, 4th–1st century B.C.

This pendant is carved in the form of a seated Horus-the-Child (see cat. nos. 9 and 10). The head, both hands, and lower legs are missing. There was a horizontal loop, which is broken on the back.

H: 1⅛" (3.0cm) 71.537

HISTORY: Purchased from Dikran Kelekian, Paris, 1923; on same base as catalogue nos. 9 and 10.

12. FEMALE DWARF

Hippopotamus ivory figurine. Egyptian, Predynastic period, mid-4th millennium B.C.

In this stylized figure of a female dwarf with large forehead, perforations serve for the eyes (black material remains in the right), ridges for the brows. The dwarf has fat upper arms, a narrow chest, and low, pendulous breasts, wide hips, and short twisted legs. The wide pubic triangle is marked by holes.

The back is almost flat. The legs are recessed below the buttocks. This is the mate to catalogue no. 13.

H: 1⅝" (4.2cm) 71.532

HISTORY: Old number 3584; MacGregor Collection, lot 712; purchased from Dikran Kelekian, Paris, 1923.

BIB.: Capart, *Primitive Art in Egypt*, 173, fig. 135; Steindorff, no. 3; Vandier, *Manuel*, I, 1, 427, fig. 286; Smith, *AAE*, 14, pl. 1a; Ucko, no. 18.

See also colorplate 5

13. MALE DWARF

Hippopotamus ivory figurine. Egyptian, Predynastic period, mid-4th millennium B.C.

This stylized figure of a male dwarf with large forehead has arms and bowed legs twisted into curves. The ears are pointed and perforations mark the eyes. There are grooves for the brows. The stomach is distended and there is a ridge across the buttocks that may have originally connected the figure to a seat.

The front of the right leg is missing. This is the mate to catalogue no. 12.

H: 1¹³⁄₁₆" (4.6cm) 71.534

HISTORY: Pencil mark "7" on back of head; MacGregor Collection, lot 712; purchased from Dikran Kelekian, Paris, 1923.

BIB.: Steindorff, no. 2; Smith, *AAE*, 14, pl. 1a; Ucko, no. 22.

See also colorplate 5

14. FEMALE DWARF

Hippopotamus ivory figurine. Egyptian, Predynastic period, mid-4th millennium B.C.

This plump female dwarf has a large head, pointed ears, small round eyes, and pendulous breasts. A hole marks the navel. The pubic triangle is marked by incised dots. The figure has short, distorted arms and thick legs. The right arm and left forearm are broken.

H: 2" (5.2cm) 71.531

HISTORY: Old number 3585; MacGregor Collection, lot 712; purchased from Dikran Kelekian, Paris, 1923.

BIB.: Capart, *Primitive Art in Egypt*, 175, fig. 135; Steindorff, no. 4; Vandier, *Manuel*, I, 1, 427 ff., fig. 286; Smith, *AAE*, 14, pl. 1a; Ucko, no. 19.

See also colorplate 6

15. MALE DWARF AND CHILD

Hippopotamus ivory figurine. Egyptian, Predynastic period, mid-4th millennium B.C.

A bearded dwarf with pudgy nose and elongated head covered with short curls is shown on his hands and knees holding a child. The child's hand is preserved on the left side of the face of the dwarf, but its arms and head are missing. There is an unnatural protrusion from the stomach of the dwarf.

A perforation from the back to the groin suggests that this piece may have been part of a mechanical toy.

L: 2¼" (5.7cm) 71.533

HISTORY: Old number 3585; MacGregor Collection, lot 712; purchased from Dikran Kelekian, Paris, 1923.

BIB.: Capart, *Primitive Art in Egypt*, 173, fig. 135 (correctly oriented); Steindorff, no. 5; Smith, *AAE*, 14, pl. 1a; Ucko, no. 20 (wrongly oriented).

See also colorplate 8

16. DWARF

Hippopotamus ivory mechanical toy(?). Egyptian, Old Kingdom(?), 2680–2258 B.C.

A Pygmy or dwarf is shown with his hands clasped and knees bent as if dancing. He has a large head with ridges for a brow, heavy eyelids, straight lips, and fat cheeks. He has short hair (indicated only on the front) and sideburns. There is a deep, square dowel hole in the head and a perforation from the hands through to the back. The lower legs and both feet are missing.

The position of the figure is like that of a set of dancing Pygmies (see figure 11) from Lisht of the twelfth Dynasty, 1991–1786 B.C.; see A. Lansing, *BMMA*, Egyptian Supplements, Nov. 1934, 33 ff.; and *Scepter* I, 222–223 (Metropolitan Museum, no. 30.1.130); see also in the British Museum, no. 58409; and in the Ägyptisches Museum, Berlin (DDR, no. 13246), H. Fechheimer, *Kleinplastik der Ägypter*, Die Kunst des Ostens, III, pl. 153, left, dated New Kingdom. The perforation and dowel on the Walters piece may have been used to make the figure turn.

H: 3½" (8.9cm) 71.504

HISTORY: Purchased before 1930.

See also colorplate 9

17. FEMALE DWARF

Bone figurine. Egyptian, Predynastic period, mid-4th millennium B.C.(?).

This carefully carved plump female figure has dwarfed limbs, a large head with short curly hair, and large breasts. A deep hole marks the navel. The wide pubic triangle is marked by holes. There is a depression on top of the buttocks. On the head is a large lotus blossom. A ball surrounded by ridges has been inserted into the hollow lotus to form the calyx of the flower.

For a somewhat similar figure of the Predynastic period, see J. E. Quibell, *Hierokonpolis*, I, London, 1900, pl. 11.

H: 2⅝" (6.7cm) 71.507

HISTORY: Purchased before 1931.

BIB.: Steindorff, no. 633.

See also colorplate 7

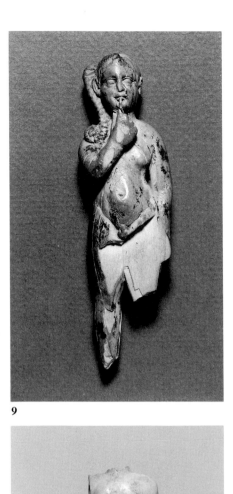

9

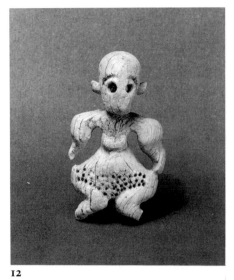

12

15

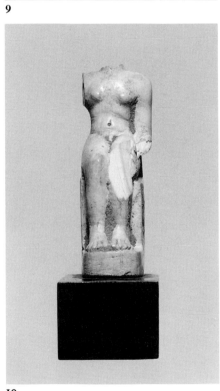

10

13

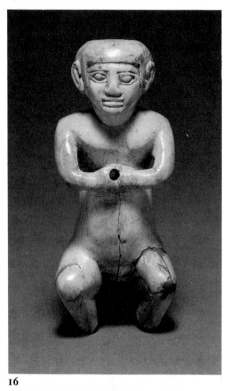

16

11

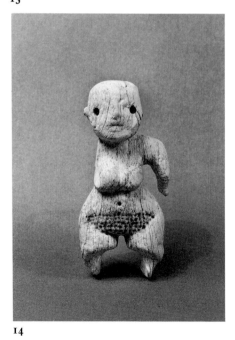

14

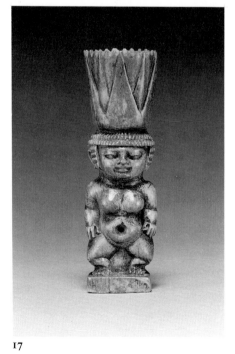

17

18. HIPPOPOTAMUS

Hippopotamus ivory figurine. Egyptian, Badarian period, mid-5th millennium B.C.

This very sensitively modeled figure of a hippopotamus shows rolls of skin under the neck, bulging, heavy-lidded eyes, and a thick lower lip. There is a ridge on the snout in which the nostrils are deeply recessed.

For a close, excavated parallel now in the British Museum, see *PKG* XIII, fig. 189, 238, from Mostagedda grave 3522; mid-fifth millennium B.C. (G. Bruton, *Mostagedda and the Tasian Culture*, London, 1937, 53).

L: 1⅝″ (4.2cm) 71.528

HISTORY: MacGregor Collection, lot 708; purchased before 1931.

BIB.: Steindorff, no. 11.

See also colorplate 2

19. HIPPOPOTAMUS

Hippopotamus ivory figurine. Egyptian, Predynastic period, mid-4th millennium B.C., if genuine

This figure of a hippopotamus has a platform on its back. The hooves are indicated schematically. A ridge suggests the eyes. File marks remain on the surface of the dense ivory. There are some cracks and the snout is partly broken off.

The good condition of the piece and the summary style of carving are unusual. The platform here may imitate the hollowed projections for ointments on the backs of other hippopotamuses of the period.

L: 1½″ (3.9cm) 71.530

HISTORY: MacGregor Collection, lot 708; purchased from Dikran Kelekian, Paris, 1923.

BIB.: Steindorff, no. 12.

20. LIONESS

Hippopotamus ivory game piece. Egyptian, 1st Dynasty, 3200–2980 B.C.

A lioness is represented reclining, tail curled over her right haunch. Her drooping snout and protruding chin are characteristic of contemporary representations. From a wide band around the neck a rectangular pendant, decorated by incised dashes, hangs on the chest. Two holes are drilled on the underside. The right forepaw has been reattached.

Sets consisting of three lions and three lionesses were used on a circular game table in the shape of a coiled serpent (Emery, *Archaic Egypt*, 249, 251, fig. 150). There is a good parallel for the piece from Abydos(?) (Barbara Adams, *Ancient Hierakonpolis*, Warminster, 1974, no. 356, pl. 43). Also see the pair from Abu Roash (J. Gates, A. P. Kosloff, and E. Ertman, *Arts of Ancient Egypt: Treasures on Another Scale*, Brooks Memorial Art Gallery, 1981, fig. 11 [Cairo Museum, J. 44918]).

L: 2¼″ (5.8cm) × H: 1⅛″ (3cm) 71.623

HISTORY: Purchased from Arthur Sambon, Paris, 1926; "found at Abydos."

BIB.: Steindorff, no. 6.

See also colorplate 12

21. DOG

Hippopotamus ivory game piece. Egyptian, 1st Dynasty, 3200–2890 B.C.

This game piece is made in the form of a dog reclining with his tail over his rump. He wears a wide collar and counterpoise decorated with rectangular elements. The modeling is very careful.

This is a well-known type of gaming piece (see J. E. Quibell, *Archaic Objects*, Catalogue général des antiquités égyptiennes du musée du Caire, XXIII, 204 ff., nos. 140 and 141; and W. M. F. Petrie, *The Royal Tombs of the Earliest Dynasties*, II, London, 1901, pl. 34:22).

L: 2½″ (6.4cm) 71.622

HISTORY: Purchased before 1931.

BIB.: Steindorff, no. 7.

22. DOG

Hippopotamus ivory game piece. Egyptian, Predynastic period, mid-4th millennium B.C.

This figure of a reclining short-tailed dog (seluki?) with ears perked is schematically carved. The eyes are shown in relief. The piece is perforated horizontally through the belly; another hole leads from this perforation to the base.

L: 2⅛″ (5.7cm) 71.523

HISTORY: MacGregor Collection, lot 708; purchased before 1931.

BIB.: Steindorff, no. 8.

23. DOG

Hippopotamus ivory game piece. Egyptian, Predynastic period, mid-4th millennium B.C.

This crudely carved figure of a dog(?), crouching with forepaws on the ground, head up, and ears perked, is probably a game piece.

L: 1¼″ (3.2cm) 71.524

HISTORY: MacGregor Collection, lot 708; purchased before 1931.

BIB.: Steindorff, no. 13.

24. ANIMAL

Hippopotamus ivory game piece(?). Egyptian, Predynastic period, mid-4th millennium B.C.

This animal with hanging belly, short legs and tail, oval head, wide mouth, and large ears shown flat against the head is probably a pig. Details of the figure are partly modeled, partly incised.

The right leg has been reattached.

L: ½″ (1.4cm) 71.527

HISTORY: MacGregor Collection, lot 708; purchased from Dikran Kelekian, Paris, 1923.

BIB.: Steindorff, no. 13.

25. MONKEY

Bone game piece. Egyptian, 900–700 B.C.

This monkey, seated, with its right paw supporting its head, left paw on the genitals, is carefully designed to look as though it had been carved from an astragal (knucklebone). The prototypes for such objects were undoubtedly made from real astragals.

For close parallels in the Metropolitan Museum of Art, see N. Scott, "The Daily Life of the Ancient Egyptians," *BMMA*, XXXI, 3, 1973, nos. 41, 43.

L: 1⅜″ (3.5cm) 71.512

HISTORY: Old label "54"; purchased from Dikran Kelekian, Paris, 1925.

See also colorplate 13

26. ANTELOPE(?)

Bone comb. Egyptian, Prehistoric period, 4th millennium B.C.

This fragment of a comb has decorative projections on the top, the uppermost of which is broken off. The quick sketch of a long-horned, long-eared animal of the antelope family incised on one side is unusual.

H: 4″ (10.2cm) 71.604

HISTORY: Purchased from Dikran Kelekian, Paris, before 1931.

27. ANIMALS

Bone cosmetic(?) spoon. Egyptian, Predynastic period, mid-4th millennium B.C.

This miniature spoon with a double-curved end is decorated with a grazing boar on a plinth shown in relief. Over the bowl, a gazelle's head with large eyes is seen *en face* in relief.

Spoons are common in the Predynastic period, but the figures carved on this piece are unusual. Dr. Robert Bianchi of the Brooklyn Museum has suggested that both animals seen here may be related to the god Seth and that the spoon may be some sort of medical-magical instrument; see P. E. Newberry, "The Pig and the Cult Animal of Seth," *Journal of Egyptian Archaeology*, XIV, 1928, 211 ff.; G. Daressy, "L'animal Sethien à tête d'ane," *Annales du service des antiquités de l'Egypte*, XX, Cairo, 1920, 165 ff.; and idem, "Seth et son animal," *Bulletin de l'institut français d'archéologie orientale*, 13, Cairo, 1917, 77 ff. For Egyptian amulets in the shape of a sow, see W. M. F. Petrie, *Amulets*, London, 1914, no. 234, color pl. 40.

L: 4⅞″ (12.4cm) 71.607

HISTORY: Purchased before 1931.

28. MINIATURE VESSEL

Ivory cosmetic container. Egyptian, Predynastic period, mid-4th millennium B.C.

This tiny imitation of a slender, pointed vessel has semioval handles in relief. The interior has been deeply hollowed out. There are several old breaks and repairs. For the shape in pottery, see Emery, *Archaic Egypt*, 208, nos. 1 and 2.

H: 6″ (15.3cm) 71.605

HISTORY: Purchased before 1931.

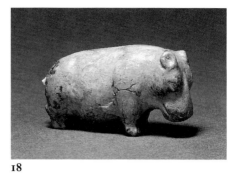

18

23

27

19

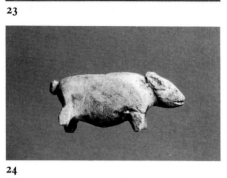

24

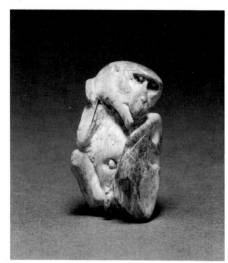

20

25

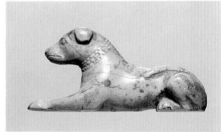

21

22

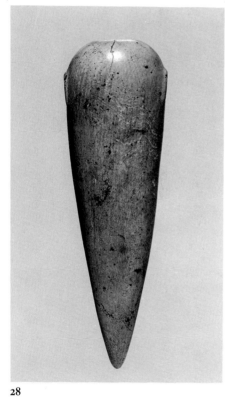

28

26

29. MINIATURE VESSEL

Hippopotamus ivory cosmetic container. Egyptian, Predynastic period, mid-4th millennium B.C.

This imitation of a tall vessel with rim turned outward has small vertical handles and a round base, now partly broken. There are several repairs. The shape is characteristic of larger vessels of the period (see Emery, *Archaic Egypt*, 217, fig. 125, no. 29).

H: 3⅝" (9.2cm) × INT. D: 3⅝" (9.2cm) 71.555

HISTORY: Purchased before 1931.

30. MINIATURE VESSEL

Hippopotamus ivory cosmetic container. Egyptian, Predynastic period, mid-4th millennium B.C.

This tiny imitation of a globular vessel with a ledge rim has a well-smoothed surface.

H: 1" (2.6cm) 71.542.

HISTORY: MacGregor Collection, lot 679; purchased from Dikran Kelekian, Paris, 1923.

31. KNEELING SYRIAN

Hippopotamus ivory container. Egyptian, New Kingdom to Late period, c. 1000 B.C., if genuine

This container for kohl (eye shadow) or ointment is made in the shape of a kneeling Syrian who supports on his shoulders a large amphora, which has been scooped out to hold ointment. The bearded, long-haired figure wears chest bands and a kilt with crosshatched decoration. The piece appears to be unfinished. The hastily incised chest bands, the unusual belt, the lack of a cover or a dowel hole for a lid and the opening at the mouth of the amphora are peculiar. The authenticity of this piece is not certain.

H: 5½" (14.0cm) × TH: ½" (1.3cm) 71.503

HISTORY: Purchased from Dikran Kelekian, Paris, 1911; said to be "from Memphis."

BIB.: I. Wallert, *Der Verzierte Löffel, Seine Formgeschichte und Verwendung im Alten Ägypten*, Ägyptologische Abhandlungen, XVI, 1967, 73; WAG, *Handbook of the Collections*, Baltimore, 1936, 17.

32. DUCK

Ointment box of hippopotamus and elephant ivory and bone. Egyptian, New Kingdom, 1580–1085 B.C.

This elaborate, finely carved container for cosmetics is made in the form of a swimming duck. The body, carved in one piece of elephant ivory, has bone inlay on the neck. The back of the head and beak have fine incised markings and show traces of red pigment. The eye, filled with black material, has a reddish iris. The shallowly hollowed back was intended to contain the cosmetics. There are traces of a tail once doweled to the body. The hippopotamus-ivory wings, attached by elegantly knobbed dowels, are broken and much restored so that they no longer close over the cosmetic cavity. The feathers are indicated by incisions. Three drilled holes appear on the bottom of the body; the hole under the neck is still filled with black material.

This is a fine example of a characteristic Egyptian container type. See p. 35.

L: 8⅛" (20.6cm) × H: 3¼" (8.3cm) 71.519a,b

HISTORY: MacGregor Collection, lot 703 (wrong dimensions); purchased in Paris, 1925.

BIB.: *BWAG*, I, no. 8, May 1949; Smith, *AAE*, 214, pl. 153b.

See also colorplate 10

33. DUCK HEAD

Bone finial. Egyptian, New Kingdom, 1580–1085 B.C.

This duck's head turned backward probably formed the finial of a long rod that originally had an ointment spoon at the other end. The round eye with well-marked tear ducts is perforated (for inlay?). The bill markings are indicated by incisions.

See Vandier, d'Abbadie, 33, nos. 78–81.

L: 1⅜" (3.5cm) 71.641a

HISTORY: MacGregor Collection, lot 678; purchased from Dikran Kelekian, Paris, 1923.

34. HAND

Bone cosmetic spoon. Egyptian, New Kingdom, 1580–1085 B.C.(?)

This fragment of a well-known type of spoon (ointment or eye-paint container) is in the shape of a left hand supporting a shell. The long, thin fingers are unarticulated. The thumb and tips of the fingers are missing, but there is a deep indentation in the palm. There is a dowel hole for attaching another piece.

For type, see Vandier, d'Abbadie, no. 54, 27 (E22901).

L: 1¼" (3.2cm) 71.541

HISTORY: Old number "1230"; MacGregor Collection, lot 679; purchased from Dikran Kelekian, Paris, 1923.

35. HEAD OF A SYRIAN

Hippopotamus ivory tip of a vessel. Egyptian, New Kingdom, 1580–1085 B.C.

This is the pouring element that would have been attached to a horn-shaped vessel for perfume or medicine. The head with curved nose, fleshy chin, and a plain wig is carefully carved. The Syrian physiognomy is closely paralleled in a piece from the Merseyside County Museum, Liverpool (see S. Dahl in Museum of Fine Arts, Boston, *Egypt's Golden Age: The Art of Living in the New Kingdom, 1558–1085 B.C.*, Boston, 1982, no. 403, 293). A version of the type with a classic Egyptian head is in Munich (*Staatliche Sammlung Ägyptischer Kunst*, no. 4858, 56). The band around the back of the wig is unusual. This may be a mistake on the part of a non-Egyptian carver or, as Nora Scott, curator emeritus of the Metropolitan Museum, has suggested, it might represent the tie of a wig cover.

H: 2" (5.1cm) 71.508

HISTORY: "From the Pyramids"; purchased from Dikran Kelekian, Paris, 1914.

See also colorplate 17

29

32

30

32

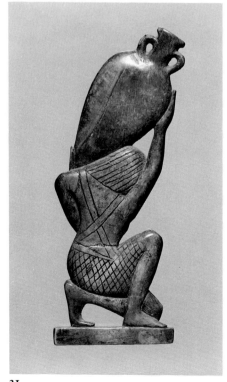

31

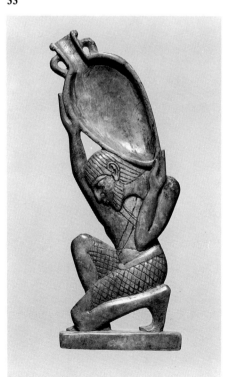

31

33

34

35

36. FEMALE FIGURE

Hippopotamus ivory cosmetic container. Egyptian, Late New Kingdom to 3rd Intermediate period, 1200–715 B.C.

This fragment of a double kohl box is decorated with a female figure shown in relief on a rectangular background. She stands facing left with one hand at her waist cupped upward. She is nude except for a wig with long lappets. The wig is surmounted by a pad in which fresh flowers could be inserted to make a crown. The mouth of the left tube is preserved. The back of the box is missing.

The box and the type of decoration are well known (see W. M. F. Petrie, *Objects of Daily Use*, 27, pl. 22:9). The date suggested here is that given for a piece in the Metropolitan Museum of Art (no. 1979-351). Concerning the pad for elaborate papyrus headdresses popular in the late nineteenth and twentieth Dynasties, see A. Wilkinson, *Ancient Egyptian Jewelry*, London, 1971, 153.

H: 5″ (12.2cm) 71.515

HISTORY: Purchased before 1930.

37. HEADS

Hippopotamus ivory mirror handle. Egyptian (date unknown)

This very carefully carved four-sided handle has heads of the goddess Hathor alternating with those of a wigged falcon (symbolizing the god Horus) superimposed on papyrus columns. There is a small dowel hole for the attachment of the falcon's beak. Some of the heads are missing. The stalks of the papyrus are broken off. One section is covered by black stain.

For the fine markings on the falcon's head, see the gold plume carrier from the horse burial of Tanwetamane at El Kurru (D. Dunham, *Royal Tombs at Kush*, I, Boston, 1950, 115, fig. 41). There is a general resemblance to the complicated mirror handles from Kush (W. S. Smith, *Ancient Egypt as Represented in the Museum of Fine Arts, Boston*, Boston, 1960, figs. 110, 112). See also the fly whisk with Egyptian figures from Nimrud, ninth–eighth centuries B.C., *Nimrud Ivories*, no. S295, 213, pl. XCI.

H: 3″ (7.7cm) 71.513

HISTORY: "Said to be from Luxor"; the piece was purchased, with an ill-fitting "electrum" mirror attached, from Dikran Kelekian, Paris, 1911.

See also colorplate 11

38. NUDE FIGURE

Hippopotamus ivory handle. Egyptian, New Kingdom, 1580–1085 B.C.(?)

This handle is in the shape of a girl clothed only in a head pad (see cat. no. 36) and a necklace, standing with hand at breast. There are traces of a monkey(?) at her feet. The wig is unusual—strands of straight hair interspersed with curled locks. The facial features are very crudely outlined by incision. The piece has a large perforation (2¼″ deep, 3¼″ wide) to hold an attached object. The surface is highly polished.

For the small animal at the girl's feet, see Vandier, d'Abbadie, no. 795, 181 (E11892).

H: 6¼″ (15.9cm) 71.511

HISTORY: Old label, "146-co 33"; purchased from Arthur Sambon, Paris, 1925.

39. MALE FIGURE

Hippopotamus ivory(?), blue faience and black semiglassy faience. Egyptian, date unknown

This thin plaque carved in fine low relief shows a male figure dressed in a striped kilt, belt, broad collar necklace, and plain long wig. He kneels on one knee and holds papyrus stalks inlaid with faience at either side. Below the figure (carved of the same piece) is a lotus inlaid with faience, which is on top of a rectangular panel with geometric inlays. The details of the figure are carved on the back of the piece. The back of the lotus and of the rectangle are flat. There is a red pigment under the inlay.

The carving appears to be genuine, but the composition of the piece is unusual (see M. E. L. Mallowan, *Nimrud and Its Remains*, New York, 1966, vol. II, 525, no. 433, and 535, no. 451).

H: 3¼″ (8.3cm) 71.536

HISTORY: Much restored and mounted on wood; detached, cleaned, and treated in 1982. Old label: "Dieu Nil 18 dyn 17 av JC"; purchased before 1931.

See also colorplate 15

40. INSCRIPTION

Hippopotamus ivory inlay. Egyptian, Saite period, 663–525 B.C.(?)

This thin rectangular plaque has hieroglyphs shallowly incised on one surface. The back is rough. The feathery pattern typical of unpolished hippopotamus ivory appears in the recessed areas. The inscription, translated by Professor Hans Goedicke, reads: "Making incense for Khonsu."

L: 4″ (10.2cm) × TH: ½″ (1.3cm) 71.583

HISTORY: Purchased before 1931.

41. ANIMAL LEG

Hippopotamus ivory foot of a game box. Egyptian, Early Old Kingdom, 2680–2258 B.C., if genuine

Legs of game boards or boxes made in the shape of the haunch of a standing bull placed on a high-ribbed plinth are well known in this period. This piece is peculiar: the hoof is that of a reclining animal. It is placed on a plain plinth, the musculature is completely stylized, and muscles are not marked on the inside. All of these peculiarities make the piece suspect.

H: 1⅝″ (4.2cm) × W: ½″ (1.3cm) 71.520

HISTORY: MacGregor Collection, lot 678; purchased from Dikran Kelekian, Paris, 1923.

BIB.: Listed as Old Kingdom in the catalogue of G. P. Killen, *Ancient Egyptian Furniture, 4000–1300 B.C.*, I, Warminster, 1980.

42. BABOON

Monkey molar seal. Egyptian, Predynastic period, mid-4th millennium B.C.

This stylized figure of a seated baboon (sacred to the god Thoth) shows a pronounced jaw and bulging eyes. There are geometric patterns on the base of the piece.

H: 1″ (2.5cm) × TH: ⁵⁄₁₆″ (0.8cm) 71.526

HISTORY: MacGregor Collection, lot 708; purchased from Dikran Kelekian, Paris, before 1931.

BIB.: Steindorff, no. 14; WAG *Jewelry*, no. 66.

43. BABOON

Monkey molar seal. Egyptian, Predynastic period, mid-4th millennium B.C.

This crudely carved figure of a seated baboon (sacred to the god Thoth) has traces of crossed lines on the base.

L: 1″ (2.5cm) × TH: ¼″ (0.4cm) 71.525

HISTORY: MacGregor Collection, lot 708; purchased from Dikran Kelekian, Paris, before 1931.

BIB.: Steindorff, no. 15; WAG *Jewelry*, no. 65.

36

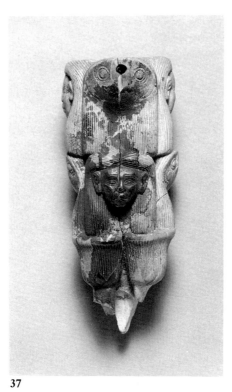

37

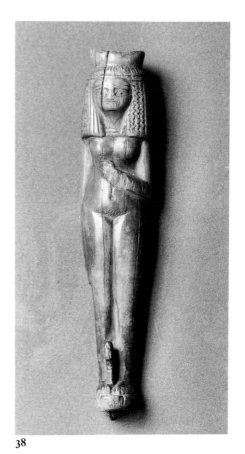

38

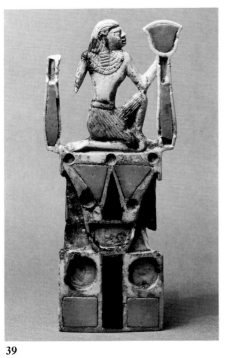

39

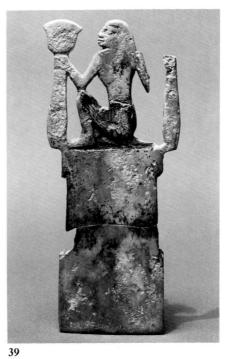

39

40

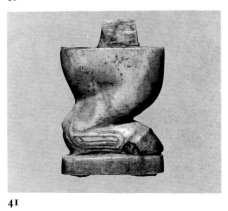

41

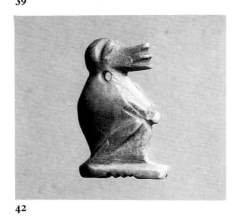

42

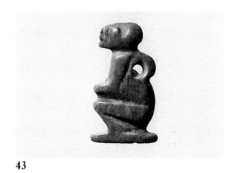

43

44. FALCON-HEADED GOD

Hippopotamus ivory amulet. Egyptian, Late period, 11th–4th century B.C.(?)

This pendant is carved into the shape of a mummified falcon-headed god who wears a heavy wig and double crown. It is perforated through the shoulders.

H: 1⅝" (4.2cm) 71.556

HISTORY: Purchased before 1931.

BIB.: Steindorff, no. 571; WAG *Jewelry*, no. 72.

45. LION-HEADED FIGURE

Canine tooth amulet. Egyptian, Merotic style, 9th century B.C.(?)

This intricate, finely carved pendant represents a lion-headed human figure wearing a rush-crown with disc. The apotropaic figure dangles a crook and a serpent. It stands back to back with a winged falcon in an atef crown, which is surmounted by a ball. The falcon's head is turned backward. On its shoulders is a perforated scarab. It has a crocodile's tail instead of feet.

This unusual piece may be related to the double figures from Kush (see D. Dunham, *The West and South Cemeteries at Meroe: The Royal Cemeteries of Kush*, Boston, 1950, V, 25, fig. 18c, 23-M-620 [faience]; and A. Wilkinson, *Ancient Egyptian Jewelry*, London, 1971, 188, fig.72).

H: 1⁹⁄₁₆" (4.3cm) 71.514

HISTORY: Purchased before 1931.

BIB.: Steindorff, no. 577; WAG *Jewelry*, no. 112.

See also colorplate 14

46a. CLAPPER FRAGMENT FROM A MUSICAL INSTRUMENT

Hippopotamus ivory. Egyptian, New Kingdom, 18th Dynasty, 1580–1349 B.C.

This fragment belonged to the top, perforated end of a clapper. On the outside face there are traces of fine, carefully incised design. At the top is a lotus petal. In the center, a pattern of squares is inside a "net" pattern. Below there are rows of wedges. There are two old breaks at the top end.

The unusual decoration is paralleled by a piece in the Louvre (C. Ziegler, *Catalogue des instruments de musique égyptiens*, Musée du Louvre, Département des antiquités égyptiennes, Paris, 1979, 25 [I D M 4]).

L: 3½" (8.9cm) 71.539

HISTORY: Old numbers "1480" and "341"; MacGregor Collection, lot 674; purchased from Dikran Kelekian, Paris, 1923.

46b. CLAPPER FRAGMENT FROM A MUSICAL INSTRUMENT

Hippopotamus ivory. Egyptian, New Kingdom, 18th Dynasty, 1580–1349 B.C.

This fragment is the mate to catalogue no. 46a. It is decorated by a pattern of squares inside a "net" pattern, rows of wedges, and a very worn panel with overlapping feathers.

L: 3" (7.6cm) 71.538

HISTORY: Old numbers "1481" and "342"; cf. catalogue no. 46a; MacGregor Collection, lot 674; purchased from Dikran Kelekian, Paris, 1923.

47. GODS AND ANIMALS

Hippopotamus ivory magic knife. Egyptian, Middle Kingdom, 2040–1786 B.C.

This thin slice of a hippopotamus tusk is incised on both sides with "protective" creatures. On the convex side, from left to right, are a long-necked leopard with "protection" hieroglyphs on its back, the hippopotamus goddess Tweret, and a griffin with wings, falcon's head, and snake tail. (There is a head between the wings.) Next appear a baboon holding a sacred eye, a lion grasping a kneeling foe, the god Bes, a frog, a jackal head on legs, an erect lioness, a snakehead on legs, and, finally, a vulture and a lion head. All these figures have snakes in their mouths and carry knives. On one end of the flat side, there is a leopard head; at the other end a fox head has been recarved into a lotus. Carved below and above the large undulating winged snakes that oppose each other are a frog, a sphinx holding the "life" hieroglyph, a sacred eye, the hippopotamus goddess, a lion eating snakes, and a jackal head on legs. The open space was reserved for the owner's name.

The type of object is well known in this period.

L: 14½" (36.8cm) 71.510

HISTORY: Purchased from Dikran Kelekian, Paris, 1914.

BIB.: Steindorff, *JWAG*, 1946, 41 ff.

See also figure 13

46a

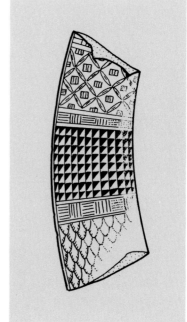

46b

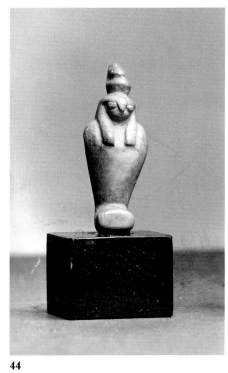

44

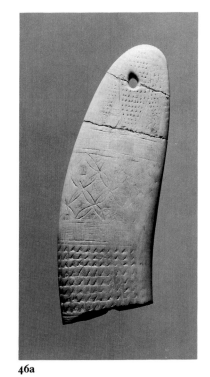

46a

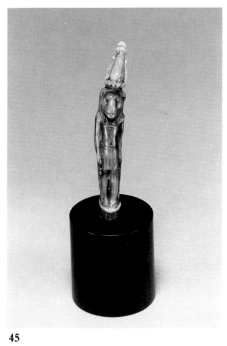

45

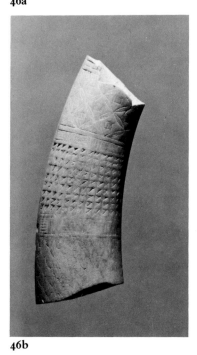

46b

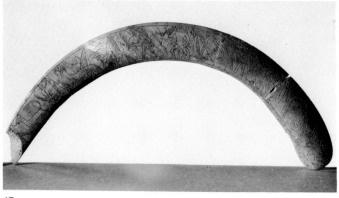

47

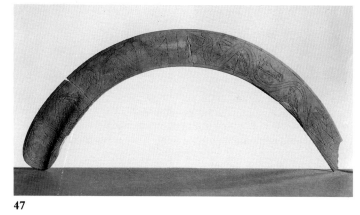

47

48. TWO FIGURES

Elephant ivory plaque. Sumerian, late 3rd millennium B.C.(?)

On one face of this square, flat plaque, two crude figures, surrounded by a thin frame, are seen in relief. They have long hair and thick bodies. The round eyes are incised. The figure at left wears a belt. The figure at right has no belt, but the tuft of his skirt(?) projects below his shoulders. Both figures appear to have their arms bent and hands raised.

The piece is in very poor condition. A hard gray material remains in the recessed areas. Between the faces of the figures and between their feet are perforations. There is an iron peg in the lower perforation and traces of brown material in the upper one.

The crude style of the figures is similar to that of Mesopotamian stone plaques of the Early Dynastic II period (see D. Hansen, "New Votive Plaques from Nippur," *Journal of Near Eastern Studies*, XXII, Chicago, 1963, 145–166).

H: 2¼" (6.4cm) × TH: ⅛" (0.5cm)
71.581

HISTORY: Purchased from Dikran Kelekian, Paris, 1928.

49. CAMEL(?)

Hippopotamus ivory figurine. Syrian, 1400–1200 B.C.(?)

This very worn and cracked head is carved on both sides. The large eye with a deep hole for inlay resembles a camel's. There are traces of indications of the nostrils and an indentation for the mouth. For other Near Eastern representations of camels, see T. Baqir, "Iraq Government Excavations at 'Aquar Quf, Second Interim Report, 1943–44," *Iraq*, Supplement 1945, fig. 30; O. Tufnell *et al.*, *Lachish II: The Fosse Temple*, Oxford, 1958, pl. 17:13,14; and A. Parrot, *Les Temples d'Ishtarat et de Ninni-ZaZa*, Mission Archéologique de Mari, III, Paris, 1967, pl. 74:2275.

H: 2" (5.1cm) × TH: ⅝" (1.6cm) 71.529
HISTORY: MacGregor Collection, lot 708; purchased from Dikran Kelekian, Paris, 1930.

50. SACRED TREES

Elephant ivory finial. Canaanite, 1400–1200 B.C.

This thick conical piece has a dowel hole in the narrow end. Incised on the wide faces are "sacred trees" composed of tendrils and papyrus stalks. On the edges are lotus blossoms. For the plant motif, see H. Kantor in C. W. McEwan *et al.*, *Soundings at Tell Fakhariyah*, Oriental Institute Publication, LXXIX, Chicago, 1958, 57–68, pls. 59, 60, and 64.

H: 1⅛" (2.9cm) 71.640

HISTORY: MacGregor Collection, lot 679; purchased from Dikran Kelekian, Paris, 1923.

51. BULL

Hippopotamus ivory handle. Near Eastern, date unknown

One side of this piece is carved as the forepart of a kneeling bull. It has large lidded eyes and a wrinkled nose. The mane is indicated by an incised ridge. There are holes for the attachment of the horn and the ear. The back of the piece is flat. It is deeply grooved for attachment.

L: 2¼" (5.9cm) × TH: ⅛" (0.5cm)
71.1149

HISTORY: Old numbers "4400" and "9–90 UG"; purchased before 1931.

52. RAM'S HEAD

Bone pendant. Ancient Near Eastern, date unknown

This tiny pendant is carved with close attention to anatomical detail. The modeled eyes have long tear ducts. There are ridges on the horns. The hair over the forehead is indicated by stripes. There are traces of red pigment on the face and under the jaw. The piece is horizontally perforated through the knob placed behind the horns.

Pendants in the shape of rams' heads are well known in the Near East (see WAG *Jewelry*, no. 18). These heads differ from the familiar ram's head of the ancient Egyptian god Khnum in having horns that lie close to the head and a forelock.

L: 1½" (3.9cm) 71.31
HISTORY: Purchased before 1931.

53. HAND

Hippopotamus ivory fragment. Urartean, 9th–8th century B.C.

This short, fat, clenched left hand must have been attached to a small statue, perhaps of a local god. On the wrist is a wide inlaid bracelet decorated by squares alternating with stripes. The hand is bent up slightly. The fingers taper unnaturally toward the (missing) thumb. The fingernails are cut very short and straight. The fingertips curve up.

The hand may have been part of a statuette made of several materials which were popular in Urartu (modern Armenia). See the hand from Toprakkle, Barnett, *Nimrud Ivories*, w. 17 (123889), pl. 131; *idem*, *Iraq*, XII, 10, 17, pl. 14:3. See also T. Özgüç, *Altintepe, II, Tombs, Storehouses and Ivories*, Ankara, 1969, 54–55, 78 ff., pl. 49:2–4. For earlier examples in Hittite art, see Özgüç, "Excavations at Acemhuyok," *Anadolu*, X, Ankara, 1966, pl. 166 ff., 12:9–11, 14:3.

L: 2¼" (5.7cm) 71.540

HISTORY: MacGregor Collection, lot 679; purchased from Dikran Kelekian, Paris, 1923.

54. HORSE HEAD

Hippopotamus ivory handle. Parthian, 2nd–3rd century A.D.

This head of a horse shown chafing at the bit, ears laid back, is the top of a knife(?) handle. The bridle with nose, cheek, and head straps also has three straps under the jaw. The cheek strap and headband are decorated with concentric circles. The mane is combed into locks. There are holes in the interior of the ear, the nostril, and the eye, and one at the back of the mouth (for a bit?).

For a close parallel, see J. Cooney, *Ancient Art: The Norbert Schimmel Collection*, ed. O. W. Muscarella, Mainz, 1974, no. 234 (not from the MacGregor Collection); also *Nimrud Ivories* (pl. 147, Suppl. 75). A very close parallel, from Saqqara, Egypt, is in the Fitzwilliam Museum, Cambridge (E 12.1971), dated to the first century A.D.

L: 2½" (6.4cm) × W: ½" (1.3cm) 71.518
HISTORY: Old label, "MacGregor 79"; MacGregor Collection, lot 678; purchased from Dikran Kelekian, Paris, 1923.

See also colorplate 18

55. PATTERN OF CIRCLES

Ivory furniture fitting(?). Assyrian, 9th–8th century B.C.(?)

This thick cylinder of ivory is decorated on the outside. Between two raised bands incised concentric circles are arranged in a zigzag pattern.

There are no parallels for the piece in the published material from Assur (see A. Haller, *Die Gräber und Grüfte von Assur*, Wissenschaftliche Veröffentlichungen der Deutschen Orient-Gesellschaft, LXV, Berlin, 1954). The unusual source attributed to the piece by the dealer Edgar Banks may, however, be of significance. He was a Near Eastern archaeologist as well as a dealer. The excellent selection of cuneiform documents that he acquired for Henry Walters shows that he knew the material. Ivory furniture at Assur would not be unexpected.

H: 1¾" (4.5cm) × D: 2⅝" (6.7cm) × TH: ¼" (0.7cm) 71.613

HISTORY: Purchased from Edgar Banks, 1929; labeled: "Ivory bracelet, found in the Royal tombs at Assur about 1200 B.C."

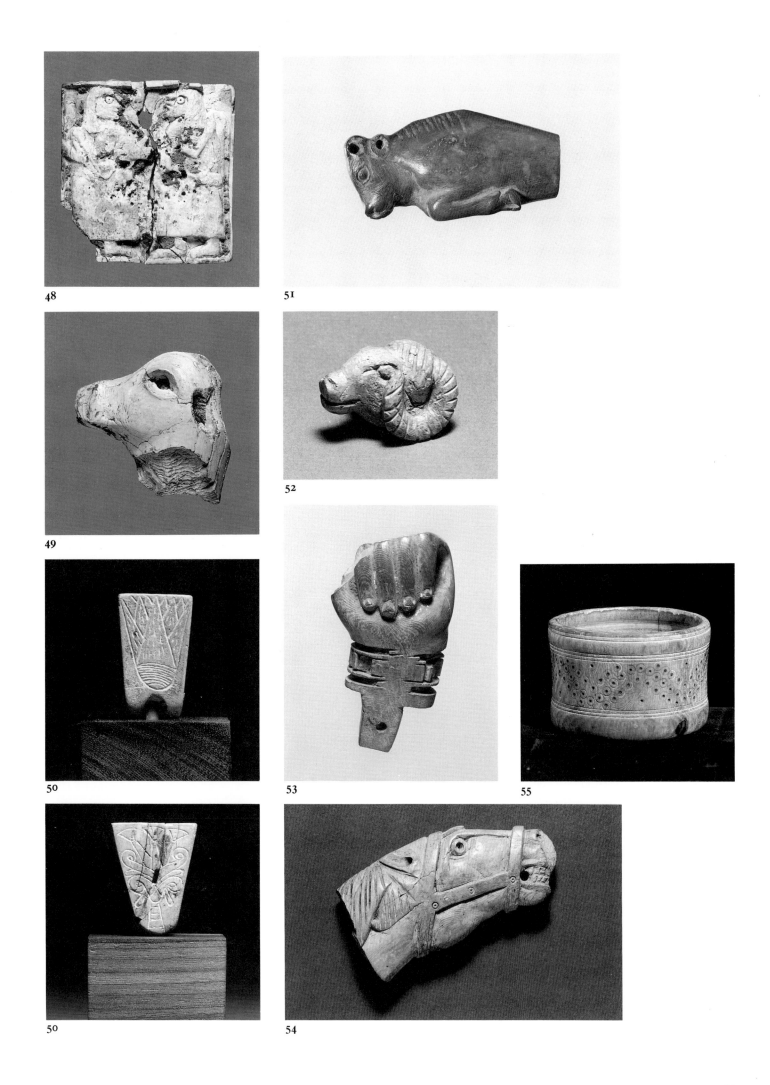

48

51

49

52

50

53

55

50

54

3 Greek, Etruscan, and Roman Ivories

by Diana Buitron and Andrew Oliver

IN THE PAINTED TOMBS of ancient Thebes along the Nile, tribute bearers of all nations are shown rendering homage to Egypt: the Syrian envoy is often pictured, for example, bearing an offering of ivory. It was from Syria, in fact, where evidence indicates elephants lived until the late ninth century B.C., that ivory first came to the Greek world. A precious material, ivory was a commodity traded by kings and affordable only by the rich.

Minoan and Mycenaean Ivories

For Crete and Greece the source of ivory from the Early Bronze Age on was through trade with the East. A tomb dating from c. 2200–2000 B.C. (Early Minoan III period) at Archanes, Crete, contained a Cycladic idol made of ivory in addition to ones of marble.[1] Ivory carving was among the arts that flourished at the palaces on the island of Crete before they were destroyed in the fourteenth century. Excavations at Knossos, and at the smaller palaces of Phaistos and Zakro, have yielded caches of unworked tusks as well as ivory chips discarded in the workshops. The ivory deposit at Knossos, buried by an earthquake in c. 1570 B.C., produced hundreds of fragments of ivory figures as well as the famous bull-vaulter now in the Heraklion Museum.[2] The gold and ivory Snake Goddess in the Museum of Fine Arts, Boston, is reputed to have come from this deposit. Its provenance and authenticity have been questioned, but most experts now accept it as genuine. The provenance of the Snake Goddess (cat. no. 56; see colorplate 19) in the Walters is not known, but it surely belongs to this milieu.

Although Cretan artists excelled at carving three-dimensional figures in ivory, they used ivory for other objects, especially seals in a wide variety of shapes: cones, pyramids, buttons, cylinders, and various animals. The seal impression was often a stylized pattern, geometric or floral, and sometimes featured animals or hieroglyphics.[3]

Even before the destruction of the Cretan palaces, ivory craftsmen from Crete, carrying their tools and techniques with them, had traveled to the Greek mainland. A sculptural group from Mycenae showing two goddesses with a child, of the mid-fourteenth century B.C., now in the National Museum, Athens, is Minoan in feeling.[4] In the fourteenth and thirteenth centuries B.C. the ivory workshops of the Palace of Mycenae and elsewhere produced combs, mirror handles, musical instruments, and, of course, seals of all shapes.[5] Mycenaean artists were masters at carving ivory in relief, both on round caskets and on flat plaques, which were made for decorating carved rectangular boxes or for inlaying on furniture. Ivories have been found in many mainland palaces and tombs, including those at Athens, Thebes, Thorikos, and Myrsinochori, near Pylos.[6] Some of the most beautiful ivories are from the shaft graves at Mycenae.[7] The furniture tablets from the Palace of Pylos record ebony and ivory furniture, including an ebony stool inlaid with ivory butterflies.[8] Ivory was also used for sword pommels, knife handles, and the ornaments on horses' bridles. A related material, boar's tusk, was used to make helmets. Homer describes the helmet Odysseus wore to ambush Dolon: "And he set on his head a leather helmet; on the inside it was drawn tight by many thongs, and on the outside the white tusks of a gleaming toothed boar were set well and with skill, this way and that, and in the middle a felt cap was fitted" (*Iliad* X. 260 ff.). A Mycenaean ivory relief from the island of Delos, now in the museum there, shows a warrior wearing such a helmet.[9]

By the time Homer's epics were in circulation, elephants were probably extinct in Syria and ivory would have had to come from farther away, from Africa and India. In his *Description of Greece* in the second century A.D., the Greek writer Pausanias tells us that "everybody obviously knew long ago about ivory, at least for arts and crafts, but until the Macedonians crossed over to Asia,

no one had seen the elephants themselves.... Homer proves this by singing about couches and rooms belonging to wealthier princes all decorated with elephant ivory, but never making a single mention of the elephant animal. If he had ever seen one, or even heard about one, I am sure he would have put it in his poetry much more eagerly than the Pygmies and the cranes" (I.12.14). Strange tales flourished about the origin of this substance, endowing it with an aura of mystery that no doubt enhanced its commercial value. According to the legend, a statue made of ivory by Pygmalion, king of Cyprus, was so realistic it came to life (Ovid, *Metamorphoses* X. 243 ff.). In another story, the shoulder of Pelops, eaten by mistake by his father, was replaced by the gods with a shoulder of ivory (Pindar, *Olympian Ode* I. 26 ff.). Ivory seems to have been the substance most closely resembling human flesh.[10]

With the collapse of Mycenaean rule in the twelfth century B.C. and the onset of the Dark Ages, luxury items became scarce on the Greek mainland, and few examples of ivory carving are known in Greece at this time. Exceptional is the ivory-handled iron knife from a tenth-century burial at Lefkandi on the island of Euboea.[11] But the craft continued to flourish in outlying areas such as Cyprus, carried there by refugees fleeing the mainland. In Cyprus, twelfth-century ivories include mirror handles and a remarkably fine gaming box. There is also evidence for ivory workshops on the island.[12]

Greek and Etruscan Ivories

High-quality ivory carving reappeared in Greece in the second half of the eighth century B.C., possibly reintroduced from the East. Figurines of this date from a grave in Athens, near the Kerameikos ("the potters' quarter"), were probably made in Greece after Near Eastern models.[13]

The craftsmen and traders who brought the technique of ivory carving with them from the East did not stop in Greece but continued west, to Phoenician territories in North Africa and Spain, and to Italy, where craftsmen developed a fine school of ivory carving in Etruria. The Etruscans combined indigenous elements with Greek and Near Eastern influences to create their own style. Unlike many Greek ivories of the archaic period, which were reserved for the gods either as images of deities or as objects dedicated in sanctuaries, most Etruscan ivories were personally owned by the well-to-do. The tombs of Chiusi, Vetulonia, Cerveteri, and Praeneste have yielded tools, combs, handles, plaques, appliqués, and boxes of intricately carved ivory.[14] The seventh-century B.C. cylindrical box in the Walters (cat. no. 57; see colorplate 20), found near the entrance of one of these princely tombs, is carved with Eastern subject matter that is imperfectly understood by the artist and was therefore probably copied from an Eastern object by a local craftsman. The fine comb decorated with crouching lions (cat. no. 58; see colorplate 21) is Etruscan work of after 500 B.C. Unworked blocks of ivory have been found in grave

circles of Etruria, and so we know that local workshops existed.[15]

In the course of the seventh century B.C., Near Eastern style and technique were assimilated in Greece and adapted to suit the Greek temperament. Trained craftsmen from the Near East settled in Greece at this time, not only because of the unrest in their own lands but because of the business created at the great sanctuaries, where ivory was considered a suitable material for the gods. The Sanctuary of Artemis Orthia in Sparta was especially rich in small-scale ivories and has yielded several hundred plaques, inlays, decorated combs, and seals of all types. The round seal decorated with a bird, perhaps a cock, and snakes (cat. no. 59) is somewhat similar to seals from Sparta. The sanctuary of Hera on the island of Samos has yielded even richer treasures of ivory and wood carvings from furniture, boxes, and utensils of the seventh and sixth centuries B.C.[16]

"The Greeks are extremely ambitious of honor and generous with money in the worship of the gods since they brought ivory from India and Ethiopia to make statues," was the opinion of Pausanias (V.12.3), who recorded more than two dozen chryselephantine (gold-and-ivory) statues of deities in Greek temples and shrines. From his comments we know that some of them were fashioned by famous Greek artists, including Phidias and Polykleitos, and that they dated from the late seventh century B.C. on. Most celebrated in antiquity were the chryselephantine statues of Athena in the Parthenon at Athens and Zeus in his temple at Olympia by Phidias. Indeed, the Zeus was considered one of the seven wonders of the ancient world. Since ivory has the color of human flesh it was a particularly appropriate medium for reproducing the face, hands, and feet of a deity. The rest of the statue was fashioned from other materials, including gold, attached to a framework of wood and metal rods.

American excavations at Corinth in 1934–1935 brought to light the life-size ivory forearm of a statue, probably of the fifth or fourth century B.C.[17] French excavations at Delphi in 1939 uncovered the fragmentary remains of several gold-and-ivory statues of deities of the mid-sixth century B.C., including faces, hands, and feet, now among the chief treasures of the museum there.[18] Eyes and eyebrows were once inlaid in other material; hair and jewelry were made of embossed sheet gold. German excavations at Olympia in 1958 revealed the workshop of Phidias, in which tools and other items, among them fragments of ivory left over from the construction of his gold-and-ivory statue of Zeus, were found.[19]

The earliest statues of historical figures to incorporate ivory for the features and exposed limbs may well be those made by the sculptor Leochares, commissioned and set up by Philip II of Macedon in the Philippeion at Olympia between 338 and 336 B.C. These included statues of Philip II himself, his parents, Amyntas and Eurydice, his wife, Olympias, and his son, Alexander the Great (Pausanias V.20.10). The idea of using a material traditionally reserved for the gods for an image of a living

person must have affronted many Greeks, but did not deter the royal family of Macedon.

Miniature ivory images found in 1977 in one of the royal burials at Vergina in northern Greece, and considered with good reason to represent members of the Macedonian royal family, were conceived of in the same spirit as the statues at Olympia. The Vergina figures, however, were used to decorate a banquet couch that served as the funeral bier in the tomb.[20] Ivory figures and ornaments of related design had been found earlier, in 1971, at nearby Naoussa in Macedonia.[21]

Ivory couches were both a sign and a symbol of luxury in the ancient world. The father of the Greek orator Demosthenes made a fortune as an arms manufacturer and as a maker of couches decorated with ivory (Demosthenes, *Against Aphorbus* I. 10, 30 ff.). A late-sixth-century B.C. tomb in the Athenian cemetery, near the potters' quarter, the Kerameikos, yielded elegant ivory inlays for a couch, including Ionic capitals from the legs with the eyes of the volutes inlaid with amber.[22] The most celebrated ivory veneers from couches are those in Leningrad's Hermitage Museum, excavated as long ago as 1830 at Kul Oba in south Russia. They feature drawings of mythological scenes as fine as any on Greek painted pottery. The Judgment of Paris, the Abduction of the Daughters of Leucippus, and the Preparation for the Chariot Race between Pelops and Oenomaus are rendered in exquisite fifth-century B.C. Greek style.[23] In another of the royal tombs at Vergina, an ivory relief, probably from the leg of a couch, was found showing a three-figured composition of a Dionysiac couple dancing to music played by Pan. This is without question the finest sculptural ivory to have survived from the Greek world.[24] An ivory bust of Alexander the Great owned by the Walters since 1924 and published here for the first time (cat. no. 60; see colorplate 22) is clearly related in style to the miniature ivory images from the first of the royal tombs to be discovered at Vergina. The Walters bust probably served as the medallion on the lower part of a fulcrum, the headrest or footrest of a couch. A satyr's head, also in the Walters, carved in relief on a curved ivory veneer and once inlaid in the upper part of a fulcrum (cat. no. 61; see colorplate 23), is done in a style totally different from that of the Alexander head and dates from the second century B.C. Horses' and mules' heads were the standard upper fulcrum ornament in bronze, and horses' heads are also known in ivory or bone.[25] The elephant's head of a bronze ornament of this type in the Antikensammlungen, Munich, may allude to the preferred and more expensive material used by craftsmen for such decoration, although, as decoration on a banquet couch, the reference could also be bacchic, alluding to the elephants that pulled the chariot of Dionysos on his return from India.[26]

Chairs and tables were also inlaid with ivory or had parts of their arms, legs, and struts fashioned in the form of doweled ivory figures. Furniture depicted on Greek painted vases is often partially in white as if to indicate ivory. Since chairs and tables, however, were rarely placed in tombs, few such ivories survived. Exceptions are a group of ivory chair leg fittings recovered during the excavations of an ancient Greek city (its ancient name not yet known) at a site called Ai Khanoum on the Oxus River in Afghanistan near the Russian border. Another, larger group of furniture legs from Nisa, east of the Caspian in Soviet Turkmenistan,[27] is now in the Ashkhabad History Museum. The figures of Athena and a giant in attitudes of combat, found at Paestum in Italy, and in the museum there, probably came from a piece of furniture.[28] A sculptural group showing Achilles and the Amazon queen Penthesilea, now in the Nelson-Atkins Museum at Kansas City, probably served a similar function (see colorplate 24).[29] These groups are thought to date from the second and first centuries B.C. respectively.

Chests and boxes were inlaid with ivory reliefs. Pausanias describes the famous seventh-century B.C. cedar chest of the Cypselids, the ruling family at Corinth, with figures on it fashioned of ivory and gold that represented a full repertoire of Greek mythology (Pausanias V.17.5). A seventh-century B.C. ivory in the Metropolitan Museum, possibly showing the daughters of Proitos, may have come from a chest.[30] Ivory boxes were dedicated at the great sanctuaries of Samos, Ephesus, and Delphi, where modern excavations have uncovered superb reliefs and statuettes that may have been independent works of art. From the Sanctuary of Hera at Samos comes a relief showing Perseus beheading Medusa; from the Temple of Artemis at Ephesus, a masterly sphinx; from the Sanctuary of Apollo at Delphi, a figure of a man (or god) holding a spear (or scepter) in his right hand—with a rearing lion on his left side—perhaps the subduer of animals, Master of Beasts.[31] The subject matter—fantastic creatures such as gorgons or sphinxes, or the Master of Beasts—as well as the style show Near Eastern influence. Also from Delphi, from the same cache of objects that included the fragmentary chryselephantine statues of deities, came hundreds of fragments of human figures, many of which have been reassembled to form reliefs. They must once have decorated wood-framed boxes and furniture of the sixth century B.C. Among the subjects are the Harpies and the Boreads and the Departure of a Warrior by Chariot[32] (see colorplate 25). The figure in the Walters of Eros masquerading as the child Herakles, with lion skin and amphora over his shoulder, could well have come from a box or a piece of furniture of perhaps the third or second century B.C. (cat. no. 64; see colorplate 26).

Musical instruments could be fashioned in part from ivory or bone. The Greek poet Pindar alludes to a lyre inlaid with gold, ivory, and coral of a figure of one of the Muses (*Nemean Ode* VII.77–79). Four ivory lyres are mentioned in the inventories of the Parthenon of the 430s B.C. and later.[33] The ivory figure of a jumping boy of the late seventh century B.C., found on the island of

Samos, is plausibly considered to be one of the side struts of a stringed instrument.[34] The same is thought true of an early sixth-century B.C. ivory statuette of a woman standing on the back of a sphinx or siren with an armature in the form of a duck's head extending from the woman's head, now in the Antikenabteilung of the Staatliche Museen, Berlin.[35] Flutes, called *auloi*, and reed instruments more like a clarinet, were made of ivory. They were also made from the leg bones (tibiae) of deer, according to the grammarian Pollux (*Onomasticon* IV.75), and from the actual discovery of fragmentary deer-bone *auloi* in the sanctuary at Perachora near Corinth.[36] The ivory case for an *aulos* is mentioned in one of the Parthenon inventories.

Ancient craftsmen decorated weapons with ivory —obviously special orders—and it is worth recalling that Demosthenes' father combined the manufacture of weapons with furniture—ivory was needed for both. Among the discoveries in the first royal tomb at Vergina was a badly disintegrated shield, with a wood-and-leather frame decorated round the rim with a spiral meander in ivory and a medallion at the center showing a man seizing a woman, also in ivory.[37] This brings to mind a story in the life of the sixth-century B.C. Greek philosopher Pythagoras, in which reference is made to a shield dedicated by Menelaos at the Temple of Apollo at Didyma on his way home from Troy that was so rotten by the time of the story that only the ivory facing was left (Diogenes Laertius VIII.1.5). Another of the tombs at Vergina contained a sword with an ivory-inlaid scabbard and a gold-sheathed hilt.[38] Swords and daggers inlaid with ivory have also been found in Italy.[39]

Fittings and handles of utensils were fashioned of ivory, bone, or wood. The Greek lyric poet Anacreon speaks of an ivory parasol, probably referring to the handle (Loeb Classical Library, *Lyra Graeca* II, Cambridge, Mass., 1958, 189, frag. 97). A mid-fifth-century B.C. bronze mirror in the Louvre still possesses a fine ivory handle normally lost or disintegrated on most preserved mirrors.[40] Carved bone handles are preserved on many Etruscan bronze mirrors.[41]

Jewelry was fashioned from ivory and bone: brooches, pins, and rings could be made from small pieces left over from larger works. "Figure-eight" safety pins, dating from the seventh century B.C., are known from some two dozen sites in mainland Greece, the Greek islands, and Sicily.[42] Circular ones are also known, some inlaid with amber in a kind of cloisonné technique.[43] A group of ivory and bone rings with portraits possibly of the Ptolemaic queens Arsinoë II and Arsinoë III carved in relief on the bezel are from a later period (the third century B.C.). Two such rings are in the Walters Collection (cat. nos. 62 and 63; see colorplate 27).

Our survey would suggest that ivory carving was practiced extensively in ancient Greece. This required quantities of ivory, which, although elephants seem to have been unlimited before the Roman period, was still expensive. Inscriptions from the Acropolis at Athens record the expenses for the materials used by Phidias in fashioning the chryselephantine statue of Athena Parthenos, including the purchase of ivory for the work and the sale of what was left over afterward.[44] The doors of the Temple of Asklepios at Epidauros of the late fifth or early fourth century B.C. were of ivory (they were probably inlaid with ivory), and cost 3,150 drachmas, one drachma being the standard daily wage of the period.[45]

The ivory surely came from African elephants, the Syrian supply having long been exhausted. The fifth-century B.C. Greek comic poet Hermippus said that Libya provided abundant ivory to buy (quoted by Athenaeus, *Deipnosophistae* I. 27). Herodotus stated that every second year Ethiopia sent twenty elephant tusks to the Persians.[46]

In Africa, in the Hellenistic period under the Ptolemies, a potential conflict loomed between military procurers, who needed elephants alive as instruments of war, and suppliers of ivory, who had to kill them for their tusks. Nevertheless, elephants seem to have been plentiful.[47] The trade must have been lucrative for everyone involved. Tax records from the third century B.C. in Egypt, written in ink on potsherds, provide evidence for the taxing of ivory shipped through Egypt to the Mediterranean world.[48]

In 54 B.C., Ptolemy XII Auletes of Egypt presented thirty-four tusks weighing either thirty-two or forty pounds each to the Temple of Apollo at Didyma.[49] This represented a considerable financial contribution. A cache of actual tusks was discovered in 1959 or 1960 at Wad ben Naga, on the Nile south of Meroë in the Sudan, in the ruins of what is judged to be the late-first-century B.C. palace of Queen Amanishakhete, called Candace by Roman writers.[50] In the Roman period there is also evidence for the export of African ivory from the emporium of Sabratha in Libya to Ostia, the port of Rome.[51] Bronze statuettes from Algeria and a mosaic at Piazza Armerina, Sicily, show personified representations of Africa holding a tusk in the attitude of a cornucopia.[52]

The number of tusks used could be staggering. The Roman general Lucius Scipio carried 1,231 ivory tusks in his triumphal procession in Rome after the death of Antiochus of Syria in 189 B.C. The historian Livy enumerates the tusks together with the gold and silver vessel and coins also displayed in the triumph, thus calling attention to their value. To anyone skeptical of this figure, note should be taken of the more than fifty Parthian rhytons (ritual vessels) made from sections of ivory tusks found at Nisa in Soviet Turkmenistan.[53] Widespread taste for ivory began to deplete the supply of elephants. Pliny the Elder, writing in the first century A.D., stated that, ". . . recently owing to our poverty even bones have begun to be cut into layers in as much as an ample supply of tusks is now rarely obtained except from India, all the rest of the world having succumbed to luxury" (*Natural History* VIII.7).

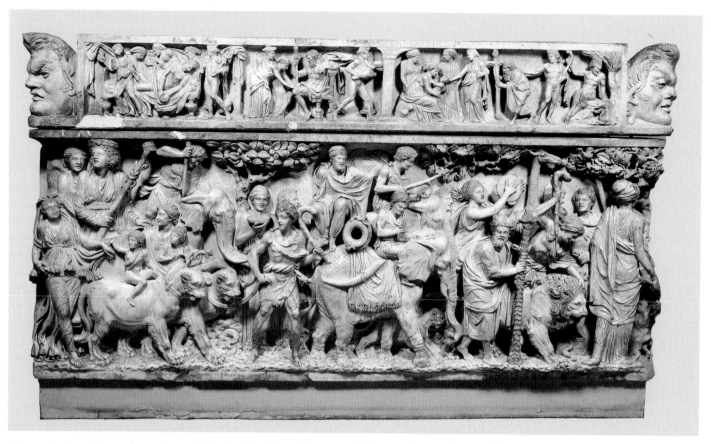

Figure 16. Detail from a sarcophagus depicting the triumphal return of Dionysos from India, marble, Roman, 2nd–3rd century. The riches of India meant jewels, spices, and ivory, all increasingly exploited after the conquest of Alexander the Great. Roman myth linked Dionysos, god of wine, with the triumphal return of Alexander from India, and visual representations show tusks among the booty. Walters Art Gallery (23.31).

India had presumably been supplying tusks for centuries. The Persian king Darius had obtained ivory not only from Ethiopia but from Afghanistan and India. Following the military conquests of Alexander the Great, Indian ivory must have been more easily available in the West. A marble sarcophagus of the second century A.D. in the Walters shows a triumphal procession of the god Dionysus in imitation of that of Alexander's return from India. Tusks are carried as booty on the back of an elephant (figure 16).[54] A late Roman silver dish in the Archaeological Museum, Istanbul, features the personification of India seated on a cushioned throne with two pairs of crossed tusks as legs.[55]

An ivory statuette, apparently a mirror handle, representing a yakshi, or Indian courtesan, and found at Pompeii but carved in India, testifies unequivocally to the trade in ivory between India and Italy in the first century A.D.[56] A collection of Indian ivories of the first and second centuries A.D., now in the Kabul Museum, was found in the ruins of a Kushan palace at Begram in Afghanistan in 1937. With them were found collections of Chinese lacquers and Roman glassware and bronzes, an assemblage attributable to the collecting tastes of the local ruler and his geographical situation on the trade routes between the great cultures. Among the ivories is a box embodying Indian and Roman styles, further evidence of a connection involving ivory between the

Roman Empire and India. The box has a lid formed by six joined panels on which is engraved a scene of four women at a bath, one playing with a parakeet, done in Indian style. The decorative borders of the panel, however, are drawn in Roman style.[57]

Roman Ivories

In contrast to the Etruscans, the Romans in the time of the early Republic (fifth and fourth centuries B.C.) used ivory sparingly, in line with the prohibitions against the ostentatious use of silver tableware and jewelry. Insignia of high office alone embodied ivory—scepters and the curule chairs—as reported by Livy and other Roman writers.

Ivory was probably not used as it was in Greece until the second century B.C., when the Roman military conquests and the influx of material spoils of war altered Roman taste. Ivory statues of the leading citizens, in the fashion of Greek rulers, were not made until the first century B.C. The Roman senate decreed that an ivory statue of Julius Caesar should appear in the procession at the circus games (Dio Cassius XLIII.45.2–4), and other Romans were later portrayed in ivory. In their sweeping appropriation of Greek works of art, the Romans collected at least one Greek chryselephantine statue: after defeating Antony at the Battle of Actium in 31 B.C.,

Augustus took home to Rome the sixth-century B.C. image of Athena from Tegea and set it up near the Roman Forum (Pausanias VIII.46.4). By the time of the Emperor Constantine, in the early fourth century A.D., there were said to be seventy ivory statues in Rome.

The nearly life-size ivory face and arm of a woman in the Vatican Museum probably came from a Roman chryselephantine statue,[58] as did the half-life-size sandaled foot in the Metropolitan Museum of Art (see colorplate 28).[59] Gods and people were also represented in smaller scale in the Roman period. A statuette of Apollo from the Athenian Agora is a second- or third-century A.D. copy after the fourth-century B.C. statue of Apollo in Aristotle's Lyceum.[60] Four miniature portraits of the third century A.D., obviously meant to represent real people, were excavated in 1968–1969 at Ephesus in Asia Minor.[61]

Roman furniture was inlaid with ivory and bone. The Latin playwright Plautus refers to couches inlaid with ivory and gold (*Stichus* 377). The funeral couch of Julius Caesar was of ivory (Suetonius, *Caesar* 84). Horace speaks of scarlet covers glittering on ivory couches (*Satires* II. vi. 103). The Latin poet Martial refers to tables of citrus wood with ivory legs (*Epigrams* XIV.91), and Seneca owned tripod tables with ivory legs (Dio Cassius LXI.10.3). But Clement of Alexandria, a Christian writer, is scornful of these luxuries: "Will a table with legs carved of ivory take it ill that it supports only bread worth one obol . . . a lowly cot affords no worse repose than an ivory bed" (*Paidagogos* II. 37).

Numerous ivory inlays and veneers for furniture have been recovered in the excavations of Pompeii, while in many parts of central Italy tombs have yielded funerary couches, once used in real life, which are inlaid with ersatz ivory—that is, bone. The use of bone, probably the bone of horses and oxen, recalls Pliny's statement about its substitution for ivory. A lion's head and two garlanded cupids in the Walters come from such a couch (cat. no. 66). A statuette of Autumn, clutching the season's fruits in his arms, also in the Walters (cat. no. 68), similarly decorated a piece of furniture, or perhaps a box.

Roman boxes came in many styles. In the first century A.D. lidded, cylindrical boxes of bone or ivory, frequently decorated with Erotes in playful poses, two examples of which are in the Walters (cat. nos. 71 and 72; see colorplate 29), were popular. Also common in the same period are rectangular bone boxes with sliding lids and figural reliefs on the side panels.[62] An ivory panel of grander conception and quality, now in the National Museum of Naples, comes from a villa at Boscoreale, on the slopes of Vesuvius, and shows two cupids, one pouring wine from an amphora into a mixing bowl.[63]

In the Walters is the panel of a box in another style, probably of Italian manufacture, which shows cupids in bold relief in the guise of the four seasons (cat. no. 75; see colorplate 30). Also in the Walters are several objects, mostly rectangular plaques, with mythological scenes that must once have been set into jewelry boxes or similar objects (cat. nos. 81, 83, 84, 90, 91; see colorplates 31–34).

One plaque shows Achilles in his tent sulking (cat. no. 87; see colorplate 35), another Artemis and Apollo (cat. no. 88; see colorplate 36). They are traditionally dated in the third or fourth century A.D., which may well be accurate, but one of the plaques shows a helmeted and cuirassed warrior (cat. no. 82; see colorplate 37) so similar in style to a plaque from a first-century B.C. tomb at Cumae, Italy, that perhaps it and others also are earlier in date than hitherto suspected.[64]

Ivory reliefs of yet another style, dating from the late second or early third century, have recently been excavated at Ephesus and are thought to have decorated a chest or piece of furniture: scenes from an ancient comedy and a Roman triumph are two subjects represented.[65] These selected examples of relief work from furniture and boxes oblige us to recognize the existence of different schools of ivory and bone carving of high quality in many parts of the Roman world (cat. nos. 81 and 91, for instance, from Egypt).

Ivory and bone were used for dice, game counters, and boards for games. Game counters shaped like checkermen bore reliefs of many types on one face, on the other, Greek and Latin numerals running from one to fourteen. A game counter in the Walters shows the sign of the zodiac Capricorn (cat. no. 94; figure 17). Sometimes the counters were in the shapes of objects: actors' masks, birds, fish, hares, boars, rams' heads, cicadas, scallop shells, frogs, peapods, or almonds. A set of nine ivory counters in the form of trussed fowl, bearing a sequence of Roman numerals, was found in a tomb in Athens.[66] A Roman game board of wood with ivory inlay was found at Qustul, in the Sudan, in a leather bag that also contained fifteen ivory and fifteen ebony gaming pieces, five ivory dice, and a wooden dice-casting box of special cheat-proof design, called a *fritillum*.[67] The game board has thirty-

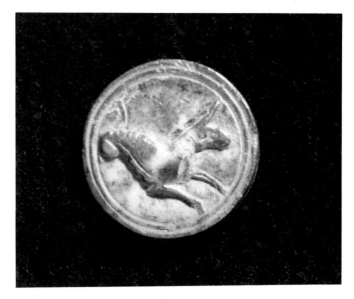

Figure 17 (cat. no. 94). Game counter, bone, Roman, 1st century. Game counters, shaped like modern checkermen, are marked with a wide variety of symbols including signs of the zodiac, as this of Capricorn.

six "squares," and three circular spaces. We have no idea how the game was played, but it cannot have been unlike a modern game of two opposing sides; a Roman epigram refers to a game played with white and black men moving out and toward home (*Palatine Anthology* IX.482).

Fragments of an ivory board found in 1967 at Grand (in France) are engraved with signs of the zodiac and with Egyptian deities in concentrically arranged panels. This object was probably used to cast horoscopes.[68]

Musical instruments continued to be made of ivory, as they had been in earlier centuries. Ivory *auloi* with bronze fittings of Roman date have been found at Meroë in the Sudan and at Pompeii. As many as a dozen, from Meroë, are in the Museum of Fine Arts, Boston, while four, from Pompeii, are in the Naples Museum.[69] Other *auloi* of bone are known.

Knife handles were commonly made of ivory and bone, the knives themselves straight or switchblades. The sculpted handles took the form of powerful animals and monsters such as griffins, hounds, and lions; sometimes only their heads were used as finials; a handle of this type is in the Walters (cat. no. 101). Some were carved as armed gladiators, singly or in pairs.[70] An exceptionally fine knife handle in the Walters represents a seated child clutching grapes (cat. no. 103; see colorplate 38). Handles from a special group of knives, or possibly whips, were used by charioteers in the arena; on their tapering grips are found engraved a horse's head, the name of the horse or the charioteer, and symbols of the game: a cap, a whip, or a palm branch of victory.[71]

The bridles of horses were decorated with circular ornaments known as *phalerae* and a nosepiece known as a *prometopidion*. Usually these are made of bronze or silver but they are known also in other materials. Two medallions in the Walters, one of ivory showing a lion's face, the other of bone featuring a head of Herakles, probably decorated leather bridles (cat. nos. 105 and 106; see colorplate 39).

Many other types of objects were made of ivory and bone, some of which have no counterpart today. In his epigrams Martial refers to writing tablets, boxes for gold coins, birdcages, doctors' tools, and even a scratcher ending in a miniature hand—all made of ivory (*Epigrams* 5, 13, 77, 78, 83). Several hundred inscribed rectangular bone labels, pierced at one end, have been identified as tags that were tied with a cord around the openings of bags of coins, after the authenticity of the coins had been established. They were used in Italy in the second and first centuries B.C. by *numularii* who were charged with the double function of changing money and testing for counterfeit coins.[72] In the Fitzwilliam Museum, Cambridge, is a pair of folding ivory writing tablets, originally equipped with silver hinges.[73] The Walters owns several ivory or bone styluses used for writing on the wax, which was evenly spread on the recessed inner surfaces of such folding tablets (cat. nos. 109–111). Decorative ivory pins for garments or hairdressing occur in considerable numbers (cat. no. 107; see colorplate 40). Also in the Fitzwilliam Museum is a contraption that may have been used for winding a papyrus roll between two reels while keeping exposed several columns of text for easy reading. It has two specially contoured side panels of ivory forming the frame.[74] Similar pairs of specially contoured ivory panels, but with the addition of genre scenes carved in relief on their outer faces, have been found at Pompeii, Ostia, and Cologne.[75]

All the Greek and Roman objects described here, having been buried in tombs, dedicated at sanctuaries, or lost on habitation sites, have been discovered in modern times by archaeological excavation. By contrast, many of the ivory objects made in the late Roman and early Medieval periods, such as consular diptychs and ivory book covers, have survived continuously above ground to the present day. Preserved in a sequence of ecclesiastical and secular collections, they owe their preservation to a continuity of traditions sanctioned by church and state.

NOTES

1. J.-P. Michaud, "Chronique des fouilles et découvertes archéologiques en Grèce en 1972," *BCH*, XCVII, 1973, 405–406, fig. 335.

2. A. J. Evans, *The Palace of Minos at Knossos*, III, London, 1930, 430, fig. 296.

3. R. Higgins, *Minoan and Mycenaean Art*, London, 1967, 50–52.

4. E. Vermeule, *Greece in the Bronze Age*, Chicago, 1964, 218, pl. 38.

5. J.-C. Poursat, *Catalogue des ivoires Myceniens du Musée National d'Athènes*, Paris, 1977.

6. K. Demakopoulou and D. Konsola, *Archaeological Museum of Thebes Guide*, Athens, 1981, pls. 24, 26, 27; J.-P. Michaud, "Chronique des fouilles et découvertes archéologiques en Grèce en 1970," *BCH*, XCV, 1971, 834, fig. 65; E. Vanderpool, "Newsletter from Greece," *AJA*, LXI, 1957, 283, pl. 85, fig. 13.

7. E. Vermeule, *Greece*, 218–221, pls. 36 and 37.

8. E. Vermeule, *Greece*, 174–175.

9. E. Vermeule, *Greece*, 221, pl. 39b.

10. R. D. Barnett, "Early Greek and Oriental Ivories," *JHS*, LXVIII, 1948, 1–2. For a more recent publication by Barnett, see *Ancient Ivories in the Middle East* (Qedem, Monographs of the Institute of Archaeology, no. 14, The Hebrew University of Jerusalem, 1982).

11. L. H. Sackett, "Excavations at Lefkandi, Euboia, 1981," abstract of a paper delivered at the annual meeting of the Archaeological Institute of America, 1981, *AJA*, LXXXVI, 1982, 284.

12. V. Karageorghis, *Cyprus*, London and New York, 1982, 108–109.

13. E. Kunze, "Anfänge der griechischen Plastik," *AM*, LV, 1930, 147–155, pls. V–VIII.

14. Y. Huls, *Ivoires d'Étrurie*, Brussels and Rome, 1957; E. Aubet, *Los marfiles orientalizantes de Praeneste*, Publicaciónes Eventuales, no. 19, Inst. de Arqueología y Prehistoria, Universidad de Barcelona, 1971.

15. Circolo della Costiaccia da Vetulonia, Huls, *Ivoires*, 135.

16. R. M. Dawkins, *The Sanctuary of Artemis Orthia at Sparta*, JHS suppl. paper no. 5, 1929; L. Marangou, *Lakonische Elfenbein- und Beinschnitzereien*, Tübingen, 1969; B. Freyer-Schauenburg, *Elfenbeine aus dem samischen Heraion*, Hamburg, 1966. See also review of same by J. Boardman in *Gnomon*, XXXIX, 1967, 844–846.

17. R. Stillwell, "Excavations at Corinth, 1934–1935," *AJA*, XL, 1936, 43–45, figs. 22–25.

18. P. Amandry, "Les statues chryséléphantines de Delphes," *BCH*, LIII, 1939, 86 ff., and all new guidebooks to the site; J. Boardman, *Greek Sculpture: The Archaic Period*, New York, 1978, 77, fig. 127.

19. E. Kunze, "Neue Ausgrabungen in Olympia," *Neue Deutsche Ausgrabungen im Mittelmeergebiet und im vorderen Orient*, Berlin, 1959, 289–290. For a further association of Phidias and ivory, see M. Le Glay, "Un Eros

de Phidias à Timgad," *Antiquités africaines* XIV, 1979, 129–133.

20. M. Andronikos, *The Royal Graves at Vergina*, Athens, 1978, 40, figs. 16–20.

21. K. Rhomiopoulou, "A New Monumental Chamber Tomb with Paintings of the Hellenistic Period near Lefkadia," *Athens Annals of Archaeology*, 1973, 87–92.

22. U. Knigge, *Die Südhügel, Kerameikos*, IX, Berlin, 1976, 60–83.

23. E. H. Minns, *Scythians and Greeks*, Cambridge, 1912, 204, figs. 100–103.

24. M. Andronikos, "The Finds from the Royal Tombs at Vergina," *Proceedings of the British Academy*, LXV, 1979, 361, pl. 39.

25. E. Brizio, "Ancona," *Notizie degli scavi*, 1902, 458–459, figs. 26 and 27; *Collection Borelli Bey*, sale, Hôtel Drouot, Paris, June 11–13, 1913, lot 399, pl. 35.

26. G. M. A. Richter, *The Furniture of the Greeks, Etruscans, and Romans*, London, 1966, 107, fig. 544.

27. P. Bernard, "Sièges et lits en ivoire d'époque hellénistique en Asie Centrale," *Syria*, XLVII, 1970, 327–343.

28. P. C. Sestieri, "Statuine Eburnee di Posidonia," *Bollettino d'arte*, XXXVIII, 1953, 9–13.

29. E. C. Banks, "Achilles and Penthesilea —A Roman Ivory of the First Century B.C.," *The Nelson Gallery and Atkins Museum Bulletin*, V, 1979, no. 5, 3–21.

30. J. Boardman, *Greek Sculpture: The Archiac Period*, New York, 1978, 41, fig. 39; J. Dörig, "Lysippe und Iphianassa," *AM*, LXXVII, 1962, 72–91, pls. 16–17. Another interpretation is given by G. M. A. Richter, "An Ivory Relief in the Metropolitan Museum of Art," *AJA* XLIX, 1945, 261–299, and C. Picard, "L'ivoire archaïque des deux-déesses," *Monument Piot*, XLVIII, 1956, 8–23.

31. R. Hampe and E. Simon, *The Birth of Greek Art*, New York, 1981, 230–231.

32. P. G. Themelis, *Delphi*, 1980, figs. 39 and 40. Later in date, of the 3rd century B.C., was an ivory relief, now lost, from Demetrias, Greece: H. Kyrieleis, *Throne und Klinen*, suppl. 24, *Jahrbuch des Deutschen Archäologischen Instituts*, 1969, 146, pl. 18, 3.

33. W. E. Thompson, "The Early Parthenon Inventories," *AJA*, LXIX, 1965, 223–230.

34. H. Walter, "Ein samischer Elfenbeinjüngling," *AM*, LXXIV, 1959, 43 ff.; E. Simon, "Zwei Springtänzer ΔOIΩ KYB-IΣTHTHPE," *Antike Kunst*, XXI, 1978, 66–69.

35. A. Greifenhagen, "Ein ostgriechisches Elfenbein," *Jahrbuch der Berliner Museen*, VII, 1965, 125–156.

36. T. J. Dunbabin, ed., *Perachora*, II, Oxford, 1962, 448–451.

37. M. Andronikos, "The Finds from the Royal Tombs at Vergina," *Proceedings of the British Academy*, LXV, 1979, 362.

38. Idem, 364.

39. D. Ridgway, "Archaeology in Central Italy and Etruria, 1968–73," *Archaeological Reports for 1973–74*, 1974, 43.

40. J. Charbonneaux, "Nouvelles Acquisitions," *La Revue des arts, Musée de France*, VII, 1957, no. 2, 85, ill.

41. S. S. Weinberg, "Etruscan Bone Mirror Handles," *Muse*, IX, 1975, 25–33.

42. T. J. Dunbabin, ed., *Perachora*, II, Oxford, 1962, 433–437, pls. 183–185.

43. École Française d'Athènes, *Guide de Thasos*, Paris, 1968, 161–162, fig. 101. Ivory berries occur on a bronze laurel wreath from a first-century B.C. context at Kommos, an extreme instance of using up leftover bits (J. W. Shaw, "Excavations at Kommos (Crete) during 1980," *Hesperia*, L, 1981, 229, pls. 58b–c).

44. *Inscriptiones Graecae*, i², 352, 354–355; R. Meiggs and D. Lewis, *A Selection of Greek Historical Inscriptions*, Oxford, 1969/1980, no. 54.

45. *IG*, iv², 1, 102; A. Burford, *The Greek Temple Builders at Epidauros*, Toronto, 1969, 183, 214.

46. Book III, 97; W. W. How and J. Wells, *A Commentary on Herodotus*, Oxford, 1928, I, 288.

47. Agatharchides, *On the Erythraean Sea* (Photios' epitome), Book I:56, translation in *The Periplus of the Erythraean Sea*, ed., G. W. B. Huntingford, The Hakluyt Society, London, 1980, 187.

48. S. V. Wångstedt, "Demotische Steuerquittungen aus ptolemäischer Zeit," *Orientalia Suecana*, XVII, 1968, 28–34.

49. A. Rehm, *Didyma II: Die Inschriften*, Berlin, 1958, no. 394; H. H. Scullard, *The Elephant in the Greek and Roman World*, Ithaca, 1974, 61–62.

50. J. Vercoutter, "Un palais des 'Candaces,' contemporain d'Auguste," *Syria*, XXXIX, 1962, 262–299.

51. S. Aurigemma, "L'elefante di Leptis Magna," *Africa Italiana*, VII, 1940, 67 ff.

52. M. LeGlay, "Africa," *Lexicon Iconographicum Mythologiae Classicae*, I, Zurich and Munich, 1981, 253, pls. 188 and 189.

53. M. E. Masson and G. A. Pugačenkova, *The Parthian Rhytons of Nisa*, Florence, 1982. These ivories are divided among the Ashkhabad History Museum, the State Pushkin Museum of Fine Arts, Moscow, and the Hermitage Museum, Leningrad.

54. K. Lehmann-Hartleben and E. C. Olsen, *Dionysiac Sarcophagi in Baltimore*, Baltimore, 1942, 12, fig. 7.

55. *Art Treasures of Turkey*, exh. cat. Smithsonian Institution, Washington, D.C., 1966, 95, no. 155, ill.

56. A Maiuri, "Statuetta eburnea di arte indiana a Pompei," *Le arti*, I, 1938–39, 111–115; R. C. Craven, *A Concise History of Indian Art*, London, 1976, 72–73, fig. 41.

57. J. Hackin, "Recherches archéologiques à Begram," *Mémoires de la délégation archéologique française en Afghanistan*, IX, 1939, 87–91, figs. 181 and 182; XI, 1954, 55-57, fig. 233.

58. C. Albizzati, "Two Ivory Fragments of a Statue of Athena," *JHS*, XXXVI, 1916, 373–402; W. Helbig, *Führer durch die öffentlichen Sammlungen klassischer Altertümer in Rom*, 4th ed., Tübingen, I, 1963, 373, no. 475.

59. G. M. A. Richter, "Miscellaneous Accessions in the Classical Department," *BMMA*, Dec. 1926, 286, fig. 6. Another ivory foot of this type is in the Saint Louis Art Museum, acc. no. 227:1923.

60. L. T. Shear, "The Campaign of 1936," *Hesperia*, VI, 1937, 349–351, figs. 13 and 14. Other statuettes of the Roman period include a hunchback in the British Museum (A. H. S.

Teames, "An Ivory Statuette," *Papers of the British School at Rome*, IV, 1907, 279–282), a figure of Harpocrates in the Archaeological Museum, Florence (F. W. v. Bissing, "Materiali archeologici orientali ed Egiziani," *Studi Etruschi* XII, 1938, 297–298, pl. LVIII), the figure of an actor in the Petit Palais, Paris (M. Bieber, *The History of the Greek and Roman Theater*, Princeton, 1961, fig. 799), and a Bacchic group carved out of a whole tusk, from Sidon (G. Contenau, "Deuxième mission archéologique à Sidon," *Syria* IV, 1923, 269–273).

61. J. Inan and E. Alföldi-Rosenbaum, *Römische und frühbyzantinische Porträtplastik aus der Türkei*, Mainz, 1979, 191–194, nos. 157, 159–161, pls. 120, 122, and 123.

62. V. Karageorghis, "Chroniques des fouilles et découvertes archéologiques à Chypre en 1968," *BCH*, XCIII, 1969, 485–487, fig. 106; N. Lambert, "Rapports sur les travaux de l'école française en 1970," *BCH*, XCV, 1971, 781–782, fig. 8; Marangou, 125, no. 213, pl. 65a; Staatliche Museen Preussicher Kulturbesitz, *Römisches im Antikenmuseum*, Berlin, 1978, 193–194, fig. 303.

63. M. Della Corte, "Boscoreale: Parziale scavo della villa rustica 'M. Livi Marcelli,'" *Notizie degli Scavi*, 1929, 185, fig. 7.

64. A. Levi, "Cuma (Necropoli)," *Notizie degli scavi*, 1925, 88, fig. 6. The discovery of an ivory plaque with the Rape of Ganymede in a Hellenistic level at Jerusalem strengthens this hypothesis (Y. Shiloh, "Excavating Jerusalem: The City of David," *Archaeology*, XXXIII, no. 6, 1980, 12–13).

65. M. Dawid and P. G. Dawid, "Restaurierungsarbeiten von 1965–1970," *Jahreshefte des Österreichischen Archäologischen Institutes in Wien*, L, 1972–1975, 542–549; M. Dawid, "Bemerkungen zu zwei Relieffriesen aus dem ephesischen Elfenbeinfund," *Forschungen und Funde, Festschrift B. Neutsch*, ed. F. Krinzinger, Innsbruck, 1980, 95–102, pls. 15–17.

66. G. Behrens, "Römische Lose in Tiergestalt," *Germania*, XXIV, 1940, 20–22.

67. W. B. Emery, *Nubian Treasure*, London, 1948, pls. 32a–c.

68. "Informations Archéologiques," *Gallia*, XXVI, 1968, 402, fig. 42. For similar objects, see H. Stern, *Le calendrier de 354*, Paris, 1953, 179–180.

69. N. B. Bodley, "The Auloi of Meroë," *AJA*, L, 1947, 217–240; A. A. Howard, "The Aulos or Tibia," *Harvard Studies in Classical Philology*, IV, 1893, 47–56, pl. 2.

70. J. M. C. Toynbee, *Art in Roman Britain*, London, 1962, 149, no. 53, pl. 56.

71. J. M. C. Toynbee, "Beasts and Their Names in the Roman Empire," *Papers of the British School at Rome*, XVI, 1948, 33, fig. 20.

72. M. Crawford, "Money and Exchange in the Roman World," *JRS*, LX, 1970, 45.

73. Fitzwilliam Museum, Cambridge, *Annual Reports . . . Year Ending 31 December 1980*, 13, pl. 3.

74. *Annual Reports . . . Year Ending 31 December 1980*, 13, pl. 3.

75. German Archaeological Institute, Rome, photographs, nos. 66.1838, 74.1337; D. Vaglieri, "Ostia," *Notizie degli scavi*, 1912, 97, fig. 5; Römisch-Germanisches Museum, *Römer am Rhein*, exh. cat., Cologne, 1967, 319, F 44, pls. 116 and 117.

Catalogue, Greek, Etruscan, and Roman Ivories

56. GODDESS OR PRIESTESS

Ivory and gold statuette. Cretan, Late Minoan I period, 16th century B.C.

The figure is constructed from five pieces of ivory originally fastened together with ivory pegs, but now secured with modern wires. The pieces forming the skirt are hollow and possibly came from the base of a tusk. Elements of the dress—the short sleeves, tight bodice, apron, and edges of flounces—are made of thin gold sheeting cut into elaborate openwork patterns and decorated with punched circles. The raised arms were entwined with gold snakes—part of one remains—and a gold diadem formed part of the tall headdress. The surface of the ivory is almost entirely destroyed, and so little idea can be formed of the style of the modeling.

The figure is similar in some aspects of costume and pose to three faience statuettes found at the Palace of Knossos in Crete by Sir Arthur Evans (A. J. Evans, *The Palace of Minos at Knossos*, London, 1921–35, I [frontispiece], II [fig. 306]) and identified by him as snake goddesses or priestesses. Despite its eroded surface, the Walters ivory displays a tenseness of pose and sense of movement comparable to the faience figurines from Knossos. Gold-and-ivory figures of this type allegedly from Crete were acquired by various museums in the early part of this century. Closest to the Walters figurine is the goddess in Boston (L. D. Caskey, "A Chryselephantine Statuette of the Cretan Snake Goddess," *AJA*, XIX, 1915, 237–249, pls. 10–16; and G. Chase and C. Vermeule, *Greek, Etruscan and Roman Art*, Museum of Fine Arts, Boston, 1963, 13–14, fig. 6). Despite the different accounts of its origin, the Boston ivory is generally accepted as authentic (K. P. Foster, *Aegean Faience*, New Haven and London, 1979, 77, n. 85). The authenticity of this group of ivories cannot be determined on the basis of the age of the ivory because there was reputed to have been a deposit of unworked tusks excavated at Knossos, from which (if the statues are modern) they could have been made.

H: 8½" (21.5cm) 71.1090

HISTORY: Purchased from Feuardent, Paris, before 1931.

BIB.: D. K. Hill, "Two Unknown Minoan Statuettes," *AJA*, XLVI, 1942, 254–260; C. Seymour, *Tradition and Experiment in Modern Sculpture*, Washington, D.C., 1949, ill. 8; J. C. Kirby, "The Care of a Collection," *JWAG*, XV–XVI, 1952–53, 28–29, figs. 23–25.

See also colorplate 19

57. WOMEN WITH SPHINXES; CHARIOTS; ANIMALS

Ivory box. Etruscan, 650–625 B.C.

This pyxis is fashioned from the large, hollow end of an elephant's tusk. Its surface is divided by four undecorated bands into three registers decorated with figural reliefs. On one side of the lower register, rampant sphinxes flank a group of three women holding hands; the leftmost woman also grasps the stem of a lotus plant, a gesture the rightmost woman presumably repeated, but that section is not preserved. On the other side, a woman holds the raised paws of the two sphinxes flanking her. Behind the two sphinxes are male figures who grasp their tails; of the figure on the right only the hand on the tail remains.

On the middle register are four chariots ready to parade, with charioteers in long cloaks behind each chariot prepared to mount. Although two pairs of reins indicate there are two horses pulling each chariot, only one horse is shown.

On the upper register there are four animals, with no clear relationship to one another: a crouching deer, looking over its shoulder; a lion; a bull, or deer, upside down; a second feline. A Phoenician palmette separates the lion from the deer. The cover of the pyxis is missing, but its knob, which is carved in the form of a sphinx, is preserved. The sphinx carries its wings high, its tail low, and wears a Phoenician palmette crown.

The pyxis is generally identified as the one described in an Italian excavation report of 1877 found "near the Regolini-Galassi tomb in the Sorbo cemetery at Cerveteri" (Fiorelli, "Cerveteri," *Notizie degli scavi*, 1877, 155). It is similar to a pyxis found in that tomb now in the Vatican Museum (L. Pareti, *La tomba Regolini-Galassi*, Vatican City, 1947, 226, no. 168, pl. 18). The two are postulated to be products of the same workshop. Motifs such as those of the Phoenician palmette, the "Subduer of Sphinxes," the chariots, and the group of three women, as well as the shape of the pyxis and the ivory material, derive from the Phoenician Near East and from Greece, which was also strongly influenced by its eastern neighbors during the seventh century B.C. A certain lack of clarity represented by the upside-down animal, the charioteers standing behind their chariots instead of being mounted, and the unclear gestures of the three women between the sphinxes suggest that the artist copied several different models and perhaps added touches of his own. It is likely, then, that this pyxis was made in Etruria after Near Eastern models, and was not a direct import from the Near East. Unworked ivory blocks were found at Vetulonia, and so it is clear that Etruscan workshops existed.

H (of pyxis): 5½" (16.0 cm); H (of the sphinx handle): 1¾" (4.5cm) 71.489

HISTORY: Found near the Regolini-Galassi tomb in Cerveteri, 1877; Bourguignon Collection, *Catalogue des objets antiques... provenant des collections du Dr. B. et de M. C.*, sale, Hôtel Drouot, Paris, May 19–21, 1910, no. 338, ill; purchased before 1931.

BIB.: *Notizie degli scavi*, 1877, 155; R. D. Barnett, "Early Greek and Oriental Ivories," *JHS*, LXVIII, 1948, 24, n. 147; L. Banti, *Die Welt der Etrusker*, Stuttgart, 1960, 37, pl. 27; W. L. Brown, *The Etruscan Lion*, Oxford, 1960, 30, pl. 14b; R. Rebuffat, "Une pyxis d'ivoire perdue de la tombe Regolini-Galassi," *Mélanges d'archéologie de l'école française de Rome*, 1962, 369–431; E. Richardson, *The Etruscans*, University of Chicago, 1964, pls. 9a, 10; G. Mansuelli, *The Art of Etruria and Rome*, New York, 1965, 65, fig. 25; K. Schefold, *Die Griechen und ihre Nachbarn*, Berlin, 1967, fig. 395a; L. Banti, *Il mondo degli etruschi*, Rome, 1969, 294, pl. 15a; H. Demisch, *Die Sphinx*, Stuttgart, 1977, 107, fig. 302; V. A. Hibbs, "A New View of Two Carmona Ivories," *AA*, 1979, 471, figs. 10 and 11; WAG *Jewelry*, ill., 52.

See also colorplate 20

57

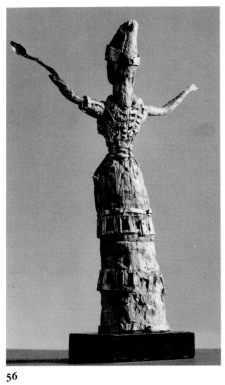

56

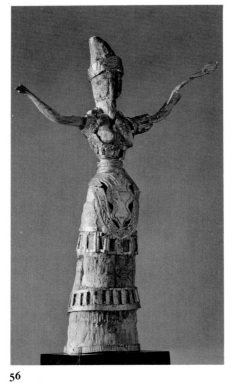

56

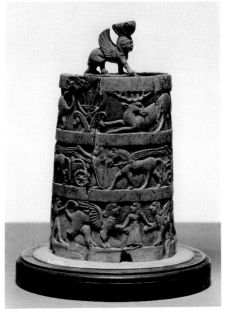

57

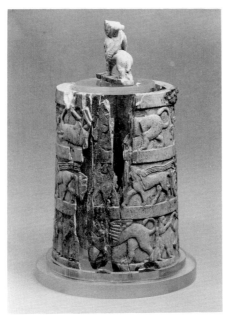

57

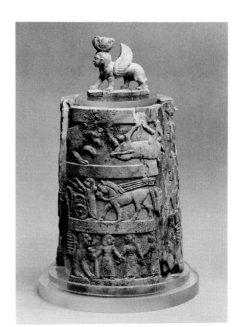

57

58. LIONS

Bone comb. Etruscan, after 500 B.C.

The comb is composed of three pieces of bone. The upper element is a rectangular piece incised with ten meanders on one side, nine on the other, and circles on the ends. Above the meanders are two gaunt lions, seated facing with their tails curled under prominent haunches. They have well-marked ribs, ribbonlike manes, and square faces with open jaws. Eyes, nostrils, and whiskers are incised. Set into a groove on the underside of this piece are two sections of bone, each carved with thirteen teeth making a total of twenty-six. The outermost teeth are ornamented on their edges with raised dots, perhaps continuing the pattern of incised circles on the ends of the rectangular upper element. The teeth are graduated in length and butt up against two triangular areas incised with concentric circles and artfully deformed meanders. Across the top is a row of narrow meanders. The comb is similar to one of unknown provenance in the Terme Museum, Rome (W. L. Brown, *The Etruscan Lion*, Oxford, 1960, pl. 48), so similar, in fact, that they both might be attributed to the same hand or workshop. The lions on the Terme comb have been linked by Brown to a group of eleven others, all made in Etruria shortly after 500 B.C. Their inspiration is ultimately Egyptian but comes by way of Greek bronze vases of the late sixth century B.C. on which lions often appeared as handle attachments.

MAX. H: 3½″ (8.9cm) × L: 3⅜″ (8.5cm) × TH: ⁵⁄₁₆″ (0.9cm) 71.495

HISTORY: Said to have been found at Naples; purchased from Dikran Kelekian, Paris, before 1931.

See also colorplate 21

59. BIRD

Ivory disc seal. Greek, 7th century B.C.(?)

One face of the seal is decorated with a bird, perhaps a cock, its beak open and wing raised, striding to the right. In the field above and below the bird are snakes with which it seems to be fighting. The upper snake is rather confusingly represented as emanating from the cock's comb. The other face is undecorated. There are no borders on either face, and the edge of the seal is plain.

Disc seals, normally pierced transversely so that they could be strung singly or in groups, were found in quantity in the sanctuaries of Artemis Orthia at Sparta, Hera Limenia at Perachora, and the Argive Heraeum at Argos, all in the Peloponnese where there must have been a center of production for such seals (T. J. Dunbabin, ed., *Perachora*, II, Oxford, 1962, 410–432; J. Boardman, *Island Gems*, London, 1963, 145). Although the objects may well have been used first as seals, their survival is due to their dedication in sanctuaries as votive gifts. Birds with snakes are a favorite motif, but there are no close parallels to this composition among the excavated examples. Most disc seals are decorated on both faces, unlike the Walters example. The plain face, and the lack of a hole for suspension, suggest either that this seal was never finished or that it is not ancient.

D: 1⅞″ (4.75cm) × TH: 5/16″ (0.8cm)
71.1103

HISTORY: Collection of Sir Arthur Evans; gift of Philip B. Perlman, 1942.

BIB.: A. J. Evans, *An Illustrative Selection of Greek and Greco-Roman Gems*, Oxford, 1938, 9, no. 32.

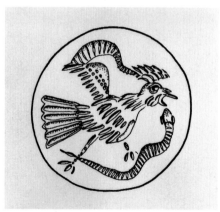

59

60. ALEXANDER THE GREAT

Ivory furniture ornament. Greek, late 4th–3rd century B.C.

The head and shoulders are meant to be seen in a three-quarter view. The back of the head and shoulders are flattened in two planes that meet at an angle behind the neck. A single groove, used for attachment, cuts vertically through both surfaces. The top of the head is also flat; the remains of a wooden pin suggest that the top part of the head was made of a separate piece of ivory attached with the pin. The bust probably ornamented the fulcrum, or headrest, of a couch.

The upswept hair falling back from the low, furrowed forehead, the large deep-set eyes with upward gaze, and the full lips conform to the descriptions of Alexander the Great and to other known representations of him.

The closest comparison with this piece is the tiny ivory head identified as Alexander found in a royal tomb at Vergina in northern Greece and thought to have ornamented, together with other ivory heads, the bier of the man buried in the tomb (National Gallery of Art, Washington, D.C., *The Search for Alexander*, New York, 1980, 187, no. 171, pl. 34). A direct comparison of the Walters head with large-scale photographs of the Vergina head shows striking similarities in the physiognomy of the features and the artistic style of representation, suggesting that the two are close in date.

The Walters head is said to come from Alexandria. During the feuding that followed Alexander's death in Babylon, the ablest of his generals, Ptolemy, managed to acquire Alexander's body for burial in the city named in his honor. The Walters head could have ornamented a funeral couch in the same fashion as the heads from the Vergina tomb.

H: 3½″ (8.9cm); H (of relief): 1³⁄₁₆″(3.1cm)
71.493

HISTORY: Said to have been found at Alexandria; purchased from Dikran Kelekian, Paris, 1924.

See also colorplate 22

61. HEAD OF A SATYR

Ivory furniture inlay. Greek, Hellenistic period, 2nd century B.C.

The satyr, shown frontally, wears a wreath with two rows of ivy leaves and a centerpiece of berries. His pointed left ear is bent forward in front of the wreath. He has a bald head, low, wrinkled forehead, broad nose, and luxuriant mustache and beard.

The head was once inlaid onto a wooden or bronze fulcrum, the rising headrest of a banquet couch. This explains the strong curve of the right side of the plaque, the cutaway left side, and the molding below the beard. The back is flat, incised with a crisscross pattern for better adhesion of glue, and there are traces of an iron nail at the corner of the mouth that attached the relief to the fulcrum. Satyrs, the companions of the wine god Dionysos, were an appropriate decoration for a couch used for feasting and drinking.

Similar ivory or bone satyr heads have been found in archaeological contexts ranging from the late third century B.C. until A.D. 79 (see cat. no. 115). An early one comes from a building at Monte Sannace, in southern Italy, destroyed in the late third century B.C. (D. Ridgway, "Archaeology in South Italy, 1977–81," *Archaeological Reports for 1981–82*, 1982, 70–71, fig. 14).

H: 3¹¹⁄₁₆″ (9.4cm) 71.616

HISTORY: Acquired in 1929.

BIB.: D. K. Hill, "Ivory Ornaments of Hellenistic Couches," *Hesperia*, XXXII, 1963, 293–300; G. M. A. Richter, *The Furniture of the Greeks, Etruscans, and Romans*, London, 1966, 108, fig. 541.

See also colorplate 23

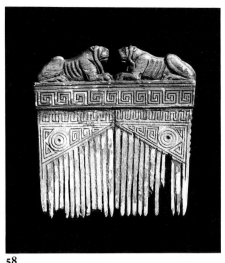

58

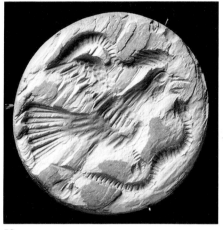

59

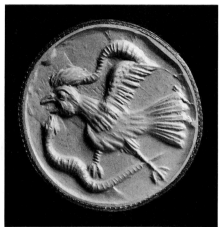

59 impression

60

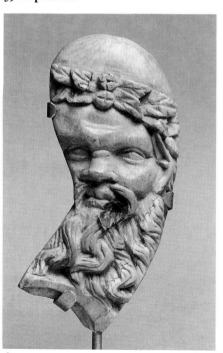

61

62. WOMAN'S HEAD

Bone ring. Greek, Hellenistic period, 3rd century B.C.

Most of the hoop is missing on this ring. Carved in relief on the nearly circular bezel is a woman's head in profile to the left. The hair is held both at the crown and at the back by double fillets. The hair at the back is more tightly contained than in catalogue no. 63.

The heads on this ring and on catalogue no. 63 resemble, but are not necessarily those of, Arsinoë III, queen of Egypt in the late third century B.C.

D (of bezel): 1⅛" (3cm) 71.609

HISTORY: Said to be from Lower Egypt; purchased from Dikran Kelekian, Paris, 1914.

BIB.: L. Marangou, "Ptolemäische Finger-ringe aus Bein," *AM*, LXXXVI, 1971, 164, no. 14; E. Alföldi-Rosenbaum, "Ruler Portraits on Roman Game Counters from Alexandria," *Eikones, Festschrift Hans Jucker, Antike Kunst*, Beiheft 12, Bern, 1980, 30, no. 27, pl. 11:4

See also colorplate 27

63. WOMAN'S HEAD

Bone ring. Greek, Hellenistic period, 3rd century B.C.

The ring has a flattened hoop. Carved in relief on the nearly circular bezel is a woman's head in profile to the left. The hair is held at the crown by a single fillet and at the back by a double fillet. A thin garment is indicated at the back of the neck.

The heads on this ring and on catalogue no. 62 resemble, but are not necessarily those of, Arsinoë III, queen of Egypt in the late third century B.C.

D (of bezel): 1⅛" (3cm) 71.608

HISTORY: Said to be from Lower Egypt; purchased from Dikran Kelekian, Paris, 1914.

BIB.: L. Marangou, "Ptolemäische Finger-ringe aus Bein," *AM*, LXXXVI, 1971, 164, no. 13; E. Alföldi-Rosenbaum, "Ruler Portraits on Roman Game Counters from Alexandria," *Eikones, Festschrift Hans Jucker, Antike Kunst*, Beiheft 12, Bern, 1980, 30–31, no. 28, pl. 11:5

See also colorplate 27

64. EROS AS THE CHILD HERAKLES

Ivory statuette. Greek, Hellenistic period, 3rd–2nd century B.C.

Eros, shown without wings, is masquerading as the child Herakles. The lion's skin is slung over his left shoulder and reappears beside his right thigh. He steadies an amphora over his left shoulder, one hand on the butt end, the other beside the handles. The amphora is awkwardly modeled; the top and bottom parts are not aligned. Eros wears a serpentine bracelet on his right leg, a bracelet on his right wrist, and a fillet on his head. The figure is finely modeled and, despite wear, careful attention to details is apparent.

The feet and right hand of the figure are broken off, and the surface is worn. The back side is flat and is notched behind the upraised arm, probably to facilitate attachment to a box or a piece of furniture. There are two pairs of holes on the back, one pair in the notch, the other higher up, none piercing the relief.

Erotes with amphoras over their shoulders appear elsewhere in Hellenistic art: for example, as relief figures on a tall-stemmed silver cup from Taranto, Italy, now in the collection of the Rothschild family (P. Wuilleumier, *Le trésor de Tarente*, Paris, 1930, pls. 5 and 6).

Ivory sculptural work of the Hellenistic period is uncommon. One of the few other pieces known in the United States is an unpublished ivory torso of a nude male, perhaps Apollo, in the Portland Art Museum, Oregon (56.1, gift of C. Ruxton Love, H: 4⅝"). Lacking the head, lower arms, and legs, the sculpture nevertheless exhibits the same excellent modeling as is apparent on the Walters Eros.

H: 2¹⁵⁄₁₆" (7.1cm) 71.18

HISTORY: Acquired before 1931.

See also colorplate 26

65. HERAKLES AND THE DELPHIC TRIPOD

Bone handle of a utensil. Hellenistic period, 2nd–1st century B.C.

The upper edge of the handle is carefully recessed to fit into a socket of the missing utensil. A section of the lower end has broken away; otherwise the handle is in good condition. On one side the bold relief shows Herakles carrying off the Delphic tripod. He also holds his club and has a lion's skin knotted across his shoulder. On the other side is an ithyphallic herm of Apollo, rather than the complete figure of Apollo himself, with whom Herakles struggled for possession of the tripod. A tree, probably a laurel, indicative of the site of Delphi, completes the relief.

Five other bone handles of similar design are known, all, however, showing Egyptian deities of the Ptolemaic period and not scenes from Greek mythology: one, formerly on the Paris art market, was said to be from Greece (*Collection H. Hoffmann*, sale, Hôtel Drouot, Paris, May 28–29, 1888, lot 572); a second, in the Cyprus Museum, Nicosia, was found at Paphos (T. P. Spiteris, *The Art of Cyprus*, New York, 1970, 201, ill.). The other three are in Brussels, Musées royaux d'art et d'histoire (E 2499: unpublished and without provenance; R 1515, R 1516: *Musée de Ravestein*, Notice par E. de Meester de Ravestein, 2nd ed., Brussels, 1884, 433; nos. 1515–1516: Morey, 55–56, fig. 60a–c, R 1515 only). The last two came from an Etruscan tomb at Cerveteri. The iconography of all five points to an Egyptian origin, but whether the Walters example also was made in Egypt cannot be determined.

H: 4" (10.0cm) 71.1126

HISTORY: Purchased from the estate of Dikran Kelekian, New York, 1951.

66. HEADS OF A LION AND OF CUPIDS

Three bone decorations from a couch. Roman, 1st century B.C.–1st century A.D.

The lion's face and heads of two garlanded cupids are from a couch. Four pieces of bone form the lion's face; missing are pieces that would have completed the mouth, the chin, and the top of the head. The eyes were once inlaid with colored glass. Five pieces make up the more complete cupid to the left; a sixth piece, in place on the top of the head, is an ancient one but probably does not belong there. The end of the chin is also missing. The face of the cupid to the right is from another figure and of a different style. Three pieces form what remains of the bust and wings; missing elements would have formed the original head and closed off the bottom of the bust. The bone is probably that of a horse or an ox.

More complete couches, found in Roman tombs in Italy (in Umbria, the Marches, and the Abruzzi), show that lions' faces like this one decorated the frames of couches, while garlanded cupids ornamented the lower parts of the fulcra. Bone decorations of this type come from funeral couches placed in tombs, but the couches were undoubtedly used also in real life. For similar couches, see R. V. Nicholls, "A Roman Couch in Cambridge," *Archaeologia*, CVI, 1979, 1–32, and *Collection H. Hoffmann* (sale, Hôtel Drouot, Paris, May 28–29, 1888, lots 573–594).

Lion's face H: 3¼" (8.2cm) × L: 4¾" (12.0cm) 71.496
Cupid (less complete) H: 2½" (6.3cm) × L: 2½" (6.5cm) 71.497
Cupid (more complete) H: 3¼" (8.2cm) × L: 2¾" (7.0cm) 71.498

HISTORY: Provenance not known but probably Italy. Purchased before 1931.

67. SATYR'S HEAD

Ivory furniture appliqué. Roman, 1st century B.C.–1st century A.D.

Carved in high relief is a wreathed satyr's head in profile to the left, his neck and wreath extending beyond the circular back. The appliqué, originally a circular medallion but now damaged at the sides, ornamented the lower end of a fulcrum. The undecorated back surface has a central depression from which the once circular contour was compass drawn. The medallion would have been glued to the fulcrum, its back surface heavily scored for proper adhesion.

H: 3" (7.3cm) 71.595

HISTORY: In a Paris collection by 1910 (see Bib.); purchased from Dikran Kelekian, Paris, 1914.

BIB.: *Catalogue des objets antiques . . . provenant des collections du Dr. B. et de M. C.* (sale, Paris, Hôtel Drouot, May 19–21, 1910, lot 340).

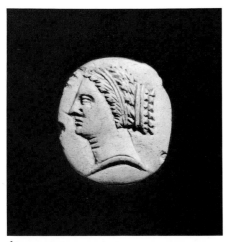

62

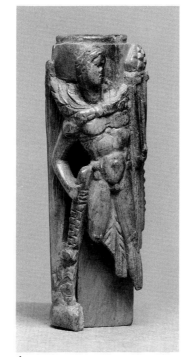

65

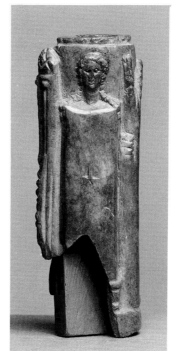

65

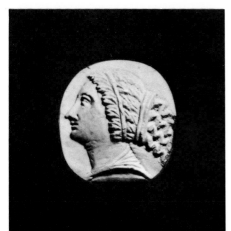

63

66

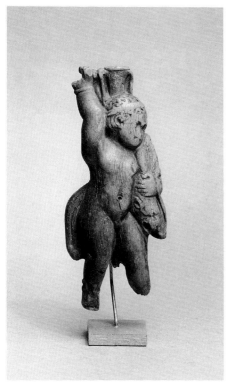

64

67

68. AUTUMN

Bone statuette. Roman, 2nd–3rd century

The figure wears a pointed cap and cloak and cradles a cluster of grapes and apples, distinguishing attributes that identify him as Autumn. The right arm, right leg, and left foot are broken off. Since no visible sign of attachment is preserved, the function of the figure is unclear. However, the manner in which the drapery and the figure's back form an angle, as seen from the rear, suggests that the piece once stood at the corner of a box or piece of furniture, perhaps together with representations of other seasons.

A comparable statuette of Autumn, in ivory, is in the Princeton Art Museum (F. F. Jones, "Recent Acquisitions of Ancient Art," *Record of the Art Museum, Princeton University*, XVII, 1958, 53, fig. 3). A standing figure of Autumn also appears in the stone reliefs of the Arch of Trajan at Beneventum, Italy (G. M. A. Hanfmann, *The Season Sarcophagus in Dumbarton Oaks*, II, Cambridge, 1951, no. 307, fig. 123).

H: 2⅝" (6.5cm) 71.624

HISTORY: Purchased from Dikran Kelekian, Paris, 1926.

69. DOLPHINS AND SHELL

Bone furniture attachment. Roman, 1st–3rd century

Dolphins flank a seashell, their eyes and mouths exaggerated by the bone carver. The object is intact but was never meant to function by itself. The hollow of the bone runs lengthwise with openings at each end; in addition, openings have been cut at the two low points of the upper side, probably to accommodate metal rods, perhaps of bronze, which would account for the green-stained surface of the object.

L: 4⅛" (10.3cm) 71.639

HISTORY: Purchased before 1931.

70. CORINTHIAN CAPITAL

Bone. Roman, 1st–3rd century

The capital consists of two tiers of acanthus leaves forming a calyx out of which spring the larger leaves and tendrils that constitute the upper part of the capital. The hollow of the bone, running vertically through the capital, allowed it to be doweled to a post. The capital probably functioned as a finial on a couch or chair. The ends of many of the leaves and tendrils are broken. The upper surface is smoothly finished.

H: 1⅜" (3.5cm) 71.558

HISTORY: Purchased before 1931.

71. EROTES

Bone pyxis. Roman, 1st century

Carved in relief are two plump Erotes sitting on rocks: one leans over his shoulder to open the lid of a large box; the other, wings spread on either side, sits and watches. A pillar or stele between them supports an urn with a conical lid and two projections on the sides that are intended to be griffin heads. The small cylindrical container is missing its base and cover. Similar urns, perched on

73

a pillar and arcade, appear on a silver cup from Pompeii (V. Spinnazzola, *Le arti decorative in Pompei e nel museo nazionale di Napoli*, Milan, 1928, 232).

This pyxis and the following (cat. no. 72) are typologically related to a group of pyxides excavated at Pompeii and Herculaneum. They were found mainly in houses, and many retained traces of paint used for women's cosmetics (Marangou, no. 61). Little decorative boxes must have been popular objects of everyday use since they have been found all over the Mediterranean world. The modeling of the figures on the Walters pyxis, with its rounded forms and detailed representation of wings, faces, etc., is different from the Pompeiian examples and suggests another workshop, perhaps one in Egypt, as the provenance of this pyxis indicates.

H: 1⅜" (4.1cm) × D (of bottom): 1⁷⁄₁₆" (3.7cm) 71.45

HISTORY: Said to be from Egypt; purchased before 1931.

See also colorplate 29

72. EROTES

Bone pyxis. Roman, 1st century

This cylindrical container, missing its cover, is decorated with four Erotes. One, seated on a cushioned ledge, holds a ribboned staff. A second approaches from the right with a basket of fruit; a third comes from the left with a wreath. A fourth Eros carries two vases. The modeling is summary. The eyes of three of the Erotes are rendered by cutting out the socket leaving a large round iris. The eye of the Eros with the wreath is narrow, with no iris indicated. The head, wings, and drapery of this Eros are carved from another piece of bone, probably at a later time, neatly fitted in to fill a missing section of the original. Another patch is between the legs of this Eros.

H: 2½" (6.4cm) × D (of bottom): 1¹⁵⁄₁₆" (4.9cm) 71.59

HISTORY: Collection of Michel Boy (sale, Paris, May 24, 1905, lot 580); Dikran Kelekian; purchased before 1931.

See also colorplate 29

73. MYTHOLOGICAL FIGURES

Bone pyxis. Roman, 1st century

This thick-walled ovoid container, its lid missing, has a separate, disklike base. On it are carved in low relief, now quite worn: a nude woman seated on a rock with a lyre; a kneeling, half-draped woman, possibly

Hebe, cupbearer of the gods, pouring from a jug into a bowl with an eagle in front of her, perhaps the eagle of Zeus; a tripod on a base with flames and smoke issuing from the bowl; a kneeling, half-draped winged Victory writing on a shield; facing her and seated on a rock, back-to-back with the first figure to be described, a man, nude except for a plumed helmet, probably Ares.

The motif of Victory inscribing a shield goes back to the Aphrodite of Capua shown admiring herself in the polished shield of Ares—the original statue may have been part of a group with Ares. In early imperial times the motif was transformed into a Victory writing a list of victories on a shield, the most famous example being the bronze Victory of Brescia (A. Fürtwangler, *Masterpieces of Greek Sculpture*, London, 1895, 384–388). On this pyxis the figure of Victory is associated with a helmeted male figure, probably Ares, the god of war.

H: 1¼" (3.2cm) × D (of bottom): 1⅛" (3.0cm) 71.600

HISTORY: Collections of Michel Tyskiewicz (sale, Paris, June 8–10, 1898, lot 168); and Michel Boy (sale, Paris, May 24, 1905, lot 575); acquired before 1931, probably from Dikran Kelekian, Paris, who had purchased the pyxis at the Boy sale.

BIB.: A. de Ridder, *Collection de Clercq*, IV, Paris, 1906, 153, mention only.

74. VICTORY AND EAGLE

Ivory pyxis lid. Roman, 1st century

The edge of the cover is decorated with a row of dentils between bands. On the top is a winged Victory kneeling on one leg beside an eagle. The surface is worn and discolored.

H (of lid): ⁷⁄₁₆" (1.1cm) × D: 2¹⁄₁₆" (5.2cm) 71.601

HISTORY: Purchased before 1931.

74

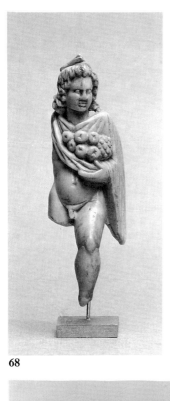

68

69

70

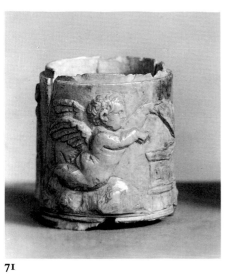

71

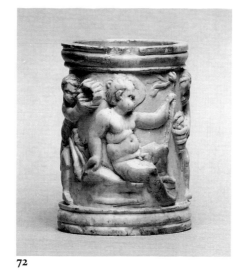

72

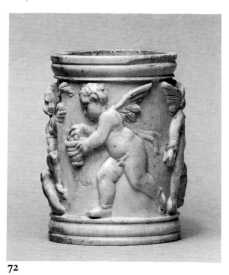

72

73

73

74

75. CUPIDS

Ivory box panel. Roman, 2nd–3rd century

Carved in high relief on the front are four cupids carrying fruit and baskets. The figures may well represent the four seasons and are comparable to the seasons shown on a marble sarcophagus in the Museo Conservatori, Rome (G. M. A. Hanfmann, *The Season Sarcophagus in Dumbarton Oaks*, II, Cambridge, 1951, 183, no. 529, fig. 30).

The upper left and right edges are broken off but with no loss of the relief, except the wings of the rightmost figure. The upper border is recessed as if to receive the flange of a lid and has a center hole, possibly part of the clasp. A horizontal slit on the lower back probably held the floor of the box; the rest of the back surface is smooth.

A comparable ivory relief showing Bacchus and six other figures (formerly in the Musée Départmental de l'Oise, Beauvais, but lost in a fire in 1940) was excavated from a third-century tomb at Beauvais in 1856 (Mathon, "Bas-relief en ivoire," *Revue archéologique*, XV, 1858, 475–486).

H: 1¹¹⁄₁₆″ (4.3cm) × L: 4³⁄₁₆″ (10.7cm)
71.499

HISTORY: A sticker on the back states: "Castellani sale," but no such box figures in either of the two 1884 Castellani sales; purchased before 1931.

BIB.: D. K. Hill and M. C. Ross, "Decorative Arts from Antiquity to the Early Nineteenth Century," *The Greek Tradition*, Baltimore Museum of Art, Baltimore, 1939, 70, no. 67, ill. 67.

See also colorplate 30

76. SCENE OF SACRIFICE

Bone box panel. Roman, 4th–5th century

The relief is of a funeral scene with seven people gathered around a garlanded altar making a sacrifice and paying their respects to the deceased, whose portrait appears in a niche, also garlanded, above the altar.

The beaded borders above and below the relief are characteristic of late antique silverware and suggest a date not earlier than the fourth century (J. P. C. Kent and K. S. Painter, ed., *Wealth of the Roman World A.D. 300–700*, London, 1977).

The panel is broken at both ends but is intact on the upper and lower edges; the back surface has a tapering hollow characteristic of a bone.

H: 2¹⁄₁₆″ (5.3cm) × L: 4″ (10.0cm) 71.302

HISTORY: Purchased before 1931.

BIB.: *Byzantine Art*, 99; Wessel, *Christentum am Nil*, fig. 92.

77a,b. CLASSICAL STATUES

Bone box panels with later carving. Roman, 2nd–3rd century

In the nineteenth or early twentieth century a modern engraver embellished the panels with scenes taken from the antique. The relief on panel 77a shows the gods bringing gifts to Peleus and Thetis, seen seated at the right, at their wedding. Above the relief is the head of Oceanus flanked by marine creatures. These are copies of scenes on a second-century Roman sarcophagus excavated in Rome in 1722 and now in the Villa Albani (*RM*, LX/LXI, 1953–54, pls. 88 and 89). The corrugated strip reproduces a dentil molding on the sarcophagus while the marine frieze reproduces the carving on the edge of its lid. The figures on panel 77b are derived from ancient statues and include Pan, Apollo, Dionysos, and Herakles.

Both panels are broken vertically and repaired. Originally the same height, the upper edge of one panel (77a) has split off; and the top of the other (77b) has also broken, but two-thirds is preserved and has been reattached. The ancient upper edge has two grooves. The back surfaces are also grooved at the top and bottom, the bottom groove to retain the floor of the box, the top to accommodate a sliding lid. The panels form two adjacent sides of a box; the ends are mortised and can be snugly dovetailed together.

77a. H: 1³⁄₁₆″ (3.0cm) × L: 3½″ (9.0cm)
71.500
77b. H: 1⁵⁄₁₆″ (3.3cm) × L: 3⅞″ (9.8cm)
71.501

HISTORY: Purchased from Léon Gruel, Paris, 1929.

BIB.: F. Brommer, *Denkmälerlisten zur griechischen Heldensage*, III, Obrige Helden, 1976, 365 (71.501 only).

78. DEITIES AT AN ALTAR

Ivory box panel. Roman, 4th–5th century

The relief, carved in two tiers in the manner of many later Roman and Christian sarcophagi, shows a sacrifice. Zeus, framed by a medallion, is seated with thunderbolt and eagle. Flanking him are Sol and Luna, identifiable by the sun's rays and the moon's crescent. Victory and a soldier approach from the left, Athena and two nude women from the right. Below, three figures, among them Hermes with his caduceus, lead an ox to sacrifice at the altar; dancers and others bearing gifts or paraphernalia for the sacrifice approach from the other side.

The modeling is crude but the classical subject matter is significant at this relatively late date.

The back of the panel is flat, its lower edge recessed and grooved as if made to fit against the bottom of a box. Attachment holes are visible in the lower grooved border and are concealed in the acanthus leaves along the sides and top. The background of the relief is cut so thin it is translucent; it is damaged in the bottom center and repaired with plaster.

H: 3¹¹⁄₁₆″ (9.4cm) × W: 7¹⁄₁₆″ (18.0cm)
71.116

HISTORY: Purchased in 1924.

79. SATYR

Ivory relief. Roman, 1st century B.C.

The relief shows a satyr walking to the left. He wears a short, belted garment made of leaves, a deerskin knotted over his shoulders, and an evergreen wreath. He carries a club. Modern repairs include his right arm, left forearm together with an adjacent section of the club, and both feet (one above, the other below, the ankle). Holes for attachment are visible at his groin, behind the club, and to the left of the knotted skin. The back surface is flat. The satyr's face is expressively drawn and sculpted. The modeling of the body is well conceived: for instance, his left, nearer leg is done in higher relief than his right leg.

Comparable in size and style is a cutout ivory figure of Herakles in the Louvre (inv. A.D. 21084).

H: 9″ (22.8cm) 71.557

HISTORY: Said to have been found in Sicily in the late nineteenth century; collection of Arthur Sambon; purchased before 1931.

BIB.: A. Sambon, "Jeune satyre, figurine découpée en ivoire," *Le musée*, IV, 1907, 176, ill.; S. Reinach, *Répertoire de la statuaire grecque et romaine*, IV, Paris, 1913, 74, no. 5.

80. APHRODITE

Bone statuette. Roman, 1st–2nd century

The carving shows Aphrodite, after a bath, arranging her hair, and is derived from a large-scale sculpture of the Greek period, of which countless versions in many materials are known.

The head, left arm, and left foot are missing and the bone is split down the center. The back of the torso is not modeled, its surface formed merely by the hollow of the bone.

H: 2⅝″ (6.6cm) 71.598

HISTORY: Purchased before 1931.

75

78

76

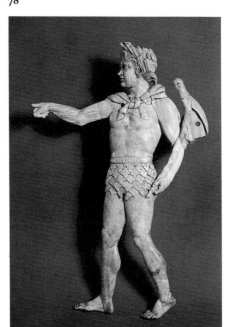

79

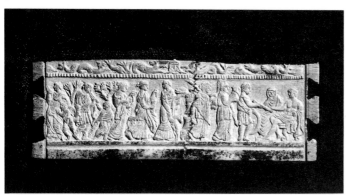

77a

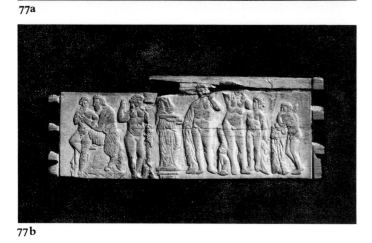

77b

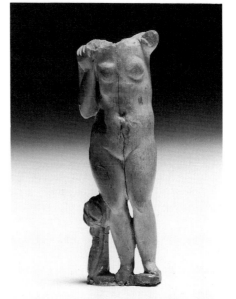

80

81. EROS ON A DOLPHIN

Ivory appliqué. Roman, 1st–2nd century

The representation of Eros on a dolphin occurs as early as the fifth century B.C., but retained its popularity throughout antiquity, appearing on gems, coins, and in other mediums (F. Brommer, "Delphinreiter," *AA*, 1942, 67; A. Greifenhagen, *Griechische Eroten*, Berlin, 1957, 26, 33, 70, fig. 26). The motif sometimes occurs as an adjunct to images of Aphrodite, and would therefore be an appropriate embellishment of a woman's jewel box or cosmetic container.

One wing of Eros has broken off, otherwise the object is intact. A white incrustation adheres to the left part of the appliqué; the back is flat and lacks any indication of how it might have been attached to a larger object.

Its history suggests it was found in Egypt.

L: 2¹⁄₁₆″ (4.3cm) 71.606

HISTORY: Collection of Giovanni Dattari, Cairo; sale, Jean P. Lambros and Giovanni Dattari, Paris, June 17–19, 1912, lot 553; purchased 1912(?).

BIB.: D. K. Hill and M. C. Ross, "Decorative Arts from Antiquity to the Early Nineteenth Century," *The Greek Tradition*, Baltimore Museum of Art, Baltimore, 1939, 70, no. 73.

See also colorplate 31

82. SOLDIER

Bone box plaque. Roman, 3rd–4th century A.D. or possibly 1st century B.C.

The soldier on the plaque wears a tunic and cuirass and a crested and plumed helmet with cheek guards. His spear is beside him. The modeling is bold and chunky but not unaccomplished.

The left side of the frame and the front of the soldier's helmet are both chipped. The plaque is sharply convex on a vertical axis (not apparent in the illustration) and probably decorated a cylindrical box or a piece of furniture. It must have been secured by vertical framing that overlapped the grooved frame on the sides since no attachment holes exist.

Plaques of this type normally have been attributed to the third or fourth century A.D., but the similarity of this one in size and style of carving to a plaque from a first-century B.C. tomb at Cuma, Italy, raises the question whether this and perhaps other plaques may not be much earlier in date (A. Levi, "Cuma [Necropoli], Tomba *a schiena* del periodo greco-sannitico," *Notizie degli scavi*, 1925, 88, fig. 6).

H: 3⅜″ (8.4cm) × W: 2⅜″ (5.9cm) 71.615

HISTORY: Purchased from Dikran Kelekian, Paris, 1923.

BIB.: Marangou, 47, fns. 240, 245 (mention only).

See also colorplate 37

83, 84. SCENES OF HERAKLES

Two bone plaques. Roman, 4th century

83. Herakles is shown cutting his club from an olive branch. Bracing the limb against his left thigh and straining backward, he breaks off the projecting spurs of wood. The subject is unusual, but not unique. Parallels to this motif are discussed in *Age of Spirituality*, nos. 205 and 206.

84. Herakles here dispatches the Nemean Lion by strangling the beast. The hero also wields his club, rarely present among representations of this labor.

Apart from the partial loss of their borders, both plaques are well preserved. Plaques like these usually belonged to a larger set with a thematic cycle and often served to decorate caskets similar to the one of later Byzantine date (cat. no. 199). Lacking rivet holes, the Herakles plaques were probably set into a supportive frame rather than attached to one by pins. Exposure to corroded metal has given catalogue no. 83 a greenish discoloration.

There is a similar treatment of the figure and the raised grooved border in an ivory plaque from Egypt in the Landesmuseum, Stuttgart (cf. Marangou, 46, pl. 52d).

83. H: 3¼″ (8.2cm) × W: 2″ (5.0cm) 71.12
84. H: 3¼″ (8.2cm) × W: 1¹³⁄₁₆″ (4.6cm) 71.11

HISTORY: Purchased before 1931.

BIB.: K. Weitzmann, "The Heracles Plaques of St. Peter's Cathedral," *Art Bulletin*, LV, 1973, 5, figs. 5a–b; *Age of Spirituality*, 299, no. 206; Marangou, 46, fns. 240, 245.

See also colorplate 32

85. APOLLO

Bone plaque. Roman, 3rd–4th century

The relief shows Apollo, casually draped and leaning on a fluted column. His quiver is slung over his right shoulder and he holds a plectrum in his right hand. The right third of the plaque is missing. The missing section must have shown a lyre, held with his other hand and resting on a matching column. In fact, the edge of the lyre's crossbar is just preserved to the right of his head, and the plaque appears to have broken along the line of the lyre and the column. A grooved border frames the composition.

A plaque in the Princeton Art Museum showing Apollo in a similar pose, save for minor details, preserves the lyre and second column (see Bib.). Plaques with Apollo and other gods were standard decoration for Roman jewelry boxes.

H: 3¼″ (8.2cm) × W (as preserved): 1¼″ (3.2cm) 71.591

HISTORY: Purchased before 1931.

BIB.: K. Weitzmann, "A Bone Carving of the Lyre-playing Apollo," *Record of the Art Museum, Princeton University*, X, 1951, no. 2, 6–9, fig. 2.

86. MAN AND BOY

Ivory plaque. Roman, 3rd–4th century

The man, shown looking sharply over his right shoulder, grasps the boy's right arm and may have held the boy's missing shoulder also. The boy, repeating the sharp turn of the head, has gone down on his left knee. Both figures wear cloaks; the drapery folds visible at the left probably belong to the man's cloak, but that is not fully clear. The subject has not been identified.

The right edge, top, and upper half of the left side are missing. To judge from the apparently symmetrical positioning of the attachment holes, no more than the frame and boy's left arm on the right and the frame above the man's head are missing. The plaque probably decorated a cosmetic or jewelry box to which it was pinned through the holes in the raised and grooved frame.

H: 2⅝″ (6.7cm) × W: 1⅞″ (4.7cm) 71.592

HISTORY: Purchased from Dikran Kelekian, Paris, 1926.

87. ACHILLES

Bone plaque. Roman, 4th century

The relief shows Achilles in his tent sulking, and refusing to fight the Trojans until the injustice done to him by Agamemnon is rectified (*Iliad* I). Achilles is on a couch or chair holding drapery up over his head. The leg of the furniture is in the form of a lion's foot. His sheathed sword hangs from his left hand, his helmet and cuirass are on the ground beside him, and his shield leans against a column at the far left.

A raised border with grooves and hatching frames the relief. Holes for attaching it to a box pierce the frame. Typologically this plaque is related to catalogue no. 88.

A fragment with a figure in the same pose is in the Smart Gallery at the University of Chicago (1967.115.310).

H: 2⅞″ (7.2cm) × W: 1¹⁵⁄₁₆″ (4.9cm) 71.594

HISTORY: Purchased from Dikran Kelekian, Paris, 1926.

BIB.: *Byzantine Art*, 52, no. 173; Marangou, 47, fns. 240, 244, 247.

See also colorplate 35

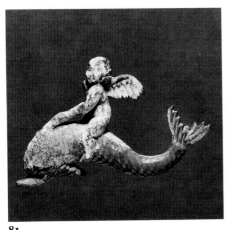

81

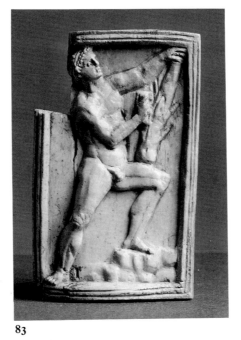

83

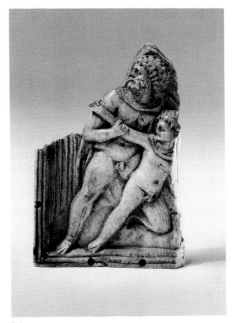

86

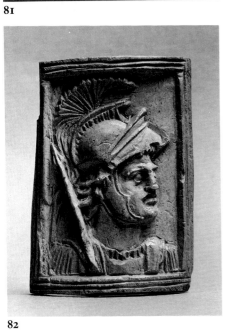

82

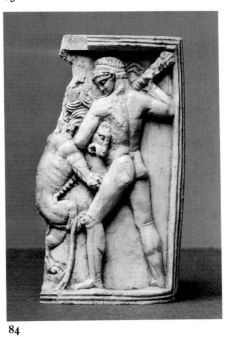

84

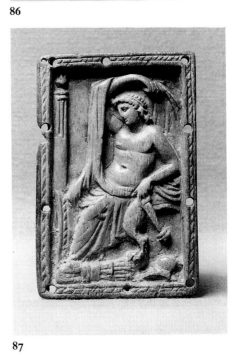

87

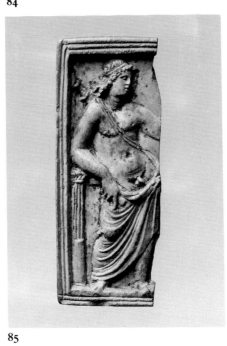

85

88. ARTEMIS AND APOLLO

Bone plaque. Roman, 4th century

Artemis and Apollo sit on a rock under a grape arbor, a dog between them. Artemis is dressed in hunting boots and short chiton, her quiver visible behind her right shoulder, torch in hand. Apollo, nude, holds a stringed instrument (a *kithera*) and a plectrum.

The relief of the slightly convex plaque is framed by a grooved and hatched border pierced with rivet holes. The plaque's frame and mythological subject relate it to a series of plaques of mainly Egyptian provenance (Marangou, 46–47). Typologically this plaque is related to catalogue no. 87.

H: 3½" (8.9cm) × W: 2⁷⁄₁₆" (6.2cm) 71.29

HISTORY: Said to have been found at Aleppo, Syria; purchased from Dikran Kelekian, Paris, 1922.

BIB.: *Byzantine Art*, 52, no. 172; Marangou, 47–48, fns. 244, 247.

See also colorplate 36

89. THE RAPE OF GANYMEDE

Ivory plaque. Roman, 3rd–4th century

Zeus in the guise of an eagle is about to carry off Ganymede to Mount Olympus to be cupbearer to the gods. The boy, shown falling to his knees and raising his hand in alarm, wears a Phrygian cap, trousers, and cloak. He holds a *pedum*, or shepherd's staff, but has dropped his shield, visible at the lower right.

The upper left corner and part of the bottom are missing, and the plaque is cracked along the lower left side. The relief probably decorated a cosmetic or jewelry box, its four edges originally sliding under and retained by the framing panels of the box.

The subject was popular in ivory and other materials in Roman art. Other ivory plaques showing the myth are in Corinth (G. R. Davidson, "The Minor Objects," *Corinth*, XII, Princeton, 1952, 338, no. 2901, pl. 138), in the Benaki Museum, Athens (Marangou, 119, no. 179, pl. 52a), and in the de Menil collection, Houston (H. Hoffmann, *Ten Centuries That Shaped the West*, exh. cat., Houston, 1970, 456–457, no. 210). Yet another was excavated in Jerusalem in 1978 or 1979 in a level of the Hellenistic period, 3rd–1st century B.C. (Y. Shiloh, "Excavating Jerusalem: The City of David," *Archaeology*, XXXIII, no. 6, 1980, 12–13). A small ivory sculpture of this subject, dated to the third century, was found at Samaria, Palestine (J. W. Crowfoot, G. M. Crowfoot, and K. M. Kenyon, *The Objects from Samaria*, London, 1957, 84, pl. 14:5). Typologically this plaque is related to catalogue no. 90.

H: 2⅝" (6.5cm) × W: 2³⁄₁₆" (5.5cm) 71.596

HISTORY: An old label states: "found near Alexandria"; purchased before 1931.

BIB.: *Flight: Fantasy, Faith, Fact*, Dayton Art Institute, Dayton, 1953, no. 39; *Age of Spirituality*, 169, no. 148, ill.

90. EUROPA ON THE BULL

Ivory plaque. Roman, 3rd–4th century

Zeus in the form of a bull carries off Europa who rides on his back, left hand on his head, legs turned toward the rear. Her cloak, held over her head, flies in the breeze.

The upper corners of the plaque and the ledge beneath Europa's feet are broken away. The plaque probably decorated a box, and was secured by pins through two holes flanking Europa's waist and by a grooved frame into which the projecting edges of the background of the relief fit. Typologically this plaque is related to catalogue no. 89.

H: 2¼" (5.9cm) × W: 2" (5.1cm) 71.593

HISTORY: Collection of Émile Molinier, Paris; purchased from Dikran Kelekian, Paris, 1911.

BIB.: *Age of Spirituality*, 168, no. 147, ill.

See also colorplate 33

91. TRIUMPHANT SOLDIER

Ivory plaque. Roman, 4th–5th century

A soldier in armor, holding his sword and its sheath, stands in front of a trophy of shields.

Although the piece is broken on all sides, the uppermost and right edges are original. The piece, therefore, was the right-hand corner of a large triumphal subject decorating a box. A similar subject is in Berlin (Wulff, no. 406).

L: 3¼" (8.0cm) 71.63

HISTORY: Said to have been found at Alexandria; purchased from Dikran Kelekian, Paris, 1924.

BIB.: *Byzantine Art*, 169; Wessel, *Christentum am Nil*, 214, fig. 90; A. Carandini, *Secchia Doria, Studi miscellanei*, IX, pl. 32, fig. 48.

See also colorplate 34

92. EROS AND PSYCHE

Bone plaque. Roman, 3rd–5th century

The summary relief, framed by an incised hatched border, shows a man, probably Eros, nude and with an arrow, and a woman, probably Psyche, partially draped, beside him. The bottom is broken and a lower piece has been reattached.

Two oval plaques in the Benaki Museum, Athens, show an identical subject and positioning of holes, top and bottom, for pinning the pieces to a backing (Inv. 10324, 18980, Marangou, 134, nos. 288 and 289, pl. 72). Only one hole is preserved on the Walters piece. The function of these oval plaques is unknown.

H: 2³⁄₁₆" (5.8cm) × W: 1⅝" (4.2cm) 71.619

HISTORY: Purchased in 1925.

93. TWO FIGURES

Bone plaque. Roman, 3rd–5th century

Two figures are carved in relief: a woman facing forward, with a veil for partial modesty, and a second figure, probably, but not necessarily, a woman, facing away. Carefully drawn lines for features and hair contrast with the loose modeling of the fleshy figures.

The object is intact except for the broken tang, which once projected at the top. The surface is worn. The front is convex, but the back is flat with lateral ridges. The left and right sides are beveled inward.

H: 2¼" (5.7cm) × W: 1⁵⁄₁₆" (2.5cm) 71.16

HISTORY: Purchased before 1931.

94. CAPRICORN

Bone game counter. Roman, 1st century

Capricorn, the sign of the marine goat in the zodiac, is carved in relief on the counter. The number 8 is inscribed on the back in both Latin and Greek numerals (VIII and H).

Roman game counters show a wide variety of objects: Muses, deities, and heroes, heads of Roman rulers, poets, philosophers, theatrical subjects, fingers indicating numerical calculation, buildings in Alexandria, and signs of the zodiac, as here. They have been discussed by Elisabeth Alföldi-Rosenbaum in several publications (*Frühmittelalterliche Studien*, V, 1971, 1–9; *Muse, Annual of the Museum of Art and Archaeology, University of Missouri-Columbia*, IX, 1975, 13–20; *Chiron*, VI, 1976, 205–239; *Eikones, Festschrift Hans Jucker, Antike Kunst*, Beiheft 12, Bern, 1980, 20–39).

D: 1⅛" (2.8cm) 71.479

HISTORY: Purchased from Léon Gruel, Paris, 1926.

See also figure 17

95. HEAD OF A MAENAD

Bone game counter. Roman, 1st century

The head of a maenad, wearing an ivy wreath, is carved in relief on the counter. A Bacchic staff, or *thyrsos*, is visible at the right. The number 13 is inscribed on the back in both Latin and Greek numerals (XIII and IΓ).

D: 1⅛" (3.0cm) 71.1102

HISTORY: Collection of Henry Walters before 1931; Mrs. Henry Walters; Brummer Gallery; gift of Mr. and Mrs. Nelson Gutman.

96. MAN'S HEAD

Bone game counter. Roman, 1st century

The head of a man in profile to the left is carved in relief. The back is pitted, obscuring any numeral that may once have been inscribed there.

D: 1⅜" (3.5cm) 71.1122

HISTORY: Gift of Douglas H. Gordon, 1947.

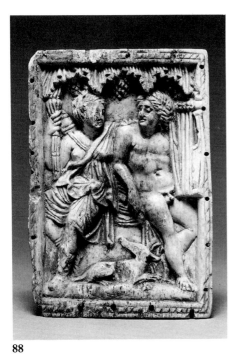

88

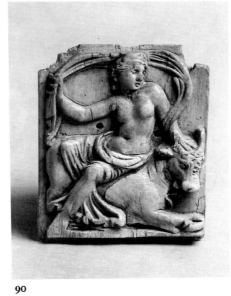

90

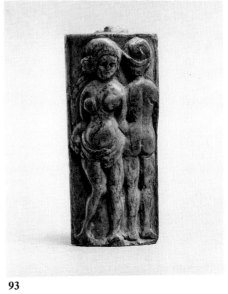

93

89

91

94

95

92

96

97. THE NUMERAL XII

Bone game counter. Roman, 1st–3rd century

A rectangular strip with a pierced rounded end. The Latin numeral XII (twelve) is engraved on the front. A Chi-Rho monogram and the name ΧΡΙΣΤΟΥ (of Christ) inscribed on the back are modern additions.

L: 2¼″ (5.8cm) 71.1124

HISTORY: Collection of Joseph Brummer (sale, Parke-Bernet, New York, May 11–14, 1949, lot 288); purchased at the sale.

98. NUMBERS

Bone die. Roman, 1st–3rd century

The die is chipped at several corners. The sides are not exactly square. The edges are beveled. The numbers are represented by dotted concentric circles. Those on opposite faces add up to seven, a feature characteristic of both Roman and modern dice.

L: c. ¾″ (1.8cm) 71.637

HISTORY: Purchased before 1931.

99, 100. NUMBERS

Unfinished bone dice. Roman, 1st–3rd century

The lengths of bone have been worked into rectangular form and marked off with three dice each. The numbers are indicated by dotted circles. Only three sides of each length have been finished. Eventually the dice would have been separated, the natural hollows of the bone plugged by additional pieces of bone, and numbers carved on all six sides. Unfinished lengths such as these are probably from a bone carver's workshop.

99. H: 2⅜″ (6.0cm) 71.635
100. H: 2⅞″ (7.3cm) 71.636

HISTORY: Purchased before 1931.

101. LION'S HEAD FINIAL

Bone knife handle. Roman, 1st–2nd century

The handle is oval in section and has a lion's head summarily carved at its end. Diagonal lines form a chevron pattern on its sides to assure a better grip. The blade is missing but was once well seated in a deep and vertical slot at the base of the handle. Bone knife handles of related design are in the Louvre (inv. S.2676, S.2677)

L: 2⁷⁄₁₆″ (6.1cm) 71.629

HISTORY: Dom Marcello Massarenti collection, Rome; purchased in 1902.

BIB.: Massarenti catalogue, part 2, 16, no. 65.

102. RAM'S HEAD

Bone tool handle. Roman, 1st–2nd century

The handle is round in section and ends in a ram's head. The rings were made by turning the ivory on a lathe before the head was carved. A tang fitted into the object, now missing, for which it served as the handle. Almost identical moldings occur on a bone knife handle in the Louvre (inv. S.2674).

L: 2⅝″ (6.6cm) 71.627

HISTORY: Purchased before 1931.

103. BOY HOLDING GRAPES

Ivory knife handle. Roman, from Egypt, 2nd–4th century

A finely carved figure of a seated boy holding a bunch of grapes, modeled in the round. He looks over his shoulder as if afraid someone might steal his fruit. His eyes were once inlaid with bits of glass. A number of bone or ivory knife handles of similar pattern exist showing boys holding birds: there is one in Munich (Ä S 5340; *Staatliche Sammlung Ägyptischer Kunst*, Munich, 1972, 169, pl. 98), and several in the Vatican Museum (Kanzler, pls. 10, 11, and 14). The circular base, chipped on one side, has a round hole underneath, and the figure is partially hollowed to receive a tang. Marvin Ross proposed a fourth-century date, based on comparisons with the hairstyles of fourth-century sculpture. But the ivory is said to have been found at ancient Hermopolis in Egypt with a collection of second-century Roman silver now in the Antikenabteilung, Staatliche Museen, Berlin, and might therefore be earlier. (E. Pernice, "Hellenistische Silbergefässe im Antiquarium der Königlichen Museen," *Berliner Winkelmannsprogramm*, 58, 1898; E. Pernice, "Zum Hildesheimer Silberschatz," *AA*, 1899, 129–130.)

The pose and subject are derived from Hellenistic sculpture (M. Bieber, *The Sculpture of the Hellenistic Age*, rev. ed., New York, 1961, 137).

H: 2⁹⁄₁₆″ (6.5cm) × D (of base): 1⅛″ (2.8cm) 71.602

HISTORY: Reported (in the first publication, see below) to have been found at El Ashmûnein, Egypt, ancient Hermopolis Magna; Paris art market c. 1900; collection of Michel Boy, Paris (sale, Paris, May 24, 1905, lot 578); purchased in 1905.

BIB.: *Bulletin de la société nationale des antiquaires de France*, 1900, 164–165; A. Sambon, "Un tableau de Zeuxis: L'enfant aux raisins," *Le musée*, III, 1906, 58–59, fig. 1; M. C. Ross, "A Fourth Century Ivory Statuette," *Art in America*, XXXIV, 1946, 105–108, ill.; *Byzantine Art*, 94, pl. 12.

See also colorplate 38

104. A LEOPARD AND HERAKLES

Bone razor handle. Roman, 4th century

The curving body of the leopard forms the raised grip of the razor, and a striding Herakles with lion skin and club fills the body of the handle. The reverse is uncarved.

The razor has been burned, and the bone has flaked along the back of the leopard, the paws, the jaw, the face of Herakles, the lion skin, Herakles' feet, and the adjoining border. The iron razor is reduced to corrosion products.

Similar razors, illustrated by Weitzmann, are in Dumbarton Oaks and the Metropolitan Museum. Another was recently in the London art market (sale, Christies, London, Apr. 23, 1980, 31, lot 125).

H: 3½″ (9.0cm) × W: 2⅜″ (6.0cm) 71.2

HISTORY: Purchased before 1931.

BIB.: *Byzantine Art*, no. 155; Weitzmann, *Ivories and Steatites*, III, 1972, pl. 7, fig. 11.

105. LION'S FACE

Ivory horse trapping. Roman, 1st–2nd century

Chipped at the top and upper left, this bridle ornament is otherwise intact. Ten holes at the perimeter allowed the roundel to be sewn to a leather bridle. A lion's head, ears upright, ruff enclosing the face, is done in relief. A stepped border surrounding the head was drawn with a compass, centered at the pinprick indentation in the lion's forehead. The edge of the roundel is grooved. Horse trapping ornaments of this sort, called *phalerae* in antiquity, are also known in silver (K. Schefold, *Meisterwerke griechischer Kunst*, Basel, 1960, 264, no. 349, ill., 261) and in mother-of-pearl (Arthur Sambon collection, sale, Paris, May 25–28, 1914, lot 142, ill.).

Alternatively, though less likely, this and another roundel (cat. no. 106) were ornaments sewn or pinned to *ptergys*, the leather tabs lining the bottom of bronze breastplates worn by Roman soldiers, and visible on so many marble statues of emperors and other notables (G. M. A. Hanfmann and C. C. Vermeule, "A New Trajan," *AJA*, LXI, 1957, 223–253).

D: 1¾″ (4.4cm) 71.618

HISTORY: Purchased in 1913.

See also colorplate 39

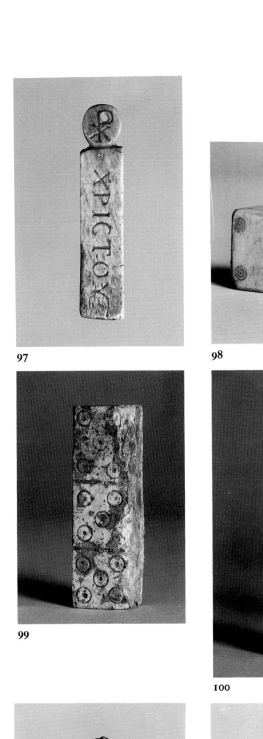

97

98

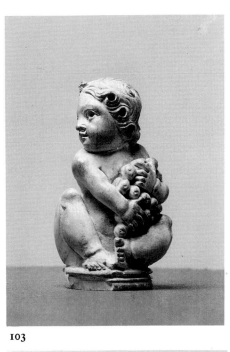

103

99

100

104

101

102

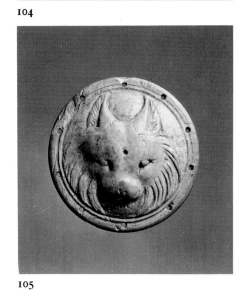

105

106. HEAD OF HERAKLES

Bone horse trapping. Roman, 1st–2nd century

The left side is missing and the roundel is warped on a vertical axis, rendering it concave from the back. Eleven holes (originally fifteen) at the perimeter allowed the piece to be sewn to a leather bridle. The relief shows in profile the head of Herakles, or perhaps Alexander the Great shown as Herakles, wearing a lion's scalp. Part of the animal's skin, including a paw, is slung over his shoulder along with a spear and a knotty staff. A molding frames the composition. This roundel served the same function as catalogue no. 105.

D: 2⅛" (5.3cm) 71.617

HISTORY: Purchased before 1931.

See also colorplate 39

107. BUST OF A WOMAN

Bone pin. Roman, late 2nd–3rd century

The pin itself has broken off and all that remains is the elaborate pinhead: a scallop shell, an orb, and the bust of a woman. The hairstyle of the woman is that favored by Julia Domna, wife of the emperor Septimius Severus, and this is possibly a representation of the empress herself. Elaborate bone pins were common, their heads frequently in the form of miniature Aphrodites or female heads, as here.

H (as preserved): 1¹¹⁄₁₆" (4.5cm) 71.625

HISTORY: Purchased before 1931.

See also colorplate 40

108. INCISED ORNAMENT

Bone spoon. Roman, 1st–2nd century

A round, tapering handle holds the small deep bowl of the spoon. An incised triangular ornament marks the join of the handle and bowl on the back.

L: 4³⁄₁₆" (10.7cm) 71.633

HISTORY: Dom Marcello Massarenti collection, Rome; purchased in 1902.

BIB.: Massarenti catalogue, 66.

109. MALE BUST

Bone stylus. Roman, mid–5th century

The shaft of the stylus (a writing implement) is carved with an uneven spiral and terminates in a flattened male bust. The head of the bust has large staring eyes, and the hair is arranged with a part in the center, emphasized by two rising locks or curls. The hair falls in back to the neck, where it is squared off. Although this hairstyle does not appear in emperor or patrician portraits, it does occur on members of the Roman crowd viewing the translation of relics on the early ivory of Pulcheria and Theodosius II at Trier (Delbrueck, 67). The scene has recently been related to events of 421, though the ivory could be somewhat later (K. Holum and G. Vikan, "The Trier Ivory," *Dumbarton Oaks Papers*, XXXIII, 1979, 115–133).

The point of the stylus is broken.

L: 3⅞" (10.0cm) 71.628

HISTORY: Dom Marcello Massarenti Collection, Rome; purchased in 1902.

BIB.: Massarenti catalogue, 64.

110. UNORNAMENTED STYLUS

Bone. Roman, 1st–3rd century

Round in section, the stylus is pointed at one end to write on a waxed tablet and broad at the other to erase the writing by smoothing out the wax.

L: 4¹⁄₁₆" (10.3cm) 71.634

HISTORY: Purchased before 1931.

111. UNORNAMENTED STYLUS

Bone. Roman, 1st–3rd century

Round in section, the handle tapers gently to a small rounded point. The writing end, now lost, would have tapered to a sharper point.

L: 3⁹⁄₁₆" (9.1cm) 71.631

HISTORY: Purchased before 1931.

112, 113. UNORNAMENTED SPINDLES

Bone. Roman, 1st century B.C.–1st century A.D.

Both spindles are round in section and taper. The complete spindle (cat. no. 113) has lathe-turned finials at each end. The broken spindle (cat. no. 112) is larger and is stained brown; its preserved finial appears to have been carved freehand, not turned on a lathe.

112. L: 5¾" (14.6cm) 71.632
113. L: 8¹¹⁄₁₆" (22.0cm) 71.630

HISTORY: Dom Marcello Massarenti Collection, Rome; purchased in 1902.

BIB.: Massarenti catalogue, 12, 15.

114. INSCRIBED PLAQUE

Bone. Rome(?), 4th–5th century

This small rectangular tablet is divided by incised lines and inscribed in Latin with the monogram of Christ, XP, and the name RENNIA ATTIDIAE MARCELIAE. Its use is unknown. It has been chipped on each side and broken at the lower right corner.

H: 1¹⁵⁄₁₆" (5.0cm) × W: 1¹¹⁄₁₆" (4.3cm)
71.1112

HISTORY: Gift of Piero Tozzi, New York, 1944.

BIB.: *Byzantine Art*, 91.

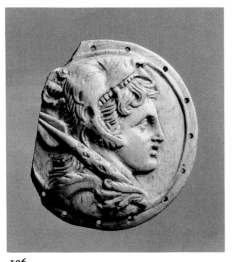

106

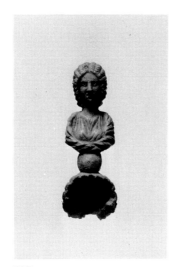

107

108

109

110

111

112

113

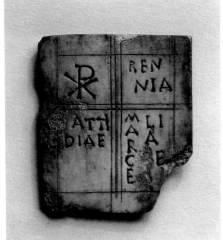

114

4 Late Roman and Egyptian Ivories

by Richard H. Randall, Jr.

ONE OF THE RICHEST GROUPS of ivory and bone carvings has come to us from the dry sands of Egypt. The material is of a most complex nature, relating to the art of Egypt, Greece, and Rome, and to the newer traditions of the Coptic Christians, Byzantines, Sasanians, and the Umayyads, the first Arab conquerors of Egypt. The entire range of this production has often been referred to as "Coptic," but this is a misleading designation, since a large body of the material still reflects—if at some distance —Hellenistic style. We have attempted in this catalogue to distinguish among the several traditions of Egyptian material, frequently a difficult task because of the considerable overlapping of the groups. Furthermore, it is unclear from historical evidence what set or sets of workmen were actually employed in their manufacture.

In the great age of Greek dominance, the Mediterranean ports of Antioch, Tunis, and Alexandria, as colonial outposts of the Greek mainland, shared similar traditions. The population of Alexandria, for example, was a mixture of peoples from the Greek world, but the majority of the Egyptian natives spoke Greek and adopted a Hellenized way of life. It is not surprising that their iconographical vocabulary focused on the gods and mythological stories of the Greeks. Late manifestations of this culture continued unabated into the first four centuries A.D., existing side by side with the even more ancient Egyptian traditions. Small nude female figures, long called "dolls," for instance, have more recently been identified as fertility amulets. They continued to be produced in the Egyptian manner as late as the third and fourth centuries and were buried in the graves of women and girls (cat. no. 117). Similarly, little bits of inlay are found representing Egyptian deities, such as Hathor (cat. no. 162), who was still worshiped in the Roman period.

The Romans dominated Egypt politically and militarily from 30 B.C. until the invasion of the Sasanians under Chosroes in 616. During these centuries of Roman domination, the country became the personal dominion of the emperor and was a hotbed of political and religious disagreements, persecutions, and wars. Greek tra-

ditions remained dominant in art; only after Constantine's Edict of Milan in 313 did Christianity introduce new subject matter.

A typical example of an object carved in the early Christian period at the beginning of the sixth century by craftsmen in the Greek tradition is a small ivory pyxis with scenes in relief of the Banquet of the Gods and the Apple of the Hesperides, and of the awarding of the Apple to Aphrodite (cat. no. 170; see colorplate 41). Closely related objects depicting Christian subjects, for instance, a pyxis with the Miracle of the Loaves and Fishes in the Metropolitan Museum, suggest the heterogeneous nature of the groups patronizing these artists.

Ivories of this period often reflect the taste for Nilotic and bucolic scenes found in the textiles and mosaics of Alexandria and the African coast, scenes often filled with amusing incidents, fisher boys, and putti. A typical example is a panel from a casket that depicts in low relief a river goddess with a symbolic water vase and fish in one section and in the other the sun god Helios in his chariot (cat. no. 159; figure 18). The borders of various boxes were decorated with friezes of female figures amid clouds or waves (cat. no. 142; see colorplate 42).

Another panel shows a single putto that utilizes a different and often-used technique. The figure is delineated with incised lines originally inlaid with colored wax (cat. no. 134; see colorplate 43). Other areas of the surface were also covered with wax decoration. This panel would once surely have been on a casket similar to the great Walters example (cat. no. 135; see colorplate 44), in which wax inlaid panels alternate with relief panels of dancers. This truncated pyramidal box, despite the fact that it is a reconstruction, presents one of the best-preserved ensembles of its kind. Its iconographical repertoire includes maenads, a faun, Erotes with offerings, and a series of winged and wingless male and female dancers. The subject matter shows little regard for true classical iconography; the images have become decorative devices cast in a Hellenistic mode. The casket's general imagery would have been acceptable to Coptic Christian, Hellenized

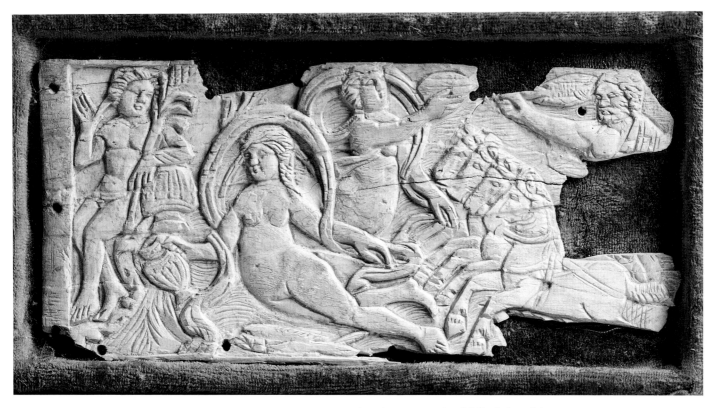

Figure 18 (cat. no. 159). Panel from a box with a river goddess and Helios, bone, Egyptian (Hellenistic style), late 5th century. The river goddess, whose drapery flows above her head, can be identified by the water jar and fish. On the right side of the panel the sun god Helios appears in his chariot, saluting a goddess in the heavens.

Egyptian, Roman legionnaire, and Alexandrian Jew alike.

This iconographic mixture was assuredly a contrived solution to the difficult artistic problem of satisfying a heterogeneous audience. Dancers and Erotes are continually combined with figures of Herakles, Apollo, and Artemis, almost to the extent of becoming the iconographic "vernacular" of the era. Some fine classical figures such as the Bacchus with a cornucopia and bunch of grapes (cat. no. 120; see colorplate 45) were used as furniture mounts, and occasionally entire scenes such as those on the pyxis with the Banquet of the Gods (cat. no. 170) show a rather more thorough understanding of the classical subject matter and style.

While many ivories of fine quality from Egypt have survived, the majority are somewhat casual in workmanship and seem to have been produced rapidly. Numerous bone carvings use the natural shape of the bone without its having been squared, which makes it difficult to understand exactly how the individual plaques were used on household furniture, boxes, funeral beds, and, perhaps, in architecture. A few plaques exist that are squared and which fit together in a series, including the group of four with Bacchus and two maenads in the Louvre.[1] The Walters pyramidal box (cat. no. 135), though reconstructed, is a rare example showing how plaques were inset in a box and contrasted with each other. In another piece of furniture, the multicolored decoration was achieved by dying and heating the bone plaques gray and buff (cat. nos. 164 and 165; see colorplate 47).

Much has been written about the design sources used by ivory and bone carvers and textile weavers in late Roman Egypt. In the years after Christianity became the dominant religion in Egypt, Christian subject matter was transmitted through textiles woven in the East Roman Empire. These great silk weavings depicted eagles, chariot races, and lions, as well as scenes of the new Christian faith, and seem to have served as models in many cases.

One of the finest examples of this transmission of designs is seen in the seventh-century ivory that depicts a victorious emperor being crowned by winged genii after a bear hunt (cat. no. 176; see colorplate 48). The design of the ivory is spirited and is repeated in almost every detail in a pair of tapestry roundels woven in Egypt at the same time, one of which is in the Textile Museum, Washington, D.C. (see colorplate 49), and the other in the Cleveland Museum of Art. The textiles identify the rider by inscription as "Alexander the Macedon," and, by inference, the ivory figure also probably represents Alexander the Great, not the then-current Byzantine ruler. There are mistakes in interpretation in the ivory, which suggest that it is an imperfectly understood copy of an imported design. For instance, the emperor has bare feet rather than sandals or boots, and in the center of the forehead of the horse is a circular pendant with no visible harness to sustain it. Conversely, a detail that is correct in the ivory—the end of the emperor's flying cape that rises above his left shoulder—has been misinterpreted in the textiles as a hand rising above the shield. From

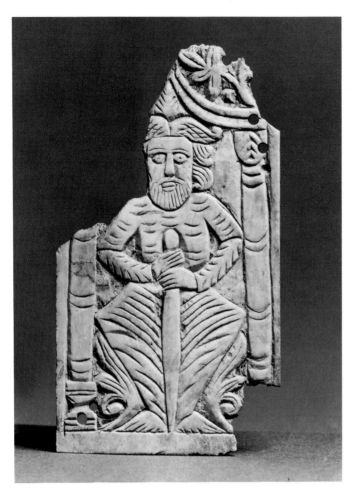

Figure 19 (cat. no. 175). Plaque with seated Sasanian king, ivory, Egyptian (Sasanian style), early 7th century. The figure of the king, so typical of Sasanian textile and metalwork designs, was probably rendered by an Egyptian carver during the Sasanian occupation of Egypt, 619–639. This particular design remained popular for several centuries and occurs in later Coptic textiles.

these examples, then, one can trace two levels of copying details from an imported model.[2]

When new trade sources or conquerors brought the Egyptian artistic community into contact with fresh ideas, this was reflected in ivories as well as other works of art. The Sasanians ruled Egypt for a brief period in the early seventh century, and a Sasanian king, seated in bent-legged splendor on his throne, is represented on an Egyptian carving (cat. no. 175; figure 19). Similar figures may be seen on Sasanian silver repoussé vessels, an example of which is in the Walters.[3] Since the type of seated king continues for centuries as the model for woven scenes of kings, including Alexander ascending into the heavens, the ivory carver is likely to have derived his design from a textile source.[4]

A few years after the end of Sasanian dominance a new style was again imposed on the carvers of the Egyptian delta. The Arab conquest of 639 was accompanied almost immediately by the production of abstract plant designs, preferred by the new Umayyad rulers of Egypt (cat. nos. 217a, b, c). Like the Romans before them, the Umayyads, inheriting a complex society, simply added

their new subject matter to the mélange that continued to be produced in the workshops—particularly those manufacturing textiles—down through the ninth and tenth centuries.

One of the most imposing Christian ivories of Egypt was produced during the Islamic period (about the ninth or tenth century). The Madonna and Child (cat. no. 180; see colorplate 50) follows the new "Eleousa," or Madonna of Tenderness, type, showing a change from the frontal, hieratic pose common to Madonnas of the early church to a pose displaying the human qualities of the Virgin as mother. Literary sources suggest that the Eleousa iconography was current in Byzantium at this time, but the Walters figure is among the earliest known representations of this subject.

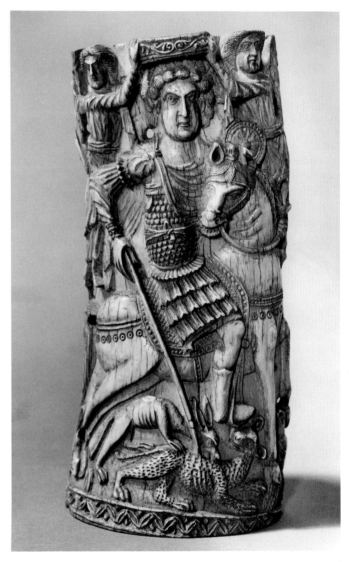

Figure 20. Plaque with victorious emperor-hunter, ivory, Egyptian, 6th century. This ivory is a somewhat earlier version of the victorious hunter crowned by genii shown in the Textile Museum tapestry (see colorplate 49) and the Walters Art Gallery ivory (cat. no. 176). In the early eleventh century it was used as part of the decoration of the great Aachen Ambo of Henry II, together with plaques of Isis, Bacchus, a Nereid, and a soldier. Their pagan subject matter seems to have been of no concern to the altar's patron. Aachen Cathedral, Germany.

The group is made from a single large piece of ivory more than ten inches in height. The opening for the root that can be seen at the back demonstrates that the piece was cut from the base of a tusk. The angels at either side form a kind of arched space for the central group. Emphasis is placed on the loving gestures of the Mother and Child. The proportions of the pair of figures are distorted: the heads are too large, the arms too small, and the eyes prominent. The drapery is treated in a highly stylized manner with rigid parallel lines of various patterns defining the different sections of the garments. Yet the artist has conveyed the strong emotionalism attached to a new interpretation of the Virgin that was to become the chief subject of sculpture in the thirteenth and fourteenth centuries in medieval Europe.

Among the greatest surviving Coptic ivories are six large-scale plaques now mounted as part of the decoration of the pulpit of Henry II in the Cathedral at Aachen.[5]

The pulpit was assembled between 1002 and 1014, and the ivories are thought to have come from the treasure of the great coronation church of the emperors of the Carolingian and Ottonian dynasties. Yet the subjects of the ivories are strictly pagan. Isis appears in one panel, Bacchus in two, another shows a typical Nilotic scene with Nereids and Tritons, and two more depict military figures. One of the latter two is a hunting emperor or commander being crowned victorious in the chase (figure 20); it is closely related in concept to the Walters emperor-hunter (cat. no. 176; see colorplate 48). While the Aachen emperor panel might possibly have a Christian connotation and refer to the Byzantine emperor, the other five panels combine Egyptian and Hellenistic subjects. Such objects were probably deemed acceptable as church decoration because of an appreciation of their importance as works of art. Great respect for objects from the classical past was fostered by Charlemagne and his successors.

NOTES

1. Marangou, pl. 17a.
2. R. Berliner, "Horsemen in Tapestry Roundels Found in Egypt," *Textile Museum Journal*, I, 1963, 44, fig. 9.

3. R. Ghirshman, "Scènes de banquet sur l'argenterie sassanide," *Artibus Asiae*, XVI, 1953, 51.

4. R. Ghirshman, *Iran; Parthians and Sasanians*, Paris, 1962, fig. 289.
5. E. Grimme, *Der Aachener Domschatz*, Düsseldorf, 1972, no. 27, pl. 7.

Catalogue, Later Roman and Egyptian Ivories

115. MAN'S HEAD

Bone finial. Egyptian (Hellenistic style), 1st century B.C.

The head, carved in the round, has human ears and a hair cap. There is a garland of leaves and a flower on the forehead.

A cut on the lower left edge has removed the tip of the mustache. The head is hollowed out and a fill material plugs the upper opening.

Although the head is that of a man, it has the attributes usually associated with satyrs' heads on furniture mounts—the fierce expression, mustache, and garland in the hair—seen in the Hellenistic example, catalogue no. 61, dated in the second century B.C.

H: 1¼″ (3.2cm) 71.590

HISTORY: Purchased from Dikran Kelekian, Paris, before 1931.

116. BOY WITH A SCROLL

Bone plaque. Egyptian (Hellenistic style), 2nd–3rd century

This large-scale figure of a nude boy once formed part of a large relief, which has been determined from the edges broken all the way around the piece and from the fragment of the background behind the youth's neck. A scarf falls over his right arm and down over his leg; in his hands he holds what appears to be the end of a scroll. The head is finely finished in the round and the details of the anatomy are carefully handled, with the exception of the coarse fingers of the boy's right hand.

A comparable ivory relief showing two priests of the Isis cult is in the Dumbarton Oaks Collection. Its scale and finish are similar, and it is one of the few works datable by means of an inscription with the name of a second-century city. The Dumbarton Oaks example illustrates the early use of large-scale reliefs (Weitzmann, *Ivories and Steatites*, 1).

The figure's right leg is broken at the knee and its left is missing entirely. There is a hole in the groin which was drilled at a later date.

H: 5¼″ (13.2cm) × W: 2³⁄₁₆″ (5.5cm) 71.54

HISTORY: Collection of Michel Boy (sale, Paris, May 15, 1905, lot 579); purchased before 1931.

BIB.: *Byzantine Art*, 97.

117. FEMALE FIGURE

Ivory amulet. Egyptian, 3rd–4th century

The nude female figure has her arms pressed to the sides and no modeling of the hands. The piece, stained brown, is in the round. The legs are broken off at the knees and a portion of the upper right arm is missing.

Such figures were called dolls, but have been shown to be fertility amulets. They are found in many female burials. Other examples of this early type are in the Victoria and Albert Museum, London (Longhurst, no. A-170-1926), and in Berlin (Wulff, 525).

H: 4″ (10.0cm) 71.1130

HISTORY: Purchased from the estate of Dikran Kelekian, New York, 1951.

118. SATYR

Bone plaque. Egyptian (Hellenistic style), 3rd–4th century

The squared plaque is carved in intaglio with a satyr carrying a bundle. The lines were filled with colored wax, of which traces remain. One filled hole at the upper left appears to have been for attachment, and the piece is broken along the lower edge. Pieces in a similar technique, such as the hunter lunette at Dumbarton Oaks (Weitzmann, *Ivories and Steatites*, 16), appear to have originally decorated boxes and large chests.

H: 1½″ (3.9cm) × W: 1¹⁵⁄₁₆″ (4.9cm) 71.620

HISTORY: Purchased from Dikran Kelekian, Paris, 1929.

119. BACCHUS

Bone plaque. Egyptian (Hellenistic style), 3rd–4th century

The youth with drapery around the hips and vine leaves in his hair is probably intended to represent Bacchus. The cross-hatched rear surface indicates that the plaque was glued to a wooden object. The top preserves its squared edge; all other sides are broken.

H: 3¾″ (9.5cm) 71.23

HISTORY: Purchased before 1931.

120. BACCHUS

Bone plaque. Egyptian (Hellenistic style), 3rd–4th century

A finely finished nude figure of Bacchus holds a cornucopia and a bunch of grapes. He stands between two spiral columns. The plaque was originally squared. It is broken at the left and top, and chipped along the right edge.

H: 4⅛″ (10.6cm) 71.1099

HISTORY: Collection of Henry Walters until 1931; Mrs. Henry Walters; Brummer Gallery; gift of Mr. and Mrs. Nelson Gutman, 1942.

BIB.: Wessel, *Christentum am Nil*, 213, fig. 87. *See also colorplate 45*

121. APOLLO

Bone plaque. Egyptian (Hellenistic style), 3rd–4th century

The figure of Apollo stands with his arm raised above his head, grasping the branch of a tree. Beside him on a pedestal are his lyre and *askos*. The panel is slightly convex, and is broken at the lower right corner.

The type of the Apollo figure derives from the Apollo Lykeios of Praxiteles and was repeated often in Egyptian works. The same pose, however, was used as frequently for Bacchus (cat. no. 144), so that many fragments cannot be correctly identified, as in catalogue nos. 122 and 123. (Marangou, 31, n. 129.)

H: 5¹³⁄₁₆″ (14.9cm) × 2⅛″ (5.3cm) 71.43

HISTORY: Purchased from Polovtsoff, Paris, 1928.

BIB.: Wessel, *Christentum am Nil*, 213.

122. MALE FIGURE

Bone plaque. Egyptian (Hellenistic style), 3rd–4th century

A male figure, either Apollo or Bacchus, with wavy hair is set against a piece of drapery. The plaque is squared at the top and left sides, the right and bottom are broken.

H: 3⅞″ (9.8cm) 71.3

HISTORY: Purchased before 1931.

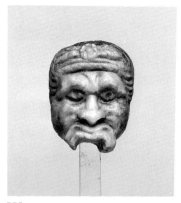

115

118

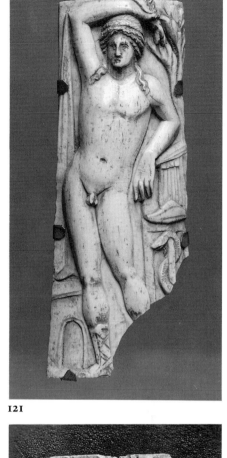

121

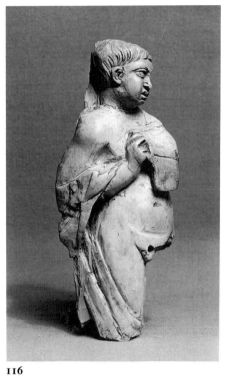

116

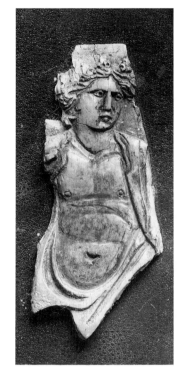

119

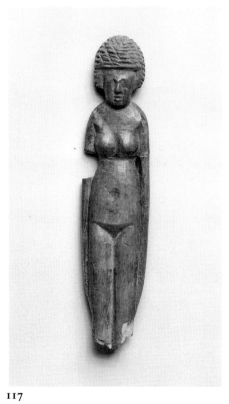

117

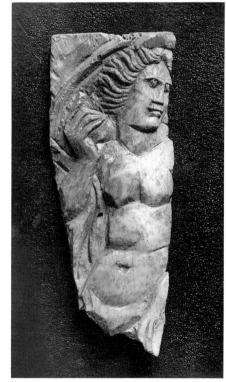

120

122

123. YOUTH (APOLLO?)

Bone plaque. Egyptian (Hellenistic style), 3rd–4th century

A youth posing with his hand above his head could be intended for either Apollo or Bacchus (see cat. nos. 121, 144). The fragment is carved from a convex bone and has been broken on all edges.

H: 4½" (11.5cm) 71.24

HISTORY: Purchased from Dikran Kelekian, Paris, before 1931.

124. SEASON FIGURE AND A VICTORY

Bone. Egyptian (Hellenistic style), late 3rd–4th century

A figure of the season, Autumn, carrying fruits, is accompanied by a Victory holding a bunch of grapes. The plaque is probably one of four groups representing the seasons, each with a male season figure accompanied by a Victory. The closest parallels with male season figures accompanied by Victories are three third-century sarcophagi in Paris, Weiden, and Copenhagen (G. Hanfmann, *The Season Sarcophagus in Dumbarton Oaks*, Washington, D.C., 1951, figs. 44–46). The corner season figure of the Weiden sarcophagus is similar in pose to the figure of the ivory. At the base is a seated goat, very similar to the goat on the season sarcophagus in the Palazzo Conservatori, Rome, which has both male and female season figures (Hanfmann, fig. 30).

The lower border of the plaque is carved with a bead-and-reel border. It has a number of cracks from drying after burial, and the nose and forehead of the Victory have flaked away.

H: 5⅛" (1.3cm) × W: 2½" (6.3cm) 71.51

HISTORY: Purchased from Dikran Kelekian, Paris, before 1931.

125. PUTTO

Bone plaque. Egyptian (Hellenistic style), 3rd–4th century

The convex bone is carved with a portion of a pattern of vine interlace, which contains a basket above a putto. The putto grasps the vine and holds fruit in his hand. The plaque has been buried, and shows surface flaking. It is broken at the left side and bottom.

H: 3⁹⁄₁₆" (9.0cm) 71.15

HISTORY: Purchased from Dikran Kelekian, Paris, before 1931.

126. YOUTH

Bone plaque. Egyptian (Hellenistic style), 3rd–4th century

The convex panel is carved with the figure of a youth leaning on a staff. It has been broken and repaired with minor fills at the neck, hip, and knee.

H: 6¼" (15.8cm) × W: 2⅞₁₆" (6.2cm) 71.41

HISTORY: Purchased before 1931.

127. YOUTH

Bone plaque. Egyptian (Hellenistic style), 4th century

A nude youth is shown leaning on a staff. The convex bone is squared at the sides and top; the bottom has been broken.

H: 4¼" (10.7cm) 71.28

HISTORY: Purchased before 1931.

128. YOUTH HOLDING A CLUB

Bone plaque. Egyptian (Hellenistic style), 4th century

This convex bone plaque shows a nude youth holding a club in his right hand. The natural edges of the bone have been broken at the sides.

H: 5¹¹⁄₁₆" (14.5cm) 71.57

HISTORY: Purchased from Léon Gruel, Paris, before 1931.

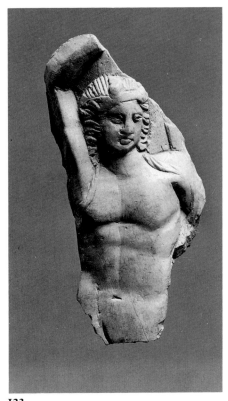

123

125

127

124

126

128

87

129. HERAKLES

Bone plaque. Egyptian (Hellenistic style), 4th century

A convex section of bone is carved with Herakles wearing the lion's skin and holding his club. It is broken on all edges except the top, which is squared.

H: 4½" (11.5cm) 71.1098

HISTORY: Collection of Henry Walters; Mrs. Henry Walters; Brummer Gallery; gift of Mr. and Mrs. Nelson Gutman, 1942.

130. BACCHUS

Bone plaque. Egyptian (Hellenistic style), 4th century

Bacchus is seen with a flowing drapery and his club, looking back over his shoulder. The plaque was squared for inlay, and has been broken at the left side and bottom.

Two plaques with similar figures, carved in the same rough technique, with male figures looking back over their shoulders, are in Berlin (Wulff, 394–395). They apparently come from the same or a similar object, and have a band of molding at the base.

H: 3%6" (9.0cm) 71.27

HISTORY: Purchased from Dikran Kelekian, Paris, before 1931.

131. BUST OF A WOMAN

Bone plaque. Egyptian (Hellenistic style), 4th century

The plaque is unusual in that it has a raised border on the right, a border with drilled dots on the lower edge, and a squared side on the left. The wavy-haired woman looks up and raises her hand. The top and right side are broken off.

H: 2¹³⁄₁₆" (7.1cm) 71.597

HISTORY: Purchased before 1931.

132. SATYR

Bone plaque. Egyptian (Hellenistic style), 4th century

The satyr wears an animal skin and carries a wineskin over his shoulder. There is a basket of fruit in the background. The plaque is squared; the left side is split off and there are chips on the right edge.

H: 5¾" (14.6cm) 71.611

HISTORY: Collection of Grand Duke Nicolas Michaelovitch, St. Petersburg, until 1919; purchased in Paris, 1927.

133. SEATED FIGURE

Bone plaque. Egyptian (Hellenistic style), 4th century

The plaque shows a seated figure holding a basket of fruit and a staff. His drapery appears to be animal skin and falls to the ground at the right. The panel has suffered from burial and is desiccated and chipped on the surface, including half of the figure's face. It is broken at the left and upper right corners.

H: 3¹³⁄₁₆" (9.6cm) × W: 3⅜" (8.4cm) 71.599

HISTORY: Said to have been found in Alexandria; collection of Joachim Ferroni, Rome (sale, Apr. 14, 1909, lot 663); purchased from Dikran Kelekian, Paris, before 1931.

BIB.: Beckwith, *Coptic Sculpture*, fig. 15; Wessel, *Christentum am Nil*, 213.

134. PUTTO

Bone plaque. Egyptian (Hellenistic style), 4th century

The plaque is carved in intaglio to receive wax inlay of red and dark green. Originally squared for inlay on a box or piece of furniture, it is broken at the top and left sides, and chipped at the lower right corner.

H: 3³⁄₁₆" (8.2cm) × W: 2⅛" (5.4cm) 71.25

HISTORY: Purchased from Dikran Kelekian, Paris, before 1931.

See also colorplate 43

129

131

133

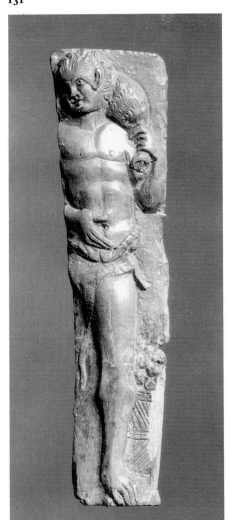

132

130

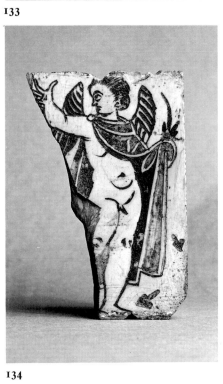

134

135. DANCERS, EROTES, AND FAUN

Wood box inlaid with bone and wax. Egyptian (Hellenistic style), 4th–5th century

The box is a reconstruction from a nearly complete series of original parts. These include eight carved bone plaques with male and female dancers; two carved bone plaques of Erotes with offerings; three wax-inlaid bone plaques of two maenads and a faun; and eight wax-inlaid bone triangular plaques of winged female dancers. The bone sheathing of the wood core was sufficiently intact to restore one face of the box and one side of the lid in entirety. The majority of the members of the pedimented niches are original. The top is outlined with four strips of turned bead-and-reel ornament, which give the original scale and match the columns flanking the niches.

The wax-inlaid plaques are unusually well preserved, and show the use of black, dark green, and red.

Three carved plaques are missing, as well as the top ornamental panel of the lid. The four turned feet are original.

The careful restoration is borne out by other surviving objects, for example, the lid of a box with a reclining female nude in the Benaki Museum, Athens (Marangou, no. 169). The sheathing with bone in three strips, including one with striations, and the figure style are identical. Fragments of a box with similar figures, now in the Art Museum, Princeton, are shaped to form a similar truncated pyramidal casket (Rodziewicz, 2, and Bib.). Single plaques in a similar, careless but rhythmic style exist in the Louvre, Benaki Museum, and elsewhere (Marangou, 44b, 52b, and pl. 27c).

H: 13¾" (35.0cm) × L: 13⅛" (33.0cm) × W: 11¾" (29.8cm) 71.40

HISTORY: Restored by Charles Kelekian in Paris; purchased from Dikran Kelekian, Paris, 1931.

BIB.: *Exposition d'art byzantin*, Louvre, 1931, no. 12; *Pagan and Christian Egypt*, no. 97; *Byzantine Art*, no. 181; F. Rodziewicz, "Aleksandryjska Plakietka," *Rocznik Museum Narodowego w Warszawie*, IX, 119–129; Marangou, nos. 27, 32, 132.

See also colorplate 44

136. FEMALE FIGURE

Bone plaque. Egyptian (Hellenistic style), 4th century

Carving on this panel follows the contour of the bone, which was not trimmed for inlaying. It shows a nude female (Aphrodite?) beside a striated column. All the edges are broken except for the top and side of the column.

H: 5" (12.8cm) 71.61

HISTORY: Purchased before 1931.

137. FEMALE FIGURE

Bone plaque. Egyptian (Hellenistic style), 4th century

A partially draped female leans on a pillar. The ivory, which was buried, has broken and been repaired, and it has suffered flaking on the surface.

H: 7⅜" (18.6cm) × W: 2⁷⁄₁₆" (6.0cm) 71.34

HISTORY: Said to have been found at Alexandria; purchased from Dikran Kelekian, Paris, 1931.

138. DANCER

Bone plaque. Egyptian (Hellenistic style), 4th century

A poorly carved figure of a dancer holding a tambourine is represented on this carefully trimmed plaque, probably for inlay on a box or piece of furniture.

H: 3" (7.6cm) × W: 1⁵⁄₁₆" (3.3cm) 71.21

HISTORY: Purchased from Dikran Kelekian, Paris, before 1931.

139. BEARDED FIGURE

Bone plaque. Egyptian (Hellenistic style), 3rd–4th century

The bearded figure holding an object in his left hand is possibly intended to represent Herakles. It is carved on a convex bone, and is broken at the bottom and right edge.

H: 3" (7.6cm) 71.17

HISTORY: Purchased from Dikran Kelekian, Paris, before 1931.

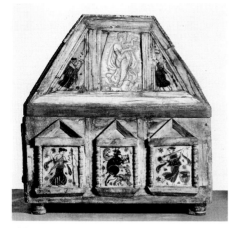

135

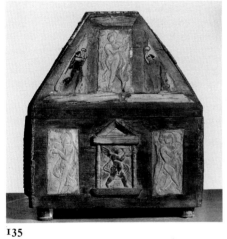

135

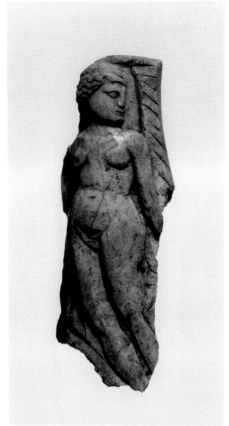

136

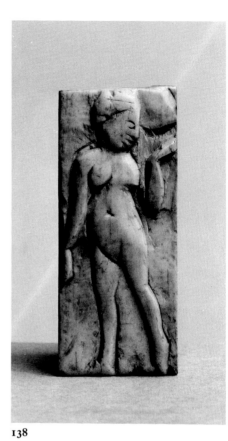

91

138

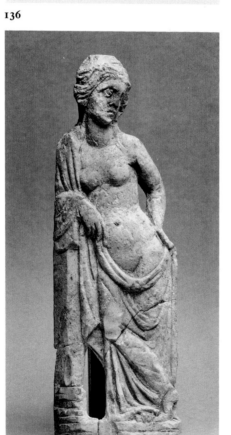

137

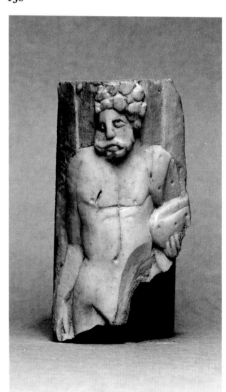

139

140. TWO FIGURES

Bone plaque. Egyptian (Hellenistic style), 4th century

The plaque shows a male figure with arm raised above his head and a putto holding a shell. It has been squared for use as inlay, and has been badly broken and repaired.

H: 2⅞" (7.2cm) 71.19

HISTORY: Purchased from Dikran Kelekian, Paris, before 1931.

141. DANCER

Bone plaque. Egyptian (Hellenistic style), 4th century

A nude girl dances and plays a tambourine in front of a draped table and a basket of fruit. The scene is flanked by two fluted columns. There are chips in the center of the base and at the lower right corner. Similar subjects can be seen in the Benaki Museum (Marangou, nos. 89, 90).

H: 3³⁄₁₆" (8.0cm) ✕ W: 1⅞" (4.7cm) 71.26

HISTORY: Purchased from Dikran Kelekian, Paris, before 1931.

142. FEMALE FIGURE

Bone plaque. Egyptian (Coptic style), 4th–5th century

A reclining female nude with flying drapery is seen amid clouds (or waves?). The plaque was originally part of a border of similar figures. It is broken on the left edge.

A plaque of very similar design and finish is in the Benaki Museum (Marangou, no. 165).

H: 1¹⁵⁄₁₆" (5.0cm) ✕ W: 3¾" (9.5cm) 71.56

HISTORY: Purchased from Dikran Kelekian, Paris, before 1931.

See also colorplate 42

143. DIONYSOS AND ARIADNE

Bone lunette from a casket. Egyptian (Hellenistic style), 4th–5th century

The figures are incised, and various surface textures are indicated with incisions and cross-hatching. Cupid is seen between the figures, and a leopard on a leash is at the lower left.

The lower left corner and a small section at the top are chipped.

Demi-lune plaques engraved with various subjects occur in some number and appear to have filled lunettes above paired columns with a figure or other subject below. See Weitzmann, *Ivories and Steatites*, no. 16.

H: 2⅛" (5.4cm) ✕ W: 3⅝" (9.2cm)
71.1127

HISTORY: Purchased from the estate of Dikran Kelekian, New York, 1951.

144. DIONYSOS

Bone relief. Egyptian (Hellenistic style), 4th–5th century

The panel is in very high relief and shows the nude figure of Dionysos, his right hand above his head, standing amid grapevines, a young boy at his side. The figure is finely modeled, but the relief has suffered from burial and is in desiccated condition.

The composition, the depth of carving, and the grapevine setting are repeated in two Bacchus panels of the Pulpit of Henry II at Aachen, dated to the sixth century (E. Grimme, *Der Aachener Domschatz*, Aachen, 1972, pls. 27 and 28). While Wessel has suggested a fourth-century date for the Walters relief and a relationship with Constantinian style, Beckwith has proposed a date in the fifth century (see Bib.).

H: 4¹⁵⁄₁₆" (12.7cm) ✕ W: 2⁷⁄₁₆" (6.3cm)
71.47

HISTORY: Purchased from Polovtsoff, Paris, 1928.

BIB.: G.W. Elderkin, *Art in America*, XXIV, no. 2, 1936, 61; Beckwith, *Coptic Sculpture*, fig. 28; Wessel, *Christentum am Nil*, 213; Marangou, nos. 87, 88, and 91.

145. FEMALE TORSO

Bone plaque. Egyptian (Hellenistic style), 4th–5th century

The female torso is dressed in a chiton, exposing the right breast, suggesting a traditional Amazon type. The plaque has been squared on both sides, for use in an inlaid frieze. It is broken at top and bottom.

H: 5⅜" (13.5cm) 71.1119

HISTORY: Purchased from Raphael Stora, New York, 1946.

146. FEMALE TORSO

Bone plaque. Egyptian (Hellenistic style), 4th–5th century

Torso of a female figure, wearing a chiton, exposing the right breast. The arms, head, and legs have been broken. The reverse is crosshatched to be glued to a piece of furniture.

H: 3¾" (9.5cm) 71.13

HISTORY: Purchased before 1931.

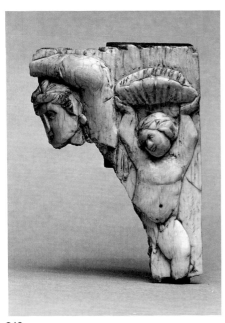

140

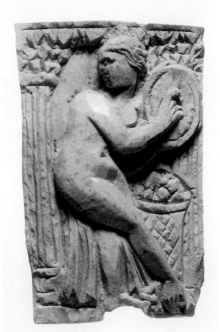

141

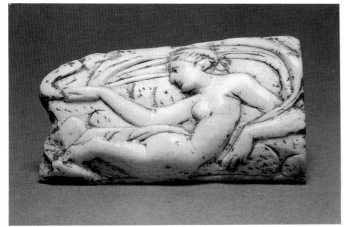

142

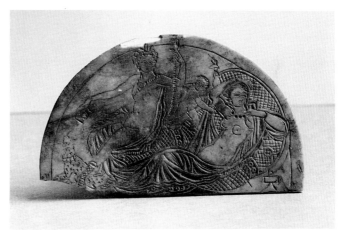

143

144

145

146

147. PUTTO AND ACANTHUS

Bone relief. Egyptian (Hellenistic style), 4th–5th century

This elaborate furniture mount is carved with a series of moldings at the bottom, and depicts a large putto set against a bank of waving acanthus leaves. The modeling of the figure is unusually fine, recalling Roman knife handles of the fourth century (see cat. no. 103), with the rendering of the chubby body and face and the naturalistic treatment of the curly hair. Only the wings are stiffly handled. The acanthus is carefully rendered, and the effect of the waving leaves relates to a limestone capital from Saqqara at Berlin (*Koptische Kunst-Christentum am Nil*, Essen, 1963, no. 112).

The panel is flat on the back. There are four chips in the acanthus leaves, and part of the base and the putto's left foot are chipped.

H: 5" (12.7cm) × w: 2⁹⁄₁₆" (6.5cm) 71.32

HISTORY: Purchased from Dikran Kelekian, Paris, 1913.

148. FEMALE FIGURE

Bone plaque. Egyptian (Coptic style), 4th–5th century

This nude female figure, with raised arms and flying drapery, has been cut at the thighs. It was part of a border of similar figures, and has been broken along the top and bottom edges.

L: 3⅛" (8.0cm) 71.1097

HISTORY: Collection of Henry Walters, until 1931; Mrs. Henry Walters; purchased from the Brummer Gallery, New York, 1942; gift of Mr. and Mrs. Nelson Gutman, 1942.

149. PORTION OF A FEMALE FIGURE

Bone plaque. Egyptian (Coptic style), 4th–5th century

The plaque shows only the legs and lower torso of a dancing nude figure amid clouds. It was part of a long running border of similar figures, of which many examples have been found.

There is a slight break at the lower right edge, and the bottom edge is broken. Such pieces must have been glued to a wooden core, as there are no signs of attachment.

L: 3⁷⁄₁₆" (8.9cm) × w: 2¼" (5.8cm) 71.7

HISTORY: Purchased before 1931.

150. DANCER

Bone plaque. Egyptian (Hellenistic style), 4th–6th century

This spirited but casually finished figure of a dancer holds a tambourine. There is a piece missing at the base, and the asymmetrical shape follows the original contour of the bone.

H: 5⅜" (13.6cm) 71.1110

HISTORY: Gift of Marvin C. Ross, 1943.

151. WOMAN WITH BOWL

Bone plaque. Egyptian (Hellenistic style), 4th–5th century

The figure and two flowers in the background are carved in intaglio for the application of inlaid colored wax, which has since disappeared. The left edge and a corner of the right are broken. The edges are beveled for use as an inlay.

H: 2¹³⁄₁₆" (7.0cm) × w: 1⁹⁄₁₆" (4.0cm) 71.14

HISTORY: Purchased from Dikran Kelekian, Paris, before 1931.

152. WOMAN WITH RAISED HAND

Bone plaque. Egyptian (Hellenistic style), 4th–5th century

The figure is carved in intaglio and was inlaid with colored wax, now missing. As the indented border at the left shows, it was the inlay of a box or piece of furniture.

H: 3⅝" (9.1cm) × w: 1⁹⁄₁₆" (4.0cm) 71.6

HISTORY: Purchased before 1931.

153. PUTTO

Bone plaque. Egyptian (Hellenistic style), 4th–5th century

The winged putto, incised in profile, is holding a bowl. The base of the wings and the drapery are carved in intaglio for colored wax inlay. The piece is broken along the lower edge.

H: 2½" (6.5cm) × w: 1⅝" (4.1cm) 71.1115

HISTORY: Purchased from Joseph Brummer, New York; gift of Mrs. Saidie A. May, 1944.

147

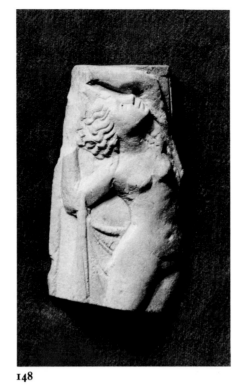

148

149

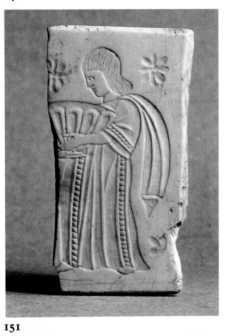

150

151

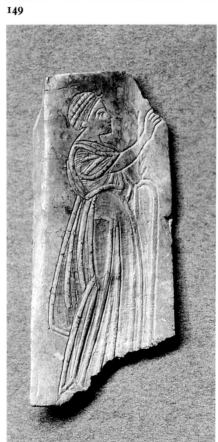

152

153

154. HORSE HEAD

Bone finial. Egyptian (Hellenistic style), 5th century

The horse's head is hollowed out for only a short length, indicating use as a finial on a piece of furniture or a shaft. Its highly polished surface shows a pattern of root marks from burial.

L: 3¼″ (8.3cm) 71.1100

HISTORY: Collection of Henry Walters before 1931; Mrs. Henry Walters; Brummer Gallery; gift of Mr. and Mrs. Nelson Gutman, 1942.

BIB.: *Byzantine Art*, 180.

155. THREE FEMALE FIGURES

Bone plaque. Egyptian (Hellenistic style), 5th century

This fragment of a border strip with nude female figures floating in the sea or clouds has a distinct ground plane on the lower edge. The figures overlap and intertwine in a casual manner, one floating on a ball-like representation of a cloud or wave. The heads and other parts of two figures are missing, and only a leg of the third survives.

The left edge is the original end of the plaque, and the elbow of the first figure is intentionally cut. Strokes of the carving tool are still visible. While the forms are quite casually rendered, the surface has been polished.

A similar example is in the Benaki Museum (Marangou, no. 153).

H: 1⅝″ (4.0cm) × W: 5¾″ (14.5cm) 71.49

HISTORY: Purchased before 1931.

BIB.: M. C. Ross, "A Coptic Bone Carving," *Bulletin de la société d'archéologie copte*, VI, 1940, 125.

156. FEMALE FIGURE

Bone plaque. Egyptian (Hellenistic style), 5th century

The draped female figure stands under an arch with a column on her right. She holds a cornucopia in her left hand and a wreath in her right. The bone is convex and carefully trimmed to a rectangular shape for application to a piece of furniture.

H: 5³⁄₁₆″ (13.3cm) 71.55

HISTORY: Purchased before 1931.

BIB.: *Byzantine Art*, no. 179; Beckwith, *Coptic Sculpture*, fig. 23.

157. NUDE FEMALE

Bone plaque. Egyptian (Hellenistic style), 5th century

This subtle carving of an undraped female appears to be in the round, but is actually a high relief. The thin background has been broken away all around the figure and only two fragments of it at her right hand and right knee remain. The left arm and lower legs are missing.

H: 4¼″ (11.0cm) 71.52

HISTORY: Purchased before 1931.

BIB.: S. der Nersessian, "Pagan and Christian Art in Egypt," *Art Bulletin*, June 1941, 167; Beckwith, *Coptic Sculpture*, fig. 29.

See also colorplate 46

158. DANCING FIGURE

Bone plaque. Egyptian (Hellenistic style), 5th century

The dancing female figure with a tambourine was an ornamental plaque for a box or piece of furniture. The left half of the figure and border have been broken away.

H: 3¼″ (8.3cm) 71.1123

HISTORY: Gift of Douglas H. Gordon, 1947.

159. RIVER GODDESS AND HELIOS

Bone panel from a box. Egyptian (Hellenistic style), late 5th century

The panel shows a river goddess and a male figure with an inverted vase on the left, and Helios in his quadriga saluting a female deity in the sky on the right. The Nilotic subject is reflected in other Roman works and Coptic textiles of the period. A fragment of a similar box showing a Nereid with flying drapery and a merman with an oar is in the Archaeological Museum, Split, Yugoslavia (Marangou, pl. 47b).

The panel has dried from burial and is missing five large pieces. It was originally attached with dowels to the side of a box.

H: 4″ (10.2cm) × W: 9″ (22.9cm) 71.1113

HISTORY: Collection of J. P. Morgan; purchased from Joseph Brummer, New York, 1944.

BIB.: Morgan sale, New York, March 22, 1944, lot 76; *Byzantine Art*, no. 152; Wessel, *Christentum am Nil*, 216, fig. 91 (dated late fifth century by Johannes Kollwitz).

See also figure 18

160. FEMALE FIGURE

Bone plaque. Egyptian (Hellenistic style), 5th–6th century

This portion of a female figure has drapery rendered by paired incised lines. The plaque is squared at the sides and bottom, indicating that it was from a frieze or long composition in which the figures were divided over a number of contiguous plaques. The head is missing, as well as the object held in the hand, probably a tambourine or wreath.

A series of contiguous plaques, showing Bacchus and two women, in which the various parts of the figures appear on adjoining sections, may be seen on five panels in the Louvre (Marangou, pl. 17a).

H: 4⅛″ (10.5cm) 71.1104

HISTORY: Purchased from Gimbel Brothers, New York, 1943.

154

155

156

157

158

160

159

161. FEMALE FIGURE

Bone plaque. Egyptian (Hellenistic style), 5th–6th century

A woman, wearing a chiton and veil, is seen against a spiral column and beneath an arch. The arched panel above has an egg-and-dart border. The bottom and sides are squared, indicating that this panel joined others to form a scene, probably from the side of a box. The upper left border has been broken.

H: 5½" (14.0cm) × w: 1⁷⁄₁₆" (3.6cm) 71.46

HISTORY: Purchased from Dikran Kelekian, Paris, 1930.

162. HEADS OF HATHOR

Bone plaque. Egyptian, 5th century

The piece is carved with two superimposed heads of Hathor, goddess of mirth and joy. It is pierced with a hole at the top for attachment and is broken at the bottom, which suggests that it was an inlay in a handle or a cult object of the goddess. A similar piece with three heads is in the Staatliche Sammlung Ägyptischer Kunst, Munich (AS-5909).

L: 2⅝" (6.5cm) 71.612

HISTORY: Collection of Grand Duke Nicolas Michaelovitch, St. Petersburg, until 1919; purchased before 1931.

163. LAND AND WATER BIRDS

Stained fossilized bone handle. Egyptian, 5th–6th century

This handle of a knife or other implement is decorated with deeply incised birds. Four appear on each side: on the convex front, a duck, a swallow, and two wading birds; on the flat back, two songbirds, a grouse, and a duck. They are divided by highly stylized plants, including papyrus. The top is incised with a star.

A similarly incised handle with comparable hatchings for feathers is in Berlin (Wulff, no. 347). It was found in Alexandria. Another example is in the British Museum.

The handle, stained brown, is drilled for a circular tang, and has a large chip at the opening. It has been broken in half and repaired.

L: 4¹⁄₁₆" (10.3cm) 71.603

HISTORY: Purchased before 1931.

164. FEMALE FIGURE

Stained bone plaque. Egyptian (Coptic style), 5th–6th century

A nude female with drapery falling behind her holds a basket. A partridge is shown below within a square.

The plaque is semicircular in section, and was dyed and is now a warm buff color. It has been broken in half and repaired. Several small sections are lost. There are four original holes for attachment, probably to a piece of furniture. Although from the same object as catalogue no. 165, it is of a different color.

The partridge often appears in Coptic textiles. An example showing the bird in a roundel from Akhmim, with similar single strokes modeling the bird, is in the Victoria and Albert Museum, and dated fourth–fifth century (A. Kendrick, *Catalogue of Textiles from Burying Grounds in Egypt*, I, 168).

H: 9¹⁄₁₆" (23.0cm) × w: 1¹⁵⁄₁₆" (4.9cm) 71.60

HISTORY: Purchased from Arthur Sambon, Paris, 1930.

See also colorplate 47

165. MALE FIGURE

Stained bone plaque. Egyptian (Coptic style), 5th–6th century

A cross-legged youth, holding a purse in his right hand, leans on a column. Leaves flank his head. A cheetah is shown below within a square.

The plaque is carved from a curved section of bone, and has been stained or smoked a putty color. It has been broken in half and repaired. There are four original drill holes for its attachment, probably to a piece of furniture. Although from the same object as catalogue no. 164, it is of a different color.

The cheetah resembles a number of animals in woven textiles, for instance, the lions and cheetahs in roundels on a cushion cover in Trier, dated fifth–sixth century (C. Nauerth, *Koptische Textilkunst im spätantiken Aegypten*, no. 41).

H: 9⁵⁄₁₆" (23.6cm) × w 1⅞" (5.0cm) 71.42

HISTORY: Purchased from Arthur Sambon, Paris, 1930.

See also colorplate 47

161

164

165

162

163

166. FEMALE NUDE

Bone plaque. Egyptian (Coptic style), 5th–6th century

This unusually large bone inlay is coarsely carved from a piece of bone that is semicircular in section. It is squared on the edges and broken at both top and bottom. Compare with the similar modeling of catalogue no. 164.

H: 11¼″ (27.3cm) 71.1120

HISTORY: Purchased from Raphael Stora, New York, 1946.

167. PROCESSION

Bone plaque. Egyptian (Hellenistic style), 5th–6th century

The plaque is a section of a frieze showing a procession. At the right is a dancing satyr carrying a basket, followed by a maenad with a staff. The upper border is carved with bead-and-reel decoration. The sides are squared, and the right lower corner is broken.

H: 2½″ (6.5cm) × W: 3″ (7.6cm) 71.20

HISTORY: Purchased from Dikran Kelekian, Paris, before 1931.

BIB.: Marangou, 95, no. 48 note.

168. BANQUET SCENE

Bone plaque. Egyptian (Hellenistic style), 5th–6th century

A male figure is seen reclining on a couch, while a female figure with a horn or cornucopia approaches from the right. The trimmed edges indicate that it was part of a larger scene made of small squared pieces. The entire left side is broken.

H: 2¼″ (5.5cm) × W: 3⅛″ (7.9cm) 71.44

HISTORY: Purchased from Dikran Kelekian, Paris, 1930.

169. FEMALE FIGURE

Bone plaque. Egyptian (Hellenistic style), 5th–6th century

A nude female figure with falling drapery is depicted on this plaque squared for inlaying. The left edge and lower section are broken. The work is summary but well designed.

H: 3⅜″ (8.5cm) 71.1117

HISTORY: Purchased from Raphael Stora, New York, 1946.

170a,b. CLASSICAL SCENES

Round ivory pyxis. Egyptian (Hellenistic style), early 6th century

The pyxis is carved with two scenes, one (a) of the Banquet of the Gods, with the gods seated around a tripod table holding the Apple of the Hesperides, and the other (b) of Hermes awarding the Apple to Aphrodite, who stands with Athena and Hera.

The cover and base are missing. The pyxis has been broken and repaired with two modern metal rims at top and bottom. It is drilled with holes at various points along the top and bottom edges.

The figure style relates to other round pyxides with classical subjects such as the lion hunt in the Treasury at Sens Cathedral (Volbach, no. 102), and Christian subjects such as the Loaves and Fishes in the Metropolitan Museum (Volbach, no. 166), both datable to the beginning of the sixth century.

H: 3³⁄₁₆″ (8.4cm) × D: 3½″ (9.0cm) 71.64

HISTORY: Collection of Count Girolamo Possenti, Fabriano (sale, Florence, Mar. 29, 1880, no. 16, pl. 15); Eugen Felix, Cologne (sale, Cologne, Oct. 25, 1886, lot 319); purchased in 1926.

BIB.: H. Graeven, *Pyxide en os, monuments Piot*, 1899, 160 (no. 9), 163; Westwood, *Ivories*, 372; *Pagan and Christian Egypt*, no. 104; *Byzantine Art*, no. 106; Volbach, no. 104; *Age of Spirituality*, no. 115.

See also colorplate 41

171. ANIMALS IN A VINE SCROLL

Stained bone plaque. Egyptian (Coptic style), 6th century

The strip of inlay is carefully made of a straight section of bone with raised borders. It shows a lion and a partridge in a vine scroll that emanates from a vase. It is stained a bluish gray.

The strip has been broken into four pieces with the loss of a number of small chips. There is a diagonal break at the top and two holes for attachment.

H: 7⅝″ (19.4cm) × W: 1¹⁵⁄₁₆″ (5.0cm) 71.262

HISTORY: Purchased in 1930.

BIB.: M. C. Ross, "A Coptic Bone Carving," *Bulletin de la société d'archéologie copte*, VI, 1940, 125.

166

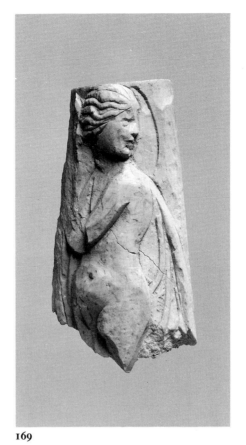

169

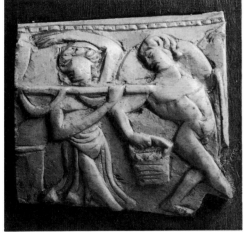

167

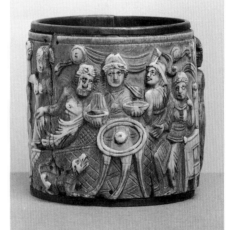

170a

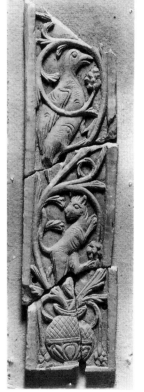

171

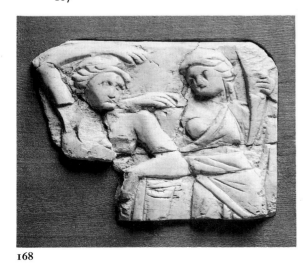

168

170b

172. FISH

Bone pendant. Egyptian (Coptic style), 4th–7th century

This pendant has the same pattern of circular dots with eyes that many box ornaments and spindle whorls found in Egypt have. Part of the tail is chipped.

L: 1⁷⁄₁₆″ (3.6cm) 71.1105

HISTORY: Purchased from Gimbel Brothers, New York, 1943.

173. APHRODITE(?)

Bone plaque. Egyptian (Coptic style), 6th–7th century

The short, stubby proportions of this figure relate it to a number of textile designs. The female figure with flowing drapery is probably intended to be Aphrodite. The edges are broken on all but the left side, and there are three holes for attachment, indicating that it was probably an inlay for furniture.

H: 3³⁄₁₆″ (8.0cm) 71.33

HISTORY: Purchased from Léon Gruel, Paris, 1927.

BIB.: *Pagan and Christian Egypt*, no. 106; *Byzantine Art*, no. 186.

174. MALE FIGURE

Bone plaque. Egyptian (Hellenistic style), 6th–7th century

A male nude with arm raised over his head is carved from a convex section of bone. The figure was never polished and shows the surface marks of chisels and files. The panel is broken on the top right, lower right, and bottom.

H: 3⅞″ (9.7cm) 71.1118

HISTORY: Purchased from Raphael Stora, New York, 1946.

175. SEATED SASANIAN KING

Ivory plaque. Egyptian (Sasanian style), 619–639

A king, holding a sword, is seated with spread knees between two columns under a reversed arch. Above the arch, stylized plant forms appear on a roughened ground. The modeling is achieved with small semicircular incisions.

The upper section of the plaque at the left and the area above the plants at the right are broken off. The lower right corner is also broken. Four of the holes for mounting are not original.

As Ross suggests (see Bib.), given the considerable influence of Persian textiles in Egypt, this concept of a Persian king may have been transmitted through a textile or other work. The image is misunderstood in certain details, such as the crown. The plant carving is paralleled in other Coptic work.

H: 7″ (17.6cm) × W: 4″ (9.8cm) 71.62

HISTORY: Said to have been found at Sohag; purchased from Dikran Kelekian, Paris, before 1931.

BIB.: *Pagan and Christian Egypt*, no. 107; *Byzantine Art*, no. 159; M. C. Ross, "A Coptic Bone Carving," *Bulletin de la société d'archéologie copte*, VI, 1940, 123–126; idem, *Art Bulletin*, June 1941, 167; R. Ghirshman, *Iran; Parthians and Sasanians*, Paris, 1962, 304, fig. 402.

See also figure 19

176. VICTORIOUS EMPEROR-HUNTER

Ivory relief. Egyptian (Coptic style), second half 7th century

The relief shows a victorious emperor-hunter crowned by a pair of winged genii. Beneath the legs of the horse, one can discern the rear legs of the bear being hunted. The relief, badly broken, has been repaired with some blank fills. Two holes indicate that it was originally applied to a piece of furniture or architecture.

The relationship has often been surmised between ivories and the many surviving textiles of late classical and Coptic Egypt, but actual cases of parallel designs are very rare. This ivory provides a demonstrable case of the close connection between the two arts. A pair of tapestry roundels showing the identical subject have survived in the Textile Museum, Washington, D.C. (see colorplate 49), and the Cleveland Museum of Art. Comparing them with the ivory reveals identical details of costume, animals, and poses.

Moreover, it shows that the weaver misinterpreted the cape of the emperor, transforming it into a hand rising above the shield. In both the textiles and the ivory the emperor is barefoot, and a tiny circular pendant decorates the forehead of the horse without a bridle to support it. These mistakes indicate the textile's dependence on the Walters ivory and also that the ivory is itself a modest interpretation of an imperial emblem, with its own share of misunderstandings. The Cleveland and Washington textiles bear the inscription "Alexander the Macedon," signifying that the scene of the victorious emperor-hunter glorifies Alexander the Great rather than the reigning emperor of Byzantium.

H: 5⅛″ (13.0cm) × W (at base): 4¹⁵⁄₁₆″ (12.5cm) 71.1144

HISTORY: Purchased from Adolph Loewi, Los Angeles, 1962.

BIB.: R. Berliner, "Horsemen in Tapestry Roundels Found in Egypt," *Textile Museum Journal*, I, 2, Dec. 1963, 44, fig. 9; W. F. Volbach, "Zur Ikonographie des Styliten Symeon des Jungeren," *Tortulae*, XXX, supplement 1966, 299, pl. 76; D. G. Shepherd, "Alexander—the Victorious Emperor," *Cleveland Museum Bulletin*, Oct. 1971, 245–250.

See also colorplate 48

177. FEMALE FIGURE

Bone statuette. Egyptian (Hellenistic style), 7th–8th century

The figure of a poorly proportioned nude female against a tree is carved in the round. She is possibly Aphrodite. A drilled hole, apparently for attachment, passes through her mass of wavy hair. The figure has been broken in several parts and repaired.

H: 3⁷⁄₁₆″ (8.8cm) 71.478

HISTORY: Purchased from Dikran Kelekian, Paris, 1929.

BIB.: Weitzmann, *Ivories and Steatites*, 10, pl. 3, fig. 2.

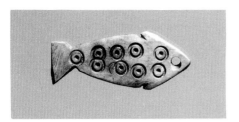

172

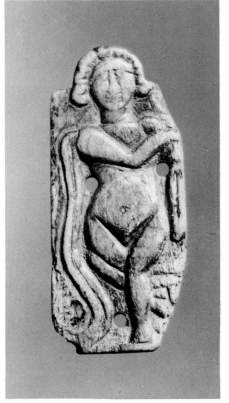

173

174

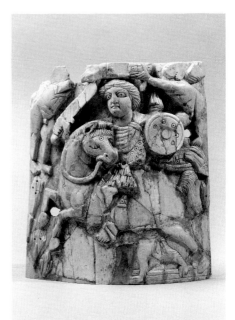

176

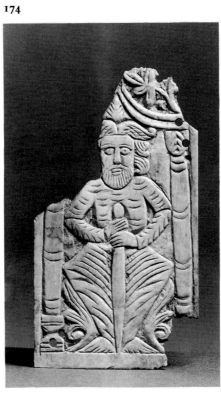

175

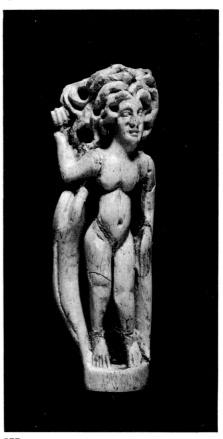

177

178. FIGURES, PLANTS, AND FISH

Pair of ivory bracelets. Egyptian (Coptic style), 7th century or later

Both bracelets are carved in low relief around the outer circumferences; one shows crosses and human figures separated by stylized plants; the second shows fish between small panels of crosses, stars, and incised patterns. Both pieces are cracked.

No exact stylistic parallels have been found.

D (of each): 3⅞" (9.8cm) 71.1128–1129

HISTORY: Purchased from the estate of Dikran Kelekian, New York, 1951.

179. WOMAN

Ivory plaque. Egyptian (Coptic style), 8th century

The female figure walks to the left carrying a staff over her shoulder. Although the top of her head has been damaged, it is evident that either the hair is highly stylized or she is wearing a wig. The base is treated with file marks.

H: 3¾" (9.5cm) 71.1101

HISTORY: Collection of Henry Walters before 1931; Mrs. Henry Walters; Brummer Gallery, New York; gift of Mr. and Mrs. Nelson Gutman, 1942.

180. VIRGIN AND CHILD ("ELEOUSA")

Ivory relief. Egyptian (Coptic style), late 9th–early 10th century

This half-round relief carved from the base of a tusk represents the Virgin and Child enthroned between angels. She holds the Christ Child in her arms, embracing him, as she presses his cheek to hers. Her position is not frontal but turned slightly to her right.

There is an original ivory plug over the Virgin's right eye, and a number of holes for attachment. The base has been cut off above the hemline, and the angel on the left is severely chipped. While the top of the right-hand angel's head is incomplete and appears to be cut down, the surface engraving of leaves on the top indicates that the piece was made in its present form. Above the Virgin's head is a rectangular attachment hole. The entire surface has been stained a reddish brown.

The ivory can be dated to the late ninth–early tenth century on the basis of comparisons with miniatures in Coptic manuscripts. It stands as the earliest example of the Eleousa, or Virgin of Tenderness. The iconography is thought by some to have been known in Byzantium. More recent scholarship suggests that the Eleousa concept originated in Egypt (see M. Werner, Bib.). A Virgin Hodegetria in the Castello Sforzesco, Milan, is carved in the same manner and is probably from the same workshop (Wessel, *Christentum am Nil*, no. 35).

Dated manuscripts that show the same unclassical and stylized drapery are Morgan Library M. 612, dated 895 or 898 (*Pagan and Christian Egypt*, no. 13); Morgan M. 577, dated 895, and Morgan M. 609, dated 903

(Weitzmann, "An Early Coptic Miniature in Leningrad," *Ars Islamica*, X, 1953, figs. 17 and 18).

H: 10¼" (26.0cm) 71.297

HISTORY: Collection of Pierre Leven (sale, Cologne, 1853); M. B. Myers (sale, Paris, Nov. 28, 1877); Garthe (sale, 1877); von Hirsch and Gereuth, 1878; Michel Boy (sale, Paris, May 15–24, 1905, lot 240); owned in Paris, 1912; purchased in Amsterdam before 1931.

BIB.: Aus'm Weerth, *Fundgraben der Kunst und Ikonographie in den Elfenbeinarbeiten*, Bonn, 1912, pl. 16; A. Goldschmidt, "Exhibition of the Art of the Dark Ages at the Worcester Art Museum," *Parnassus*, IX, no. 3, March 1937, 28; D. Bryan, "Pagans and Christians in the Twilight of Egyptian Art," *Art News*, XL, no. 3, Mar. 1941, 9; *The Dark Ages*, Worcester Art Museum, Feb.–Mar. 1937, 61; *Pagan and Christian Egypt*, no. 108; S. der Nersessian, "Pagan and Christian Art in Egypt," *Art Bulletin*, XXIII, no. 2, June 1941, 167; S. Poglayen-Neuall, "Eine Frühe Darstellung der Eleousa," *Orientalis Christiana Periodica*, VII, 1941, 293–294; Volbach, no. 254; C. F. Battiscombe, *The Relics of St. Cuthbert*, Durham, 1956, pl. 13, fig. 2; *Koptische Kunst*, Villa Hugel, Essen, 1963, no. 136; *Koptische Kunst*, Kunsthaus, Zurich, 1963, no. 117; *L'art copte*, Petit Palais, Paris, 1964, no. 89; K. Wessel, *Koptische Kunst der Spätantike in Aegypten*, Recklinghausen, 1963, 36, 127, 129–130, fig. 36; Beckwith, *Coptic Sculpture*, fig. 133; G. Vorbrodt, "Das ottonische Figurenkapitell in Gernrode," *Die Mitte*, fasc. 2, 1966, 194; Verdier, *Art International*, no. 3, fig. 1; F. Rademacher, *Die Regina Angelorum*, Dusseldorf, 1972, fig. 44, 52; M. Werner, "The Madonna and Child Miniature in the Book of Kells," *Art Bulletin*, March 1972, fig. 4; S. der Nersessian, *Byzantine and Armenian Studies*, I, Louvain, 1973, 197; K. Kolb, *Marien-Gnadenbilder*, Würzburg, 1976, 56–57; Zastrow, no. 17; Schiller, IV, no. 2, 24.

See also colorplate 50

178 **178**

179

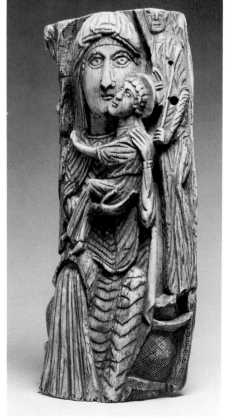

180

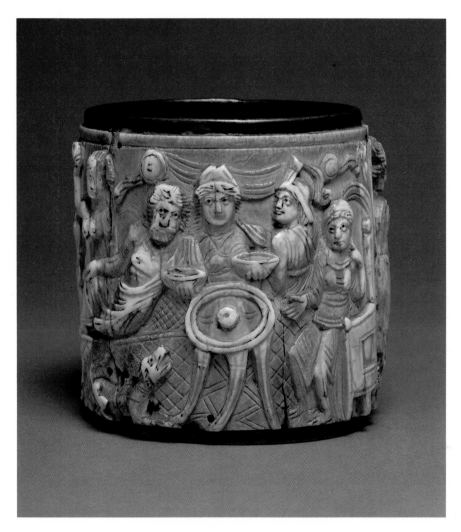

Colorplate 41 (cat. no. 170). Round pyxis with the Apple of the Hesperides, ivory, Egyptian (Hellenistic style), early 6th century. The first scene depicts the Banquet of the Gods; the gods recline on couches in front of a table holding the Apple of the Hesperides. In the second, Hermes is seen awarding the Apple to Aphrodite, who is accompanied by Hera and Athena in her armor.

Colorplate 42 (cat. no. 142). Bone plaque with a female figure, Egyptian (Coptic style), 4th–5th century. The figure with her flying drapery floats on either waves or clouds. The subject was repeated on many bone border strips from boxes or chests, and other examples may be seen in catalogue nos. 148 and 149.

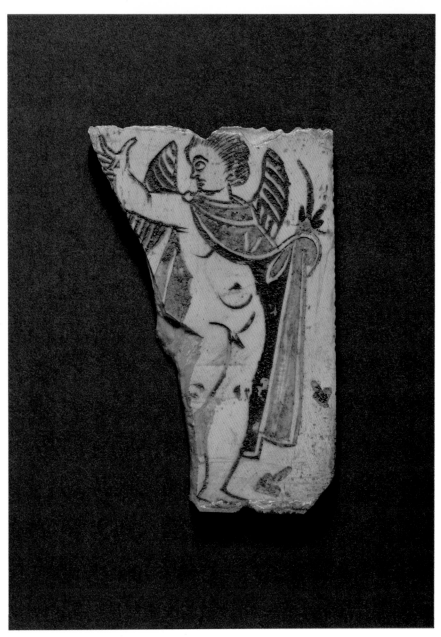

Colorplate 43 (cat. no. 134). Plaque with putto, bone, Egyptian (Hellenistic style), 4th century. The figure is carved in intaglio and inlaid with unusually well-preserved red and green wax.

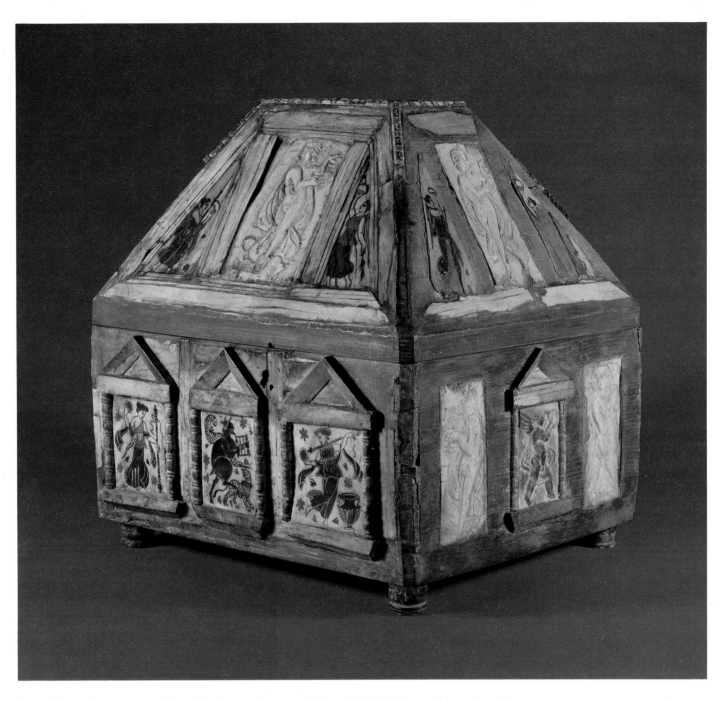

Colorplate 44 (cat. no. 135). Box with dancers, Erotes, and faun, inlaid with bone and wax, Egyptian (Hellenistic style), 4th–5th century. Furniture, boxes, and funeral beds were commonly inlaid with bone or ivory in Egypt, but very few have survived intact. This box is a reconstruction of an almost complete ensemble. It shows an interesting combination of carved relief panels alternating with wax inlaid panels. The subjects all concern dancing and include maenads, a faun, winged figures, and male and female dancers.

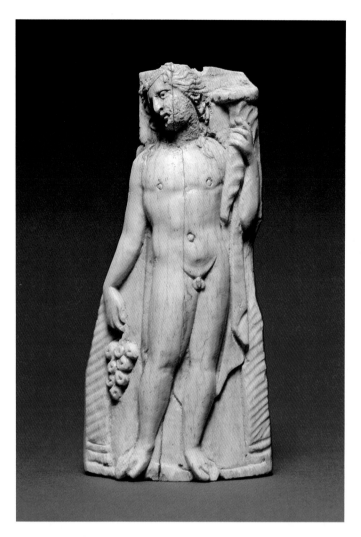

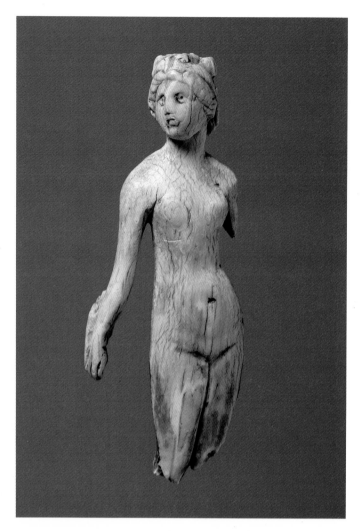

Colorplate 45 (cat. no. 120). Plaque with Bacchus, bone, Egyptian (Hellenistic style), 3rd–4th century. This is a typical furniture mount carved with a classical nude, Bacchus holding a bunch of grapes and a cornucopia. It shows a thorough knowledge of the classical repertoire, and is more finely finished than many works of the time.

Colorplate 46 (cat. no. 157). Plaque with nude female, bone, Egyptian (Hellenistic style), 5th century. The great majority of carved work found in Egypt is made of animal bone rather than ivory. The bone is finely carved and polished and consequently the two materials are almost indistinguishable. The more expensive pieces were made of ivory.

OPPOSITE:

Colorplate 47 (cat. nos. 164 and 165). Plaques with female and male figures, stained bone, Egyptian (Coptic style), 5th–6th century. An unusually large pair of carved furniture mounts from the same object but in different colors. The male figure has been heated, and perhaps smoked, to acquire a gray or putty color; the female figure has been dyed a buff color. No furniture with multicolored decoration has survived intact.

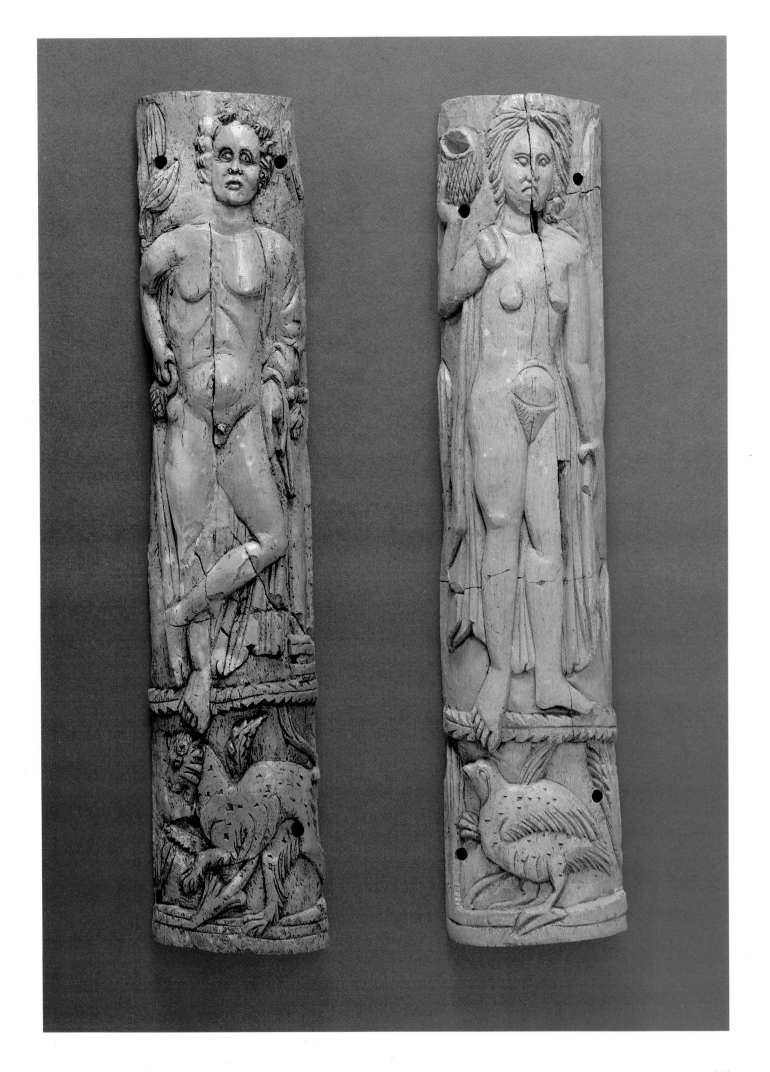

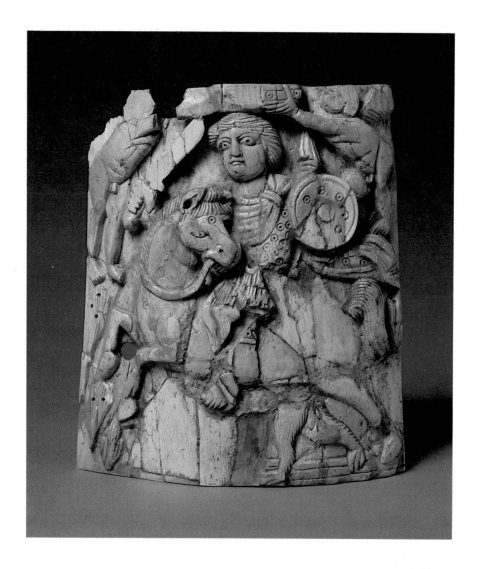

Colorplate 48 (cat. no. 176). Relief with victorious emperor–hunter, ivory, Egyptian (Coptic style), second half 7th century. The subject of an emperor–hunter being crowned by genii after a hunt appears in a number of Egyptian works. In deriving his design from a Byzantine textile, the ivory carver made modest mistakes in interpretation, omitting the rider's boots, or sandals, and the part of the horse's harness that sustains its forehead ornament.

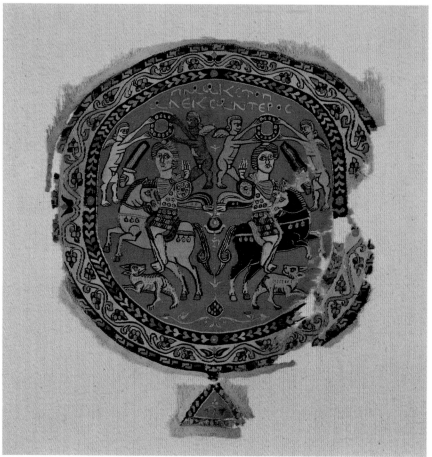

Colorplate 49. Textile with Alexander the Great as a victorious hunter, tapestry, Egyptian (Coptic style), second half 7th century. The textile follows the same design source as the ivory (cat. no. 176), and incorporates some of the same errors, such as the circle on the horse's forehead and the bootless rider. The inscription in the sky identifies the rider as "Alexander the Macedon." Textile Museum, Washington, D.C.

OPPOSITE:

Colorplate 50 (cat. no. 180). Plaque with Virgin and Child ("Eleousa"), ivory, Egyptian (Coptic style), late 9th–early 10th century. This large ivory is the earliest surviving representation of a new humanitarian concept of the Virgin expressing her love for the Christ Child. This interpretation of mother and child became one of the most popular iconographies for the Virgin in succeeding centuries.

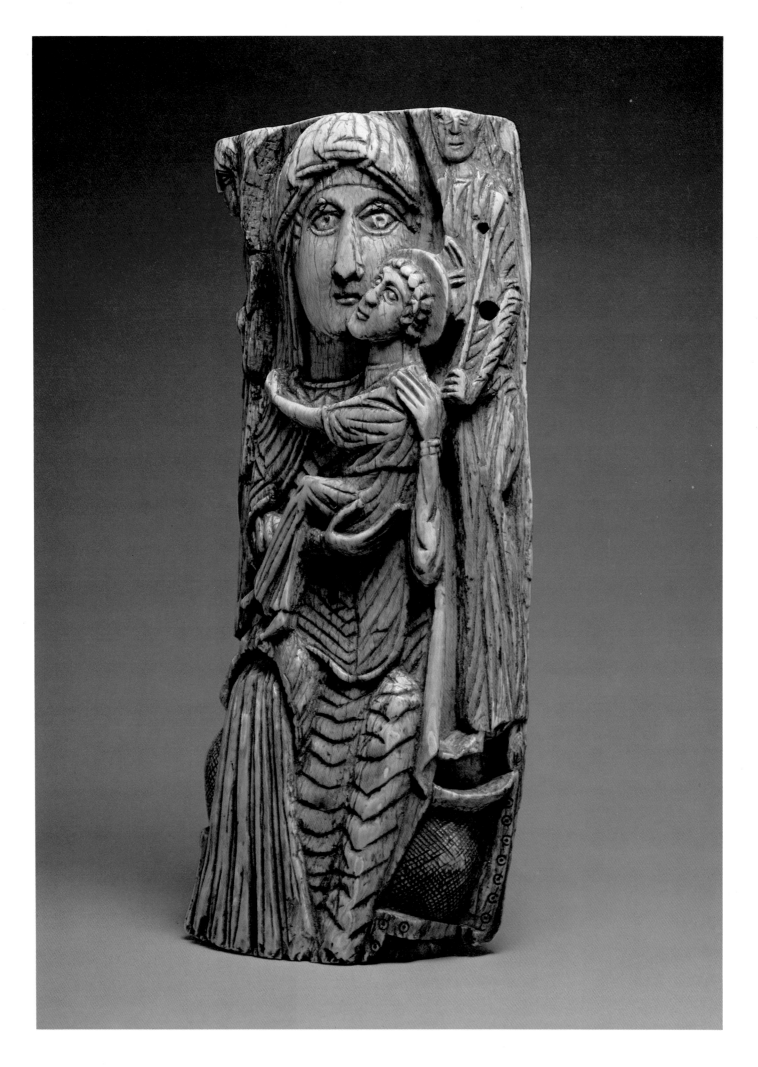

Colorplate 51 (cat. no. 181). Fragment of a consular diptych, ivory, Roman, 460–470. The diptych leaf is closely related to an example found at Ostia inscribed with the name C. L. Severus. This example has been cut down and the name of the individual for whom it was made is thus lost. The back is recessed for wax, the original intent of diptychs being to bear honorific inscriptions. It was donated to a church as early as the sixth century, according to an uncial inscription on the reverse.

5 Consular Diptychs

by Richard H. Randall, Jr.

THE ROMANS considered ivory an appropriate material for presents of great importance. As early as 84 A.D. the poet Martial, in his *Apophoreta*, wrote of "gifts of wooden and ivory books."[1] He was apparently alluding to the large ivory-and-wood diptychs that were inlaid with wax on one side for inscribing appropriate messages. These diptychs were used for various purposes: for commemorating triumphs, honoring the emperor, or displaying a pair of gods. All were of considerable size and of the finest workmanship. One of the most beautiful pairs of diptych wings, now divided between the Victoria and Albert Museum, London, and the Musée de Cluny, Paris, is carved with two classical women in profile in a fine Roman understanding of the Hellenistic style. The wings bear the names of two great families—the Nicomachi and the Symmachi—and probably commemorate a wedding between the two families.[2]

Many diptychs have survived, but the special class of consular diptychs has particular significance in the history of ivory carving. From the beginning of the fifth century, diptychs carved with the consular images and/or inscriptions were distributed upon the consul's elevation to office. In the case of the consul Areobindus, for example, who took office in 506, six consular diptychs or parts of diptychs have survived.[3] The diptychs are of varying subject matter and quality, apparently graded for their recipients, and, as their survival in various parts of Europe indicates, were distributed far and wide in the empire. The series of preserved consular diptychs commences with that of Probus of 406 in the treasury of the Cathedral of Aosta and ends with that of Basileus in 541, the year the consulate was abolished. The group offers a remarkably full picture of stylistic change during that period and is one of the most complete datable series in the history of ivory.

Numerous diptychs have been preserved because they were later donated to churches, where they were used to record appropriate events. A typical example is a diptych of Flavius Anastasius, who was appointed consul in Constantinople in 517. Half of the diptych is in the Victo-

Figure 21. Leaf of a consular diptych of Flavius Anastasius, ivory, Constantinople, 517. The consul is shown with the symbols of his office: the curule chair, the scepter, and the *mappa circensis*, which was ceremonially dropped to signal the start of the circus games. Above him are the busts of the emperor, the empress, and the second consul, and below his feet are scenes of some of the games. Victoria and Albert Museum, London.

ria and Albert Museum (the other half was destroyed in Berlin during World War II), and shows the consul seated on his curule chair, holding a scepter and the *mappa circensis*, used to signal the start of the circus games (figure 21). The games themselves are shown below the figure of the consul; above and to the right of him are the heads of the emperor and empress—Anastasius and Ariadne—and to the left the head of the second consul.

Nearly identical leaves of other diptychs of Flavius Anastasius are in the collections of the Cabinet des Médailles, Paris, and the Biblioteca Capitolare, Verona.[4] The Victoria and Albert example is inscribed on the back with the names of saints and persons important to the church where the ivory was dedicated as early as the seventh century. One of these inscriptions is IGISI, probably the Bishop Ebregisi of Tongres in Belgium, which fits with the early history of the ivory in Liège.

Because of their political importance and high quality as works of art, consular diptychs exercised considerable influence on artists of the empire. In North Africa the designs of diptychs were cast in terra-cotta trays that probably served some purpose related to presentations.[5] In Spain, at San Miguel de Lillo, one of the diptychs of Areobindus, now in Paris, was used as the source of design for two stone monoliths by Asturian carvers in the ninth century.[6]

The fragment of a diptych in the Walters Collection (cat. no. 181; see colorplate 51) is not definitely identified as a consular diptych, although it has been so published by Marvin Ross and Wolfgang Volbach.[7] Because it has been cut off at the top, and broken at the bottom, any inscription that might have been over the head of the figure is lost. The drapery suggests that the figure was seated, and, as in the Flavius Anastasius leaf, a scene may therefore have appeared below its feet. The Walters panel later served a Christian liturgical function, and bears a sixth-century uncial inscription: MARCELLIN(US) MARTYR, commemorating a priest who was martyred in the fourth century.

A diptych closely related to Walters catalogue no. 181 bearing the name of C. L. Severus was found at Ostia. It is complete and has an interestingly shaped terminal at the top.[8] Precisely this form of diptych is shown in the hands of the Walters figure, the only example of a diptych leaf figure holding a diptych. The diptychs are both dated after 450, perhaps 460–470.

Since almost all consular diptychs can be accurately dated, they provide a bridge in the history of art. The majority of examples of the fifth century were made in Rome while, with one exception, those of the sixth century were carved in Byzantium. The diptych of the consul Orestes made in Rome in 530 uses a design very similar to the diptych of Magnus made at Constantinople in 518.[9] From that time on, the styles of the two capitals followed different courses. The iconographic and stylistic influence of Byzantium, however, remained extremely important to the development of Western European art.

NOTES

1. A. Maskell, *Ivories*, London, 1905, 71.
2. Volbach, *Spätantike*, no. 55.
3. Richard Delbrueck, *Die Consulardiptychen*, Berlin, 1929, nos. 9–15.
4. Delbrueck, nos. 19, 21.
5. J. W. Salmonson, "Kunstgeschichtliche und ikonographische Untersuchungen zu einem Tonfragment der Sammlung Benaki in Athens," *Bulletin Antike Beschaving*, XLVIII, 1944, 5–82.
6. Zodiaque, *L'art preroman hispanique*, Pierre-Qui-Vire, France, 1973, figs. 117 and 118.
7. M. C. Ross, "Fragment of a Consular Diptych," *AJA*, XLIX, 49, 19, no. 4, 1945, 449–451; Volbach, *Spätantike*, no. 37.
8. Delbrueck, no. 65a.
9. Delbrueck, nos. 22, 32.

181. FIGURE OF A MAN

Ivory leaf of a diptych. Roman, 460–470

The figure of a man (consul?) sits beneath a low arch with brickwork, between two columns with stylized Corinthian capitals. He is bareheaded, wears a tunic and pallium, and holds in his hand what appears to be a crested diptych.

The back is recessed to receive wax for inscriptions. This piece has been roughly incised with irregular lines and bears several inscriptions in ink. The plaque has been cut down at the top, where there is no surround on the reverse. It is broken in a jagged line across the bottom, and is missing the right upper corner. There is one hole and half of a second hole on the right side for hinging, showing that it is the rear leaf of a diptych.

One inscription reads in sixth-century uncial: MARCELLIN(US) MARTYR, probably referring to the priest Marcellinus of the fourth century. Other writing in Merovingian minuscule shows its continued use for commemorations in a church.

There is a question of its being a consular diptych since the man has no symbols of office but holds a diptych, which is unusual. The half-diptych found at Ostia (Delbrueck, no. 65a) is very similar in style and indicates that the Walters piece, when complete, may have had an inscribed band with the name above the figure and perhaps a shaped terminal at the top. Because the man appears, from the drapery on his left side, to be seated, the plaque may have had a scene below his feet.

The diptych of imperial priests in the Louvre (Delbrueck, no. 57) shows a similar fold of drapery in a seated figure, and the diptych with the stags in the arena in Liverpool (Delbrueck, no. 58) shows seated figures without chairs or backgrounds.

Close in style to this diptych leaf and the one at Ostia is a series of figures from North African terra-cotta reliefs, published by J. W. Salomonson (see Bib.). They include a fragment with a seated figure in the Benaki Museum, a fragment of a presentation dish in Cairo, and two figures from a bottle in a private collection. The drapery in this group is very similar to the Walters diptych, as are the hairstyle, the stylization of the capitals, and the low arch. The entire African terra-cotta group seems to have been based on consular diptychs.

H: 4¹⁄₁₆″ (10.2cm) × W: 3⅜″ (8.5cm)

71.304

HISTORY: Purchased in New York, 1925.

BIB.: M. C. Ross, "Fragment of a Consular Diptych," *AJA*, XLIX, no. 4, 449–451; *Byzantine Art*, no. 100; Volbach, *Spätantike*, no. 37; J.W. Salomonson, "Kunstgeschichte und ikonographische Untersuchungen zu einer Tonfragment der Sammlung Benaki in Athen," *Bulletin Antike Beschaving*, XLVIII, 5–82, figs. 14, 16, 17a, b, 18.

See also colorplate 51

6 Middle and Late Byzantine Ivories

by Richard H. Randall, Jr.

A GREAT REVIVAL of learning and artistic production occurred in the Byzantine Empire in the ninth century, reaching its apogee under the emperor Constantine VII Porphyrogenitus in the mid-tenth century. Constantine himself was a great scholar, who wrote books, copied texts, and painted miniatures. He was also a significant teacher. He developed the court school where talented artists were trained in many areas, founding a tradition of excellence that continued long after his death in 959.

The tenth-century style is well illustrated by the triptych with the Virgin and Saints (cat. no. 182; see colorplate 52), formerly in the pilgrimage church of Altötting, Upper Bavaria. The central panel is the image of the Virgin Hodegetria, in which the Virgin and Child are shown frontally, the Child making the teaching gesture with his right hand. While the pose is formal and hieratic, the carving emphasizes the plasticity of the figures, particularly in the rendering of the Child's head and knee. It is evident that the artist was in total command of his technique and of the shallow space of the ivory; he has presented a strong and convincing classical image. The wings with four saints suffer by comparison and may have been the work of a lesser hand.

By contrast, a Crucifixion panel of the late tenth to early eleventh century departs from the classical proportions of the serene Virgin of Altötting, expressing a new spirit (cat. no. 194; see colorplate 53). The faces have greater individuality, with their large noses and ears, and the surface treatment is more nervous and linear than in the earlier work. There is a psychological relationship among the figures not seen in earlier Crucifixions, for example, catalogue no. 190, which is a simple classical statement of Christ's triumph over death. The later ivory was also the center of a triptych, and its wings, preserved in the British Museum, contain saints of a very individual and more personalized nature than those of the Altötting work (figure 22).

At the same time another Byzantine atelier created works like the Veroli Casket in the Victoria and Albert Museum[1] and the closely related box in the Walters (cat.

no. 200; see colorplate 54), which has scenes of putti playing and dancing. A number of the figures from the two works are interchangeable—for instance, the putto riding a sea horse—although the Walters box is slightly less refined in quality. It is made of bone instead of ivory, and has suffered from use. The putti are direct descendants of the classical Roman putti on catalogue nos. 71 and 72, but are more informal in their cavorting in the dances and war games.

The boxes were made in an atelier that turned out long strips of border ornament, some with rosettes only and some with rosettes alternating with profile heads. When a box was to be assembled the strips were cut to size with complete disregard for the pattern, resulting, in spite of the quality of the panels and borders, in a case of slight disarray. In a second casket from the Rosette Group in the Walters, this one showing scenes of the lives of Adam and Eve, the same technique was used for the flat sides (cat. no. 201; figure 23). On the truncated pyramidal roof, however, the borders of profile heads had to be made to fit the angles at the corners, and so were made the correct length and shape for the box.

The Adam and Eve casket, produced for an everyday customer, allows comparison with a work of higher quality. The scene of the Sorrowing Adam, seated on a basket with head in hand, even in its worn state can be seen to be inferior to the similar figure of Adam from another casket, shown in colorplate 55 (cat. no. 202). Other plaques from this second casket showing scenes of Adam and Eve are preserved in the Metropolitan Museum and the British Museum and confirm the quality of the work.[2] The plaques have been dated by Adolph Goldschmidt and other writers to the twelfth century, demonstrating the continued vitality of Byzantine work into the twelfth century under the rule of the Comnenian Dynasty.[3]

The Byzantine Empire at its greatest extent included all the territory of Turkey, Armenia, Syria, the kingdom of Georgia in what is now south Russia, Greece, and the Balkans. Because of a series of disastrous wars that started in the tenth century, the boundaries of the empire were

gradually reduced. However, from a cultural point of view, the style of Byzantium prevailed in all these lands, and was influential in areas like the Near East and Italy.

While the highest quality work has always been attributed to Constantinople and the court, work that may have been done in other parts of the empire remains difficult to identify. Many works were undoubtedly carried out in Europe, some, perhaps, by craftsmen trained in Constantinople. There are indications, for instance, that the Byzantine princess Theophano may have brought works of art and artists with her to Germany when she married the German emperor Otto II in 972. An ivory of the Dormition of the Virgin in the Walters Collection (cat. no. 192) is a puzzling piece and contains unusual features such as the triangular heads of the Apostles and the swaying drapery of one of them, which relate it to Ottonian art. The question remains, is this a German copy of a Byzantine model or the creation of a Byzantine artist in the West?

Pieces like the Last Judgment relief in the Victoria and Albert Museum[4] have been attributed to Venice for iconographical reasons, though the work is of the highest Byzantine quality. Others, like the Nativity plaque (cat. no. 197; see colorplate 56), treat subjects in an unusual way and are thought to have been made by non-Byzantine craftsmen. Italy has been suggested as the place of origin for this scene and a closely related one in the Victoria and Albert Museum. In both panels, the Annunciation to the Shepherds is divided into two registers: an angel looks out of the composition in the upper register; and, lower down, a shepherd observes the Virgin and Child. The shepherd in the Walters example is rather out of scale. In addition, the Child is being bathed in the lower area or foreground of the scene, observed by Joseph. These elements and other aspects of style do not seem truly Byzantine. On the other hand, the two ivories do not relate to any other work that can be tied to a specific Italian center.

Figure 23 (cat. no. 201). Detail of a plaque of the Sorrowing Adam, ivory, Byzantine, 11th–12th century. The figure is from a panel located beneath the lock plate on a rectangular casket showing scenes of the life of Adam and Eve. The subject is taken from the statue of Herakles by the great Greek sculptor Lysippos, which stood in the center of the Hippodrome in Constantinople and was reinterpreted by the Christian population as "Adam." Compare with catalogue no. 202 (colorplate 55).

The plaque with the Nativity and Adoration of the Magi (cat. no. 196) presents a similar problem, and has also been tentatively attributed to Italy. Here once more are unusual features of scale and placement of the figures. There are three other related ivories with similar borders and nervous compositions—one in Ravenna and two in Leningrad—but again no center suggests itself.[5] There is also little knowledge of what was being produced in other sections of the Byzantine Empire, for example, in Greece and the Balkans.

One eleventh-century ivory can be localized in the kingdom of Georgia, however, on the basis of the orthography of the letter *A* in the inscription. This is a panel from a box with two large half-figures of Saints George and John Chrysostom (cat. no. 198; see colorplate 57). It is unusual to have figures of such scale, and while they are somewhat schematized, the carving is of good quality. Two book-cover panels of standing saints in the Morgan Library (Glazier Collection), New York,[6] appear to be from the same atelier.

After the fall of the Byzantine Empire in 1453, the Byzantine style continued in the old provinces of the empire for several centuries. In monastic centers in the Near East, in Greece, Russia, and as far afield as Ethiopia, icons, miniature altars, and reliquary crosses in wood and bone were produced as late as the seventeenth and eighteenth centuries. Some of the finest of this work has been attributed to the monastery of Mount Athos in Greece. One of these small works, in bone, is a seventeenth-century panaghiarion, or container for the Host, which is worn by a priest around his neck, and, when opened, used as a tray for the wafer (cat. no. 210; see colorplate 58). It is finely carved with the three angels who were feasted by Abraham,[7] a subject that is repeated on a number of examples (e.g., cat. nos. 208 and 211). The figures have become long and thin with elongated heads, and the drapery folds are schematized with pairs of parallel lines.

Many objects in the same style as the panaghiarions have small-scale carving in wood, bone, and ivory. All of them have Slavonic inscriptions, and appear to have been produced at the Russico Monastery at Mount Athos. Russian rather than Greek in style, they relate to works actually made in Russia during the seventeenth century.

NOTES

1. J. Beckwith, *The Veroli Casket*, London, 1962, 19.

2. Goldschmidt and Weitzmann, I, nos. 89, 91–93.

3. Goldschmidt and Weitzmann, I, nos. 89–93.

4. Gaborit-Chopin, no. 187.

5. Goldschmidt and Weitzmann, II, 201–203.

6. Goldschmidt, IV, no. 286.

7. Genesis, 18.

Catalogue, Middle and Late Byzantine Ivories

182. THE VIRGIN AND CHILD WITH SAINTS (VIRGIN HODEGETRIA)

Ivory triptych. Byzantine, second half 10th century

The central panel shows the half-length Virgin and Child in frontal position, the Child making the gesture of teaching (Virgin Hodegetria). The figures are set beneath a pierced canopy supported by two spiral columns.

Each wing of the triptych shows a full-length saint with the bust of a second saint above. Tradition suggests that they are Saint Demetrios, on the left, with Saint Prokopios above, and Saint George(?) on the right, with Saint Nicholas above. The reverse sides of the wings are carved with foliate crosses in relief.

The ivory belongs to the Nicephoros Group, so called from a datable reliquary inscribed to the emperor Nicephoros II Phocas (963–969). A number of examples are closely related, including the triptych wing in the Berlin Museum (Goldschmidt and Weitzmann, II, no. 120) and the triptych mounted as a book cover in Stuttgart (Goldschmidt and Weitzmann, II, no. 87).

The central panel is drilled with six holes in the top border and four later hinge sockets at the sides. There is minor chipping in the canopy. Both wings have cut upper corners, a cut in the middle of one side, and all three pieces have been trimmed of the raised lower border.

Central section. H: 4¾″ (12.1cm) × w: 4⁹⁄₁₆″ (11.6cm)
Wings. H: 4¼″ (10.8cm) × w: 2³⁄₁₆″ (5.6cm)
71.158

HISTORY: The triptych was in the treasury of the pilgrimage church of Altötting, upper Bavaria. A facsimile of it is shown at Altötting in a frame inscribed "Ex voto Henricus Episcopus Passairensis, A.D. 1867," indicating it was a gift of Henry II, bishop of Passau in that year. It was published as being at Altötting in 1905, and passed out of the treasury before 1929, when it was purchased in Paris from Tycon and Smith.

BIB.: Goldschmidt and Weitzmann, II, no. 84; *Byzantine Art*, no. 124; Diehl, *Byzantium: Greatness and Decline*, New Brunswick, 1957, 254; Verdier, *Art International*, VII, no. 3, 29; idem, "The Riches of Byzantium," *Apollo*, LXXIV, no. 58, no. 8, 41; B. Riehl, *Die Kunstdenkmäler*, I, part 3, 1905, 2375, pl. 274.

See also colorplate 52

183. CRUCIFIXION WITH THE VIRGIN AND JOHN

Central panel of an ivory triptych. Byzantine, second half 10th century

The plaque was originally the center of a triptych belonging to the series of ivories called the Nicephoros Group, named for the emperor Nicephoros II Phocas. The style of the group, however, began before and lasted beyond his reign. Christ is shown dead on the cross with bowed head and closed eyes, a type introduced in Byzantium as early as the eighth century (Schiller, II, 330). This type also appears in a few Carolingian ivories of the ninth century. The Nicephoros Group adopted this type in numerous examples.

The Walters ivory is very close to two other plaques, one in Hildesheim and one in Naples (Goldschmidt and Weitzmann, II, no. 106 and 107). It resembles the Hildesheim plaque in the drapery, in Christ's facial features, and in the rendering of the hair. The Hildesheim plaque is of special interest because it was used to decorate the binding of the small Gospel book of Archbishop Bernward, and therefore can be dated before 1022. The Walters plaque resembles the Naples piece in its treatment of Christ's body and in the elongated proportions of the figures.

There are holes for attachment and suspension in the borders.

H: 5¼″ (13.5cm) × w: 4³⁄₁₆″ (10.6cm)
71.113

HISTORY: Acquired in 1924.

BIB.: *Byzantine Art*, no. 133; *A Medieval Treasury*, White Museum of Art, Cornell University, Ithaca, New York, 1968, no. 12.

184. AN ANGEL AND THREE SAINTS

Right wing of an ivory triptych. Byzantine, late 10th century

This piece and catalogue no. 185 formed the wings of a triptych, the center of which probably depicted the Crucifixion. It represents an archangel, Saint Peter(?), and two young saints with wounds—Theodore, or Procopios, and Demetrios(?). The reverse is carved with a cross. The style is that of the Triptych Group.

The panel is cracked in several places, and the nose of the bottom figure has been broken and filled. There is later cross-hatching on the back.

H: 6⅜″ (16.1cm) × w: 2¹⁄₁₆″ (5.3cm)
71.159

HISTORY: Collection of Victor Gay (sale, Paris, Mar. 23, 1909, lot 80); Gaston le Breton, Rouen (sale, Paris, Dec. 6–8, 1921, lot 193); purchased in Paris, 1926.

BIB.: Goldschmidt and Weitzmann, II, no. 185; *Byzantine Art*, no. 146.

185. AN ANGEL AND THREE SAINTS

Left wing of an ivory triptych. Byzantine, late 10th century

This piece and catalogue no. 184 formed the wings of a triptych. The archangel surmounts three saints tentatively identified as Paul, Anthony Abbot (or Theodore with wound), and Stephen (or George). On the back is a cross. The style is related to the Triptych Group.

This piece is slightly darker in color than catalogue no. 184, owing to the application of varnish at a later time. There are pinholes in the corners and a crack in the lower left.

H: 6⁷⁄₁₆″ (16.4cm) × w: 2⅛″ (5.5cm)
71.67

HISTORY: Collection of Count Gregorii Stroganoff, Rome; purchased in Paris, 1926.

BIB.: Goldschmidt and Weitzmann, II, no. 184; *Byzantine Art*, no. 146.

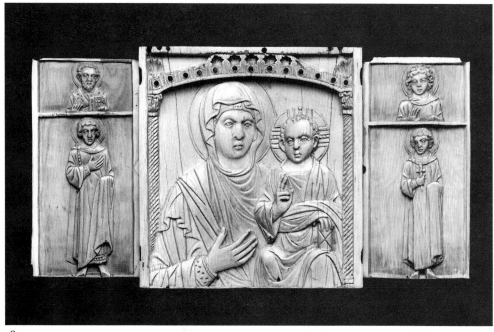

182

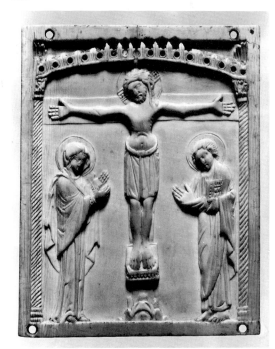

183

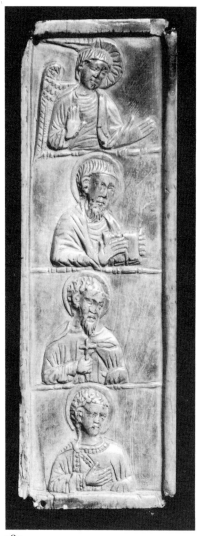

185

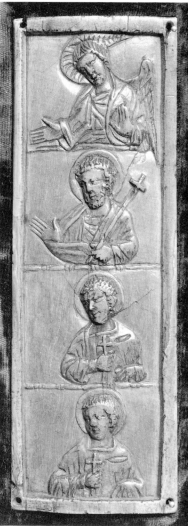

184

186. SIX SAINTS

Pair of wings of an ivory triptych. Byzantine, late 10th century

Each wing has three saints: a bishop saint at the top, identified by the crosses on his *maphorion*, and two unidentified deacon saints below. The wings are made to overlap when closed. The backs are carved with a cross. The style is related to the Triptych Group. There are later holes in each wing for attachment.

H (each): 3⅛″ (8.0cm) × W: 1⅜″ (3.5cm)
71.161–162

HISTORY: Purchased in 1924.

BIB.: *Byzantine Art*, no. 147.

187. FOUR SAINTS

Right wing of an ivory triptych. Byzantine, late 10th century

This wing of a triptych shows John the Baptist and a saint, possibly Peter, in the upper register, and two youthful saints below, possibly Demetrios and George. The matching wing is in the Hermitage (Goldschmidt and Weitzmann, II, no. 135) and portrays Saints Paul and Mary above two youthful saints. The central panel would have shown the Deesis.

The wing belongs to the Triptych Group and is related in style to catalogue no. 194. There are holes for hinges in the left border, and later pinholes in the ground. The surface is irregularly stained.

H: 5⁵⁄₁₆″(12.9cm) × W: 2³⁄₁₆″ (5.5cm)
71.160

HISTORY: Acquired in 1926.

BIB.: *Byzantine Art*, no. 145.

188. CRUCIFIXION WITH THE VIRGIN AND JOHN

Central panel of an ivory triptych. Byzantine (Europe?), late 10th century

This piece, which was the center of a triptych, belongs to the Triptych Group of the late tenth century. It can be compared to the panel in Lille (Goldschmidt and Weitzmann, II, no. 162) in the poses and drapery, and in the form of Christ's torso. The type of body, with its hunched shoulders, and the face, with its straight profile and strongly marked nostrils, appear to be a different development of the style seen in catalogue no. 194. A complete triptych of the type is in Liverpool (Goldschmidt and Weitzmann, II, no. 155).

The lower portions of the left and right sides and the upper right corner are broken off. The upper left corner has split and been mended in two places. There are two holes for attachment and one for suspension, and a guideline for a frame is visible on the upper border. Two holes have been bored through the columns of the canopy, the upper molding of which has been broken off. The surface is stained, possibly as a result of polychromy, and there are traces of gilding on the canopy, the halos of Christ and the Virgin, and the Virgin's sleeve.

H: 6¼″ (16.6cm) × W: 4⁹⁄₁₆″ (11.6cm)
71.68

HISTORY: Collection of Godard Desmarais; purchased from Henry Daguerre, Paris, 1925.

BIB.: Goldschmidt and Weitzmann, II, no. 167; *Byzantine Art*, no. 134.

189. VIRGIN AND CHILD

Central panel of an ivory triptych. Byzantine, late 10th century

This small panel is interesting for the manner in which it represents the Virgin and Child. The two are shown in a posture midway between that of the Hodegetria, where Mother and Son stand rigidly frontal, and the Eleousa, where the Virgin bends her head tenderly toward the Child. Here, although the faces do not touch, the Virgin's head is inclined, and the Child's body is turned sideways to face her rather than out toward the viewer.

The first surviving example of the Eleousa type is a Coptic ivory, catalogue no. 180, dating from the late ninth or early tenth century. Although this panel is later, it is still one of the earliest of the type from Byzantium itself. The same iconography is represented on a gem of the twelfth century in the Vatican (W. Volbach, *Museo sacro, l'arte bizantina*, Rome, 1935, pl. 14a).

The technique of the ivory is unusual and rather like that of a gem. The figures stand out in blocklike high relief, and the interior divisions are indicated by sharply incised lines with very little modeling.

There are holes in the borders for attachment and suspension. The back shows an unusual pattern of cracks. The color is a rich brown.

Inscribed in Greek: MͰ(TH)P Θ(EO)Y (*Mother of God*).

H: 3⅛″ (8.0cm) × W: 2⁷⁄₁₆″ (6.1cm)
71.587

HISTORY: Purchased from Dikran Kelekian, Paris, 1926.

BIB.: *Byzantine Art*, no. 129.

190. CRUCIFIXION WITH MARY AND JOHN

Central panel of an ivory triptych. Byzantine, end of 10th century

Some of the details of the drapery, such as the twisted horizontal folds of Christ's *perizonium*, are paralleled in two triptychs in London and Paris (Goldschmidt and Weitzmann, II, nos. 38 and 39), although the body of Christ, with its lack of modeling and prominent hips, is closer to the type of a piece in Hildesheim (Goldschmidt and Weitzmann, II, no. 106). The gesture of John, with the back of the hand showing, is unusual but is to be found in a fragment in Paris (Goldschmidt and Weitzmann, II, no. 231).

There are two cracks, one to the left of Christ and one above the Virgin. A triangle of ground between Christ and the Virgin and a strip about one-half inch wide down the right edge are modern. There are holes for attachment in the borders, and horizontal guidelines for a triptych frame.

Inscribed in Greek: I(ΗΣΟΥ)Σ ΧΡ(ΙΣΤΟΣ) (*Jesus Christ*); MͰ(TH)P Θ(EO)Y (*Mother of God*); Ὁ Ἅ(ΓΙΟΣ) ΙΩΑΝΝΗΣ (*Saint John*).

This panel was questioned by Goldschmidt and Weitzmann because of its physical condition and the unusual gesture of John. It has been published since, however, by Victor Elbern, together with its nineteenth-century copy, as a work of about 1000, belonging to the Triptych Group but with the elegance of the Romanos Group.

H: 6½″ (16.5cm) × W: 4⅝″ (11.7cm)
71.244

HISTORY: Collection of Octave Homberg (sale, Paris, May 16, 1908, lot 463); purchased at the sale through Jacques Seligmann, Paris.

BIB.: G. Migeon, "Collection de M. Octave Homberg," *Les arts*, no. 36, 42, ill. 33; Goldschmidt and Weitzmann, II, no. 227; *Byzantine Art*, no. 136, not ill.; E. Broun, "A Byzantine Crucifixion Triptych," *BWAG*, XXIV, no. 5, 3; V. Elbern, "A Byzantine Ivory Relief and Its Copy," *JWAG*, XXVII/XXVIII, 1964–1965, 45–47.

191. DORMITION OF THE VIRGIN

Central panel of an ivory triptych. Byzantine, about 1000

This plaque of the Nicephoros Group represents the Dormition, or Death, of the Virgin, whose soul is shown in the arms of Christ, with two angels descending to receive it. The composition is common to a large group of ivories that includes a plaque in Breslau (Goldschmidt and Weitzmann, II, no. 112). The closest parallels to the treatment of the hair and the Apostles' drapery are found in the Dormition in Seattle (Goldschmidt and Weitzmann, II, no. 181). The form of the bed, with its legs hidden by the drapery, is rather unusual.

There is a discoloration through the center of the ivory. There are holes in the borders for attachment, as well as diagonal holes in the four corners. The front surface of the border has been planed down.

H: 6¹¹⁄₁₆″ (17.0cm) × W: 5½″ (14.4cm)
71.66

HISTORY: Collection of Paul Cassirer, Berlin; purchased from Henry Daguerre, Paris, 1927.

BIB.: Goldschmidt and Weitzmann, II, no. 109; *Byzantine Art*, no. 141; P. Verdier, "The Riches of Byzantium," *Apollo*, LXXXIV, no. 58, 461.

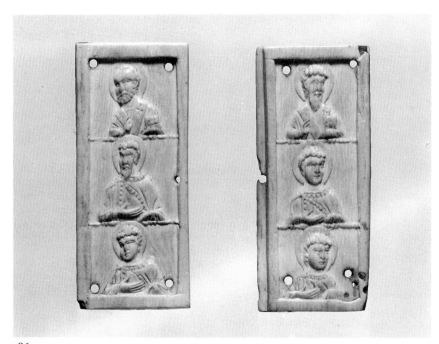

186

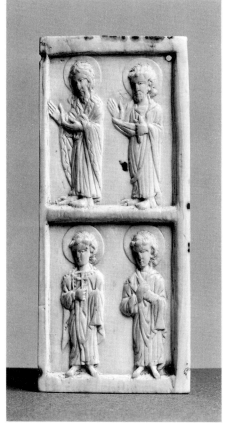

187

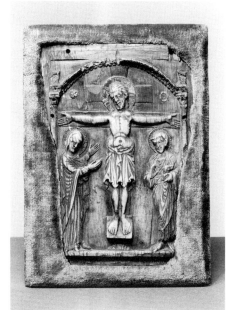

188

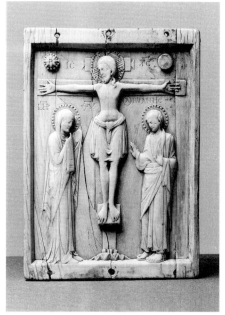

190

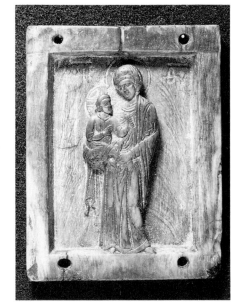

189

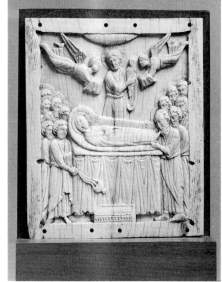

191

192. DORMITION OF THE VIRGIN

Center of an ivory triptych. Byzantine (Ottonian copy?), c. 1000

This plaque represents the same subject as catalogue no 191 except that here the Virgin's soul is shown twice: in the arms of Christ and borne aloft by an angel. The composition and the way in which the Virgin's hands are wrapped in her robes are very close to two pieces in Leningrad and Hanover (Goldschmidt and Weitzmann, II, nos. 175, 177). The treatment of the rest of the Virgin's drapery, however, belongs to the same type as catalogue no. 191.

The heads of the Apostles, with their frontal placement and strongly marked, pointed features, are related to Ottonian ivories, particularly the plaques from the Magdeburg antependium of 970–980. The treatment of the eyes and long noses and the grouping of figures can be compared to the Feeding of the Ten Thousand in the Louvre (Goldschmidt, II, no. 9). The Magdeburg ivories are attributed to Milan. An ivory like the Dormition at Wolfenbüttel of the Triptych Group probably served as the model (Goldschmidt and Weitzmann, II, 176).

The drapery, with swinging folds and fluttering hems of the left front figure, is unusual and finds no Byzantine parallels. It is also rare that Christ's nimbus is shown without a cross.

The panel is cracked in several places and part of the right border has broken off. There are holes for attachment in the borders.

H: 5¼″ (13.7cm) × W: 4⅞″ (12.5cm)
71.135

HISTORY: Purchased from Henry Daguerre, Paris, 1926.

BIB.: Goldschmidt and Weitzmann, II, no. 226; *Byzantine Art*, no. 143, not ill.

193. VIRGIN AND CHILD WITH ANGELS

Central panel of an ivory triptych. Byzantine, mid-11th century

This panel, originally forming the center of a triptych, was probably used later on a book cover. The canopy is similar to that of the Crucifixion panel, catalogue no. 183. The Virgin's elongated proportions resemble a piece in the Metropolitan Museum (Goldschmidt and Weitzmann, II, no. 48), although the Metropolitan figure does not share the slightly hip-shot pose. The style is that of the Romanos Group, so named for the ivory showing the crowning of the emperor Romanos IV and the empress, Eudokia, datable to between 1068 and 1071. The Romanos Group has recently been redated to the mid-eleventh century (I. Kalavrezou-Maxeiner, "Eudokia Mahrembolitissa and the Romanos Ivory," *Dumbarton Oaks Papers*, no. 31. 1977, 305–325).

The front of the panel is stained brown. There are holes for attachment and suspension in the upper and lower borders. Two grotesque faces have been scratched on the background by a later hand.

H: 5½″ (14.0cm) × W: 4¼″ (11.0cm)
71.293

HISTORY: Collection of Gaston le Breton, Rouen (sale, Paris, Dec. 6–8, 1921, lot 194); purchased from Henry Daguerre, Paris, 1923.

BIB.: *Byzantine Art*, no. 128; *The World As Symbol*, Queens College, Flushing, New York, 1959, no. 20.

194. CRUCIFIXION WITH THE VIRGIN AND JOHN

Center of an ivory triptych. Byzantine, late 10th–early 11th century

This Crucifixion originally formed the center of an ivory triptych. The wings to this center panel are in the British Museum. All the figures from the triptych share the same idiosyncratic features: beaklike noses and large ears. They also share a similar treatment of drapery, with flat surfaces marked by grooved folds, and hair, with short, tufted locks. Elizabeth Broun further linked these pieces with a panel from a casket in Lyons representing scenes from Genesis (Goldschmidt and Weitzmann, I, no. 70). The panel from Lyons shows great similarities to the Crucifixion panel in its treatment of anatomy, particularly in such details as the muscles of the arms and tendons of the hands and feet. The drapery is also close to that of the Walters panel, with the tunics hanging lower at the back than at the front, as in Christ's loincloth. In addition, Eve's gesture of hands on the casket repeats that of the Virgin. For these reasons, Broun proposed that the reconstituted triptych and the box originated from the same workshop (see Bib.). The style is a slight variant of the Triptych Group.

There are holes for attachment and suspension in the borders. The upper and lower borders are scored with guidelines for the frame. There are traces of polychromy on the cross, halos, sun, moon, and ground plane.

H: 5³⁄₁₆″ (13.3cm) × W: 3⅞″ (9.9cm) 71.65

HISTORY: Collection of Godard Desmarais; purchased from Henry Daguerre, Paris, 1925.

BIB.: Goldschmidt and Weitzmann, II, no. 168; *Byzantine Art*, no. 135; E. Broun, "A Byzantine Crucifixion Triptych," *BWAG*, XXIV, no. 5, 1–3.

See also colorplate 53

195. CRUCIFIXION AND ASCENSION

Right wing of an ivory diptych. Byzantine, early 11th century

From its proportions, Adolf Goldschmidt deduced that this panel formed the right wing of a diptych, comparing it to two pieces in Dresden and Hanover (Goldschmidt and Weitzmann, II, nos. 40 and 41). As the left border is broken, however, it is not possible to confirm this hypothesis.

The composition of the Ascension is very similar to a panel in the Victoria and Albert Museum (Goldschmidt and Weitzmann, II, no. 114), although here the figures stand more upright and gesticulate less. In the Crucifixion, the sun and moon and Stephaton and Longinus are reversed from their usual positions. Longinus carries a sword rather than a spear. Philippe Verdier linked this reversal to a Byzantine identification of the moon with the Church, but this seems unconvincing. The style is related to the Nicephoros Group.

The bottom border and parts of the figures of the Crucifixion are broken off, as are the left border and upper left corner. There are several pinholes in the upper border and ground. AVE MARIA has been scratched on the back and there is the impression of a seventeenth-century French seal.

Inscribed in Greek, top register: Η ΑΝΑΛΗΨΙΣ (*The Ascension*); bottom register: Η ΣΤΑΥΡΩΣΗΣ (*The Crucifixion*).

H: 9¼″ (23.6cm) × W: 4¹¹⁄₁₆″ (12.0cm)
71.294

HISTORY: Collection Bastini; Count Gregorii Stroganoff, Rome (1911 catalogue, II, pl. 107).

BIB.: Graeven, II, no. 70, 38; Longhurst, I, 44; Goldschmidt and Weitzmann, II, no. 117; *Byzantine Art*, no. 139; P. Verdier, "Un monument inédit de l'art du XIIe siècle," *Revue belge d'archéologie et d'histoire de l'art*, XXX, 165, ill., 164; P. Verdier, "The Riches of Byzantium," *Apollo*, LXXXIV, no. 58, 461.

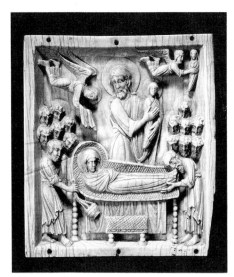

192

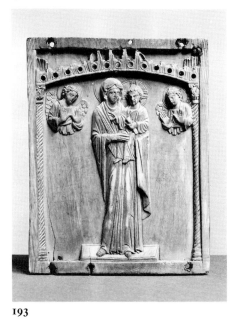

193

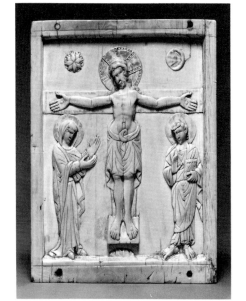

194

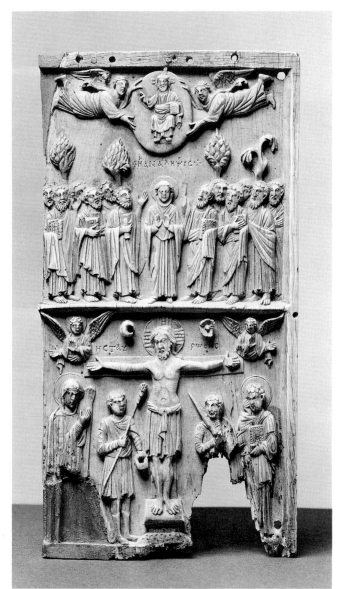

195

196. NATIVITY AND ADORATION OF THE MAGI

Ivory icon. Byzantine (Venice?), early 11th century

The representation of the Nativity is combined with the Adoration of the Magi. The closest parallels are Nativity plaques in Paris and Ravenna (Goldschmidt and Weitzmann, II, nos. 197, 203). Goldschmidt and Weitzmann consider these and related ivories Byzantine, and described them as the Frame Group because of their elaborately decorated borders. Several works of the Frame Group have been included with the Walters piece among ivories attributed to Venice by A. S. Keck (see Bib.). Four of the pieces of the Frame Group have histories related to Murano and are now in Ravenna. The agitated style of several of the works, including this example, suggests a center outside of Byzantium.

The lower right corner is broken off, and there is a crack in the upper portion. The hole in the upper border is not original. There are traces of gilding on the border and figures, and of polychromy on the cloud, halos, and manger. The Greek inscription above the Virgin is original: MH(TH)P Θ(EO)Y (*Mother of God*); while that in the upper border was added later: H X(PIΣTO)Y ΓENNHΣIΣ (*The Birth of Christ*).

The plaque served originally as an icon, like the closely related example of the Nativity with a similar frame on a book cover formerly in the Marquet de Vasselot Collection (Goldschmidt and Weitzmann, II, no. 197).

H: 4¹¹⁄₁₆″ (12.0cm) × W: 3½″ (8.8cm)
71.292

HISTORY: Collection of Count Gregorii Stroganoff, Rome (1911 catalogue, II, pl. 120); purchased from Henry Daguerre, Paris, 1930.

BIB.: Graeven, II, nos. 51, 55, 56, 71; F. Hermanin, *L'arte*, 1898, 6; E. Modigliani, *L'arte*, 1899, 288; A. S. Keck, "A Group of Italo-Byzantine Ivories," *Art Bulletin*, XII, no. 2, 156, fig. 20; Goldschmidt and Weitzmann, II, no. 199; *Byzantine Art*, no. 131; P. Verdier, "A Byzantine Relief of the Adoration of the Christ Child," *BWAG*, XIV, no. 3.

197. NATIVITY

Central panel of an ivory triptych. Byzantine (Italy?), 11th century

This panel belongs to a group of ivories that have been attributed to either Byzantium or Italy and dated in the eleventh to twelfth century. Margaret Longhurst in the Victoria and Albert Museum catalogue discusses the tenuous attribution to Italy in describing a wing from a triptych of the Frame Group (A 66-1925) that is close in style to the Museum's (295-1867), discussed below. The new arguments concerning the Frame Group and a possible attribution to Venice are noted under catalogue no. 196. Characteristic of this group are a crowded composition and landscape setting. The composition of the Walters panel is almost identical to that of a Nativity in the Victoria and Albert Museum (Goldschmidt and Weitzmann, II,

no. 198). The major difference is in the number of figures: in the London piece a second shepherd appears at the left, and there are four angels rather than three. The bath of the Child is placed to one side whereas in the Walters ivory it is located at the center of the lower register.

In spite of the similarities in composition, stylistic elements in the Walters panel suggest that it may have a different origin from the London plaque. Chief among these is the disproportion of the figures, particularly of the shepherd and the angel on the right. The rendering of the Virgin's cloak is also rather schematic compared to the London example. On the other hand, there is a new element of interaction between the figures evident in both panels. It would appear that the two pieces, while based on a common prototype, may have been executed in different places and at different times. The London example is related to the Frame Group, but both pieces have features of the Nicephoros Group.

There is a dark marking down the center of the ivory, and the surface shows many fine cracks. Holes for attachment are seen in the top and bottom borders and there is a further hole for suspension at the top.

H: 5⅜″ (13.8cm) × W: 4¹³⁄₁₆″ (12.3cm)
71.305

HISTORY: Collection of Girolamo Possenti, Fabriano (sale, Florence, 1880, no. 24); Count Gregorii Stroganoff, Rome (1911 catalogue, II, pl. 115); purchased from Henry Daguerre, Paris, 1930.

BIB.: Westwood, *Ivories*, 373; Graeven, II, 41; Goldschmidt and Weitzmann, II, no. 118; *Byzantine Art*, no. 130.

See also colorplate 56

198. SAINTS GEORGE AND JOHN CHRYSOSTOM

Side of an ivory casket. Byzantine (Georgia), early 11th century

This panel with two saints is an unusual subject to be found on a box; either biblical narratives or secular scenes appear more frequently, as in catalogue nos. 199 and 200. However, two rare types of boxes do occur with half-length figures of saints or Apostles, the most elaborate example of which is in Florence and can be compared to the reconstructed box at Dumbarton Oaks (Weitzmann, *Ivories and Steatites*, no. 30, figs. 28–32). An Apostle casket of quite a different style is in the Metropolitan Museum (Goldschmidt and Weitzmann, I, no. 100).

The figure on the left, which is not named, can be identified as Saint George because of its resemblance to a figure on a panel formerly in Zurich (Goldschmidt, IV, no. 128b), now in the Morgan Library (MS. G. 21). This and another panel in the Morgan show the closest stylistic affinity to the Walters piece. Goldschmidt had placed all three pieces in Italy because of the unusual form of the A in the inscription, but on the basis of a letter from Kurt Weitzmann of February 2, 1958, they have since been reassigned to Georgia.

There is a crack running across the panel two-thirds of the way down, and parts of

the border are broken off. There are small pinholes in the ground.

Inscribed in Greek: ὁ Ἅ(ΓΙΟΣ) (*Saint*); ὁ Ἅ(ΓΙΟΣ) ΙΩ(ΆΝΝΗΣ) (*Saint John*); ὁ ΧΡΥΣΌΣ ΤΟΜΟΣ (*The Golden Book*).

H: 3⅛″ (8.0cm) × W: 6½″ (16.6cm) 71.291

HISTORY: Collection of Leonce Rosenberg, Paris; purchased from Léon Gruel, Paris, 1923.

BIB.: Goldschmidt and Weitzmann, I, no. 101; A. Goldschmidt, "Collection de M. Leonce Rosenberg," *Parisia*, no. 3, 1914, 11, fig. 12; C. R. Morey, Review of Goldschmidt and Weitzmann, *AJA*, XXXVI, no. 1, 1932, 591; J. Pijoan, *History of Art*, Chicago, 1940, II, 111; *idem, Summa Artis*, Madrid, 1935, vii, 450, fig. 639.

See also colorplate 57

199. PUTTI AS WARRIORS

Ivory box. Byzantine (Italy?), 10th–11th century

The warriors depicted on this box derive from representations of the Labors of Herakles. While Weitzmann believes that a narrative content is implied by the figures, it seems more likely that they have become purely conventionalized. Similar figures appear on many other boxes with no apparent interrelationships.

The depiction of the anatomy is strongly classical in spirit, especially in the rendering of the abdomen. Two of the plaques on the lid (the second and fourth from the left) appear to be by a different hand.

The box belongs to a subgroup of the Rosette Caskets, in which the grapevine is formed of cornucopialike segments and has triangular bunches of grapes. The Adam and Eve caskets in Leningrad and Darmstadt have this grape decoration (Goldschmidt and Weitzmann, I, nos. 68 and 69).

The box is still on its original wood core. Parts of the plaques on the lid have been patched, and portions of the rosette borders and edging strips, as well as some of the ivory pins, are modern.

H: 4³⁄₁₆″ (10.6cm) × L: 11¹⁵⁄₁₆″ (30.2cm) × W: 7″ (17.8cm) 71.115

HISTORY: Purchased from Tycon and Smith, Paris, 1929.

BIB.: *Byzantine Art*, no. 115; K. Weitzmann, *Greek Mythology in Byzantine Art*, Princeton, 1951, 161, figs. 190 and 191.

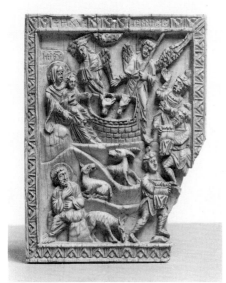

196

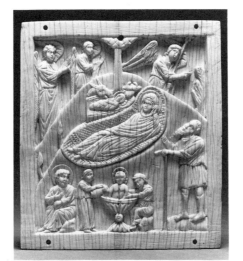

197

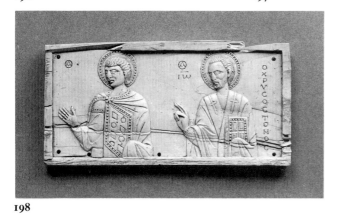

198

199

199

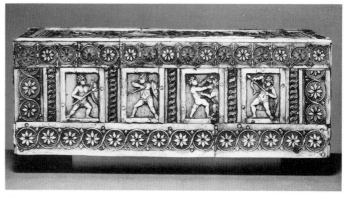

199

199

199

200. SCENES WITH PUTTI

Bone casket. Byzantine, mid-11th century

This casket is one of a number of the Rosette Group, which show putti in the guise of warriors, philosophers, and Dionysiac revelers. Many of the figures and groups are taken from a repertory of subject matter used and reused by Byzantine ivory carvers. The box was certainly for secular use.

The finest related example, the Veroli Casket in the Victoria and Albert Museum (J. Beckwith, *The Veroli Casket*, 1962), shows close parallels in the use of alternating borders of rosettes and profile heads around the lid and of acanthus borders around the top plaque. The roundness of the figures, emphasized by deep undercutting, is similar on both caskets, though the crispness of the Veroli Casket is lacking in the Walters example, partially because of wear.

Certain subjects, such as the putto on a hippocamp on the rear panel of the lid, may be found in nearly identical form on the Veroli Casket and on a panel in the Martin Le Roy Collection, Paris (Goldschmidt and Weitzmann, I, no. 25).

The early-eleventh-century dating of the Veroli Casket is generally accepted. The connection between it and the Walters example indicates a related, if not the same, workshop, the Walters example made at a somewhat later date, perhaps the middle years of the eleventh century.

The rosette borders on the back are missing and have been replaced by paper strips. The rosettes on the back of the lid have been pieced with a mismatched strip. One corner of the left lid panel is chipped, and there is a hole in the center for a handle. Most of the pegs are original. The interior was lined with paper in the seventeenth century, and the lid decorated with a painted monogram covered by glass. The lock and hinges are medieval replacements.

H: 5" (13.0cm) × W: 7⅜" (19.0cm) × D: 5⅜" (14.0cm) 71.298

HISTORY: Collection of Edward Joseph (sale, London, Christies, May 6, 1890, lot 1003, and Feb. 1894, lot 357); Isaac Falke (sale, London, Christies, Apr. 19, 1910, lot 166); purchased from Jacques Seligmann, Paris, 1910.

BIB.: Goldschmidt and Weitzmann, I, no. 40; *Byzantine Art*, no. 117; K. Weitzmann, *Greek Mythology in Byzantine Art*, Princeton, 1951, 155, fig. 168.

See also colorplate 54

201. SCENES OF ADAM AND EVE AND OF JOSEPH

Ivory casket. Byzantine, 11th–12th century

This is one of several caskets with scenes of Adam and Eve to survive from the middle Byzantine period; others are in Cleveland, Leningrad, Darmstadt, and Reims (Goldschmidt and Weitzmann, I, nos. 67–69, 84). Most of the plaques on the sides of this casket have been lost; those that remain show the Fall of Adam, the Sorrowing Adam, and the Temptation of Eve (front), and Adam in Paradise (back). On the lid is a plaque with three scenes of Jacob sending Joseph in search of his brothers. Scenes on the lids of such caskets are frequently unrelated to those on the sides, and point to their having been assembled from ready-made plaques. This is especially clear in the case of this box, where the lid and side plaques were made by different hands.

The representation of the Sorrowing Adam without a corresponding Eve is somewhat unusual, but the latter may have appeared on one of the lost pieces. For the iconography of the Adam, see catalogue no. 202.

Goldschmidt compared the drapery style on the lid to works of the Triptych Group, for example, the Crucifixion triptych in Berlin (Goldschmidt and Weitzmann, II, no. 72; see also cat. no. 190). A closer comparison, however, would seem to be with two plaques in Pesaro with scenes from Genesis (Goldschmidt and Weitzmann, I, nos. 86 and 87).

Chief among the casket's extensive losses are two plaques and some border strips from the back and borders and part of the plaited decoration from the lid. There is also considerable staining, particularly on the corners and around the former hinges. The wood core is original, although some of the pegs have been replaced by metal pins. The lock is of a later date. On the lid is a metal hasp, and there are two holes in the Joseph plaque for a handle.

Inscribed in Greek with identifications: lid (next to chair): ΙΑΚΩΒ ΑΠΟΣΤΕΛΩΝ ΙΩΣΗΦ ΠΡΟΣ ΤΟΥΣ ΑΔΕΛΦΟΥΣ ΑΥΤΟΥ (*Jacob Sending Joseph to His Brothers*); lid (beside angel): ΑΓΓΕΛΟΣ Κ(ΥΡΙΟ)Υ (*Angel of the Lord*); box front (Adam panel): Η ΠΑΡΑΒΑΣΙΣ ΑΔΑΜ (*The Transgression of Adam*); box front (Eve panel): ΟΦΙΣ ΟΜΙΛΩΝΤ(?) ΕΥΑ (*Serpent Speaking to Eve*); box back panel: ΑΔΑΜ (*Adam*).

H: 7¼" (18.5cm) × L: 10⅝" (27.0cm) × W: 6¾" (17.2cm) 71.295

HISTORY: Acquired in Paris, 1926.

BIB.: Goldschmidt and Weitzmann, I, no. 82; *Byzantine Art*, no. 119; J. Dorig, "Lysipps letztes Werk," *JDAI*, no. 72, 1957, 26, fig. 2; H. Maguire, "The Depiction of Sorrow in Middle Byzantine Art," *Dumbarton Oaks Papers*, no. 31, 1977, 133, fig. 14.

See also figure 23

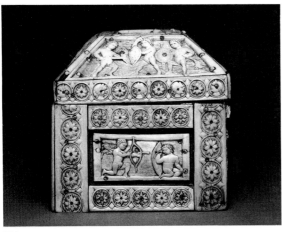

200

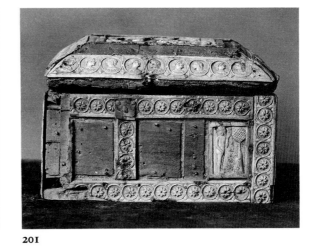

201

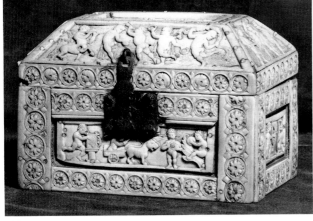

200

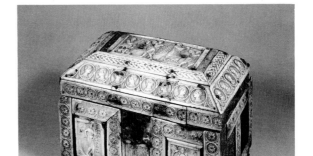

201

201

202. SORROWING ADAM

Plaque from an ivory casket. Byzantine, 12th century

This plaque was originally attached to a box from which four other panels survive, one in the British Museum and three in the Metropolitan Museum (Goldschmidt and Weitzmann, I, nos. 89–93). Its representation of the Sorrowing Adam seated on a basket and resting his head on his hand has been traced back to a statue of Herakles by Lysippos that stood in Constantinople until 1204 (Weitzmann, see Bib.). Several other versions of this figure exist, all showing the influence of intermediary sources, such as manuscripts, in their slight variations. A similar figure appears in a nonreligious context with warriors and animal slayers on two boxes in Xanten and Arezzo (Goldschmidt and Weitzmann I, nos. 10, 29). On the Xanten box, the figure may still be identified as Herakles by the lion skin on the basket.

There are several comparable representations of Adam on boxes of the eleventh and twelfth centuries, the closest one being on catalogue no. 201. Here the position of the hand and knee, and the basket on which Adam is seated, are similar, although the style is very different. A slightly different type appears on plaques in Berlin, Darmstadt, and Cleveland (Goldschmidt and Weitzmann, I, nos. 78 and 79, 67c, 69), where Adam and Eve are seated facing one another in the crooks of two trees. A related scene, that of the reproach of Adam by God, also appears on the Darmstadt and Cleveland boxes.

The back of this plaque is unusually shaped: the top edge is grooved, the right side beveled, and the left cut away. This was probably done in order to fit the plaque to its surrounding borders. There is also a single hole for attachment. As with the related plaques there are traces of red coloring.

Inscribed in Greek: ΑΔΑΜ (*Adam*).

H: 2¾" (7.0cm) × W: 3" (7.7cm) 71.296

HISTORY: Collection of Count Auguste Bastard; purchased from Léon Gruel, Paris, 1926.

BIB.: Goldschmidt and Weitzmann, I, no. 90, pl. 55; *Byzantine Art*, no. 120; J. Dorig, "Lysipps letztes Werk," *JDAI*, no. 72, 1957, 26, fig. 3; see also K. Weitzmann, *Greek Mythology in Byzantine Art*, 161, fig. 189.

See also colorplate 55

203. CRUCIFIXION, HARROWING OF HELL, ASCENSION, AND PENTECOST

Center of an ivory triptych. Byzantine, 14th century

The compositions of the Crucifixion and the Ascension on this piece are almost identical to those on catalogue nos. 190 and 195, but the style is late Byzantine. Unusual details include the way the angels' legs turn outward while their bodies face inward toward the ascending Christ, and the extraordinary floating half-length figure of Eve behind Adam in Hell.

Kurt Weitzmann has related this ivory to the Cantacuzene family pyxis at Dumbarton Oaks, which can be dated to the mid-fourteenth century (Weitzmann, *Ivories and Steatites*, no. 31). The small-figure scale is reproduced, and may be seen also in the Menologian at Oxford (O. Pächt, *Byzantine Illumination*, Oxford, 1952, figs. 16, 24) of the same period.

The pierced holes show that the plaque was the center of a triptych. There are some losses in the Crucifixion scene, in the borders, and in the lower right corner. There is a vertical crack down the left side of the piece, held together at the top and bottom by silver plates. The ivory is brownish in color.

Later inscriptions in Greek have been added to the background: Crucifixion scene: Η ΣΤ(ΑΥ)ΡΩΣΙΣ (*The Crucifixion*); Ascension scene: Η ΑΝΑΣΤΑΣΙΣ (*The Resurrection*); Ascension scene: Η ΑΝ(ΑΛ)ΗΨ(ΙΣ) (*The Ascension*); Pentecost scene: Η ΠΕ(Ν)ΤΗΚ(Ο)Σ(ΤΗ) (*The Pentecost*).

H: 5⁹⁄₁₆" (14.2cm) × W: 3½" (8.9cm)
71.137

HISTORY: Purchased from Léon Gruel, Paris, 1929.

BIB.: Weitzmann, *Ivories and Steatites*, 81, fig. 143; Goldschmidt and Weitzmann (reprint), I, 3.

204. THE TWELVE FEASTS

Cross of bone, filigree, enamel, and stones. Russian (Byzantine style), 17th century

The subjects shown on this cross are the Twelve Feasts of the Orthodox Church: (front) Nativity, Entry into Jerusalem, Crucifixion, Harrowing of Hell, Ascension, Pentecost; (back) Annunciation, Presentation in the Temple, Baptism, Raising of Lazarus, Transfiguration, Dormition of the Virgin. There are Slavonic inscriptions identifying the scenes, but these are hidden by the frame. A cross with a very similar filigree and enamel frame, though with slight differences in carving, is in the Vatican Museum, Rome.

The frame is set with four turquoises on the sides and an amethyst(?) on top. The enamel is red and blue. The handle unscrews, and there are two loops for suspension.

All the following late Byzantine entries (cat. nos. 205–216) have inscriptions in Slavonic, which merely name the subjects of the scenes. The inscriptions shed no light on the dating or origins of the ivories and are therefore not reproduced in this catalogue.

H: 6⁹⁄₁₆" (16.5cm) × W: 2¹⁵⁄₁₆" (5.0cm)
71.138

HISTORY: Acquired before 1931.

205. THE TWELVE FEASTS

Bone pectoral cross. Russian (Byzantine style), 17th century

This cross is carved with the same scenes (front and back) as catalogue no. 204, but in a slightly different order.

The cross is surrounded by a silver mount with a loop at the top for suspension. One arm is cracked at the front and broken at the back.

The scenes are identified by Slavonic inscriptions on ogival arches.

H: 2⅞" (7.0cm) × W: 1⅝" (4.2cm)
71.485

HISTORY: Acquired in 1931.

206. THE TWELVE FEASTS

Walrus ivory and silver icon. Russian (Byzantine style), 17th century

This icon shows the same scenes as the two crosses, catalogue nos. 204 and 205, but with more attention given to setting. The scenes are identified by Slavonic inscriptions on ogival arches.

The ivory panel has been mounted in a frame of repoussé silver, with a loop for suspension. It is inscribed along the side of the frame in Slavonic.

H (in frame): 3½" (9.0cm) × W: 3¹⁄₁₆" (7.8cm) 71.254

HISTORY: Acquired before 1931.

202

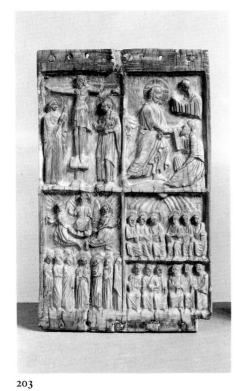

203

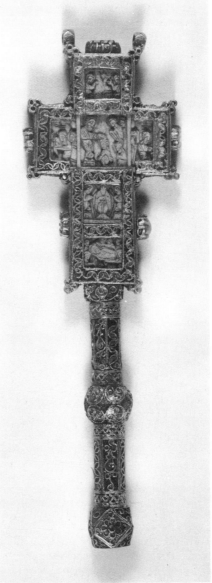

204

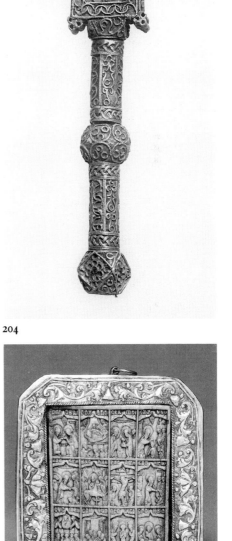

204

205

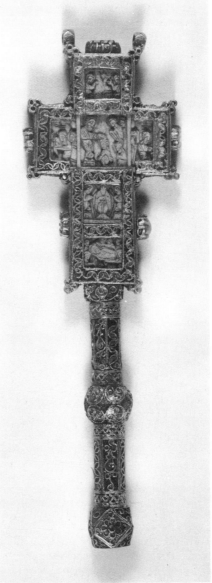

206

207. EIGHT FEASTS

Ivory panel. Russian (Byzantine style), 17th century

This panel shows eight of the Twelve Feasts: Entry into Jerusalem, Annunciation, Presentation, Crucifixion, Harrowing of Hell, Transfiguration, Baptism, and Pentecost. In addition, the Three Angels at Mamre appear in the center of the top row. All the scenes are identified by inscriptions in Slavonic on ogival arches.

The ivory is rather dark in color; two corners are chipped and the central portion is worn.

H: 2⁷⁄₁₆″ (6.1cm) × W: 1¾″ (4.4cm) 71.486

HISTORY: Acquired before 1931.

208. THE THREE ANGELS

Half of an ivory panaghiarion. Russian (Byzantine style), 17th century

This piece and catalogue no. 209 together form a panaghiarion, or container for consecrated wafers. They would have been enclosed originally in a frame of precious metal, as indicated by the bare hatched borders on the reverse. These small pyxides, which were also used as episcopal insignia, are generally decorated with an image of the Virgin and Child, whence their name (*panaghia*—most holy).

The interior of this piece has a representation of the Trinity in the form of the Three Angels welcomed by Abraham. Above the head of the central figure, shown in the act of blessing the chalice and loaves, is inscribed I͞CXI, identifying him as Christ. This scene is surrounded by twelve medallions with the half-length figures of Mary, John the Baptist, and ten Apostles, some of whom hold books or scrolls. Reading clockwise, these are: John the Baptist, Paul, Andrew, Mark, Luke, James the Great, Simon, James the Less, Matthew, John, Peter, and the Virgin. Around the edge is carved part of a hymn to the Trinity, which is recited during the elevation of the panaghiarion.

On the exterior is a representation of the Crucifixion with Mary, John, a holy woman, and a soldier. The poses of the figures, the body of the Christ, and the stylized background are all very similar to an example in the Vatican (Morey, no. 129), although the two angels of the Vatican example have been replaced by an inscription in the Walters piece.

All of the panaghiaria, together with some small carved icons in the Vatican and elsewhere (Morey, nos. 127–130), have been attributed to the workshop of the Russico Monastery of Mount Athos.

The piece is slightly chipped on the border.

D: 2½″ (6.2cm) 71.257

HISTORY: Said to have been found in Smyrna; purchased from Dikran Kelekian, Paris, 1912.

BIB.: For a discussion of similar panaghiaria with inscriptions transcribed, see Morey, nos. 129 and 130. For the symbolism of the Trinity, cf. V. Lasareff, "La Trinité d'André Roublev," *Gazette des beaux arts*, Dec. 1959, 289ff.

209. VIRGIN AND CHILD

Half of an ivory panaghiarion. Russian (Byzantine style), 17th century

This piece, the mate to catalogue no. 208, represents the Virgin and Child surrounded by roundels with twelve half-length Old Testament figures, accompanied by inscriptions. Reading clockwise, these are: Solomon (crowned), Jeremiah, Aaron, Jonah, Elijah, Habakkuk, Abraham(?), Daniel, Moses, Zechariah, Jacob, and David (also crowned). All the figures hold scrolls. Around the edge of the disc is inscribed part of a hymn to the Virgin, which is recited during the elevation of the panaghiarion.

On the exterior are three bishop saints designated as Gregory, Basil, and John Chrysostom. The style of these three figures is rather close to that of the second Vatican panaghiarion (Morey, no. 130), particularly in the decoration of their robes.

The border is slightly chipped and there is a crack on the exterior.

D: 2½″ (6.2cm) 71.258

HISTORY: Said to have been found in Smyrna; purchased from Dikran Kelekian, Paris, 1912.

BIB.: cf. Morey, nos. 129 and 130.

210. THE THREE ANGELS

Half of a bone panaghiarion. Russian (Byzantine style), 17th century

On the interior are the Three Angels entertained by Abraham (see cat. no. 208). Under the table is the ox Abraham prepared for the feast. Around the disc is carved part of the hymn to the Trinity. On the exterior is a Crucifixion with Mary, John, a holy woman and soldier, and two angels. There are ten roundels with half-length apostles: Paul, Mark, James, Philip, Simon, Bartholomew, Thomas, Andrew, John, and Peter. Paul, Mark, and John hold books.

The style of the Trinity in particular is very close to an example in the Vatican (Morey, no. 129).

The staff of the central angel and the left arm of Christ have broken off.

D: 1¹³⁄₁₆″ (4.7cm) 71.259

HISTORY: Purchased in 1922.

BIB.: See catalogue no. 208.

See also colorplate 58

211. DEPOSITION, THREE ANGELS, AND THREE MARYS

Ivory and silver folding triptych. Russian (Byzantine style), 17th century

This triptych, with three leaves of similar size, represents the Deposition, the Three Angels, and the Three Marys at the Tomb. In the Deposition, Christ is lowered upright from the Cross while disciples and a soldier look on. On the right, the nails are handed down from the Cross to a disciple. Opposite, the three Marys approach the rectangular tomb in a rocky setting.

The composition of the central panel is taken directly from examples of panaghiaria such as catalogue nos. 208 and 210, including the border with the hymn to the Trinity. In the corners, cherubim and seraphim have been added. The handling of the drapery of this piece is different from that of the other two, suggesting a different hand.

The three panels are set in an engraved silver frame with a hook fastening and two rings for suspension. The outer frames are decorated with heads in the corners. All three panels are backed with velvet. The Deposition panel is broken.

Inscriptions are in Slavonic.

H (in frame): 3½″ (8.5cm) × total W: 9″ (23.0cm) 71.488

HISTORY: Purchased in 1930.

212. THREE SAINTS

Ivory and silver pax. Russian (Byzantine style), 17th century

This ivory represents Saint Nicholas, in the center, flanked by Saints Boris and Gleb, who bear crosses.

The ivory, probably used as a pax, is worn and darkened, and the silver mount has broken and been soldered in several places. There are two loops at the top for suspension.

Identifying inscription is in Slavonic.

H: (in frame): 2¾″ (7.0cm) × W: 2⁵⁄₁₆″ (5.9cm) 71.136

HISTORY: Acquired before 1931.

207

210

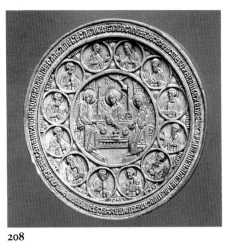

208

211

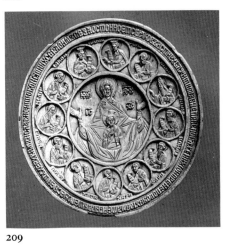

209

212

213. ANNUNCIATION AND SAINT NICHOLAS

Ivory panel. Russian (Byzantine style), 17th century

This small panel shows the Annunciation on the front and Saint Nicholas, standing in an attitude of teaching, on the back. The representation of drapery with short double strokes is similar to that in catalogue no. 208, although the rounded forms and poses show quite a different conception.

The execution of this piece, with forms in high relief set off by incised lines, is similar to that of catalogue no. 189 and shows a continuation of an earlier Byzantine tradition.

The dark color of the ivory comes from its having been stained; the light areas are those that rejected the stain. The upper border is broken on the back and on both sides. There is one hole for suspension.

Identifying inscriptions are in Slavonic.

H: 2½″ (6.4cm) × w: 1¾″ (4.8cm)
71.255
HISTORY: Acquired before 1931.

214. HARROWING OF HELL AND SAINTS

Ivory panel. Russian (Byzantine style), 16th–17th century

This ivory has as its main subject the Harrowing of Hell, with Christ raising Adam while Eve, David, Solomon, and other patriarchs look on. Above, between Michael and Raphael is the Deesis; beside and below are Saints Peter, Nicholas, a bishop, Athanasius (with a cross and chalice), George (with a cross), Catherine ([?] crowned and with a cross), Sergius, another female saint with a cross, two more bishops, and Saint Paul.

On the back inside a plain border is the Cross with instruments of the Passion: the crown of thorns, spear, and sponge.

The ivory is slightly chipped on the left front border. There is a hole in the top border for hanging.

Identifying inscriptions are in Slavonic for the two main scenes and individual saints.

H: 3″ (7.8cm) × w: 2¼″ (5.7cm) 71.260
HISTORY: Acquired before 1931.

215a,b. VIRGIN ENTHRONED WITH SAINTS

Ivory icon. Russian (Byzantine style), 17th century

The front of this icon represents the Virgin and Child enthroned, surrounded by angels, with God the Father behind. Below stand the saints, including Constantine and Helen (far right) and John of Damascus (near the throne). Behind them appear the glorified church and the trees of Paradise. The main scene is surrounded by the Twelve Feasts of the Church, preceded by the Three Angels at Mamre. In the lower left and right corners are Saints Basil and Gregory. There are comparable pieces in the Vatican Museum (Morey, no. 127) and the Sir John Soane Museum, London (A.T. Bolton, *A Brief Description . . .* , Oxford, 1930, 38, fig. 14).

The reverse is divided into six unequal compartments: in the upper left, Saints Gregory, Athanasius, and a monastic saint (Demetrius?); upper right, Saint George and the dragon with the princess and a crowning angel; lower left, a prophet (Isaiah?), a bishop, and two deacon saints with crosses (Stephen and Nikita?); and lower right, three female saints with crosses, one of whom is crowned.

The treatment of the drapery, with flying cloaks and serrated hems, is unusual.

The panel is slightly cracked, and has darkened.

There are identifying inscriptions in Slavonic.

H: 2¹⁵⁄₁₆″ (7.5cm) × w: 2³⁄₁₆″ (6.0cm) 71.261
HISTORY: Purchased before 1931.

216. CHRIST ENTHRONED IN PARADISE

Ivory panel. Russian (Byzantine style), 17th century

This piece has the rare subject of Christ Enthroned in Paradise. Christ is seated in a mandorla, with tetramorph and seraphim. On either side are Mary, John, and angels; behind, the starry firmament, sun, moon, and clouds. Below stand the saints, and kings, women, and children. In front of them, Paradise is indicated by trees and animals flanking a single river, which flows from above the throne of Christ.

The ivory is cracked, and the lower border is chipped.

An inscription in Slavonic runs across the top of the scene.

H: 3½″ (9.0cm) × w: 2⁷⁄₁₆″ (6.3cm) 71.256
HISTORY: Acquired before 1931.

213

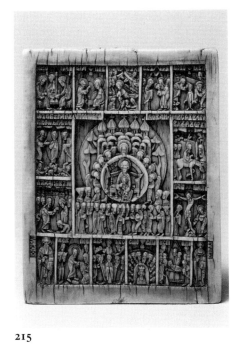

215

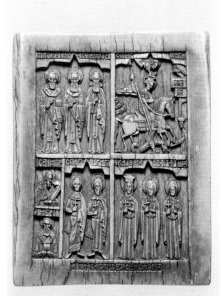

215

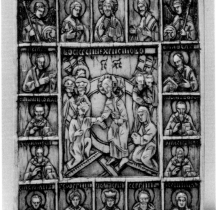

214

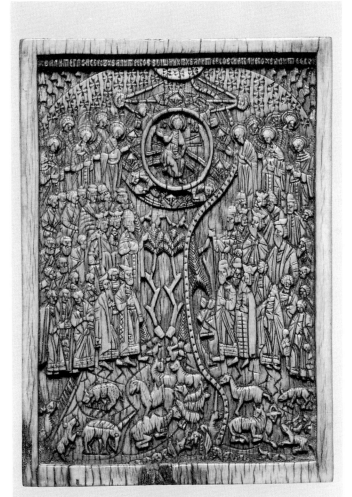

216

Colorplate 52 (cat. no. 182). Triptych with the Virgin Hodegetria and saints, ivory, Byzantine, second half 10th century. The triptych was formerly in the pilgrimage church of Altötting, Upper Bavaria, and, except for its original wood frame, has survived in its entirety. It is a fine example of the classical style revived by the emperor Constantine VII Porphyrogenitus in the mid-tenth century.

Colorplate 53 (cat. no. 194). Crucifixion panel with Mary and John, ivory, Byzantine, late 10th–early 11th century. The panel, the center of a triptych, is distinctive for the exaggerated features of its figures, and their expressions and gestures toward one another, which signal a new concept in Byzantine art. The missing wings of the triptych are shown in figure 22.

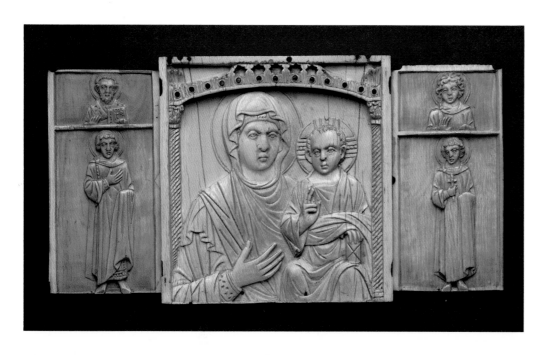

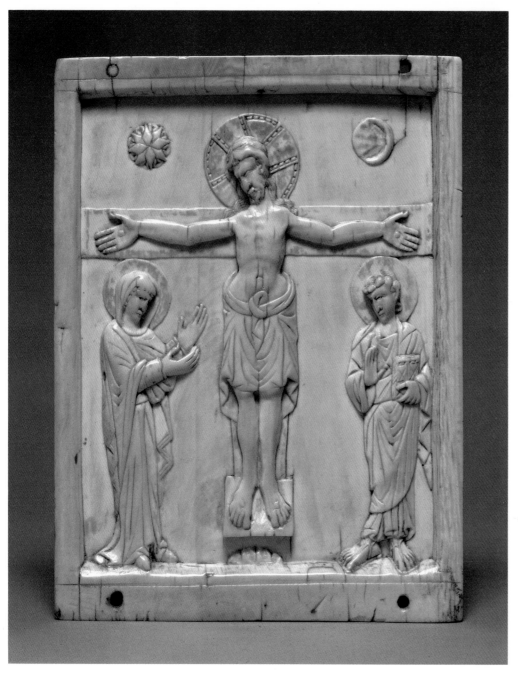

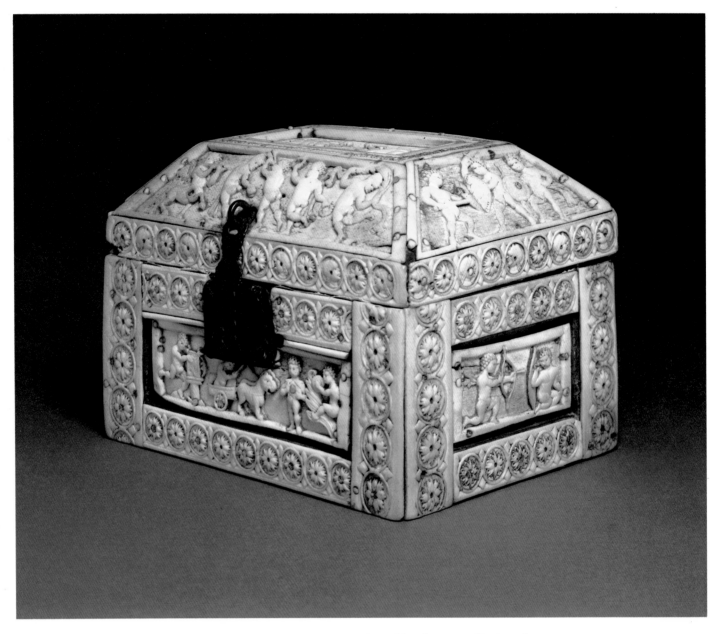

Colorplate 54 (cat. no. 200). Casket with scenes of putti, bone, Byzantine, mid-11th century. Putti are shown on panels engaging in war games, dancing, and playing musical instruments on all sides of the truncated pyramidal box. The box is an example of the Rosette Group in which the border sections of alternating heads and rosettes were carved in long strips and cut to size for assembly.

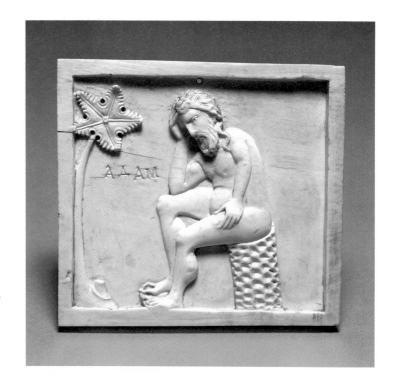

Colorplate 55 (cat. no. 202). Plaque with the Sorrowing Adam, ivory, Byzantine, 12th century. Although the subject is the same as that on a plaque on catalogue no. 201, this panel, from a similar casket, illustrates the finest quality in workmanship. Adam is seated on a basket, with a fig tree for a setting, contemplating the tragedy of Eden.

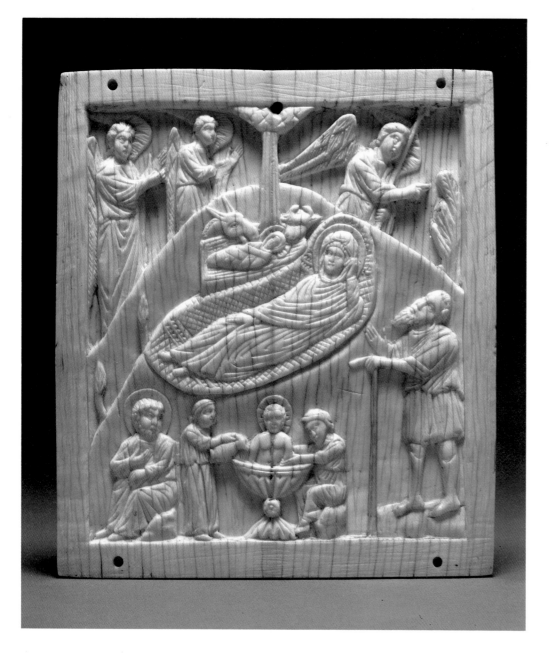

Colorplate 56 (cat. no. 197). Central panel of a triptych with the Nativity and other scenes, ivory, Byzantine (Italy?), 11th century. This panel divides the scene of the Annunciation to the Shepherds into two registers, and includes the Washing of the Christ Child in the foreground. The unusual "copyist" composition and the exaggeration of the scale of the shepherd suggest that the panel was not carved in Constantinople but perhaps in Italy.

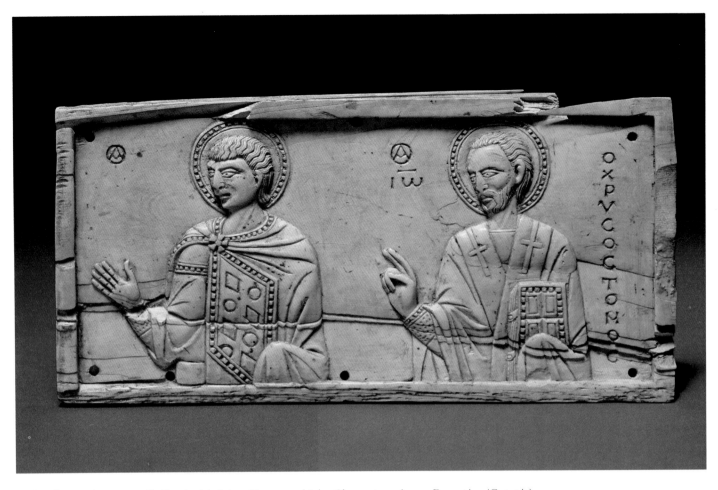

Colorplate 57 (cat. no. 198). Panel with Saints George and John Chrysostom, ivory, Byzantine (Georgia), early 11th century. This panel from a box is unusual in showing half-length saints. The orthography of the letter *A* suggests that the box originated in Georgia, and the style of the figures relates it to a pair of book covers in the Morgan Library.

Colorplate 58 (cat. no. 210). Half of a panaghiarion, bone, Russian (Byzantine style), 17th century. A panaghiarion, or container for the Host, was worn around the neck of a priest. A special hymn was sung at the elevation of the Host. The subject is Abraham and the Three Angels at Mamre.

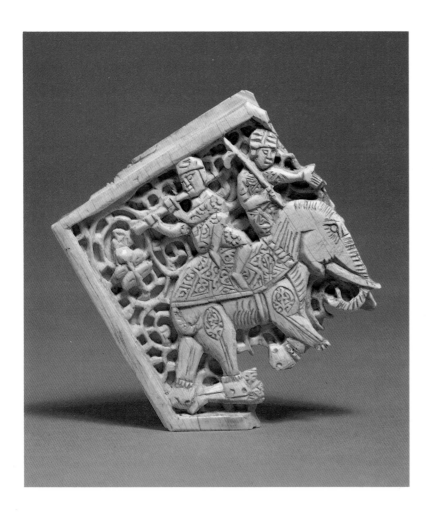

Colorplate 59 (cat. no. 220). Inlay with elephant and riders, ivory, Egyptian (Fatimid style), first half 12th century. This five-sided inlay was part of a door or screen with alternating panels of wood and ivory. The handsomely decorated war elephant is trampling on an enemy.

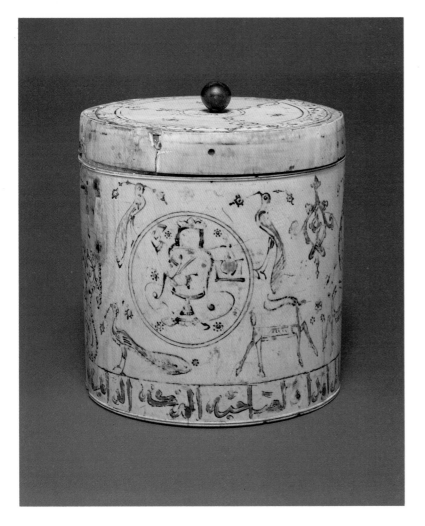

Colorplate 60 (cat. no. 226). Cylindrical box with painted and gilded decoration, ivory, Sicilian (Siculo-Arabic style), 12th century. The decoration in brown paint and gilding has circles with arabesques and seated figures in the Persian manner. In between are gazelles and birds, with inscriptions around the base and the edge of the lid. The lower inscription in nashki reads, in part: "To its owner, the enduring blessing."

Colorplate 61 (cat. no. 234). Truncated pyramidal box with painted and gilded decoration, ivory, Sicilian (Siculo-Arabic style), 13th century. The boxes made in Sicily by Islamic workmen were sometimes painted with European heraldic symbols and occasionally with the actual coat of arms of the future owner. In this example the motifs are generalized and show lions and an eagle within circles.

Colorplate 62 (cat. no. 238). Dagger grip, walrus ivory, Turkish, first half 17th century. The surface is carved with arabesques interrupted by bands of guilloche. A nearly similar grip decorates a dagger captured from the Turks before 1674 and is displayed in the Turkenkammer, Dresden. Walrus ivory was prized by the Persians and Turks for sword and dagger pommels and was acquired by trade with Scandinavia.

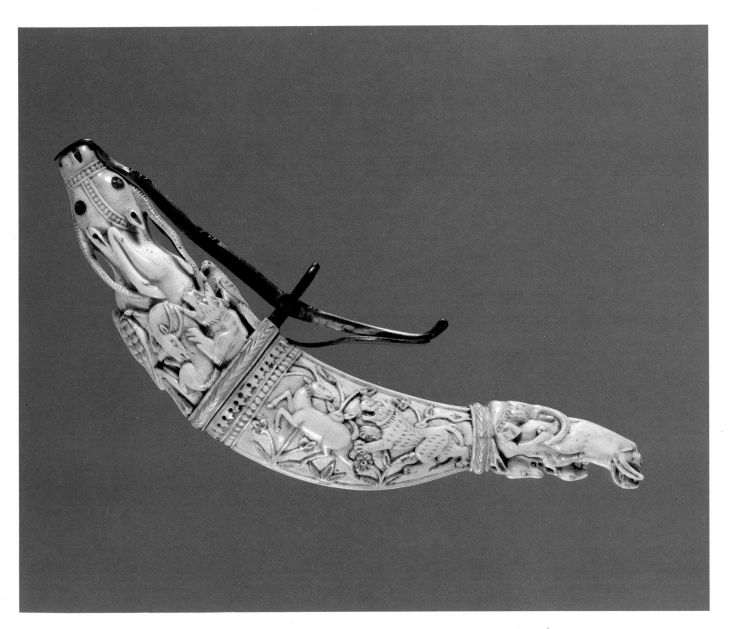

Colorplate 63 (cat. no. 240). Powder flask, ivory, Indian (Mughal style), second half 17th century. The Mughal princes of India were enthusiastic hunters, and a large group of ivory powder flasks were produced for their use. Most of the flasks have spouts with intertwined groups of animals, which were thought to have magical significance. It is interesting that the antelope on the spout wears a bridle while the one being hunted by a lion wears a collar.

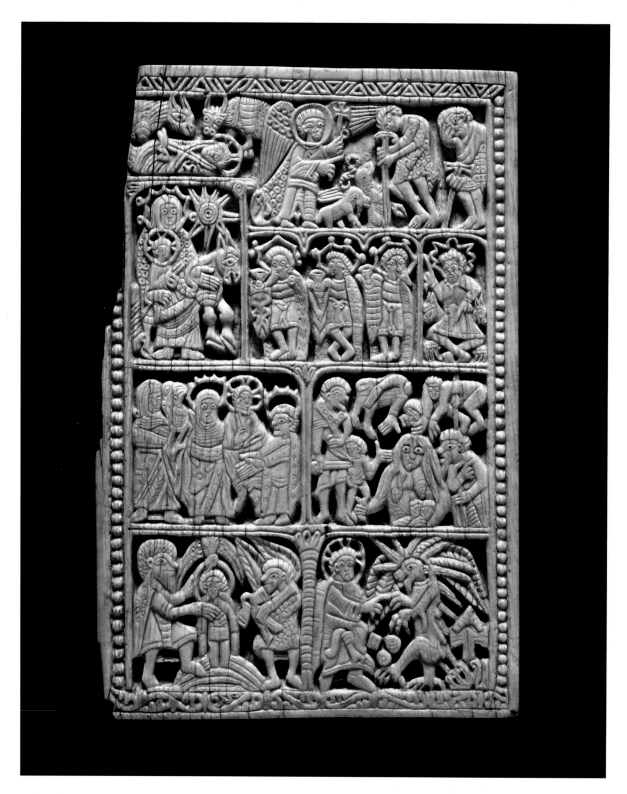

Colorplate 64 (cat. no. 244). Plaque with Life of Christ, ivory, Spanish (Asturian), 9th century. The plaque was probably used on a book cover. In the top register are the combined scenes of the Nativity and the Annunciation to the Shepherds. The second register is curious because while the Virgin and Child ride on a donkey, as in the Flight into Egypt, they are visited by the Three Kings, as in an Adoration scene. At the right, Herod speaks to the kings, and also points to the scene below him: the Massacre of the Innocents. In the same tier is the Presentation in the Temple, and, below, the Baptism and the First Temptation of Christ.

OPPOSITE:

Colorplate 65 (cat. no. 245). Book cover with Crucifixion and Three Marys at the Tomb, ivory, north French (Carolingian), 870–880. The plaque belongs to the Carolingian renaissance, and is related to a series of works called the Liuthard Group, after a scribe who worked for the emperor Charles the Bald. The Crucifixion shows Christ, open-eyed, on a cross that represents the Tree of Life, and at the foot of the cross is a dragonlike monster. The scene of the Three Marys is based on an early Christian model, closely reflected in another Carolingian ivory at Liverpool.

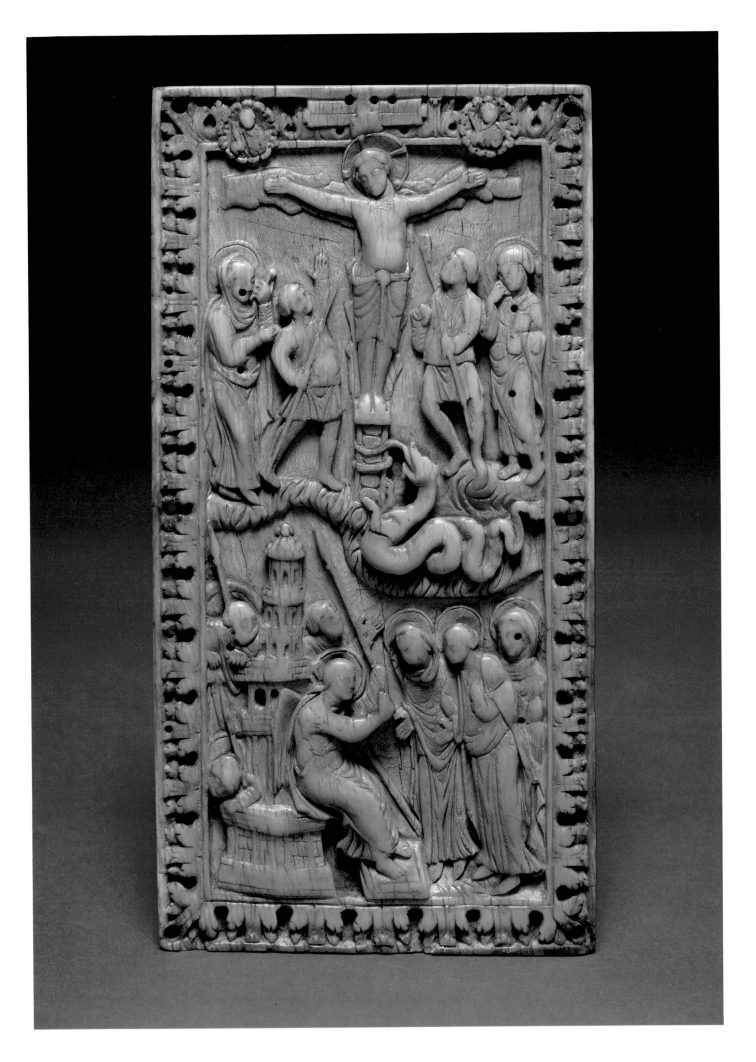

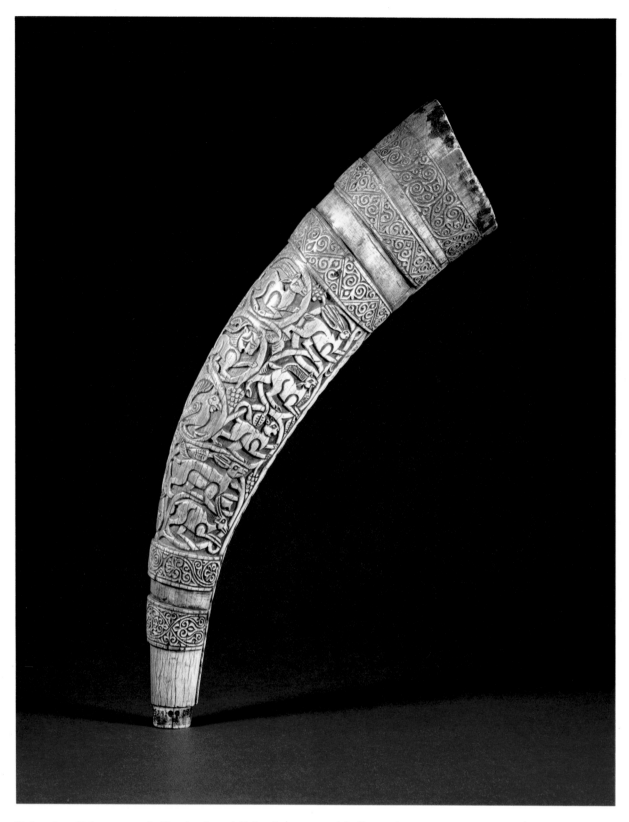

Colorplate 66 (cat. no. 247). Hunting horn (oliphant), ivory, south Italian, 11th century.
This oliphant is one of a large group made by Islamic craftsmen in Italy for the European
market. Only one oliphant has Christian scenes on it, but most have a mingling of Islamic and
European motifs. On this example the vine is symmetrical and grows out of a classical vase;
on the upper side is a caduceus of intertwined snakes, symbol of the herald Hermes and also
of medicine.

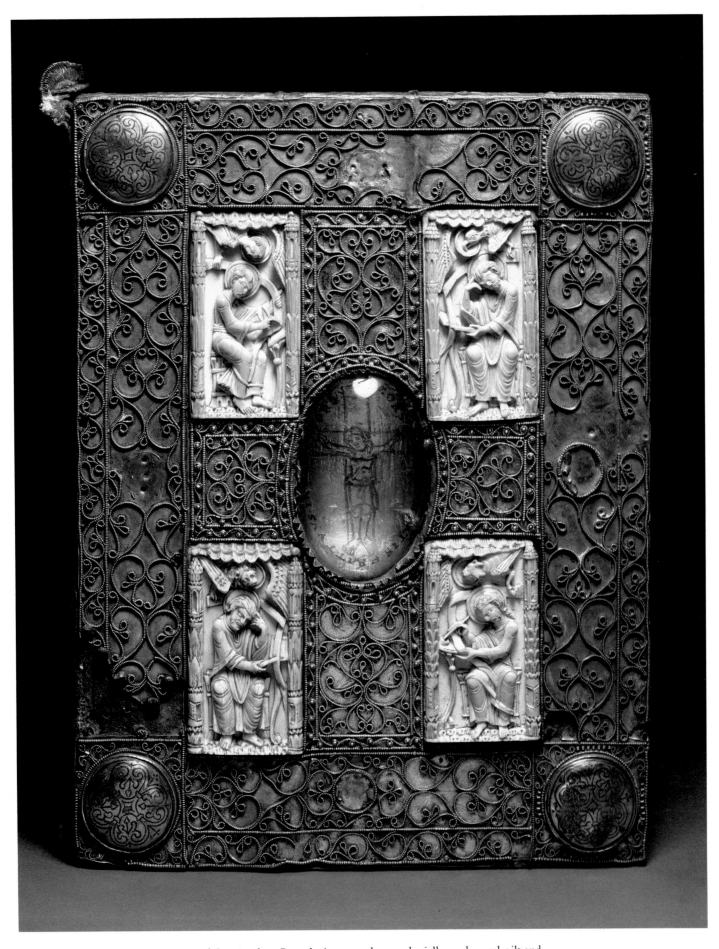

Colorplate 67 (cat. no. 248). Cover of the Mondsee Gospels, ivory, rock crystal, niello, and parcel-gilt and silver filigree, German (Regensburg), third quarter 11th century. The binding contains the original manuscript written by the scribe Othlon, who worked at Saint Emeran, Regensburg, before 1055. The ivories show the Evangelists writing their gospels, with their symbols above them. The Evangelist on the lower left is a nineteenth-century replacement.

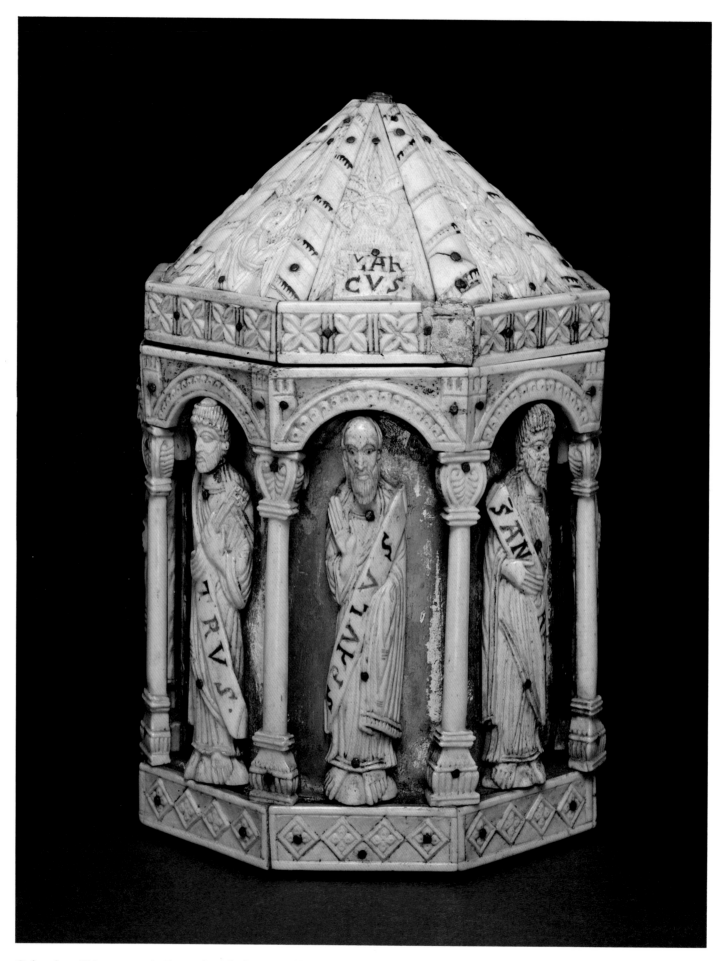

Colorplate 68 (cat. no. 258). Tower-shaped reliquary, gilded and painted bone, German (Cologne), mid-13th century. This is one of a group of octagonal reliquaries made in Cologne with eight Apostles in niches on the sides and the symbols of the Evangelists and cherubim on the gores of the roof. The number that has survived suggests a huge industry and a large market in the thirteenth century.

7 Islamic Ivories

by Richard H. Randall, Jr.

THE EARLIEST Islamic ivories are the small bone plaques carved with leafy vines found in some number in Egypt (cat. no. 217). They date from the seventh and eighth centuries, but their specific use is unclear, though they must have decorated furniture or architecture in some manner. There are also a few round boxes in the same style.

An important group of ivories was produced in Spain in the tenth and eleventh centuries. These refined works are carved with leaves, figures, and birds, from which the background is recessed. The resultant carving on two planes gives the scene a flat-relief effect like that on Moorish stucco decoration and stone carving. Almost all the surviving objects are boxes, either rectangular or circular; the majority have animals and plants as their chief motifs, although a few have figures carved in the Persian manner within quatrefoils or circles. Two of the most typical of these boxes are a tenth-century domed circular box with peacocks and deer among plants in the Archaeological Museum, Madrid,[1] and a similar box in the Louvre,[2] but with musicians, fruit pickers, and hunters in the decoration. A third box with purely plant decoration in the Hispanic Society of America, New York, is inscribed with the name of the carver, who worked in Madinat-az-Zahra about 970 (figure 24).

Another important group of works are the oliphants, or great hunting horns, carved from the ends of elephant tusks which were produced in considerable numbers in south Italy (cat. no. 247; figure 25; see also colorplate 66) in the eleventh and twelfth centuries. These works are of mixed Islamic and European origin, but since no examples have been found in the East, one can assume they were made for European consumption. One horn has been in the treasury at Aachen since the Middle Ages, others in the treasuries of Saint-Denis and the Cathedral of Le Puy.[3] The Walters example is a typical mixture of Islamic animals with Roman vine scrolls and other elements.

From Fatimid Egypt comes a series of caskets and architectural inlays of the eleventh and twelfth centuries. These show figures and animals among plant decoration. The elephant (cat. no. 220; see colorplate 59) is typical of a shaped inlay intended to be part of the decoration of a door or panel with alternate areas in contrasting wood. The scene of a man and dog (cat. no. 221; figure 26) is an unusual departure from Islamic subject matter.

Inscriptions are frequent among Islamic inlays and, since they were mostly inlaid in mosque doors or pulpits (mimbars), often carry religious sentiments. One large

Figure 24. Box with plant decoration, ivory, Hispano-Moresque, made at Madinat-az-Zahra c. 970. The decoration is typical of a number of fine ivories made in Spain by Islamic craftsmen, many of which are inscribed. This example was signed by the carver "Halaf," working at Madinat-az-Zahra. Hispanic Society of America, New York.

Figure 25 (cat. no. 247). Hunting horn (oliphant), ivory, south Italian, made by Islamic craftsmen, 11th century. A large group of oliphants were produced in south Italy for the European market. Like this example, the Islamic elements, in this case the animals, are placed in a symmetrical vine scroll issuing from a vase, in the Roman fashion. On the side of the horn is a caduceus, the intertwined snake symbol of a herald. (See also colorplate 66.)

Figure 26 (cat. no. 221). Inlay with man and dog, ivory, Egyptian (Fatimid style), first half 12th century. The realism of the scene is unusual in Islamic art; the subject is thought to be based on the European manuscript calendar scene for November, the symbol for which is a man killing his pig with an ax.

fourteenth-century inscription in thuluth script has a non-religious sentiment: "Night and day have mixed in the enjoyment of it," and is therefore thought to have been inlaid as the side of a box (cat. no. 236; figure 27). The inlay is Egyptian, of the Mamluk Dynasty. A second thuluth inscription (cat. no. 237), probably part of a door, compares with similar pieces from the tomb of Shaf Ismā'il.[4] The inlay is Persian, of the Safavid Dynasty, and dates from the early sixteenth century. The inscription translates: "In the evening and the morning, thou wilt give food."

The game of chess originated in the East, probably in India, and some of the earliest known chessmen were made in India and Persia. While many were abstract in form, some were figural, and one of the earliest and most interesting of these is a king in the form of a ruler riding an elephant, surrounded by a group of horsemen. The piece is six and one-quarter inches high, and is attributed to the ninth century and thought to have been a gift of Harun al-Rashid to Charlemagne.[5] Formerly in the Treasury of Saint-Denis, the chessman is now in the collection of the Cabinet des Médailles in Paris.

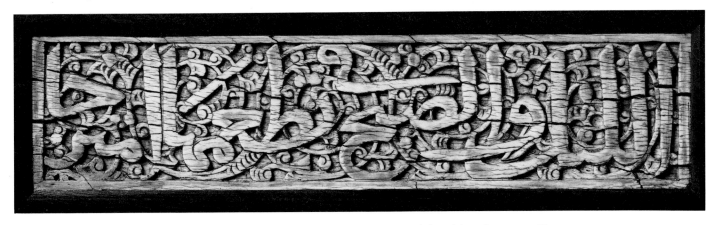

Figure 27 (cat. no. 236). Inlay with inscription from a box, ivory, Egyptian (Mamluk style), 14th century. The use of the word as ornament is one of the oldest of Islamic traditions. This panel has the nice sentiment: "Night and day have mixed in the enjoyment of it." The inscription is in thuluth characters.

A second large group of Islamic works made by Islamic craftsmen for the European market, in addition to the oliphants, were the so-called Siculo-Arabic boxes of Sicily, which were produced from the twelfth to the fourteenth centuries.[6] They fall into two physical types: round or in the shape of a truncated pyramid. The surfaces are decorated with painted subjects, usually in a pale-brown pigment with darker brown for emphasis and details picked out with gilding. There are three kinds of decoration. One has subjects of pure Islamic derivation, such as seated figures within circles or quatrefoils, alternating with arabesques (cat. no. 226; see colorplate 60). A second has subjects based on European heraldry, including lions and eagles within circles (cat. no. 234; see colorplate 61) and occasionally actual European coats of arms. A box in Madrid bears the blazons of Don Martín of Aragón (1374–1409), who married Marie, queen of Sicily, in 1391, the probable date of the box.[7] The third and most numerous group is decorated with birds and animals only (cat. no. 230).

During the entire period of production, Sicily was ruled by the Normans, and while many boxes have purely Islamic decoration, they seem to have been sold primarily to Europeans. Boxes in various cathedral treasuries of Europe, and combs in the same style in Florence and at the Cathedral of Roda,[8] indicate that Islamic subject matter was not considered a detriment to Christian use.

Other ateliers in Sicily produced bishops' croziers of ivory. The shafts are square in section with truncated corners, and the central subject of the volute is cut out of flat sections of ivory so that the figures are in openwork profile. The majority of them have the Lamb of God as the central motif. These croziers were clearly made for the Christian community, and while many are found in Italy, they also may be found in Austria and other countries as well. The original painted and gilded decoration on their surfaces has not survived well on most examples.[9] They had considerable influence on the forms of thirteenth- and fourteenth-century European croziers, a thirteenth-century Italian example of which has taken its basic form from the Sicilian prototype (cat. no. 260). The eagle in the center, however, is carved, whereas those of the Sicilian ateliers were flattened profiles.

The Islamic ivory trade with Europe in the eleventh and twelfth centuries was probably the key to the interest in ivory that developed in Europe in the thirteenth and fourteenth centuries. There is also evidence that actual Islamic objects, such as the twelfth-century Persian caskets with applied standing figures in bronze, of which there is an example in the Museum of Fine Arts, Boston,[10] were the source of design for certain European objects like the Cologne reliquary boxes with applied figures in bone (cat. no. 258). The Sicilian croziers, as mentioned above, were another source for European copies. European objects with Kufic inscriptions, such as Limoges enamels, also confirm the artistic flow from east to west during the twelfth and thirteenth centuries.

Some seventeenth-to-nineteenth-century Persian and Turkish daggers have carved ivory hilts (cat. no. 238; see colorplate 62), and there is also a group of seventeenth-century Mughal powder flasks with relief figures (cat. no. 240; see colorplate 63). These flasks are carved with intertwined animals at the spouts, some with several heads so that a head with eyes and horns can be seen from any direction (cat. nos. 240 and 241). The concept relates to the complex Indian drawings which have many animals drawn within the outline of a single larger animal.

NOTES

1. E. Kühnel, *Die Islamischen Elfenbein- skulpturen, VIII–XIII Jahrhundert*, Berlin, 1971, no. 22.

2. Kühnel, no. 31.

3. Kühnel, nos. 55 and 56, 77.

4. *The Arts of Islam*, Hayward Gallery, London, 1970, nos. 156a–e.

5. Kühnel, no. 17.

6. P. Cott, *Siculo–Arabic Ivories*, Princeton, 1939.

7. Cott, no. 139.

8. Cott, nos. 59 and 60.

9. Cott, nos. 148–181.

10. Kühnel, text fig. 53.

Catalogue, Islamic Ivories

217a,b,c. VINE MOTIFS

Bone plaques. Egyptian (Umayyad style), 7th–8th century

These three plaques have similar designs of grapevines and dotted ornament. Each plaque has a hole for attachment, and two are chipped at the edges.

217a. H: 3⅞" (9.9cm) 71.1107
217b. H: 2⅝" (6.8cm) 71.1108
217c. H: 3½" (8.9cm) 71.1116

HISTORY: Purchased from Gimbel Brothers, 1943; 217c the gift of Mrs. Saidie A. May, 1944.

218. EAGLE AND IBEX

Bone plaque. Egyptian (Fatimid style), 11th–12th century

This is a small flat plaque with an eagle above an ibex against a rough plant ornament.

The plaque has been cut at the left and at the bottom and has two chips—at the lower right corner and in the top right.

Two similar plaques are in the Islamic Museum in Berlin (Kühnel, no. 114) and the University Museum in Cairo (Kühnel, no. 116). The same design is repeated in a plaque in the M. A. Mayer Memorial Institute, Jerusalem (Kühnel, no. 120).

H: 3¼" (8.2cm) × W: 1½" (4.0cm) 71.1114

HISTORY: Purchased from Joseph Brummer, New York; gift of Mrs. Saidie A. May, 1944.

219. PEACOCK AND RABBIT

Ivory inlay. Egyptian (Fatimid style), 11th–12th century

This fragment of a cruciform inlay from a piece of furniture shows a peacock and the head of a rabbit against a ground of scrollwork. Such inlays were used in doors, boxes, and trunks with carved wooden frames of contrasting color. This example was found at Al-Fustāt (Old Cairo).

H: 3½" (8.9cm) × W: 1¾" (4.4cm) 71.566

HISTORY: Found at Al-Fustāt; purchased from Dikran Kelekian, Paris, 1914.

BIB.: Kühnel, no. 107.

220. ELEPHANT AND RIDERS

Ivory inlay. Egyptian (Fatimid style), first half 12th century

This is a five-sided inlay for furniture. Two edges are broken away. The elephant carries a driver with an ankus and a rider playing the trumpet. The background is decorated with a vine scroll.

H: 2¹³⁄₁₆" (7.1cm) × W: 2⁹⁄₁₆" (6.4cm) 71.563

HISTORY: Purchased from Dikran Kelekian, Paris, before 1931.

BIB.: R. Ettinghausen, "Early Realism in Islamic Art," *Studi orientalistici in onore di Giorgio Levi della Vida*, Rome, 1956, I, 259; Kühnel, no. 92.

See also colorplate 59

217a

217b

217c

218

219

220

221. MAN AND DOG

Ivory inlay. Egyptian (Fatimid style), first half 12th century

A five-sided inlay from a piece of furniture. The subject of a man and dog is unusual in Islamic art; it is thought to be an interpretation of the European calendar scene for November, in which a man kills his pig with an ax. The background is a vine scroll.

H: 2⅞″ (7.3cm) × W: 3⅝″ (9.1cm)
71.562

HISTORY: Purchased from Dikran Kelekian, Paris, before 1931.

BIB.: R. Ettinghausen, "Early Realism in Islamic Art," *Studi orientalistici in onore di Giorgio Levi della Vida*, Rome, 1956, I, 257 ff.; Kühnel, no. 91.

See also figure 26

222. EAGLE AND RABBIT

Ivory inlay. Egyptian (Fatimid style), 12th century

The eagle and rabbit motif is one of the most frequent in Fatimid art. It is seen here against a background of vines. The five-sided plaque is broken at its lower margin.

H: 2⅜″ (6.0cm) × W: 1⁵⁄₁₆″ (4.9cm)
71.564

HISTORY: Purchased from Dikran Kelekian, Paris, before 1931.

BIB.: Kühnel, no. 102.

223. EAGLE AND RABBIT

Ivory inlay. Egyptian (Fatimid style), 12th century

The eagle and rabbit are on a ground of vine scrolls. The rabbit is decorated with a textile pattern. The upper section of the five-sided plaque is broken away.

H: 2⅛″ (5.4cm) × W: 2³⁄₁₆″ (5.5cm)
71.565

HISTORY: Acquired before 1931.

BIB.: Kühnel, no. 103.

224. STANDING FIGURE

Ivory inlay. Egyptian (Fatimid style), 12th century

A hexagonal furniture inlay with the figure of a standing man in a coat, decorated with palmettes.

H: 2¹¹⁄₁₆″ (6.8cm) × W: 1¼″ (3.1cm)
71.567

HISTORY: Purchased from Dikran Kelekian, Paris, 1926.

BIB.: Kühnel, no. 93.

225. INCISED DECORATION

Cylindrical ivory box with gilt-copper mounts. Sicilian (Siculo-Arabic style), 12th century

This is a small undecorated box with an incised molding below the lid. The hinge and hasp appear to be replacements, though the ring handle of the lid and its rosette washer are original.

H: 2¹³⁄₁₆″ (7.5cm) × D: 3⁹⁄₁₆″ (9.0cm)
71.307

HISTORY: Purchased from Dikran Kelekian, Paris, before 1931.

BIB.: Cott, no. 96.

226. ROUNDELS WITH FIGURES

Painted and gilded cylindrical ivory box. Sicilian (Siculo-Arabic style), 12th century

The lid and base of the box are reinforced with a wooden core, and the metal clasps that originally connected the ivory veneers to one another are now missing. The decoration consists of two roundels, each showing a seated figure with a glass and with arabesque ornament. Between the roundels are birds and gazelles. There is an arabesque design below the area where the lock once was. The base has an inscription in nashki around its circumference that translates: "To its owner, the enduring blessing, the enduring, all-inclusive blessing; the enduring, the sublime good health, the sound one, forever." On the lid are three palmettes and a border of scrolling vines. A second inscription around the lid cannot be read. The gilt knob is a replacement. There are considerable traces of gilding, best preserved in the inscription.

H: 5⅛″ (13.0cm) × D: 5⅛″ (13.1cm)
71.311

HISTORY: Collection of Baer, Frankfurt; Nuremberg, Germanisches Museum; collection of J. G. Pollack, London; purchased from Henry Daguerre, Paris, 1925.

BIB.: E. Diez, "Bemalte Elfenbeinkästchen und Pyxiden der Islamischen Kunst," *Jahrbuch der Preussischen Kunstsammlungen*, 1910, XXXI, 235; XXXII, 138; Cott, no. 81; A. Pope, *A Survey of Persian Art*, New York, 1938, pl. 1435D, III, 2662.

See also colorplate 60

221

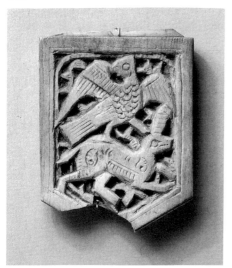

222

223

224

225

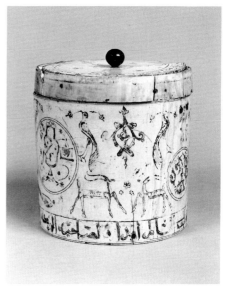

226

227. BIRDS AND VINE SCROLLS

Painted ivory comb. Sicilian (Siculo-Arabic style), late 12th century

This small comb is painted on one side with a rectangular panel showing a lively vine-scroll design. The terminals on each side are painted with circles. The reverse has a roundel with a bird that is flanked by two open-winged birds. The drawing is in brown; the frame of the vine scroll and details of the birds were gilded.

The comb has lost many teeth on each side. It was broken in half and has been repaired.

H: 3¼" (8.3cm) × W: 2⅝" (6.5cm) 71.48

HISTORY: Purchased from Dikran Kelekian, Paris, 1930.

BIB.: Cott, no. 141.

228. PEACOCKS, CHEETAH, AND SCROLLS

Painted ivory comb. Sicilian (Siculo-Arabic style), late 12th century

The comb is painted on one side with two roundels containing peacocks, which flank a cheetah; the terminals are painted with circles. The reverse side is treated with a long rectangular panel of scroll ornament and circle decoration.

The comb possibly had a liturgical use, since two nearly identical combs survive in the treasuries of S. Trinità, Florence, and the Cathedral of Roda, Spain (Cott, nos. 59 and 60). All three have been attributed to the same workshop.

Two teeth are missing on one side, and the tips of the teeth on the other side are broken in a jagged line. The tails of the peacocks and the lotus pod were painted brown, and there are traces of gilding.

H: 3¹³⁄₁₆" (9.7cm) × W: 3¾" (9.5cm) 71.58

HISTORY: Purchased before 1931.

BIB.: Cott, no. 146; F. Swoboda, *Die liturgischen Kämme*, Tübingen, 1963, 51, nos. 136–138.

229. MOLDED DECORATION

Turned ivory cylindrical box. Sicilian (Siculo-Arabic style), 12th century

This ivory box is made with molded decorations, where both the body and lid are composed of elements turned on the lathe with raised ribbed moldings at top and bottom. The mounts are complete: lock, hasp, handle, hinges, and suspension rings. The four supports at the base not only tie the bottom and sides together but also serve as feet.

H: 6⅛" (15.5cm) × D: 5¹³⁄₁₆" (12.5cm) 71.309

HISTORY: Purchased from Dikran Kelekian, Paris, before 1931.

230. BIRD AND ANIMAL SUBJECTS

Turned and painted ivory cylindrical box. Sicilian (Siculo-Arabic style), 12th century

The lid and body of the box are turned with moldings at top and bottom, and the surface is painted with birds, rabbits, and eagles catching ducks. The painting has been strengthened at a later time. The gilt-copper mounts are complete, but the feet have been bent.

H: 5⅛" (13.0cm) × D: 4¹¹⁄₁₆" (11.5cm) 71.308

HISTORY: Collection of Count Gregorii Stroganoff, Rome; Elia Volpi, Florence (sale, Florence, 1916, lot 3); purchased before 1931.

BIB.: Cott, no. 129.

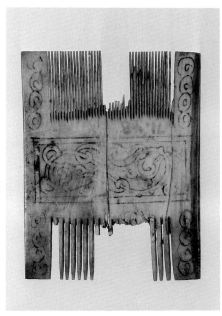

227

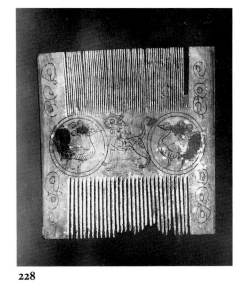

228

228

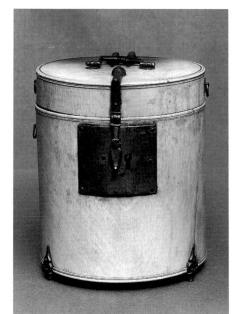

229

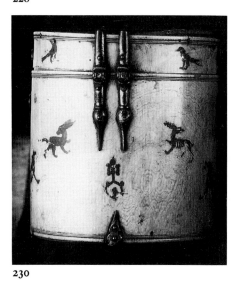

230

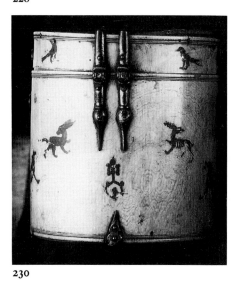

230

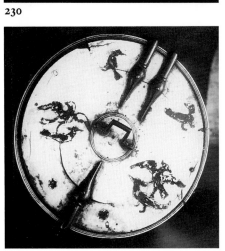

230

231. PUNCHED DECORATION

Truncated pyramidal ivory box with copper-gilt mounts. Sicilian (Siculo-Arabic style), 12th century

This box differs from others in the Siculo-Arabic style in having the diagonal joints between plates connected with ivory pins. There are punched crosses at the corners and on the lid, with traces of red pigment. One edge of the cover is damaged.

H: 2¾″ (7.1cm) × L: 4¾″ (12.4cm) × W: 3⅛″ (8.1cm) 71.312

HISTORY: Purchased before 1931.

BIB.: Cott, no. 66.

232. PUNCHED DECORATION

Truncated pyramidal ivory box with copper-gilt mounts. Sicilian (Siculo-Arabic style), 12th century

This box is of simple design, with the original corner mounts. The intermediate joints are connected with copper wire, passing through adjoining ivory plates. There is punched decoration of crosses on the ends, with traces of red and black pigment.

H: 3¹³⁄₁₆″ (10.0cm) × L: 6⁷⁄₁₆″ (16.5cm) × W: 4⅛″ (10.5cm) 71.310

HISTORY: Purchased from Léon Gruel, Paris, 1925.

233. PUNCHED DECORATION

Truncated pyramidal ivory box with gilt-copper mounts. Sicilian (Siculo-Arabic style), 12th century

While the walls and structure of this box are the same as other Siculo-Arabic examples, the gilt-copper accessories suggest that it was built for security. Three unusually heavy mounts are on each corner of the box, plus two on each corner of the lid. The customary lock and additional reinforcing straps are on each end of the lid and on the box. It is equipped with carrying handles at each end and four flattened ball feet. The decoration consists of small crosses made of punched dots, stained red and black.

H: 5½″ (14.0cm) × L: 8¹³⁄₁₆″ (22.5cm) × W: 5¾″ (14.6cm) 71.313

HISTORY: Purchased before 1931.

BIB.: Cott, no. 63.

234. HERALDIC MOTIFS

Truncated pyramidal ivory box with painted and gilded decoration. Sicilian (Siculo-Arabic style), 13th century

This box is a conventional example of the Siculo-Arabic style, with ivory panels mounted on a wooden core and a truncated pyramidal cover, but the decoration is unusual. The mounts are standard for Sicilian work: long strap hinges and copper connectors tying each ivory plate to the adjoining plate. The decoration is in the painted technique of the Islamic boxes from Sicily, but displays largely European motifs: heraldic lions and an eagle, lions and birds with plant ornament, two tiny dragons, and bands of acanthus and vine-scroll ornament. As is true for the boxes in the Victoria and Albert Museum (Longhurst, no. 369-1871) and the Historical Museum, Madrid (Cott, no. 139), which show European coats of arms, the decoration must have been added in Europe. A box in Florence (Cott, no. 115) shows motifs of vine scrolls, a griffin, an eagle, and cheetahs painted in a similar manner, which Cott has compared to early majolica decoration in Italy. The decoration is probably Italian. The original lock and hasp are missing, and the paint is considerably rubbed.

H: 4¼″ (11.0cm) × L: 7½″ (19.0cm) × W: 4¼″ (11.0cm) 71.306

HISTORY: Collection of Robert Forrer, Strasbourg; purchased from Léon Gruel, Paris, 1925.

BIB.: Cott, no. 114.

See also colorplate 61

235. ARABESQUES AND LIONS

Cylindrical ivory box with painted decoration. Sicilian (Siculo-Arabic style), first half 13th century

This cylindrical box has a flat lid and is painted on the sides with three arabesques in quatrefoil frames. The lid has three smaller circles with arabesques and, between them, striding lions. The figures are painted in brown and gilded.

The copper rim of the lid appears to be original. It is attached with four metal straps on the outside and a number on the inside; some are missing. The lock is missing but part of the catch plate is preserved. The base is attached with four copper-gilt straps.

At some time the box was converted to a Christian pyx with the attachment of a copper-gilt handle with a glass ball finial.

H: 5⅛″ (13.0cm) × D: 3¾″ (9.6cm) 71.314

HISTORY: Formerly in the collection of the Germanisches Museum, Nuremberg; purchased from Léon Gruel, Paris, 1925.

BIB.: Cott, no. 84.

236. INSCRIPTION

Ivory plaque. Egyptian (Mamluk style), 14th century

This unusually fine plaque with an inscription probably decorated the side of an ivory box, rather than a door or pulpit. The inscription in thuluth characters may be translated as: "Night and day have mixed in the enjoyment of it." The plaque was originally inlaid between pieces of wood for contrast. The present frame is modern.

H: 2½″ (6.3cm) × W: 11⅛″ (28.2cm) without frame 71.561

HISTORY: Purchased before 1931.

BIB.: A. Welch, *Calligraphy in the Arts of the Muslim World*, Austin, 1979, no. 25.

See also figure 27

237. INSCRIPTION

Ivory inlay. Persian (Safavid period), early 16th century

This is a shaped panel for inlay into a secular door or frame. The inscription in thuluth translates: "In the evening and the morning, thou wilt give food." The two lower corners of the star ends of the plaque have been broken.

Five similar panels from the tomb of Shaf Ismā'il (1502–1524) are in the collection of the Iran Bastan Museum, Teheran (*The Arts of Islam*, Hayward Gallery, London, 1970, nos. 156a–e).

L: 7⅞″ (20.1cm) × W: 1⅝″ (4.1cm) 71.580

HISTORY: Purchased from Dikran Kelekian, Paris, 1911.

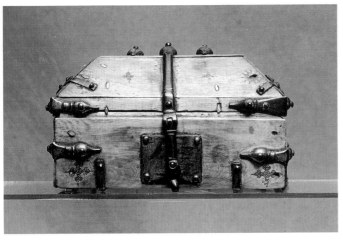

231

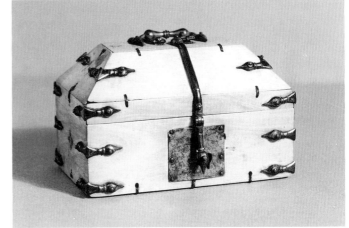

232

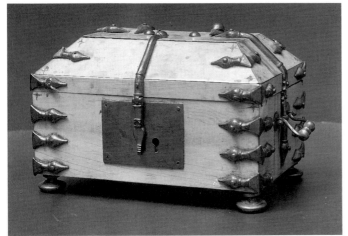

233

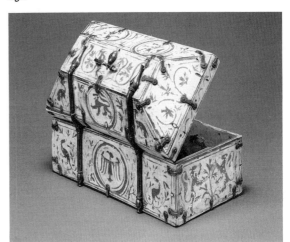

234

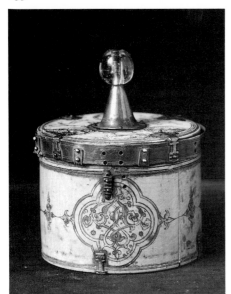

235

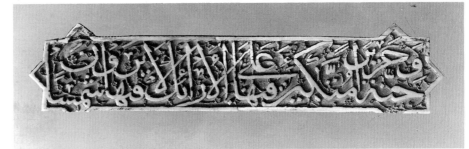

236

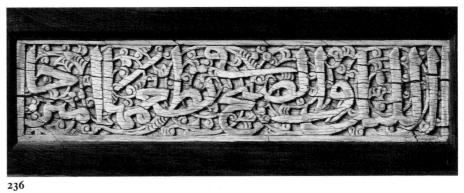

237

238. ARABESQUES

Walrus ivory dagger grip. Turkish, first half 17th century

The surface of this dagger grip is crisply carved with an arabesque of vines and flowers, interrupted by bands of guilloche. These designs have for many years been called Hispano-Moresque on the basis of examples in the Armeria Reale, Madrid (Exhibición de Madrid, 1892, no. cii), and the collection of the countess of Behague (G. Migeon, *Manuel d'art musulman*, Paris, 1927, fig. 161, 358). However, a related complete dagger in Dresden forms part of the captured Turkish booty, and appears in the inventory of the Turkenkammer of 1674 as no. 139 (J. Schobel, *Princely Arms and Armour*, London, 1975, no. 176a, 229). The style of the dagger grips is consistent with Turkish ornament of the early seventeenth century. Other examples are in the British Museum (Dalton, no. 573) and the Victoria and Albert Museum (Longhurst, no. 269-1895).

L: 4⁹⁄₁₆″ (11.5cm) × W: 1¾″ (4.6cm) 71.571

HISTORY: Collection of Michel Boy, Paris (sale, Paris, May 15, 1905, lot 337); purchased at the sale.

See also colorplate 62

239. HORSEMAN AND LIONS

Ram's horn ink horn. Singhalese, early 17th century

The body of the horn is carved with elaborate interlacing vine scrolls that emanate from the mouths of two seated and confronted lions. On the reverse is a rectangular panel between columns with floriate capitals showing a European horseman dressed in early-seventeenth-century costume. At the base the grip is carved with the head of a man in native costume that includes a woven hat. The base has been treated with varnish and has a dark, mottled color.

H: 3¼″ (8.3cm) 72.18

HISTORY: Collection of Henry Walters before 1931; Mrs. Henry Walters (sale, New York, May 1, 1941, lot 1025); purchased at the sale.

240. INTERTWINED ANIMALS

Ivory powder flask. Indian (Mughal style), second half 17th century

An unusually complex decoration of intertwined and composite animals decorates the two ends of the flask. At the spout end a head with four eyes has the horns of a black buck and an antelope; it can be read in four directions. The head is combined with figures of antelope, lions, and birds. The other end is composed of boar, elephant, lion, and mongoose. The central field shows a cheetah or lion hunting an antelope or goat wearing a collar. It is thought that there was a magical significance in the use of such animal combinations on powder flasks.

There is a spring catch over the spout and a ring for suspension.

L: 8¾″ (22.1cm) 71.418

HISTORY: Purchased from Demotte, Paris, 1925.

BIB.: W. Born, "Ivory Powder Flasks from the Mughal Period," *Ars Islamica*, IX, 1942, 94–111.

See also colorplate 63

241. INTERTWINED ANIMALS

Ivory powder flask. Indian (Mughal style), second half 17th century

This small flask for gunpowder is decorated with zigzags and conjoined animals. The animals are so arranged that there appear to be animal combats as well as heads with two faces or pairs of horns. This tradition occurs in Indian painting, where figures of single elephants or horses have bodies composed of a conglomeration of animals.

There is a cord for suspension and a spring catch over the spout.

L: 6⅜″ (16.1cm) 71.419

HISTORY: Collection of Max and Maurice Rosenheim (sale, Sotheby's, London, May 9–11, 1923, lot 304); purchased at the sale.

BIB.: W. Born, "Ivory Powder Flasks from the Mughal Period," *Ars Islamica*, IX, 1942, 94–111.

242. RED AND BLACK DECORATION

Ivory and steel chopping tool. Persian or Indian, 18th century

This small chopping tool is of unknown use. The ivory handle is decorated with red and black punching. The Damascus steel blade has openwork panels with inscriptions at the tang. The Arabic inscription includes the date 1189 Hijra (A.D. 1775–1776) and a portion of a Koranic verse.

A second example is in the Museum of Fine Arts, Boston (07.660).

L: 5⅜″ (13.8cm) 52.101

HISTORY: Purchased before 1931.

BIB.: A.U. Pope, *Masterpieces of Persian Art*, New York, VI, 1945, pl. 107A.

243. HUNTERS AND PORTRAITS

Walrus ivory pen-box. Persian, 1815–1816

This pen-box is a hollowed-out walrus tusk, into which a sliding drawer has been fitted. The surface is carved with hunting horsemen and busts of three men and a woman within floral frames. The underside of the box is signed in a cartouche: "Work of Kazim al-Hasani, 1231" (A.D. 1815–1816). There is a chip and a repair where the side touches the cover.

L: 9″ (22.8cm) × H: 1½″ (3.6cm) 71.570

HISTORY: Purchased before 1931.

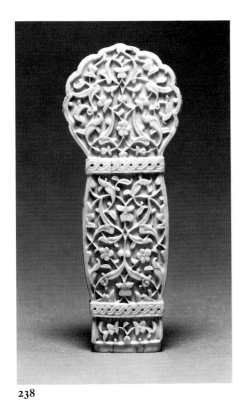

238

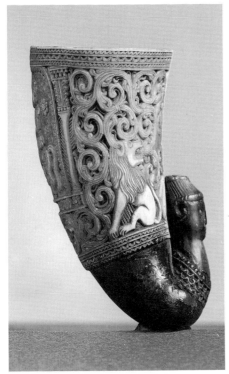

239

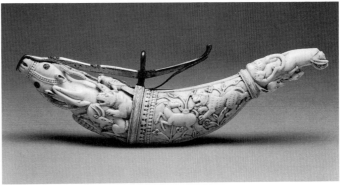

240

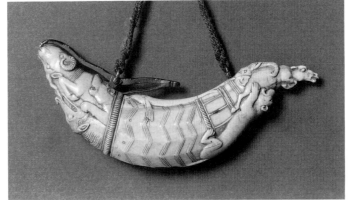

241

242

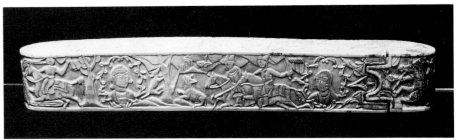

243

8 Early Medieval Ivories

by Richard H. Randall, Jr.

AFTER THE FALL OF ROME IN 476, there ensued a period of tribal migrations and warfare throughout Western Europe. The Huns, Visigoths, Avars, Franks, Germans, and other barbarian tribes changed territories, fought among themselves, and conquered and reconquered the older cities of the former Roman Empire. Because they carried their wealth with them in their wanderings, these migrating peoples particularly valued the arts of the metalworker and the goldsmith. A few ivories have survived from that period, but they are scattered and difficult to date for lack of comparative evidence.

Among the earliest of these ivories is the belt buckle from the Tomb of Saint Césaire at Arles, which can be dated to the mid-sixth century.[1] It is carved in relief with a scene of the two guards of the Holy Sepulcher. Animal and abstract interlace, probably brought to the Continent by Irish monks, is reflected in an ivory casket now in the Anton-Ulrich Museum, Brunswick, Germany. In the Middle Ages the casket was in the Abbey of Gandersheim, Brunswick, where it formed part of the "loot of Ely by the Danes in 866."[2] The interlace reflects similar concepts in metalwork, and parallels may be seen on buckles and high crosses in the British Isles. The British Museum displays the famous "Franks Casket," a series of panels from a box carved in flat relief. Its iconography is both rich and curious, combining images of Romulus and Remus with battles and scenes of the infancy of Christ.[3] It was probably made in Northumbria in the eighth century.

A Spanish ivory in the Walters Collection, apparently created in the Christian kingdom of Asturias, is one of these great early rarities (cat. no. 244; see colorplate 64). This remarkable panel combines a series of scenes from the early life of Christ in a rectangular format. A number of omissions and conflations in the scenes suggest the naïveté of the early period. The joining together of the Flight into Egypt with the Adoration of the Kings, which appears here, can be found in a metalwork example of the seventh century, although the Walters ivory dates later, probably from the ninth century.

During the Carolingian period (c. 800) carving in ivory experienced a true revival. Charlemagne, having solidified the kingdom of the Franks in the late eighth century, sought to capture both the glory and the culture of ancient civilization by setting scribes and artists to work copying classical—particularly late classical—texts and illustrations. Under his guidance, a court school of artists produced magnificent books with lavish miniatures, often with covers of goldsmiths' work and/or ivory. Some of their models came from the Byzantine East, but many more came from Italy. This borrowing of iconography and stylistic features from all available sources continued for some centuries, forming the complex roots of Western art.

During the Carolingian period and under the succeeding reigns of the Ottonian emperors, the system of imperial and ecclesiastical patronage fostered considerable change in the location of manuscript and ivory workshops. Aachen, Reims, Metz, Liège, and other centers in turn shared the patronage and contributed to the production of manuscripts and ivories.

Although the ancient models themselves have rarely survived, one ivory plaque of the Three Marys at the Tomb, which was copied by court artists during the Carolingian period, is extant.[4] It dates from about 400 and is now in the Bayerisches Nationalmuseum, Munich. The Munich plaque was employed as the point of departure for a Carolingian ivory in Liverpool, where the tomb and figures of the angel and the Holy Women are carefully copied, even to the gestures of the hands (figure 28). This iconographic type seems to have influenced the same scene on the cover of the Book of Pericopes of Henry II, also in Munich, although the character of the Holy Women has been altered.[5]

The Walters Collection contains a third ivory related to the early Munich plaque, which may date from 870 to 880 (cat. no. 245; see colorplate 65). Here the influence of both the book cover of Henry II and the early scene of the Three Marys in Munich can be noted. The Three Marys and the angel display the same gestures as the

globe of the world in the Gospel Book of Emperor Lothair, executed about 851.[8] Second, the angels who hold the mandorla wear mittenlike sleeves, a misinterpretation of the folds of drapery often used to cover the hands of figures holding a sacred object. Third, the eyes of Christ are strangely rendered with wide-flanged sockets. These alterations or misunderstandings of the model suggest that the ivory and its companion plaque, which shows the angel at the Tomb,[9] are Carolingian copies, perhaps from a provincial center.

The important, "classical" revivals of the Carolingian and Ottonian emperors had a lasting impact on medieval art, but there were a number of other influences that also affected the stylistic features of ivories in the ensuing

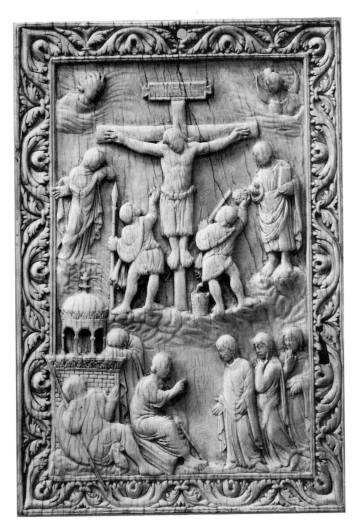

Figure 28. Crucifixion and Three Marys at the Tomb, north French (Carolingian), ivory, third quarter 9th century. The same scenes are shown on the Walters ivory, catalogue no. 245. The scene of the Three Marys at the Tomb is a very close copy of a fourth-century ivory in the Bayerisches Nationalmuseum, Munich. The Carolingian subject is carved on the reverse side of a Roman consular diptych. The Merseyside County Museum, Liverpool.

Figure 29 (cat. no. 246). Christ in a mandorla, ivory, from a book cover, Carolingian, 9th–10th century. The ivory is based on a Coptic model like the five-part book cover in the Bibliothèque Nationale, Paris, made in the sixth century. The copyist misunderstood some of the details of the original; one notes that Christ sits in midair without a throne, and that the angels have mittenlike sleeves where they touch the mandorla. The place of origin is uncertain.

Munich and Liverpool ivories, but the figures have become attenuated and crowded together. In the Crucifixion scene only the monster serpent at the foot of the cross has been borrowed and exaggerated from the book cover of Henry II. This suggests that models were used and reinterpreted continually as the schools of Carolingian illumination and ivory carving developed.

A second Carolingian ivory in the Walters Collection (cat. no. 246; figure 29) is based on a sixth-century Coptic model similar to those in the Cabinet des Médailles at the Bibliothèque Nationale and the Musée de Cluny in Paris.[6] The plaque depicts Christ in Majesty.[7] As in the case of the Coptic emperor ivory mentioned earlier (cat. no. 176; see colorplate 48), the carver has somewhat altered his model in the interpretation of Christ in a mandorla. First, the Christ figure, though powerful and energetic, sits in midair rather than in the conventional manner on a rainbow, globe, or throne. A typical representation would be that of the similar painted figure of Christ seated on a

centuries. One of these was the presence of Islamic craftsmen in Europe, in south Italy, Sicily, and Spain. An example of the blend of Islamic and European cultures may be seen in a great eleventh-century oliphant, or hunting horn, from south Italy (cat. no. 247; figure 25; see colorplate 66). It depicts characteristic Islamic animals —birds, lions, rams, and other creatures—within a symmetrical vine scroll that issues from a vase in the classical Roman manner. There is also on the upper surface of the horn a pair of intertwined snakes, perhaps a reference to the caduceus, or wand, symbolic of the herald Mercury. This same feature occurs on several other surviving oliphants and illustrates the intermixture of Roman features with the Islamic vocabulary.

A large group of Siculo-Arabic round and truncated pyramidal ivory boxes, croziers, and combs were made by Islamic craftsmen in Sicily.[10] They have painted decoration with gilded details and appear to have been made to serve the European and Arab markets (cat. nos. 225–235). Some of the decoration is of purely Islamic significance (for example, cat. no. 226), which is painted in the Persian style with scenes and arabesques, while others (for example, cat. no. 234) depict European motifs of plants, animals, and heraldic emblems. Many are generically decorated with animal subjects that would have served customers of any religious persuasion. It is interesting to note, however, that the character of the decoration did not stop their use by European religious communities: an ivory liturgical comb in the Cathedral of Roda in Spain is ornamented with typical Islamic interlace.[11]

Another strong influence, particularly in Italy, was that of Byzantium. In fresco and mosaic cycles, in manuscripts, ivories, and metalwork, Byzantine art left a strong impression. One has only to think of the mosaics of Saint Mark's in Venice to understand the extent of Byzantium's influence on Western culture, brought on through trade with the East and by the Crusades. A fine example of this influence is an early twelfth-century north Italian ivory plaque of the Last Supper (cat. no. 251; figure 30). Two other panels survive from this series, which probably decorated a single large object such as an altar frontal. The Walters panel shows the Byzantine type of banquet, with a sigma-shaped table and the figures at the two ends reclining in Eastern fashion. Buildings in the background indicate the city of Jerusalem. Other examples, however, like the great Last Judgment panel in the Victoria and Albert Museum, which was perhaps made in Venice, remain more faithful to Byzantine canons and may have actually been created by artists trained in the East.[12]

As a result of the melding of numerous influences with the indigenous style, the emerging Romanesque style developed differently in ivory carving, as it did in architecture, in various parts of Europe. The Early Middle Ages was an age of great creativity and individualism, with important abbots and bishops vying with one another for ascendancy in making perfect creations for God. The

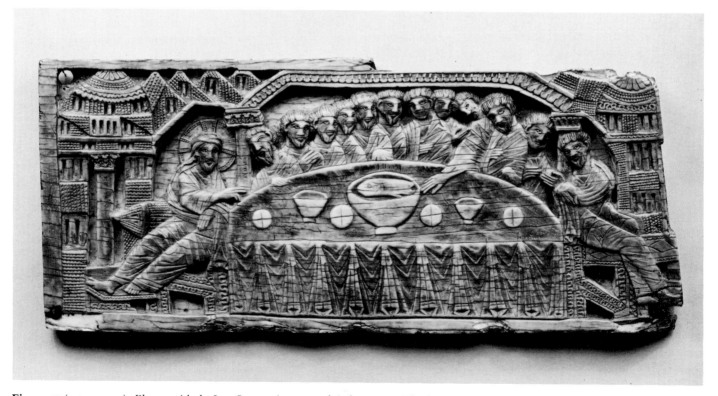

Figure 30 (cat. no. 251). Plaque with the Last Supper, ivory, north Italy, c. 1100. This large plaque is one of three to survive from a large composition, perhaps an altar frontal. All are derived from Byzantine models but have been altered in concept and in details. The figures here recline on couches, as in Byzantine examples, and the composition has been abstracted to give a pattern of repeated triangles in the tablecloth, figures, and rooflines.

Figure 31 (cat. no. 252). The Sacrifices of Cain and Abel, ivory, Anglo-Norman, first half 12th century. The division of the scene by stylized trees and plants is characteristic of English work. While the subject was often used on portable altars, the shape of this ivory suggests that it was part of a reliquary.

contrast of works of art across the Continent is revealing. For instance, the Victoria and Albert Museum's Adoration of the Kings from Spain, made of whalebone in the late eleventh century, combines a frieze of animals, typical Romanesque architecture, and a series of elongated figures with handsomely stylized drapery.[13] It is unlike any other ivory of the age and stands in strong contrast to works like the early-twelfth-century Cologne panels with their strong Byzantine overtones in the Victoria and Albert Museum[14] and the German Romanesque panels on the cover of the Mondsee Gospels, which trace their descent from the Carolingian revival (cat. no. 248; see colorplate 67).

The Mondsee panels refer back to Evangelist portraits in works of the early ninth century, such as those in the Carolingian Lorsch Gospels.[15] The settings have been altered by substituting Romanesque turrets for columns. The figures have become elongated and the drapery represented in a shorthand method, but the ultimate source is nevertheless evident. The Mondsee ivories have been attributed to Regensburg on the basis of the text of the manuscript they decorate, which has been credited to Othlon, a scribe at the monastery of St. Emeran from 1032 to 1055. The Walters also possesses a variant and slightly higher quality ivory from the same atelier (cat. no. 249).

The nervous, linear quality of an Anglo-Norman half-round ivory, probably from a reliquary, with a scene of the offerings of Cain and Abel, demonstrates the continuation of the Anglo-Saxon tradition (cat. no 252; figure 31). It was characteristic of English work in the twelfth century to frame and interrupt scenes with waving plants, as shown by this ivory and by manuscript illuminations such as those of the Winchester Bible in the Morgan Library (M. 619).[16] Another group of very different English-related works, which were probably carved at

Saint-Omer, are close in style to the Anglo-Saxon school of illumination of that great abbey.[17] Recent publications have singled out Canterbury and Bury Saint Edmunds as other centers of illumination where ivories were produced.[18]

The more formal and monumental Byzantine-influenced approach of the artists of the Meuse Valley is represented by the Romanesque Christ in Majesty plaque of the mid-twelfth century (cat. no. 253; figure 32). The figure is closely related to metalwork, and can be compared to the silver figure on the cover of the Evangelary of Anastasia in Warsaw.[19] It is also interesting to compare this Romanesque Christ with the Carolingian copy of a Coptic Christ (cat. no. 246) shown in a similar composition. The peculiar feature of outlining the eye sockets is present in both examples.

Romanesque Italy has left a number of magnificent works, including the "altar frontal" of Salerno of the late eleventh century. Thirty-eight panels, ten portrait busts, and fifteen border strips have survived. These show a combination of Lombard and Byzantine traditions. The derivation of the "altar" or "door," as has very recently been proposed, is a problem that illustrates the complexity of the development of style in the eleventh and twelfth centuries.[20]

One of the best-known groups of Romanesque ivories are the seventy-eight chessmen discovered on the Isle of Lewis in the Hebrides in 1831, now in the British Museum. These remarkably individual figures include kings, queens, knights on horseback, bishops, and pawns. Some of the soldier pawns are fiercely warlike; others bite the tops of their shields in fear. The backs and thrones of the kings and queens are beautifully carved with panels of Romanesque vine interlace.[21] Because of its size and the odd numbers of various pieces, the group must have represented the wares of a merchant or workshop active at

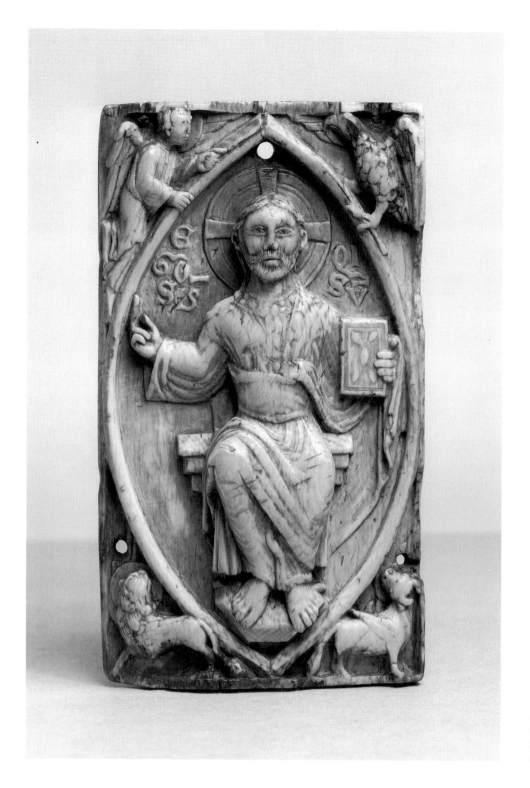

Figure 32 (cat. no. 253). Panel with Christ in Majesty, ivory, Belgian (Valley of the Meuse), mid-12th century. The mandorla of Christ is supported and held by the four symbols of the Evangelists and is inscribed in Latin with the words "I am that I am" from Exodus 3:14.

the end of the twelfth century. Because the pieces are made of walrus ivory and were found in the Hebrides, they have been attributed to Iceland or Norway.

There was a large production of ivory in Germany during the Romanesque period. Cologne was among the most prominent centers, producing book covers, chessmen, reliquaries, and portable altars. The finer pieces were made of walrus ivory and included objects like the corner of a shrine or portable altar in the Walters (cat. no. 257) and many sets of chessmen. Four fine plaques of the Evangelists, of about 1150, now in the cathedral treasury, Utrecht, are related in form to those on the Mondsee

Gospels (cat. no. 248; see colorplate 67), and are also made of walrus ivory.[22] However, a large number of late Romanesque boxes, altars, and reliquaries were made of bone. One Cologne form that has survived in large numbers is the tall octagonal reliquary box with standing figures of the Apostles (cat. no. 258; see colorplate 68). More than thirty examples are known, varying only in minor details. This series suggests the existence of a type of "mass-produced" ivory carving that seems to have been a Cologne specialty in the late twelfth and thirteenth centuries.

The lids on these eight-sided reliquaries have eight gores,

showing the four Evangelists and four cherubim. Originally there were ball finials as handles on the lids, and each reliquary had four ball feet. The finial and feet are missing from the Walters reliquary but they are preserved on the example in the Berlin Museum.[23] The Walters figures and plaques show traces of the original paint, and the gilding on the backgrounds of the eight figures is well preserved. The columns are foliate and the arches rounded in true Romanesque style. Despite the thirteenth-century date, the effects of the new French Gothic style had not yet been felt along the Rhine, where the Romanesque style was long-lived.

Farther to the north, the Romanesque style continued on for yet another century. A Scandinavian chessman (cat. no. 259), made of walrus ivory, is related in general form to the famous twelfth-century Lewis chessmen but was actually made in the fourteenth century.

Figure 33 (cat. no. 256). Draughtsman, walrus ivory, English (or north French), mid-12th century. This game piece has the curious subject of a sheep being presented to an enthroned figure by two soldiers. The carving is deeply undercut, and the eyes are inlaid with jet beads.

NOTES

1. Gaborit-Chopin, no. 36.
2. M. Longhurst, *English Ivories*, London, 1926, pls. 13 and 14.
3. Dalton, no. 30.
4. Berliner, no. 1.
5. Goldschmidt, I, no. 41.
6. Gaborit-Chopin, no. 38; Volbach, no. 150.
7. *Age of Spirituality*, no. 475.
8. J. Hubert *et al.; The Carolingian Renaissance*, New York, 1970, fig. 132.
9. The companion plaque in a German private collection was formerly in the Brugelmann Collection, Volbach, no. 236.
10. Cott, nos. 1–181.
11. Cott, no. 145.
12. Longhurst, no. A 24–1926.
13. Longhurst, no. 142–1866.
14. Longhurst, nos. 144, 145–1866, 378–1871.
15. J. Hubert, *The Carolingian Renaissance*, fig. 78.
16. M. Rickert, *Painting in Britain: The Middle Ages*, London, 1954, pl. 86.
17. Gaborit-Chopin, nos. 141–146.
18. K. R. Bateman, *St. Albans: Its Ivory and Manuscript Workshops*, Ph.D. diss., University of Michigan, Ann Arbor, 1976.
19. P. Verdier, "Un ivoire mosan du XIIème siècle et la reliure de l'evangeliare d'Anastasie," *Bulletin du Musée National de Varsovie*, XV, 1974, no. 3/4, 51–63.
20. R. P. Bergman, *The Salerno Ivories: Ars Sacra from Medieval Amalfi*, Cambridge, Mass., 1980.
21. Dalton, nos. 78–125.
22. Avril, *Le temps des croisades*, 229, no. 300.
23. Goldschmidt, III, no. 69.

Catalogue, Early Medieval Ivories

244. LIFE OF CHRIST

Ivory plaque. Spanish (Asturian), 9th century

This ivory plaque, probably from a book cover, combines various episodes of the early life of Christ. At the top are the Christ Child with the ox and the ass and the Annunciation to the Shepherds. In the second register, the Adoration of the Magi is combined with the Flight into Egypt. The Virgin and Child are seated on a donkey at the left before the central Magi who are adjacent to Herod, who sits on a *faltstuhl* at the right. The Herod figure points to the scene below, the Massacre of the Innocents, which forms a register with the Presentation of the Christ Child in the Temple; the bottom register shows the Baptism and the First Temptation of Christ.

The surface of the ivory is flat, and the background is cut away from the figures, giving them a silhouetted effect. The modeling is sharply incised. The side borders are pearled; the top border has a pattern of diagonals and the bottom border that of palmettes. The scenes are divided by double lines; the vertical divisions include a palm tree in the lowest register, a floriate column in the second, and a bird-headed column in the top. The crowns and halos of the figures are irregular shapes, some of which are decorated with balls. The upper left edge is broken at the top.

The scenes of the upper tier are best explained by a comparison with the bottom plaque of the Carolingian cover of the Lorsch Gospels in the Victoria and Albert Museum, which dates from about 810 (Goldschmidt, I, no. 14). There are three scenes in the Victoria and Albert plaque: the Virgin and Joseph at the left, the swaddled Child with the ox and ass in the center, and the Annunciation to the Shepherds at the right. The artist of the Walters ivory has eliminated the Virgin and Joseph and shown only the other scenes; the position of the angel is similar in both works.

The second tier relates to a Langobard bronze relief in the Berlin Museum, which dates from the mid-eighth century. The Berlin relief shows the Virgin and Child in a stable with the ox and ass, combined with the Adoration of the Kings and the seated Herod (H. Kehrer, *Die Heiligen Drei Könige*, Leipzig, 1908, II, 101). Herod's crown has ball decoration like that of the kings in the ivory. The type of sculptural stylization occurs in another Langobard work, the Pemmo Altar of 734–737, in which the angel is close to that of the Annunciation scene (Schiller, I, no. 262). The altar is in the Museo Archeologico Nazionale, Cividale.

Classical prototypes for the Baptism can be seen on several sarcophagi, for example, one of the fourth century in the Lateran Museum, Rome (Schiller, I, no. 148), and

in the ivory of the same subject on the Cathedra of Maximian of 454–553 in Ravenna (Schiller, I, no. 361). The profile head of John the Baptist is closely related to the Baptism on a Gaulish sarcophagus at Arles (Schiller, I, no. 352).

The most striking parallel is a group of scenes on a gold medal from Adana in Istanbul, which is in the Syro-Palestinian style of the Monza ampula (Kehrer, II, 51). Dated in the early seventh century, it combines horizontal scenes in three tiers, placing them in an unusual order. In the middle tier, one sees the Christ Child with the ox and the ass, similar to the ivory, followed by the Flight into Egypt, in which the frontally seated Virgin is positioned on the ass precisely in the manner of the ivory. In the bottom register, the Adorations of the Shepherds and of the Kings are combined into a single scene.

In the scene of the Massacre of the Innocents on the ivory, a large female figure at the lower edge holds two dead infants. This is undoubtedly Rachel and her dead children, mentioned in Jeremiah's prophecy concerning Rachel, who mourned for her children "because they were not." The biblical parallel was long held important and appears in twelfth-century mystery plays, like one written in Limoges (Bibliothèque Nationale, Ms. lat. 1139).

The Temptation of Christ appears in the Book of Kells, before 807 (C. Nordenfalk, *Celtic and Anglo-Saxon Painting*, New York, 1977, pl. 46), and in the Stuttgart Psalter of the same era (Schiller, I, no. 389). The concept in these two versions is different from that of the ivory, nevertheless, and the devils are winged manlike creatures. In the ivory Satan is a two-legged beast with claws and spines. He is posed beneath a spreading tree, as in a mid-ninth-century ivory of the Metz School (Schiller, I, no. 391). The same concept, however, is seen in the Temptation in an initial of the Otbert Psalter, made in Saint-Omer about 1000 (J. Devisse, *The Image of the Black in Western Art*, New York, 1979, II, 68, fig. 20). The composition is not only the same but the spiky crest of the devil is similar.

While the Presentation in the Temple occurs as early as the fifth century on the Triumphal Arch of S. Maria Maggiore, Rome, and in a fresco at Castelseprio of the seventh century (Schiller, I, nos. 230 and 231), the closest parallels are on the enamel cross of the Sancta Sanctorum in Rome and in the silver relief on its case, both of which date from 817 to 824 (H. Grisar, *Die Römische Kapelle Sancta Sanctorum und Ihr Schatz*, Freiburg, 1908, figs. 31, 38).

Other works of Spanish sculpture show a similar approach to the silhouetting technique of the ivory. The most striking comparison is the pair of monoliths in the Church of

San Miguel de Lillo, where the scenes are copied from the ivory diptych of Areobindus. This is Asturian work of the ninth century. The backgrounds are cut away from the figures, and there is also a relation in the stylization of the hair caps (*L'art préroman hispanique*, Zodiaque, La-Pierre-Qui-Vire, 1973, pls. 117 and 118). The same technique may be seen at San Pedro de la Nave and other ninth-century Asturian buildings (*idem*, pls. 68–75). A similar palmette to that in the lower border of the ivory, for instance, can be seen on an impost block at Sant Père de les Puelles of the ninth to tenth century (Puig y Cadafalch, *L'art wisigothique*, Paris, 1961, pl. 47c).

In Spanish works of later centuries, the same condensed scenes reappear. The combination of Herod with the Adoration of the Magi compressed into a single scene occurs in the fresco on the north wall of Sta. Maria, Tahull, of about 1123 (C. Kuhn, *Romanesque and Gothic Mural Painting in Catalonia*, Cambridge, Massachusetts, pl. 11), and the Flight into Egypt combined with the Adoration appears in an altar frontal from Lérida in the Museo d'Art de Catalunya, Barcelona (Folch i Torres, *La Pintura Romanica Sobre Fuste*, Barcelona, 1956, pl, 47).

The relationships of the subject with major works of the early ninth century or earlier, and the silhouetting technique, which is characteristic of the Asturian sculpture of the same period, allow one to place the ivory in Asturias in the ninth century. The successful narrative technique of the ivory combined with the unusual quality of such scenes as the Temptation of Christ and the Massacre of the Innocents suggest that the ivory is an early example of the revival of Christological scenes in the ninth century.

H: 5⁵⁄₁₆″ (13.5cm) × W: 3⁹⁄₁₆″ (9.1cm) 71.50

HISTORY: Purchased from Henry Daguerre, New York, 1924.

See also colorplate 64

244

245. CRUCIFIXION AND THREE MARYS AT THE TOMB

Ivory book cover. North French (Carolingian), 870–880

The plaque shows the Three Marys at the Tomb in the lower tier, and a five-figure composition of the Crucifixion in the upper tier, with the sun and the moon shown amid the leafage of the acanthus border. In style it belongs to the Liuthard Group of Carolingian ivories, named for the scribe who wrote the Psalter of Charles the Bald and several other manuscripts.

An ivory cover of the Liuthard Group now on the Book of Pericopes of Henry II in Munich (Munich Staatsbibliothek, Clm. 4425) is carved with the same subjects, and shows a large serpent at the foot of the Cross (Goldschmidt, I, no. 41). This serpent motif, which occurs in a number of Carolingian works, was greatly enlarged by the carver of the Walters ivory to become an important feature in the composition. From the serpent's mouth a tonguelike line entwines the Cross. The form of the serpent is similar to that of the salamander in the Carolingian Physiologus in Bern (Burgerbibliothek, Cod. 318, f.17v). There is perhaps a conscious connection between the salamander spitting poison at the dove in the Tree of Life and the serpent in the ivory spitting at the Cross and Christ.

A second plaque with the same subjects is in the Merseyside County Museum, Liverpool (Goldschmidt, I, no. 139), where the Crucifixion with its five-figure composition is closer to the Walters example. The gesture of the Virgin, with her left hand drying her tears on the end of her garment, is also related. (See figure 28.)

The Liverpool panel follows the fourth-century ivory in Munich (Berliner, no.1) as its model for the Marys at the Tomb. The angel and the gestures of the three women are rather directly copied. In the Walters plaque the figures are more congested and have been attenuated. While the angel's gesture is the same, he is closer to the women as they crowd toward him. The tomb in the Liverpool ivory carefully follows that of the Munich model, but the Walters example is more closely related to the three-tiered tomb on the cover of the Pericopes of Henry II.

An ivory in the Louvre (*Vingts ans d'acquisitions au Musée du Louvre, 1947–1967*, Paris, 1967, no. 260) with the Arrest of Christ in three tiers has a closely related border with large circular accents in the floral decoration. Its figure style is comparable to that of the Walters panel, with tall, attenuated figures crowded together, and with a certain ease of gesture and action. All of the related works date from 870 or slightly later.

The dealer Henry Daguerre and the scholar Adolph Goldschmidt stated that the Walters ivory came from the Abbey of Maroilles in Picardy. Goldschmidt also noted that the emperor Lothair had made a gift to the Abbey in 831, which appears too early for the ivory. Goldschmidt had not seen the ivory, only a photograph, and was unsure if it was genuine. He revised his opinion of it later, however, when he saw it at an exhibition at the Worcester Art Museum in 1937 (see Bib.).

The ivory is considerably rubbed from its use on a book cover, for which there are four holes in the corners for attachment. Three later holes on each side—several in the faces of the figures—suggest that the cover was studded with gems at one time.

H: 6⁷⁄₁₆″ (16.3cm) × W: 3⅜″ (8.6cm) 71.142

HISTORY: Said to be from the Abbey of Maroilles, Picardy; collection of Augustin Lambert, Paris; bought from Henry Daguerre, Paris, 1926.

BIB.: A. Goldschmidt, "Exhibition of the Art of the Dark Ages at the Worcester Art Museum," *Parnassus*, IX, 3, March 1937, 29–30; G. Swarzenski, "Just a Dragon," *Studies for Belle da Costa Greene*, Princeton, 1954, 177 ff.; Randall, *Ivories*, no. 1; P. Verdier, "Deux plaques d'ivoire de la Résurrection avec la représentation d'un Westwork," *La revue suisse d'art et d'archéologie*, XXII, 1962, 3 ff.

See also colorplate 65

246. CHRIST IN A MANDORLA

Ivory book cover. Carolingian, 9th–10th century

This ivory has engendered much comment as it is closely related to Early Christian works from Egypt of the sixth century, such as the five-part diptych in the Bibliothèque Nationale (Volbach, *Spätantike*, no. 145) and the Saint Paul plaque in the Musée de Cluny (Volbach, *Spätantike*, no. 150). It has been interpreted equally often as a Carolingian copy of an early work. Since its pendant survives in an ivory of the Angel at the Tomb, formerly in the Brugelmann Collection (Volbach, *Spätantike*, no. 236), both must be dated together. There are certain naive interpretations, for example, the rendering of the eyes, the masking of the angels' hands, and the lack of a throne for the seated Christ, which suggest the misunderstanding of a model copied at a later date. The Brugelmann ivory misinterprets the Early Christian form of a baldachin, producing, instead, a towered church, and it repeats the eye treatment and crosshatched hair caps of the subsidiary figures. The combination of vigor and naiveté suggests an early Carolingian provincial copy of an earlier model, rather than a work from the end of the tenth or early eleventh century as Volbach suggested.

Another feature indicates that the ivory is not only a copy but follows in one detail a mistake from the Coptic Saint Paul in the Musée de Cluny. This is in the treatment of the drapery of Christ's left hand, which is meant to be between the hand and the book but is actually shown behind the hand. This point was noted by Stern, who also attributed the Walters ivory to the Carolingian period (see Bib.).

Five-part diptychs were copied from antique models by carvers of the Ada Group, the Liuthard Group, and the Metz School. The use of a Coptic model is less usual, but the five-part-diptych copies are usually early, dating either in the ninth century or about 900. A plaque in Munich of the same subject, quite different in style, is possibly a Western copy of a Coptic work or a later Syrian or Egyptian version of the seventh or eighth century (Goldschmidt, I, no. 185a).

The mandorla of Christ is bordered with six-pointed incised stars, and the edges of the plaque have columns with simplified hatched surfaces. The narrow borders with a projecting flange indicate that this was the central panel of a five-part composition.

H: 6¹¹⁄₁₆″ (17.0cm) × W: 4³⁄₁₆″ (9.6cm) 71.303

HISTORY: Collection of J. Campe, Hamburg; Alphonse Kann, Paris (sale, New York, Jan. 6–8, 1927, lot 447); purchased from Henry Daguerre, Paris, 1930.

BIB.: A. Goldschmidt, "Mittelstücke Fünfteiliger Elfenbeintafeln des VI–VII Jahrhunderts," *Jahrbuch für Kunstwissenschaft*, I, 1923, 30; *idem*, "Exhibition of the Art of the Dark Ages at the Worcester Art Museum," *Parnassus*, IX:3, March 1937, 29; E. Capps, Jr., "An Ivory Pyxis in the Museo Cristiano and a Plaque from the Sancta Sanctorum," *Art Bulletin*, IX, 1927, 340 (located incorrectly in the Metropolitan Museum); R. Delbrueck, "Constantinopler Elfenbein um 500," *Felix Ravenna*, Aug. 1952, 14; Volbach, *Spätantike*, no. 235; H. Stern, "Quelques ivoires d'origine supposée gauloise," *Cahiers archéologiques*, VII, 1954, III; *Bookbinding*, no. 5; *Age of Spirituality*, no. 475.

See also figure 29

245

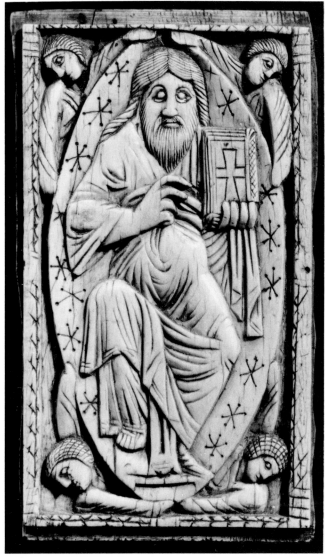

246

247. ANIMALS IN VINE SCROLLS

Ivory hunting horn (oliphant). South Italian, 11th century

One of the large group of ivory hunting or signal horns made by Islamic craftsmen in south Italy, this horn shows more European influence in its decoration than others of the group. On the upper side is the entwined snake symbol, probably a reference to the caduceus of Mercury in his role as herald of the Roman pantheon, and thus appropriate to a signal horn. The symbol also decorates the oliphant in the Anton-Ulrich Museum, Brunswick (Kühnel, no. 79). More important, the vine scroll, in which the Islamic animal decoration is entwined, issues from a vase in the manner of classical models and Coptic textiles.

The main decoration on the body of the horn consists of the vine scroll filled with animals—steinbock, rabbits, lions, antelope, rams, peacocks—displayed in five parallel transverse rows, seen also on the British Museum horn (Kühnel, no. 65) with the interstices filled with fruits and leaves. At the upper end of the horn are two bands of zigzag and plant ornament and one of plant scrolls, and a blank area for the metal hanging strap; at the lower end are two bands of scrollwork flanking the blank area for the strap, identical in form to those on the Boston oliphant (Kühnel, no. 52), which has an uncarved central section.

The metal straps and mouthpiece are missing, and several drilled holes indicate the use of the horn as a reliquary.

L: 17⁹⁄₁₆″ (45.0cm) × largest D: 4¾″ (12.3cm) 71.234

HISTORY: According to the dealer Heilbronner, Berlin, the horn was purchased from the widow of a general who said that it was presented to her husband by the Duke of Brunswick; a note in the horn says it was thus part of the Guelph Treasure; purchased from Henry Daguerre, Paris, 1926.

BIB.: E. Kühnel, *Islamische Kleinkunst*, Berlin, 1925, fig. 158; O. V. Falke, "Elfenbeinhorner II," *Pantheon*, V, 1930, 41; E. Kühnel, "Die sarazenischen Olifanthorner," *Jahrbuch der Berliner Museen*, I, 1959, 41 ff.; Verdier, *Art International*, no. 3, 30, fig. 4; Randall, *Ivories*, no. 9; H. Fillitz, *Zwei Elfenbeinplatten aus Suditalien*, Bern, 1967, fig. 18; Kühnel, no. 59.

See also figure 25, colorplate 66

248. COVER OF THE MONDSEE GOSPELS

Ivory, rock crystal, niello, parcel-gilt, and silver filigree. German (Regensburg), third quarter 11th century

Three ivories of the Evangelists from a set of four survive; the ivory of Mark at the lower left is a nineteenth-century replacement. The Evangelists are shown between turrets, seated on thronelike stools with lecterns. The symbols of the Evangelists descend from above them holding scrolls. The ground plane for each is delineated as two layers of boulders.

Saint Matthew (upper left) sits in profile, pointing at his scroll. Saint John (upper right), in full face, holds his book and places his hand against his head in the act of contemplation. Saint Luke (lower right), with frontal body and head in profile, dips his pen to write.

The cover, which is original to the Gospels, is of silver filigree with niello-interlaced crosses at the corners. The central cross section is gilded and contains a rock crystal, painted on the reverse to imitate gold glass. The spine is the original Byzantine or Islamic textile; the rear cover retains its central engraved brass plaque of Saint Michael and the Dragon.

The codex, two covers, and textile spine can be dated to the third quarter of the eleventh century. The text is attributed to Othlon of Regensburg, who worked at St. Emeran from 1032 to 1055 (Bernard Bischoff, note made March 24, 1959); the textile is dated mid-eleventh century (A. Muthesius, "The Silk over the Spine of the Mondsee Gospel Lectionary," *JWAG*, XXXVII, 1978, 51–73).

These ivories are somewhat more mannered than catalogue no. 249, from the same atelier. The lecterns have curved supports and the edges of the thrones are also curved. The poses of the figures are somewhat rigid and the wings of the Evangelists' symbols are awkwardly placed in comparison to the other ivory. These suggest the work of a younger master. The ivories are slightly rubbed and have traces of polychromy.

Ivories: H (each): 2⅞″ (7.2cm) × W: 1¾″ (4.4cm) W.8

HISTORY: Purchased from Jacques Rosenthal, Munich, before 1931.

BIB.: Goldschmidt, IV, no. 300; F. Steenbock, "Kreuzförmige Typen frühmittelalterlicher Prachteinbände," *Das Erste Jahrtausend*, Düsseldorf, 1962, 498, 505, 507, fig. 6; *idem*, *Der Kirchliche Prachteinband im frühen Mittelalter von den Anfängen bis zum Beginn der Gotik*, Berlin, 1965, no. 87; *Bookbinding*, no. 10; Randall, *Ivories*, no. 5.

See also colorplate 67

249. SAINT LUKE

Ivory from a book cover. German (Regensburg), third quarter 11th century

The panel of Saint Luke was one of four from a book cover like catalogue no. 248, though the panel is slightly larger in scale than the ivories on the Mondsee Gospels. Luke is shown between a pair of turrets, seated on an elaborate stool with a scroll in his hands. A lectern is before him and the ox symbol above him, emerging from a cloud and offering a scroll.

The Romanesque drapery is characterized by circular folds at the knees, a zigzag in the lap, and the use of a double line to define the folds. The style is related to Bavarian (particularly Regensburg) illumination of the late eleventh and early twelfth centuries. Special features are the turrets instead of columns at the sides, though a similar usage in ivory is found in a set of Cologne bookcover plaques of the mid-twelfth century (Avril, *Le temps des croisades*, 229, no. 300).

Unquestionably from the same atelier as the three ivories on the cover of the Mondsee Gospels, this example is somewhat bolder and finer in execution. The drapery folds are more varied and the details of the throne, lectern, and Evangelist symbol more carefully rendered. The ground plane is shown as a series of grasses in clumps, rather than the layers of boulders as in the Mondsee ivories. See notes for dating under catalogue no. 248.

Six holes have been drilled for a later function, and the lower left corner has been cut.

H: 3¹¹⁄₁₆″ (9.4cm) × W: 2⅜″ (6.1cm) 71.139

HISTORY: Purchased in 1929.

BIB.: Randall, *Ivories*, unnumbered, 2.

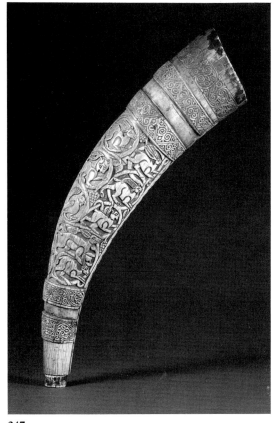

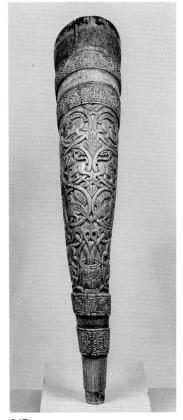

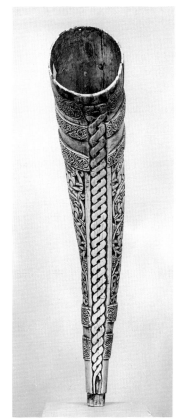

247

247

247

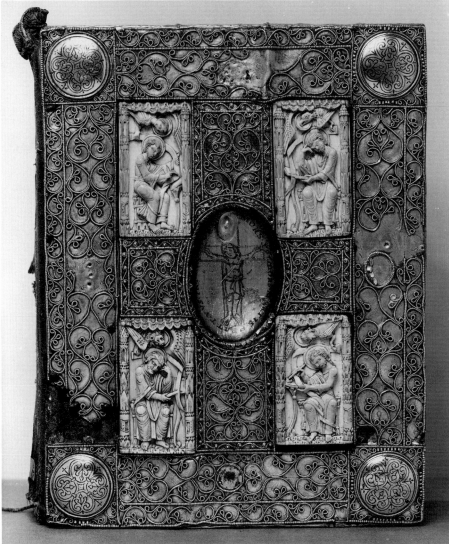

248

249

250. THE STONING OF SAINT STEPHEN

Ivory plaque. Belgian (Valley of the Meuse?), c. 1100

Saint Stephen is shown in an attitude of prayer, asking God to pardon the men who stone him. The scene is witnessed by Saul, who sits at the left with the clothes of the false prophets.

The panel is closely related in format and figure style to a Nativity in the Bayerisches Nationalmuseum, Munich, which is called Belgian or West German (Berliner, no. 16). Both panels seem to be the sides of caskets.

The top left side of the border is broken away from the point where a later hole has been drilled.

H: 2¹⁵⁄₁₆″ (7.5cm) × W: 1³¹³⁄₁₆″ (9.6cm)
71.140

HISTORY: Purchased from Arnold Seligmann, Rey & Co., Paris, 1923.

BIB.: Goldschmidt, IV, no. 285.

251. THE LAST SUPPER

Ivory plaque. North Italy, c. 1100

This plaque is one of three surviving from a large composition, probably an altar frontal, based on Byzantine models. The other two scenes, the Washing of the Feet and Gethsemane, in the Museo Civico, Bologna, show similar Westernization in the addition of architectural and landscape settings for the scenes. In the Last Supper the buildings in the background are intended to represent Jerusalem. A close parallel for the scene is to be found in a Byzantine Gospel book of the thirteenth century (Paris, Bibliothèque Nationale, 54, fol. 96v).

The Apostles recline at a sigma-shaped table in the classical tradition, as demonstrated by the two end figures: Christ on the left and Peter on the right. Judas is seen reaching toward the sop, and the table is set with a central bowl with a fish, symbol of the Eucharist, and four loaves, each inscribed with a cross.

The abstraction of the figures, tablecloth, and buildings results in a powerful repetition of triangular forms.

Goldschmidt compared the composition to a drawing after a lost fresco, formerly in Rome. The attribution of this plaque and the two in Bologna to north Italy is somewhat conjectural.

H: 4¹⁄₁₆″ (10.4cm) × W: 10⅛″ (25.8cm)
71.483

HISTORY: Collection of Count Gregorii Stroganoff, Rome; Dr. Kurt Cassirer, Rome; purchased in 1929.

BIB.: Graeven, no. 80; Goldschmidt, IV, no. 156; L. Pollak and A. Munoz, *La collection Stroganoff*, Rome, 1911–1912, pl. 114; A. Venturi, *Storia dell'arte italiana*, Milan, II, 1901, 614, fig. 446; F. Wormald, *The St. Alban's Psalter*, London, 1960, 58, pl. 11d; Avril, *Le temps des croisades*, no. 260, 276; *Arts of the Middle Ages*, Museum of Fine Arts, Boston, Feb. 1940, no. 123.

See also figure 30

252. THE SACRIFICES OF CAIN AND ABEL

Ivory. Anglo-Norman, first half 12th century

Abel raises a lamb and Cain a sheaf of wheat as offerings to the Hand of God. The figures are shown frontally with heads in profile, and are flanked by trees with leafy terminals.

The style of the drapery is closely paralleled by the illuminations of a Bible made at Jumièges in the late eleventh century (Rouen, Bibliothèque Municipale, Ms. 8-A6, *Trésors des abbayes normandes*, Rouen, 1979, no. 136). The outlining of the falling capes and the use of double lines to define folds of drapery are similar. The emphasis on the profiles of the heads, the type of nose, and the large eyes with drilled pupils are very close to the concept of the figures in the Saint Albans Psalter, dated before 1123, where the drapery style is schematized in a Romanesque manner. The Psalter is preserved in the Church of St. Godehard, Hildesheim. The treatment of heads, hair caps, and eyes is also related to the ivory book cover in the Morgan Library, attributed to the Abbey of St. Alban's (J. Beckwith, *Ivory Carvings in Early Medieval England*, London, 1972, no. 134).

Because of the close ecclesiastical interrelationships between Norman and English abbeys, the term "Anglo-Norman" seems an appropriate way to refer to this work.

The recessed band around the curved top, which has been purposefully roughened with triangular cuts, is unusual. There are nails at each side for the attachment of the metal or textile band that filled the recess. The base is deeply rabbeted to receive another member, and two ivory pins remain for securing the joint. Two iron nails pass through the ivory, and a large hole has been made at the top center as though for hanging. The back is plain.

It has been suggested that the object was the top of a hanging liturgical calendar, though no parallels have been found. The subject of Cain and Abel was often associated with portable altars, but the shape suggests a demilune reliquary rather than an altar.

H: 2½″ (6.3cm) × W: 4⅛″ (10.6cm)
71.289

HISTORY: Collection of Count Auguste de Bastard; purchased from Henry Daguerre, Paris, 1926.

BIB.: Goldschmidt, IV, no. 286; *Arts of the Middle Ages*, Museum of Fine Arts, Boston, 1940, no. 127; Randall, *Ivories*, no. 2; F. Wormald, *The St. Albans Psalter*, London, 1960, the initials, particularly Psalm 127, pl. 85.

See also figure 31

253. CHRIST IN MAJESTY

Ivory plaque. Belgian (Valley of the Meuse), mid-12th century

The panel shows Christ in Majesty, seated on the throne, holding the Gospels, and making the gesture of teaching with his right hand. On the background of his mandorla is inscribed: EGO S(UM) (I)S Q(U)I SU(M) *(I am that I am*, Exodus 3:14). At the corners are the symbols of the four Evangelists: top, the Man of Matthew and the Eagle of John; bottom, the Lion of Mark and the Ox of Luke.

Many examples of the type in ivory, metalwork, and enamel descend from models like the ivory book cover of Abbot Notger, datable to about 982. The ivory is closely paralleled by the silver book cover of the Evangelary of Anastasia in Warsaw of Mosan origin and datable to the third quarter of the twelfth century, made in the region of Liège.

The panel was intended for a book cover, but was reused, as the three holes indicate. It is considerably rubbed from use, and shows evidence of brown stain.

H: 5½″ (14.2cm) × W: 3⅛″ (8.0cm)
71.220

HISTORY: Purchased from Léon Gruel, Paris, 1928.

BIB.: H. Swarenski, review, *Burlington Magazine*, May 1953, 157; *Bookbinding*, no. 13; P. Verdier, "Un ivoire mosan du XIIème siècle et la reliure de l'evangeliaire d'Anastasie," *Bulletin du musée national de Varsovie*, XV, 1974, 3–4, 51–63.

See also figure 32

254. QUEEN OF CHESS

Walrus ivory chessman. Spanish, 12th century

The figure within a throne-shaped castle takes its form from the Islamic chess piece for the queen, or dame, which although abstract was of the same shape. The arcuated castle with punched decoration relates to other Spanish ivories. The headdress of the queen, a hood enclosing the face, tight at the chin, and retained by a headband, is characteristic of Spain in the twelfth century.

The left corner of the throne is a restoration.

H: 2¾″ (7.1cm) × W: 1¾″ (4.5cm) 71.145

HISTORY: Collection of Count Auguste de Bastard; purchased from Henry Daguerre, Paris, 1926.

BIB.: A. Goldschmidt, IV, no. 284 (as Spanish); Randall, *Ivories*, no. 4 (as German); for costume, J. Hunt, "The Adoration of the Magi," *Connoisseur*, CXXXIII, 1954, 156 ff.; H. and S. Widmann, *Schach*, Munich, 1960, pls. 6, 7, and 10 for Islamic pieces of the eighth to tenth centuries.

250

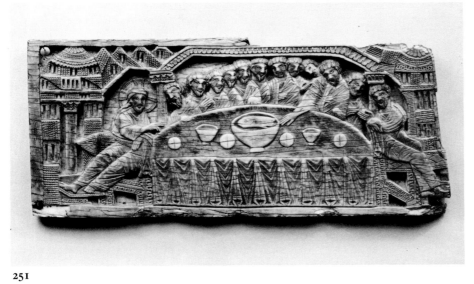

251

252

253

254

255. FIGURES IN A CASTLE

Narwhal ivory draughtsman. German, mid-12th century

Such pieces were used for checkers, trictrac, and backgammon and occur in considerable quantity with a variety of animal, literary, and biblical subjects. The subject of this piece is unidentified, and shows two guards inside the wall of a castle, one blowing his horn and the second pointing with his left hand.

The border of Kufic writing makes the game piece highly unusual, and no other related example is known. A hole has been drilled through the center.

D: 2" (5.0cm) 71.221

HISTORY: Collection of Frau Tilla Durieux; purchased from Henry Daguerre, Paris, 1927.

BIB.: Goldschmidt, III, no. 220.

256. ENTHRONED FIGURE

Walrus ivory draughtsman. English (or north French), mid-12th century

An enthroned figure is presented with a sheep by two soldiers, one with a sword and one with sword and shield. The subject has not been identified, but it is related to that of a tableman from the same atelier, now in Leningrad, showing soldiers protecting a goat from the attack of a griffin (Goldschmidt, III, no. 201).

The figures are finely carved, deeply undercut, and have jet beads inlaid in the eyes. The upper border is a restoration. The Walters game piece is related to the Saint Martin's group of tablemen attributed to north France by Goldschmidt and Mann, but is finer in quality. It has different borders and more carefully handled drapery.

D: 2⅛" (5.3cm) 71.141

HISTORY: Collection of Sigismund Bardac; Berlin Museum; purchased in 1926.

BIB.: Goldschmidt, III, no. 202 (as Tournus); Randall, *Ivories*, unnumbered, 1; J. Beckwith, *Ivory Carvings in Early Medieval England*, London, 1972, no. 269, cat. 142 (as English); V. Mann, *Ivory Tablemen*, Ph.D. diss., New York University Institute of Fine Arts, 1977, no. 63; *idem*, "Mythological Subjects on North French Tablemen," Essays in Honor of Harry Bober, *Gesta*, XX/1, 1981, 165 and note (as French).

See also figure 33

257. FIGURES FROM TWO SCENES

Walrus ivory fragment. German (Cologne), late 12th century

Probably the corner of a portable altar, this piece is curious because it combines two scenes in one. On one side are two figures under an arch; a king bearing a gift in what must have been the Adoration of the Magi; and, behind him, Joseph carrying a dove from the Presentation in the Temple. Four other examples of Cologne work in ivory of the same period combine the Adoration with the Presentation. One of these, a portable altar now in the Cleveland Museum of Art, is very similar in format to the present piece (Goldschmidt, IV, no. 302).

On the second side, under a similar arch, is a soldier in a conical helmet and chain mail with sword and shield, who may have been a soldier of Herod in the Massacre of the Innocents. He is paralleled by a soldier almost identical in posture and armament, though slightly later in style, together with figures from the Adoration on the Basilica Reliquary in the Würtemburgisches Landesmuseum, Stuttgart.

The soldier here does not have to be part of a larger scene; a number of Cologne works have soldiers or military saints, like Gereon, at the corners, as seen in the shrine in Stuttgart (Goldschmidt, III, no. 80). Jörg Rasmussen has proposed that the Walters fragment is part of the destroyed tower reliquary of the three kings from the Hällesche Heiltum of Albrecht of Brandenburg.

H: 3¹⁄₁₆" (7.7cm) 71.144

HISTORY: Hällesche Heiltum about 1541(?); purchased in 1926.

BIB.: M. C. Ross, "Eine Deutsche Walrozschnitzerei Romanischer Zeit," *Pantheon*, July 1939, 243; J. Beckwith, *Ivory Carvings in Early Medieval England*, London, 1972, nos. 70 and 71 (as English); J. Rasmussen, "Untersuchungen zum Hälleschen Heiltum des Kardinals Albrecht von Brandenburg," *Münchener Jahrbuch*, 1976, 65–67. For iconography, compare Goldschmidt, II, no. 103a; III, nos. 61a, 62a; IV, no. 302.

258. TOWER-SHAPED RELIQUARY WITH APOSTLES

Bone on wooden frame. German (Cologne), mid-13th century

A series of these tower reliquaries exists among the large production of a Cologne workshop that produced caskets, portable altars, and reliquaries. Six very similar reliquaries survive among the forty or more examples from the workshop (Goldschmidt, III, nos. 68–70).

Eight Apostles are shown in three-quarter relief in columnar niches beneath arches. Each holds a scroll with his name: PETRUS, S PAULUS, S ANDREAS, S IACO . . . ES, S THOMAS, S MATHEUS, S IHILIPPUS, S IOHANNES. The horizontal divisions are bands of geometric patterns. The roof is formed of eight triangles, four with cherubim and four with the signs of the Evangelists. The four feet, knob finial, and the heads of four Apostles are missing. The backgrounds of the niches retain much of their gilding and the figures, traces of polychromy.

H: 7⅞" (20.1cm) × D: 5⁵⁄₁₆" (13.4cm)
71.146

HISTORY: Acquired before 1931.

BIB.: Randall, *Ivories*, no. 8.

See also colorplate 68

259. CHESS ROOK

Walrus ivory chessman, stained brown. Scandinavian, 14th century

This is one of a group of figures from similar sets found in many European sites. A bishop was excavated from the Randers Fjord, Denmark; the present example was found in London. A watchman with his back to a fence seems to be the Scandinavian form for a rook. The warder generally holds a horn and either a dog on a leash or a sword, and is flanked by two smaller military figures with shields.

Other similar or related pieces are to be found in the Musée de Cluny, a king and a rook (H. and S. Widmann, *Schach*, Munich, 1960, pl. 68); British Museum, a rook (Dalton, no. 391); formerly Vienna, Figdor Collection, a knight (Goldschmidt, IV, no. 268); Royal Collection, Copenhagen, a bishop (F. Lindahl, "Spillelidenskab," *Hikuin*, VI, 1980, fig. 6).

The costumes and armor of the Figdor knight indicate a dating in the fourteenth century.

H: 2½" (0.62cm) × 1¾" (0.45cm) 71.1157

HISTORY: Found at the edge of the Thames at Puddle Dock, Blackfriars, London, 1962; sale, Sotheby's, London, April 9, 1973, lot 14; purchased from Mrs. John Hunt, Dublin, 1977, in memory of Marvin C. Ross.

BIB.: R. H. Randall, "In Honor of Marvin Ross," *BWAG*, XXX, no.7, 1978, 2.

255

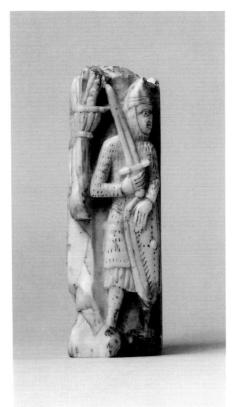

258

259

256

257

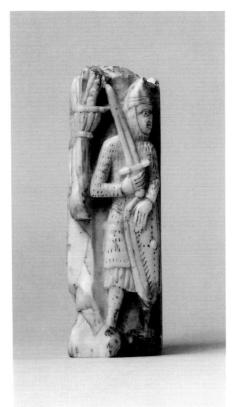

257

9 Gothic Ivories

by Richard H. Randall, Jr.

THE SUDDEN AVAILABILITY of large quantities of ivory to Europeans in the thirteenth and fourteenth centuries was, as has been pointed out, the result of the control of the African coast along the Mediterranean by the Mamluks in Egypt. Their maritime trade with Europe brought a new supply of ivory across the Mediterranean that helped effect a massive change in taste, first in France and ultimately on the whole Continent. Throughout the thirteenth century, the French Limoges enamel industry dominated the European markets with its vast production of attractive goods made in brilliant blue, white, and green enamel against a gilt-copper ground. The chief production of Limoges was religious objects, especially reliquary caskets, crucifixes, and croziers, and many smaller pieces such as incense boats, pyxides, mantle fasteners, and candlesticks. Some large special commissions were carried out for altar frontals, tombs, and huge crosses. For the secular market, Limoges produced basins (gemellions), candlesticks, caskets, sword pommels, and horse bits. These enamels were sold throughout Europe, and may be found today in numerous Continental and English church treasuries and collections.[1]

The earliest Gothic ivories were produced in the middle and second half of the thirteenth century while Limoges enamel was still the dominant material. By the end of the century, ivory had become the vogue, and the taste for objects in the new and rarer material swept across Europe. Paris and the Île-de-France became the focus of the Gothic style, not only in architecture but in other branches of the arts including manuscript illumination, sculpture, and ivory production. This dominance was to last more than a century. It is fortunate that some of the records concerning ivory production have survived, particularly the *Livre des métiers* of Étienne Boileau of 1260.[2] Here the various branches of the trade are outlined and the statutes of the workers' corporations of Paris summarized. Boileau's book describes four corporations, or guilds, among ivory workers. The largest and apparently the most important group were the *"Peintres taillières ymagiers"* (painters and carvers of images) who presumably both carved and painted ivory figures and plaques. The second group were the *"Ymagiers tailleurs et ceux qui taillent cruchefix"* (sculptors and those who carve crucifixes), a curious designation since ivory crucifix figures are of the utmost rarity. It is possible that this group also made bishops' croziers (cat. no. 286; figure 34). This second corporation merged with the first by the end of the fourteenth century. The *"Pigniers et Laterniers"* (comb and lantern makers), the third corporation, made mirror cases, combs, and lanterns of ivory. It is for the production of this group that we have the best records of sales to the court and nobility. The fourth corporation was composed of workers who made knife handles and ivory writing tablets, little notebooks covered with wax on which messages were written with a stylus. Certain other productions of ivory were included under guilds that worked in several materials, such as that of the dicemakers, who worked in bone and ivory, or the corporation that made rosary beads, which worked in a number of mediums including ivory.[3]

In his important book *Les Ivoires gothiques français*, published in 1924, Raymond Koechlin illustrated the extent of the ivory industry. He gathered together over thirteen hundred examples of reliefs, statuettes, mirrors, combs, and boxes that he attributed to Parisian ateliers. Koechlin was surely correct that Paris was the focal point of ivory production, but he left the unfortunate impression that ivory was not worked to any extent in other major centers of Europe. Koechlin's view has gradually been revised. Surviving examples suggest that ivory carving was widespread across Europe, and certain groups can now be assembled around centers like Mainz in the Middle Rhine, Exeter in England, and Venice and Milan in Italy. There is still little evidence documenting production in great cities like London, where one must conjecture that the style was very much influenced by France. The objects produced in such centers cannot as yet be recognized as significantly different from their French brothers.

One medieval account suggests the difficulty in recognizing the nuances of style. It concerns Pierart Aubert, a

carver of ivory in Tournai, and his nephew, Jehan Aubert, a carver and painter of ivory working for the queen of France in Paris.[4] When Pierart's widow died in 1408, she left the shop and its contents in Tournai to her Parisian nephew. The problem remains to find traces of Tournai influence in Paris work, or Paris influence in Tournai. Ivories, being extremely portable, are seldom found in or near their place of production.

While many ivories were bought directly from the workshops in Paris, many were also sold by agents of these workshops, who traveled with their goods to various parts of Europe. Countess Mahaut d'Artois bought ivory knife handles from a Parisian in 1311, and the barber of the duke of Burgundy bought combs and mirrors from Jehan Coilly of Paris three times in a decade.[5] A typical bill for such a sale is recorded in the royal accounts for 1388: "*à Hanryet de Gres, pingnier à Paris... pour 2 etuys garnis de pignez d'yvoire, l'un pour Mgr. L'autre pour Mons. le conte de Nevers, son fils, à 6 fr. piece, 12 fr*" ("to Henry de Gres, combmaker of Paris... for two cases equipped with combs of ivory, one for Monsieur, the other for Monsieur the count of Nevers, his son, at 6 francs each, 12 francs").[6] A leather case to protect the combs was almost always included. The example pre-

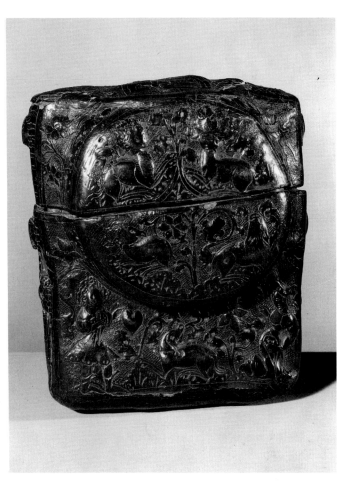

Figure 35. Case for an ivory mirror and comb, leather, French, c. 1400. Medieval accounts indicate that most French comb and mirror makers sold their wares in protective cases. This is a rich example in embossed and hardened leather (*cuir bouilli*) showing animals, monsters, and two lovers against a ground of Gothic foliage. Deutsches Ledermuseum, Offenbach.

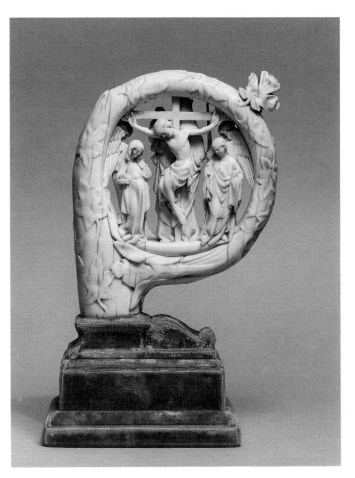

Figure 34 (cat. no. 286). Virgin and Child and Crucifixion, head of an ivory crozier, French (Paris), 1340–1350. On this fully developed crozier the Crucifixion with Mary and John is placed back to back with the Virgin between candle-bearing angels. This example represents Parisian carving in a highly developed state at the end of the first half of the fourteenth century.

served in the collection of the Deutsches Ledermuseum, Offenbach (figure 35), can be dated to about 1400. It is of hardened leather, embossed with a man and a woman toying with a heart, a group of playful animals, and monsters, amid Gothic foliage.

Although the men named in the accounts may have been carvers themselves, it is more likely they were salesmen for the firm. Only in one or two instances, for example, the inventory of the goods of King Charles V of France, does an entry indicate that an ivory was "made by" a certain carver. In this case it is one Jean le Braillier, who created a diptych of the Three Marys for the king. Le Braillier is elsewhere noted as a goldsmith and jeweler.[7] When King Jean le Bon was in prison in the Tower of London after losing the Battle of Poitiers, a bill was paid in 1358 to J. de Savoie for making the missing pieces of the king's ivory chess set.[8]

A natural affiliation existed between the ivory carvers and the sculptors of the monumental buildings that were rising in the Île-de-France in the thirteenth and fourteenth centuries. Some ivory Virgin and Child figures, for instance, followed the much admired Virgin of the trumeau of the north porch of Notre Dame in Paris (figure

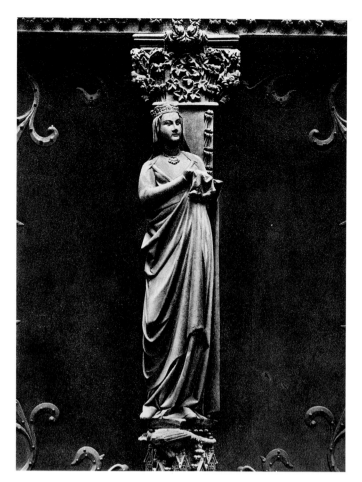

Figure 36. Virgin and Child, limestone, French, trumeau of the north porch of Notre Dame de Paris, c. 1250. This figure, much admired in the thirteenth century, was copied in many ivories, for example catalogue no. 264 (see colorplate 69).

Designs for Ivories

That the ivory carvers worked from either carved models or drawings is indicated by the repetition of subjects, which one finds on the carved romance caskets, for example (cat. no. 324; figures 38 and 39; see colorplate 76). There was virtually no exact copying, however, and there seems always to have been some variety in the interpretation of similar scenes. It is interesting in comparing the scenes on the ends of two boxes from the same shop to see the differences in interpretation.

Another method of understanding the latest design ideas from Paris was to have the cast of an actual ivory as a model for the use of the shop. Several such "prints" from casts, made in terra cotta, have in fact survived. There is a group of five in the Museum of Fine Arts, Boston (figure 40), which were dredged up from the bed of the Scheldt River in Belgium. The models, however, are French, and the actual example from which they were taken is the remarkable ivory casket with two tiers of scenes of the lives of Christ and the Virgin preserved in the Musée Saint-Raymond in Toulouse.[10] The models have suffered from immersion, however, and it is difficult to tell how fine they were in their original state. Another terra-cotta showing the Adoration of the Kings, excavated in the region of Liège, is in the Musée Curtius, Liège.[11] This model also is worn, although one can see on close examination that it was never intended as a "finished" work of art. It is cast without care at the corners and

36), which dates from about 1250. A very close copy, with the remnants of its original red and blue polychromy on the garments, is in the Walters Collection (cat. no. 264; see colorplate 69). A number of other variants have been discovered and published.[9] One of these French ivories apparently was taken to Pisa, where the great sculptor Giovanni Pisano used it as his model for his very large ivory Virgin and Child for the Cathedral of Pisa.

But the ivory carvers were facile designers themselves, and they invented a repertoire more appropriate to their medium. Two mirror cases admirably illustrate this fact. The first is a bold work carried out with skill and decision, showing a pair of young lovers in a landscape; she places a coronet on his head as he kneels at her feet (cat. no. 320; figure 37). The scene is achieved with a great economy of means. The second mirror case shows the symbolic Attack on the Castle of Love, with a castle, twenty human figures, and four horses (cat. no. 322; see colorplate 71). It is a work to be admired at a distance of no more than an arm's length and as such is filled with delightful detail not normally found in monumental sculpture: knights assaulting the citadel of love with crossbows and catapults hurling roses; the defending ladies throwing roses on the attackers; and one knight, reaching the top of the wall, being assisted, even encouraged, in his assault.

Figure 37 (cat. no. 320). Two lovers in a landscape, ivory mirror case, French (Paris), first quarter 14th century. Scenes of lovers were favorite subjects for mirror cases, and here the lover is crowned with a chaplet. The carving is bold and sure.

Figure 38 (cat. no. 324). King Mark in the Tree and the Capture of the Unicorn, end of an ivory casket, French (Paris), 1330–1350. Shown are two of the ten stories on the casket, which include historical stories, Arthurian legends, and tales from the Bestiary. King Mark is hiding in the tree to overhear the conversation of Tristan and Queen Iseult, a story of unfaithful love, which is contrasted with the capture of the Unicorn by a virgin.

Figure 39. King Mark in the Tree and the Capture of the Unicorn, end of an ivory casket, French (Paris), 1330–1350. The identical subjects appear on the box in the Walters Collection (cat. no. 324; see figure 38 and colorplate 76). The two scenes were probably made in the same atelier by different carvers. The King Mark scenes are very different, but the Unicorn scenes were certainly taken from the same model with a few changes in detail. The Metropolitan Museum of Art, New York.

edges, and the details are too soft for it to have been a commercial product. On the other hand, it would have served admirably as a workshop model showing the relationship of the figures, the gestures, and the drapery folds.

The relationship between manuscript illumination and ivory carving has always been puzzling. Many scholars have correctly made attempts to show parallels in style but have had no success when it comes to the use of common models or iconography. This is particularly curious in the fourteenth century, when both arts were highly developed in Paris and the artisans lived in the same quarter of the city. Yet despite the use of the rectangular format, Gothic framing, and similar subjects, the traditions seem to have developed differently.

A few close parallels exist in subject matter: the common type of May calendar scene in manuscripts—a couple on horseback hunting or hawking—appears as a subject on ivory mirror covers. But it is surprising that none of the remaining eleven labors of the months appear, as they did in the previous century in Limoges enamel roundels. The ivory carvers seem to have been following another set of criteria.

Figure 40. Presentation in the Temple, terra-cotta model, French (Paris), fourth quarter 14th century. This is one of a group of five terra cottas made from casts of an ivory box in Toulouse, probably in Paris. The models were found in the bed of the Scheldt River in Belgium. Museum of Fine Arts, Boston.

A few parallels can be drawn between drapery styles —for example, catalogue no. 309 is related in feeling to a Châlons-sur-Marne manuscript—but such occasions are rare. Considering the tremendous impact of the art of the illuminator Jean Pucelle on French art about 1325, and that of his successors, who worked for the duke of Berry, Jean Bondol, Jacquemart de Hesdin, and the Limbourg brothers, it is unusual that so little transfer of ideas occurred in the ivories, which were created for the very same patrons.

One or two comparisons occur: for example, between the drapery styles of the Petites Heures of the duke of Berry and one of the ivory boxes of the Atelier of the Boxes (cat. no. 340). The drapery of the Angel Annunciate of the ivory resembles that of a king in the Adoration miniature of the manuscript. A second ivory box from the same atelier (cat. no. 339) has a hermit seated in the upper register of the box bottom, reading a book in front of his hermitage within a wattle fence. A drawing of precisely this subject appears in the sketchbook of the illuminator Jacques Daliwe, now in Berlin.[12] Yet for reasons that cannot be explained the distance maintained between the two mediums remained relatively constant.

Religious Ivories

The earliest productions of the Paris ivory workers fall into two distinct categories. The first category is the three-dimensional sculpture—much of it small in size and intended for devotional use, often in connection with a domestic altarpiece. The most common subject is the Virgin and Child, either seated or standing. Such pieces,

generally about four to six inches in height and with touches of painted decoration, have fortunately been preserved in large numbers, the majority dating from the mid-thirteenth to fifteenth century. A rare early example is the standing Virgin and Child of the second quarter of the thirteenth century (cat. no. 261; see colorplate 70), whose angular drapery relates to sculpture at Amiens Cathedral. Only rarely were special saints portrayed, as for example the Saint Margaret emerging from her dragon, now in the British Museum.[13]

The styles of the carved ivory figures followed the latest styles in stone or metal sculpture, for instance, the silver-gilt Virgin statue of the famous reliquary of Queen Jeanne d'Évreux in the Louvre seems to have been used as a model for an ivory Virgin formerly in the Heugel Collection, Paris, particularly in the details of drapery.[14] The ivory may be close to the 1339 date of the precious metal figure. Other variants, such as catalogue no. 275 in this collection and a figure in the Metropolitan Museum,[15] still follow this basic model but have drifted away from some of the more complex details. They probably date from some years later, perhaps as much as a quarter century.

The second category of ivory work is the religious diptychs and triptychs depicting in relief four or more scenes from the lives of Christ or the Virgin. The earliest of these are large in size, perhaps in imitation of the earlier consular diptychs, and show scenes of the Passion of Christ. The most famous representative of this group is traditionally referred to as the Soissons Diptych because it came from Saint-Jean-des-Vignes, Soissons. It is now in the Victoria and Albert Museum.[16] Study of these ivory reliefs reveals that many masters and hands were involved in their making. It also seems evident that the systems of compositional organization and iconographic selection were in an experimental stage from about 1250 to the end of the third quarter of the century (cat. no. 266; figure 41).

By the beginning of the fourteenth century, the format had become more standardized. There remain many individual works from this time, but groups of diptychs with certain characteristics begin to appear. In one series of ivories of very high quality known as the Rose Group, which can be dated to the first quarter of the fourteenth century, simple rectangular scenes are divided by architectural moldings decorated with roses. Among the largest works of the group is a diptych in the Escorial showing eight scenes, beginning at the bottom with the Adoration of the Kings and ending at the top with the Harrowing of Hell. A fine diptych leaf of the Rose Group in the Walters (cat. no. 288; see colorplate 72) depicts with great feeling the Crucifixion and Flagellation. The companion leaf, which shows the Deposition and Entombment, is in the British Museum.

By far the most common arrangement of Gothic diptychs featured two scenes: the Virgin and Child, between candle-bearing angels, and the Crucifixion. This became the standard format for small traveling altars,

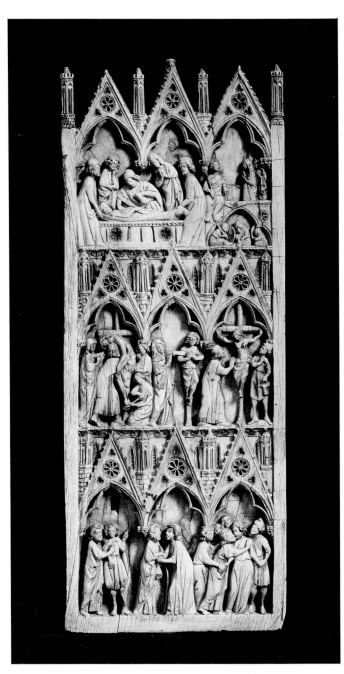

Figure 41 (cat. no. 266). Scenes of the Passion of Christ, leaf of an ivory diptych, French (Paris), 1250–1270. These early diptychs are large in scale and are related to the architectural detail of the south transept of Notre Dame, Paris. The carvers' ateliers had not settled on formulas for such programs, and the present leaf reads from the bottom to the top, from right to left, left to right, and right to left in the upper register.

and throughout the fourteenth century the type was produced in various sizes and with a variety of architectural embellishments (cat. nos. 297, 298, and 301; see colorplate 73).

A group of large Passion diptychs dating from after the mid-fourteenth century is preserved whose iconographic cycles begin with the Entry into Jerusalem and terminate with the Harrowing of Hell (cat. no. 299; see colorplate 74). Toward the end of the century this series was succeeded by a very elegantly carved group of works in which scenes of the early life of Christ were combined with Passion scenes. One of the most beautiful

examples of this type is catalogue no. 312 in the Walters Collection. The group also includes the fine diptych in the Musée des Beaux-Arts de la Ville, Paris, where the scenes are identical to those on the Walters example but read from bottom to top.[17] Typically, smaller diptychs with only two scenes and other variants were made in the same workshops. One small example—only two and three-quarters inches high—is in the Louvre and shows scenes of the Ascension and Pentecost. Undoubtedly carved in the same shop as the two foregoing larger examples, it must have served a less grand purpose.

There was much originality as well as much repetition in the religious ivories produced during the fourteenth century, and popular types and subjects tended to be repeated over and over again. But ivory carvers existed who invented their own figural and compositional types. One of these carvers, known as the Master of Kremsmunster after an ivory diptych preserved in the Austrian abbey of that name, was probably a German from the Middle Rhine who may have been trained in Paris. The master was completely familiar with the variety of architectural embellishment that formed an important part of the *ivoirier's* formal vocabulary and was remarkably facile with his carving tools. He invented a new type of Saint John figure with a mountain of curly hair, and utilized a wide repertoire of tragic gestures. In the wing of the diptych in the Walters (cat. no. 313; figure 42), the other half of which is in the Musée des Beaux-Arts, Lyons,[18] his characteristic figure of John appears in all three scenes. Other small details like the carving of the halo on the cross in the Crucifixion are hallmarks of this atelier.

The flowing gestures and smoothness of drapery of the nearly contemporary carver called the Berlin Master (cat. no. 301; see colorplate 73), after a triptych in the Berlin Museum, stand in stark contrast to the flickering surfaces that characterize the work of the Kremsmunster Master.

The importance accorded ivory sculpture during the Gothic period is indicated by the fortunate survival of a number of major commissions for important medieval buildings. A very large and superbly carved Virgin and Child, now in the Louvre, was created for the Sainte-Chapelle in Paris during the third quarter of the thirteenth century (figure 43).[19] It is sixteen inches in height and retains details of the beautiful gilding along the borders of the garments. A very different conception of the Virgin figure, accompanied by a pair of angels, was made for the Abbey Church of Saint-Denis. The Virgin is now in the Taft Museum, Cincinnati, without the angels who long ago were incorporated in a reliquary in the Cathedral Treasury at Rouen.[20] We know from inventory accounts that the Virgin originally had a gold halo and was decorated with pearls, rubies, and emeralds. At Villeneuve-les-Avignon one finds a seated Virgin and Child seventeen and one-half inches tall, given to the Collégiale in the fourteenth century. The group dates

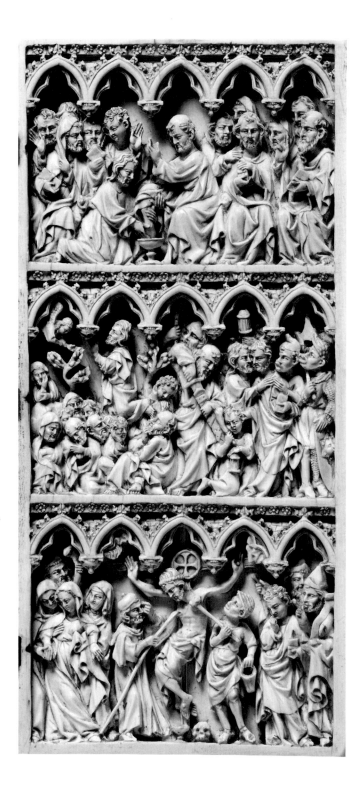

tors turned to the medium of ivory for precious work. It is recorded that Jean de Marville, valet de chambre and sculptor of the duke of Burgundy, bought twenty-two pounds of ivory in 1377.[23] Only a single work has come down from a Burgundian atelier, however, the figure of a standing God the Father of about 1410–1420 now in the Houston Museum of Fine Arts. It shows the hand of a great monumental sculptor, unquestionably one of Jean de Marville's successors at the court.[24]

Another figure remarkable for its size and quality is the Walters Virgin and Child from Laval (cat. no. 285; see colorplate 75). It introduces new concepts into ivory sculpture and indicates that the carver was aware of the currents in artistic representation attributable to the Master of Flémalle and others of the early fifteenth century. The carver has created an image of the peasant Mother and sturdy Child characteristic of a new strain of fifteenth-century thought and paralleled in no other works in ivory. The group was originally ornamented with gold or silver halos, corner ornaments on the cushions, and an apple or bird in the Virgin's hand.

Secular Ivories

There is a playful streak in secular ivories that is also found in German carved wooden boxes (*minnekästchen*), Spanish copper overlaid caskets, and other trinkets of courtly love life. Many mirror cases have scenes of the God of Love throwing arrows down on his youthful victims (cat. nos. 332–334) or a gentleman offering gifts of a comb or his heart to his lady (cat. no. 345). A great series of ivory boxes, undoubtedly made as lovers' gifts, juxtapose scenes of female superiority, such as the story of Aristotle and Phyllis, with those of male heroism, such as the Arthurian legends or the story of the Capture of the Unicorn (catalogue no. 324; see colorplate 76). A mixture of religion, tragedy, romance, and folklore is thus incorporated in a single love token, a juxtaposition unlikely in a contemporary manuscript, painting, or sculpture. While there are many boxes from the same Parisian atelier that made catalogue no. 324, no two are exactly alike. On one box front, catalogue no. 326, for example, scenes of Pyramus and Thisbe replace those of the Fountain of Youth, which are depicted on catalogue no. 324. A box in the British Museum and catalogue no. 324 are nearly identical except for size, and the scene of Enyas and the Wodehouse on the British Museum box is omitted on the Walters example.[25]

from about 1330–1340. Still in the hands of its medieval owners, it retains almost all of its original polychromy.[21]

Other unusual commissions occurred. Three groups from a large freestanding composition of the Descent from the Cross along with single figures of Synagogue and an annunciate angel are preserved in the Louvre, suggesting that ivory altarpieces or shrines of major scale—most of which have disappeared—did exist.[22] The relief figure of Saint Simeon in the Walters of about 1250–1260 (cat. no. 265; figure 44), which is nearly seven inches tall, may have formed part of a large folding altarpiece or altar frontal.

As in the case of Giovanni Pisano, other stone sculp-

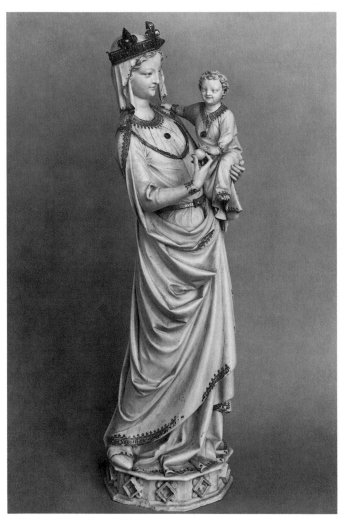

Figure 43. Virgin and Child, ivory with gilt details, French (Paris), 1250–1260. This superb group, which is sixteen inches tall, was commissioned for the Sainte-Chapelle, Paris, and appears in an inventory datable to between 1265 and 1279. The figure is the work of one of the finest sculptors in ivory of the period and perhaps was the gift of King Louis IX, who built the Sainte-Chapelle to house the relic of the Crown of Thorns. Musée du Louvre, Paris.

As the supply of ivory diminished at the end of the fourteenth century, bone began to be substituted for ivory. The Embriachi atelier in Venice began making works in bone or ivory in a new technique whereby altars, boxes, mirror frames, and other pieces were assembled from a number of small sections about three-quarters of an inch wide by two and one-half inches tall. The technique was undoubtedly suggested by the sizes of the bones available to the trade; the pieces were then given a high polish to make them appear like ivory. This assembly system meant that a single carver could repeat his subject many times over, and the resultant pieces could be put together with those of other workers to make a series of boxes or altars.[26]

Other series of pieces in bone were produced in Lombardy and Milan, followed soon with bone productions by the Flemish and Germans. One example from Venice (cat. no. 351) is instructive: a medium-sized triptych in bone, its wings are copies of those of an ivory triptych in the Victoria and Albert Museum.[27] This suggests that,

when necessary or for price considerations, ateliers could change to the lesser material and still produce fine works of art.

Not surprisingly, by the mid-fifteenth century the influence of the earliest prints was felt in the production of ivories. A bone-and-wood box, probably made in Flanders between 1430 and 1460, in six of its scenes follows carefully the early woodcuts of the *Biblia Pauperum*, or Poor Man's Bible, which was issued at the earliest about 1430 (cat. no. 359; figures 45 and 46). Even the technique of the ivory carver, using a crosshatched background, suggests the influence of metalwork or copperplate engraving. The *Biblia Pauperum* was a woodblock-printed book of great popularity and was copied and reprinted in various editions in Holland, Flanders, and Germany for some thirty years. It is interesting to conjecture what

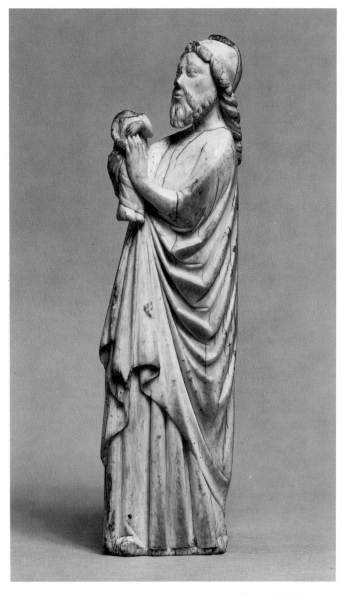

Figure 44 (cat. no. 265). Saint Simeon and the Christ Child, ivory, French (Paris), 1250–1260. The figure comes from a scene of the Presentation in the Temple, which because of the scale—nearly seven inches—must have been either a large folding altarpiece or an altar frontal. The strong, sharp drapery folds are related to Paris stone sculpture of the mid-thirteenth century.

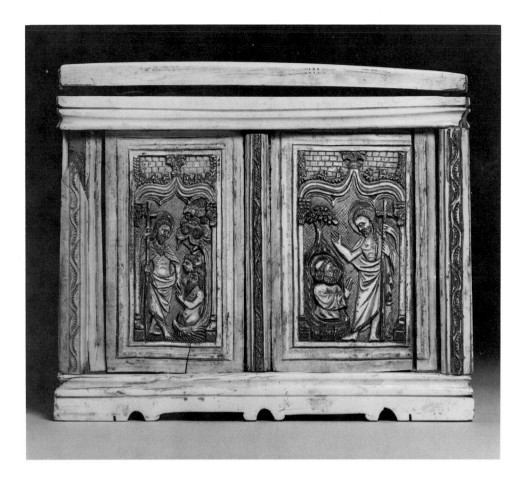

Figure 45 (cat. no. 359). Scenes of the Life and Passion of Christ, end of a bone and wood box, polychromed, Flemish, 1430–1460. Among the scenes shown are the Harrowing of Hell and the rare scene of Christ's Appearance to Saint Peter. The carver of the box used as a source for the Harrowing scene a woodcut from the *Biblia Pauperum*, one of the earliest block books, first printed about 1430. Five other scenes on the box follow other woodcuts from the same work.

the sources of the many other scenes on the box might have been, since no related prints have apparently survived.

Polychromed Decoration

Many, though not all, Gothic ivories were originally painted. The decoration could be confined to the gilding of borders of garments or to details of the hair or of thrones, as in catalogue nos. 271 and 272. On numerous sculptured figures the paint has worn away with handling over the years, but on a few, sufficient color has remained to show how they originally appeared. The Virgin modeled on the Notre Dame de Paris trumeau (cat. no. 264; see colorplate 69) has a red gown covered by a dark-blue mantle. Her head cloth is blue, dotted with gold, and the bole on the Child's figure indicates that his garments were also painted or gilded. The seated Virgin and Child (cat. no. 277; figure 47) was carefully preserved in the Treasury of the Priory of Marcigny (Saône-et-Loire) until the nineteenth century and retains its entire color scheme. The faces of the Virgin and Child, originally painted with flesh tints, are now slightly gray. The garments are again red and blue: the Virgin's and Child's gowns are red with gold floral ornament and the Virgin's head cloth and mantle are blue patterned with gold stars. The base, interestingly enough, is gilt with Gothic vine patterns in dark brown.

In contrast to the completely painted figures were those with only touches of color. One of these is the standing German Virgin and Child, where the reversed lining of the Virgin's mantle is stained red (cat. no. 282). This treatment occurs again on a related figure in the Burrell Collection, Glasgow.

Similar principles seem to apply to ivory relief sculpture, some examples of which were completely painted while others were given highlights of one type or other. In the large Passion Diptych (catalogue no. 299; see colorplate 74), only the green paint of the trees and landscape elements has been well preserved, and it appears to be dotted with gilding wherever it is used. Scientific examination, however, has revealed that the trees were gilded first and then painted green, so the gold showed through. The architectural elements of the framework were also painted: the arches red, with a line of blue for emphasis, the crockets and trefoils green. In the Entry into Jerusalem, an original blue border can be seen on Christ's garment, and there are traces of paint on the donkey. Tiny traces of other color are evident on the figures, but one cannot be certain that all the figures were painted since they read well within the enframements of color.

The north Italian comb with a procession of figures on one side and a hunting scene on the reverse, which is in almost perfect condition, is painted in an entirely different technique (cat. no. 349; see colorplate 77). The ends of the comb are gilded with wavy patterns within frames; the backgrounds of the figures are dotted with gold and blue paint. The hair caps and certain lines of

Figure 46. The Harrowing of Hell, from the *Biblia Pauperum*, woodcut, Flemish or German, 1430 or later. The scene of the Harrowing of Hell appears in the center of a page with Old Testament prophecies and prototypes for the episode. It is the earliest known use of a print source by an ivory carver, and was the model for catalogue no. 359 (see figure 45). Walters Art Gallery.

emphasis are gilded on the figures, whose garments are dotted with red, blue, and gold. The horns of the stag, the ribs of the hounds, and the animal hair are gilded, while the stylized trees have leaves of blue and red.

The miraculous survival of the paint on the comb, which was probably never used, suggests that some mirror cases may have been painted originally. But because they were used in the hand, almost none shows any remains of polychrome. Some, like catalogue no. 347, a later fourteenth-century Italian case, were almost certainly not painted at all, since the cross-hatching of the background was used as a tonal quality to emphasize the figures.

In the Neoclassical eighteenth century, when ivories were first collected in Europe, one suspects many of them were cleaned of any partially remaining paint to give a consistent look. It is hard to imagine that the fine pair of romance caskets in the Walters Collection (cat. no. 324; see figure 38 and colorplate 76) and the Metropolitan Museum were not originally painted, yet no traces remain. Their joint history, however, shows that they were already known and published by John Carter in 1787 and had passed together through eight collections before being purchased separately by J. P. Morgan and Henry Walters in the early twentieth century.

Late Medieval Ivories

The decline in quality of many ivories in the second half of the fourteenth century has been attributed to the Hundred Years War, the Black Death, and other disasters. Evidence that poor work was accepted in high places is given by the diptych used to decorate a pair of book covers for the Abbey Church of Saint-Denis between 1360 and 1380.[28] The work is poorly designed and executed and relates to the diptych with colonettes (cat. no. 304) and the small box with the life of Saint Margaret (cat. no. 338).

Much fine work was created, however, in ateliers like the one in Paris that produced the diptych of the Child-

Figure 47 (cat. no. 277). Virgin and Child, polychromed ivory, French, third quarter 14th century. This group was preserved until the nineteenth century in the Abbey of Marcigny, which accounts for the preservation of the original scheme of the polychrome decoration. The red robes of Christ and the Virgin are richly decorated with floral patterns in gilding, as is the Virgin's head cloth. The blue mantle of the Virgin is decorated over its entire surface with eight-pointed stars; the base of the group is gilded with a pattern of vines. Most interesting is the off-white painting of the faces, which has rarely survived in other sculptures, and was certainly not always employed, as the Virgin of the Sainte-Chapelle indicates.

hood and Passion of Christ of about 1370–1380, with its beautiful sense of balance and details (cat. no. 312). And one of the great masters of the later part of the fourteenth century, the previously mentioned Master of Kremsmunster, brought a new and vibrant life to the leaf of a diptych with Passion scenes (cat. no. 313; see figure 42). Many new details were also added by the Master of Kremsmunster's atelier, such as a baby donkey accompanying Christ in the Entry scene and an imaginative variation of enframements.

Carvers and ateliers of the late Gothic period are generally difficult to place geographically. An interesting ivory plaque of a Coronation of the Virgin shows an unusual format, with angels standing on the leaf ends of the throne (cat. no. 302). The leaf-end throne is found in a number of English works, which has suggested a possible attribution to England. With the exception of a small group of unusual diptychs and triptychs made for John Grandisson, bishop of Exeter, before 1358,[29] this reminds us how little we know of English work.

The fifteenth century presents the picture of a century that produced a few great works by sculptors, such as the Laval Virgin (cat. no. 285; see colorplate 75) and the standing God the Father from Burgundy, now in Houston. The rest of the century's production seems to have amounted to objects of a more mass-produced nature, including those of the Embriachi in Venice (cat. no. 355; see colorplate 78) and the bone-casket ateliers in Flanders (cat. no. 359; see figure 45), the Upper Rhine (cat. no. 358), and north Italy. A few new forms appeared, for example a series of paxes of generally indifferent quality, probably from the Low Countries, one of which is in the Ghent Archaeological Museum and bears the date of 1502,[30] and another, a Ghent coat of arms. Little *images de chevet*, or tiny religious pictures hung within the bed curtains, were made in enamel, oil paint, and ivory. The Flemish Annunciation (cat. no. 364), although reframed in the sixteenth century, illustrates the type and is probably based on a print or painting.

The burgeoning of Flemish art in the fifteenth century was replete with new dramas and iconographies in the field of painting. Yet only two ivories have been shown to follow the design of a master painter of the period. One of these, a leaf of a Dutch diptych in the Princeton Museum of Art, shows the figure of the mounted Saint George killing the dragon based on a famous lost painting of the same subject by Jan van Eyck. The painting is best known from an oil copy attributed to Rogier van der Weyden, now in the National Gallery of Art, Washington, D.C. The second ivory, a miniature pendant in the Metropolitan Museum, probably of Flemish origin, reproduces the same Saint George.[31]

NOTES

1. M. M. Gauthier, *Émaux limousins champlevés des XII, XIII, et XIV siècles*, Paris, 1950.
2. The best discussion is in R. Koechlin, *Les ivoires gothiques français*, Paris, 1924, pp. 7 ff.
3. Koechlin, I, 9.
4. Koechlin, I, 535.
5. Koechlin, I, 531–533.
6. Koechlin, I, 537.
7. Koechlin, I, 10.
8. Koechlin, I, 533.
9. M. Seidel, "Die Elfenbeinmadonna im Domschatz zu Pisa," *Mitteilungen des Kunsthistorischen Instituts in Florenz*, XVI, 1972, 1–50.
10. Koechlin, no. 821.
11. Musée Curtius, *La Nativité dans l'art*, Liège, 1959, no. 120.

12. H. Kreuter-Eggemann, *Das Skizzenbuch des Jacques Daliwe*, Munich, 1964, pl. 8a.
13. Koechlin, no. 709.
14. Koechlin, no. 702.
15. Koechlin, no. 631.
16. M. Longhurst, II, no. 211-1865, Frontispiece.
17. *Les fastes du gothique*, no. 162.
18. Koechlin, no. 836.
19. D. Gaborit-Chopin, figs. 198 and 199.
20. *Idem*, fig. 200; and for the angels, Musée des Arts Décoratifs, *Les trésors des églises de France*, Paris, 1965, no. 209, pl. 140.
21. *Les trésors des églises de France*, no. 627, pl. 154.
22. Koechlin, nos. 16, 18, 19.

23. Koechlin, I, 11.
24. Gaborit-Chopin, fig. 267.
25. R. S. Loomis, *Arthurian Legends in Medieval Art*, New York, 1938, no. 158.
26. J. Schlosser, "Die Werkstatt der Embriachi in Venedig," *Jahrbuch des Allerhöchsten Kaiserhauses*, 1899, 200–282.
27. Longhurst, no. 143-1866.
28. *Les fastes du gothique*, no. 210.
29. M. Longhurst, *English Ivories*, London, 1926, 45–46, suppl., 171.
30. Koechlin, no. 945.
31. R. Randall, "Jan van Eyck and the St. George Ivories," *JWAG*, XXXIX, 1981, 39–48.

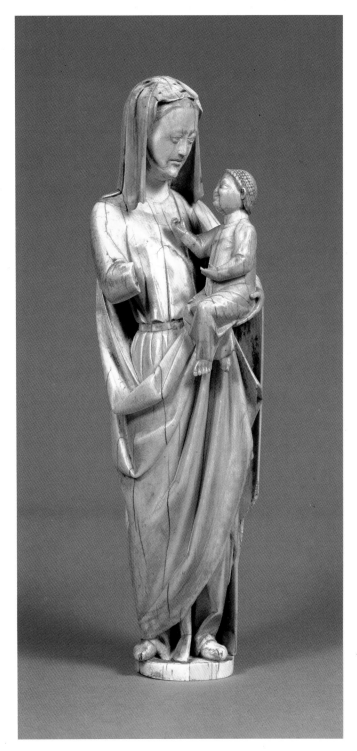

Colorplate 69 (cat. no. 264). Statuette of Virgin and Child, ivory, polychromed, French (Paris), 1250–1270. The figure is based on the famous Virgin of the trumeau of the north porch of Notre Dame de Paris. Although most of the figure of the Child is lost, the statue retains its original red-and-blue color scheme.

Colorplate 70 (cat. no. 261). Virgin and Child, ivory with traces of polychrome, French (Paris or north France), second quarter 13th century. The nobility of this group and the angular folds of the drapery relate it to architectural sculpture at Amiens Cathedral and the Priory Church of Villeneuve-l'Archevêque. Silhouettes of the gilt patterns reveal the original decorative scheme of the Virgin's robe.

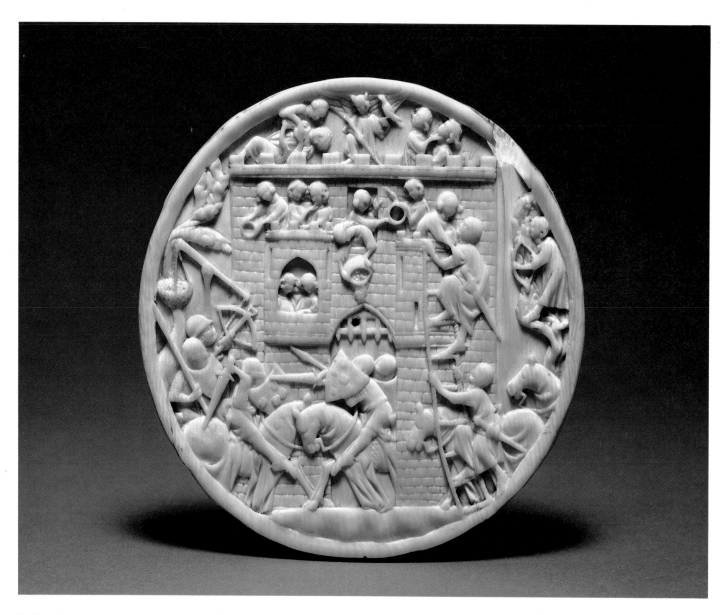

Colorplate 71 (cat. no. 322). Attack on the Castle of Love, ivory mirror case, French (Paris), 1320–1340. The God of Love supervises the symbolic battle in which the knights shoot roses with crossbow and catapult at the ladies, who throw roses down on the attackers. A knight scaling the walls is welcomed by one of the ladies.

OPPOSITE:

Colorplate 72 (cat. no. 288). The Crucifixion and Flagellation, left leaf of an ivory diptych, French (Paris), first quarter 14th century. This large diptych leaf of the Rose Group shows an unusually sculptural treatment in which the figures are allowed far more space than is usual in ivories. The right leaf of the diptych in the British Museum shows the Deposition and the Entombment.

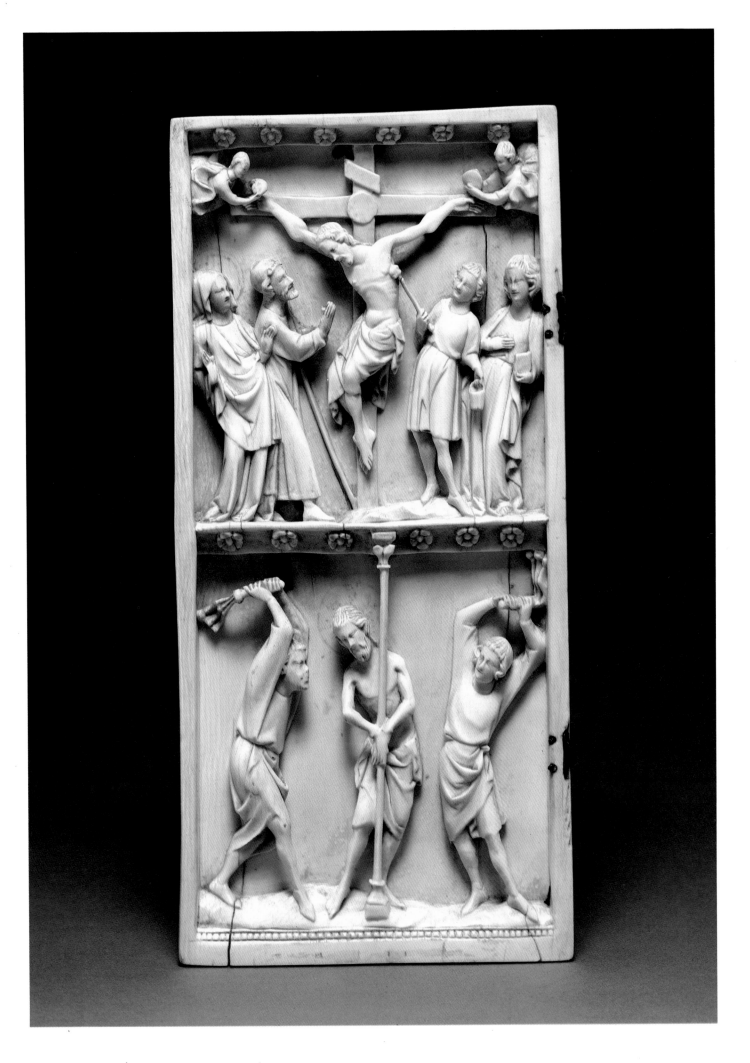

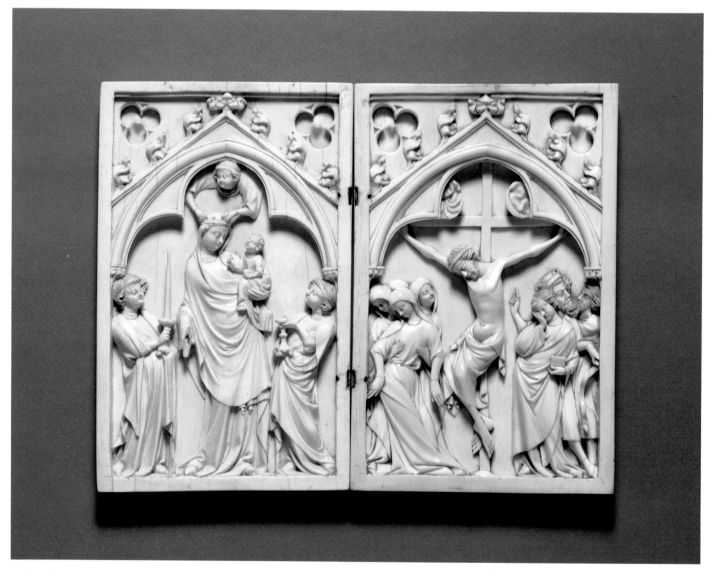

Colorplate 73 (cat. no. 301). Virgin and Child and Crucifixion, ivory diptych, French or German(?), third quarter 14th century. The grand serenity imparted by this work is typical of a small group of ivories attributed to the Master of the Berlin Triptych, who owes his name to a fine triptych of a seated Virgin in the Berlin Museum. The master did not repeat himself in any of his recognized works, an unusual occurrence within the ivory ateliers.

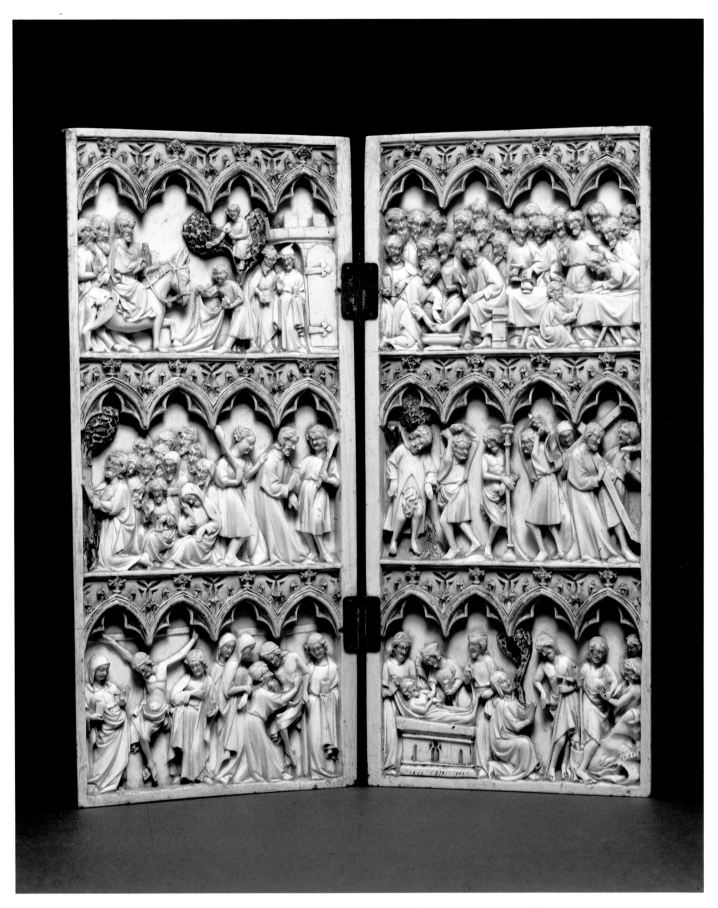

Colorplate 74 (cat. no. 299). Scenes of the Passion and Resurrection, ivory diptych, French, 1350–1365. This diptych, which has much of the original paint, was in the Treasury of the Cathedral of Vich, Catalonia, in 1430. The green and gold paint on the trees is finely preserved; examination shows that the trees were first gilded and the green then put on top, allowing the gold to shine through. There is red and blue on the arcades, and some details, like the blue line on Christ's robe in the Entry scene, can be noted. The scenes are the Entry into Jerusalem, Washing of the Feet, and Last Supper in the top tier; Gethsemane, Arrest of Christ, Judas Hanging, Flagellation, and Way to Calvary in the middle tier; Crucifixion, Deposition, Entombment, Christ's Appearance to his Mother, and Harrowing of Hell in the bottom tier.

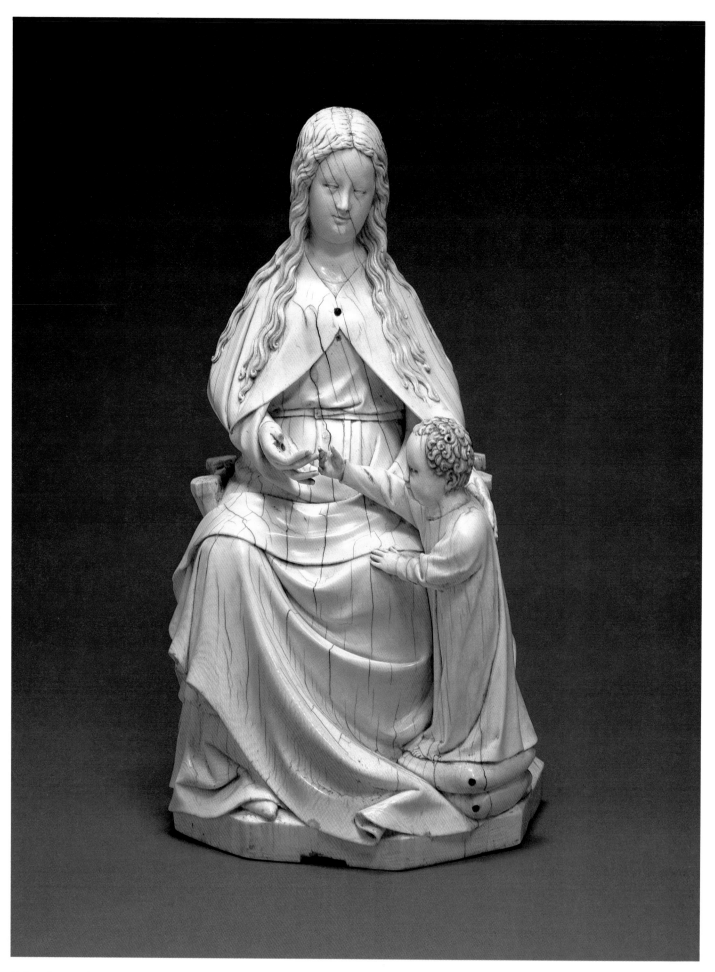

Colorplate 75 (cat. no. 285). Virgin and Child, ivory, French (Touraine), mid-15th century. Probably the work of a sculptor, this large group reflects the new type of peasant mother adopted for the Virgin in the fifteenth century. The statue has a history of possession in the family of Chanoine Sauvé of Laval Cathedral.

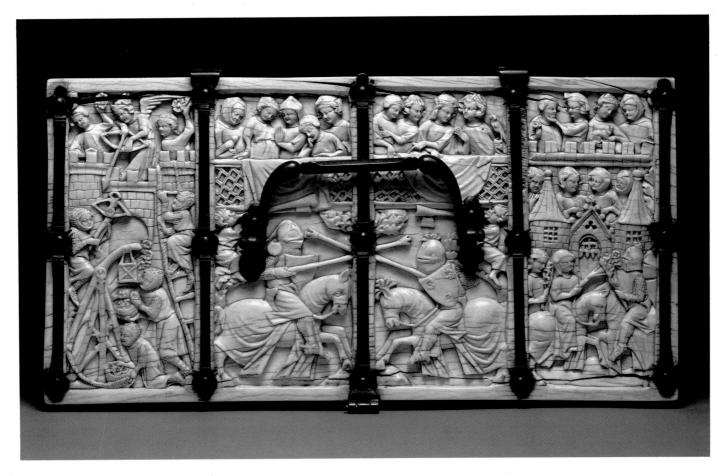

Colorplate 76 (cat. no. 324). Tournament scene, lid of an ivory casket, French (Paris), 1330–1350. The casket is from an atelier that produced a large series of related pieces. The scenes (from the left) are the Attack on the Castle of Love, two knights jousting before spectators on a balcony, and a mock tilt between a knight and a lady brandishing tree limbs. The general theme of the casket is the trials and tribulations of love.

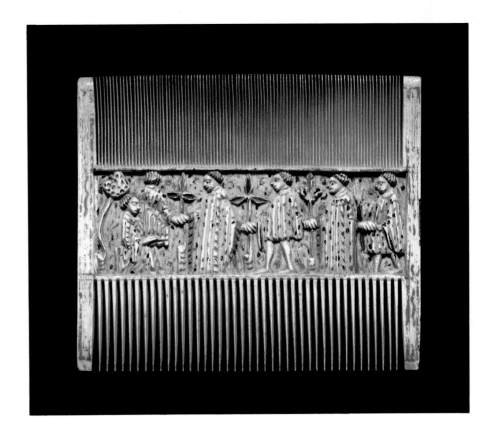

Colorplate 77 (cat. no. 349). Double comb with scenes of courtly life, ivory, north Italian (Lombardy or Piedmont), first third 15th century. The figures in a garden are painted in a dotted technique with red, blue, and gilt; the stylized trees have leaves of blue and red.

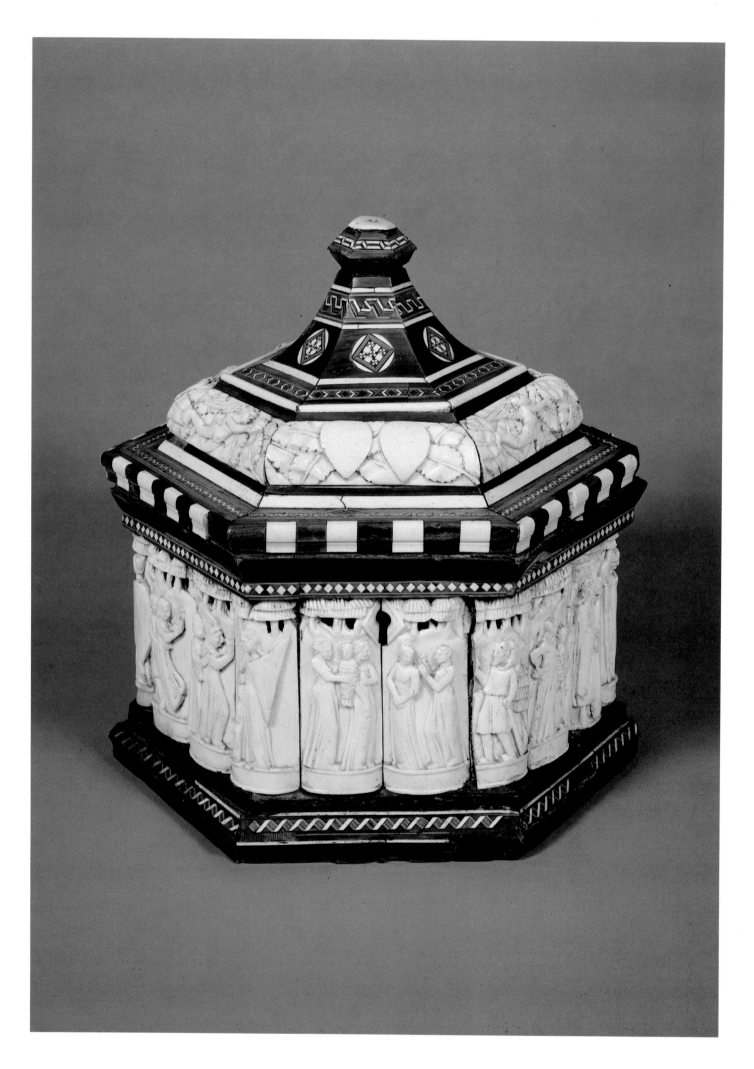

Colorplate 78 (cat. no. 355). Marriage casket with the life of Paris, bone and cow horn on wood, Venetian (Embriachi workshop), early 15th century. The box is revetted with narrow plaques of cow bone telling the stories of the birth and youth of Paris. The remainder of the box is veneered with cow horn and interspersed with intarsia in bone and cow horn. The two blank shields were intended for the coats of arms of the married couple.

Catalogue, Gothic Ivories

260. EAGLE OF SAINT JOHN

Head of an ivory crozier. Italian(?), 13th century

The form of this crozier is adopted from a group of Sicilian croziers with faceted volutes, simple knops, and painted decoration. It combines the dragon volute with four acanthuslike leaves at the cardinal points. The volute encloses a carefully rendered and warlike Eagle of Saint John, which confronts the open-mouthed dragon's head. The base of the volute and the top section of the shaft are carved with ovals that were originally inlaid with glass paste, much of which is now missing. Each oval is set within a pattern of four dots. The knop is a simple, flattened ball form. The eyes of the eagle and dragon are inlaid with glass.

Traces of paint and gilding within the volute and on the eagle indicate that the crozier was originally polychromed and gilded. The book beneath the eagle is inscribed: IONES/EVANG.

Closely related is a crozier in the British Museum (Dalton, no. 75) with a cockatrice fighting the dragon. That example retains its painted and gilded surface, which was covered with small pastes. By tradition the British Museum example is called French; it must nevertheless have been produced in the same atelier as the Walters crozier.

H: 8¹³⁄₁₆" (20.3cm) 71.300

HISTORY: Purchased from Henry Daguerre, Paris, before 1931.

BIB.: Randall, *Ivories*, no. 7.

See also colorplate 1

261. VIRGIN AND CHILD

Ivory statuette. French (Paris or north France), second quarter 13th century

This statuette is one of the earliest extant standing Virgin and Child groups of the Gothic period. The Virgin's drapery falls in angular folds. The Christ Child has a cap of tightly curled hair and reaches for his mother's face.

Silhouettes of gilt patterns remain on the borders of the garments. The Virgin's right arm and the child's fingers on both hands are broken. The outside fold of the Virgin's drapery on her left side is broken at the bottom, giving the statuette a narrow appearance. The base is small and round. In the back is a later hole, possibly for a relic.

The geometric style of drapery can be seen in some of the minor sculpture at Amiens Cathedral and in the north portal of the Priory Church at Villeneuve-l'Archevêque (Yonne) of the end of the 1230s (W. H. Monroe, "An Early Gothic French Ivory of the Virgin and Child," *Museum Studies of the Art Institute of Chicago*, IX, 1978, 6–29).

A very closely related ivory with similar angular drapery was preserved in the Cistercian Abbey of Aulne-sur-Sambre in Hainaut. It is now in Namur, Belgium (Monroe, figs. 15 and 16).

H: 9⁵⁄₁₆" (24.0cm) 71.239

HISTORY: Collection of Alphonse Kann, Paris; purchased from Dikran Kelekian, Paris, 1922.

BIB.: Koechlin, no. 13; Verdier, *Art International*, no. 3, 31, fig. 8; Randall, *Ivories*, no. 10; L. Grodecki, *Ivoires français*, Paris, 1947, 82; R. Suckale, *Studien zu Stilbildung und Stilwandel der Madonnastatuen der Île-de-France zwischen 1230 und 1300*, Munich, 1971, 91 ff.; C. Little, "Ivoires et l'art gothique," *Revue de l'art*, XLVI, 1979, 59, fig. 3.

See also colorplate 70

262. VIRGIN AND CHILD

Ivory statuette. France (Paris or north France), second quarter 13th century

The Virgin sits in a frontal pose, her feet on a dragon. The leaning figure of the Child raises his right hand in blessing. The Virgin's face is large and egg-shaped, with small squinting eyes. Her drapery falls in large, sharp angular folds. The figure is in three dimensions, although the back is unfinished.

The head of the Child was a separate piece and is missing. Two holes in each end of the throne and five in the back were perhaps used to attach other pieces of ivory or to attach the figure to a background. The borders of the garments have remains of patterns of gilding. The Virgin's head is carved to receive a metal crown.

The angular drapery is related to catalogue no. 261 and to the seated Virgin in the Art Institute of Chicago (see note under cat. no. 261).

H: 8¹³⁄₁₆" (22.5cm) 71.235

HISTORY: Collection of Henry Daguerre, Paris; H. Economos, Paris; purchased from Jacques Seligmann, Paris, 1922.

BIB.: S. de Ricci, *Exposition d'objets d'art du moyen age et de la renaissance*, Hôtel de Sagan, May–June 1913, pl. 42; Koechlin, no. 12; Verdier, *Art International*, no. 3, 31; Randall, *Ivories*, no. 11; J. Natanson, *Gothic Ivories of the 13th and 14th Centuries*, London, 1951, 14, fig. 2; R. Suckale, *Studien zu Stilbildung und Stilwandel der Madonnastatuen der Île-de-France zwischen 1230 und 1300*, Munich, 1971, 70 ff.; W. Monroe, "A French Gothic Ivory of the Virgin and Child," *Museum Studies of the Art Institute of Chicago*, IX, 1978, 6–29.

263. VIRGIN AND CHILD

Ivory statuette. Spanish, second half 13th century

A small seated Virgin with deep folds in her skirt holds a seated Christ Child with her left hand. Her head was fitted for a metal crown.

The figure can be compared to a Virgin and Child in the Treasury of San Marcos, León (Koechlin, no. 661), and another in the Cathedral Treasury, Seville; the facial types and drapery are closely related.

The right arm of the Virgin and the head, right hand, and left lower arm of the Child are missing. The crown is missing, and there is a large chip in the base below the left foot.

H: 5⅞" (15.0cm) 71.86

HISTORY: Purchased from Léon Gruel, Paris, 1914.

BIB.: M. C. Ross, "An Ivory Statuette," *Parnassus*, X, no. 6, 1938, 24–25.

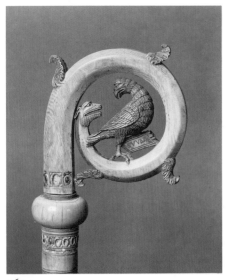

260

261

262

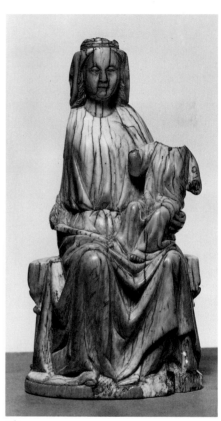

263

264. VIRGIN AND CHILD

Polychromed ivory statuette. French (Paris), 1250–1270

The standing Virgin raises her right hand to hold a flower(?) and clasps the Child with her left. She glances upward, and her body arches slightly backward. The folds of the drapery are bold, particularly those below the waist on the left side.

This small-scale ivory statuette follows the grand model of its day: the Virgin and Child on the trumeau of the north porch of Notre Dame de Paris of about 1250. A careful study of ivory statuettes based on that model was published in 1972 by Max Seidel ("Die Elfenbeinmadonna im Domschatz zu Pisa," *Mitteilungen des Kunsthistorischen Institut in Florenz*, XIV, no. 1, 1–50).

The statuette has suffered the loss of the Child's head, upper body, and arms and the Virgin's fingers of the right hand. The original base block has been trimmed, along with the edges of the skirt at the bottom. The entire front of the figure is considerably worn from handling. The head cloth is bound with a fillet; there are no indications of a crown.

There are substantial remains of the original paint. The Virgin's dress is dark red with faint traces of gilded designs, and the mantle, head cloth, and infant's robe are dark blue. There are traces of gilding in the Virgin's hair and head cloth and in the garments of the Child.

H: 7⁷⁄₁₆″ (19.0cm) 71.236

HISTORY: Purchased from Léon Gruel, Paris, before 1925.

BIB.: *Court Style*, no. 13.

See also colorplate 69

265. SAINT SIMEON AND THE CHRIST CHILD

Ivory appliqué. French (Paris), 1250–1260

This large figure comes from a group of the Presentation in the Temple, carved in the half-round, which must have been attached to a retable or altar frontal. Simeon stands in profile, holding the Child. He is dressed in a priest's cap and a gown with a series of deep folds.

The figures have traces of painted and gilded borders on their garments. The head of the Christ Child is missing. There is cross-hatching as well as two holes for attachment on the slightly rounded back.

A series of relief figures of comparable scale are mounted on the folding wings of a polyptych of the late thirteenth century in Trani Cathedral in south Italy, and the subjects are similarly taken from the infancy cycle of Christ's life (P. Giusti and P. Leone de Castris, *Medioevo e produzione artistica di serie: smalti di Limoges e avori gotici in Campania*, Florence, 1981, 46).

The drapery style closely reflects that of the Virgin of the trumeau of the north porch of Notre Dame de Paris.

H: 6¹³⁄₁₆″ (17.5cm) 71.174

HISTORY: Purchased from Léon Gruel, Paris, 1914.

BIB.: Verdier, *Art International*, no. 3, 31, fig. 9; Randall, *Ivories*, no. 14.

See also figure 44

266. SCENES OF THE PASSION OF CHRIST

Leaf of an ivory diptych. French (Paris), 1250–1270

This panel is related to the earliest of the Gothic diptychs, the Soissons Group, so called after the fine diptych in the Victoria and Albert Museum originally from Saint-Jean-des-Vignes, Soissons. Members of the group are generally large in scale and show scenes from the Passion. There was much experimentation in the shop or shops where they were made, resulting in many changes in the choice and ordering of scenes. Some read from top to bottom, others from bottom to top. The Walters leaf reads from bottom to the right, then back to the left in the second tier, and to the right again in the top tier.

A fragment of the other wing survives in the Musée de Cluny and shows portions of the scenes of the Way of Calvary (middle tier) and Harrowing of Hell (upper tier). The scenes on the Walters leaf show the Temptation of Judas, Payment of Silver, and the Arrest of Christ in the lowest tier; a portion of the Crucifixion and Deposition in the middle row; and in the upper tier the Entombment and Marys at the Tomb.

The architectural framework in each tier has three tall gables pierced with tracery, divided by buttress towers. The architectural effect is close in feeling to the south porch of Notre Dame de Paris, completed in the mid-thirteenth century. A molding carved with ivy leaves serves as the ground plane for the upper two tiers of scenes.

The ivory is considerably rubbed, and small portions of decay on the surface indicate that it was buried. There is a diagonal break in the upper right gable, and the restoration includes the figure of the second Mary. On the left side the original curved fill, required by the shape of the ivory plaque, has been replaced by a new piece that includes the outer half of the Virgin in the Deposition. There is a small break in the background of the lowest tier, and the panel shows considerable cracking. The two outer turrets at the top are restored.

There are numerous traces of polychromy, including blue on the garments, gilding on the hair and beards, and black behind the tracery.

H: 12¹⁵⁄₁₆″ (33.0cm) × W: 5¹⁄₁₆″ (13.0cm) 71.157

HISTORY: Collection of Frédéric Spitzer (sale of his heirs, New York, Jan. 9–12, 1929, lot 544); purchased at the sale.

BIB.: Frédéric Spitzer catalogue, I, 1890, no. 43; *idem*, sale catalogue, 1898, lot 78, pl. 3, bought in; Koechlin, no. 40; C. R. Morey, *Italian Gothic*, 184, no. 4; Verdier, *Art International*, no. 3, 32; R. H. Randall, "A Passion Diptych," *BWAG*, XXI:7, 1969, 1–2.

See also figure 41

267. VIRGIN AND CHILD

Ivory appliqué. French, third quarter 13th century

The enthroned Virgin holds the Child on her left knee and a flower in her right hand. Her left foot is placed on a hillock. The standing Child holds an apple and gazes upward.

The folds of the drapery are deep and crisp.

The oil polychromy is old but not original. The shapes of the faces and painting of the eyes and hair give a doll-like appearance. The doll-like faces relate to the French ivory Madonna (1248–1259) in the Abbey of Zwettl (Koechlin, no. 62) and the Madonna in the Cathedral Treasury, Toledo, of the late thirteenth century (Koechlin, no. 107), which has similar but more complex drapery.

There is an old ivory plug through the lower part of the Virgin's drapery. Her head is carved to receive a metal crown. The back is slightly curved and shows the bark of the exterior of the tusk.

H: 8½″ (21.5cm) 71.74

HISTORY: Purchased from Jacques Seligmann, Paris, 1912.

268. VIRGIN AND CHILD

Ivory statuette fragment. French (Paris), fourth quarter 13th century

This fragment of the Virgin's head and bust is from a large standing statuette. She wears a head cloth retained by a band that is designed to receive a metal crown. She also wears a large ring brooch for which the Child reaches.

Traces of gilt patterns appear on the neck of the dress and the edges of the mantle. The statuette is cut off at the waist and has a chipped and ragged lower edge. The Christ Child is missing except for his right arm. A wedge of ivory has flaked off in the center of the Virgin's face, destroying her nose.

It is difficult to date this piece accurately since it lacks the characteristic lower parts of the drapery, but the narrow eyes and expression of the mouth suggest a date in the late thirteenth century.

H: 4¼″ (10.8cm) 71.285

HISTORY: Collection of Mme. L. Stern, Paris; purchased from Henry Daguerre, Paris, 1923.

BIB.: C. Dreyfus, "La collection de Madame Louis Stern," *Les arts*, Nov. 1911, no. 119, 2; Koechlin, no. 625.

269. VIRGIN AND CHILD

Ivory statuette. French (Paris), 1290–1310

The Virgin stands with her right hand upraised; she holds the Child in her left hand. Her jewel and mantle cords are prominent.

The Child's upper torso, head, and right hand are a single restored section that has been inset with great precision and disguised with blue polychromy. The bottom folds of the Child's drapery and left foot are likewise restored. There are many traces of polychromy, but the gilt pattern on the Virgin's skirt is modern. The Virgin's right hand lacks two fingers. The silver crown is modern.

The object in its present state was in the Micheli Collection before 1895, so the restoration in question must have been done by then.

H: 8¹¹⁄₁₆″ (22.1cm) 71.240

HISTORY: Collection of Carlo Micheli, Paris; Dr. de St. Germain, Paris; purchased from Henry Daguerre, Paris, 1922.

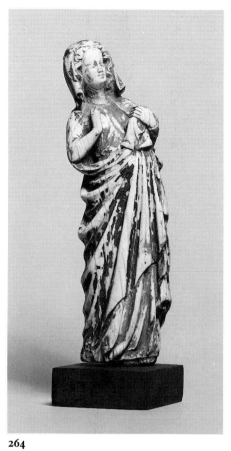

264

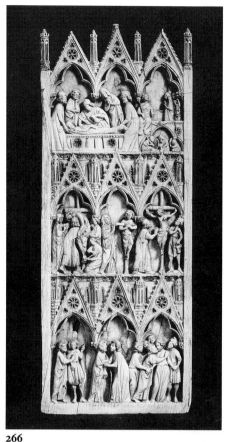

266

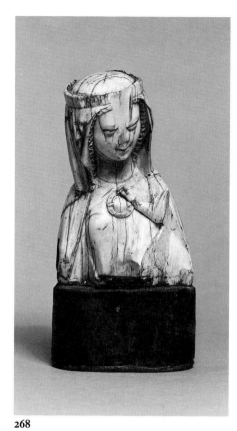

268

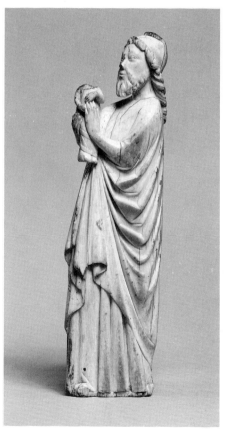

265

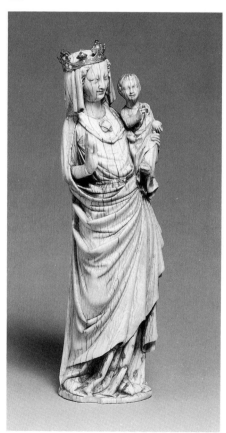

267

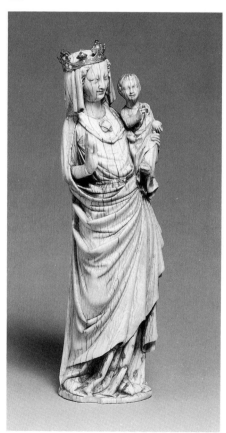

269

270. VIRGIN AND CHILD

Ivory seal. French, second quarter 14th century

The tiny seal is carved in the form of a Virgin statue; the letter H is in intaglio on the bottom. The Christ Child is standing and reaching for an apple. The Virgin wears the original silver crown, which is slightly damaged; the piece shows considerable wear. The base was bound with a silver band and the piece suspended upside down from the girdle of a lady or, more likely, an abbess.

H: 1¹¹⁄₁₆″ (4.3cm) 71.1162

HISTORY: Collection of John Hunt, Dublin; purchased from Mrs. John Hunt, March 1981.

271. VIRGIN AND CHILD

Ivory statuette. French (Paris), 1320–1340

The seated figure of the Virgin arches gently backward to conform to the curve of the ivory tusk. The Christ Child stands in her lap, with one foot on the throne, and reaches for the stem of lilies(?) that were held in the Virgin's right hand. The group is carved in the round. The throne is decorated with thin colonnettes supporting pointed arches, and there is a band of rosettes on the molding of the seat.

Traces of blue pigment remain on the skirt, painted over a reddish stain, and the silhouettes of gilt embroidery patterns occur on the borders. The Virgin's crown and right arm are missing. The Child's head, his left hand, and part of his right hand are missing. A wedge of ivory at the base, which established the proper position of the group, is missing, and there are two major chips along the base. The right half of the Virgin's face was restored in the nineteenth century.

A number of related groups exist, including one at Villeneuve-les-Avignon (Koechlin, no. 103); two in the Victoria and Albert Museum (Longhurst, nos. 4685-1858, 200-1867); and the standing group in the Metropolitan Museum (30.95.114), all of large scale.

H: 10¾″ (27.5cm) 71.243

HISTORY: Purchased from Henry Daguerre, Paris, 1930.

BIB.: R. H. Randall, Jr., "A Monumental Ivory," *Gatherings in Honor of Dorothy Miner*, Baltimore, 1974, 285–287.

272. VIRGIN AND CHILD

Ivory statuette. French (Lorraine?), 1340–1350

The seated Virgin is crowned and holds a flower in her right hand. The standing Christ Child, who looks up at the spectator, reaches for the flower with his right hand. In his left hand he holds an apple.

The sturdy quality of the figures and the facial type recall the stone sculpture of Lorraine, but it is possible that the ivory is a Parisian work with Lorraine overtones. A very similar Virgin and Child is in the Louvre (OA 6332).

The silhouettes left by the polychromed decoration include a floral border on the Virgin's skirt and a design of large flowering branches across the back of the robe. The rear of the throne is decorated with two tall, elegant trefoil arches, which were stained or painted and had a gilt outline, now in white silhouette. The flower is a restoration.

H: 6¹³⁄₁₆″ (18.0cm) 71.491

HISTORY: Collection of L. Cottreau, Paris, before 1900; purchased before 1931.

BIB.: *Exhibition rétrospectif*, Paris, 1900, no. 143.

273. VIRGIN AND CHILD

Ivory statuette. German (Middle Rhine), second quarter 14th century

The Virgin is carved from a thin curved piece of ivory, backed with a fill of hardwood (chestnut?) to stabilize the figure. The tall Virgin wears a mantle that falls straight from her shoulders, and offers a flower to the Child, whom she holds with her right hand.

The crown, which was of carved ivory, is missing, and the head is crosshatched to receive it. There are traces of gilding in the hair and a gilt line across the raised base. The Child's head has been broken and repaired with the original piece.

H: 7¹¹⁄₁₆″ (19.5cm) 71.153

HISTORY: Collection of M. Antocolsky, Paris; purchased at the sale (June 10, 1901, lot 72).

270

270

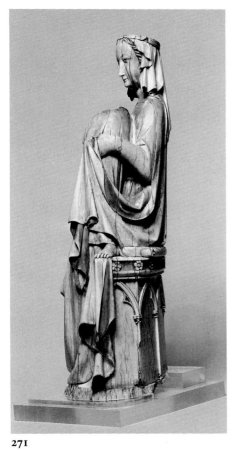

271

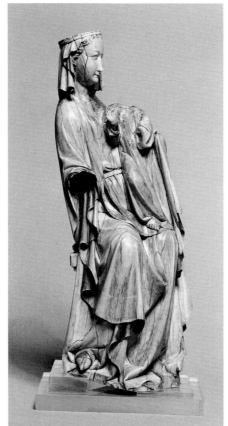

271

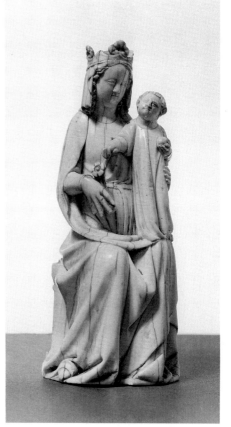

272

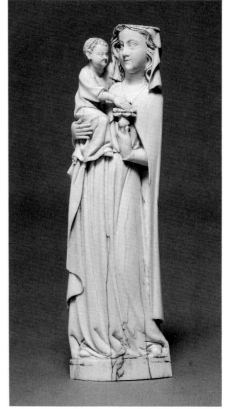

273

274. VIRGIN AND CHILD

Ivory statuette. French, 1340–1350

The seated Virgin wears a low crown and a mantle, and holds a bird in her right hand. The standing Christ Child holds an apple and looks at the viewer. The reverse edges of the Virgin's robe are stained red, and there are traces of gilded borders on the outer edges of both robes.

The back is curved and the lower half crosshatched for attachment to a throne. The fleurons of the crown are damaged, and the lower part of the Virgin's skirt is damaged on both sides. There are candle burns on the face of the Virgin.

Compare catalogue no. 272 of the same date, which is carved fully in the round.

H: 5⅞" (14.9cm) 71.88

HISTORY: Purchased from Jacques Seligmann, Paris, 1912.

275. VIRGIN AND CHILD

Ivory statuette. French (Paris), 1350–1360

The tall, elegant Virgin holds the Child in her left arm and offers a flower with her right hand. The Child has a large babylike head and holds a globe in his left hand. The crown is integral with the Virgin's head, and the drapery is in the apron style of the second half of the fourteenth century.

A minor repair has been made to the lower folds of the Virgin's dress.

H: 8⅞₆" (22.0cm) 71.287

HISTORY: Collection of Carlo Micheli, Paris; Octave Homberg, Paris; Dr. de St. Germain, Paris; purchased from Henry Daguerre, Paris, 1922.

BIB.: G. Migeon, "Collection de M. Octave Homberg," *Les arts*, Dec. 1904, no. 36, 35; Koechlin, no. 665; *International Style*, no. 115.

276. VIRGIN AND CHILD

Ivory statuette. French (Paris?), 1340–1360

The Virgin supports the Child with her left hand, and the Child grasps the end of her head cloth and holds a bird. The Virgin's crown is carved of ivory.

The Virgin's right hand with the globe and the Child's upper torso, including his left hand and the bird, are restorations. There are repairs on the base, the Virgin's feet, and the lower edges of the Virgin's drapery. The very skillful restorations were probably executed by the same restorer who inset the torso of the Christ Child on catalogue no. 269, which was in the Carlo Micheli Collection before 1895.

H: 7⅞" (18.0cm) 71.128

HISTORY: Purchased before 1931.

277. VIRGIN AND CHILD (FROM MARCIGNY)

Ivory statuette. French, third quarter 14th century

The seated Virgin holds the standing Child in her lap. He carries an apple and wears a copper-gilt crown. The Virgin's and Child's gowns are painted red with gilt floral ornament, the gilt patterns on the Child's gown being the richer. The veil and mantle of the Virgin are blue with an overall pattern of eight-pointed stars. The base and throne are gilt; the base has an added original block of unpainted wood, which must have fitted into a base of another material.

An ivory plug in the Virgin's hip may be a repair of a flaw in the ivory. A hole filled with a wooden peg, which pierces the Child's chest and shoulder, could have been for the attachment of the piece to a support at a later date. There is evidence of two layers of similar paint.

The group was in the Priory of Marcigny until the nineteenth century and illustrates a type of polychromy common to many ivory statuettes.

H: 6⅟₆" (15.4cm) 71.286

HISTORY: Priory of Marcigny (Saône-et-Loire); collection of Edouard Jeannez, Roanne; Claudius Cote, Lyons; purchased before 1931.

BIB.: *Exposition Forezienne*, Roanne, 1890, pl. 3; T. Destève, "La collection de M. Claudius Cote," *Les arts*, Nov. 1906, 32; Koechlin, no. 705.

See also figure 47

278. VIRGIN AND CHILD

Ivory appliqué. French (Paris), 1350–1360

The seated Virgin holds the standing Child, who pulls her veil. The throne projects on the left. The veil was stained, and there are traces of polychromy and patterns of gilding along the borders of the garments. The Child's left arm is broken. The missing top of the Virgin's head was a separate piece of ivory, and the remaining head section has been crosshatched for its attachment. The flat back is also crosshatched for attachment to a shrine, and there is an old hole in the center of the back for a wooden plug. Small chips occur along the base.

H: 6⅝₆" (16.0cm) 71.90

HISTORY: Purchased from Léon Gruel, Paris, 1914.

BIB.: R. H. Randall, Jr., "A Monumental Ivory," *Gatherings in Honor of Dorothy Miner*, Baltimore, 1974, 295, fig. 11.

279. VIRGIN AND CHILD

Ivory statuette. Upper Rhine (Basel?), 1360–1370

The seated Virgin wears a crown and mantle. She holds a bird in her right hand and supports the standing Christ Child taking his first step. This is one of a group of works that are large in proportion and have a naturalistic approach to the Christ Child, with unusual emphasis on the large eyes. The group includes the standing Virgin in the Rijksmuseum (Leeuwenberg, no. 786, called Lorraine); the seated Virgin in Copenhagen (Koechlin, no. 696, dated 1364); the seated Madonna with a cradle in the Metropolitan Museum (Koechlin, no. 701); and a seated figure whose location is unknown (sale, Lempertz, Cologne, Nov. 14–17, 1956, lot 940). Similar proportions and eye treatment can be seen in Upper Rhenish sculpture, from Freiburg-im-Breisgau to Fribourg, and are especially notable in Basel, where they appear as early as 1290 in the facade sculpture of the Cathedral.

The seated Virgin with the Christ Child taking his first step was very popular in Swiss sculpture of the fourteenth and early fifteenth centuries. A related sandstone example is in Simmerberg (I. Futterer, *Gotische Bildwerke der Deutschen Schweiz*, Augsburg, 1930, fig. 119); and wooden examples like the one from Bruderen, now in Zurich, which emphasizes the size and strength of the Child (P. Bouffard, *L'art gothique en Suisse*, Geneva, 1914, fig. 9), are numerous. The proportions of the Christ Child, and the treatment of the Virgin's veil and of her and the Child's eyes, are similar in the standing group from Delémont, now in Bern (Bouffard, fig. 45).

The Christ Child's left hand and the fleurons of the Virgin's crown are damaged.

H: 7⅟₆" (20.0cm) 71.109

HISTORY: Purchased in Vienna in 1926.

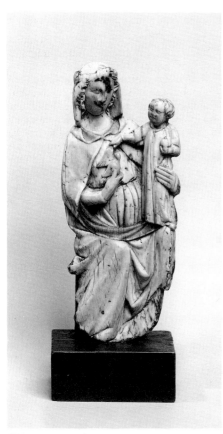

274

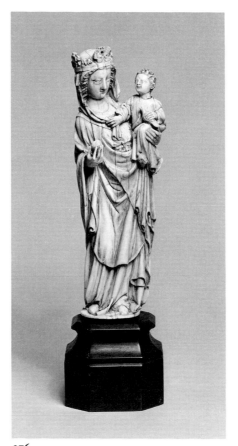

276

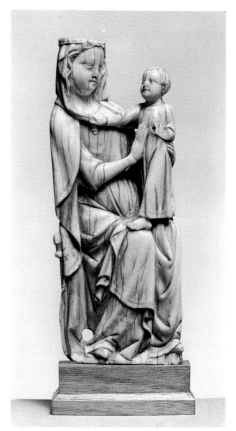

278

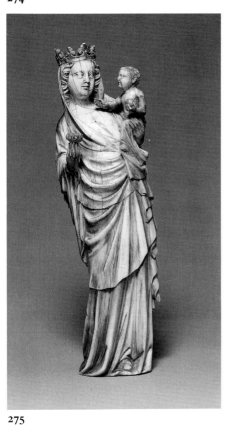

275

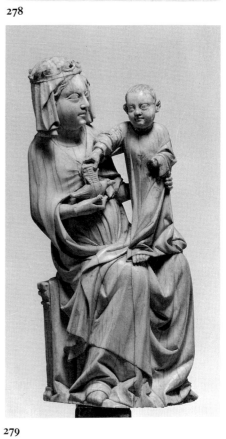

277

279

280. VIRGIN AND CHILD

Ivory statuette. English, third quarter 14th century

The standing figure of the Virgin has apron-style drapery with deep folds, and there are two strong horizontal accents. The Virgin's stance is hip-shot, with the missing Child supported on her left hip. The head is carved to receive a metal crown. The figure is in the round, and the drapery of the back is fully developed, with a monumental series of folds.

The statuette has suffered considerable damage. The Child is completely missing except for a fragment of his right foot. The deep fold in the center of the mantle, several edges of the drapery, and the right foot of the Virgin and adjoining drapery are broken. The Virgin's right hand and crown are missing.

In 1912 Edward Prior and Arthur Gardner (*Medieval Figure Sculpture in England,* London, 1912, 364) suggested that a series of closely related seated figures, characterized by deep folds in their drapery, were English. This was refuted by Koechlin, but the evidence of the Virgin statuette at Yale (*Court Style,* no. 21) and of three figures in the Victoria and Albert Museum (Longhurst, nos. 201-, 202-, 204-1867) and one in the Hermitage, Leningrad, tend to confirm the English attribution. The rendering of the deep-set eyes is not found in French work, and can be seen in England as early as the Annunciation in Westminster Abbey (1252). Similar eye treatment is also found in alabaster sculpture, as in the deep-fold God the Father in the Kress Collection in Washington, D.C. (C. Seymour, *Masterpieces of Sculpture from the National Gallery of Art,* New York, 1949, 45).

H: 6¼" (15.9cm) 71.237

HISTORY: Purchased from Léon Gruel, Paris, 1914.

BIB.: Randall, *Ivories,* no. 20 (as French).

281. VIRGIN AND CHILD

Ivory statuette. Mosan, third quarter 14th century

The standing figure of the Virgin is very thin, almost pointed at the sides. Her drapery is fully developed on the back, displaying a complex series of folds at the haunch and at the bottom of the skirt. The head veil is carefully carved in overlapping folds. There is a rectangular hole in the center of the back for attachment to a shrine.

The carver of this ivory was working outside the conventional formulas of French sculpture with the wide, unusual sweep of apron-style drapery across the figure of the Virgin and the free-floating pendant of drapery hanging from her right sleeve, which breaks the outline of the figure. The hands and wrists are unusually delicate, and the Virgin stares vacantly into space.

These features relate the ivory to a group of marble sculptures showing unusual treatment of the drapery from the region of Liège in the Meuse Valley dating from 1340 to about 1370. The group centers around the datable Virgin and Child of 1345 in the Metropolitan Museum (W. Forsyth, "A Group of Fourteenth-Century Mosan Sculptures," *JMMA,* I, 1968, 41–59). A strong sweep of drapery similar to that found in the Walters ivory may be seen in a marble Virgin Annunciate from the group in the Cathedral Baptistry at Carrara, Italy.

Unlike the eyes of the marble figures, which were probably painted, the pupils of the eyes of the ivory are drilled. The Virgin's crown and the Child's head are missing. The Virgin's skirt has a large chip in the center from the iron spike of the later copper-gilt base, several minor chips, and a truncated toe of each foot. Considerable traces of red paint may be seen on the rear of the Virgin's robe. The Child's left hand, which holds an apple, is an old replacement in wood with traces of polychrome.

H: 8" (20.4cm) 71.241

HISTORY: Purchased in 1914.

282. VIRGIN AND CHILD

Ivory appliqué. German (Middle Rhine), third quarter 14th century

The figure is made of a curved section of ivory. It was designed to be seen from the front and may have been attached to the background of a shrine. The Virgin, who stands in a curved posture, holds the Child with her right hand and the stem of a flower in her left.

The borders of the long robe are patterned and gilded; the reversed lining of the garment is stained red. There are remains of polychromy on the heads, veil, and other areas. An iron hook, which may replace the original pin, pierces the center of the figure.

A standing Virgin and Child made from a piece of curved ivory and with similar painted drapery is in the Burrell Collection, Glasgow (inv. 15). The Child and two flying angels in the Glasgow example are very Germanic in type and the eyes of the figures (unlike the Walters example) have pierced pupils, slightly varied from the Mainz group (see cat. no. 284). A second related piece, which also has a similar unusual construction and was probably the center of a shrine, is a standing Virgin and Child in high relief on a plain rectangular ground. It was in the Joseph Brummer sale (New York, Apr. 23, 1949, lot 649). The Child is closely related to the Burrell ivory, and the Virgin stands on a dragon, a retardataire feature found in some of the Kremsmunster group (see cat. no. 313). The atelier seems to be Middle Rhenish.

H: 8⅜" (21.5cm) 71.233

HISTORY: Collection of Prof. Paul Soubeiran de Pierres, Montpellier (sale, New York, Dec. 8, 1927, lot 69); purchased from Henry Daguerre, Paris, 1928.

283. VIRGIN AND CHILD

Ivory statuette. Flemish or north French(?), fourth quarter 14th century

The small seated Madonna with a standing Christ Child displays unusual geometric drapery folds and profiles. The Virgin's long robe falls to the ground, and the Child is framed with drapery. The faces are somewhat pinched and the Child is unusually thin and vivacious. The gilt-copper crown is original.

The left arm of the Child is broken, and there are two later holes in the Virgin's skirt for attachment by wooden pins to the bone support, which is probably Scandinavian work of the eighteenth century.

H: 4⅜" (11.0cm) 71.163

HISTORY: Collection of A. André, Paris (sale, Paris, Apr. 23–24, 1920, lot 256); purchased from Léon Gruel, Paris, 1922.

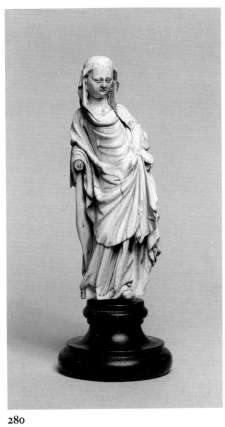

280

280

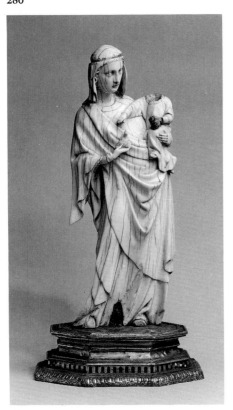

281

282

283

284. VIRGIN AND CHILD

Ivory statuette. German (Middle Rhine, Mainz?), fourth quarter 14th century

The standing Virgin originally held the Child on her right arm; her left hand is outlined against her garments. Her eyes are small and show carved pupils. The remains of the broken Christ Child were carved away in the nineteenth century. The metal crown is missing, and there is a small restoration of drapery at the feet. Although the figure is quite flat, the reverse is carved with folds of drapery.

A seated Virgin in Berlin (Koechlin, no. 844) is probably by the same sculptor. It has the identical gesture and formation of the left hand. The group has been assigned to the Middle Rhine, probably Mainz, by Danielle Gaborit-Chopin (*Ivoires du moyen age*, no. 170), who suggests a date in the early fifteenth century. Géza Jászai ("Zur Elfenbein-Madonna der Kirche des ehemaligen Augustinerinnenklosters im Langenhorst," *Westfalen*, LVIII, 1979, 16–23) also attributes the group to the Middle Rhine but dates a related figure from Langenhorst c. 1300–1325. The folds on the reverse of the Langenhorst Virgin and the Walters example are closely related.

H: 5¾" (14.6cm) 71.246

HISTORY: Spanish collection; collection of Octave Homberg, Paris (sale, Paris, May 11, 1908, lot 941).

BIB.: Koechlin, no. 697.

285. VIRGIN AND CHILD

Ivory statuette. French (Touraine), mid-15th century

The Virgin, seated on a folding chair, offers an object to the Christ Child. Her long hair falls on her shoulders and her gown is modeled with heavy, simple folds. The Christ Child stands on two cushions at her left and reaches for the object in her hand.

The halo, the object in her hand—an apple or bird—the brooch on her breast, and the corner ornaments of the cushion are missing. They were probably of gold or silver gilt.

The lack of square folds in the drapery and the monumental calm of the group have been used as convincing arguments by Danielle Gaborit-Chopin for attributing this work to the Touraine, where it had a long family history.

The same drapery style is seen in a Book of Hours in the Morgan Library (M. 834), in the miniature of the Annunciation attributed to Jean Fouquet. The Book was made in Tours and can be dated to about 1460 (J. Plummer, *The Last Flowering*, Morgan Library, New York, Dec. 1982, pl. 42a).

H: 10¹³⁄₁₆" (27.5cm) 71.188

HISTORY: Collection of Chanoine Sauvé of Laval Cathedral, sold in 1892; purchased from Jacques Seligmann, 1913.

BIB.: Gaborit-Chopin, no. 268; Koechlin, no. 982.

See also colorplate 75

286. VIRGIN AND CHILD AND CRUCIFIXION

Head of an ivory crozier. French (Paris), 1340–1350

This double-faced crozier has two scenes carved back to back: the Crucifixion and the Virgin and Child. The compositions are so organized that the Virgin and John flanking the Crucifixion are back to back with the candle-bearing angels attending the Virgin on the other side. The volute is carved with oak leaves in relief; one leaf projects in the round.

The carving is considerably rubbed, and one angel has lost both hands and the candle. On the Crucifixion side, the Virgin has lost her left hand and John his right. The socle and knop are lacking.

H: 5³⁄₁₆" (13.1cm) 71.231

HISTORY: Collection of John Edward Taylor, London (sale, July 1, 1912, lot 82); purchased from Seligmann Bros., New York, 1913.

BIB.: Koechlin, no. 757; *Treasures of Medieval France*, Cleveland Museum of Art, 1966, no. V17; Randall, *Ivories*, no. 15; "The Medieval Artist and Industrialized Art," *idem, Apollo*, LXXXIV, no. 58, 1966, 16.

See also figure 34

287. VIRGIN AND CHILD AND CRUCIFIXION

Head of an ivory crozier. French, 1340–1350

The subjects of the Crucifixion with the Virgin and John and the Virgin and Child with candle-bearing angels are placed back to back. There is a thin wall of ivory between the scenes, except where it is pierced above and on both sides of the Cross. The volute is carved with oak leaves, three of which project in the round at the corners. The socle is carved with oak leaves, and a serpent is coiled beneath the scenes. The knop and shaft section are late-nineteenth-century restorations.

This is the only crozier head carved with a wall of ivory between the two sides. Several examples are carved for viewing from one side only. The technique and quality of the work suggest a minor or provincial atelier. The snake is also unknown on other crozier heads, though the Mouth of Hell, or of a monster, occurs on several examples.

H: 9⁷⁄₁₆" (24.0cm) 71.232

HISTORY: Collection of Frédéric Spitzer (sale, Paris, Apr. 27, 1893, lot 127); purchased in Paris, 1923.

BIB.: Frédéric Spitzer catalogue, I, 1890, no. 92; F. de Mely, "La collection Spitzer—les ivoires," *Révue de l'art chrétien*, 1890, 426.

288. CRUCIFIXION AND FLAGELLATION

Left leaf of an ivory diptych. French (Paris), first quarter 14th century

The two nearly square scenes are placed beneath moldings carved with six roses each. At the top, the Crucifixion includes the Virgin and John, Longinus, and Stephaton. Angels with the sun and moon flank the cross, on which appear a *titulus* and a carved halo. Below, Christ stands behind a thin, freestanding column in the Flagellation.

This is one of the more powerful examples of the work of the Rose Group of ivories, which share a concern for open compositions and careful placement of the figures. The sculptural quality gives the piece a monumentality seldom found in ivory carving.

The halos have slight traces of gilding, and there is diapering on the background. The plaque has a faint reddish color. There are the remains of broken silver hinges. The ivory has several cracks.

According to George R. Harding, the ivory was stained purple, and gilding and diapering were apparent in 1907. It was cleaned before the Homberg sale in 1908. The matching leaf of the diptych in the British Museum (1943.4-1.1) shows the Deposition above, the Entombment below. It is stained pale green and retains much diapering and gilding.

H: 8¾" (22.2cm) × w: 4³⁄₁₆" (10.6cm) 71.124

HISTORY: Anonymous sale, London (June 10, 1897, lot 70, purchaser George R. Harding); collection of Octave Homberg, Paris (sale, May 12, 1908, lot 468); purchased from Jacques Seligmann, Paris, 1908.

BIB.: Koechlin, no. 235; Randall, *Ivories*, no. 17.

See also colorplate 72

284

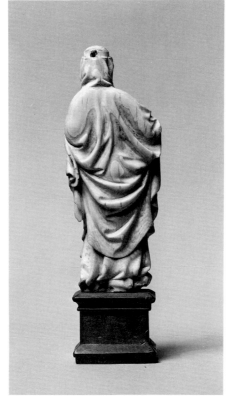

284

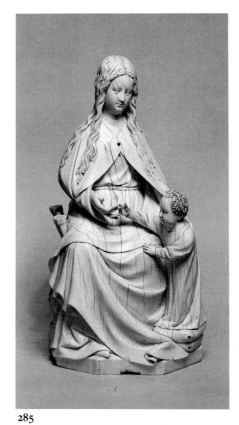

285

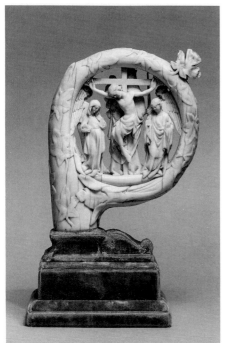

286

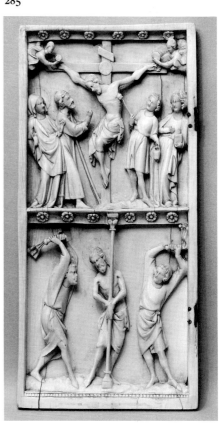

287

288

289. DEPOSITION AND FLAGELLATION

Left leaf of an ivory diptych. French (Paris?), first quarter 14th century

The upper scene is the Deposition from the Cross, the lower one the Flagellation of Christ. The scenes are placed below moldings with rosette decoration; the sides and the lower border are roped. The openness of the compositions and the relative scale of the figures give this small panel a monumental quality.

The panel belongs to the Rose Group, and the scenes are rather comparable in treatment to, though entirely different in detail from, catalogue no. 288. The Rose Group is complex: while there is a general similarity in composition among the individual ivories, there is a great variety of subjects and approaches. It is questioned, as well, whether all the works in the group were made in the same area. Although the scenes in this example are adapted from catalogue no. 288 and its matching leaf in the British Museum, the figures are like those of a Rose Group diptych in the Victoria and Albert Museum (Longhurst, no. 367-1871). The position of Joseph of Arimathea is close to that of the Victoria and Albert work, and the scale of the Magdalen figure is comparable to that of John in the British Museum example.

The insertion of a single element of landscape beneath the feet of one of Christ's tormentors in the Flagellation is unusual, though landscape elements occur in catalogue no. 288 and other Rose ivories. No other examples have roped sides.

The panel has slight chipping at the hinges and the lower right corner.

H: 4⁹⁄₁₆″ (11.6cm) × W: 2¹¹⁄₁₆″ (6.9cm) 71.122

HISTORY: Purchased from Léon Gruel, Paris, before 1931.

BIB.: *Court Style*, no. 15.

290a,b. SCENES OF THE PASSION

Two ivory wings of a folding tabernacle. Spanish, 1300–1330

These are the only surviving ivories from a folding tabernacle that contained a Crucifixion. They are of unusually tall form, and combine features of the Rose Group in the bands of roses that divide the scenes horizontally with trefoil arches flanked by rosettes. The placement of the wings in the shrine was second from the left (290a) and far right (290b).

The left wing (290a) is carved from bottom to top with the Arrest of Christ, Carrying of the Cross, and Three Marys at the Tomb. The wing is hinged on both sides with diagonally set iron hinges. The right wing (290b) is carved from bottom to top with the Buffeting of Christ, Deposition from the Cross, and Harrowing of Hell. Diagonal iron hinges are inset on the left edge.

Among the iconographical rarities are the Harrowing of Hell with large devils in the air and the Buffeting of Christ, which both appear in the Escorial diptych and the diptych from Amiens (Koechlin, nos. 240, 258).

The other scenes are typical of Rose Group ivories. A Parisian work like the Amiens diptych may have served as the model. The Escorial diptych might be reconsidered as a Spanish work.

The carving here is very uneven in quality. The enframements are unusual, and the form of a tabernacle for a central Crucifixion group is unique. These features, combined with the use of iron hinges, suggest a non-French center. The frequent use in Spain of tabernacle enclosures for sculpture would seem to confirm a Spanish attribution.

Both plaques have suffered from exposure. They have been cut horizontally at the top, and the remaining hinges have rusted and broken the ivory. The right wing (no. 290b) has been cut diagonally at the bottom. There are iron nails centrally placed in the trefoil arches of three scenes. Each plaque is inscribed on the back: "8809/R—73101/*las dos tiras.*"

290a. H: 11³⁄₁₆″ (28.7cm) × W: 1¹³⁄₁₆″ (4.6cm) 71.176
290b. H: 11⅞″ (29.8cm) × W: 2⁷⁄₁₆″ (6.2cm) 71.175

HISTORY: From a Spanish collection; purchased from Léon Gruel, Paris, 1923.

BIB.: L. Randall, "Games and the Passion in Pucelle's Hours of Jeanne d'Évreux," *Speculum*, XLVII, no. 2, Apr. 1972, fig. 6.

291. VIRGIN AND CHILD WITH SAINTS AND ANGELS

Left wing of an ivory diptych. French (Paris), 1340–1350

The scene is framed beneath a single large trefoil arch with bud crockets. Above the arch are two quatrefoils with protruding cones. The Virgin stands in the center holding the Child and is crowned by an angel. She is flanked by an angel and Saint Catherine on the left and an angel and Saint Clare on the right.

There are numerous traces of gilding. The panel shows the remains of three hinges and is pierced with two holes at the top, as though for suspension. There is a strip of ivory background missing to the left of the Virgin's head.

The strong faces and leaning postures of the figures can be related to a diptych of the Virgin and the Crucifixion from the Mege Collection (Louvre, OA 9960), and the center of a triptych of the Coronation of the Virgin (Louvre, OA 2598).

H: 5¼″ (13.5cm) × W: 4⅛″ (10.5cm) 71.248

HISTORY: Collection of Edouard Aynard, Lyons (sale, Paris, Dec. 1, 1913, lot 177); purchased from Léon Gruel, Paris, 1914.

BIB.: A. Michel, *Histoire de l'art*, II, Paris, 1906, 484; Koechlin, no. 400; R. H. Randall, "A Parisian Ivory Carver," *JWAG*, XXXVIII, 1980, 60–69.

292. FLAGELLATION AND RESURRECTION

Left leaf of an ivory diptych. French (Paris), 1340–1350

The scenes of the Flagellation and Resurrection each contain three figures carefully spaced in unusually rhythmic compositions. The figure of Christ in the Resurrection merely stepping on the tomb rather than out of it is unusual. The scenes are placed beneath arcades of three trefoil arches with large crockets.

The cross staff of Christ is broken. The hinges are fragmentary, and there is a chip out of the lower right corner.

H: 6½″ (16.8cm) × W: 3¼″ (8.2cm) 71.219

HISTORY: Unknown sale, Paris, lot 71; purchased from Léon Gruel, Paris, before 1931.

293. VIRGIN AND CHILD WITH ANGELS

Center of ivory triptych or polyptych. French(?), 1340–1350

The Virgin, who holds the Child, is shown standing between candle-bearing angels, and is crowned by an angel issuing from the clouds.

The figures are carved in relief on a thin panel. Two sets of hinge miters suggest that it was the center of a triptych or, more likely, a polyptych. The panel has an original indentation at the top left and is broken at the top right. The arms of the angel in the clouds and the crown are missing. The base has been cut at the bottom. There are traces of polychromy, including patterns of gilt dots in the background.

The extraordinary elongation of the Virgin finds parallels in ivories dating from the second quarter to the end of the century, for example, the two standing Virgins in the Metropolitan Museum (71.287; Koechlin, no. 631). The drapery, on the other hand, is of the apron type found in the second quarter of the fourteenth century, which may indicate that the ivory is a conservative and later provincial work. The unusual construction is paralleled exactly in a more coarsely carved example in the British Museum (Dalton, no. 264), which probably came from the same area.

H: 6⅞″ (17.6cm) × W: 2⅞″ (7.0cm) 71.211

HISTORY: Purchased from Henry Daguerre, Paris, 1924.

BIB.: Randall, *Ivories*, no. 13.

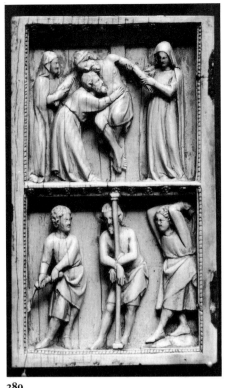

289

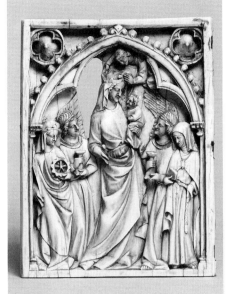

291

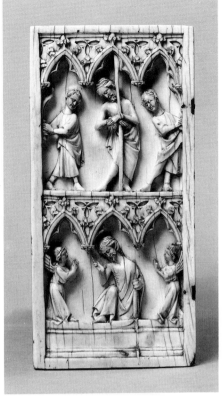

292

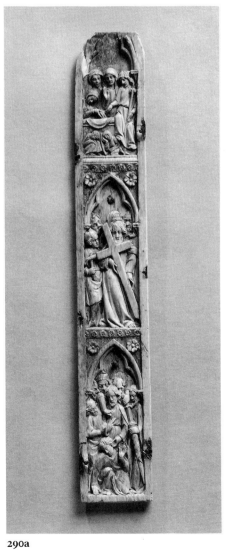

290a

290b

293

294. VIRGIN AND CHILD WITH ANGELS

Ivory plaque. French (Paris), 1340–1350

The small plaque was not made to be half of a diptych since it was never hinged. It may have been intended for a book cover. The nineteenth-century frame was made in the style of the thirteenth century and incorporates silver gilt, filigree, and cabochon stones and pastes. The standing Virgin holds the Child with her left hand and a stem of flowers in her right. She is shown between two candle-bearing angels beneath an arcade of three trefoil arches.

H: 2⅝″ (6.6cm) × W: 1¹⁵⁄₁₆″ (4.9cm) 71.213

HISTORY: Purchased from Émile Rey, New York, 1913.

295. SAINTS AND CENSING ANGEL

Ivory wing of a triptych. French (Paris), 1330–1350

Two female saints, one with a jar and book and the other with a bird and palm, face to the left beneath a trefoil arch. Above, an angel kneels beneath a round arch and holds a censer and incense boat.

The panel has been broken and cut to conform with the arch at the top and has broken miters for hinges on the left side. The right border has been narrowed. There are traces of polychromy, particularly in the surrounds of the lower arch.

The back of the panel shows signs of having had a clasp attached to it and there are remains of a standing bearded saint in polychrome. The head of the saint is incised into the ivory.

Although the style of the carved figures on the front is broad, with apron-style drapery, that of the painted saint on the back is elegant and elongated, normally datable to about 1250–1260. While it seems likely that the ivory was painted in a second and very conservative atelier, the fact that the head of the saint is incised into the ivory suggests it was drawn by an ivory worker.

H: 6⅝″ (16.8cm) × W: 1¾″ (4.5cm) 71.126

HISTORY: Exhibited at the South Kensington Museum, 1862, no. 161; collection of J. Brett (sale, London, Apr. 18, 1864, lot 2008); Octave Homberg (sale, Paris, May 11, 1908, lot 484); purchased from Jacques Seligmann, Paris, 1912.

BIB.: Koechlin, no. 184.

296. CRUCIFIXION

Right leaf of an ivory diptych. English or north French, second quarter 14th century

The figures of the Crucified Christ and of Mary and John are placed beneath a single rounded trefoil arch. Two rosettes appear above the arch.

The plaque was stained dark brown. The borders are badly chipped at the top, lower right, and bottom. The head of one of the angels and the hands of both are missing. The faces of the figures are considerably rubbed; that of the Virgin is nearly obliterated.

The panel is thick, its curved back being brought to a rough center line. The missing hinges were thicker and smaller than was usual and were pinned differently from most ivories.

The spirited poses of the figures and the treatment of the drapery give a monumental effect. The unusual details—the rounded trefoil arch, the rosettes, the shape of the piece of ivory, and the rare hinges—suggest a center unrelated to Paris. The combination of a rounded arch and rosettes may be seen on the central panel of a triptych in Liverpool (M. Longhurst, *English Ivories*, London, 1926, no. 54) and on a second English ivory of unusual form (Dalton, no. 244) reused on a binding made for Henry VIII.

H: 4½″ (11.5cm) × W: 2⅜″ (5.9cm) 71.191

HISTORY: Collection of Émile Molinier (sale, Paris, June 21–28, 1906, lot 155); purchased before 1931.

297. VIRGIN AND CHILD AND CRUCIFIXION

Ivory diptych. French (Paris), 1350–1360

The scenes on this large diptych are placed beneath elaborate architectural canopies. Each wing has three trefoil arches, the central one larger, beneath gables with crockets and pinnacles. In the background is a sloping slate or tile roof. The left wing shows the Virgin and Child between two winged candle-bearing angels. Above, censing angels flank an angel who has crowned the Virgin. The right wing depicts the Crucifixion with three Holy Women supporting the fainting Virgin and John accompanied by three Hebrews. There is a rugged cross with two mourning angels; a spout of blood flows from Christ's wound.

Traces of polychromy remain. The left hand of the crowning angel is missing, and the blood from Christ's wound is broken. There are several flaws in the material of the left leaf in the roof area and a number of cracks in both panels.

On the reverse a fourteenth-century inscription lists a series of dates for special services and the words: "*Ardenus Grassus de Morario, loci de Burossa, Lascurensis diocesis,*" indicating a provenance in Buros, near Pau, diocese of Lescar in the late fourteenth century (read by H. Stein).

H: 8″ (20.3cm) × W (each): 5¹⁄₁₆″ (12.8cm) 71.276

HISTORY: Collection of George de Waroquier, Toulouse; Sigismond Bardac, Paris; purchased from Arnold Seligmann, New York, 1922.

BIB.: Baron de Bouglon, "Note sur un diptyque d'ivoire du 14ᵉᵐᵉ siècle," *Bulletin de la société archéologique du Midi*, 1901, 326; H. Leman, *Collection Sigismond Bardac*, Paris, 1913, no. 39; Koechlin, no. 569; C. R. Morey, "A Group of Gothic Ivories in the Walters Art Gallery," *Art Bulletin*, XVIII, 1936, 199 ff.; Morey, I, 1936, 39; idem, *Italian Gothic*, I, 191; *International Style*, no. 181; Randall, *Medieval Ivories*, no. 16; *Les fastes du gothique*, no. 151.

298. VIRGIN AND CHILD AND CRUCIFIXION

Ivory diptych. French (Paris), 1350–1360

Each scene is placed beneath a single trefoil arch that is surmounted by a crocketed gable pierced with a trefoil. Two quatrefoils with protruding cones decorate the wall above. In the left wing the standing Virgin holds the Child and is crowned by an angel. She is flanked by two winged candle-bearing angels. The Crucifixion has an angel descending with the sun and moon. On the left are the Three Marys and on the right John and two Hebrews.

The original hinges are missing and have been replaced with modern ones. The originals were long hinges with trefoil ends, probably silver, and have left silhouettes of their forms. Their removal caused several breaks, which have been restored, one at the legs of Christ and another near the crowning angel, whose left arm is restored. There is a replaced section of the lower border of the Virgin plaque which includes her left foot. Bronze rings for hanging are placed at the top.

The candles in the angels' hands are restored.

H: 5⁷⁄₁₆″ (13.8cm) × W: 3⁵⁄₁₆″ (6.4cm) 71.178

HISTORY: Purchased in 1923.

294

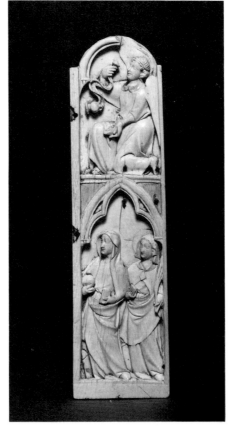

295

295

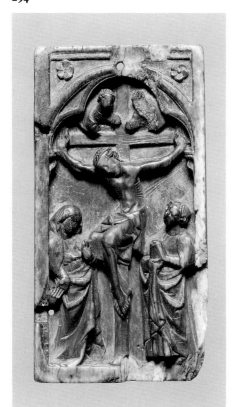

296

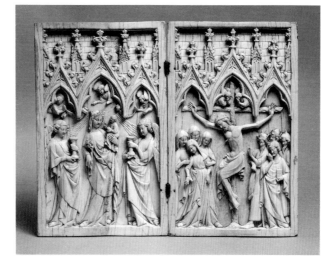

297

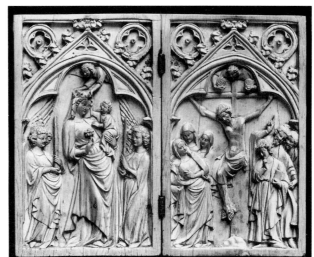

298

299. SCENES OF THE PASSION AND RESURRECTION

Ivory diptych. French, 1350–1365

The thirteen scenes are placed beneath arcades of four trefoil arches. Reading left to right, top to bottom, they include: Entry into Jerusalem, Washing of the Feet, Last Supper, Gethsemane, Arrest of Christ, Judas Hanging, Flagellation, Way to Calvary, Crucifixion, Deposition, Entombment, Christ's Appearance to his Mother, Harrowing of Hell. This program reflects the introduction of new scenes into the repertoire of the Passion Diptychs, which occurred in mid-century. It is experimental in the spacing of figures.

The spatial treatment and iconography relate this work to the diptych in the Fitzwilliam Museum, Cambridge (Koechlin, no. 286). This is particularly evident in the detail of the Virgin helping in the Way to Calvary and in the iconography of the Deposition, Flagellation, and Entombment. A nearly identical handling of the Way to Calvary is seen in the leaf of a diptych in Liverpool (Koechlin, no. 290). Another ivory diptych leaf in Liverpool repeats each detail in the Walters example and is probably by the same hand (*Carvings in Ivory*, Burlington Fine Arts Club Exhibition, London, 1923, no. 113). A diptych in the Louvre (OA 10006) also shows correspondences to several scenes.

There are considerable traces of polychromy, including red and blue for the arches, and green for the crockets and trefoils, all interspersed with gold. The trees have retained their green and gold, and traces of color are evident on the figures. The hinges are replacements.

H: 9¾" (24.8cm) × w (each): 4½" (11.4cm) 71.179

HISTORY: Treasury of the Cathedral of Vich, Catalonia (inventory of 1430); Museum of Vich, until 1903; purchased before 1931.

BIB.: *Catalogue of Museum of Vich*, Vich, 1893, 176; Koechlin, no. 814; *International Style*, no. 116; P. Verdier, "Les ivoires de Walters Art Gallery," *Art International*, no. 4, 30, fig. 4.

See also colorplate 74

300. SCENES OF THE PASSION

Left leaf of an ivory diptych. French (Paris), 1350–1365

This leaf typifies the diptychs with arcades. It represents the standard subjects of the group: the Entry into Jerusalem, Last Supper, Arrest of Christ, and Death of Judas. The figures are conventional types whose heads are slightly oversized.

There is a small break where the upper hinge was removed.

Identical scenes may be seen in the left-hand leaves of diptychs in the National Museum, Copenhagen (Tardy, 39), the Victoria and Albert Museum (Longhurst, no. 291-1867), the Toledo Museum of Art, Ohio (50.300), and others.

The matching leaf with the Washing of the Feet, Gethsemane, and Crucifixion was in the Kofler Collection (Kofler, no. S-73).

H: 7¾" (19.6cm) × w: 3⁵⁄₁₆" (8.5cm) 71.208

HISTORY: Purchased before 1931.

301. VIRGIN AND CHILD AND CRUCIFIXION

Ivory diptych. French or German(?), third quarter 14th century

The scenes are depicted beneath wide trefoil arches surmounted by gables with crockets and trefoil piercings. The Virgin, holding the Child and standing between candle-bearing angels, is crowned by an angel. The Crucifixion is shown between the sun and moon. Three Holy Women support the fainting Virgin while John is accompanied by two Hebrews.

This is a refined work by the Master of the Berlin Triptych, which shows great finesse in carving and slight mannerism in the figures. The twisted skirt of the Virgin in the Crucifixion seems to have originated with this master and appears in later works, such as Louvre OA 2959. The subject of the Virgin is handled differently in each of his major works: the diptych in the Louvre (Koechlin, no. 533), the single leaf in Houston (Koechlin, no. 411), and the triptych in Berlin (Koechlin, no. 120).

The Berlin Master's work is so original and different in detail from that of his contemporary carvers that it defies localization. Danielle Gaborit-Chopin has suggested that he was a German working somewhere in the Rhineland. She drew a comparison between the Berlin Master's work and the facial features of a group of Madonnas centered around the Master of Hallgarten (E. Lüthgen, *Gotische Plastik in den Rheinlanden*, Bonn, 1924, figs. 47–49). The turned-up nose, domed cheeks, and pursed lips of the Virgin and of the angel figures of the ivories, while they do have something in common with this Rhenish type, can also be found in miniatures painted in Paris for the duke of Berry: for example, the Annunciation in Walters W. 96, painted about 1390 (*International Style*, no. 43). The pert faces of the angels are precisely paralleled by the horn-blowing angels on the Reliquary of the Holy Thorn made for the duke of Berry about 1400 (M. Meiss, *French Painting in the Time of Jean de Berry: The Late 14th Century and the Patronage of the Duke*, London, 1967, pl. 571). The style

of the drapery and figure groups is typical of the third, rather than the fourth, quarter of the century.

The hinges are lacking and one candle is missing.

Left leaf. H: 5⁹⁄₁₆" (14.2cm) × w: 3⁹⁄₁₆" (9.2cm) 71.214a
Right leaf. H: 5⅝" (14.3cm) × w: 3¹¹⁄₁₆" (9.4cm) 71.214b

HISTORY: Purchased before 1931.

See also colorplate 73

302. VIRGIN AND CHILD WITH ANGELS

Left leaf of an ivory diptych. English or German(?), third quarter 14th century

The Virgin, seated on a wide throne with a curved top and leaf finials, is being crowned by two angels. The Child is taking his first step and holds a bird in his hand. The panel is surmounted by a trefoil arch and a gable with crockets and a trefoil piercing. The concept is original and the throne a rare feature. The motif of angels standing on leaf terminals to raise the crown is unknown in other works. A throne of similar shape may be seen in a miniature of God the Father in Walters W. 107, f. 40, which is English, and in an English ivory of God the Father in the Victoria and Albert Museum (Longhurst, no. 34-1867).

The throne type also appears in a Coronation on a diptych in the Louvre (OA 2607) that is German or Mosan work and in a leaf of a diptych with the Martydom of Becket and a Coronation in the Victoria and Albert Museum (Longhurst, no. A 38-1923). The Becket ivory was called French by Longhurst and is currently called German.

The Coronation of the Virgin in ivories is usually shown with a single angel descending from Heaven with the crown. A second example of two angels standing on a throne exists in a lead cast or model in Berlin (W. Volbach, *Mittelalterliche Bildwerk aus Italien und Byzanz*, Berlin, 1930, no. 2972, 147).

Triptychs with gabled tops are frequently French in character, but diptychs with gabled tops seem to appear in the third quarter of the fourteenth century and are usually non-French in character. Some of these diptychs have been called English, for example, the Annunciation in the Louvre (OA 2761) and the matching Nativity in the Victoria and Albert Museum (Longhurst, no. 242-1867).

The seven holes in the border suggest subsequent use on a book cover. There is a chip in the right corner of the gable, a break at the lower left corner, and a candle burn on the face of the angel at the right.

H: 5⁹⁄₁₆" (14.2cm) × w: 2½" (6.4cm) 71.247

HISTORY: Collection of Octave Homberg, Paris (sale, Paris, May 16, 1908, lot 472); purchased from Jacques Seligmann, Paris, 1908.

BIB.: Koechlin, no 123.

299

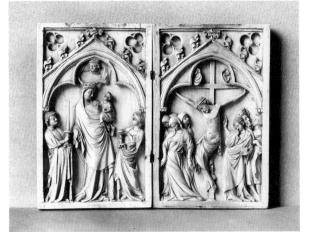

301

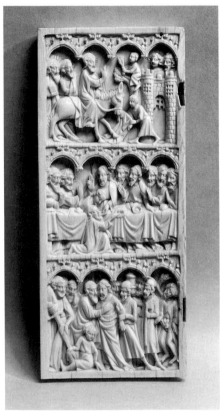

300

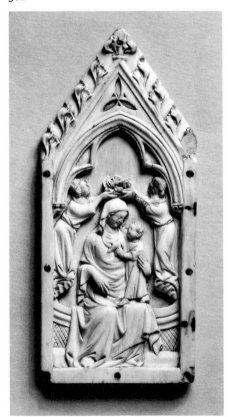

302

303. CRUCIFIXION

Right leaf of an ivory diptych. French, third quarter 14th century

This large and coarsely carved ivory shows the Crucifixion beneath a single trefoil arch with a crocketed gable and two trefoils above. The Three Marys are at the left of the Cross, and John and a Hebrew at the right.

The hinges are missing, and a break appears at the upper hinge slot. The surface is considerably rubbed; several cracks are visible.

H: 7¹³/₁₆″ (19.9cm) × W: 4⁷/₁₆″ (11.2cm) 71.277

HISTORY: Collection of Raoul Heilbronner (sale, Paris, June 22–23, 1921, lot 57); purchased from George R. Harding, London, 1921.

304. SCENES OF CHRIST'S LIFE

Ivory diptych. French (Paris?), third quarter 14th century

The lower register has scenes of the Annunciation, Nativity, Adoration of the Magi, and Entry into Jerusalem. The upper register depicts the Last Supper, Gethsemane, Crucifixion, and Entombment. The scenes are divided by colonnettes. Silver hinges are set diagonally. The two leaves are drilled with four extra holes at the top and bottom inner edges.

The so-called group of diptychs with colonnettes are consistent in style. They feature a conventional repertoire of doll-like figures and exaggerated gestures and tend to be rough in workmanship. A diptych in Brussels (Koechlin, no. 370) is carved with all the same scenes except for three and is based on the same models. This is especially notable in the Adoration and Entry into Jerusalem. The drapery of John in the Crucifixion is very similar in both works.

The book covers of Saint-Denis (*Les fastes du gothique*, no. 210) are inset with a pair of ivories, originally a diptych with no colonnettes that reflects the same model for the Gethsemane scene, datable to between 1360 and 1380.

H: 4⅞″ (12.4cm) × W: 3½″ (8.9cm) 71.273

HISTORY: Collection of Consul Becker (sale, Cologne, May 23, 1898, lot 60); Thome (sale, Cologne, Feb. 1906, lot 110); purchased from Jacques Seligmann, Paris, 1912.

305. SCENES OF THE PASSION

Ivory quadriptych. German(?), third quarter 14th century

The usual form of a quadriptych altarpiece allowed the carver to isolate the scenes beneath single trefoil arches. The episodes are those conventionally found in the diptychs of the Passion: Raising of Lazarus, Entry into Jerusalem, Washing of the Feet, Last Supper, Gethsemane, Arrest of Christ, Way to Calvary, and Crucifixion.

The use of the Raising of Lazarus as a prefiguration of the Resurrection can be noted in the Passion Diptychs, for example, one in the Toledo Museum of Art, Ohio (50.300). A number of iconographic features like the Virgin helping Christ in the Carrying of the Cross and the sword piercing the side of the Virgin in the Crucifixion relate the piece to German mysticism. These elements, together with details such as the carved halos in three of the scenes and the inclusion of the baby donkey in the Entry scene, indicate an origin outside of France. C. R. Morey suggested Italy, but this attribution is not convincing. The rendering of the scenes shows an intimate knowledge of the Paris Passion Diptychs, including such details as the slightly oversized heads of the figures. It appears to be the work of a German carver in Paris or, more likely, a Parisian-trained carver in Germany.

Other quadriptychs include one in the Metropolitan Museum of about the same date (Koechlin, no. 282); half a quadriptych in the British Museum (Dalton, no. 268); and one in the Vatican (Morey, no. A 90).

It is apparent that two carvers were employed. The first executed three of the plaques, and the second completed the leaf with the Washing of the Feet and the Way to Calvary. The architecture in this plaque varies, and the figures are at a slightly different scale, with larger heads.

Previous writers have stressed the Germanic aspect of the iconography used in this and other ivories, arguing that it was unknown in France. It is worth noting that the royal court in France from the time of Jeanne d'Évreux (1325) was dominated by Dominicans and that the "German" iconography was in fact a Dominican iconography. The retable from the Sainte-Chapelle and two other similar Parisian works, for instance, show the Virgin helping Christ with the cross (*Les fastes du gothique*, nos. 18, 20, 44A). The scene of the sword piercing the Virgin's side is found in the Evangelary of the Sainte-Chapelle and the Psalter and Hours of Yolande de Soissons (Morgan M. 729).

There are considerable traces of polychromy: the green-gold on the trees and the gilding of the three carved halos are the best preserved. The right lower corner of the right plaque has been broken and repaired.

H: 7³/₁₆″ (18.7cm) × W (each): 2⁵/₁₆″ (5.9cm) 71.200

HISTORY: Purchased from Arnold Seligmann, Rey and Co., Paris, 1923.

BIB.: C. R. Morey, "A Group of Gothic Ivories in the Walters Art Gallery," *Art Bulletin*, XVIII, 1936, 199 ff.; Morey, I, 1936, 41, pl. 20; *International Style*, no. 119.

306. CRUCIFIXION

Right leaf of an ivory diptych. German or Mosan, third quarter 14th century

The scene is placed beneath a sturdy five-lobed arch. Two angels appear above the gable, which has eight crockets and a large finial. The Crucified is on a rugged Cross, with sun and moon above, and the gilded inscription INRI is on the *titulus*. Three Holy Women are at the left of the Cross, one supporting the Virgin, and John is at the right with two Hebrews.

The angels above the arch appear on ivories of French, Mosan, and German origin. The figure style is close to the quadriptych (cat. no. 305), which has many German iconographic features. The grouping and postures of the Holy Women are paralleled in ivory diptychs of uncertain origin in the British Museum (Dalton, nos. 299, 301, 303; and inv. nos. 1919, 7-10, 1 and 1970, 3-3, 1) and the Louvre (Koechlin, no. 590). The five-lobed arch can be seen in a second diptych, which, though in a different style, also has angels above the gable (Koechlin, no. 546). The Hebrews with two hands in the air are also found on Dalton, no. 299.

The borders of the plaque show traces of gilded roping.

H: 5⅝″ (14.4cm) × W: 3¼″ (8.3cm) 71.102

HISTORY: Collection of Georges Hoentschel, Paris; purchased in Paris, before 1931.

307. CRUCIFIXION AND MURDER OF THOMAS BECKET

Leaf of an ivory diptych. German(?) (Rhenish?), third quarter 14th century

The scenes are in two levels under an arcade of three trefoil arches. The Crucifixion includes the Three Marys, with the sword piercing the Virgin's side, and John with two Hebrews. In the murder of Thomas Becket, three knights are depicted attacking the saint, who kneels before the altar and is defended by his crucifer, Grim.

A similar ivory is in the Victoria and Albert Museum (Longhurst, no. A 38-1923). Although most Becket ivories are called German, there is no specific evidence to support this attribution. The iconography of the sword piercing the Virgin's side, while Rhenish in origin, is also found in Paris work.

There are nicks at the two remaining iron hinges and along the lower border.

H: 4½″ (11.5cm) × W: 2¹³/₁₆″ (7.1cm) 71.250

HISTORY: Collection of Octave Homberg (sale, Paris, May 11–16, 1908, lot 486); purchased in 1924.

BIB.: T. Borenius, *Thomas à Becket in Art*, London, 1932, pl. 31, fig. 3 (mislabeled); C. R. Morey, "A Group of Gothic Ivories in the Walters Art Gallery," *Art Bulletin*, XVIII, 1936, 199 ff.; Morey, I, 1936, 41, pl. 21; Koechlin, no. 346.

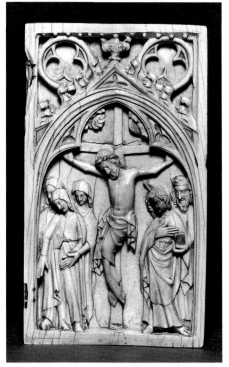

303

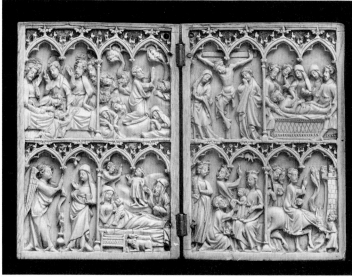

304

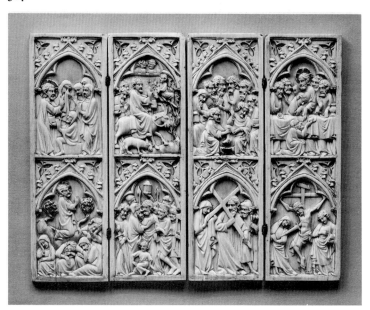

305

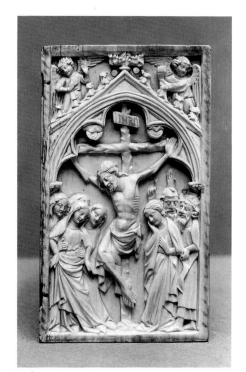

306

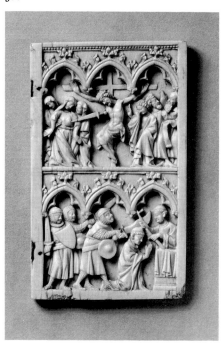

307

308. SCENES OF THE PASSION

Ivory diptych. Flemish, third quarter 14th century

The scenes of the Passion, which are shown beneath arcades of four trefoil arches, read from the bottom left: Entry into Jerusalem, Last Supper, Arrest of Christ, Death of Judas, and Crucifixion. While the iconographic details are standard and found in Parisian work of the same period, the figure style is unusual. The crowded scenes are populated by thin, tall figures with sharp facial features.

A diptych with the same figure style and with many nearly identical figures in the Crucifixion scene is in Munich (Berliner, no. 46). The scene of the Coronation of the Virgin between saints in the Munich diptych's upper left leaf is Flemish in character, particularly the four musical angels playing within the confines of the wide Gothic throne. The tiled castle of Flemish character with corner turrets in the Munich ivory resembles the gate in the Walters Entry into Jerusalem.

The figure style is found on a few other related pieces, particularly a leaf in the British Museum (Dalton, no. 306) that has the unusual scene of the Miracle of the Wheat Field. Another related plaque was in the Auspitz Collection (Koechlin, no. 354) and its matching leaf was in the Kofler Collection (Kofler, no. S 90). A set of related writing tablets is in the Victoria and Albert Museum (Longhurst, no. 804-1891).

A related figure type can be seen slightly later in miniature ivory reliefs thought to be north French or Flemish (for example, Victoria and Albert Museum, Longhurst, no. A-19-1923) and in small boxwood and some larger-scale Flemish sculpture. The elongation of figures can be seen in Flemish manuscripts such as the Romance of Alexander (Bodley, no. 264), which was written in Bruges in 1344 (M. R. James, *The Romance of Alexander*, Oxford, 1933).

The silver hinges are nineteenth century.

H: 4¾″ (11.9cm) × w (each): 2⅞″ (7.4cm)
71.177

HISTORY: Purchased in Paris, before 1931.

BIB.: *Medieval Art*, Philbrook Art Center, Tulsa, 1965, no. 101.

309. CRUCIFIXION

Right leaf of an ivory diptych. North French or German(?), third quarter 14th century

The scene is placed beneath three trefoil arches and shows the Virgin at the left and John at the right, with the sun and moon above. The bending pose of the Virgin is unusually exaggerated.

Her gesture occurs in Paris work of about 1370, such as the diptych in the Louvre (Gaborit-Chopin, no 256), but is also found in the German(?) quadriptych in the Walters Collection (cat. no. 305).

The drapery of John is closely paralleled by that of the John in the Crucifixion miniature of a missal for the use of Châlons-sur-Marne (Morgan, M. 331). The figure is similarly broad, and the outlines emphasized with repeated S-folds (*International Style*, no. 44).

There are remains of broken silver hinges, and an original diagonal hole at the top for hanging.

H: 4⁹⁄₁₆″ (11.6cm) × w: 3⅛″ (8.0cm) 71.182

HISTORY: Purchased in Paris, 1922.

310. SCENES OF CHRIST'S LIFE

Ivory diptych. Flemish or Mosan, last quarter 14th century

The scenes read from the top left and include the Nativity, Adoration, Crucifixion, and Last Judgment. They are placed under arcades of three trefoil arches. While the first scenes derive from the Passion Diptychs, the Last Judgment was reintroduced into ivories at the end of the fourteenth century from northern sources.

The carving is very crisp, the spatial relationships unusually well controlled. The Last Judgment appears in the Schoolmeesters Diptych (Koechlin, no. 783, certainly a Mosan work) and in diptychs in Berlin (Koechlin, no. 779) and the Vatican (Morey, no. A 97, called German).

H: 6⅝″ (16.8cm) × w (each): 3³⁄₁₆″ (8.0cm)
71.201

HISTORY: Collection of E. Chappey, Paris (sale, Paris, June 5, 1907, IV, lot 1682); purchased from Léon Gruel, Paris, 1925.

BIB.: *International Style*, no. 110; Randall, *Ivories*, no. 19.

311. NATIVITY AND ADORATION

Ivory diptych. Flemish or Mosan(?), last quarter 14th century

The left wing combines the scene of the Nativity with that of the Annunciation to the Shepherds; the right shows the Adoration of the Three Kings. The scenes are set beneath arcades of three trefoil arches.

The two scenes are based on the large Passion Diptychs, for example, catalogue no. 312. Details relate to catalogue no. 310 and other works attributed to Mosan or Flemish artists.

Both panels are cracked vertically and one has been rejoined.

H: 2⅞″ (7.3cm) × w (each): 2⅛″ (5.4cm)
71.194

HISTORY: Purchased before 1931.

312. SCENES OF CHRIST'S LIFE AND PASSION

Ivory diptych. French (Paris), fourth quarter 14th century

This diptych consists of three tiers in which the scenes are beneath arcades of five trefoil arches. The scenes, reading from the top left, include: Annunciation, Nativity, Adoration of the Magi, Kiss of Judas, Death of Judas, Crucifixion, Resurrection, Ascension, and Pentecost.

Closely related diptychs include those of the Duthuit Collection, Petit Palais (no. 1277); Metropolitan Museum (50.195); British Museum (Dalton, no. 284); Musée Lazaro Galliano (Koechlin, no. 813); and the Louvre (*Les fastes du gothique*, no 163). Variations occur in all of them, but there is a recurrent problem of consistent scale. All must have originated in the same workshop.

The diptych was once supplied with a stand, attached through square holes pierced in the center arch of the two lower arcades. These are now plugged with ivory. There is an incised outline of the stand on the back and six V-shaped slots are filed into the back of each leaf.

H: 7¾″ (19.7cm) × w (each): 4½″ (11.3cm)
71.272

HISTORY: Collection of John Malcolm of Poltalloch, County Argyll, Scotland; exhibited at Manchester, 1857, and Leeds, 1868; Burlington Fine Arts Club, 1879; Baron Malcolm of Poltalloch; Col. Edward Donald Malcolm (sale, London, May 1, 1913, lot 21); purchased from Arnold Seligmann, Rey and Co., New York, 1922.

BIB.: *International Style*, no. 113; *Les fastes du gothique*, no. 163.

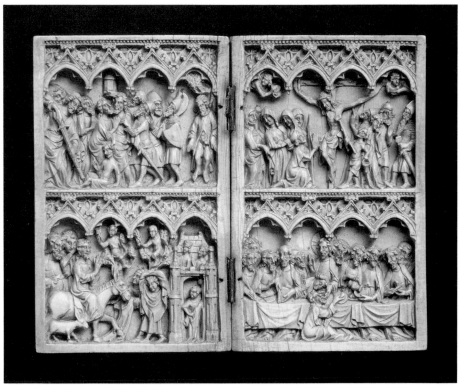

308

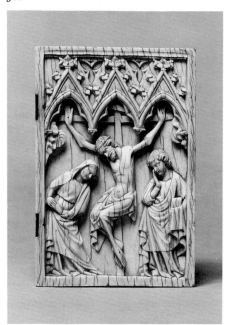

309

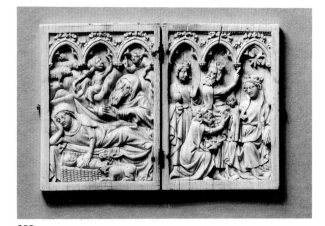

311

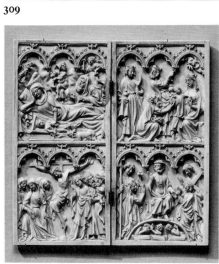

310

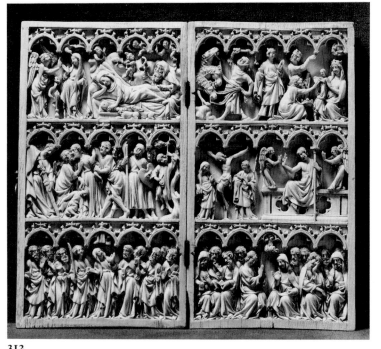

312

313. SCENES OF THE PASSION

Right leaf of an ivory diptych. German (Mainz), fourth quarter 14th century

This is the right leaf of a diptych, the left of which is in Lyons, Musée des Beaux-Arts (Koechlin, no. 836). The scenes, reading from left to right, top to bottom, are: Washing of the Feet, Gethsemane, Arrest of Christ, and Crucifixion. The florid style, the rendering of the eyes, and the individual character of the curly-headed John relate this to other works by the Mainz carver known as the Master of Kremsmunster.

The Master of Kremsmunster derives his name from a diptych of the Adoration and Crucifixion in the Treasury of the Abbey of Kremsmunster (Koechlin, no. 824). His works include one diptych in Berlin (Koechlin, no. 833), one in the Metropolitan Museum (Kofler, no. S 93), and about ten other works in Lyons, Berlin, Langres, and the Musée de Cluny (Koechlin, nos. 825, 831, 832, 836). Although many types of enframements were used in the shop, crowded scenes are common to all the pieces, with particular attention paid to the play of light and shade in the rich compositions. The individualization of the type of John is notable, and the halo of Christ is often, but not always, carved on the Cross of the Crucifixion.

The atelier of the Master of Kremsmunster has been tentatively placed in Mainz because of the similarity of its work and the sculpture on the Memorial Portal of the Cathedral of Mainz, whose figures have the same heavy folds of drapery in violent motion as those of the master (P. Metz, *Der Dom zu Mainz*, Cologne, 1927, figs. 36, 38).

The second wing was given to Lyons in 1850. A false wing was made for Spitzer and appeared in his sale.

H: 10¼″ (26.2cm) × W: 4¼″ (12.5cm)
71.156

HISTORY: Collection of Frédéric Spitzer, Paris (sale, Paris, Apr.–June 1893, lot 66); Sigismond Bardac, Paris; purchased from Jacques Seligmann, Paris, 1912.

BIB.: *Exposition Universelle*, Paris, 1900, no. 132, 18; Koechlin, no. 836; D. Rosen, "Photomacrographs as Aids in the Study of Decorative Arts," *JWAG*, XV–XVI, figs, 2–4; *International Style*, no. 107; Randall, *Ivories*, no. 21 (as French).

See also figure 42

314. NATIVITY AND CRUCIFIXION

Reversible ivory panel. German (Rhenish?), last quarter 14th century

The panel is carved on each side with a scene set beneath an arcade of three trefoil arches. On one side is the Nativity with the Annunciation to the Shepherds in the background; on the other, the Crucifixion between the Three Marys and John with a pointing Hebrew.

Such plaques may have been mounted in metal frames and hung within bed curtains as *images de chevet*, or they may have formed half of a reversible diptych, on one side of which were Passion scenes, on the other, scenes of Christ's infancy. Another example, in the Victoria and Albert Museum (Longhurst, no. 1984-1899), shows the Adoration and Way of the Cross. It also appears to be Rhenish. A plaque in Berlin (Volbach, no. 631) has an Adoration and Saint George. The hole at the top for suspension suggests it was a reversible hanging image. In the Hunt Collection, Limerick, a two-sided reversible diptych is complete, and is possibly Irish. It shows Infancy and Passion scenes.

It is also possible that this two-sided plaque was one of two covers of a set of wax tablet leaves, on the basis of a complete set from the Linsky Collection recently given to the Metropolitan Museum. This set of six leaves has no hinges, but is bound, like a book, with a glued spine of sheepskin.

A comparable rendering of the two scenes may be noted in a German ivory panel in the Schnütgen Museum (F. Witte, *Die Skulpturen der Sammlung Schnütgen Cöln*, Berlin, 1912, pl. 83. no. 8).

H: 3⅛″ (8.0cm) × W: 1�15⁄16″ (5.0cm) W.106

HISTORY: Inset in the cover of an English manuscript by Léon Gruel; purchased from Gruel and Engleman, Paris, June 9, 1903.

315. CORONATION OF THE VIRGIN

Ivory wax tablet. French(?), last third 14th century

Three angels hold a cloth of honor behind the Virgin and two others swing censers at the sides while she is crowned. The scene is placed beneath a canopy of three trefoil arches.

The panel is recessed on the reverse to receive wax for writing. It was attached to other panels with two holes in the right side for cords, and a hole in the center of the left side for securing the other tablet or tablets.

Although wax tablet covers are usually decorated with secular scenes, a number of others exist with religious subjects—for example, the Virgin with angels in Berlin (Volbach, no. 670)—which suggests that wax notebooks were used by the clergy as well as by the laity.

H: 3⅝″ (9.3cm) × W: 2⅞6″ (6.0cm) 71.203

HISTORY: Purchased from or shipped by Léon Gruel, Paris, 1914.

316. ANOINTING OF CHRIST'S BODY AND ADORATION OF THE MAGI

Ivory panel. German (Westphalia?), 1400–1420

The scenes are set beneath arcades of six poorly formed arches, topped by crockets. The upper scene is the Anointing of the Body of Christ and the lower the Adoration of the Magi.

The plaque has no hinges and shows traces of having once had a metal frame. It has been broken on the left side and repaired. It is possibly half of a diptych, which was mounted in silver, or was used as a pax.

The sharp folds of the Virgin's skirt and the angular posture of her knees are related to German alabaster sculpture of the early fifteenth century; for example, the figure of God the Father in the Bayerisches Nationalmuseum (G. Swarzenski, "Deutsche Alabasterplastik des 15 Jahrhunderts," *Staedel Jahrbuch*, I, 1921, fig. 44). The kneeling king resembles a second alabaster attributed to the Crucifixion Master by Swarzenski (fig. 56).

H: 3¹³⁄16″ (9.8cm) × W: 2¼″ (5.8cm) 71.249

HISTORY: Collection of Edward Aynard, Lyons (sale, Paris, Dec. 1, 1913, lot 179); purchased from Léon Gruel, Paris, 1914.

317. LIFE OF THE VIRGIN

Left leaf of an ivory diptych. French, end 14th century

The upper register contains the Presentation in the Temple; the lower, the Nativity, with the Annunciation to the Shepherds in the background. The heavy Burgundian-type drapery in the upper scene, particularly that of the Virgin, suggests a date close to 1400. The scenes are shown beneath arcades of three trefoil arches.

The hinges are missing, and the panel was recut for second hinges. The upper register shows traces of lapis blue behind the crockets; the lower scene has traces of green landscape and blue sky.

The reverse of the panel is engraved with the Magdalen at the foot of the Cross in an oval with decorative borders, taken from an Italian(?) print of the late sixteenth century. The engraving would indicate that the ivory was still in use in the sixteenth century.

H: 4″ (10.2cm) × W: 2¼″ (5.8cm) 71.210

HISTORY: Purchased before 1931.

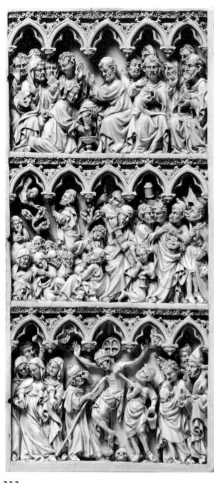

313

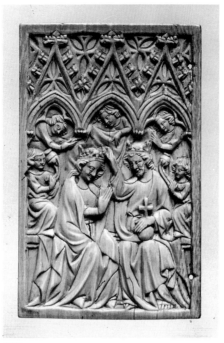

315

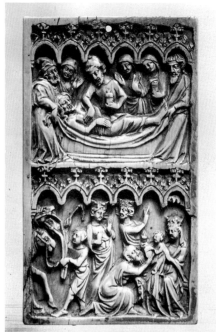

316

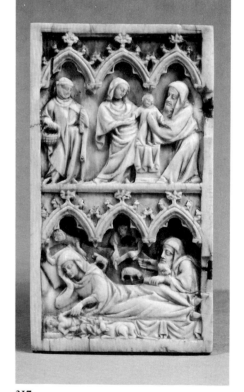

317

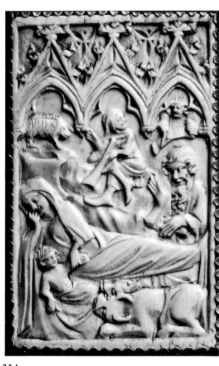

314

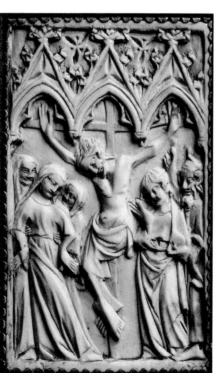

314

318. SCENES OF CHRIST'S PASSION

Right leaf of an ivory diptych. French or Mosan, c. 1400

The Washing of the Feet, Gethsemane, and Crucifixion are shown beneath arcades of five undecorated trefoil arches. The carving is summary and gives an impressionistic effect of light and shade.

Two of the three hinges remain. A rough hole in the center of the top arcade and a chip from the lowest arcade occur, and there are several long vertical cracks in the panel. The whole panel is stained brown, probably reflecting an early application of varnish.

The left leaf with the Entry into Jerusalem, Last Supper, and Arrest of Christ is in the collection of the British Railways Pension Fund, on loan to the Walters Art Gallery. The format of the diptych follows the Parisian Passion Diptychs, with several unusual details, for example, the fainting posture of the Virgin, which is seen in some German and Mosan examples in Liège (Koechlin, no. 783), Leningrad (Koechlin, no. 585), and the Louvre (Koechlin, no. 488 bis). The style of the carving suggests either a Mosan artist working in Paris or a Mosan interpretation of a Parisian work.

The carving technique is very different, with simplified cutting that has left high ridges for the play of light and shade. A rare feature is the use of heads, or in some cases heads and shoulders, to indicate figures in the background. In the Gethsemane scene, for instance, there are three Apostles behind Christ: one indicated by a head with his shoulder fading into the hillock, a second with only a head, and the third with a hand and right arm making a gesture. In the Washing of the Feet, heads are also used to indicate figures in the background. The background figures are, in addition, purposefully less well defined, so that the carver has, in effect, introduced what appears to be atmospheric perspective. The same treatment may be seen in a diptych in Berlin (Koechlin, no. 788) in the Gethsemane scene.

Somewhat related in technique is a stone sculpture finished in a similarly summary manner from the tomb of Jean de Berry at Bourges (1401–1416) by Jean de Cambrai (*Les fastes du gothique*, no. 112).

The matching leaf is carved by another hand in a more conventional manner, and relates to leaves in Berlin and Madrid (Koechlin, nos. 788, 795).

H: 8½″ (22.5cm) × w: 4″ (10.1cm) 71.280

HISTORY: Collection of Charles Tesart (sale, Paris, June 24–25, 1924, lot 88); purchased from Henry Daguerre, Paris, 1925.

319. CRUCIFIXION

Right leaf of an ivory diptych. South German, c. 1400

The attenuated figure of Christ on the Cross is flanked by the Virgin and John. The Virgin, whose drapery sweeps in a curve, makes a gesture of grief with her left hand. John's drapery is in violent motion, and his hand is held against his cheek. The scene is placed beneath an arcade of three trefoil arches with coarse fleurons and finials.

The unusual emotionalism of the figures relates to south German works such as the mourning group from Mittelbiberach in the Berlin Museum (G. Weise, *Mittelalterliche Bildwerke des Kaiser Friedrich-Museums*, Reutlingen, 1924, I, 8).

The hinges are missing; two holes have been drilled at the top and one at the bottom.

H: 2¹⁵⁄₁₆″ (6.3cm) × w: 1¾″ (4.4cm) 71.183

HISTORY: Purchased before 1931.

320. THE LOVER CROWNED

Ivory mirror case. French (Paris), first quarter 14th century

Enframed in a simple circular molding, a gentleman kneels before his lady, who places a chaplet on his head. Both are dressed in *houppelandes*. The scene is broadly and powerfully carved, with the background indicated by a stylized tree and other smaller plants. Originally there were four crouching-monster corner terminals; one is now missing and two are damaged.

The style of the figures finds only one major parallel in monumental sculpture showing secular subjects. These are the reliefs of student life on the south transept of Notre Dame de Paris, finished sometime after 1258 (M. Aubert, *Notre-Dame de Paris*, Paris, 1909, 131, pl. opp. 121), where one sees similar figures with the same quick movements and slightly exaggerated gestures, and a similar variety of drapery folds, in the less facile medium of stone.

A large hole in the lower right corner terminal appears to be an original means of securing the mirror. The piece is rubbed from use.

H: 3⁹⁄₁₆″ (9.0cm) × L: 3⅜″ (8.5cm) 71.284

HISTORY: Collection of Victor Gay (sale, Paris, Mar. 23, 1909, lot 76); purchased from Jacques Seligmann, Paris, 1912.

BIB.: Koechlin, no. 1001.

See also figure 37

321. LOVERS

Ivory mirror case. French, first quarter 14th century

This unusually small mirror case, perhaps for a child, depicts the meeting of two lovers. It is framed in a hexafoil, and the simple outer molding has four crouching monsters as corner terminals. A large hole is drilled in the center; holes in each of the corner terminals indicate a later use as a button or ornament. The mirror case was buried at one time, and there are losses from flaking, including the right arm of the youth.

The costumes, gestures, and subject are paralleled in mirror cases in Florence and Oxford, and in the collection of Martin Le Roy, Paris (Koechlin, nos. 988, 990, 993).

H: 2¼″ (5.8cm) × w: 2³⁄₁₆″ (5.7cm) 71.95

HISTORY: Purchased from Henry Daguerre, Paris, 1924.

322. ATTACK ON THE CASTLE OF LOVE

Ivory mirror case. French (Paris), 1320–1340

In a complex scene with twenty human figures and four horses, a group of knights attack the Castle of Love, which is defended by ladies and the God of Love. The attackers use a catapult and crossbows with which they shower roses on the castle. The ladies, in turn, pour baskets of roses on the heads of the attackers. A lady welcomes a knight scaling the wall and another succors a knight on the battlement.

The mirror is now round with a simple molded border. Four corner monster terminals have been cut away, as the remains of their tails indicate. There is a large chip in the upper right edge. A diagonal hole in the top appears to be original.

The French mirror case showing the Elopement, now in the City of Liverpool Public Museum (Koechlin, no. 1105), is closely related in composition and figure style and can be attributed to the same carver. While the Liverpool ivory cannot be compared stylistically to the miniatures in the Life of Saint Denis of 1317 (Paris, Bibliothèque Nationale, ms. fr. 2090–2092), the spirit is the same, and the scenes of Paris bridges are very close in feeling to the ivory (V. Egbert, *On the Bridges of Medieval Paris*, Princeton, 1974, pl. 6, fol. 116).

D: 5¹⁄₁₆″ (12.9cm) 71.169

HISTORY: From the Treasury of the Cistercian Abbey of Rein, Styria; exhibited Vienna, 1873 (K. Lind, "Die österreichische kunsthistorische Abteilung aus der Wiener Weltausstellung," *Mitteilungen Zentral-commission*, Vienna, 1873, pl. 22); Munich, 1876 (pl. 81); Graz, 1883 (album, fasc. 9, pl. 55); sold by the Abbey in 1928; purchased from Jacques Seligmann, Paris, Dec. 1, 1928.

BIB.: A. Schultz, *Das Höfische Leben*, I, Leipzig, 1889, 577; Westwood, *Ivories*, 468; Koechlin, no. 1097.

See also colorplate 71

323. THE FOUNTAIN OF YOUTH

Ivory mirror case. French (Paris), 1330–1340

Older people and cripples are shown walking or being carried or brought by horsecart to the Fountain, where they bathe and turn young again. Youths are seen dressing and entering the castle; on the parapet, three couples are courting. The simple enframing molding has four corner terminals, two in the form of crouching monsters and two in the form of bipeds with human heads and cowls.

The subjects appear on a number of Parisian caskets of the same date, as in catalogue no. 324.

There is a large chip at the drilled hole at the top and a crack through the right side.

H: 5¹⁄₁₆″ (13.0cm) × w: 5″ (12.5cm) 71.170

HISTORY: Collection of Count Gregorii Stroganoff, Rome; purchased from Léon Gruel, Paris, before 1931.

BIB.: Koechlin, no. 1067; Randall, *Medieval Ivories*, no. 23; *idem*, "The Medieval Artist and Industrialized Art," *Apollo*, LXXXIV, 1974, no. 58, 16.

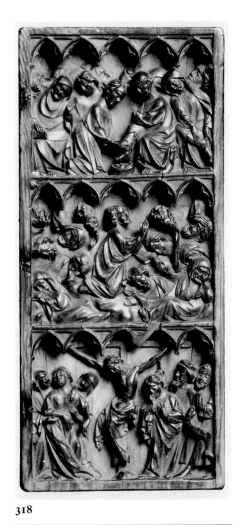

318

320

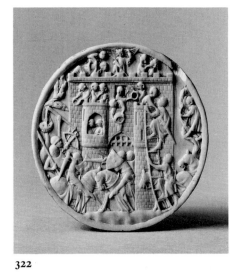

322

321

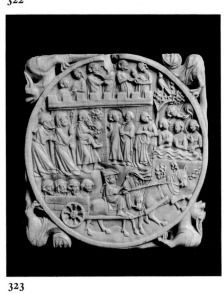

323

319

324. SCENES OF ROMANCES

Ivory casket with iron mounts. French (Paris), 1330–1350

The lid of the box is carved with a tournament held before a group of courtiers on a balcony. At the left is the Attack on the Castle of Love, in which a catapult throws roses at the castle and the God of Love defends it. At the right a mock tournament between ladies and knights is depicted.

The front panel shows, from the left, Aristotle teaching Alexander, Phyllis riding Aristotle, and two scenes of the Fountain of Youth. The right end panel depicts Galahad receiving the keys to the Castle of Maidens. The rear contains four scenes: Gawain fighting the lion, Lancelot crossing the sword bridge, Gawain on the perilous bed, and the three maidens at the Château Merveil. The scenes are out of order and somewhat conflated. Lancelot on the bridge is represented with a sky full of falling spears, a detail borrowed from the adjacent scene. The left end panel shows Tristan and Iseult with King Mark in the tree and the Capture of the Unicorn.

The box and others related to it have been considered French since they were first published in 1780, and are among the chief examples of the style attributed to Paris in the second quarter of the fourteenth century. The group includes Koechlin no. 1285 and no. 1289, and a casket in the Metropolitan Museum (17.190.173). The subjects are explained in detail by R. S. Loomis (see Bib.).

The iron mounts were added when the box was in the Spitzer Collection. The top is cracked in three places along the back edge.

H: 4½″ (11.5cm) × L: 9¹¹⁄₁₆″ (24.6cm) × D: 4¹³⁄₁₆″ (12.4cm) 71.264

HISTORY: Collection of Rev. John Bowle (1725–1788), Wiltshire, about 1780; Gustavus Brander, Christchurch, Hampshire, 1787; Francis Douce (1757–1824), London, until 1824; Sir Samuel Rush Meyrick (1783–1848), Goodrich Court, Herefordshire, until 1848; Lt. Col. Augustus Meyrick; Frédéric Spitzer, Paris, 1896; Oscar Hainauer, Berlin, 1897; H. Economos, London, 1913; purchased from Arnold Seligmann, Rey, Paris, 1923.

BIB.: J. Carter, *Specimens of Ancient Sculpture*, II, London, 1780, 49, written by F. Grose in 1757; S. R. Meyrick, "The Doucean Museum," *Gentleman's Magazine*, Apr. 1836; W. Bode, *Die Sammlung O. Hainauer*, Berlin, 1897, 142; R. Koechlin, "Quelques ivoires gothiques français connus antérieurement au XIXᵉ siècle," *La revue de l'art chrétien*, LIX, 1911, 398–399; S. de Ricci, *Album*, Palais Sagan, Paris, 1913, pl. 44; Koechlin, no. 1281; *Treasures from Medieval France*, Cleveland Museum of Art, 1967, no. V-20; Randall, *Ivories*, no. 18; V. H. Fruhmorgen-Voss, *Text und Illustration im Mittelalter*, Munich, 1975, 132 ff.; R. S. Loomis, *Arthurian Legends in Medieval Art*, New York, 1938, 60, 70, 76.

See also figure 38 and colorplate 76

325. A TOURNAMENT

Ivory box lid. French (Paris), 1340–1350

Two knights are jousting in front of a grandstand, in which a king, queen, and courtiers appear behind a draped railing. Two heralds are on horseback at the left; three spectators stand at the right. The knights wear chain mail with plate leg armor and great helms. Both helmets have crests, and the knights are defended with ailettes on their shoulders and shields. The knights' horses are caparisoned. The scene is a variant of the one shown on the Parisian box, catalogue no. 324.

Two sections of the border are missing and have been replaced with wood. There are twelve holes for the metal mounts. Where three lateral mounts crossed the lid, the ivory has been recarved to continue the design, which would originally have been unfinished.

H: 3¹⁵⁄₁₆″ (10.0cm) × W: 6¾″ (17.2cm) 71.274

HISTORY: Collection of Charles Stein, Paris; Lord T. G. Carmichael, London, 1902; purchased from George R. Harding, London, 1903.

BIB.: Koechlin, no. 1294; L. Reau, *L'art gothique en France*, Paris, 1945, 63; *Transformations of the Court Style*, Rhode Island School of Design, Providence, Feb. 2–12, 1977, no. 20, 64–65.

326. SCENES OF ALEXANDER AND PYRAMUS

Front of an ivory box. French (Paris), 1330–1350

The first two scenes, from the left, show Aristotle teaching Alexander and Aristotle ridden by Phyllis, observed by Alexander. The next two scenes show Thisbe and the lion and the death of Pyramus and Thisbe. There is a roughened area for the lock in the upper center.

A complete casket with the same scenes on the front panel is in the Treasury of Cracow Cathedral (Koechlin, no. 1285). The other scenes on the Cracow example are comparable to catalogue no. 324.

The upper border is recessed for the lid and has been cut down on each side. A piece of raised border is missing at each end. There is a longitudinal break, and pieces of ivory are missing along the break and at the right end.

Although the first two scenes depict two of the same subjects found on the Paris box (cat. no. 324), the work here is somewhat coarser and must either have come from another shop or been done by a lesser hand. The change of the second two scenes from the Fountain of Youth to Pyramus and Thisbe suggests that there was a variety of subjects available to the carvers.

H: 3⅝″ (9.4cm) × L: 7¹⁵⁄₁₆″ (20.2cm) 71.196

HISTORY: Purchased form Henry Daguerre, Paris, 1923.

327. PAIRS OF LOVERS

Ivory mirror case. French, second quarter 14th century

This relatively small mirror case is divided into four compartments by four highly stylized trees growing from the center. The scenes show pairs of lovers of different ages and social conditions embracing, admonishing, and caressing each other. The four monster corner terminals are restorations, and the back has been scored as if for some other use.

The subject of pairs of lovers divided by four trees appears in other French mirror cases in the Louvre and in a French private collection (Koechlin, nos. 1007, 1014). A very similar example is in the Metropolitan Museum (1979.521.1).

H: 2¹¹⁄₁₆″ (7.0cm) × W: 2⅝″ (6.5cm) 71.168

HISTORY: Purchased before 1931.

328. LOVERS

Ivory mirror case. English or German(?), 1340–1350

Two couples are separated by a tree from which the God of Love throws arrows down on them. At the right the young gentleman kneels and is crowned by his lady; at the left the young lady holds a chaplet and is caressed by her gentleman. The left portion, including the male figure, is a restoration dating before 1924. The case has a simple beveled edge on which perch the monster corner terminals.

Some question has been raised about the nationality of the mirror: whether it might be German or English because of the large heads and faces and the rather simple drapery, which are uncharacteristic of French work. A diptych with similar facial types and subjects of lovers is in the British Museum (Dalton, no. 360). The diptych has unusual features such as mask quatrefoils in the spandrels and one rosette and three pearled borders, and while currently called French, it is English or possibly German.

D: 4³⁄₁₆″ (10.6cm) 71.193

HISTORY: Purchased from Henry Daguerre, Paris, 1924.

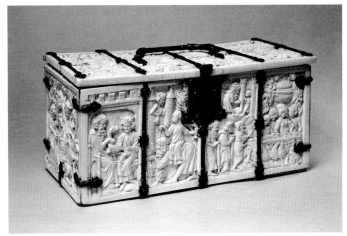

324

325

324

326

324

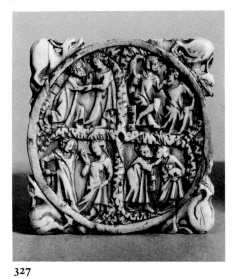

327

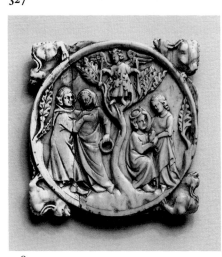

328

329. HAWKING PARTY

Ivory mirror case. French (Paris), second quarter 14th century

The scene shows a lady and gentleman hawking on horseback. She wears a hat with a pointed brim (*chapeau à bec*) and chucks him under the chin; he turns toward her and the hawk on his wrist. They are followed by a huntsman with a spear. A small ground plane is indicated, but the figures are shown against a plain background set within a complex of frames. The circular frame has an inset hexafoil, each lobe of which is subdivided by a trefoil. The corner terminals are four crouching monsters; the upper right one is drilled for attachment. There is a break at the top center from a later drilled hole.

The identical subject in reverse appears on a mirror in the Sulzbach Collection (Koechlin, no. 1027, where the references are confused with the present example). The subject is based on the scene for the month of May in manuscript calendar scenes and occurs on a number of French mirror cases (Koechlin, nos. 1020, 1024, 1028, 1034).

H: 4½″ (12.1cm) × L: 4½″ (12.1cm) 71.275

HISTORY: Collection of Walter Sneyd, Keele Hall, Staffordshire, until 1888; exhibited in Manchester, 1857; Leeds, 1868; a cast in the Victoria and Albert Museum; Keele Hall (sale, London, July 7, 1902, lot 23); purchased from Jacques Seligmann, Paris, before 1931 (1902?).

BIB.: A. Didron, *Annales archéologiques*, XIX, 1859, 253; Westwood, *Ivories*, no. 859.

330. LOVERS

Ivory mirror case. French, mid-14th century

A young gentleman wearing a sword and a lady with a pet squirrel meet in the woods, indicated by trees in the background. The scene is set within a frame of nine lobes, whose spandrels are filled with bearded masks. Two of the four crouching-monster corner terminals have been damaged by burial. There are losses on the back as well, and a new hole is drilled at the top.

The lobed frame is usually considered a sign of a date after the mid-century, but the figure style suggests that this may be an early use of the mask frame.

The same scene appears with some slight variation on a double-sided pair of French secular panels, perhaps the covers of a book of wax tablets, in Naples. The male figure is very closely related. The Naples panel must date from the third quarter of the fourteenth century due to the treatment of the architectural ornament (*Smalti di Limoges e avori gotici in Campania*, Museo Duca di Martina, Naples, Oct. 1981–Apr. 1982, no. 2, 4).

H: 3¾″ (9.5cm) × W: 3¾″ (9.5cm) 71.97

HISTORY: Said to have been disinterred by an artillery shell in northern France between 1914 and 1918; purchased from Henry Daguerre, Paris, 1924.

331. CHESS GAME

Ivory mirror case. German(?), mid-14th century

A young couple plays chess beneath a tree. Both figures gesture with their hands, and the lady holds two pieces in her left hand. The scene has a ten-lobed frame with bearded masks in the spandrels. There are four crouching monsters as corner terminals.

The subject was a very popular one and appears on three fine French mirror cases in London, Paris, and Vienna (Koechlin, nos. 1046, 1049, 1053), which show the figures in a tent. The gesture of the man, however, with his hand around the tree, and the lady's drapery are very closely related. The Walters example, as shown by the enframement and the masks of the border, is later. Furthermore, the summary workmanship and a series of small misunderstandings, such as the lady's right knee, suggest that it is a copy after a Parisian model. Its history points to a German origin.

The mirror case was excavated and has suffered from burial.

H: 3¾″ (9.5cm) × L: 4″ (10.0cm) 71.268

HISTORY: Collection of Freiherr von Wambolt, Aschaffenburg, 1847; Jakob von Hefner-Alteneck, Munich (sale, Munich, June 6–7, 1904, lot 308); purchased from Léon Gruel, Paris, 1925.

BIB.: J. von Hefner-Alteneck, *Trachten*, III, Frankfurt, 1889, 9, pl. 158; Koechlin, no. 1043; W. von Bode and W. Volbach, *Mittelrheinische Ton und Steinmodel*, Jahrbuch der Königlich Preussischen Kunstsammlungen, III, 1918, 99, fig. 8.

332. THE GOD OF LOVE

Ivory mirror case. French, mid-14th century

The God of Love, crowned and winged, stands in a tree and throws arrows on the two lovers below. The seated man is shown with a hawk, and the kneeling woman, already struck by an arrow, holds a chaplet in her hand for her beloved. The scene has a seven-lobed frame with masks in the spandrels. Four monsters form the corner terminals. The mirror is considerably worn from use.

D: 3¾″ (9.5cm) 71.265

HISTORY: Collection of Count Dimitri Stroganoff, Rome; Elia Volpi, Florence (sale, New York, Nov. 21, 1916, lot 1); purchased from H. Wareham Harding, New York, 1916.

BIB.: Koechlin, no. 1070.

333. SCENES OF LOVERS

Ivory mirror case. French, second half 14th century

Within a frame of eight lobes, two couples appear below the Castle of Love, from which the God of Love, winged and crowned, throws arrows down upon them. The youth on the left is crowned by his lady while the right-hand pair embrace. Kneeling figures are shown on the battlements on either side of the God of Love. The men wear capes and hoods over the *cote-hardis*; the *cote-hardis* of the women have liripipes at the elbows. The circular format is brought to a square with triangles of leaves at the corners, incised with veins. The carving is very rough in quality.

H: 3¾″ (9.5cm) × W: 3¾″ (9.5cm) 71.167

HISTORY: A text glued to the reverse records an 1858 description of the object by Viollet-le-Duc; purchased in 1926.

334. THE GOD OF LOVE

Ivory plaque. French, third quarter 14th century

Two couples are seen beneath a tree, from which the God of Love throws arrows down upon them. The scene is set within a seven-lobed frame, with three-pointed leaves in each spandrel. The corners are brought to a square with leaf-corner terminals. The liripipes from the hoods and sleeves of the lovers suggest a date in the second half of the century.

The plaque is cut square, trimming the edges of the circular frame on three sides. The back is polished smooth and does not seem to have been altered from a mirror case, as had been suggested. Its original use is unknown; it could have been the cover of a square box, an ornament for a book cover, or inset in some object. It has been burned in the lower side and discolored, most noticeably at the lower left corner.

H: 3¹⁄₁₆″ (7.8cm) × W: 3″ (7.7cm) 71.207

HISTORY: Purchased from Léon Gruel, Paris, 1925.

BIB.: *Images of Love and Death*, 108–109, no. 68. pl. 6.

335. SECULAR STORIES

Ivory mirror case. North French(?), third quarter 14th century

A sequential story in three scenes is portrayed in a landscape with a stream, trees, and a small house. A young couple plays chess, observed by a lady wearing a wimple; a lady threatens a bearded man or hermit, with a club or broom; and the old man climbs up to his house, still threatened by the lady. The scenes are surrounded by an eight-lobed frame with youthful masks in the spandrels. The back has been trimmed of the raised parts of the turned depression for the mirror, probably to reuse the plaque on a book cover. Several chips are evident on the edges and several candle burns may be seen.

Scenes from a similar, unidentified story concerning an elder and a young couple appear on the box and cover of catalogue no. 339, attributed to the Atelier of the Boxes (cat. nos. 339 and 340). This example can be attributed to the same shop.

D: 3¾″ (9.5cm) 71.206

HISTORY: Thought to have been purchased in 1929.

BIB.: *Images of Love and Death*, no. 71, pl.8.

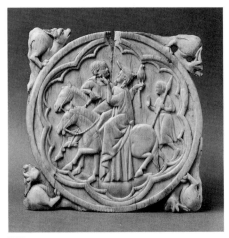

329

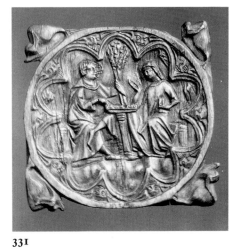

331

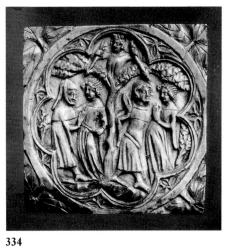

334

330

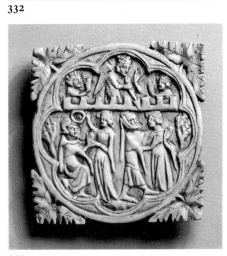

332

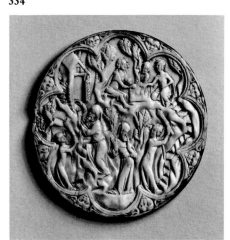

335

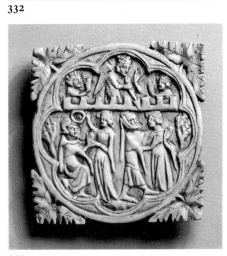

333

336. THE PRODIGAL SON

Ivory wax tablet. French (Paris), 1330–1350

The plaque illustrates the first two scenes of the story of the Prodigal Son and should be read from bottom to top. In the first scene, the father divides his inheritance as the Prodigal, who is shown in an elegant hat, is observed by his mother and brother. Above, the Prodigal rides with his hawk, followed by a servant with a chest full of treasure. As they approach a young woman, the servant raises a warning finger.

The scenes are set beneath canopies of trefoil arches. There are two holes drilled in the center at the sides for cords to attach the leaf to others. The back is recessed to receive a coat of wax for writing.

A second tablet cover with later scenes of the story is in the British Museum (Dalton, no. 365) showing the Prodigal in the brothel, chased from the brothel, feeding swine, and returning to his father.

H: 5⁹/₁₆″ (11.6cm) × W: 2½″ (6.3cm) 71.279

HISTORY: Fictile cast in the Victoria and Albert Museum (1873-165); collection of Max and Maurice Rosenheim, London (sale, Sotheby's, May 9–11, 1923, lot 294); purchased before 1931.

BIB.: Westwood, *Ivories*, no. 440, 193; Koechlin, no. 1213; *International Style*, no. 114; Randall, *Ivories*, no. 22; idem, "The Prodigal Son," *BWAG*, XXII:5, 1970; 2–3.

337. SCENES OF VIRGIL AND ALEXANDER

Ivory wax tablet. French (Paris), 1340–1360

The tablet contains episodes from two romances. At the top is the story of Virgil ridiculed in the basket, with his revenge on the princess and the lighting of the candles of Rome. In the lower register is the story of Campaspe at the loom being bribed by Alexander to enchant Virgil, with whom she consorts in the second scene.

The scenes are shown beneath canopies of four trefoil arches. There is a triangle of five holes in the right center section of the panel, which were probably drilled for later hinging. The left side has been rabbeted and the other corners notched, perhaps for suspension.

The same subjects are shown on another set of French wax tablets, now lost, published in Bernard de Montfaucon, *L'antiquité expliqué*, Paris, 1722, III, pl. 194, with other scenes of the Campaspe story, and on a comb formerly in the Figdor Collection (Koechlin, no. 1150), possibly north Italian in origin.

H: 3¾″ (9.5cm) × W: 2″ (5.1cm) 71.267

HISTORY: Collection of John Lumsden Propert, London (1834–1902); Sir Thomas Gibson-Carmichael, London, 1902; purchased from H. Wareham Harding, New York, 1902.

BIB.: Koechlin, I, 440; *International Style*, no. 112; Verdier, *Art International*, no. 4, 32, fig. 7.

338. LIVES OF THE VIRGIN AND SAINT MARGARET

Ivory box with silver and enamel mounts. French (Paris), 1360–1380

This is a small box with four scenes of the life of the Virgin on the lid: Annunciation, Visitation, Nativity, and Adoration of the Magi. The tightly composed vertical scenes appear under trefoil arches. The sides of the box show the life of Saint Margaret, beginning on the left end panel with the scene with the Roman governor Olybrius. On the front, in a four-part composition, Margaret is brought before the governor in judgment. On the right end panel she is whipped before the governor, on the rear, in a four-part arrangement, she is shown with witnesses, thrown in prison, overcoming the dragon, and being decapitated. The carving is extremely coarse.

The mounts are silver incised with arches containing tiny dragons and birds. Two of the bands on the lid and two on the sides are original; the other bands are replacements. A central silver ring on the lid is en suite and has traces of enamel.

There are two other small, coarsely carved caskets (Dalton, no. 371, and Longhurst, no. 263-1867) with closely related scenes of Saint Margaret's life. The carving techniques vary, and each box utilizes somewhat different framing elements. The lid of the present casket, while original, is by a finer hand than the sides.

A box with scenes of the life of Saint Catherine (collection of W. Lawrence, *Burlington Fine Arts Exhibition*, London, 1923, no. 137) and a diptych of Saint Catherine in the collection of M. Piet-Lataudrie (G. Migeon, "La collection de M. Piet-Lataudrie," *Les arts*, Aug. 1909, 6) are of the same quality. A somewhat finer box with the life of Saint Margaret was formerly in the Garnier Collection (G. Migeon, "La collection de M. Paul Garnier," *Les arts*, May 1906, 16). All appear to date in the third quarter of the fourteenth century. The boxes have lids with religious subjects unrelated to the saint's life on the sides. The lids are also generally of a slightly higher quality, as though the master had carved the lid and someone else in the shop the sides.

A separate box lid in the Detroit Institute of Arts is derived from the same, or a similar, model. The scenes of the Annunciation and Visitation are nearly identical, although the scene of the Adoration has been divided into two scenes to fill the last two of the four arched components. The carving style is very similar to the Walters casket.

The coarse carving relates this piece to the ivories of the colonnette group (cat. no. 304) and to the diptych used on the book covers in the Treasury of Saint-Denis (*Les fastes du gothique*, no. 210), further confirming the date and the Parisian provenance.

H: 1⅞″ (4.8cm) × L: 4¼″ (10.9cm) × W: 2¹¹/₁₆″ (6.8cm) 71.197

HISTORY: Purchased before 1931.

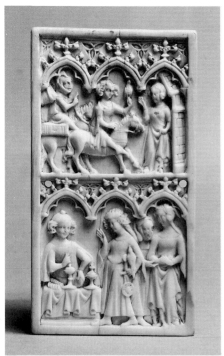

336

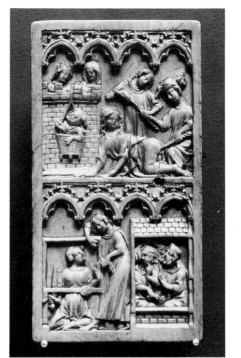

337

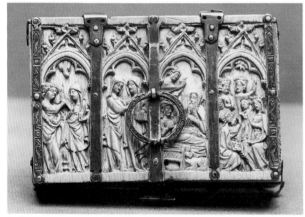

338

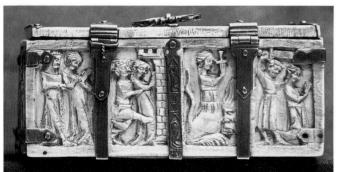

338

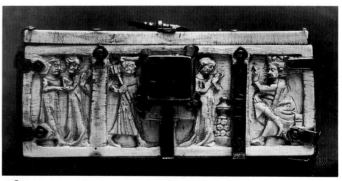

338

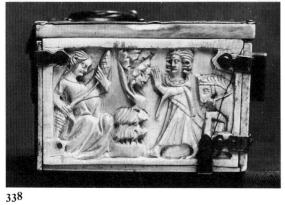

338

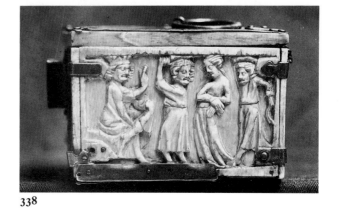

338

339. LOVE STORIES

Ivory box and cover. North French(?), third quarter 14th century

The sliding cover of the box is carved with a walled town, from which two ladies look over the parapets and report to a cowled gentleman about two pairs of lovers who are outside the walls. The couple in the foreground is young and stylishly dressed. He caresses her chin while she holds a dog in her lap. In the background an older woman with a tall hood holds the hand of a young man with a hawk. There is a canopy of three trefoil arches.

The bottom of the box is carved with three scenes that take place outside the walls of a town. A lady with a hawk is caressed by a gentleman in a tent; a gentleman presents a chaplet to a lady under a tree; and a hermit reads outside his cell. The architectural canopy is the same as on the cover. The box is three-sixteenths of an inch deep; its use is not known.

The box was produced by the Atelier of the Boxes, which specialized in wax tablets, mirrors, and boxes for various purposes. Works from the Atelier of the Boxes include a mirror case (cat. no. 335), the Stroganoff wax tablets (Koechlin, nos. 1179 and 1180; Kofler, S-111 and 112), a wax tablet with wild men (Dalton, no. 364), a wax tablet with hunters (Kofler, no. S-109), and two mirror cases in Florence (Koechlin, nos. 1064 and 1108).

The playfulness and courtly costume of some of the ivories, combined with the rustic type of Gothic architecture and the inclusion of wild men in some of the subjects, suggest to certain scholars that the works of the Atelier of the Boxes originated in the Savoy. The scene of the hermit reading within a wattle fence in front of his hermitage, however, appears in a closely related drawing in the sketchbook of Jacques Daliwe, a northern artist who worked in the circle of the duke of Berry from the late fourteenth century until about 1415 (H. Kreuter-Eggemann, *Das Skizzenbuch des "Jacques Daliwe,"* Munich, 1964, pl. 8). In the case of the Annunciation box (cat. no. 340), close parallels with the marble angel from Flavigny (*Les fastes du gothique*, no. 80), attributed to Jean de Liege, and other works point to northern artists working in court circles in Paris and northern France.

The rendering of the landscape in little ridges with incised grass and the character of the architecture are closely related to manuscript illumination. Especially noteworthy is a Guillaume de Machaut manuscript in Paris (Bibliothèque Nationale ms. fr. 1586) in this regard (F. Avril, *Manuscript Painting at the Court of France*, New York, 1978, pls. 23–26).

H: 3¹¹⁄₁₆″ (9.3cm) × L: 2³⁄₁₆″ (5.4cm)
71.283a,b

HISTORY: Anonymous collection, Cologne, 1893; collection of M. Antocolsky, Paris, 1901; purchased from George R. Harding, London, June 15, 1901.

BIB.: *International Style*, no. 111; *Images of Love and Death*, no. 75.

340. ANNUNCIATION

Ivory bottom of box. North French(?), third quarter 14th century

Gabriel approaches from the left, pointing his finger toward a scroll. The Virgin, who raises her right hand in surprise, holds a book in her left. Her apron-style drapery has cascades of small folds falling at either side. A vase with a lily sits between the figures, and the Holy Ghost descends from the clouds above. The scene is set beneath a canopy of three trefoil arches surmounted by a band of dentils.

The Annunciation box appears to be the only religious ivory known from the Atelier of the Boxes (see cat. no. 339). The treatment of the architectural canopy is identical to other works from the workshop. The gesture of the angel's right hand may be compared to that of the bearded lover in the Stroganoff-Kofler wax tablets (Kofler, no. S-112).

The type of the Virgin Annunciate, which is also found in a marble group that is divided between the Cleveland Museum and the Louvre, may be dated in the mid-fourteenth century (*Les fastes du gothique*, no. 60). The type of the Angel Annunciate can be seen in the marble from Flavigny in the Metropolitan Museum of the third quarter of the fourteenth century (*Les fastes du gothique*, no. 80). The drapery style is closely paralleled by the Petites Heures of the duke of Berry, 1376–1380 (*Les fastes du gothique*, no. 297—Adoration of the Magi).

The interior, which is the bottom of the box, is divided into compartments to hold a balance and weights. The sliding top of the box is missing.

L: 3⅛″ (7.9cm) × W: 1¾″ (4.5cm) × H: ¹¹⁄₃₂″ (0.9cm) 71.1156

HISTORY: Collection of John Hunt, Dublin; Lewis V. Randall, Montreal; purchased from Ruth Blumka, New York, Feb. 1977.

BIB.: *Medieval Art from Private Collections*, The Cloisters, New York, Oct. 1968–Jan. 1969, no. 79.

341. LIVES OF THE VIRGIN AND CHRIST

Ivory wax tablet. Flemish(?), last quarter 14th century

Although this wax tablet has scenes divided by colonnettes, its style bears no relationship to that of the so-called group of ivories with colonnettes (see cat. no. 304). The architectural canopy of two trefoil arches over each scene relates it to, among others, the Atelier of the Boxes of the later fourteenth century. The scenes in the lower register are the Annunciation and Visitation; in the upper, Gethsemane and Arrest of Christ.

The iconography of the Annunciation is very similar to that of the Atelier of the Boxes (see cat. no. 340). The Annunciation and Visitation are close to the same scenes on a panel from the Kofler Collection (no. S-90), including the arrangement of the headgear of Saint Anne. The Kofler plaque's unusually rich enframement and stylistic features suggest a north French or Flemish attribution.

A large hole is drilled at the top for attachment to the other cover and intervening tablets. There is a depression for wax on the back.

H: 4⅞″ (12.4cm) × W: 2⅞″ (7.4cm)
71.192

HISTORY: Purchased from Arnold Seligmann, Paris, 1926.

342. APOSTLE OR PROPHET

Ivory statuette. School of Giovanni Pisano, Italian, first half 14th century

This unusual bearded figure stands bent forward, head projecting at a forty-five-degree angle, his hood falling back off his head. He holds an open book, which forms an X with the folds of drapery below. The straight folds on the front of the figure contrast with the sharp V-folds at the sides. Although the back is flat, as if the figure were intended to be seen against a background, it is carved with vertical folds. The eyes are half closed, the mouth is partially open.

The projecting head and open mouth, the boldness of the concept, and the contained emotion of the figure relate it to the works of Giovanni Pisano. The unusual treatment of the waist, with the decided break in the composition, is a favorite device of Pisano and may be seen in his Justice figure in the Palazzo Bianco, Genoa, among others. The half-closed eyes also appear in the Justice. The treatment of the figure's right knee under the drapery is paralleled in Pisano's Pisa Cathedral pulpit, the sharp drapery folds in his ivory Madonna in the Pisa Cathedral (see Ayrton, Bib.). However, the composition and treatment are weaker in the Walters figure, and the date seems to be more toward the middle of the century.

The base has been cut above the feet and minor alterations made to the hemline of the garments. The surface was partially cleaned at one time. There is a wide hole in the top of the hood.

H: 4⁷⁄₁₆″ (13.9cm) 71.245

HISTORY: Collection of Octave Homberg, Paris (sale, Paris, May 16, 1908, lot 493); purchased from Léon Gruel, Paris, before 1931.

BIB.: Koechlin, no. 717; Randall, *Ivories*, no. 24; M. Ayrton, *Giovanni Pisano, Sculptor*, New York, 1947, pls. 184, 156, 117.

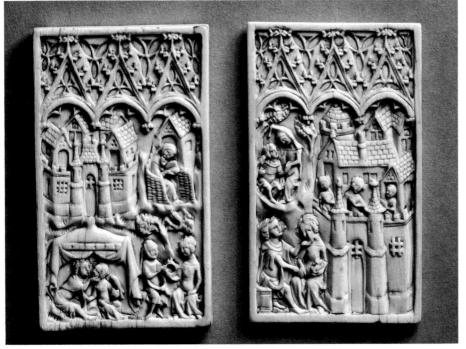

339

340 interior

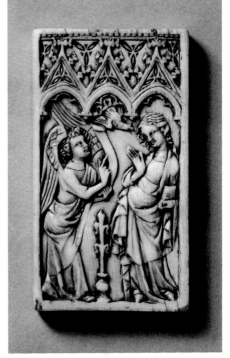

340

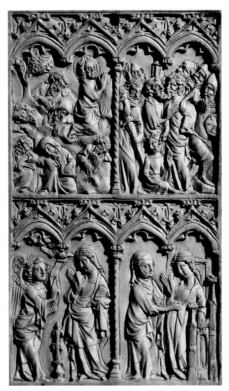

341

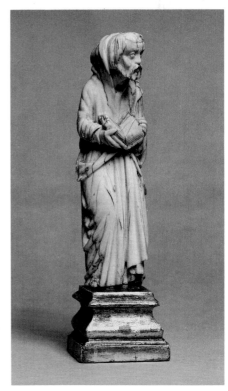

342

343. VIRGIN AND ANGELS AND CRUCIFIXION

Ivory diptych. Italian (Tuscan?), third quarter 14th century

This roughly carved diptych presents its subjects beneath large single trefoil arches with crockets and heavy pinnacles. The Virgin and Child of the left leaf are flanked by candle-bearing angels. The crucified Christ, the wound in his side conspicuously carved and painted, is shown between Mary and John.

Considerable traces of polychromy, perhaps a retouching of the original scheme, include four painted roundels containing trefoils above the gables. The reverse sides of the panels are recessed, filled with gesso, and painted with two scenes on a gilt ground. On the right is a Byzantine-type Nativity before the cave, a somewhat later version of the Giottesque Nativity in the Lower Church at Assisi (see Morey, Bib.); on the left is an Ascension with Saint Francis and Saint Clare among the witnesses (much repainted). The paintings were apparently part of the diptych's original design.

One corner and two small breaks in the bottom edges are filled with gesso and the silver hinges are applied to the surfaces of the ivory, rather than inset in the usual manner.

The unusual architectural details, the emphasis on painted details, and the non-French manner of hinging suggest that this is a French-inspired copy made in Italy. The paintings indicate the area of Assisi and a strong connection with the Franciscan order.

H (each leaf): 3¹³/₁₆″ (10.0cm) × w: 2¼″ (5.7cm) 71.185

HISTORY: Purchased from Ongania, Venice, before 1931.

BIB.: Morey, "Italian Gothic," I, 203, no. 38.

344. DORMITION OF THE VIRGIN

Bone crozier head. Italian (Venice), third quarter 14th century

The crozier head is circular and contains a double-sided carving of the Dormition of the Virgin. Six Apostles attend the bier, and the figure of Christ holds the Virgin's soul. The circular surround is roughly carved with leaves. It is surmounted by a figure of God the Father and prophets holding scrolls within vine surrounds. Three of the applied prophet figures are missing. At the base is a monster representing the mouth of Hell.

Precedents for the vine scroll border with prophets can be seen at S. Lorenzo, Vicenza, of 1340–1350, and a similar Dormition is found on the tomb of Doge Francesco Dandolo of 1339 (L. Planiscig, "Geschichte der venezianischen Skulptur im XIV Jahrhundert," *Jahrbuch des Allerhöchsten Kaiserhauses*, XXXIII, 1916, 52).

Croziers of circular form are rare. A second Italian example still in the Treasury of Klosterneuburg was already listed in an inventory of 1550 (*Katalog der Kunstsammlungen des Stiftes Klosterneuburg*, Vienna, 1942, no. 7).

The crozier was buried and has warped into a curve. Many small chips and flakings occur over the surface. The base is fitted with a wooden insert threaded for the crozier shaft.

H: 10⅝″ (27.0cm) 71.484

HISTORY: Purchased before 1931.

BIB.: P. Lesley, "Two Triptychs and a Crucifix," *Art Bulletin*, XVII, 1936, 477, fig. 17.

345. THE GIFT OF THE COMB

Ivory mirror case. North Italian (Lombardy or Milan), 1390–1400

A couple is seen in the center of the composition; the gentleman, in belted robe, offers a comb to his lady. She is dressed in a *houppelande*, with long pendants from the elbows, and her hair is braided and dressed in a cap over the ears. The landscape consists of a stylized castle at each side, a tree at the center, and a boulderlike ground plane. The subject is contained within a quatrefoil of tracery with leaf terminals. The circular mirror form is brought to a square with four leaf-corner projections with incised veins.

Similar confronted figures exchanging gifts are shown in three scenes on a comb in Bologna (Koechlin, no. 1113). The attitude is taken from the conventional Italian marriage picture (see cat. no. 348), and the costumes and hairstyles of the ladies are identical. The hairstyle may also be seen in the Visconti Hours, in a miniature finished some years before 1402 (M. Meiss and E. Kirsch, *The Visconti Hours*, New York, 1972, f. 1080).

A mirror with a similar subject, the gift of a wreath, in the British Museum (Dalton, no. 384), is now recognized as Italian and is probably by the same hand. Two others from the same shop but by a different hand are in the Victoria and Albert Museum (Longhurst, II, no. A 108-1920) and the British Museum (Dalton, no. 385).

H: 3¹³/₁₆″ (9.8cm) × w: 3¹¹/₁₆″ (9.5cm) 71.269

HISTORY: Collection of Lord H. Gibson-Carmichael (sale, London, May 12–13, 1902); purchased from George R. Harding, London, Feb. 1903.

346. FRAU MINNE AND A HUNTING SCENE

Fragment of an ivory comb. North Italian (Lombardy or Milan), c. 1400

The comb is carved on either side in two sunken panels between the teeth; about three-quarters of each scene is preserved. On one side Frau Minne sits enthroned, presenting mantled helms to kneeling knights. The knight on her right wears a steel cap and coif, a jupon with a dagged edge (brigandine?), and hose. The second knight, who is standing, is helmetless and holds a spear and shield; the third, also standing, wears a cloth hood with a dagged edge.

On the reverse is a hunting scene with two men in dagged jupons wearing hunting hats with turned-up brims. In a setting defined by two stylized trees, the first figure spears a boar emerging from a rocky landscape; the second figure spears a missing animal. Traces of gilding and color remain. The comb is broken nearly in half, and all its smaller teeth are missing.

Several combs of similar style exist. Examples depicting Frau Minne and knights are in the Kunsthistorisches Museum, Vienna (J. Schlosser, "Die Werkstatt der Embriachi in Venedig," *Jahrbuch des Allerhöchsten Kaiserhauses*, XX, 1899, 220–282); the Victoria and Albert Museum (Longhurst, no. 151-1879); the Metropolitan Museum (D. Egbert, "North Italian Gothic Ivories," *Art Studies*, VII, 1929, fig. 29).

H: 3⅛″ (9.0cm) × L: 3⅝″ (9.3cm) 71.78

HISTORY: Purchased from Léon Gruel, Paris, 1925.

347. THE GIFT OF THE ROSE

Ivory mirror case. North Italian (Lombardy or Milan), 1390–1400

A couple stands within a hexafoil against a crosshatched ground; a stylized castle is at the right and a tree at the left. The man wears a *houppelande* with wide sleeves; the woman's *houppelande* is pleated and belted. The woman wears a veil on her head and presents her partner with a large rose. The spandrels of the hexafoil are filled with masks, and the mirror is brought to a square with four corner leaves showing incised veins. There are two later holes drilled in the cover.

The iconography relates this piece to catalogue no. 345. The figure style can be compared to the linear figures in the manuscript of the *Theatrum Sanitatis*, attributed to Lombardy (Milan?), in the H. P. Kraus Collection (*Choice Manuscripts, Books, Maps, and Globes*, catalogue 56, New York, 1951, no 33).

D: 4⅛″ (10.8cm) 71.281

HISTORY: Collection of Bourgeois Frères, Cologne (sale, Cologne, Oct. 19, 1904, lot 1082); purchased from Henry Daguerre, Paris, 1925.

BIB.: *The Waning of the Middle Ages*, no. 84.

343

343

344

345

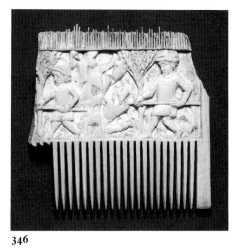

346

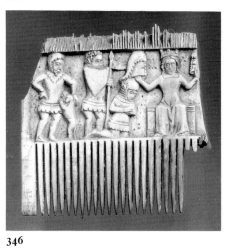

346

347

348. TWO LOVERS

Ivory mirror case. North Italian (Milan?), c. 1410

This mirror cover of unusual quality shows a young man offering his lady a flower. The figures stand on a patch of carefully rendered turf between two trees, against a crosshatched background. The man wears a *houppelande* with large dagged-edged sleeves and a big cloth cap, or *chaperon*. The lady's gown also has pendant sleeves with elaborate facings; she wears a *bourrelet* on her head.

A band of roping surrounds the scene, and two holes for attachment are visible. When in the eighteenth century the cover and its mate were drawn by Jan Ivan Gravenbroeck for the catalogue of the collection of Pietro di Giacomo Gradenigo in Venice, its corner leaf projections, now lost, were still intact. Interestingly, the label beneath Gravenbroeck's illustration reads: "*Antico Diptico Nuziale Veneto.*"

Above the young man's head is inscribed the word PRENES, the first word of a motto which is completed on the pendant mirror case in the Louvre depicting a similar couple. Here the inscription reads: EN GRE. Taken together the two parts of the motto may be translated: "Take kindly." The same phrase appears on a goblet in the 1369 inventory of the possessions of Louis I of Anjou. The full phrase is found in a stanza of Christine de Pisan's poetry: "*Prenez en gre le don de votre amant*" ("Take kindly the gift of your lover").

Because the motto was used in France and Burgundy, and the elaborate costumes are reflected in miniatures such as the calendar pages of the Très Riches Heures of the duke of Berry, the ivory has often been called French, Flemish, or Burgundian. However, all of the features of this example, including the particular balance of the landscape elements and the figures, are found more frequently in works from north Italy, for example, in a casket now in Berlin (Volbach, no. 689). The crisp carving and stylized postures of the figures do not relate to identified Venetian works, but rather to those attributed to Milan and Lombardy, where, significantly, the language, like the motto, was French.

The attitude of the figures, facing each other in profile, is that of the conventional Italian wedding portrayal of the fifteenth century. It occurs on the marriage certificate of Bianca Maria and Francesco Sforza of 1441, on a similar scene in a Mantuan manuscript of 1435, and on a *tarocchi* card of Filippo Maria Visconti. The strict profile confrontation contrasts strongly with the interaction of the two figures in similar scenes on French mirror cases (L. Ottolenghi, "Alcuni manoscritti ebraici miniati in Italia settentrionale nel secolo XV," *Arte lombarda*, 60, 1981, 45 ff.).

D: 3³/₁₆" (8.2cm) 71.107

HISTORY: Collection of Pietro di Giacomo Gradenigo, Venice, in the eighteenth century; purchased in 1914.

BIB.: P. Molmenti, *Storia di Venezia nella vita privata*, I, Bergamo, 1922, 437; M. C. Ross, "A Gothic Ivory Mirror Case," *JWAG*, II, 1939, 109–111.

348a. Drawing of a pair of ivory mirror cases, by Jan Ivan Gravenbroeck, ink on paper, Dutch, mid-18th century. The drawing is part of the inventory of the museum of Pietro di Giacomo Gradenigo in Venice. The case at the left is Walters catalogue no. 348, which has lost its corner leaves, and that at the right is now in the Louvre. Museo Civico, Venice.

349. SCENES OF COURTLY LIFE

Ivory double comb. North Italian (Lombardy or Piedmont), first third 15th century

The center of the comb on one side is carved with courtly figures holding hands and dancing in a garden. At the left, a seated lady plays a hand organ. The landscape setting is indicated by stylized trees between the figures. The reverse side is carved with hunters, hounds, and a deer wearing a collar.

The original polychromy and gilding are well preserved. Both costumes and landscape are accented with dots of red, blue, and gilt. The ends of the comb have patterns of gilding.

H: 4⁹/₁₆" (11.5cm) × L: 5½" (14.0cm) 71.215

HISTORY: Collection of Richard Forrer, Strasbourg; purchased from Léon Gruel, Paris, before 1931.

See also colorplate 77

350. CRUCIFIXION

Right leaf of an ivory diptych. North Italy (Venice?), c. 1400

The Crucifixion scene, which shows Christ with blood issuing from his wound, is placed beneath an arcade of three arches, above which angels hover. It contains seven figures. On the left are two soldiers with the robe of Christ, a third soldier, and the Virgin; on the right are John, and Longinus on horseback.

The miters for the hinges are broken, and two holes have been drilled at the top center of the panel. There is considerable gilding, including the hair and beards of the figures, wings of the angels, garment of Christ, harness of the horse, and the background, which is dotted with stars and the letters IN/RI flanking the cross.

The unusual oblong shape is characteristic of a group that includes an Italian triptych in the Vatican (Morey, no. A) and a diptych in the Burlington Fine Arts Exhibition (London, 1923, no. 167). One should also compare the central sections of combs in the British Museum (Dalton, nos. 413 and 414).

H: 3⅝" (9.2cm) × W: 4¹/₁₆" (10.2cm) 71.190

HISTORY: Purchased before 1931.

BIB.: C. R. Morey, "A Group of Gothic Ivories in the Walters Art Gallery," *Art Bulletin*, XVIII, June 1936, 199 ff.; Morey, I, 39; IV, 41, fig. 41.

351. PASSION OF CHRIST AND SAINTS

Bone triptych. Italian (Venice), end of 14th century

The central panel is carved with the Crucifixion at the top in the gable and the Deposition and Entombment below. An unusual detail in the Entombment is the rectangular wooden coffin prepared for the body of Christ. In the wings the angel of the Annunciation and the Virgin appear in the gables. Saint John the Baptist and Saint Michael stand below on the left and Saint John the Evangelist and Saint George on the right. The borders are pearled; those on the central panel have a drilled dot in each pearl. The center gable, decorated with branches of pomegranate capped with the fruit, is flanked by two towers.

The unusual treatment of the central panel with towers and pomegranates has led scholars to attribute the triptych to Portugal or various colonies. The model for the triptych, however, is a Venetian ivory in the Victoria and Albert Museum (Longhurst, no. 143-1866). The wings of the Walters piece, including the pearled borders, are copied exactly from the London example. The main panel is different, as is the gable, which in London lacks the pomegranates. However, the gable of the Victoria and Albert example was originally flanked by towers of a similar nature, which have been cut off. The question arises whether the bone example is a copy, made in another location, or a cheaper product from the same Venetian workshop. It is noteworthy for its Byzantinizing style, especially the figures of Saint George and Saint Michael.

The triptych, considerably rubbed, has a small break at the base of the central panel and four cuts for earlier hinges. The present pin hinges are replacements.

H: 9¹¹/₁₆" (24.7cm) × W: 5⅞" (14.6cm) 71.101

HISTORY: Said by the vendor to have come from a Portuguese convent; purchased from Henry Daguerre, Paris, 1925.

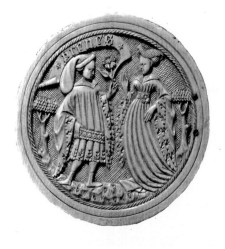

348

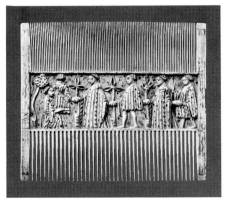

349

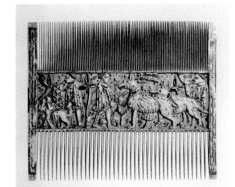

349

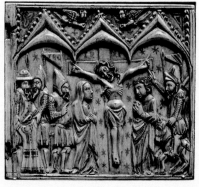

350

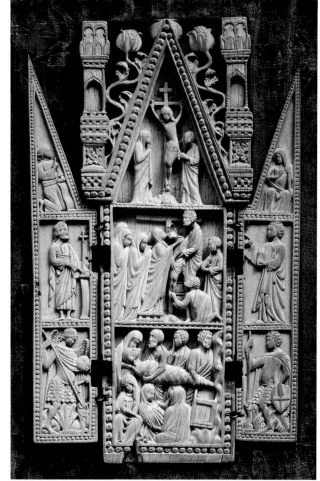

351

352. SAINT JAMES MAJOR

Ivory fragment. Italian (Tuscan?), late 14th–early 15th century

Saint James Major, holding a staff and a book, stands facing left beneath a Gothic arch that has spandrels filled with large leaves. The leaves are similar to the late-fourteenth-century corner finials of ivory mirror cases.

The ivory is incomplete. The outer right edge is original, but the left edge is recut. There are no signs of hinging or attachment, suggesting that the plaque was a portion of the right wing of a triptych or a folding shrine. A hole in the saint's left elbow is the result of the attachment of a clasp on the exterior. The back of the panel is painted red with three registers of vine scrolls. Several cracks and a chip occur at the base of the right border strip.

The large, flat folds of the drapery recall the painted works of Giovanni del Biondo (died 1399) and other Florentine followers of Giotto.

H: 4⁵⁄₁₆" (10.9cm) × W: 1⁷⁄₁₆" (3.6cm)
71.171

HISTORY: Purchased in Paris, 1927.

353. VIRGIN AND SAINTS

Ivory mirror case. North Italian, first quarter 15th century

The figures stand within a trefoil of tracery with rose terminals. The crowned Virgin, in voluminous drapery, holds the naked Christ Child between Mary Magdalen and Saint James Major. The background is plain, and the circular form is brought to a square with four corner leaves, carved in relief and incised with veins.

Mirror cases with religious subjects are rare. A second example with the Crucifixion is in Cracow (Koechlin, no. 1116 bis). It has a similar enframement but is a quatrefoil instead of a trefoil, with similar corner leaves. While the figure styles are different, it is possible that they are from the same shop. Another example with the Crucifixion was in a Cologne private collection (A. Schnütgen, "Elfenbein-Medallion des XV Jahrhundert als Spiegelkapsel," *Zeitschrift für Christliche Kunst*, XI, 1891, 343).

There is a hole at the lower edge from a flaw in the ivory and a drilled hole in the upper left leaf.

H: 2⅞" (7.3cm) × W: 2¹¹⁄₁₆" (6.8cm)
71.282

HISTORY: Collection of Frédéric Spitzer (sale, Paris, 1893, lot 123); purchased from Léon Gruel, Paris, 1922.

354. WEDDING MIRROR

Wood, bone, and intarsia. Venetian, Embriachi workshop, early 15th century

This circular mirror has an octagonal frame with a pinnacle containing three bone plaques depicting Cupid between a kneeling couple. Seven of the bone plaques surrounding the mirror are carved with nude cupids, and the eighth, at the top, is carved with two blank shields on which the coats of arms of the wedding couple were to be painted. The borders are intarsia of bone mixed with black and brown cow horn. The mirror is a replacement.

For the Embriachi workshop, see catalogue no. 355.

H: 17⁹⁄₁₆" (44.6cm) × L: 10¾" (27.5cm)
71.92

HISTORY: Purchased in Venice from Ongania, before 1931.

355. LIFE OF PARIS

Wood, bone, cow horn, and intarsia marriage casket. Venetian, Embriachi workshop, early 15th century

One of a large series of six- or eight-sided boxes with pairs of blank shields on which the coats of arms of the married couple were to be painted. The wood body of the box is revetted with carved bone plaques, approximately one and one-half inches wide and three and one-quarter inches high. Each plaque is carved with one or two figures relating the story of the birth and youth of Paris.

Plaques around the lid show flying putti and leaves. The intarsia on the base and lid is made up of white bone interspersed with brown and black cow horn. The finial of the lid and many areas of the intarsia are missing. One plaque has been replaced with a genuine plaque from another casket whose details differ.

The Embriachi workshop in Venice was active from the late fourteenth century until about 1433. Most of its products were in bone (see cat. nos. 354 and 356), although some of the finest works were in ivory. This box is a routine production of the shop. Others with the story of Paris are in the Museo Civico, Bologna (J. Schlosser, "Die Werkstatt der Embriachi in Venedig," *Jahrbuch des Allerhöchsten Kaiserhauses*, 1899, 220–282).

H: 9⅞" (25.0cm) × W: 8¾" (22.3cm)
71.242

HISTORY: Purchased in Venice from Ongania, before 1931.

See also colorplate 78

356. CRUCIFIXION AND OTHER SCENES

Bone, wood, and intarsia triptych. Venetian, Embriachi workshop, early 15th century

The central scene of the Crucifixion is composed of five bone plaques, flanked by the Resurrection on the left and Christ's Appearance to the Magdalen on the right. Below, the central figure of the Virgin, holding the Christ Child, is flanked by Saint Ursula and Saint Apollonia on the right and

Saint Lucy and Saint Agatha on the left. In the wings are the Apostles Bartholomew and Philip on the right and Evangelists Matthew and John on the left.

The framework is complete and original, with fine intarsia of bone and horn on the base and borders. Two panels of openwork bone carved with leaves ornament the cornice. The wings are painted on the reverse side with figures of angels in grisaille against a red ground. Four original iron fixtures for hanging are preserved.

The canopy above Saint Agatha is a restoration, and the bone border of the base at the right side and corner is missing. For the Embriachi workshop, see catalogue no. 355.

H: 23⁹⁄₁₆" (60.0cm) × W: 15¹⁵⁄₁₆" (39.0cm)
71.98

HISTORY: Purchased in Venice from Ongania, before 1931.

357. LOVERS EXCHANGING GIFTS

Rear panel of an ivory box. Burgundy or Flanders, 1410–1420

Four couples in lavish court costume are placed beneath ogee arches supported by colonnettes. From left to right, the couples exchange a ring, a pet squirrel, a flower, and a bunch of hearts. The background is lightly crosshatched.

On the rear of the panel the date "1417" is written in Arabic numerals. A poem is written in a sixteenth-century hand in two lines, divided in the center by a configuration which may be the capital letter I or H. The poem reads:

Dos Dame je vos aime leaulem[en]t
Por Die [prie] que ne mobilie mis
Et fie mon cors a vos comandens(?)
Sans moveste et sans nulle folie.

*Dear lady I love you loyally
And pray God that you not forget me
And I place myself at your command
Without evil intent and without folly.*

The date and inscription are sixteenth-century additions. The style of the costume is paralleled exactly in a group of manuscripts dated in the first quarter of the fifteenth century, some of which have the usage of Châlons-sur-Marne (for example, Walters *ms* 219, datable before 1416).

The same poem, written in langue d'oc, appears on an early-fourteenth-century enamel marriage casket (Gauthier, 159, pl. 60).

There is a large series of holes for the original mounts, some of which have been filled with plaster. A break and chip occur on the right end.

H: 2¼" (5.6cm) × W: 9" (23.0cm) 71.204

HISTORY: Purchased in 1925.

BIB.: *The Waning of the Middle Ages*, no. 87; *Images of Love and Death*, no. 65.

352

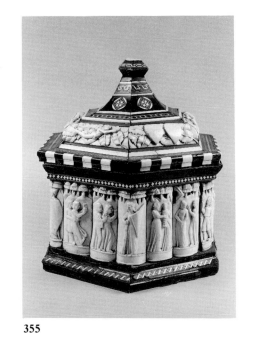

355

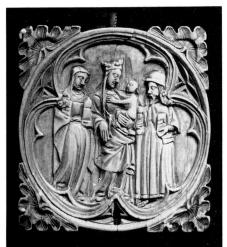

353

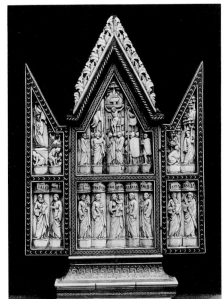

356

356

354

357

358. DANCERS AND HUNTING SCENES

Bone and chestnut chess box. French (Alsace) or German (Upper Rhine), 1440–1470

The box is one of a large group of chess boxes that depict figures of six or eight morris dancers on the lids and hunting and other scenes around the sides. The underside is a brown-and-white chessboard of wood and bone.

This example has on the lid (clockwise from the left): a musician with pipe and tabor, two male dancers, a third male dancer, Maid Marian wearing a hat, and a fool. The relief figures appear against a hatched ground. Much green paint remains on the small, hilly ground planes, and traces of gilded highlights are visible on the hair and costumes.

The sides show a boar hunt, two hounds, a boar and rabbits, and a hunter and a hound flanking the lock plate on the front. Much of the green and gilt polychromy remains. The top border strips of plants and the hasp of the lock are missing. There are an iron lock and hinges; one of the latter has been reattached with a large nail. A border strip and a square are missing from the chessboard.

In addition to the morris dancing—always one of the activities of spring—boxes of the group show other seasonal festivities: tilting scenes, children with hobby horses and windmills, lovers in gardens, music, and hunting. One box in the Burrell Collection, Glasgow, bears the arms of the counts of Würtemberg and related families around Baden-Baden and Strasbourg. A few boxes show wild men flanking the lock. While the group has often been called north Italian or Piedmontese, Koechlin suggests east France (Koechlin, I, 528). The group seems indeed to have originated along the Upper Rhine, either in Alsace or in the Schwarzwald.

H: 2¹⁄₁₆″ (5.2cm) × W: 6″ (15.3cm) × L: 7³⁄₁₆″ (18.3cm) 71.93

HISTORY: Purchased from Léon Gruel, Paris, 1925.

BIB.: *The Medieval Craftsman and His Modern Counterpart*, Indiana University, Bloomington, Indiana, 1959, no. 21a.

359. LIFE AND PASSION OF CHRIST

Bone and wood casket. Flemish, 1430–1460

This large rectangular box with scenes beneath ogee arches is one of a large group found throughout Europe in church treasuries and private collections. Although the majority show the Passion of Christ as the major subject, some show the life of the Virgin (Longhurst, no. 176-1866). The boxes cannot date earlier than the *Biblia Pauperum*, generally dated about 1430, because a number of the Passion scenes are based on the woodcuts of that work.

The Passion scenes commence on the front of the box at the left. They include the Arrest of Christ, Flagellation, Way to Calvary, Crucifixion, Deposition, Entombment, Resurrection, Christ's Appearance to the Magdalen, Doubting Thomas (missing), Christ with the Three Holy Women, Harrowing of Hell, and Christ Appearing to Saint Peter. On the lid are eight scenes beginning at the upper left with the Presentation in the Temple, followed by Christ Disputing with the Doctors, Baptism, Christ in the House of Mary and Martha, Entry into Jerusalem, Supper at Emmaus, Washing of the Feet, and Gethsemane.

The scenes retain most of their polychromed decoration of gilt, green, and blue. Green is used for the ground planes, landscape features, and some costume details; blue for the arches and costume emphasis, especially in the scenes with the Virgin; and gilding for architectural details, costume, and hair. The panels are separated by battens of bone carved with a gilded vine scroll.

The base molding is ornamented with drill holes and saw cuts with triple bracket feet at the corners and a double bracket in the center. The base of the box is inlaid with a chessboard of black-and-white bone squares with wide borders at the sides divided by bands of zigzag intarsia.

The casket is fitted with an ornamented iron bail handle on the top and a seventeenth-century gilt-bronze lock plate. The hole for the original lock hasp has been filled with bone. The box is complete but for the missing scene on the back, which is replaced with a plain bone fill. A number of panels are cracked and warped.

The designs for some of the panels have been taken from woodcuts in the *Biblia Pauperum*: the basic group of six figures in the Arrest scene, and scenes of the Way to Calvary, Entombment, Harrowing of Hell, Resurrection, and Appearance to the Magdalen. Some of these scenes, such as the Harrowing of Hell, are similar in every detail. No sources for the others have been found.

The *Biblia Pauperum* was printed in various editions in Holland, Flanders, and Germany from about 1430 to 1460, or later. The technique of the panels with the ogee arches with brickwork above and a hatched ground stems from Holland and is found in Utrecht ivories of 1430–1440 (see cat. no. 363). The coarse quality of the figures, however, is quite different in the boxes, and relates to those in the backgrounds of shrines such as that of the Virgin in the Hospital of Saint-Jean, Bruges (Koechlin, no. 946). The curious construction of the boxes in an architectural batten style finds parallels in neither furniture nor architecture.

The discovery in Spain of many boxes of the group suggests a center that traded with Spain. Flanders seems the most probable for the manufacture and distribution of the boxes. The survival in ivory of the batten style, combined with intarsia, and the same treatment of the base in a series of *crèche* reliquaries from Flanders of the late seventeenth or early eighteenth century (Tardy, I, 55) confirm an attribution to that region.

H: 6¹⁄₁₆″ (15.5cm) × L: 12¹⁄₈″ (30.8cm) × W: 7³⁄₈″ (18.8cm) 71.251

HISTORY: Collection of Count Girolamo Possenti (sale, Florence, Raphael Dura, Apr. 1, 1880, lot 38); purchased from Ongania, Venice, before 1931.

See also figure 45

360. GETHSEMANE

Polychromed bone plaque. Flemish, 1440–1470

The scene is placed on a hatched ground beneath an ogee arch with brickwork above. The plaque is from a casket like catalogue no. 359. The same subject appears on that large casket, but the designs are totally different. There are considerable traces of polychromy in red, blue, and gilt.

H: 3¹¹⁄₁₆″ (9.3cm) × W: 1¹³⁄₁₆″ (4.6cm) 71.216

HISTORY: Purchased before 1931.

358

359

359

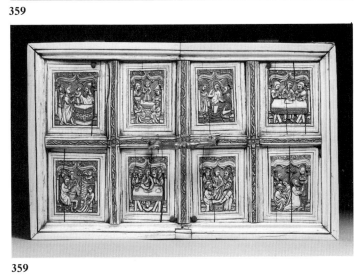

359

360

361. ANNUNCIATION TO THE SHEPHERDS

Polychromed bone plaque. Flemish, 1430–1460

The scene is placed beneath a flattened arch on a hatched ground. The landscape is painted with a black-brown color, and the ground and details are highlighted with gilding. A small blue line runs around the frame.

The same scene, but with two shepherds, appears in a wing of the Virgin Shrine in the Museo Civico, Milan (L. Vitali, *Avori gotici francesi*, Milan, 1976, no. 42). The Walters plaque presumably came from a wing of a similar shrine.

H: 2⅜″ (6.0cm) × W: 1¹³⁄₁₆″ (4.6cm)
71.217

HISTORY: Purchased before 1931.

362. ADORATION OF THE KINGS

Polychromed bone plaque. Flemish, 1430–1460

The scene is placed beneath a flattened arch and on a crosshatched gilt ground. Traces of blue paint remain on the robes of the kings, and a blue line runs around the frame. Details of crowns and gifts are gilded.

The plaque appears to be from the same shrine wing as catalogue no. 361.

H: 2⁵⁄₁₆″ (5.9cm) × W: 1¹¹⁄₁₆″ (4.8cm)
71.218

HISTORY: Purchased before 1931.

363. VIRGIN AND SAINTS

Ivory pax. Netherlands (Utrecht?), 1440–1460

The pax is curved, and there is an inset handle which notches into the back. The scene, enframed with a molding and a band of roping, is set beneath an ogee arch with piercings and brickwork above. The Virgin wears a tall crown and offers a flower to the Child, who holds a globe. On the right is Saint Catherine with wheel and palm, and, on the left, Saint John the Baptist with staff and lamb. The ground is crosshatched.

The pax is a loose copy of a similar but more carefully carved example in the Detroit Institute of Arts, attributed to Utrecht by Robert Koch ("An Ivory Diptych from the Waning Middle Ages," *Record of the Art Museum*, Princeton, XVII, 1958, 55–64). The casual approach to the carving suggests that the copy may have been made in another shop or by a lesser hand.

The pax is broken at the top and chipped at the right lower corner and along the base.

H: 3½″ (9.0cm) 71.84

HISTORY: Purchased before 1931.

364. ANNUNCIATION

Ivory picture. Flemish, third quarter 15th century

The Virgin kneels before a reading desk, above which there is a niche containing a vase of flowers. Gabriel stands behind her and presents a scroll with the painted inscription: AV. MARIA *(Ave Maria)*. The dove of the Holy Spirit descends from the clouds in a radiance of light. The background is decorated with a checkered pattern.

The plaque is attached to the frame with two rivets; its edges are not square. There is much polychromy surviving on the dress, background, flowers, and clouds; and gilding on the dove, halos, and wings. The frame is copper gilt of the late sixteenth century.

While this has been remounted, it would seem it was always intended to be a hanging picture, probably an *image de chevet*, which was placed within the curtains of a bed.

H: 1⅞″ (4.4cm) × W: 1½″ (3.5cm) 71.202

HISTORY: Collection of Dom Marcello Massarenti, purchased in Rome, July 1902.

365. SECULAR SCENES

Ivory comb. French, 1490–1500

The comb, which has floral terminals, has on one side a scene of a man and seated woman preparing to play "kick foot" in a tilt yard as spectators watch from behind the railing. On the reverse are two scenes. On the left, two nude boys, one with a bow and the other with a hand cannon, shoot at a sitting duck. On the right, a youth pulls off the stocking of a seated woman. The scenes are set against a coarsely crosshatched ground.

The small and large teeth have all been replaced by sections inset into the frame.

H: 4⅜″ (11.2cm) × L: 5¹⁵⁄₁₆″ (15.0cm)
71.266

HISTORY: Collection of Countess Petronio (sale, Paris, June 24, 1921, lot 58); purchased from H. Wareham Harding, New York, Nov. 1921.

366. FLAGELLATION OF CHRIST

Ivory pendant. Flemish, first quarter 16th century

Christ is bound in profile to a column, which supports a groin vault. He is scourged by five men. There is a wide cornice at the top.

The carving is very minute, and the complex composition suggests that a print was the source. The same subject with a comparable architectural arrangement may be seen in a print by the monogrammist MR (F. W. H. Hollstein, *Dutch and Flemish Engravings and Woodcuts, c. 1450–1700*, XIII, Amsterdam, 1949, 99, no. 9), and in another by the Master of Calvary (Hollstein, XII, 124).

It is mounted in a silver-gilt frame with a ring for suspension.

H: 1¾″ (4.5cm) × W: 1⁵⁄₁₆″ (3.3cm) 71.75

HISTORY: Purchased from J. and S. Goldschmidt, Frankfurt, before 1931.

361

362

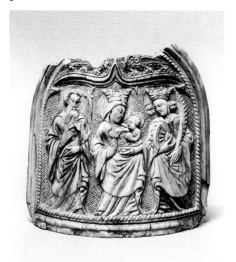

363

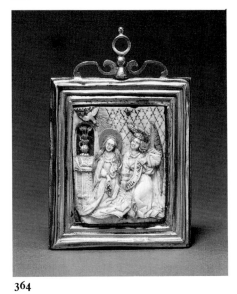

364

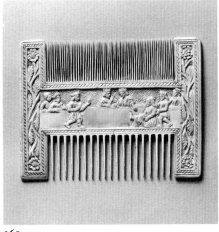

365

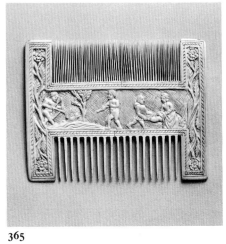

365

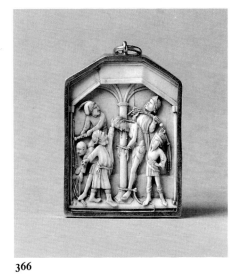

366

10 Renaissance and Baroque Ivories

by Richard H. Randall, Jr., and Christian Theuerkauff

IN NORTHERN EUROPE the ivory and bone productions of the fifteenth and sixteenth centuries were largely in the late Gothic idiom. The majority of the works of the Embriachi workshop in Venice—mirrors, altarpieces, and boxes, executed between 1393 and 1433—are also in the late medieval manner. Their subjects—such as the history of Troy and similar tales of the past—were chosen to appeal directly to the French romantic tastes of the time. Similar subject matter is found in the great fifteenth-century tapestries woven in north France and Flanders. But in some of the Embriachi ivories, there are signs of a change in approach, foreshadowing the forthcoming Renaissance. In many examples, there is a free handling of nude figures. Some of these figures are characters in the small dramas represented on the caskets, and many are putti carrying shields and floating in the air very much in the manner of the late classical decorative figures from Egypt (compare cat. nos. 148 and 354). The use of Virtues on many caskets and mirror frames may be related to similar figures on the Campanile of the Cathedral of Florence by the workshop of the fourteenth-century sculptor Andrea Pisano. A box in the Kunsthistorisches Museum, Vienna, has an important group of animal studies recalling the works of Giovannino dei Grassi and reflecting the new interest in nature studies during the Renaissance. Lastly, a few of the stories depicted on the caskets, such as the tale of Griselda, come directly from Boccaccio's *Decameron* and had no earlier medieval precedents.[1]

The techniques of the Embriachi workshop were, of course, continued by other craftsmen who inlaid ivory and bone into large chests, or cassoni. A splendid example, in Graz Cathedral in Austria, has large figural panels representing the Triumphs of Petrarch.[2] But ivory was generally out of favor during the Renaissance, and not a single major artist of the period has left behind an important work in ivory. The material was chiefly used for inlay on instruments, furniture, and minor objects. An exception to the general malaise is a fine series of French combs with typical early sixteenth-century motifs.

From the very earliest years of the seventeenth century, however, ivory again became favored for all types of works of art, especially for small sculpture. The explorations of the Dutch and Portuguese navigators rediscovered the African and Asian sources of the material, helping to bring about the change in taste. It became fashionable to collect works of art in "cabinets of curiosity," and this created a large market for ivory workers and carvers.[3] People took great pride in their collections, and many artists, such as Frans Francken II, Jan Brueghel the Elder, and Georg Hintz, did paintings of picture galleries containing tables covered with treasures. A detail of Francken and Brueghel's *The Archdukes Albert and Isabella in a Collector's Cabinet* in the Walters shows just such a display of ivories on a table (figure 48).

In Holland and Flanders major sculptors such as Francis van Bossuit, Gérard van Opstal, Lucas Faid'herbe, and J. B. Xavery worked in ivory. Their creations covered a range of subjects, from religious scenes to the decorative carving of bacchanals and putti on beer steins.

The Flemings François Duquesnoy and his pupil Artus Quellinus turned often to the medium of ivory. The small sleeping child of 1641 by Quellinus (cat. no. 377; see colorplate 79) is typical of their very popular work. The subject was so universally admired that it was translated into porcelain and produced in some numbers in the eighteenth century.

In Germany, where passion for ivory was even greater, the carver Christoph Angermair was commissioned by the elector Maximilian I to create a coin cabinet. This work, which was carved from 1618 to 1624, is a high Baroque masterpiece. At the cabinet's apex is an equestrian portrait of the prince in Roman costume. The doors are carved on the exterior with Virtues and on the interior with musicians. The cabinet, which is now in Munich's Bayerisches Nationalmuseum, helped to set the taste for ivory sculpture at the German courts. Dozens of sculptors followed the vogue and endeavored to fill the demand for objects made from the material.[4]

In addition to sculpture in the round, relief sculpture

Figure 48. Jan Brueghel the Elder and Frans Francken II, *The Archdukes Albert and Isabella in a Collector's Cabinet* (detail), oil on panel, Flemish, early 17th century. Eight ivories, the largest of which depicts a bearded male triumphing over death, are displayed on the table. There also are two animal studies, three classical nude female figures, a military figure, and a bust of a child together with seashells, cups, and other materials. The Walters Art Gallery (37.2010).

in ivory was employed throughout the seventeenth century for furniture decoration and a variety of other decorative purposes, including the ornamentation on circular vessels such as the Augsburg cup of 1685–1700 picturing scenes of the gods (cat. no. 384; see colorplate 80). This is one of a series of superb honorific cups (pokals), which were popular with collectors in north Germany. George Hintz of Altona depicted these pokals in several paintings,[5] thus enabling us to date them in the last quarter of the seventeenth century. The body of a short tankard carved in a somewhat different technique is related to the Nuremberg workshop of Leonard Kern (cat. no. 383).

An unusually large (over eighteen inches high) relief of the Deposition from the Cross showing fourteen figures was probably the centerpiece of a house altar (cat. no. 381; figure 49). The design for the altar was based on prints after a Michelangelo drawing now in Haarlem.[6] The piece is signed by the monogrammist VH, who has been identified as Johann Ulrich Hurdter from Ulm and worked in the decade 1670–1680. Two cups with carved figural supports, formerly in the Lanna Collection, Prague, are signed and dated by the same master.[7]

Ivory vessels whose parts were turned on a lathe became fashionable in the courts of Germany and Italy in the seventeenth and eighteenth centuries when princes sent these remarkable pieces to one another as gifts. Today, the most notable collections of turned ivories are in Rosenborg Castle, Copenhagen, and in Munich, Vienna, and Florence. Two examples are in the Walters (cat. nos. 379 and 380). These vessels, some of which reached three feet in height, piled confection upon confection, as in a 1639 example in Vienna by Markus Heiden. In this ivory, an elephant supports a howdah topped by a spiral column, which, in turn, supports a shaped vase in the Mannerist style. The vase forms the base of a figure who carries on his shoulders a galleon in full sail.[8]

In Germany, major artists like Georg Petel turned the concepts of Peter Paul Rubens into superb ivory figures. Petel's Venus and Cupid in the collection of the Ashmolean Museum, Oxford, is a fine example, and his Crucifixion in Munich is based on Rubens' oil sketch of the subject in Rotterdam.[9] Among Petel's religious subjects are his great Deposition from the Cross in Copenhagen and the scenes relating to the Passion in the Austrian abbey of

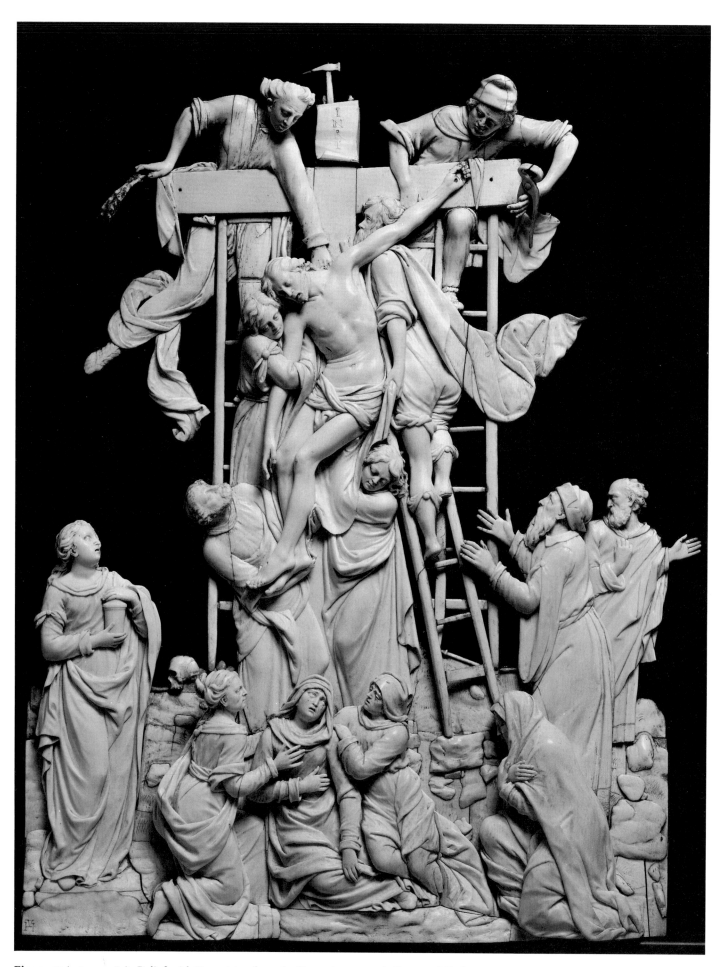

Figure 49 (cat. no. 381). Relief with Deposition from the Cross, ivory, south German (Ulm), 1670–1680. This complex group of fourteen figures is made of joined sections of ivory and was originally set against a ground of black lacquer. It is signed at the lower left with the monogram VH, which also appears on a relief of Hercules and Omphale at Brunswick. The artist is now identified as Johann Ulrich Hurdter of Ulm.

Kremsmunster.[10] Other works representative of the period were Balthasar Permoser's statuettes of the Four Seasons and his Hercules and Omphale in the Grünes Gewölbe, Dresden.[11] Bernhard Strauss, an artist from the Bodensee who was active in the mid-seventeenth century, was a master carver of relief work on steins and other vessels.[12]

Adam Lenckhardt of Würzburg used ivory as one of his chief mediums. His signed figure of Cleopatra illustrates a full-blown Baroque concept of the Egyptian queen as she reacts to the bite of the asp (cat. no. 374; see colorplate 81). The agitated drapery, with its multiple folds, is in sharp contrast to the smooth contours of the queen's torso. Lenckhardt's tall figure of Neptune in the Metropolitan Museum seems influenced by Italian bronzes of the same era.[13] Another ivory related to bronze sculpture is the figure of Christ at the Column by an anonymous carver (cat. no. 385; figure 50) after the bronze of the subject by François Duquesnoy or an ivory interpretation of it by Georg Petel.

An anonymous work with the same Baroque intensity as Lenckhardt's figures shows Hercules raising his club to strike the Nemean lion (cat. no. 376). Both this group and the Cleopatra would have been typical items for a German Wunderkammer of the period. A second anonymous example is attributed to a carver known as the Master of the Furies. This sculptor, who may have been Austrian or south German, carved figures in violent action or expressing great emotion. His screaming figure on horseback in the Kunsthistorisches Museum, Vienna, is characteristic of his work.[14] The Walters possesses his forlorn figure called a son of Laocoön, shown on a brown wooden rock pleading for mercy (cat. no. 375; see colorplate 82).

Like many decorative carvers, Johan Michael Maucher, of Schwäbisch-Gmünd, spent most of his career carving organ doors in wood and ivory and covering immense display salvers with hunting and mythological subjects. He also specialized in carving details on the wooden stocks of hunting guns, depicting intertwined animals on ivory sword hilts, and embellishing staghorn powder flasks.[15] Others carved more formal works, exemplified by Simon Troger's portraits of Christian IV of Denmark on horseback, and his complex series of religious scenes and martyrdoms, including the wood-and-ivory Saint Lawrence in the Bayerisches Nationalmuseum, Munich.[16]

The vast production of wheel-lock guns and crossbows with their wooden stocks provided an inviting opportunity for inlaid scenes of the chase. These were frequently carried out in ivory, but more often were executed in staghorn and bone inlay. The detail of a crossbow stock (figure 51) shows a hunting scene in which the chief sections of inlay are staghorn and the curlicues and border areas yellow cow horn, with ivory used only for the series of round white dots. A few gun and crossbow stocks, for example the wheel-lock gun of Philip of Croy in the Metropolitan Museum, were completely overlaid with carved plaques of ivory.[17]

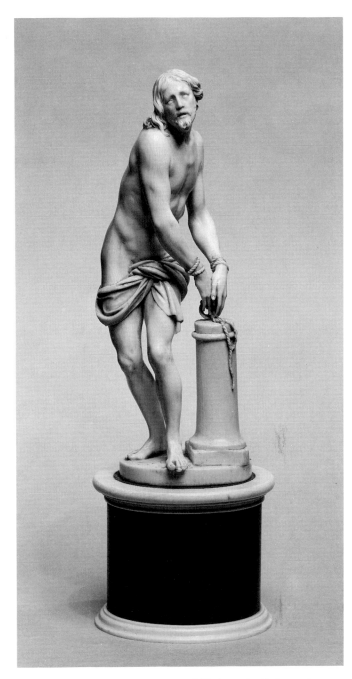

Figure 50 (cat. no. 385). Statuette of Christ at the Column, ivory, south German, 17th century. While this group seems based on a concept by Georg Petel, it is more classical in style and is probably by another hand. It has been suggested that the carver was a German who worked or studied in Italy.

In Holland, where ivory was readily available from the busy merchant marine of the period, the stocks and butts of flintlock pistols were made entirely of ivory. The butts were carved with the heads of helmeted warriors or with Turks, resulting in a very stylish and beautiful weapon. The production of these pistols was the specialty of the town of Maastricht.[18]

Ivory served excellently for knife handles, spoons, powder flasks, snuffboxes, powder boxes, and the hilts of swords. In both Flanders and south Germany, hunting swords, in particular, were richly adorned with animals (cat. no. 393; figure 52) and hunting scenes, one example in the Walters being in the manner of Rubens (cat. no.

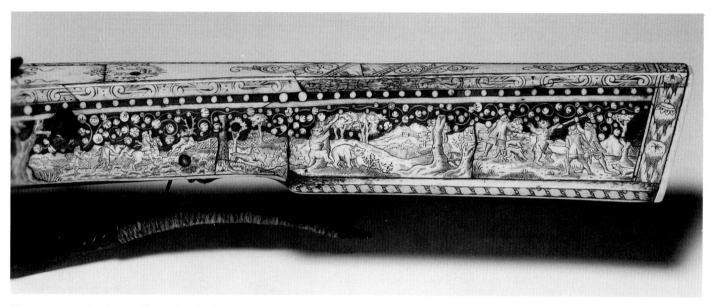

Figure 51. Stock of a crossbow (detail), fruitwood inlaid with staghorn, cow horn, and ivory, German, mid-17th century. The tiller of the bow is inlaid with hunters chasing deer into nets, bears climbing trees, and a bear hunt. The main plaques are staghorn and the scrolls and dots in the sky, cow horn. Only the row of round dots is ivory. Walters Art Gallery (71.374).

Figure 52 (cat. no. 393). Hilt of a hunting sword, ivory, south German, late 17th century. The grip is formed of fighting and intertwined animals, including hounds, bears, and a boar. A huge stag surmounts the group, and the cross guard is decorated with lions.

394). In Holland, special sets of wedding knives and forks were made and put into sheaths of ivory or boxwood. The sheaths were decorated with biblical stories and appropriate references to the stages of life and proper behavior, while the handles of the utensils often portrayed pagan gods or goddesses (cat. no. 395; see colorplate 83).

In the north, in Flanders, Holland, and Germany, chessboards and pieces of furniture continued to be inlaid with ivory, often contrasted with ebony. Such pieces were extremely popular. Doors and drawer fronts of cabinets were often carried out with tasteful details taken from the many available print sources of the time (cat. no. 372). A small ivory "picture" in the manner of Paul Bril shows the Holy Family in a landscape (cat. no. 369). Its quality suggests execution by a print engraver.

The taste for Baroque concepts in ivory continued into the eighteenth century. A typical example of the refined work that was produced in Liège is the Virgin of the Immaculate Conception standing on a globe (cat. no. 404; see colorplate 84). A favorite subject was Saint Sebastian: three examples are preserved in the Walters (cat. nos. 396, 400, and 403). One of these (cat. no. 403; see colorplate 85) shows the saint bound to a coral tree, in the Wunderkammer tradition. Two of the great works in ivory from this era in which the rococo style was beginning to spread throughout Europe are the fantastic bishop's croziers with putti made in 1745 by the German carver Joseph Teutschmann of Passau. One crozier is now in the Bayerisches Nationalmuseum in Munich; the other is in the Victoria and Albert Museum.

NOTES

1. J. von Schlosser, "Die Werkstatt der Embriachi in Venedig," *Jahrbuch des Allerhöchsten Kaiserhauses*, 1899, 220–282.

2. Philippovitch, no. 63.

3. J. von Schlosser, *Kunst und Wunderkammern der Spätrenaissance*, Leipzig, 1908.

4. Berliner, no. 124.

5. L. L. Moller, "Georg Hintz Kunstschrankbilder und der Meister der grossen Elfenbeinpokale," *Jahrbuch der Hamburger Kunstsammlungen*, VIII, 1963, 57–66.

6. C. de Tolnay, *Michelangelo*, V, Princeton, 1960, fig. 214.

7. *Sammlung des Adalbert von Lanna*, sale, Berlin, Nov. 6–16, 1909, lots 1460–1461.

8. Schlosser, *Kunst und Wunderkammern*, fig. 82.

9. A. Schädler, *Georg Petel*, Munich, 1964, figs. 11, 47, 48.

10. Philippovitch, nos. 136 and 137.

11. Philippovitch, nos. 139–141.

12. Philippovitch, nos. 146 and 147.

13. Philippovitch, no. 148.

14. *Catalogue de la collection de Rodolphe Kann*, I, Paris, 1907, fig. 20.

15. Berliner, nos. 832–837.

16. Philippovitch, nos. 162, 169.

17. C. O. von Kienbusch and S. Grancsay, *The Bashford Dean Collection of Arms and Armor*, Portland, 1933, no. 187.

18. A. Hoff, *Dutch Firearms*, London, 1978, 202–221.

Catalogue, Renaissance and Baroque Ivories

367. CHRIST, THE VIRGIN, AND A MEMENTO MORI

Ivory rosary bead. Franco-Flemish, early 16th century

This is a primary bead from a rosary carved with three heads; those of Christ and the Virgin are conjoined with a skull as a memento mori. There are leaves at the top between the heads, and there is a wreath of leaves at the base. The bead is pierced for suspension. There is considerable wear from use, especially on the noses.

H: 2″ (5.1cm) 71.326

HISTORY: Purchased before 1931.

BIB.: *The Waning of the Middle Ages*, 74; *Images of Love and Death*, 116.

368. MEMENTO MORI

Ivory rosary bead. French or Flemish, first half 16th century

This rosary bead in the form of a memento mori follows a long tradition of such beads made in the sixteenth century in north France and Flanders. A number of examples are to be seen in the Victoria and Albert Museum and other collections. The present bead is unusually large and shows a head divided so that one half represents a priest, or monk, with tonsure, mustache, and beard, and the other half, a skull. The eye is carved to show the iris, and the cornea has been filled with colored material.

A complete rosary of eight beads in the Metropolitan Museum (17.190.306) has at either end a similar bead, with half a skull and half a tonsured monk. The other six beads, which show figures in sixteenth-century costume, are variants of examples in the Victoria and Albert Museum (Longhurst, no. 362-1854), dated similarly in the sixteenth century.

The bead is drilled from the top of the skull to the base for suspension. The present brass ring is a replacement.

H: 2⅞″ (7.3cm) 71.461

HISTORY: Purchased before 1931.

369. ADORATION OF THE KINGS

Ivory panel. Flemish, late 16th–early 17th century

The kings and their attendants approach the Holy Family from the right, while at the left is a typical Flemish landscape in the manner of the Flemish painter-engraver Paul Bril (1554–1626), showing a church, trees, and small figures, with a sea and mountains beyond. The design is engraved directly on the ivory, and the lines filled with black composition. The panel does not seem to be part of a piece of furniture; it was probably made to hang as a picture. There are two filled holes in its top edge for a fixture.

A larger picture engraved on ivory in the same technique and preserved in its original seventeenth-century frame is based on a landscape print by Mattäus Merian the Elder ("Vragenrubrick," *Antiek*, May 1980, 666–667).

The panel is made of two sections, the small section, on the left side, being about half an inch wide. The frame is modern.

H: 2⅜″ (6.0cm) × W: 4½″ (11.5cm) 71.332

HISTORY: Purchased before 1931.

370. BIBLICAL AND SECULAR SCENES

Ivory and silver sheath for a wedding set. Flemish (Bruges?), 1604

A sheath for a wedding garniture of knife and fork, which are missing, is carved with biblical and secular scenes. On the front (370a) are four stages in the life of a married couple. The topmost scene, showing a young pair, is labeled: DET IS DE LIEFDE *(This is love)*; the second and third scenes show older couples in elegant early-seventeenth-century costumes; the fourth, a seated older couple. The last is labeled: ICK BEN ALTE MOEDE *(I am old and tired)*. At the bottom is a coat of arms (argent, saltire sable), probably that of Van Baerle of Bruges or Van de Grinde of Holland.

On each side of the sheath are six Apostles with a two-line vertical inscription at the base. On one side are the words: ENGEL WT HET PAREDIJS GEDREVEN/EN MOSTEN HIERNA IN ARMO(EDE), and, on the other: ET LEVEN ANNO 1604/HET COMT AL VAN GODT *(The angels were driven from Paradise and had to live in poverty ever after, 1604/Everything comes from God)*.

On the back of the sheath (370b) are five biblical scenes: The Creation of Eve, Temptation, Expulsion from the Garden of Eden, Sacrifice of Abraham, and Samson carrying the Gates of Gaza. Beneath the scenes is the inscription: ADAM HEEFT DU/ER EVA GOETS GE /BODT BEDEVEN/DAEROM SINSE/DANODEN *(Because of Eve, Adam has corrupted God's command; because of which they are damned)*.

An unusual feature of the sheath is that its central silver band has been embossed by the silversmith to complete the scenes carved on the ivory. The silver locket and chape are nineteenth-century restorations.

L: 8¼″ (20.9cm) 71.321

HISTORY: Purchased in London, 1911.

371. BOX IN BOOK FORM

Ivory and coral. Italian (Naples), early 17th century

Small boxes such as this, with coral figures inside, apparently were made as souvenirs of Naples. The cover is carved with local saints and other figures: Janarius, the deacon Festus, and Desiderius are shown on the front, and Sosius, deacon of Miserio, and an attendant are depicted on the back. On the inside are coral busts of two female figures holding a house or garden pavilion that has a curved pitched roof and two levels of arches. The covers are framed with brass wire, which also forms the hinges, and the catches are brass straps.

One catch is missing, as is most of the coral work.

H: 2¾″ (7.0cm) × W: 2¼″ (5.7cm) 71.351

HISTORY: Purchased from Ongania, Venice, 1899.

367

367

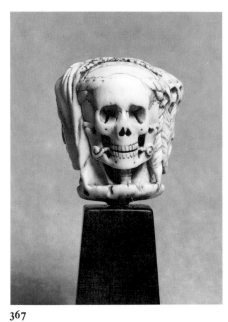

367

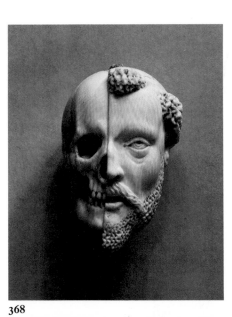

368

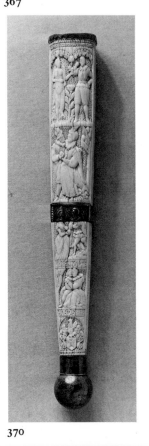

370

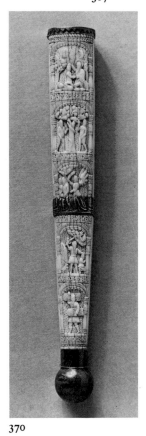

370

369

371

372. PASTORAL SCENES AND MUSICAL FIGURES

Filing cabinet of ivory, bone, and various woods. Flanders (Antwerp), first half 17th century

The two doors of the cabinet open to reveal an interior with a central cabinet with columns and pediment, flanked by two tiers of four drawers. The drawer fronts are ivory, engraved with pastoral scenes before city walls and framed with ripple moldings of ebonized wood. The exteriors of the doors are inlaid with a series of floral panels, forming rectangular frames around arched panels with figures holding musical instruments. The interior of the doors is similarly inlaid, but in a simpler manner, with central floral and bird panels. The cabinet's top and base are treated with ripple moldings in ebony and ebonized wood, as are the lips of the doors. The feet are flattened-ball turnings, and there are gilt-brass locks, drawer pulls, and handles on each end of the cabinet. Inside the interior door, which has an inlaid female figure, is a series of secret drawers.

The woods have been identified as ebony, rosewood, and mahogany, used both in its natural color and ebonized. The interior wood of the cabinet and drawers is fir.

On the bottom of the case is incised a large monogram, AM, which has not been identified. A number of similar cabinets are known; the entire group can be identified as products of Antwerp.

H: 19¼" (48.9cm) × L: 25¾" (65.4cm)
65.23

HISTORY: Purchased before 1931.

373. LION

Ivory pendant with pearls, glass, and gold. German, about 1620

Ivory jewelry seems always to have been rare, probably because of its fragility compared with the more popular enameled gold of the sixteenth and seventeenth centuries. The lion counterpassant here may have heraldic significance. It is inlaid in the side with a red paste cabochon, in imitation of a ruby, and the eyes are similarly set with red glass.

The pendant is related in a number of details to a lion which forms part of the decoration of a turned goblet by Jacob Zeller of Regensburg, court ivory-turner at Dresden from 1610 until his death in 1620 (J. Menzhausen, *The Green Vaults*, Leipzig, 1970, pl. 77b).

The gold chain, pearls, and enameled mounts are of the nineteenth century.

H: 3⅜" (8.5cm) 57.1231

HISTORY: Purchased before 1931.

BIB.: *WAG Jewelry*, no. 524.

374. CLEOPATRA

Ivory statuette. German (Würzburg), 1632–1635. Signed by Adam Lenckhardt

Adam Lenckhardt has depicted Cleopatra at the moment she is bitten by the serpent. She leans on a support, hidden by her heavy drapery, and turns her head to the side in agony. As the back view shows, Cleopatra has taken off a rich dress; its lace collar stands upright as it lies on the support. Her Rubenesque figure is carefully modeled, especially the folds of flesh as she turns in the back view and her turning neck in the front view.

The monogram AL is carved on the base beside the right foot, and resembles that on the Virgin statue in the Kunsthistorisches Museum, Vienna (D 211). The powerful massing of the drapery is similar to the handling of drapery in the two relief plaques of the Ascension and the Lamentation in the Metropolitan Museum, dated 1632 (C. Theuerkauff, "Der Elfenbeinbildhauer Adam Lenckhardt," *Jahrbuch der Hamburger Kunstsammlungen*, X, 1965, 33, figs. 1 and 2). The Virgin in the Ascension and both John and the Virgin in the Lamentation use the same posture, with the head turning to the right. These resemblances suggest a similar date for the Walters figure.

The posture of the figure seems to have been derived from the print of Cleopatra by Agostino Veneziano, in which the artist reveals his debt to Baccio Bandinelli, whose bronze of Cleopatra in Vienna shows a less related posture (J. Schlosser, *Jahrbuch des Allerhöchsten Kaiserhauses*, XXXI, 1913, 90–91, figs. 15 and 16). A somewhat similar pose is used by Rubens in his Penitent Magdalen in Berlin (R. Oldenbourg, *Rubens*, Klassiker der Kunst, Stuttgart, 1937, no. 414).

H: 9½" (24.3cm) 71.416

HISTORY: Collection of Ryfsnyder; Josephus Jitta, Amsterdam; W. S. L. Schuster, London (sale, Christie's, London, no. 24, 1911, lot 79); purchased from George R. Harding, London. 1912.

BIB.: Verdier, *Art International*, no. 4, 34; C. Theuerkauff, "Der Elfenbeinbildhauer Adam Lenckhardt," *Jahrbüch der Hamburger Kunstsammlungen*, X, 1965, 38–39, fig. 5.

See also colorplate 81

375. TORMENTED FIGURE

Ivory and wood statuette. South German or Austrian, 1640–1650

Often called "a son of Laocoön," the figure is attributed to a sculptor designated "the Master of the Furies," who is thought to be south German or Austrian. All of the carver's pieces reveal similarities in proportions and expression. The figure's face is triangular, with ropes of curly hair; the arms overlong, with large hands; the body fleshy; and the legs long and thin. The mouth is open and the face tortured.

The arms are made of separate pieces that have been attached, and half of the figure's left foot is missing. There is a hole in the back, which could have been for the attachment of flying drapery, a characteristic attribute of this carver's figures.

Of the other pieces attributed to this master, the Walters figure is most closely related to a screaming figure on horseback, formerly in the Rodolphe Kann Collection (catalogue, Paris, 1907, I, fig. 20), and a standing figure with flying drapery in Vienna (J. Schlosser, *Werke der Kleinplastik*, Vienna, II, 1910, pl. 49, no. 2). Other works by the same master, in the Berlin Museum and a private collection in Germany, are to be published in the forthcoming catalogue of the ivories of the Berlin Museum. There are other less closely related works in the same vein, of which catalogue no. 376 is a good example.

H: 11⅜" (28.9cm) 71.435

HISTORY: Collection of Rodolphe Kann, Paris; purchased from George R. Harding, New York, 1925.

BIB.: J. Mannheim, Catalogue de la collection Rodolphe Kann, Paris, 1907, I. fig. 21; A. Gabhart, *Treasures and Rarities, Renaissance, Mannerist and Baroque*, Walters Art Gallery, 1971, 29.

See also colorplate 82

376. HERCULES AND THE NEMEAN LION

Ivory statuette. South German or Austrian, 1640–1660

The muscular and tortured figure of Hercules striking the Nemean Lion with his club seems to have been inspired by an Italian model, perhaps a bronze of the school of Pollaiuolo. The style, however, is related to that of the ivory carver known as the Master of the Furies, whose work is illustrated by catalogue no. 375.

The exaggeration of the musculature, the ropey rendering of the hair, and the unusual proportions of the figure, while recalling the Master of the Furies, suggest a follower or another master working in the same vein, perhaps slightly later.

The lion's left forepaw and a small piece of the base are restored. A red tongue was added to the lion's mouth at a later date.

H: 10½" (26.9cm) 71.388

HISTORY: Collection of Josephus Jitta, Amsterdam; W. S. L. Schuster, London (sale, London, Christie's, Nov. 24, 1911, lot 73); purchased from George R. Harding, London, 1912.

372

372

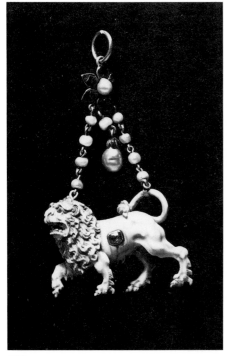

373

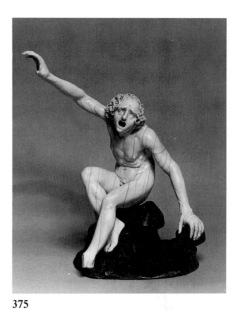

375

374

374

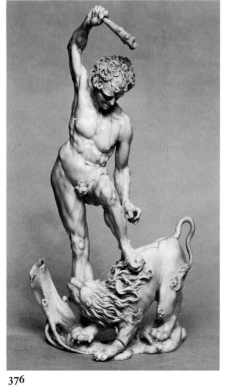

376

377. SLEEPING CHILD

Ivory. Flemish, 1641. Signed by Artus Quellinus

Artus Quellinus (1609–1668) was an Antwerp sculptor who worked for many years in Amsterdam, where he was the sculptor for the Townhall on the Dam, now the Palace of Amsterdam. He was well known for his cupids and children, and this particular model had a lasting effect on European art.

The nude child is seen asleep on a mattress with a folded blanket under his head. The chubbiness of the baby is rendered with a broad treatment of details, such as hair and baby-fat, and the deep and artless sleep of the child is naturally portrayed. The piece is signed at the head on the end: A. QUELINUS—1641.

The taste for chubby babies, cupids, and memento mori groups with a baby is largely attributable to Quellinus' master, François Duquesnoy. A terra-cotta sketch of a closely similar sleeping baby in the Casa Buonarroti, Florence, is attributed by Julius Schlosser to Duquesnoy (J. Schlosser, *Jahrbüch des Allerhöchsten Kaiserhauses*, XXXI, 1913, 100). In the Walters ivory, there are minor changes in the blanket and other details.

The model remained popular and was repeated in the eighteenth century in Chelsea porcelain, a figure in the British Museum being dated 1746 (see Lane, Bib.).

L: 4⅝″ (11.8cm) × W: 2¼″ (5.7cm)
71.393

HISTORY: Purchased in Amsterdam, 1900.

BIB.: W. Little, "Three Sleeping Children, a Further Porcelain Observation," *Connoisseur*, Apr. 1952, 35, fig. 2; A. Lane, *English Porcelain Figures of the 18th Century*, London, 1961, pl. 2c; Theuerkauff, *Bossuit*, 129, fig. 13; K. Fremantle, *Baroque Townhall of Amsterdam*, Utrecht, 1959, 148–150, fig. 170 f.

See also colorplate 79

378. THE CRUCIFIED CHRIST

Ivory. Italian, first half 17th century

This type of Christ, with fallen head and closed eyes, is that used by Benvenuto Cellini in his Escorial figure (H. Focillon, *Cellini*, Paris, n.d., 121) and also can be seen in the sketches of Guglielmo della Porta (W. Gamberg, *Die Düsseldorfer Skizzenbucher des Guglielmo della Porta*, III, Berlin, 1964, no. 159). The drapery is unusual, falling in a large squarish fold from the cord around the hips.

The carver was extremely skillful in handling the anatomy, with particular stress on details such as the straining tendons of the arms, which are made of separate pieces. The toes of both feet, the left hand, and two fingers of the right hand are restored. The portion of the loincloth on the figure's right hip has been broken and reattached, and part of the cord is missing. There are many traces of a reddish pigment on the right arm, the legs, and parts of the body.

The body type and drapery are close to the work of Francesco Terilli of Feltre, near Venice, whose dated works cover the period 1596–1633. A Crucifixion signed by Terilli, but with a very different concept of the head, was in an anonymous sale, Sotheby's, London, Nov. 18, 1982, lot 144.

H: 11⅞″ (30.2cm) 71.436

HISTORY: Purchased from Léon Gruel, Paris, 1923.

379. TURNED DECORATION

Ivory and silver vessel. German, first half 17th century

This vessel is the product of an ivory-turner. Ivory-turning was a profession much admired in the early seventeenth century; the courts of Bavaria, Dresden, and Florence all employed ivory-turners to produce puzzles and interesting vessels. Nuremberg and Regensburg were centers of the craft. The vessel is unsigned. It has on its cover a small silver Venus which serves as a handle.

H: 4⅜″ (11.0cm) 71.339

HISTORY: Purchased in Paris in 1929.

380. TURNED DECORATION

Ivory vessel. German, second half 17th century

The turnings of the four balusters are of the style of the late seventeenth century. The dome, architrave, and base are pierced with star- and round shapes, and the circular piercings in the base are filled with gesso. In the center is a support with a slot in it, which probably held a piece of turned ivory. The piercings relate to German vessels now in Florence (C. Piacenti, *Il museo degli argenti*, Milan, 1968, figs. 44, 48).

The double-tiered finial, which was present in 1934, is missing.

H: 8⅛″ (20.5cm) 71.360

HISTORY: Purchased from Ongania, Venice, before 1931.

381. DEPOSITION FROM THE CROSS

Ivory relief. South German (Ulm), 1670–1680

This complex composition of fourteen figures is made of many sections of ivory joined together, and was originally mounted on a black lacquered background. The relief is signed by the monogrammist VH by whom a number of works are known, several of them dated. VH has recently been identified by Christian Theuerkauff as Johann Ulrich Hurdter, a Swiss, who was trained in Ulm by David Heschler.

The composition, which shows Christ's body being lowered by six figures on three ladders, is closely paralleled in an ivory by David Heschler now in Stockholm, datable to about 1650 (C. Theuerkauff, "A Note on the Ulm Sculptor David Heschler," *Apollo*, October 1967, 288 ff.). At the foot of the Cross stand Nicodemus and a bearded man on the right, and the Magdalen on the left. The fainting Virgin is attended by John and two holy women. The monogram of the carver VH appears in the landscape border at the extreme left.

Hurdter also carved two standing cups with stems showing Bacchus and a nude female. Both cups are signed and dated 1673 and were formerly in the Lanna Collection, Prague (sale, Berlin, Nov. 6–16, 1909, vol. 2, lots 1460 and 1461). A standing figure of Bacchus from the top of a tankard also by Hurdter was formerly in Berlin and was destroyed during World War II (Volbach, no. K 3143). A second relief bearing the monogram VH and the date 1679 shows Hercules and Omphale. This work, which is preserved in its original setting against a background of black lacquer in an ivory frame, is in the Brunswick Collection (Scherer, no. 225).

The background of the Walters relief is modern, and many separations are visible between the sections of ivory.

H: 18⅛″ (46.0cm) × W: 13½″ (34.5cm)
71.445

HISTORY: Purchased from Tiffany & Company, New York, before 1931.

BIB.: M. C. Ross, "An Ivory of the Deposition by VH," *Oud-Holland*, 1938, p. 266; P. Verdier, *Art International*, VII, 4, 1963, p. 35; C. Theuerkauff, "Fragen zur Ulmer Kleinplastik im 17/18 Jahrhundert—II. Zu Johann Ulrich Hurdter (1631/32–1716?)," *Alte und moderne Kunst*, fasc. 192–193, 1984, 35–45.

See also figure 49

382. MOURNING VIRGIN

Ivory statuette. South German, second half 17th century

The Virgin combines the iconography of the mourning figure beneath the cross with the Mother of Sorrows, whose breast has been pierced with a sword. In the seventeenth century, this image rarely appears in the standing posture but is usually seated. A second example of the type from Bavaria is in the collection of the Bayerisches Nationalmuseum, Munich (Berliner, no. 860).

There is minor damage to the nose, and there are breaks of the lower folds on each side of the figure.

H: 6⅛″ (15.5cm) 71.471

HISTORY: Purchased before 1931.

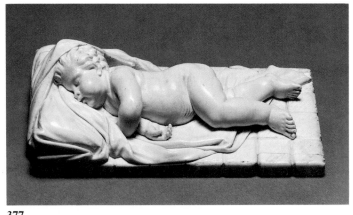

377

377

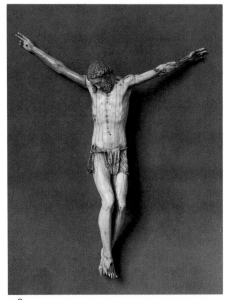

378

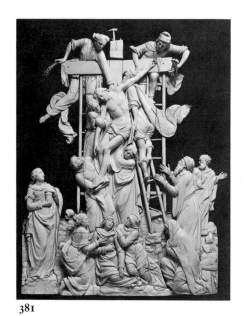

381

379

380

382

383. SCENES WITH PUTTI

Ivory body from a tankard. German (Franconia), third quarter 17th century

The carved ivory cylinder for a low tankard is one of a group attributed to a follower of the Nuremberg sculptor Leonard Kern, all showing putti and putti bacchanals. This example depicts putti drinking and dancing; a pair playing piggyback; and the unusual subject of a putto chopping down a tree.

The piggyback putti are closely paralleled by a bronze from the workshop of Leonard Kern, of which there is a cast in the Walters Collection (54.291).

Other closely related cylinders, probably by the same carver, are in Munich (Berliner, no. 203); Brunswick (Scherer, no. 358); and Berlin (Volbach, no. 3123).

The mounts are missing, and the upper edge is reinforced with a modern gilt mount.

H: 3½″ (9.0cm) × D: 4¾″ (12.0cm)
71.417
HISTORY: Purchased before 1931.

384. SCENES OF THE GODS

Ivory and silver gilt standing cup. German (Augsburg), 1685–1700

The body of the cup is a cylinder of ivory carved with the figures of the classical gods in pairs (Jupiter and Juno, Mercury and Herse, Mars and Venus), together with Cupid, Juno's eagle, and the centaur Nessus carrying Deianira. Both the cover and foot are formed of groups of putti playing with grapes. The mounts of gilded silver bear the Augsburg silver mark of a pine cone and are decorated with auricular ornament in low relief.

The cup is closely related to a cup in the Hamburg Museum with a scene of a bacchanal and to a cup from the Løvenørn family in Denmark showing a bacchanal of children. The base and cover of the Hamburg cup show putti similar to those in the Walters example, but the mounts, datable to between 1670 and 1690, are by the Hamburg goldsmith Friedrich Biesterveld. The painter George Hintz of Altona did still lifes of two collector's cabinets in which an ivory cup of this type is the centerpiece. One of these paintings, in the Hamburg Kunsthalle, shows the Løvenørn family cup. Since Hintz worked in Hamburg, and since a related cup has Hamburg mounts, it has been surmised that the cups were the products of a north German carver. The group is discussed by Lise Lotte Möller (see Bib.).

The Augsburg pine cone on the Walters cup brings the origin of the three cups into question. It is possible that they were all made in south Germany, as their style indicates, and that one ivory cylinder was mounted in Hamburg, where, according to the evidence of Hintz's paintings, the cups were clearly fashionable.

The cylinder of the cup is cracked, and the silver is stamped on the lid and base with the Viennese tax mark of 1810–1824.

H: 12¾″ (32.4cm) × D: 2⅞″ (7.2cm)
71.470
HISTORY: Purchased from Jacques Seligmann, Paris, 1912.
BIB.: L. L. Möller, "George Hintz Kunstschrankbilder und der Meister der grossen Elfenbeinpokale," *Jahrbuch der Hamburger Kunstsammlungen*, VIII, 1963, 57–66 and fig. 6.
See also colorplate 80

385. CHRIST AT THE COLUMN

Ivory statuette. South German, late 17th century

In this version of Christ at the Column, the figure of Christ twists gently in space in a gesture of resignation. The subject of the Flagellation and of Christ alone at the column was extraordinarily popular in the seventeenth century, as the dozens of versions of the bronze by François Duquesnoy illustrate (J. Montagu, "A Flagellation Group: Algardi or Duquesnoy," *Bulletin des musées royaux*, Brussels, XXXVIII/XXXIX, 1966/67, 153–193). In Germany, Georg Petel created a slightly different version in which Christ looks up and the body twists in anguish (T. Müller, *Georg Petel*, Munich, 1964, figs. 209 and 210). Petel's version had considerable success among his followers, including David Heschler (Müller, figs. 211 and 212).

The Walters work is certainly related to the Petel group, but it appears to be by neither Petel nor Heschler. It is more subtle in movement and more classical in the treatment of the face, suggesting a German sculptor working in Italy.

The base of ebonized wood, with upper and lower moldings of ivory, is nineteenth century.

H: 7″ (17.8cm) 71.356
HISTORY: Purchased in Paris before 1931.
See also figure 50

386. CORPUS OF CHRIST

Bone. French, late 17th century

Crude works in bone such as this one were probably made by prisoners of war from soup bones. They exist in varying qualities, and the present example, with its strong emphasis on the rib cage and drapery, is more detailed than many. The arms, which were made of separate pieces, are missing.

L: 5¾″ (14.6cm) 71.1163
HISTORY: Bequest of James G. O'Conor, 1970.

387. APOLLO AND MARSYAS

Ivory and wood relief. Franco-Flemish, late 17th century

This finely executed relief of the flaying of Marsyas shows great technical skill combined with purposeful exaggeration, as seen in the posture of Apollo. It was carved from a single piece of ivory, which is paper-thin at certain points. A small section between the shoulders of the two figures has cracked from each of them, and there is a crack in Apollo's left leg. The relief is applied to its original ebonized wood panel.

The relief has been considered by Theuerkauff and Asche (see Bib.) as the work of a follower of Balthasar Permoser and called German or Netherlandish. Upon reconsideration of the piece, however, Theuerkauff has suggested a Franco-Flemish origin.

H: 8¾″ (22.2cm) × W: 5¾″ (14.6cm)
71.476
HISTORY: Purchased before 1931.
BIB.: Verdier, *Art International*, no. 4, 36; Theuerkauff, *Bossuit*, 139, 88, fig. 33; S. Asche, *Balthasar Permoser*, Berlin, 1978, 33, n. 39; 61, fig. 44.

388. SAINT JEROME

Ivory. Italian (or German?), late 17th century

The bearded saint is shown holding a rock in his right hand and smiting his chest. A small lion sits beneath his left foot.

The saint's right foot and a portion of the base are broken away. There is a brass pin at the top of the head for the attachment of a halo.

H: 5½″ (14.0cm) 71.401
HISTORY: Purchased before 1931.

383

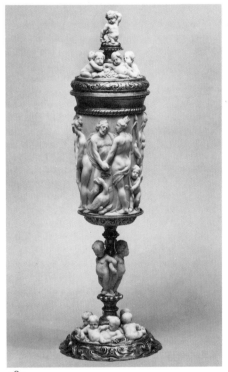

384

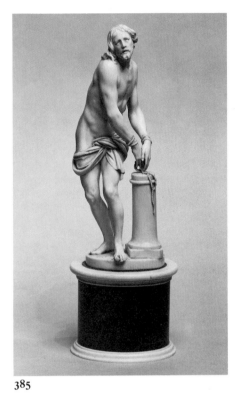

385

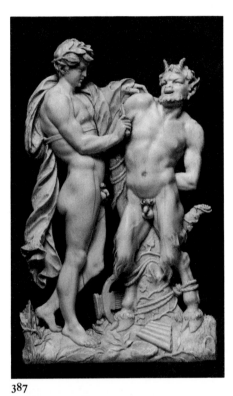

387

386

388

389. CHRIST CHILD

Ivory statuette. South German, late 17th century

Small figures such as this one exist in considerable numbers and were the gifts of nuns to their convents at the time they took orders. The figure of the Christ Child, nude or wearing a loincloth, as here, was dressed by the nun in clothes which she made, and dedicated to the convent as a visual proof of her mystical marriage with Christ.

A second ivory of the type is in the Walters (cat. no. 390), and there are two such figures in the Bayerisches Nationalmuseum (Berliner, nos. 367, 603a) and an early-eighteenth-century example in the Landesmuseum, Innsbruck (Philippovitch, no. 175). An ivory figure of slightly different form, wearing its original clothing, made by the Gräfin Thun, is in the Treasury of the Nonnberg, Salzburg (Philippovitch, no. 176).

The hair shows traces of brown paint. The forearms and the left foot are restorations.

H: 3⅝" (9.2cm) 71.413

HISTORY: Purchased before 1931.

390. CHRIST CHILD

Ivory statuette. South German, late 17th century

The hair of the figure has traces of gilding, and there are two scratches on the face. The gilt metal base is associated.

For the use of such figures, see catalogue no. 389.

H: 3½" (8.8cm) 71.414

HISTORY: Purchased from Raoul Heilbronner, Paris, 1911.

391. FLORAL SCROLLS

Ivory comb with silver piqué. Italian (Florence), late 17th century

The double comb is unusual in having small teeth on both sides. The body of the comb is inlaid with scrolls of leaves and flowers in silver piqué in the style of the late seventeenth century.

L: 5¹/₁₆" (12.7cm) × H: 3¾" (9.5cm)
71.1134

HISTORY: Collection of Mrs. M. Paronian, Nice; gift of Philippe Verdier, 1959.

392. SYMBOLIC FIGURES

Ivory knife handle. Dutch, late 17th century

The grip is carved with four symbolic female figures: Hope, with an anchor; Charity, with a purse; Faith, with a book; and Music, with a stringed instrument and small dog. The figures are surmounted by four women's heads with late-seventeenth-century hairstyles, and the finial is a crouching lion. The blade is iron, as is the ferrule, and bears the mark of an unidentified maker.

The knife, which is well worn, has been preserved in a later leather case ornamented with punchwork. The designs include a tulip, a bird, and the date 1765.

A similar knife is in the Victoria and Albert Museum (C. T. P. Bailey, *Knives and Forks*, London, 1927, fig. 35a), as is a related pair of knives slightly different in style, but displaying the same series of figures and the arms of Amsterdam (Bailey, fig. 30c,d).

L: 10¹⁵/₁₆" (27.9cm) 51.1338

HISTORY: Purchased before 1931.

393. INTERTWINED ANIMALS

Ivory hilt of a hunting sword. South German, late 17th century

The grip and cross guard of a hunting sword are carved with intertwined animals, which include bears, a boar, a stag, rabbits, lions, and hounds. The poses of the animals and the quality of the work are related to the Noah's Ark scene on a tankard in Munich attributed to Franz I. Stainhart (Theuerkauff, *Helfenbein*, figs. 9, 13a). Both sections of the hilt are slotted to receive the tang of the sword. The antlers of the stag are broken, and the lower section of one knuckle of the cross guard is restored.

L: 5⅜" (13.8cm) × W: 4⅜" (11.2cm)
71.464

HISTORY: Purchased before 1931.

See also figure 52

394. ANIMALS AND PUTTI

Ivory grip of a sword. Flemish, late 17th century

This shaped grip of a hunting sword is carved in high relief with cupids, eagles, a deer, and dogs attacking a lion. The composition has Rubensesque characteristics, and the piece was formerly attributed to Lucas Faid'herbe.

The entire grip is pierced with a square hole for the tang of the sword and is rabbeted at the bottom for a metal ferrule.

L: 5⅛" (13.0cm) 71.325

HISTORY: Purchased from Arthur Sambon, Paris, 1925.

395. MARS AND DIANA

Ivory, boxwood, silver, and iron wedding set. Dutch (Amsterdam), 1698

Cases with a knife and fork were conventional wedding presents in the Low Countries in the seventeenth century; a large group of ivory-handled examples was made in Holland. The present set is typical of the group; the knife having the figure of Mars in armor holding a sword and shield, with a growling dog behind him, and the fork displaying the figure of Diana with moon, bow, quiver, and a dog. Diana's costume and hairstyle are late seventeenth century. The blade bears the Amsterdam city mark and an unknown maker's mark. A similar pair of grips, showing Mars and Minerva, are in Brunswick (Scherer, nos. 499 and 500).

The boxwood sheath is carved on the front with the Annunciation, Nativity, Circumcision, Adoration of the Kings, grapes of Eschol, and King David harping. Between the scenes are inscriptions: GEBORTEN, BYE-SNIDEN—X, DYE WISE, JOSUL. On the back are five scenes: Abraham and the Angels (ABRAHAM); Judith and Holofernes (IUDYCK); David and Bathsheba (BARSABE); Samson with the Gates of Gaza (SAMON); and a bearded face. On each side of the sheath, in large letters, is a verse: DYENT GOD ENDE WILT HEM FRESEN/ENDE SPRECHT FOER WEDWWEN EN WESEN (*Serve God and fear Him/Always speak in behalf of widows and orphans*). The silver mounts are a locket with the Amsterdam city mark and the date letter for 1698, and a double-ball finial, or chape.

L (overall): 12" (30.5cm); handles: 3⅝" (9.2cm) and 3" (7.6cm) 71.374

HISTORY: Collection of Hollingworth Magniac, Culworth (sale, London, Christie's, July 4, 1892, lot 671).

See also colorplate 83

389

390

391

392

393

394

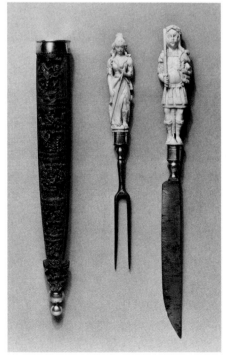

395

396. SAINT SEBASTIAN

Ivory statuette. South German (Munich),
1680–1700

Saint Sebastian is depicted pierced with ivory arrows and tied to a branch of a dead tree. The body is finely modeled, and the gestures and facial expression convey a feeling of strong emotion.

The piece has been attributed to Dominikus Stainhart, who worked in Rome until 1682 and then for the Munich court.

Two of the arrows are broken.

H: 8⅜″ (21.3cm) 71.362

HISTORY: Collection of Léon Gruel, Paris; purchased before 1931.

BIB.: C. Theuerkauff, "Der Elfenbeinbildhauer Adam Lenckhardt," *Jahrbuch der Hamburger Kunstsammlungen,* X, 49 ff., fig. 20; *idem, Helfenbein,* 22–32.

397. SOLDIER ON HORSEBACK

Ivory and silver statuette. Italian, late 17th–early 18th century

Chryselephantine work is unusual in the Baroque period, although a number of works utilizing ivory and contrasting dark wood were created. The rider wears a Roman cuirass of cast silver. His arms are ivory as were his missing head and legs. The spirited horse, with mouth open and ears laid back, is at full gallop. The finely carved tail is made in two sections. The braided mane terminates in a long pigtail with a ribbon.

The rider's head and legs are missing, and the horse's forelegs and right hind leg are broken. There is an original hole in the horse's underside for a support, and there are fragments of attached ivory which may have been plants or flames.

The subject is suggested by an ivory at Schloss Ansbach attributed to the sculptor Ignaz Elhafen (Berliner, no. 896), showing Marcus Curtius leaping into the pit. The Ansbach ivory was made in several sections. While this method may have been dictated by its size (it is larger than the Walters example), it suggests that the front legs of the horse in the Walters fragment may have been separate pieces.

H: 5¼″ (13.3cm) 71.1136

HISTORY: Bequest of Mrs. Breckenridge Long, 1959.

398. VANITAS

Ivory statuette. German (Saxon?), late 17th or early 18th century

The small figure of a chubby child holds an hourglass in his hand and rests his left foot on a skull representing Vanitas. He has thick, curly hair, and holds a drapery around himself with his left hand.

The child's right foot rests on a small pad of ground, and the eyeballs are filled with black coloring. There is some discoloration to the surface, particularly on the stomach and left hand.

H: 4½″ (11.3cm) 71.391

HISTORY: Purchased in Paris before 1931.

399. BACCHUS

Ivory statuette. Italo-Netherlandish, c. 1700(?)

The figure has a restrained classicism, which recalls, to some extent, Jacopo Sansovino's Bacchus marble of 1515 in the Bargello in Florence, yet the figure is considerably elongated. A close parallel to the stance and other features is seen in an Italian bronze in Munich from the second half of the sixteenth century (H. Weihrauch, *Die Bildwerke in Bronze,* Munich, 1956, no. 266). In the Walters ivory, Bacchus is accompanied by a goat, which stands on the stump of a tree with a grape stem in his mouth. The god wears a headdress of grape leaves and a robe of lion's skin and cut velvet with a floral pattern.

The piece is highly polished, with a strong contrast of textures—fur, cloth, skin, and roughened ground. The two back corners of the plinth were added when the figure was made to compensate for the shape of the elephant tusk.

H: 12⅜″ (31.5cm) 71.355

HISTORY: Collection of Josephus Jitta, Amsterdam; W. S. L. Schuster, London (sale, Christie's, London, Nov. 24, 1911, lot 75); purchased from George R. Harding, London, 1912.

BIB.: Verdier, *Art International,* no. 4, 33–34; Theuerkauff, *Bossuit,* 145, fig. 41.

400. SAINT SEBASTIAN

Ivory relief. Austrian, early 18th century

Saint Sebastian is shown tied to a tree, from which two angels are releasing him. A third angel is carrying the arrows with which the saint was martyred. The panel probably formed the centerpiece of a small house altar, and originally would have been framed in ebony. There is a small slanting hole in the upper edge of the panel for attachment.

Angels of similar character can be seen in other Austrian works, such as those by the sculptor Jacob Auer.

H: 4¾″ (12.0cm) × W: 2⅜″ (6.5cm)
71.329

HISTORY: Purchased from Léon Gruel, Paris, 1922.

401. JUDGMENT OF SOLOMON

Ivory and silver gilt snuffbox. Dutch, early 18th century

The box is of the typical shape of those made early in the reign of Louis XV. The scene must have been taken from a Dutch, or perhaps Flemish, drawing and is carved in ivory with the Judgment of Solomon. The ivory bottom of the box is carved with a Baroque scroll.

A rather similar box, in mother-of-pearl and showing Pharaoh's army at the Red Sea, is in the Walters Collection. It is marked by an Amsterdam maker and dated 1739 (57.107).

H: 1⅞″ (4.9cm) × W: 2⅝″ (6.8cm)
71.330

HISTORY: Purchased before 1931.

402a,b. INTERTWINED ANIMALS

Ivory and iron knife and fork. South German, early 18th century

In the seventeenth and eighteenth centuries, German knives and sword grips with entwined groups of animals were very popular. The present knife-and-fork set is typical in showing stags; a combat between a bear and a lion; a horse, bull, and boar; and a combat between a dog and a wolf.

A number of similar examples, most of which are slightly earlier than this set, exist in Munich (Berliner, nos. 551, 552), Brunswick (Scherer, nos. 407, 498), and other collections.

The blade of the knife is marked BERGER, and the horns of the stag on the fork are broken.

Knife handle (402a) L: 3⅜″ (8.5cm); Fork handle (402b) L: 3¼″ (8.2cm) 71.375a,b

HISTORY: Purchased from Léon Gruel, Paris, 1929.

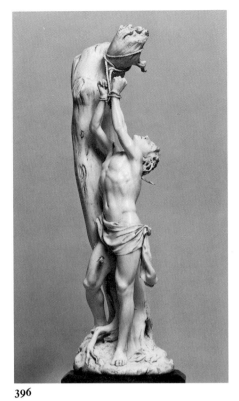

396

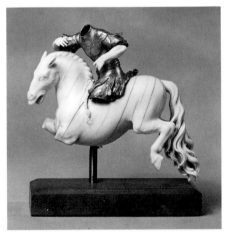

397

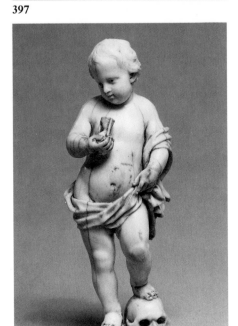

398

399

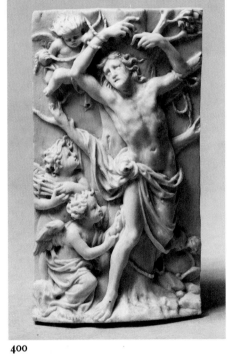

400

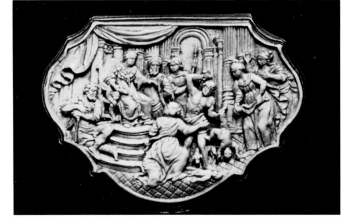

401

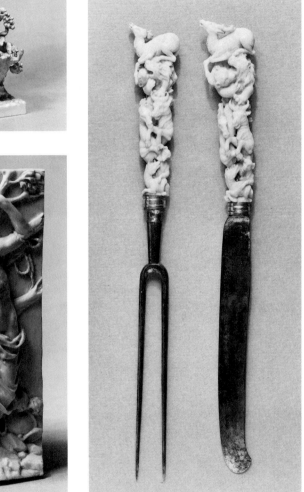

402

403. SAINT SEBASTIAN

Ivory, coral, and gold statuette. South German, early 18th century

The saint is shown in an almost ballet-like dancing posture, with one foot raised off the ground. The figure is bound to a tree of brownish coral with fetters of gold and is pierced with five golden arrows.

The subject was a popular one in south Germany, and there are five examples in Munich (Berliner, nos. 479, 522, 582, 583, 864), one of which has a coral tree and one a wooden tree painted to imitate coral.

The left arm, left leg, and toes of the left foot have been broken and repaired. The base is modern.

H: 7¼″ (18.4cm) 71.1154

HISTORY: Collection of Dr. M. Hugo Oelze, Amsterdam; gift of Mrs. Carol Brewster, 1973.

See also colorplate 85

404. VIRGIN OF THE IMMACULATE CONCEPTION

Ivory statuette. Flemish, first quarter 18th century

The type of Virgin derives from works of Jean Del Cour, for example, his Immaculata in the Musée de l'Art Wallon, Liège (*Jean Del Cour*, Musée d'Ansembourg, Liège, Sept. 1957, no. 33). A related but slightly earlier ivory is in Brussels (*La sculpture au siècle de Rubens*, Musée de l'Art Ancien, Brussels, July 1977, no. 278).

The figure is delicately detailed: the Virgin has a double braid of hair behind her ribbon, and the serpent is depicted with the stem of the apple in his mouth.

The two cherubim who were originally attached at the sides to hold up the globe of the world are missing. The Virgin's eyes are filled with black material, and there is a hole in her back for the attachment of a halo.

H: 8¼″ (29.9cm) 71.402

HISTORY: Purchased before 1931.

See also colorplate 84

405. VIRGIN AND CHILD

Ivory statuette. French (Dieppe?), first quarter 18th century

The Virgin is a conservative type, holding the frontal Christ Child in a seated position. Her right hand originally held an object, possibly a flower, which is missing.

The Virgin's physiognomy is French, though the drapery can be paralleled in other works of the seventeenth century, such as a Christopher Maucher female saint on a shrine in the Kunsthistorisches Museum, Vienna (C. Scherer, *Elfenbeinplastik*, Leipzig, 1902, 109).

H: 6¼″ (15.9cm) 71.377

HISTORY: Purchased before 1931.

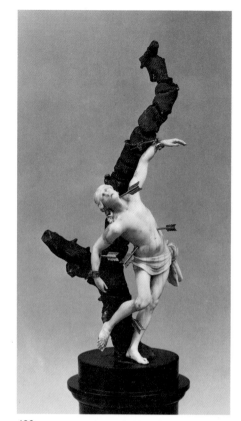

403

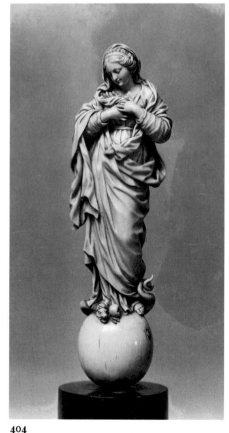

404

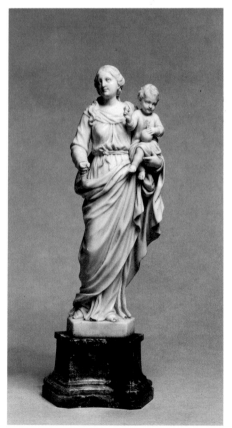

405

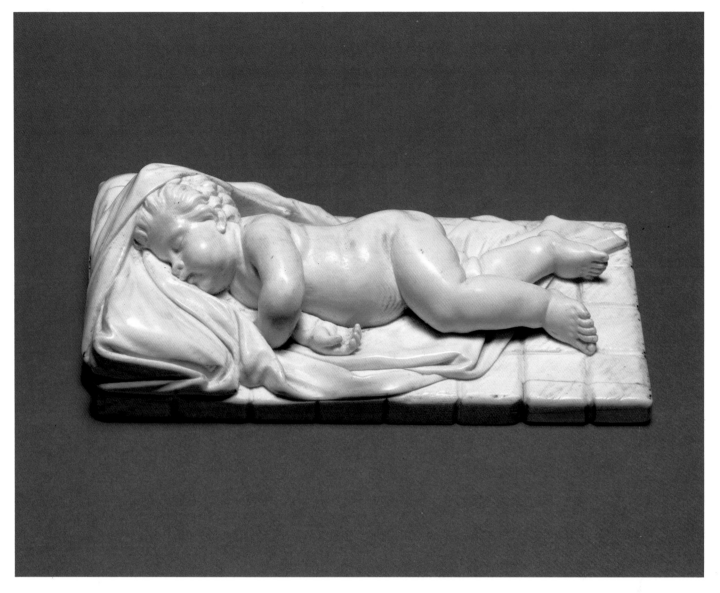

Colorplate 79 (cat. no. 377). Sleeping child, ivory, Flemish, 1641, signed by Artus Quellinus. The conviction with which Quellinus rendered the sound sleep of a fat young child had tremendous appeal. The figure, which is closely related to works by the artist's master, François Duquesnoy, aroused such universal admiration that it was reproduced in porcelain in the eighteenth century.

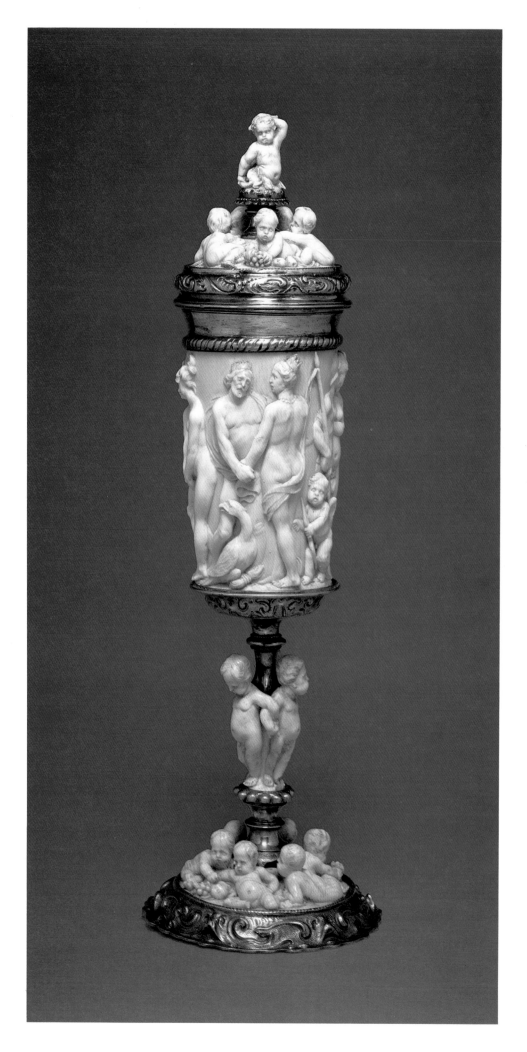

Colorplate 80 (cat. no. 384).
Standing cup with scenes of the gods,
ivory and silver gilt, German
(Augsburg), 1685–1700. This cup or
pokal is a type that was very popular
in Germany in the last quarter of the
seventeenth century. Its fine silver-gilt
mounts are in the auricular style of the
time and bear the mark of the city of
Augsburg.

OPPOSIT·E:

Colorplate 81 (cat. no. 374).
Cleopatra, ivory, German (Würzburg),
1632–1635, signed by Adam
Lenckhardt. Cleopatra is seen in a
dramatic pose as she is bitten by the
asp. Lenckhardt's work is filled with
Baroque drama and action.

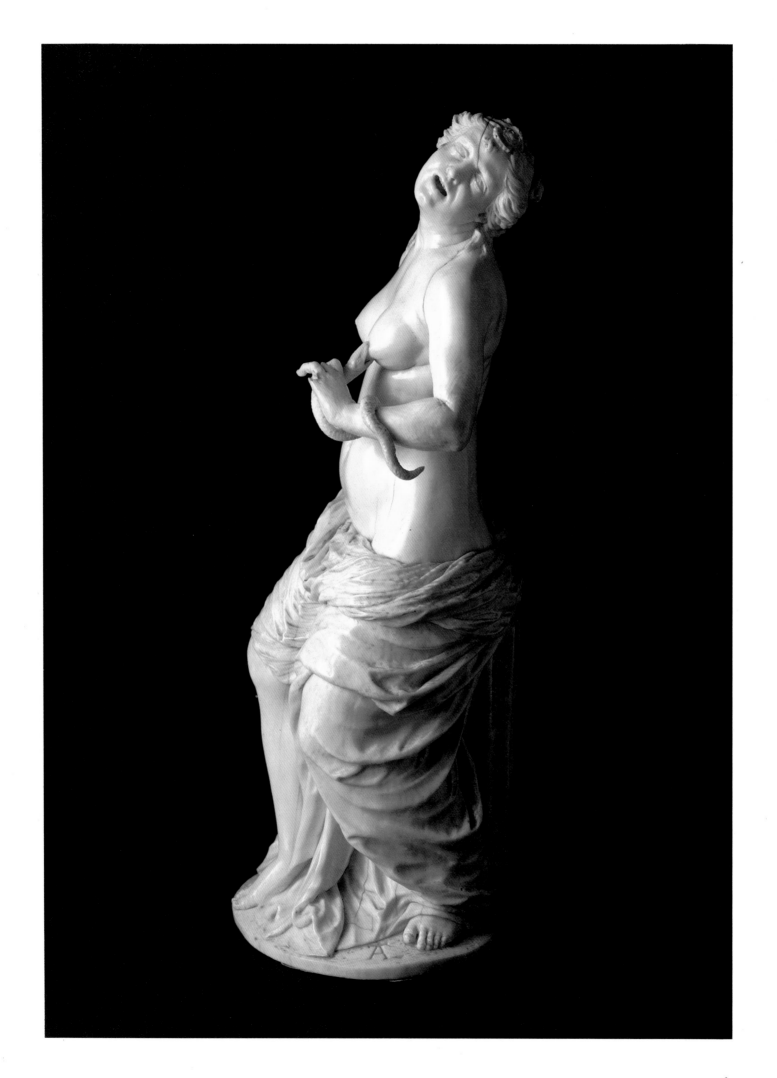

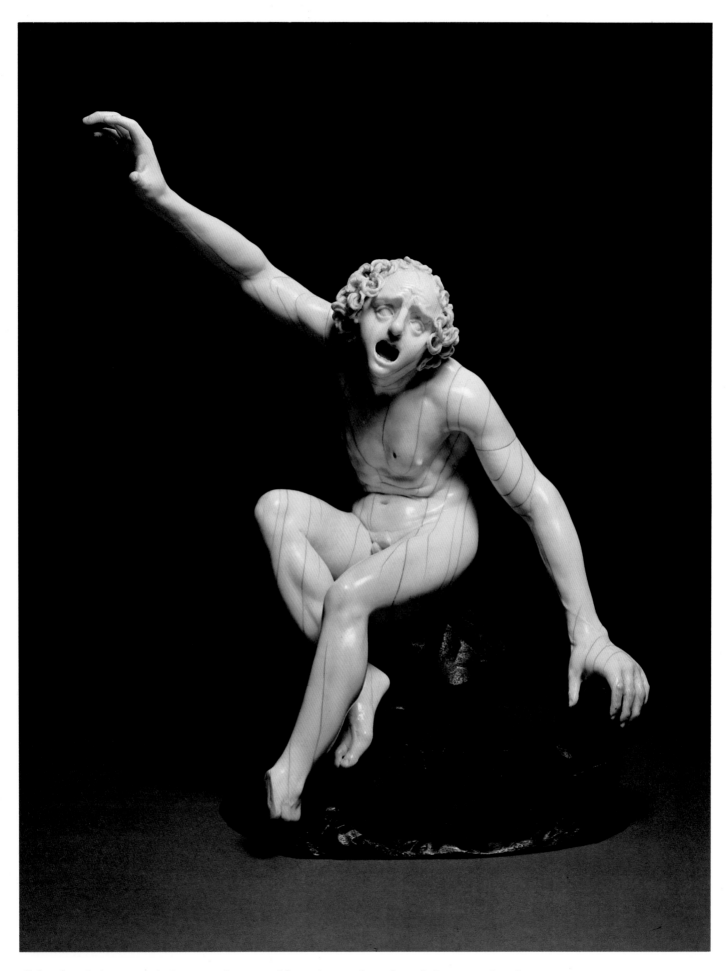

Colorplate 82 (cat. no. 375). Statuette of tormented figure, ivory and wood, south German or Austrian, 1640–1650, attributed to "the Master of the Furies." This dramatic figure has often been called "a son of Laocoön," but it may well be part of a group in a vision of Hell or a Last Judgment.

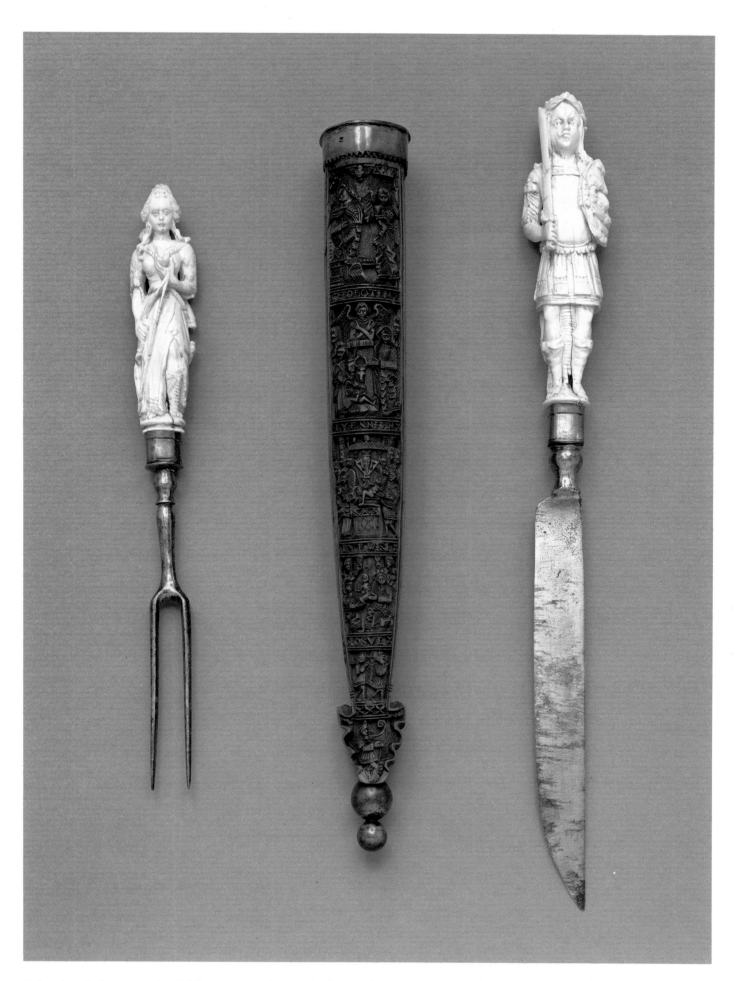

Colorplate 83 (cat. no. 395). Wedding set, ivory, boxwood, silver, and iron, Dutch (Amsterdam), 1698. Adorned knife–and–fork sets like this example were conventional wedding presents in Holland in the seventeenth century. The handles of the implements represent Mars and Diana, and the boxwood knife sheath is carved on the front with scenes of the Infancy of Christ and on the back with scenes from the Old Testament.

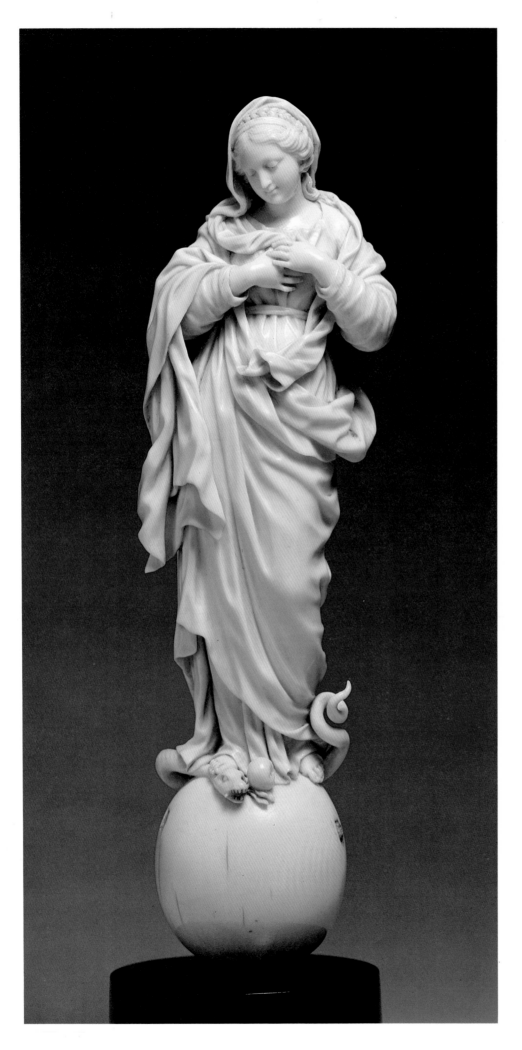

Colorplate 84 (cat. no. 404).
Statuette of the Virgin of the
Immaculate Conception, ivory,
Flemish, first quarter 18th century.
This elegant late Baroque Immaculata
follows a tradition established in Liège
by the seventeenth-century sculptor
Jean Del Cour and seems to be by
an early-eighteenth-century hand.
Certain details, such as the double
braid of hair behind the Virgin's
ribbon, are superbly conceived.

OPPOSITE:

Colorplate 85 (cat. no. 403).
Statuette of Saint Sebastian, ivory,
coral, and gold, south German, early
18th century. In this example, the
rendering of this popular subject
emphasizes the beauty of the figure
and the balletlike grace of the pose.
In the tradition of the collector's
cabinets of the seventeenth century,
the figure is placed against a tree of
semiprecious coral.

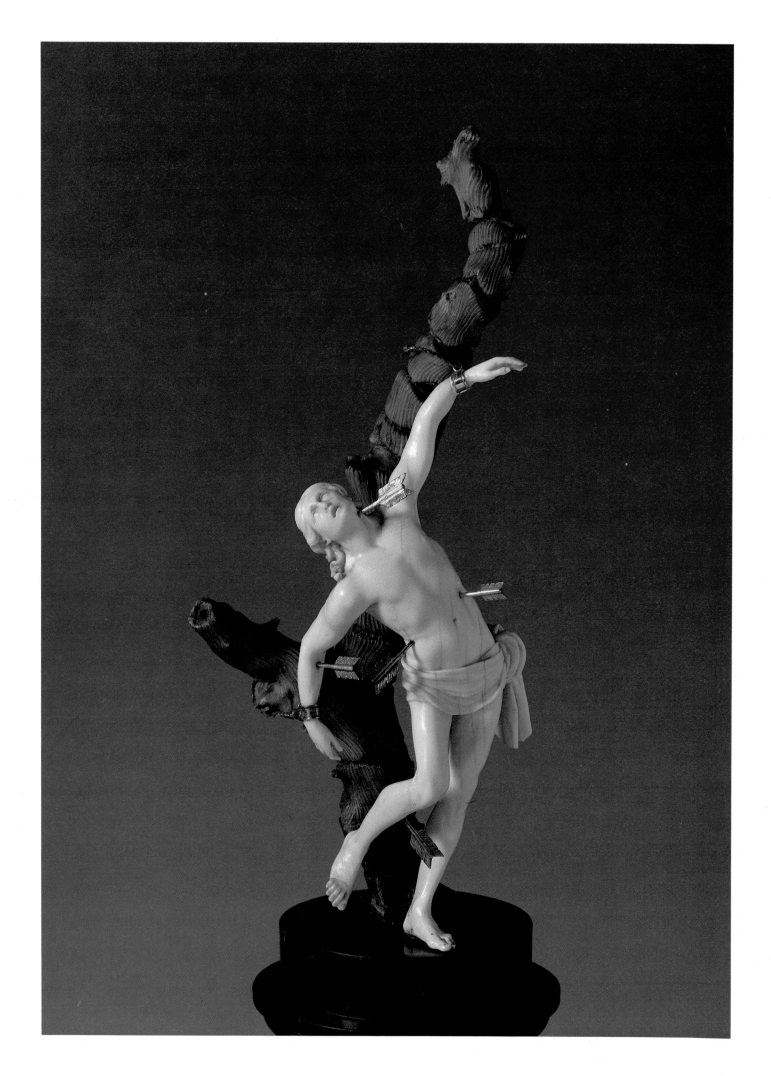

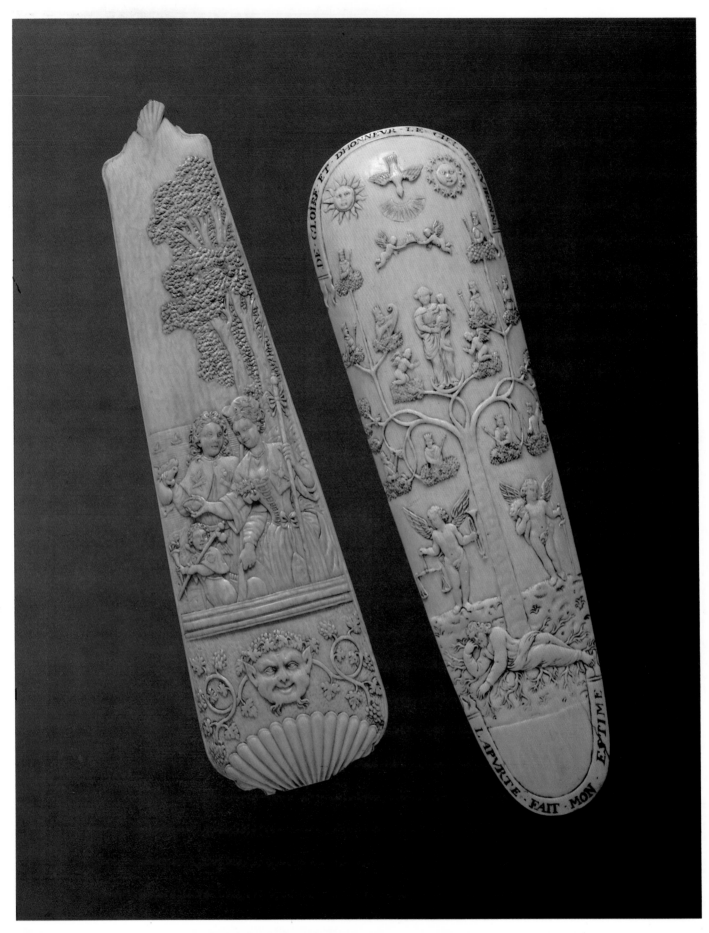

Colorplate 86. Tobacco grater, ivory, stained brown, French (Dieppe), c. 1725 (cat. no. 416); tobacco grater, ivory, French, mid-18th century (cat. no. 417). The reverse sides of these ivories were originally fitted with metal rasps which were used for grating plugs of tobacco. The example on the left (cat. no. 416), thought to have been carved in Dieppe in the early eighteenth century, shows a mythological scene in which pilgrims of love embark for the Isle of Cythera. On the grater at the right (cat. no. 417) appears the Tree of Jesse, illustrating the ancestors of Christ beginning with Jesse and including King David.

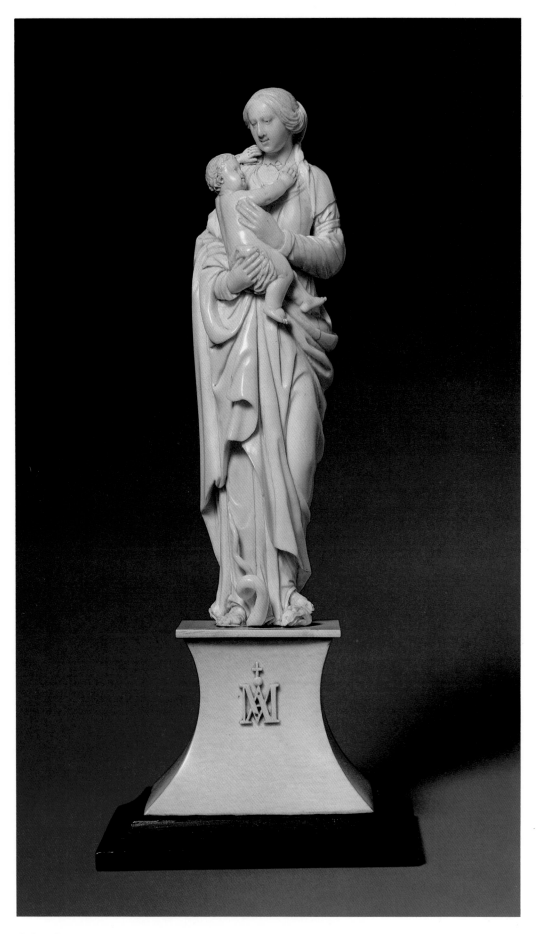

Colorplate 87 (cat. no. 409). Statuette of Virgin and Child treading on a serpent, ivory, French (Dieppe), first quarter 19th century. Reflecting an iconographic motif first developed during the thirteenth century, the Madonna holds the Infant Christ and tramples on a serpent, symbolizing the Christian triumph over sin. During much of the eighteenth and nineteenth centuries Dieppe was the primary French ivory-carving center, and small religious items for personal devotions were among the mainstays of its industry.

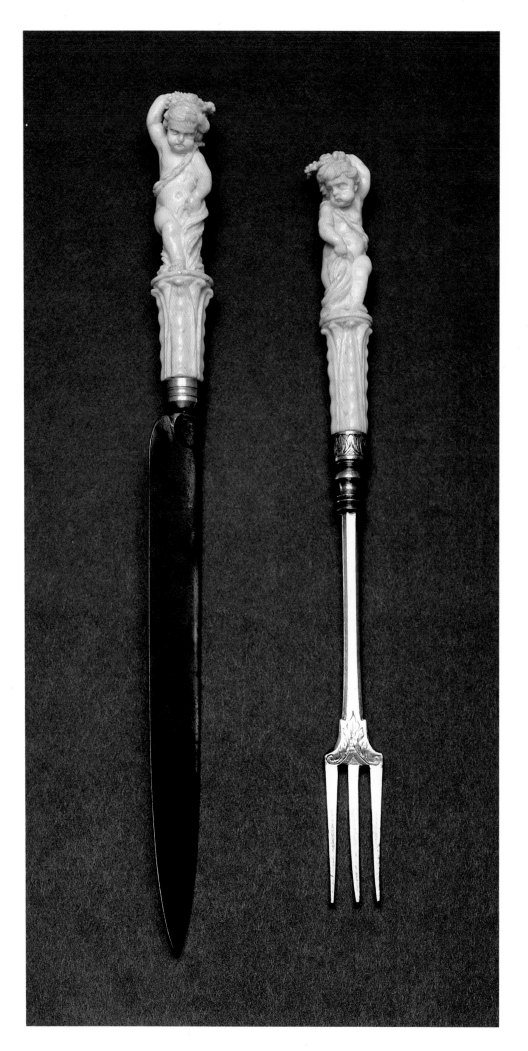

Colorplate 88 (cat. no. 415). Knife and fork, ivory handles with silver, silver gilt, and steel, French (Dieppe?), early 18th century. Knife and fork handles carved with figures were made in the seventeenth and eighteenth centuries in France, Italy, and the Lowlands. In Paris, a guild, that of the *couteliers faiseurs de manches*, was devoted exclusively to such wares. These delicately carved examples are assigned an early-eighteenth-century date.

OPPOSITE:

Colorplate 89 (cat. no. 438). Tabernacle with the *Three Theological Virtues*, ivory, French, 1855–1857, Augustin-Jean Moreau-Vauthier. The paramount sculptor of ivory in France in the second half of the nineteenth century was Augustin-Jean Moreau-Vauthier. In this early work, which was shown at the Paris Salon of 1857, he exhibits his mastery of the Gothic Revival style, a mode which continued to be used throughout the century for liturgical works.

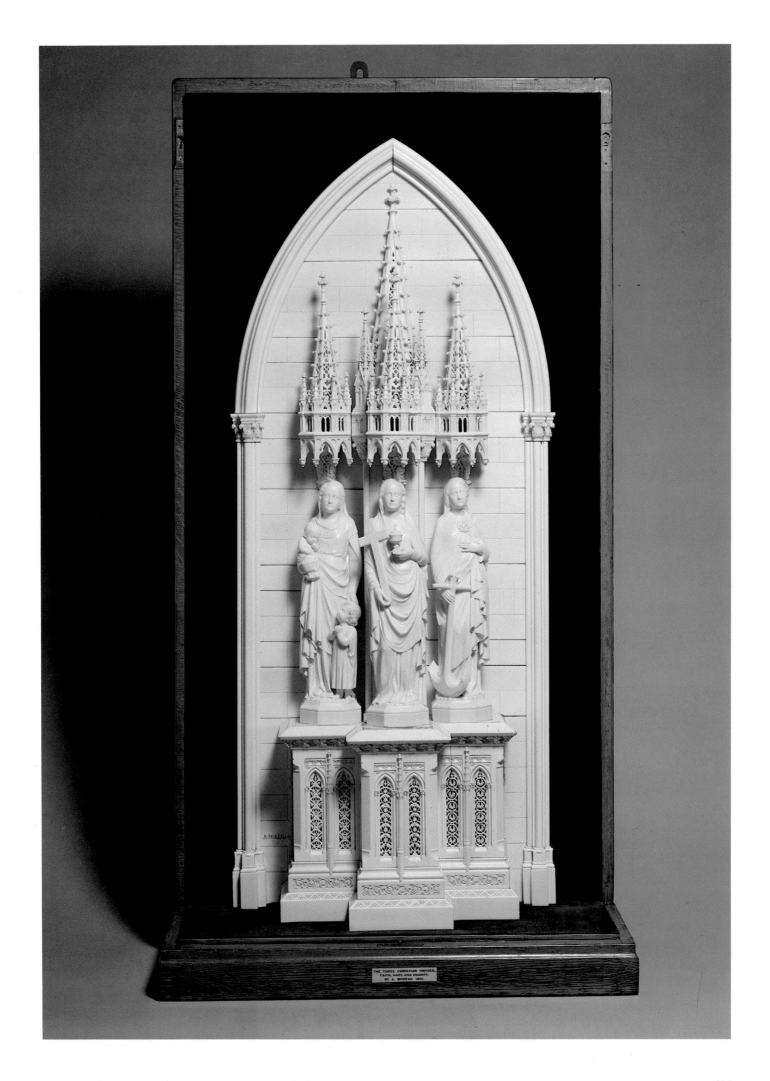

THE THREE CHRISTIAN VIRTUES,
FAITH, HOPE AND CHARITY,
BY A. MOREAU. 1855.

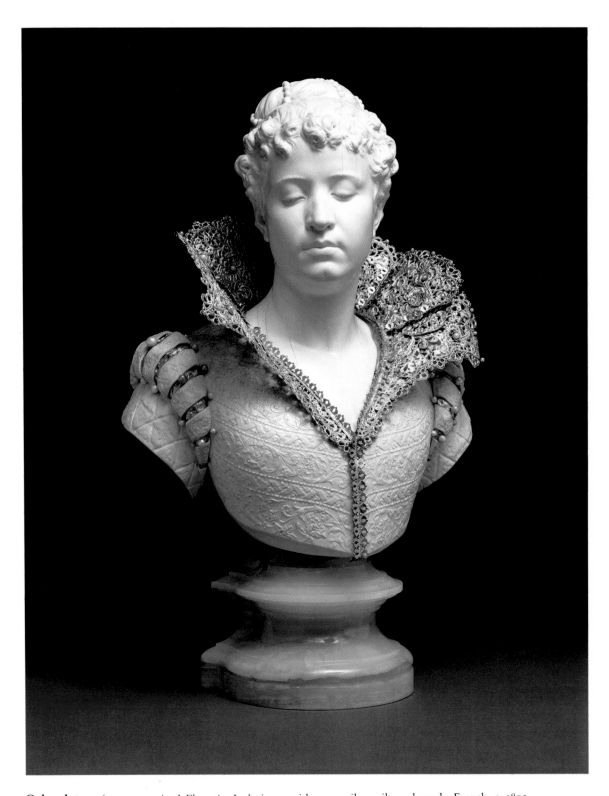

Colorplate 90 (cat. no. 439). *A Florentine Lady*, ivory with onyx, silver gilt, and pearls, French, c. 1892, Augustin-Jean Moreau-Vauthier. The young woman, traditionally identified as Marie de' Medici, wears a brocaded dress with puffed and slashed sleeves, embellished with gilt metal and pearls. Her lace Medici collar is a fantasy of pierced and gilded silver. History, particularly historical novels, became a popular form of entertainment during the nineteenth century, frequently providing subject matter for painters and sculptors. Moreau-Vauthier responded to this taste by creating elegant decorative objects representing romantic personages and fanciful costumes of the past.

OPPOSITE:

Colorplate 91 (cat. no. 444). Statuette of Amphitrite, ivory with silver gilt, pearls, coral, and gold, French, 1889–1900, Emile-Philippe Scailliet, after a design by Marius-John-Antonin Mercié, c. 1878. The Nereid Amphitrite was originally designed by Mercié as the pinnacle of an extravagant silver centerpiece for the duke of Santonia's table. The House of Christofle & Cie. subsequently commissioned Scailliet to carve at least two ivory versions which were embellished with gold and jewels. This statuette was acquired by Henry Walters at the Paris Exposition Universelle of 1900.

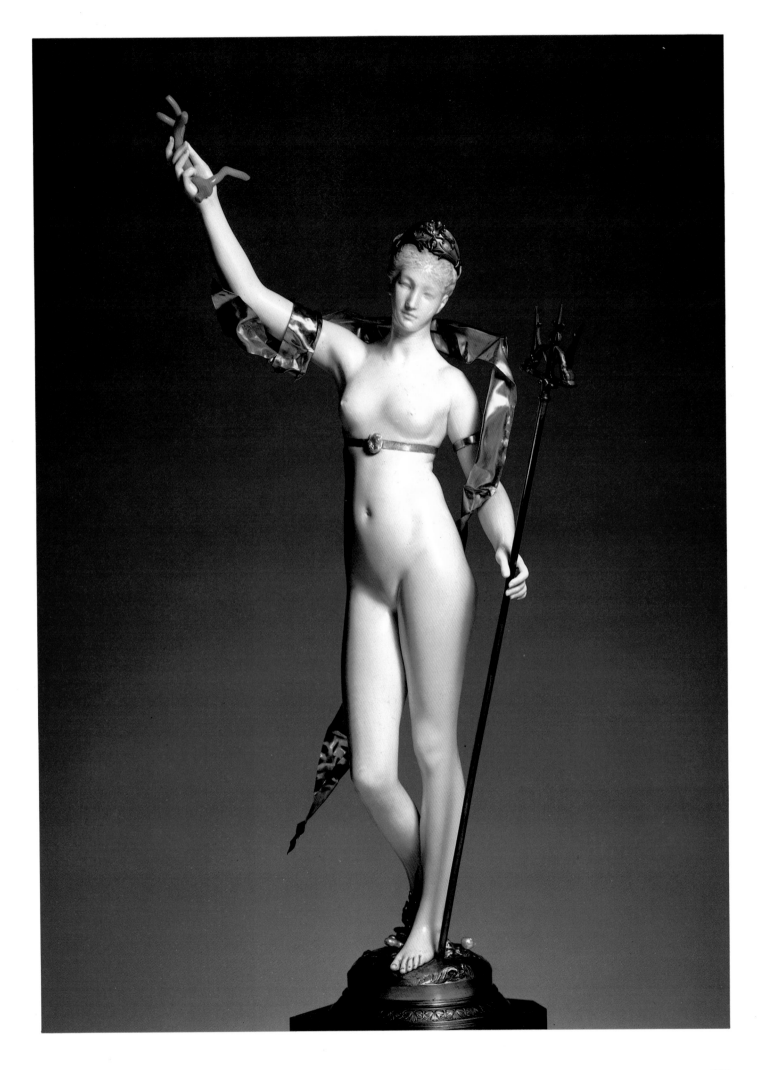

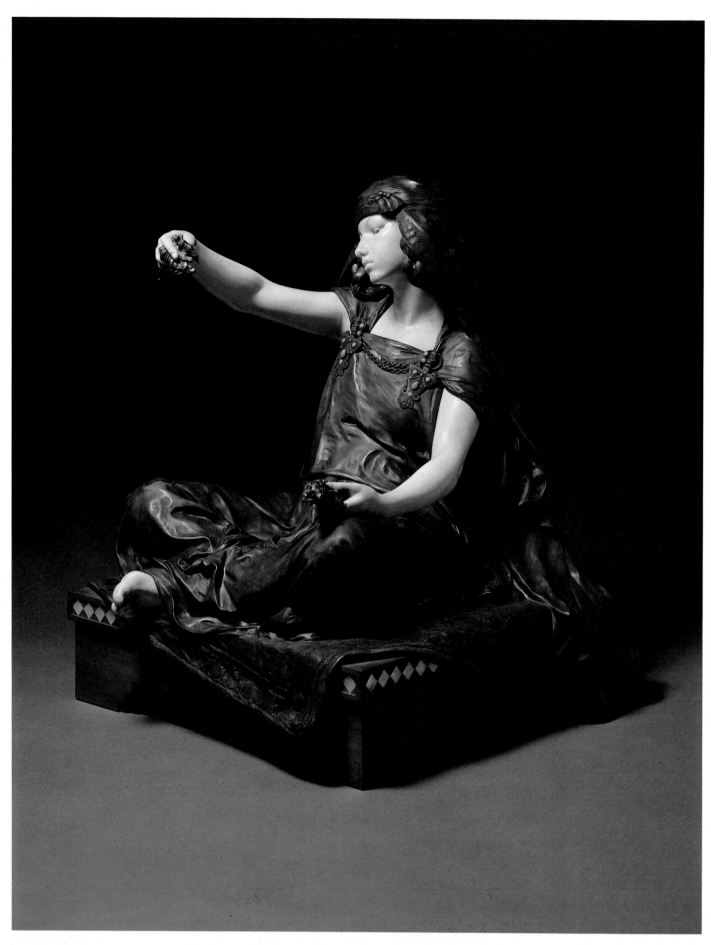

Colorplate 92 (cat. no. 446). *The Young Girl of Bou-Saada*, ivory, silver, wood, mother-of-pearl, turquoise, French, after 1890, Louis-Ernest Barrias. The Parisian foundry Susse Frères issued a number of editions in various mediums of this subject by Louis-Ernest Barrias. The initial bronze version of *The Young Girl of Bou-Saada*, created to mark the grave in Montmartre Cemetery of the Orientalist painter Gustave-Achille Guillaumet, was exhibited in the Paris Salon of 1890.

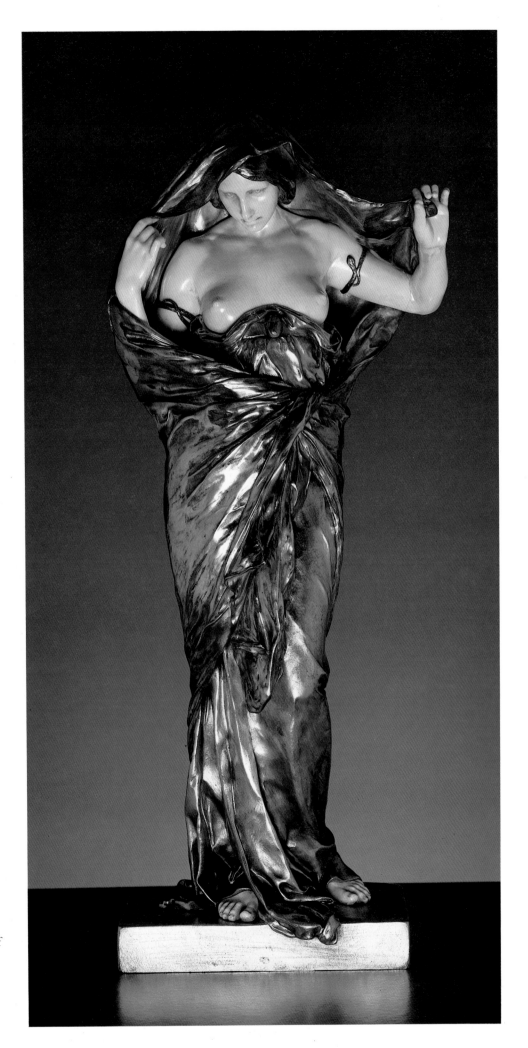

Colorplate 93 (cat. no. 445).
Mysterious and Veiled Nature Reveals Herself before Science, ivory, gilded and oxidized silver, and malachite, French, after 1899, Louis-Ernest Barrias. The figure is one of a number of versions and reductions of the subject, which Barrias first exhibited at the Salon of 1899 in polychromed stone. The Walters version was one of an edition of the subject by the firm of Susse Frères in Paris.

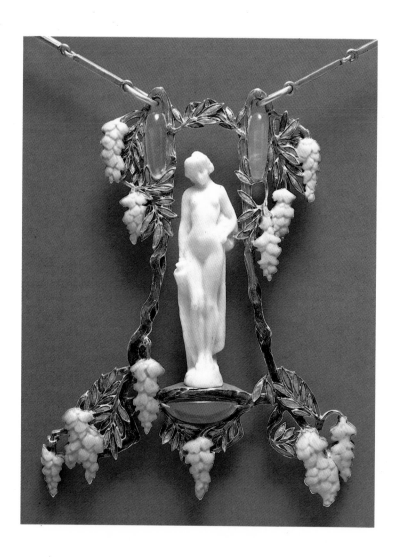

Colorplate 94 (cat. no. 447). Pendant of *La source*, ivory, opals, gold, enamel, French, c. 1902, René Lalique. The popular Victorian subject of a young girl with a water jar has been rendered as a pendant for a lavish necklace of gold and enamel. The bower surrounding the figure is enameled blue, green, and white, while the necklace links are blue. Mexican opals have been used to frame the ivory figure. The necklace was part of Lalique's exhibit at the St. Louis World's Fair, 1904.

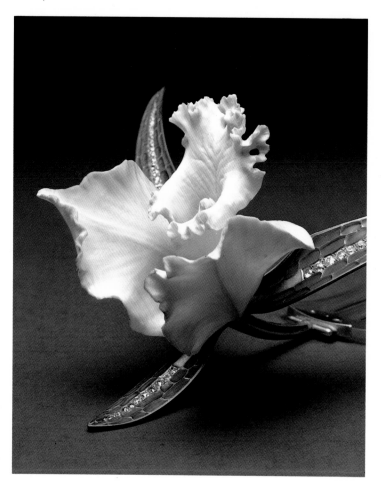

Colorplate 95 (cat. no. 448). Orchid comb, ivory, horn, enamels, gold, diamond brilliants, French, c. 1903–1904, René Lalique. Lalique utilized precious and nonprecious materials in his highly imaginative creations. This delicate comb, with the blossom carved of ivory, was made as a display piece for the St. Louis World's Fair of 1904. The orchid blossom had been popularized as a symbol of fin-de-siècle exoticism in J. K. Huysmans' novel of 1884, *A Rebours*.

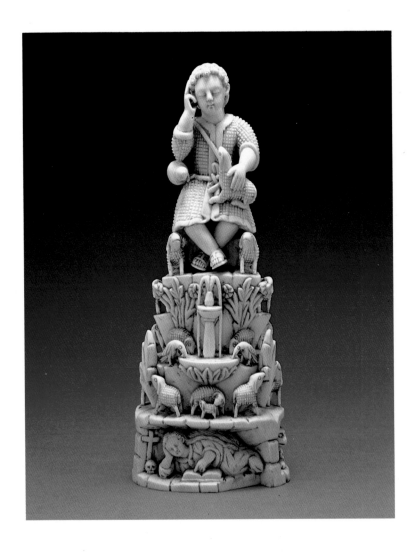

Colorplate 96 (cat. no. 468). Statuette of the Good Shepherd, ivory, Indo-Portuguese, 17th–18th century. The young Christ is represented as a shepherd surrounded by his flock. He rests on a mountain that is luxuriant with animal and vegetable life. Mary Magdalen reclines in a cavern at the base, reading the Scriptures. Harking back to early Christian imagery, this representation of the Good Shepherd also bears the imprint of formulas derived from the traditions of Indian iconography. This fusion of motifs is typically found in the production of Indian craftsmen who worked in the Portuguese colony of Goa.

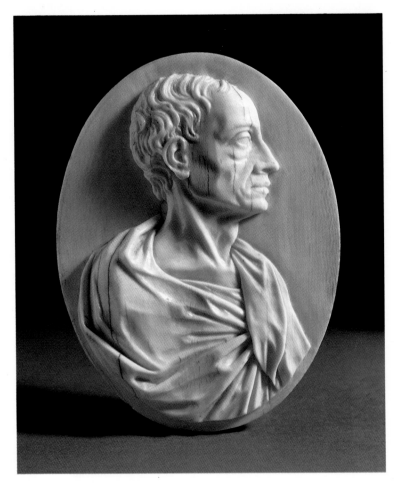

Colorplate 97 (cat. no. 485). Portrait medallion of Alexander Pope, after Louis François Roubiliac, attributed to Alexander van der Hagen, ivory relief, English, first half 18th century. An elegant Neoclassic poet, Pope is depicted proudly wearing a Roman toga. Reflecting the contemporary vogue for miniature portraits of notable personages, the ivory carver has provided an intense, if somewhat mannered, rendition of Louis François Roubiliac's grand forms in this profile after the original portrait bust of 1741.

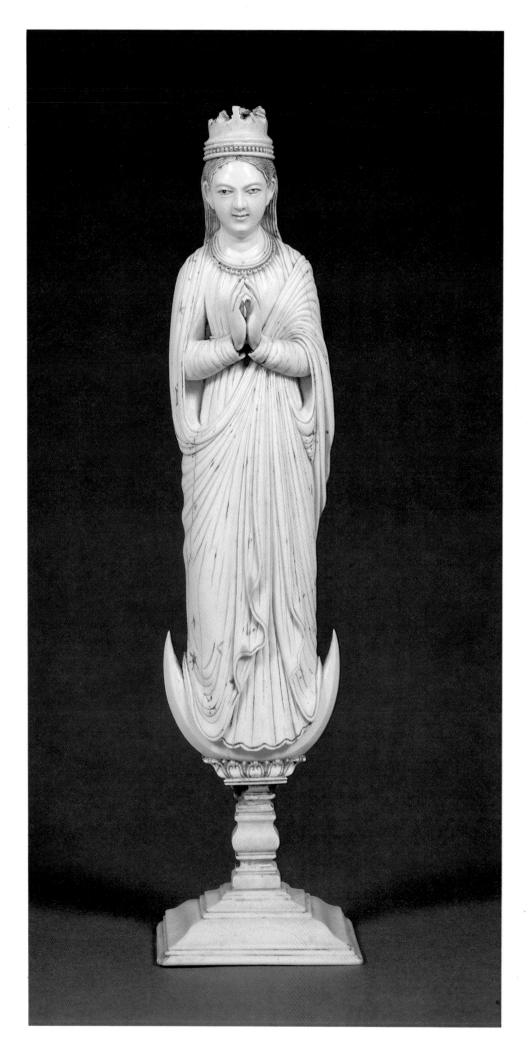

Colorplate 98 (cat. no. 469).
Statuette of the Virgin of the
Immaculate Conception, ivory, with
traces of gilding and polychromy,
Indo-Portuguese, 17th century. The
Indian origin of this colonial ivory is
apparent in the sarilike character
of the Virgin's drapery and the
elongation of her earlobes. These
characteristically Asian forms are
smoothly adapted to the apocalyptic
iconography of Mary, who is
represented standing on the crescent
moon.

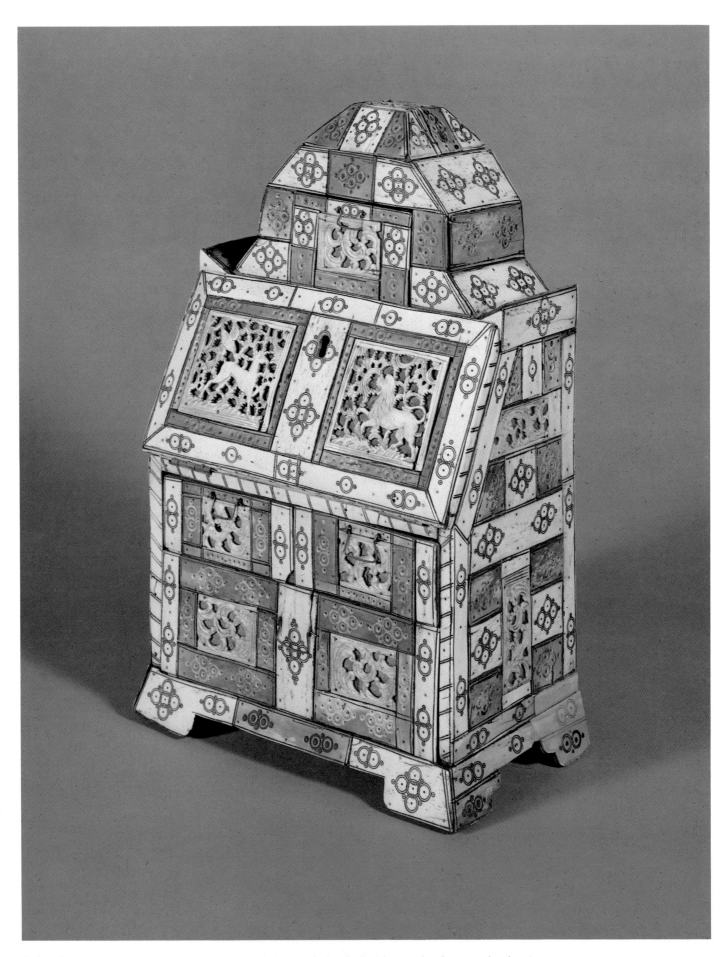

Colorplate 99 (cat. no. 491). Miniature writing desk, wood-sheathed with carved and engraved walrus ivory and bone, Russian (Kholmogory School), early 19th century. Incised plaques of walrus ivory and bone, some stained green, are attached to the wooden armature of this miniature writing desk, or *teremok* cabinet. In addition, twelve thicker plaques carved with rocaille floral motifs in the openwork technique typical of this north Russian school, have been set over mica sheets to enhance the ornamentation.

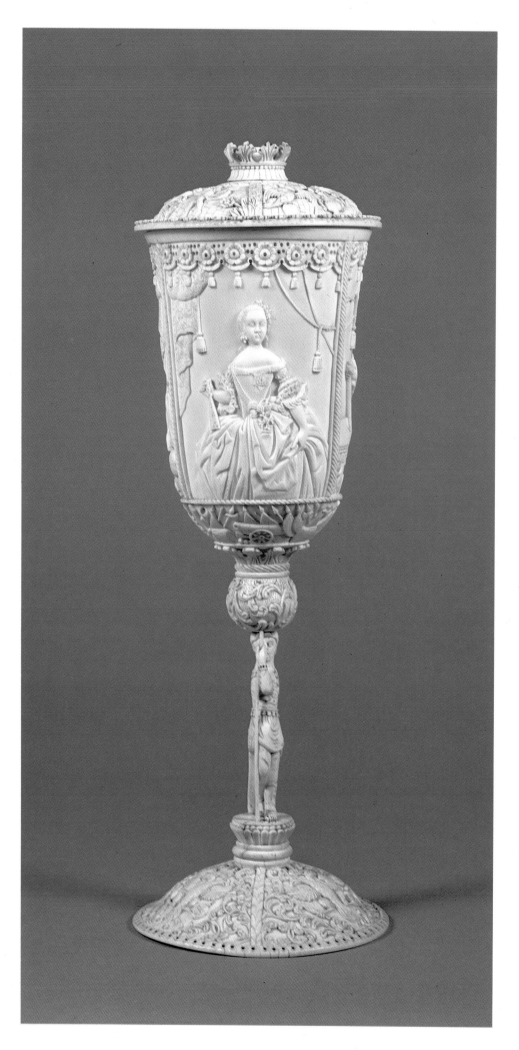

Colorplate 100 (cat. no. 488).
Covered *pokal*, mammoth ivory,
Russian (Kholmogory School), second
half 18th century. This cup is closely
related to work by one of the master
carvers of the Kholmogory School
in the eighteenth century, known
only by his monogram, AD. He
produced a number of *pokals* bearing
images of monarchs incorporated into
luxuriantly carved grounds. Catherine
the Great, the Empress Elizabeth,
and Peter III are portrayed in relief on
the cup of this *pokal*.

11 Later Ivories

by William R. Johnston

MOST SURVEYS of the history of ivory carving dismiss the post-Baroque era as one of decline or decadence. Not only was the supply of ivory limited, but other mediums, notably porcelain, wood, and silver, lent themselves more readily to the sequence of styles that marked the period. Furthermore, the capitals in which stylistic evolution was determined were often far removed from the locales where ivory carving prospered, among them Dieppe and Saint-Claude in France, Erbach and Geislingen in Germany, and Kholmogory in northern Russia. Despite these limitations, the working of ivory never ceased and at times even flourished, producing works of aesthetic significance and of interest to the history of taste.

French Ivories

The preponderance of French ivories in the Walters Art Gallery, a reflection of the founder's Francophile interests, belies ivory's relatively minor role in France after the Renaissance. Neither Louis XIV nor his successors during the *ancien régime* were recorded to have expressed a particular enthusiasm for the medium. The Parisian *ivoiriers*, or ivory workers, were never consolidated within their own guild but remained dispersed among a number of minor métiers: image-cutters, painters and makers of images, makers of escritoires, knife-handle makers, rosary-bead carvers, comb and lantern makers, and die cutters.[1] Apart from the continuing demand for religious images, especially crucifixes, the Parisian ivory carvers served a limited market, and their work echoed styles of the Lowlands set by such seventeenth-century masters as Gérard van Opstal, who, in fact, spent much of his career in France, and François Duquesnoy.

A center in France that proved to be an exception was Dieppe. According to tradition, the ivory trade in this Normandy coastal town can be traced to the year 1365, when a vessel returned from Guinea bearing a cargo of raw ivory.[2] Not until the seventeenth century, however, can a sustained commerce in the material be documented.[3]

As early as 1608, the royal physician, Héroard, presented to the Dauphin an ivory whistle as a souvenir of Dieppe.[4] Four years later, the future Louis XIII, who was evidently more attracted to ivory than were his successors, acquired a miniature table service from Dieppe with which he fed his pet monkey, and in 1617 he visited the town to purchase some ivory trinkets.[5] The English diarist John Evelyn, passing through Dieppe on Easter Monday in 1644, observed that the town abounded with workmen who made and sold curiosities of ivory and tortoiseshell.[6] In reviewing the lively production of the seventeenth century, the writer Ambroise Millet listed several categories of wares: statuettes, both secular and religious, *bénitiers*, or holy–water basins, portrait medallions, tobacco rasps, and shell-shaped boxes. Furthermore, he was able to identify a number of individuals involved in the ivory trade in the last quarter of the century. These included six merchants with open shops, as opposed to *marchands-merciers*; twelve sculptors; twenty *ivoiriers*; twenty-one turners; seven specialists in nautical instruments; and one engraver.[7]

Apart from occasional nautical instruments, tobacco rasps (cat. nos. 416 and 417), and statuettes (cat. no. 409; see colorplate 87), surprisingly few examples of this production have survived. Many works were undoubtedly lost during the economic crises resulting from the persecution and dispersal of the Protestants after the revocation of the Edict of Nantes in 1685, and more were destroyed in 1694 in a devastating bombardment of Dieppe by Anglo-Dutch naval forces.

After the town's reconstruction, the trade in ivories resumed. Much of the eighteenth-century commerce was in decorative and utilitarian wares. A prospectus for the shop of Antoine Belleteste listed every kind of curio in the medium:

> carved, engraved, fluted, fretworked cases; openwork snuff-boxes and other snuff-boxes worked in all manners; shuttles and bobbins for ladies; knives [cat. no. 415; see colorplate 88], ear-picks, baskets,

reels and trumpets; ordinary crucifixes and fine crucifixes of all sizes; figures of saints mounted on pedestals and other figures to decorate chimney-pieces; all sorts of fans cut and carved in every style; snuff-boxes with the customer's own arms or initials; beads and billiard balls, dice-boxes, backgammon-pieces, chess and domino sets; and in general everything that is made in ivory, bone or coconut, at reasonable prices.[8]

The carving of such artifacts was often executed with consummate skill, as is evinced in the openwork known as *ajouré*, or *mosaïque*, which resembles lace in its delicacy (cat. nos. 426 and 427). The motifs, however, were usu-ally not devised by the local craftsmen but were drawn from various sources, often prints, and were reused in different combinations over many years, thus complicat-ing the dating of the wares. Nevertheless, a few individuals distinguished themselves as sculptors. Among them were Antoine Belleteste's son, Jean-Antoine Belleteste, who produced statuettes of the Four Seasons for Marie-Antoinette's cabinet at Versailles; A. Lefebvre, who carved reliefs showing landscapes; and Jean Baptiste Croqueloi, who was noted for his crucifixes.[9]

Even before the French Revolution, however, there was evidently a decline in the Dieppe ivory trade. About 1775, Michel Claude Guibert observed "that there were only a few shops where one could still find good works; that the scarcity of wares and consequent mediocrity of recompense for labor resulted in a scarcity of the workers, who were becoming rare and despite their scarcity, were not well compensated."[10]

Elsewhere in France, the town of Saint-Claude, in the Jura, was long famous for its *tabletterie*, the manufacture of bibelots in exotic mediums such as rare woods, bone, shell, and ivory.[11] Among the sculptors of Saint-Claude to attain success were Joseph Villerme, who was eventually employed at the Gobelins workshops, and Jean-Claude-François-Joseph Rosset. Rosset, who is remembered for images of his friend Voltaire, was succeeded by three sons who also sculpted (cat. nos. 433 and 434).

In Paris and at Versailles, the achievements of the ce-ramic manufactories, both French and foreign, overshad-owed the efforts of the ivory carvers. Only the demand for religious images, a field for which the medium was particularly well suited, provided a continuing market.

Although the political upheavals and social turmoil in France in the late eighteenth century were not conducive to the production of the ornamental *objets de fantaisie* for which Dieppe was especially noted, the trade survived. Once peace was established following Napoleon's down-fall, the town again assumed a dominating role in commerce. By 1808, the Free School of Design was founded to revive the level of industry, and special courses in carving were offered under the direction of the ivory sculptor Marie-Joseph Flouest.[12] Equally important for the center's prosperity was its emergence as a fashionable bathing resort. Among the individuals most responsible for this development was Marie-Caroline, duchess of Berry. Accompanied by her own entourage and by members of her father-in-law's court, she traveled to the coast each season between 1824 and 1829 patronizing local arts and industries (see cat. no. 430).[13] An equally profitable market was created by the hordes of English tourists who were drawn to the beach and whose demand for souvenirs proved insatiable.[14] Numerous shops were opened in Dieppe, usually along the Grand' rue. By the mid-1800s, some, including that of the merchant-carver T. J. N. Blard, employed as many as forty workers. In addition, apprentices were trained. They were often drawn from the local orphanage and taught at the Free School of Design. Much of the work was performed during the off-season, the winter and spring, when the hotels were closed. The carvers received from two to twelve francs for a twelve-hour day. So profitable was this industry that by the 1860s offshoots had appeared in the nearby towns of Boulogne and Caen.[15]

Dieppe's production in the nineteenth century, while increasingly mechanized, remained varied. For example, the last member of the Belleteste family, Charles-Antoine, was noted for reliefs carved after nature and also made buttons. Ship models, which served as official gifts for state occasions, were a specialty in the early decades of the century. When Napoleon and Josephine first visited Dieppe on November 9, 1802, a group of women pre-sented the future empress with a model of a three-masted vessel with seventy-four cannons. Other recipients of ivory ships included empress Marie-Louise, Louis Philippe and his queen, the duchess of Berry, the dukes of Nemours and Joinville, and Napoleon III.[16] Several carvers, includ-ing Saillot and Mme. Binet, distinguished themselves for their realistically rendered sprays of flowers, often moss roses. Perhaps the chef-d'oeuvre in this naturalistic vein was an elaborate mirror frame commissioned in 1852 by the empress Eugénie from Carpentier Beauregard. Executed over a period of six years, the frame cost ten thousand francs. The pillars supporting the mirror were formed of ropework and chain and were encircled by floral wreaths of diminutive roses, lilies, hyacinths, tulips, and harebells, among which a spider had spun a web, all of ivory.[17]

Pierre-Adrien Graillon, who began his career as an ap-prentice to a shoemaker, was the only carver in Dieppe to attain national distinction. A municipal scholarship ena-bled him to train in Paris in the studio of David d'Angers, and he subsequently entered statuettes and reliefs of beggars, sailors, and fishwives in the 1849 Paris Salon. He was represented at the 1855 Exposition Universelle, winning the cross of the Legion of Honor. While these works were exceptional, most of the town's production —including articles such as crucifixes, reliefs for book covers, rosaries, vases, salad tongs, boxes, trays, and vari-ous bibelots—was more prosaic. In reviewing the exhib-its of French ivories at the 1855 Exposition Universelle in the section devoted to articles of clothing and *objets de mode et de fantaisie*, the official reporter noted that after

Figure 53. *The Curiosity Shop, Rome*, oil on canvas, English, second half 19th century, Sir William Fettes Douglas. In this historical genre scene, Douglas, a connoisseur as well as a painter, meticulously documents the variety of carved ivories available to the nineteenth-century collector. In the foreground, the dealer, dressed in eighteenth-century costume, proudly offers a carved-ivory oliphant for the observer's scrutiny. Other ivories figure prominently among the books, bronzes, and other antiquities displayed behind him. From left to right, these include: a colonial triptych featuring the Madonna, a Gothic plaque, a knife with a carved handle, and another figure, perhaps a Gothic Revival Madonna. Former collection of John Wordie. (After D. S. MacColl, *Nineteenth Century Art*, Glasgow, 1902.)

Paris, Dieppe excelled in the production of ivory sculpture.[18] Charles P. Magne, writing for *L'illustration*, was more critical: he observed that *l'ivoirerie*, the art of working in ivory, no longer existed and that Dieppe, dominant for so long, now possessed only one artist worthy of the appellation—Graillon.[19]

Dieppe continued to be a center for ivory until the end of the century, but as shopkeepers became attracted by less costly wares in celluloid and terra cotta, the production grew increasingly insipid. As late as 1908, however, one visitor remarked that there were still shops crammed with crucifixes, rosaries, and toilet articles, clustered around the entrance to the Casino.[20] A shop fitting the description is pictured in *The Curiosity Shop* of the late nineteenth century (figure 53).

Elsewhere in France, the workers in *tabletterie ordinaire* at Saint-Claude remained active, and another region, in the department of Oise, emerged as a center, specializing in fans. In 1859, M. Alphonse Baude of Saint-Geneviève introduced a device permitting the mechanical cutting of openwork. The invention was adopted in the nearby villages of Déluge, Méru, Crèvecoeur, and d'Andeville, and soon the workers of Oise were producing elaborate openwork fan sticks that compared favorably with those imported from China.[21]

In Paris during the nineteenth century a number of sculptors known for their work in more conventional mediums intermittently returned to ivory. Among them were Jean Jacques, J. J. Pradier, Jean Auguste Barre, and Henri de Triqueti. These carvers may have employed the medium in search of variegated surfaces or because they were drawn to its sensuous qualities, attributes that made the material particularly suitable for the suggestion of human flesh. Perhaps the most devoted sculptor in this regard was Augustin-Jean Moreau, listed after 1865 as Moreau-Vauthier. After training with his father, Jean-Louis Moreau, a *tablettier* known for his engine-turned ivories, Augustin-Jean pursued more formal training at the École des Beaux-Arts under Armand Toussaint. At the 1855 Exposition Universelle, the two Moreaus received a first-class medal for their entry in the "Twenty-sixth Class, Design and Ornament applied to Industry": an intricately ornamented, Renaissance-style coffer "worthy of being touched by royal hands."[22] The young Moreau's earliest independent entry in the Paris Salon was *The Three Theological Virtues* (cat. no. 438; see colorplate 89), a large composite group submitted in 1857. This work demonstrates the sculptor's mastery of the Gothic style, which, within the plurality of styles of the second half of the century, was to prevail for liturgical artifacts. Subsequently, Moreau-Vauthier worked in a number of historical styles, particularly those originating in the eighteenth century. He frequently participated in the annual Salons and occasionally in in-

ternational exhibits, entering works in bronze, terra cotta, marble, and plaster. After 1875, he resumed the carving of ivory, using it alone or in conjunction with other materials, notably silver and onyx. With his later ivories, often reductions of Salon entries in other mediums, Moreau-Vauthier provided his clientele with an attractive though costly alternative to the editions in bronze issued by so many of his colleagues. By the time of the Paris Exposition Universelle of 1889, Moreau-Vauthier had emerged as the undisputed master of this art, followed by a limited number of pupils and emulators, including Émile-Philippe Scailliet, Clovis Delacour, Henneguy, and Degoney.

Given its semiprecious nature, ivory carving also fell within the spheres of the silver- and goldsmiths and of the jewelers. A notable mid-nineteenth-century example of *orfèvrerie* in ivory was the *Reliquary of the Talisman of Charlemagne*. This masterpiece, which was praised at the Exposition Universelle of 1855, incorporated Romanesque-style ivory statuettes in a silver-and-glass architectural setting. Although signed by the silversmith François-Désiré Froment-Meurice, the reliquary was actually the creation of his follower Jules Wièse.[23]

Among the most ambitious sculptures of the century were those executed in chryselephantine by silversmiths working in collaboration with sculptors. Credit for the revival of the ancient Greek technique (*krusos*, gold; *elephas*, ivory), which combined precious metals with ivory, has been assigned to an enlightened connoisseur, Honoré d'Albert, duke of Luynes, the patron of such diverse talents as the painter Jean-Auguste-Dominique Ingres, the architect Charles Garnier, and the silversmiths Froment-Meurice, Henri Duponchel, and Fannière Frères.[24]

In 1846, the duke commissioned for the *salle des fêtes* of his château of Dampierre a reconstruction of the Athena Parthenos, Phidias' colossal statue in gold and ivory. Utilizing a model prepared by Pierre-Charles Simart, who in turn drew on ancient literary sources,[25] Duponchel completed the statue in five years, although it was not exhibited in public until the Paris Exposition Universelle of 1855.[26] The statue, which stood on a marble pedestal, was over nine feet high (figure 54). It was rendered in silver for the goddess's tunic and shield, bronze for her weapons and the serpent, and ivory for the areas of flesh: Athena's face, neck, arms, and feet; the Victory's torso; and the Medusa head on the shield. Slightly later, though in the same archaeologizing vein, the firm of Charles Christofle produced statues of the Muses Melpomene and Thalia for the atrium of Prince Napoleon's Maison Pompeienne on the Champs-Elysées. Gilded silver and ivory were used for the Muses, who actually bore the features of the prince's friends Mlle. Rachel and Mme. Arnoult-Plessy.[27]

The subsequent history of chryselephantine can be traced through exhibits of *orfèvrerie* at the international exhibitions. Among the highlights in Paris in 1878 were a clock, *L'Horloge d'Uranie*, with *orfèvrerie* ivory figures by Carrier-Belleuse and silversmithing by Glachant, exhibited by the firm of Lucien Falize,[28] and Charles Christofle's *Bibliothèque du Vatican*, a large cabinet made to contain the translations of the papal bull pertaining to the dogma of the Immaculate Conception, which was surmounted by a statue of the Virgin of Lourdes in ivory and repoussé silver.[29]

Two distinct approaches to working in chryselephantine emerged at the 1889 Exposition Universelle. In his statue of Pandora seated in *contrapposto* on a column, which was exhibited in the display of the jewelry firm of Vever, Léon Bottée adroitly overcame the limitations presented by the shape of the tusk by combining his materials and masking the seams with metal.[30] By contrast, Moreau-Vauthier, in his allegorical bust *Gallia*, worked with a piece of ivory of exceptional size and treated the metal mounts, prepared by M. E. Robert, as embellishments.[31] This additive approach is also apparent in Moreau-Vauthier's bust of *A Florentine Lady* in the Walters (cat. no. 439; see colorplate 90). Another highlight of the 1889 exhibition was a chryselephantine statuette of the Nereid Amphitrite, carved for the Christofle display by Émile-Philippe Scailliet, a pupil of Moreau-Vauthier. The figure had originally been designed in 1878 by Marius-Jean-Antonin Mercié as the centerpiece of a silver *surtout de table* commissioned from Christofle by the duke of Santonia. A replica of the 1889 version, differing from it only in that a block of jasper was used in place of the elaborate Renaissance-style base, was exhibited at the 1900 Exposition Universelle and subsequently purchased by Henry Walters (cat. no. 444; see colorplate 91).[32]

Related to nineteenth-century chryselephantine work, though a field in itself, was polychrome sculpture. Among the sculptors experimenting with polychromy toward the end of the century was Jean-Léon Gérôme. In 1890, Gérôme exhibited *Tanagra*, a marble sculpture that was colored with wax; three years later, he submitted to the Salon a large chryselephantine statue called *Bellona*, with head and limbs of tinted ivory which were actually carved by Moreau-Vauthier, and a cuirass of silvered and gilded bronze. This endeavor met with a mixed reception: the critic L. de Fourcaud cited its laborious archaism,[33] while another critic, Roger Marx, observed that its character was more bizarre than forceful.[34]

Another sculptor to explore polychromy was Louis-Ernest Barrias, who, like Gérôme, prepared a model in colored plaster which was subsequently translated into various mediums. One of Barrias' most renowned compositions, *Mysterious and Veiled Nature Reveals Herself before Science*, was presented in white marble at the Salon of 1893 and in a polychromy of colored marbles and Algerian onyx enhanced with precious stones at the 1899 Salon and again at the 1900 Exposition Universelle. Given this predilection for color, it is not surprising that Barrias should have collaborated with the silversmith Lucien Falize, entering into agreements with the foundries of Barbedienne and Susse Frères to issue edi-

Figure 54. Athena Parthenos, after Phidias, chryselephantine, French, 1851, Pierre-Charles Simart and Henri Duponchel. In 1846 the duke of Luynes commissioned a reconstruction of Phidias's colossal statue, the Athena Parthenos, for his château of Dampierre. Simart prepared the model, and Henri Duponchel, a silversmith, executed the project in ivory and silver. The completed work was widely acclaimed when first exhibited at the Paris Exposition Universelle of 1855.

Later in the century, a number of artists continued the practice of working in chryselephantine, a technique combining precious metals and ivory. (After H. Bouilhet, *L'Orfèvrerie française aux XVIIIᵉ et XIXᵉ siècles*, Paris, 1910.)

generations of the Graillon family of Dieppe. A feature of the exhibition was the number of works related to jewelry. Although ivory had been commonly employed for such objects as brooches and souvenir jewelry, prior to the nineteenth century it had seldom been used in conjunction with other precious and semiprecious materials. One of the reasons for the increased use of the material in such combinations was the widespread admiration in the 1890s for Japanese miniature carved ivories, an enthusiasm that led devotees to go so far as to mount netsukes on the handles of walking-sticks and parasols.[36] Henri Vever's survey of nineteenth-century *bijouterie* lists a number of designers who utilized ivory: the Houses of Vever and Gariod and the artists René Foy and Joe Descomps, to name a few.[37] Unquestionably the greatest master to exploit the medium's unique properties during this period was René Lalique (1860–1945), who first employed ivory in 1893–1894 on a pair of plaques mounted on a bookbinding for Richard Wagner's *La Walkyrie*.[38] Subsequently, Lalique was more innovative, carving miniature statuettes for his brooches and pendants (cat. no. 447; see colorplate 94). One of Lalique's most dramatic entries in the 1904 St. Louis World's Fair was a large orchid comb in which the blossom was rendered in ivory cut so fine as to be almost translucent (cat. no. 448; see colorplate 95).

German Ivories

In Germany, where the Baroque era extended far into the eighteenth century, the tradition of ivory carving centered around the Church, and the princely courts continued to thrive. Individual masters are too numerous to list and are not represented in the Walters; the range of their production can be suggested by mentioning several. Balthasar Permoser worked in Florence and Berlin before moving to Dresden, Saxony, to supervise the decoration of the Zwinger Palace. In addition to his large-scale statuary, Permoser produced in ivory a number of portrait medallions; the statuettes of *The Four Seasons*[39] in the Grünes Gewölbe, Dresden, carved in a particularly exuberant rococo style; and the monumental *Triumph of the Cross* in the Ratsbibliothek at Leipzig.[40] A more delicate, sensual rococo style was developed by Johann Cristoph Wolfgang von Lücke, whose early experience as a designer at the Meissen porcelain works is reflected in his enchanting *Sleeping Shepherdess* in the Bayerisches Nationalmuseum, Munich.[41] An altogether different tradition is evident in Simon Troger's figurative groups of Biblical and mythological personages, peasants and gypsies, carved in the mixed mediums of ivory and dark spruce wood.[42] The talents of Troger, a former shepherd and self-taught sculptor, had been recognized by Maximilian III, who summoned him to Munich. A more conservative approach prevailed at the court of the Landgrave Charles in Kassel, where the oeuvre of Jacob Dobbermann included reliefs illustrating biblical, mythological, and allegorical subjects drawn from engravings after the paint-

tions of his subjects in various mediums, including chryselephantine. Examples of this practice in the Walters Collection include an ivory-and-silver reduction of *The Young Girl of Bou-Saada* (cat. no. 446; see colorplate 92), after a composition first shown in bronze in the Salon of 1890, and a version in ivory and gilded and oxidized silver of *Mysterious and Veiled Nature Reveals Herself before Science* (cat. no. 445; see colorplate 93), both issued by Susse Frères.

French ivory carving at the turn of the century was seen in perspective at the Exposition de l'Ivoire held in the Musée Galliera in Paris in 1903.[35] Among the most noted artists in the exhibition were the recently deceased Moreau-Vauthier, represented by five works, including a version of the *Bacchante*; his pupil Scailliet; and two

ings of sixteenth- and seventeenth-century Venetian and Bolognese masters.[43]

In the course of the eighteenth century, attention at these German courts turned to porcelain, and in mid-century, with the Neoclassical emphasis on outline as opposed to carved internal decoration, ivory production began to wane. The working of the material might have ceased almost entirely but for the foresight of Count Francis I of Erbach-Erbach, who practiced turning as a hobby. Wishing to provide employment for the horn carvers and turners in the Odenwald, the count imported quantities of ivory and in 1783 founded the Guild of the Erbach Turners and Ivory Cutters.[44] He also served as the guild's first director. Having studied ancient art in Rome and London, Count Francis worked in a severe, Neoclassical style. This is reflected in his turned amphora with mask-handles (1788) and his undecorated round box, both preserved in the Elfenbein-Museum of Erbach.[45]

During the nineteenth century, carved and turned ivories were produced in quantity at such centers as Erbach, Geislingen, Dresden, Munich, Nuremberg, and Berlin. Among the products were jewelry, usually in the form of brooches with stag-hunting scenes incorporated into rococo settings; statuettes; and small portrait busts. In the second half of the century, innumerable *pokals* and steins carved in a range of medieval, Baroque, and rococo revival styles (cat. no. 454) were produced. At the International Exhibition held in London in 1851, the German entries included a Gothic pokal by Christian Frank of Fürth carved with scenes of the *Niebelungen Lied* after the paintings of Julius Schnorr von Carolsfeld;[46] a "rich vase by Heyl of Darmstadt; another goblet with bacchanals, by M. Hagen of Munich; and several specimens, including a large cup, by Geissmar & Co. of Wiesbaden."[47]

At the end of the century, the renewed interest in ivory sculpture, sparked by developments in France and Belgium, was apparent in Germany at the Kunst-gewerbeausstellung, held in Dresden in 1892. Featured in this exhibit were seductive statues of nymphs and maidens in ivory alone or in combination with various precious metals by such artists as H. Weisenfels and E. Herrlinger from Dresden, Otto Glenz, C. Gohrig, and Ph. Willmann from Erbach, and L. Barillot of Berlin.[48]

Other Centers

In the Lowlands, the tradition of ivory carving that produced such masters as François Duqesnoy, Gérard van Opstal, and Lucas Faid'herbe drew to a close at the end of the seventeenth century. Little of international significance was produced in the eighteenth century or during the first three-quarters of the nineteenth century. This situation, however, changed dramatically in 1885 when the Congo Free State (now Zaire) was declared a possession of Leopold II of the Belgians. With the encouragement of the monarch, Baron van Eetvelde, the secretary-general for the new state, sought to promote the commerce of the Congo by placing a supply of ivory at the disposal of Belgium's leading artists.[49] The results of this inducement were apparent at the Antwerp International Exhibition of 1894 and the Tervueren display, a section of the Brussels Exhibition of 1897. Highlights of the Brussels fair, a virtual manifesto for the renewal of sculpture in ivory, included *The Fairy of the Peacock*,[50] an elaborate work in ivory, silver gilt, opals, and enamels by the goldsmith Philippe Wolfers; two works in mixed mediums by Charles van der Stappen: *She Who Conquers Wrath* and *The Mysterious Sphinx*;[51] and the statuettes *Allegretto* and *Glory* by Julien Dillens.[52]

A distinctly Italian tradition of working in ivory cannot be isolated in the eighteenth and nineteenth centuries, although the art was intermittently practiced in several cities, particularly Naples. Recent scholarship has assigned to a Neapolitan workshop a number of multifigured religious compositions carved in a miniature tradition and formerly thought to be by the seventeenth-century Austrian carver Jacob Auer.[53] Charles III Bourbon of Naples, when not engaged in his primary pursuit, hunting, amused himself by turning ivories on a lathe presented to him by his cousin, Louis XV of France.[54] Following his arrival in Spain in 1759, Charles III summoned to his palace, Buen Retiro, the ivory carver Andrea Pozzi, who is remembered for his reliefs of classical subjects and for a portrait miniature in the Walters (cat. no 463).[55] Other sculptors in ivory recorded in eighteenth-century Italy are Giuseppe Forti,[56] a Sicilian who worked in Naples; Alberto Leoni, active in Venice about 1700;[57] and Giuseppe Maria Bonzanigo, a carver from Asti who specialized in miniature carvings of flowers, fruits, landscapes, and portrait medallions for the court at Turin.[58]

In Spain and Portugal after the Renaissance, ivory played a minor role in sculpture; in Valencia it was the preferred medium of members of the Capuz family, and in Buen Retiro it served as an alternative to porcelain for the manufacture of small articles.

Colonial Ivories

The situation differed in the Iberian colonies in Asia and the Pacific. On the west coast of India, Goa, seized for Portugal by Afonso de Albuquerque in 1510, emerged as an important center for commerce. Ivory carving by Indians in the service of the Church and religious orders has been recorded in Goa from early colonial times.[59] The production ranged from works of remarkable refinement to those in which the carving was perfunctory. Though individual styles are recognizable, Goan ivory carving remained an anonymous art with little readily discernible development. The range of subjects was restricted to a number of religious themes, the most frequently encountered being the Good Shepherd rockery (cat. no. 468; see colorplate 96). In these ivories, the youthful Christ is shown asleep on a mound above the Fountain of Life. At the base of the rockery rests the repentant Magdalen. Various explanations have been advanced for the reappearance in Goa of this motif, which had all but disap-

peared in Western art at the end of the Early Christian era. Josef Strzygowski interprets it as an adroit adaptation to Christian iconography, on the part of the missionaries, of the image of Yima, the Good Shepherd in the Zoroastrian religion practiced by the Parsees in the region.[60] Other subjects frequently found in Goan ivories include Mary in various roles (cat. no. 469; see colorplate 98), crucifixes, saints, particularly those associated with religious orders, and the Infant Christ, asleep or in the act of blessing.

Another center for the production of ivories of a hybrid Asian and European character was the Philippine Islands, secured in 1564 by the conquistador Miguel Lopez de Legaspi as the western boundary of Spain's New World empire.[61] The subsequent colonization of the islands was left to the friars, a factor reflected in the predominance of religion in early Hispano-Philippine culture.

A few European artists may have been present in the Philippines to provide requisites for the dissemination of the Faith. The church of San Augustin in Manila, for example, was built in 1614 by a nephew of the architect Juan de Herrera.[62] The friars, however, usually engaged artisans from among the Chinese residents known as the *sangleys*. As early as 1593, Huis das Demarinas, the governor of the islands, commissioned from a *sangley* a large statue of the Virgin, *La Naval*, with the face and hands of ivory, a material already esteemed for intrinsic value.[63] As tusks from both Asia and Africa became increasingly available, carried by sampans sailing to and from the port of Ormuz on the Persian Gulf, the practice of carving flourished. The products were intended not only for local use but were conveyed by the *naos de Acapulco*, the annual voyage between the Philippines and Mexico, to churches and religious houses in the Americas and the mother country.[64]

The Philippine carvings, as in Goa, were overwhelmingly religious in nature. Crucifixes predominated, followed by representations of the Virgin, shown alone or with the Christ Child. These varied in style, some approaching the images of the painter Murillo in their pious expressions, agitated draperies, and supports of cherubs' heads in clouds (cat. no. 475), and others approximating the Kuan Yins of Chinese art in their delicacy and restraint (cat. no. 474). Saints, especially those connected with religious orders, as well as the popular saints Michael, Joseph, and Sebastian, abounded, as did images of the Infant Jesus. The presence of the images of the Christ Child may result from the practice of maintaining individual altars in each convent cell. More complex representations of dogma were possible in relief carvings. Such carvings, usually in the form of triptychs, depicted Calvaries, Salvator Mundis, images associated with the Cult of Mary, and allegories of the Church.[65]

English Ivories

In England, in the eighteenth and nineteenth centuries, ivory carving was intermittently practiced, usually by artists from abroad or under Continental influence.[66] Two sculptors of French origin known for their portrait medallions cut in shallow relief were Jean Cavalier, who was briefly active in London in the 1680s, and David Le Marchand from Dieppe, who worked in England from 1674 until his death in 1726. In the second third of the eighteenth century, the dominant role in English sculpture of the Antwerp carver John Michael Rysbrack was reflected in ivories by two followers, Jacob Frans Verskovis, of whom little is now known,[67] and Alexander van der Hagen. To the latter have been attributed a number of busts and reliefs based on the statues of Rysbrack and others, including two medallions in high relief in the Walters: a bust of Sir Isaac Newton after Rysbrack (cat. no. 484) and one of Alexander Pope, after Louis-François Roubiliac's portrait of the poet (cat. no. 485; see colorplate 97).

In the nineteenth century, the replication of sculpture in ivory was often practiced with the aid of mechanical devices. One such machine, used by Benjamin Cheverton in his small-scale copies of busts by Roubiliac and F. L. Chantrey, is preserved in the Science Museum in London.[68]

The principal English sculptor to employ ivory in the mid-nineteenth century was Richard Cockle Lucas (1800–1883). He began his career carving knife-handles for his uncle, a cutler in Winchester, and later distinguished himself with wax models showing the Parthenon sculptures before and after the explosion of 1687. These wax models were acquired by the Trustees of the British Museum in 1875. Subsequently, Lucas entered carved ivories in some of the Royal Academy exhibitions and in the 1851 International Exhibition.[69] Also shown in 1851, as an example of the Elizabethan style, was a rustic ivory cup by a Mr. Hemphill of Clonmel, Ireland, carved with its handle and stem in the form of grapevines with supporting putti.[70]

At the turn of the twentieth century, renewed interest in ivory as a medium may have been sparked by the spate of entries from Continental sculptors in the Royal Academy exhibitions. In 1893 Jean-Léon Gérôme exhibited his controversial *Bellona* (no. 1826) in mixed mediums;[71] from 1895 to 1899 Alphonse van Beurden of Antwerp submitted ivory statues; and in 1896, 1901, and 1903,[72] the French artist Clovis Delacour showed his ivories.[73] Among the British artists to adopt the medium were George J. Frampton, who exhibited a bronze-and-ivory bust, *Lamia* (no. 1970), in 1900;[74] Alfred Gilbert, whose 1896 statue of *Saint George* (no. 1909) was of aluminum and ivory;[75] and Harry Bates, who in 1899 showed a group entitled *Mors janua vitae* (no. 2050) which featured a young girl in ivory representing Life and a figure in bronze representing Death.[76]

Russian Ivories

Although the northern European countries all developed regional schools of ivory carving, only that of Russia is represented in the Walters. In northern Russia, ivory and

bone carving flourished in the region of Kholmogory, on the Dvina River southeast of Archangel. Early Byzantine texts alluded to the practice of carving in this area as early as the twelfth century,[77] and by the middle of the seventeenth century the trade had grown to such proportions that Czar Alexis I Mikhailovich introduced a state monopoly.[78] Initially, the carving was a homecraft, practiced by the inhabitants of the area when they were not engaged in maritime and agricultural pursuits. As the trade developed, master craftsmen emerged, some of whom were summoned to Moscow to work in the shops of the Armory. This commerce reached its zenith in the eighteenth and early nineteenth centuries, when quantities of carvings were shipped through the port of Archangel to cities in the south and abroad. Among the products were carved utensils, pokals, scabbards, snuffboxes, tobacco rasps, etuis, and cane handles; various forms of coffers, chests, and small pieces of furniture in wood sheathed with ivory or bone (cat. no. 491; see colorplate 99); and, occasionally, statuettes. Walrus ivory, plentiful in the northern seas, mammoth tusks preserved by the Siberian permafrost, and the bones of domestic and wild animals were employed alone or in combinations. For additional variety, these materials were frequently tinted with natural dyes.

The artifacts tended to be simple in form and their decoration was conceived two-dimensionally, with an emphasis on relief carving, openwork, and incised patterns. A marked *horror vacuii* as well as an attention to fine detail were expressed in much of the work. In the course of the eighteenth century, stylistic developments became apparent. At the outset, the decoration was large in scale, with a preponderance of luxuriant foliage ornament, usually acanthus. Figurative scenes occurred, most notably biblical subjects and bestiary motifs. However, Czar Peter I, in a westernizing move, ordered that Daniel de La Feuille's *Symbols and Emblems* be published and distributed through the country. This work, which contained eight hundred and forty emblems, provided the native craftsmen with a wealth of humanistic motifs.[79] As the century progressed, the development was toward lighter and more restrained motifs, although color became increasingly important. During the second half of the century, the more cosmopolitan influence of St. Petersburg supplanted that of Moscow. The Kholmogory carvers perfected their openwork, executing scrolls and

acanthus leaves of remarkable delicacy and intricacy. Portrait reliefs were introduced, usually of the monarchs and their families, based on coins, medals, or prints (cat. no. 488; see colorplate 100). Among the artists to distinguish themselves were Osip Khristoforovich Dudin, who was drawn in 1757 to St. Petersburg, where he advertised his chessmen, snuffboxes, handles for teapots and coffeepots, caskets, cabinets, canes, and bishops' staffs,[80] and Nikolai Stephanovich Vereshchagin, who resided in Archangel, serving as a customs official as well as a master craftsman.[81] Vereshchagin created the oval vases known as *The Seasons of the Year*, which, in their classical shapes and extraordinarily finely carved decoration, represent the apogee of north Russian bonework. Intended as gifts for the emperor of Japan, they were returned to St. Petersburg between 1803 and 1806 when the diplomatic mission failed, and were placed in the Hermitage.[82]

In the early nineteenth century, the Neoclassical and Empire styles prevailed. Openwork carving was still used in conjunction with classical motifs in relief; however, it was often of a dry, reticulate nature. Throughout the nineteenth century, ivory and bone carving continued to be practiced in Russia, though its distinctive regional character was lost.

The Twentieth Century

In France and Belgium following the turn of the century, experiments with ivory, used alone or in combination with various metals, were revived. The most notable examples in France in the early thirties were the chryselephantine statues of Demetre H. Chiparus and his followers. The milky whiteness of ivory provided an attractive foil for the vibrant colors characteristic of the international Art Deco movement. In furniture, for example, ivory inlays were set against Macassar ebony and shagreen in the work of Émile-Jacques Ruhlmann. Since this period, though one can cite isolated examples of the use of the medium by individual artists in several countries,[83] it has become difficult to distinguish regional or national characteristics.

The ever-diminishing supply of tusks, and conservationists' justified concern for the survival of elephants and sea-mammals, the sources of ivory, have finally brought to a close a chapter in the history of Western art that can be traced for over five thousand years.

NOTES

1. H. Havard, *Dictionnaire de l'ameublement et de la décoration depuis le xiii⁰ siècle jusqu'à nos jours*, II, Paris, 1887–1890, 59, lists the seven corps of ivory workers: *ymagiers-tailleurs; paintres et ymagiers de Paris; fabricants de tables à escrire; couteliers faiseurs de manches; patenostriers faiseurs de noyaux à robes; pingniers et lanterniers de Paris; and déiciers.*

2. Villault de Bellefond, *Relation des costes d'Afrique appelées Guinée*, Paris, 1669, 409–

438, discusses the visit of two ships from Dieppe to the African coast in 1364. A center, Petit Dieppe, reportedly founded at that time, was not abandoned until about 1410. Villault de Bellefond claimed that he located traces of the French settlement on the African coast during his voyage to the area in 1666–1667.

3. D. Asseline, *Les antiquitez et chroniques de la ville de Dieppe*, Dieppe, 1682 (reprint, 1884), 316, recorded the return of the ship

Saint Louys from Madagascar on Oct. 7, 1660, with a cargo of gums, hide, feathers, amber, gold, live animals, and ivory.

4. A. Millet, *Anciennes industries scientifiques et artistiques Dieppoises*, Dieppe, 1904, 31.

5. Ibid., 32.

6. J. Evelyn, *Diary and Correspondence*, I, ed. W. Bray, 4 vols., London, 1862, 65.

7. Millet, op. cit., 33–34.

8. P. Bazin, *L'Ivoire et Dieppe*, Dieppe, 1981, 11.

9. S. Lami, *Dictionnaire des sculpteurs de l'école française*, I, Paris, 1910, 53–54; Tardy, 188–189, ill.; and Millet, op. cit., 40.

10. *Il reste encor quelques boutiques où se trouvent de bons ouvrages; mais le peu de vente et par conséquent la modicité de la récompense de travail fait manquer les bons ouvriers qui deviennent rares et qui, malgré leur rareté, n'en sont pas mieux payez. Ce commerce a toujours été libre et n'est assujeti à aucune maîtrise.*

in M. C. Guibert, *Mémoires pour servir à l'histoire de la ville de Dieppe*, notes by Michel Hardy, Dieppe, 1878, 220.

11. P. Benoit, *Histoire de l'abbaye et de la terre de Saint-Claude*, II, Montreuil-sur-Mer, 1882, 805–806.

12. Millet, op. cit., 43.

13. M. L. Vitet, *Histoire des anciennes villes de France, Haute-Normandie*, Paris, 1833, 249.

14. Ibid., 246.

15. "Ivory Carvings at Dieppe," *Once a Week, an Illustrated Miscellany*, June-Dec. 1862, 415–416.

16. Ibid., 417.

17. Ibid.

18. *Visites et études de S. A. I. Le Prince Napoléon au palais de l'industrie, Guide pratique et complet à l'Exposition Universelle de 1855*, Paris, 1855, 357.

19. C. P. Magne, "Ivoirerie," *L'Illustration*, II, 1855, 262.

20. O. M. Rae, "Old Dieppe Ivories," *Connoisseur*, XXI, 1908, 160.

21. L. Knab, "L'Ivoire," *La Grande Encyclopédie*, XX, Tours, 1886–1902, 1142.

22. L. N. Barbier, *Esquisse historique de l'ivoirerie*, Paris, 1857, 70.

23. This work and a tankard in ivory, silver, turquoises, and rubies by the silversmith Frédéric-Jules Rudolphi (now in the Bethnal Green Museum, London), are discussed in *The Second Empire, Art in France under Napoleon III*, Philadelphia Museum of Art, Philadelphia, 1978, nos. III–14, III–11.

24. H. Bouilhet, *L'Orfèvrerie française aux XVIIIe et XIXe siècles*, II, Paris, 1910, 251.

25. Pausanias, *Description of Greece* 1.24.5; Pliny, *Natural History* 36.18; Plutarch, *Pericles* 31.

26. Exposition Universelle, Paris, 1855, no. 4574; a plaster model of the statue is preserved in the Musée des Beaux Arts, Troyes, and a model of the shield is in the Musée des Beaux Arts, Angers. The statue itself is illustrated in Bouilhet, op. cit., II, 262.

27. Bouilhet, op. cit., 286, ill., 290.

28. Ibid., 142, ill., 139.

29. Ibid., III, 147–148, ill., 152.

30. Tardy, 200.

31. A Valabrèque, "L'Ivoire à l'exposition universelle de 1889," *Révue des arts décoratifs*, X, 1889/90, 383. *Gallia* was exhibited in the display of Bapst and Falize.

32. Bouilhet, op. cit., III, 246; the 1878 *surtout* is illustrated on 147 and the 1889 version on 251.

33. "Une Bellone d'un archaisme laborieux," in L. de Fourcaud, "Le Salon," *Revue des arts décoratifs*, 1891/92, 389–390.

34. ". . . la force, la grandeur manquent à la statue de Gérôme, elle a plus d'étrangeté que de puissance," in R. Marx, *Revue encyclopédique*, Paris, 1892, 1492.

35. "Exposition de l'ivoire," Musée Galliera, Paris, June–Oct. 1903, L. Roger-Miles, *Rapport général*, Paris, 1904. Most of the works in this exhibition were lent by E. F. Corroyer, who, in addition to collecting medieval ivories, patronized the practitioners of chryselephantine work. His influence on contemporary sculpture was considered decisive at the time.

36. Valabrèque, op. cit., 388.

37. H. Vever, *La bijouterie française au XIXe siècle*, III, Paris, 1906/8, 669 (ill.); 618 (ill.); 645 (ill.); 622 (ill.).

38. S. Barten, *Schmuck und Objets d'art, 1890–1910*, Munich, 1977, 559, no. 1756: Bucheinband, "La Walkyrie," c. 1893/4.

39. C. Scherer, *Elfenbeinplastik seit der Renaissance;* Leipzig, 1902, 85–86, figs. 56 and 57.

40. O. Beigbeder, *Ivory*, 1965, 105, figs. 102 and 103.

41. Scherer, op. cit., 91, fig. 75.

42. Ibid., 67–68, figs. 56 and 57.

43. O. Pelka, *Elfenbein*, Berlin, 1923, 280–284, figs. 201–204.

44. *Elfenbeinkunst des 19. und 20. Jahrhunderts*, Elfenbein-Museum der Stadt Erbach im Odenwald, Erbach, Oct.–Nov. 1971, no. 5.

45. Ibid., nos. 127 and 117.

46. *The Industry of All Nations, The Art Journal, Illustrated Catalogue*, London, 1851, 40, ill.

47. Ibid., XVXXX.

48. *Elfenbeinkunst des 19. und 20. Jahrhunderts*, Elfenbein-Museum der Stadt Erbach im Odenwald, Erbach, Oct.–Nov. 1971, no. 38.

49. A. Maskell, *Ivories*, New York and London, 1905, 399–400.

50. Tardy, 204, ill.

51. Scherer, op. cit., 130–131, figs. 112 and 113.

52. Ibid., 128, figs. 108 and 109.

53. See *Civiltà del '700 a Napoli, 1734–1799*, II, Dec. 1979–Oct. 1980, Florence, 1980, 265, no. 542. The original attribution of these masks to Jacob Auer was made by Berliner, no. 440. However, in the State Art Collections, Dresden, there is a *Fall of Lucifer* which is recorded as having been sent from Naples by Maria Amalia to her father, the Elector Friedrich August II.

54. A letter written by Luigi Vanvitelli dated Dec. 11, 1751, is cited in *Civiltà del '700 a Napoli, 1734–1799*, II, Dec. 1979–Oct. 1980, Florence, 1980, 85.

55. Ibid., 264.

56. Ibid., 86.

57. Tardy, 267.

58. Tardy, 257.

59. For discussions of Goan ivories, see M. McCully, "The Indo-Portuguese Ivory Crucifix in the Yale University Art Gallery," *Yale University Bulletin*, XXXIV, Nov. 1972, 4–9, and D. D. Egbert, "Baroque Ivories in the Museo Cristiano of the Vatican Library," *Art Studies, Medieval, Renaissance, and Modern*, VIII, Cambridge, 1931, part 2, 35–45. McCully, 6, n. 9 cites a letter from Dr. Trois Johnson mentioning the ongoing practice of carving ivories in the village of Ribandar, Goa.

60. J. Strzygowski, *Origin of Christian Church Art*, trans. O. M. Dalton and H. J. Braunholtz, Oxford, 1923, 122, 158.

61. For Philippine ivories, see M. E. Marcos, "Virgenes de marfil hispanofilipinas," *Archivo Español de arte*, XL, no. 160 (1967), 333–358; "Algunos relieves en marfil hispanofilipinos y sus posibles fuentes de inspiración," *Archivo Español de arte*, XLIII, 1970, 151–179; *Marfiles Hispano-Filipinos en las colecciones particulares*, Instituto de Cultura Hispanica, Madrid, Oct.–Dec. 1972; hereafter referred to as Marcos 1967, Marcos 1970, and Marcos 1972.

62. Marcos 1972, 6.

63. Ibid.

64. Marcos 1967, 335, n. 7 and 8.

65. Marcos 1970, 151–179.

66. M. H. Longhurst, *English Ivories*, London, 1926, 59–61.

67. H. Walpole in *Anecdotes of Painting in England*, III, ed. R. N. Wornum, London, 1862, 761, alludes to several works said to be by Verskovis after Rysbrack, a view that was rejected by Longhurst, op. cit., 60.

68. Longhurst, II, 119.

69. R. Gunnis, *Dictionary of British Sculptors 1660–1851*, London, 1953, 244–245.

70. *The Industry of All Nations, The Art Journal Illustrated Catalogue*, London, 1851, 21.

71. A. Graves, *The Royal Academy of Arts*, III, London, 1905, 226.

72. Ibid., VIII, 68.

73. Ibid., II, 295.

74. Ibid., III, 156.

75. Ibid., III, 233.

76. Ibid., I, 141.

77. L. Sviontkovsky-Voronovoi, *Carved Bone from the Collection of P. Schukin in the Russian Historical Museum* (in Russian), Moscow, 1923, 7. A Byzantine author, Tzetzes, is cited.

78. K. V. H. Taylor, "Russian Ivories at Hillwood, Washington, D.C.," *Antiques*, CXIX, June 1981, 1358.

79. Ibid., 1360.

80. I. N. Ukhanov, *North-Russian Carved Bone of the 18th to the Beginning of the 19th Century* (in Russian, typescript in English in Walters Art Gallery Library), Leningrad, 1969, 6–7; 32–35.

81. Ibid., 7, 35–37.

82. Ibid., 3–32.

83. Shown in the exhibition *Elfenbeinkunst des 19. und 20. Jahrhunderts*, at the Elfenbein-Museum, Erbach, Oct.–Nov. 1971, were examples of ivory sculpture by such twentieth-century artists as Oswald Ammersbach, Wilhelm Wegel, and Karl Schmidt-Rottluff. The last, one of the founders of the Brücke movement at the beginning of the century, turned increasingly to ivory in the 1940s and 1950s.

Catalogue, Later Ivories

406. SAINT JOSEPH(?)

Ivory statuette. French (Dieppe?), early 18th century

The bearded figure is lean and barefooted. He turns slightly to the right with a reverent gaze. The pose suggests that the statuette, perhaps Saint Joseph or an Apostle, was part of a sculptural group.

H: 6¼" (15.9cm) 71.349

HISTORY: Purchased before 1931.

407. VIRGIN AND CHILD

Ivory statuette. French, 18th century

The Virgin, holding the Christ Child in her left arm, stands on a crescent moon. The folds of her voluminous drapery accentuate the gesture of her raised hand and the gentle *contrapposto* of her body. This statuette appears to be a late provincial adaptation of a sixteenth-century prototype. The Virgin's crown and the cross from the orb which Christ carries in his right hand are missing. The Virgin's right hand is carved separately.

H: 6¾" (17.3cm) 71.363

HISTORY: Purchased from Léon Gruel, Paris, before 1931.

408. VIRGIN AND CHILD

Ivory statuette. French (Dieppe), late 18th century

The Madonna stands on a wooden plinth with curving, ivory-veneered sides. She wears a crown over a mantle, holds lilies in her right hand, and gestures toward the Child, whom she carries in the crook of her arm. Christ's left hand rests on an orb which has lost its cross; his right hand is missing. One of the eight fleurons from the Virgin's crown has been broken, and her right hand is restored; her lilies and crown are separate pieces.

H (with base): 9½" (24.3cm) 71.318
H (figure alone): 6¾" (17.2cm)

HISTORY: Purchased before 1931.

409. VIRGIN AND CHILD TREADING ON A SERPENT

Ivory statuette. French (Dieppe), first quarter 19th century

Mary stands holding the Christ Child, who reaches up to embrace her. The Madonna's right foot protrudes from beneath her copious drapery, while her left foot rests on the head of a serpent, whose body spirals in front of her. The group is mounted on a rectangular plinth, with curved sides veneered in ivory. On the front is affixed the monogram MA, surmounted by a sphere and cross. The motif of the Madonna treading on a serpent occurred frequently during the seventeenth century, when the serpent represented heresy. In this context, Mary, as the new Eve, conquers the serpent. The Virgin's neck and right foot have been restored. Christ's left forearm and hand are separate pieces.

H: 6⅝" (16.9cm) 71.468

HISTORY: Purchased before 1931.

See also colorplate 87

410. VIRGIN AND CHILD

Ivory statuette. French, 19th century(?)

The Virgin holds the Christ Child with her right hand and gestures toward him with her left. He rests one elbow on his mother's shoulder and extends his hand. The figure of the Madonna is elongated, and the relationship between her left leg and foot is distorted. There is heavy crackling on the front surface; the back is only summarily carved. The Virgin's left hand and the Child's right hand and foot are restored; her head is flattened to accommodate a crown, which has been lost.

H: 6⅜" (16.3cm) 71.469

HISTORY: Purchased before 1931.

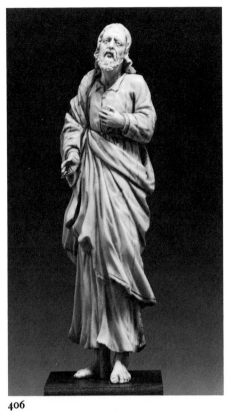

406

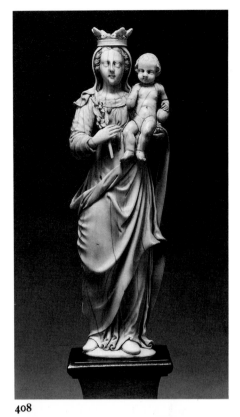

408

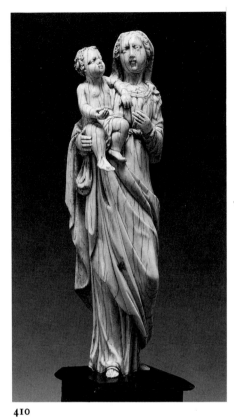

410

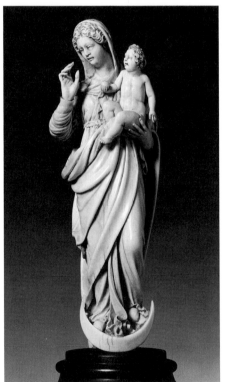

407

409

411,412. SAINT CATHERINE OF ALEXANDRIA and SAINT PETER

Ivory statuettes. French, 19th century

Saint Catherine (cat. no. 411) stands with her left hand raised. Her right hand is extended downward and has been drilled, probably to accommodate a lost attribute. She wears a crown and a pearl necklace; next to her right leg a portion of her spiked wheel can be seen. Although she bears an affinity to an ivory Saint Catherine in the British Museum identified as Flemish, late sixteenth century (Dalton, no. 476), her bodice, with its scalloped edge, is more reminiscent of the fanciful medievalizing of the nineteenth-century troubadour style. Several barbs are missing from the wheel, and her crown is severely chipped. She is missing the fifth finger on her left hand and part of her left foot. Her head has been reattached.

The balding Saint Peter (cat. no. 412) stands with his weight on his left leg; his right leg is slightly bent, and his head is turned sharply to his left. He holds a book and carries his attribute, the key. His proud posture is matched by an intense facial expression.

Saint Catherine. H: 6½″ (16.5cm) 71.467
Saint Peter. H: 6½″ (16.5cm) 71.466

HISTORY: Both purchased before 1931.

413. FIGURE FROM A CRUCIFIX

Ivory statuette. French, mid-18th century

The body of Christ, attached by three nails, falls slightly to the left. His head is raised and also turned to the left. The eyes are directed heavenward, and the mouth falls open, exposing the teeth and the tongue. A double cord supports the loincloth, which is gathered at the right.

The sculptor has treated the anatomy of the torso and the limbs with exceptional grace and subtlety.

H: 7⅝″ (19.2cm) 71.481

HISTORY: Purchased before 1931; when purchased, the figure was accompanied by an Adam's skull and a *titulus*.

414. CRUCIFIX

Ivory figure on a cross of black velvet mounted against a blue velvet ground. French, late 19th century

The figure of Christ is fastened to the Cross by blackened nails driven into the hands and feet. Christ's head is tilted and turned somewhat to the left, the same direction in which the body falls. The loincloth is knotted on the right, and a swag is looped to cover the groin. Above is the *titulus*, with the inscription INRI; below is an Adam's skull and one tibia.

The general composition suggests an eighteenth-century prototype, whereas such traits as the slight body, the restrained, sentimental facial expression, and the superficial treatment of the lance wound indicate a late-nineteenth-century date.

Figure. H: 5⁹⁄₁₆″ (14.0cm) 71.482
Cross. H: 15¾″ (40.0cm)

HISTORY: Purchased before 1931.

415. CHILDREN WITH FRUIT

Ivory knife and fork handles with silver, silver gilt, and steel. French (Dieppe?), early 18th century

On each handle, a nude boy holding a swag of drapery in one hand and supporting an osier basket of fruit on his shoulders with the other, stands on a base composed of a circular arrangement of peapods. A laurel chain is suspended over each youth's shoulders.

The three-tined fork of silver gilt is engraved with formal leaf patterns. The knife blade is of plain steel and is stamped: C RIED.

Although figures bearing baskets of fruit occur on handles of Flemish and Italian utensils of the second half of the seventeenth century, an early-eighteenth-century French origin is proposed for these pieces on the basis of their delicately contrived and executed design.

Fork. L: 6⅞″ (17.4cm); Fork handle. L: 2⅝″ (6.7cm) 71.366
Knife. L: 7¾″ (19.8cm); Knife handle. L: 2¾″ (6.9cm) 71.367

HISTORY: Purchased from Léon Gruel, Paris, 1929.

See also colorplate 88

416. PILGRIMS OF CYTHERA

Ivory tobacco grater, stained brown. French (Dieppe), c. 1725

This panel for a tobacco grater is divided into two zones by a fluted band. The upper zone shows a couple of pilgrims of love in fashionable attire being conducted by Cupid to the seashore, where they will embark for the Isle of Cythera. The lady carries a staff and a cockleshell. Pinned to her bodice is a heart pierced by two arrows. Her companion holds a flask. On the flaps of his cape are emblems of love: crossed torches and hearts. In the background are several trees with carefully rendered foliage, and, near the horizon, two boats. The source for the composition is probably Bernard Picart's well-known engraving of 1780, *Pèlerins de l'isle de Cythère*. The lower zone of the panel is decorated with a scallop shell, above which is a satyr's mask crowned and surrounded with grapevines.

At the top of the panel are the remnants of a small shell that originally served for spooning the snuff. Along the jagged edge of the bottom is a screw-hole for the attachment of a small ivory box for grated snuff. On the concave back are the channels of the rasp plate, a supporting flange, and a receptacle, which are missing.

The *Embarkation for Cythera* scene, shown in reverse and differing in details, appears on tobacco graters in the Museum für Kunst und Gewerbe, Hamburg (no. 159), and the Musée de Dieppe.

H: 7¾″ (19.6cm) 71.346

HISTORY: Purchased in Paris, 1925.

See also colorplate 86

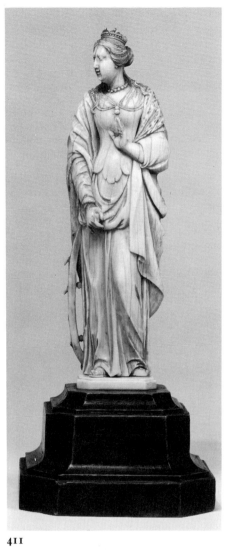

411

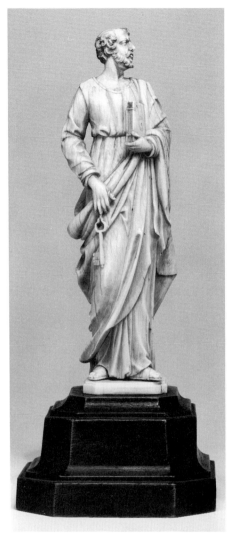

412

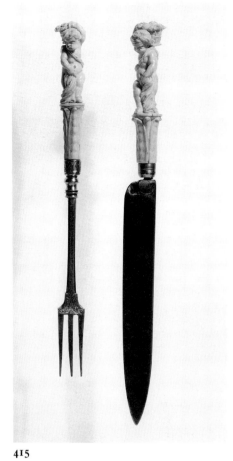

415

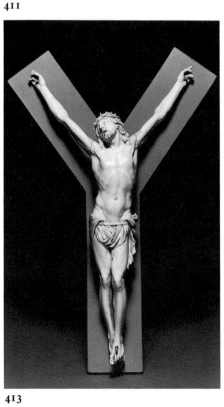

413

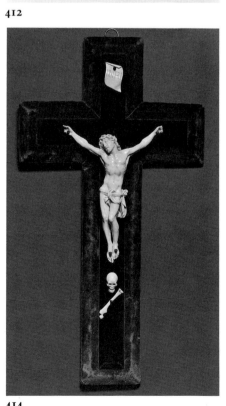

414

416

417. TREE OF JESSE

Ivory tobacco grater. French, mid-18th century

The face of the grater is carved in low relief with the Tree of Jesse, illustrating the descent of Christ from the royal line of David. Jesse reclines asleep amid the roots of the tree. Flanking the trunk are two winged putti representing Virtues. One, on the left, bears scales and a trumpet, and the other, on the right, holds a cornucopia and a sword. Above the bifurcation of the trunk, the Virgin, holding the Infant Christ, stands on the crescent moon. Two adoring cherubs kneel on boughs at the Virgin's feet; cherubs holding the crown hover overhead. The kings are placed among leafy branches. Nine of them hold scepters, while the tenth, David, plays his harp. At the top hovers the dove of the Holy Ghost, flanked by the sun and the moon. Incised and blackened on scrolls at the top and bottom is the inscription: LAPURTE FAIT MON ESTIME DE GLOIRE ET D'HONNEUR LE CIEL MEN VIRONNE (*I esteem purity; the sky surrounds me with glory and honor*).

The concave reverse of the grater is grooved and fitted with a central flange to accommodate a metal grate. Inscribed on the edge of the reverse is: JE SVIS CETTE RASPE CVRIEVZE DE QVI CHACHVN. EST AMOVREVEX. ON MEFLERE LON MECARESSE ET SOVENT JE SERS DE DIVERTISEMENT ENTRE LES MAINS DE MON MESTRE (*I am this curious rasp of whom everyone is enamored. One sniffs me, one caresses me, and often I am a pleasure in the hands of my owner*).

This tobacco grater differs in form from those associated with Dieppe in that it lacks a compartment to collect the grated snuff. Inscribed in ink on the reverse are two ciphers: A 185/BA and W 247c 99c. There is also a paper label bearing the number 154.

L: 7¾″ (19.6cm) 71.328

HISTORY: Purchased from an unknown source, Paris, 1924.

See also colorplate 86

418. BUCOLIC SCENE

Ivory fan sticks, painted paper leaf. French(?), early 18th century

The ivory fan sticks are carved with stylized trellises bearing grapes. On the upper portions of the end sticks, monster heads devour fruit. Coloring and gilding have been applied to complement the painted decoration of the paper fan leaf. The studs are amethyst-colored pastes.

On the obverse of the fan leaf is a bucolic classical scene in which a cupid hovering overhead shoots his arrow at a young woman. She is seated beside an altar and gazes at a young man who stands before it. Behind, a helmeted figure rests an elbow on the altar; at the right are two women, one reclining with a bird in her hand and the other balancing a pannier of flowers on her head and carrying a basket under her arm. On the reverse is a pastoral scene in which a woman in peasant attire summons her dog.

L: 9⅞″ (25.1cm) × W: 16¼″ (41.2cm)
86.10

HISTORY: Purchased before 1931.

419. ANIMAL SUBJECTS

Ivory hunting-dog whistle. French, mid-18th century

On the upper surface of the whistle are a pair of billing doves against a background of rays. Below the pair is a trophy of love composed of crossed quivers of arrows and an oval shield emblazoned with a burning heart. The lower surface shows a spaniel surprising a swan amid rushes, and an overturned urn. The whistle terminates in a leaf scroll.

The characteristic rococo motifs and form indicate a mid-eighteenth-century date.

L: 3⁷⁄₁₆″ (8.7cm) 71.395

HISTORY: Purchased before 1931.

420. PORTRAIT OF AN UNKNOWN MAN

Ivory medallion. French, 1680–1707. Attributed to Jean Cavalier (active 1680–1707)

The sitter is shown in right profile. The curls of his flowing wig extend down his back and over his left shoulder. He wears elaborate parade armor of Renaissance inspiration: the breastplate and pauldron are embossed with masks. Elaborate floral patterns cover the intervening stippled surface. The edge has been trimmed.

The carving is attributed to Jean Cavalier, a Huguenot who worked in London from 1680 to 1689 and in other European cities, including Cassel, Copenhagen, Stockholm, and Moscow, prior to 1707 (A. Julius, *Jean Cavalier*, Uppsala, 1926, 96 ff.). The decoration of the pauldron resembles the armor in a portrait of Louis XIV ascribed to Cavalier (Volbach, pl. 77, no. 742). The shallow carving is particularly close to Cavalier's 1693 portrait of Uldrick F. Guldenlew in the Victoria and Albert Museum, London (Longhurst II, 78, no. A4-1928). The Walters portrait is described in the sale catalogue of the Robert Napier Collection (lot 2108) as "portrait of a prince... supposed to be Peter the Great." Inscribed on the reverse is the modern notation: "Peter the Great/no. 1027/Napier collect."

H (oval): 3⅛″ (7.7cm) × W: 2½″ (6.2cm)
71.480

HISTORY: Robert Napier, West Shandon (near Glasgow); purchased at the Shandon Collection sale (Christie's, London, May 17, 1877, lot 2108).

421. PASTORAL SCENE

Ivory bonbonnière. French (Dieppe), 1730–1750

Both the lid and container of this bonbonnière, or sweet-meat container, have central, circular fields and radiating panels carved in relief. On the cover, a seated nude woman caresses a dog; on the container itself, a shepherd holding a crook pats his dog. The shallowly and rather summarily rendered radiating panels show vignettes with shepherds, shepherdesses, watchdogs, and sheep. A narrow frieze running around the side of the container illustrates a boar hunt.

The two sections of the bonbonnière are attached by a gilt-metal hinge. A hole in the rim opposite the hinge indicates that the box may also have had a metal clasp.

In his pamphlet *Le château-musée de Dieppe*, Paris, 1972, 9, Pierre Bazin illustrates a bonbonnière with a similar division of relief ornament and carving.

Incised and blackened in the inside of the container is an owner's monogram, MT. The cover bears a paper label: MACKAY & CHISHOLM/GOLDSMITHS./57 Princess Street/EDINBURGH.

D: 2⅝″ (6.4cm) × H: 1¾″ (4.4cm)
71.449

HISTORY: Purchased before 1931.

422. MARINE SUBJECTS

Ivory bonbonnière. French (Dieppe?), 1730–1750

This container for sweets and its tight-fitting cover are each subdivided by spiral gadroons into five panels containing sea monsters, dolphins, shells, and plants, carved in shallow relief against a crosshatched ground. In the center of the lid is a circular field with birds, and, on the exterior of the container, a field of fishes, crustaceans, and shells.

On the interior is the paper label: MACKAY & CHISHOLM/GOLDSMITHS./57 Princess Street/EDINBURGH.

D: 2⅝″ (6.7cm) × H: 1½″ (3.8cm)
71.443

HISTORY: Purchased before 1931.

423. PASTORAL SCENES

Ivory bonbonnière. French, 1750–1770

This cylindrical bonbonnière is composed of a convex cover hinged to a container with concave sides and a convex bottom. On the lid a shepherd embraces a seated shepherdess in a wooded landscape. The reverse of the container shows the shepherd leaning against a tree as he addresses a girl who is seated at the foot of a ruined wall. Around the rim are carved musical and pastoral trophies alternating with sheep and sleeping dogs.

There is a circular paper label inscribed in ink: 14467/9399; and a rectangular label: 171.

D: 2¼″ (7.0cm) × H: 1⅝″ (4.2cm)
71.410

HISTORY: Purchased before 1931.

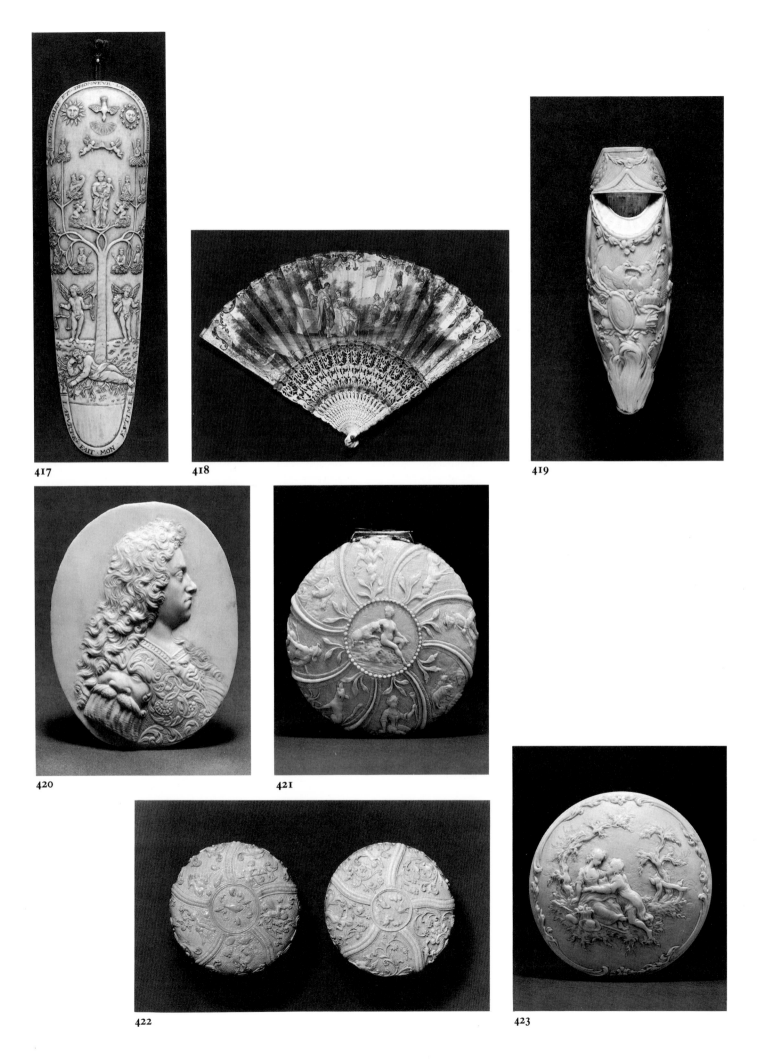

417

418

419

420

421

422

423

424. PASTORAL SCENES

Ivory bonbonnière. French, 1760s

This cylindrical box is decorated on its flat cover and bottom with delicately carved pastoral vignettes. The lid shows two woodland nymphs, one leaning against a tree and the other reclining, her arm resting on an overturned urn from which water issues. On the bottom panel, a girl, in the company of a kneeling youth, feeds chickens, who scurry out from bullrushes. Around the rim of the cover is a frieze of garlands. The rim of the container is decorated with two scenes: a man fishing beside his house and a pointer chasing quail from rushes.

D: 2¹¹/₁₆″ (6.8cm) × H: 1⅛″ (2.8cm)
71.353

HISTORY: Acquired before 1931.

425. VENUS AND CUPID

Ivory relief under glass on a tortoiseshell box. French (Dieppe), 1760–1780

The lid of this cylindrical, tortoiseshell box contains an ivory relief attached to a ground of blue glass under a shallow glass cover held in place by a gilt-metal frame. Circumscribed by a narrow, leaf-patterned ivory band, the medallion represents Venus and Cupid on clouds above a landscape.

D: 3⅛″ (7.7cm) × H: 1″ (2.5cm)
57.118a,b

HISTORY: Purchased before 1931.

426,427. CLASSICAL SUBJECTS

Pair of ivory candle shades(?). French (Dieppe), 1760s(?)

The technical virtuosity of the Dieppe carver is exemplified by openwork carving known as *ajouré*, or *mosaïque*. Such work is most frequently encountered in the eighteenth century on the backs of *bénitiers*, or holy-water fonts, and on the lids of boxes.

The Walters pair shows in shallow relief the dalliance of Bacchus and Ariadne on the island of Naxos (cat. no. 426) and Leda and the Swan (cat. no. 427). The latter theme is a recurrent one in Dieppe ivories (Tardy, 151). Below these classical scenes on each piece are framed ovals depicting cavorting infants. The scene in catalogue no. 427 is also found on a snuffbox illustrated in Tardy (155).

Although the form of the Walters pair is that usually associated with *bénitiers* (Tardy, 54), the mythological subjects rule out such a function. Rococo candle shades of indeterminate date, illustrated in the Hearn Collection, 247, differ from the Walters pieces in the manner in which they are adapted for mounting on the candlestands. The rings at the top of the Walters ivories suggest that they were intended to be suspended as a form of decoration.

426. H: 8¼″ (20.9cm) × W: 3½″ (8.9cm)
71.343
427. H: 8¼″ (20.9cm) × W: 3½″ (8.9 cm)
71.344

HISTORY: Purchased from Philippe Sichel, Paris, 1898.

428a,b. PAIR OF ORNAMENTAL VASES

Ivory vases, wood plinths with ebony veneer. French (Dieppe), late 18th century, or c. 1830

These late-eighteenth-century-style vases are related to a series of works that may have originated in Dieppe as late as the 1830s. Reliefs produced in the atelier of Charles-Étienne Thomas (1787–1857) show a pair of vases similar in form and decoration (Musée de Dieppe, Inv. 764–765). Also comparable to the Walters examples are a pair of carved vases in the Musée de Dieppe (Inv. no. 1121 a, b) from the studio of Louis-Raymond Brunel (1818–1882), and another pair in the Bayerisches Nationalmuseum, Munich (Berliner, no. 639).

The Walters pieces have been worked in five sections. The covers, decorated with acanthus leaves, bear acorn finials. The upper portions of the partially hollowed bowls are carved with four acanthus leaves separated by pendants of bay leaves in concave grooves. The lower portions are carved with stylized laurel leaves alternating with bay-leaf pendants. Encircling the bowls at mid-section are swags of fruit and foliage. The double foliate handles are entwined with ribbons. The cone-shaped foot of each vase, decorated with leaves and beading, falls to a square ivory base.

The vases stand on elaborately shaped wooden plinths, veneered with ebony and decorated with moldings of ivory with beaded edges and twisted ribbons. Sections of the applied wood have been lost from each plinth.

428a. H (with base): 12¾″ (32.5cm)
H (vase alone): 7¾″ (19.6cm) 71.345a
428b. H (with base): 12¾″ (32.5cm)
H (vase alone): 7¾″ (19.6cm) 71.345b

HISTORY: Acquired before 1931.

429. LOUIS XVI AND MARIE-ANTOINETTE

Ivory relief on blue glass, set in a maple root snuffbox. French (Dieppe), c. 1820

The snuffbox is of maple root rimmed and lined with tortoiseshell. Beneath the clear glass cover is an ivory relief applied to a blue glass ground backed with silver foil tooled in a basketwork design. The relief shows overlapping profile busts of Louis XVI and his queen, Marie-Antoinette. The monarch wears a collar ornamented with fleurs-de-lys and the Order of the Golden Fleece; a diadem and a double strand of pearls adorn the queen. The composition is reminiscent of a design by C. H. Küchler on the obverse of a silver medal of 1793 commemorating the end of the French monarchy (G. F. Hill, *A Guide to the Exhibition of Historical Medals in the British Museum*, London, 1924, no. 70).

D: 3⅛″ (7.7cm) × H: 1″ (2.5cm)
57.216a,b

HISTORY: Purchased before 1931.

430. MARIE-CAROLINE-FERDINAND-LOUISE OF NAPLES, DUCHESS OF BERRY (1798–1870)

Ivory relief with dark glass and gilt metal. French (Dieppe), 1824–1829

The bust, shown in profile facing right, is set on a dark glass ground. The heavy oval ivory liner is surrounded by a gilt-metal frame embossed with a floral pattern. Between 1824 and 1829, the duchess is known to have visited Dieppe during the bathing season with her entourage and that of her father-in-law, Charles X. She patronized the local crafts. In such details as her coiffure, diadem, and pearl necklace, this likeness resembles her portrait on a medal preserved in the Dieppe Museum (*Catalogue du musée de Dieppe*, Dieppe, 1904, no. 603, ill., 91; cf. *Madame Duchesse de Berry*, Palais Dobrée, Nantes, Dec. 1963–Feb. 1964).

L (oval): 3¹³/₁₆″ (9.7cm) × W: 3⅛″ (8.9cm)
71.347

HISTORY: Purchased before 1931.

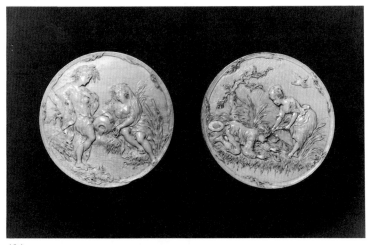

424

428

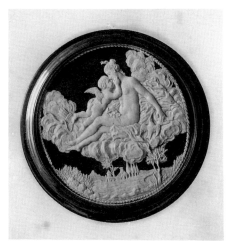

425

429

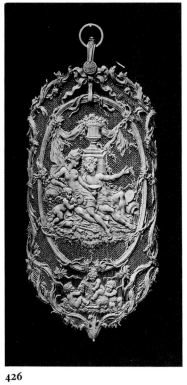

426

427

430

431. VOLTAIRE AND ROUSSEAU

Ivory reliefs on papier-mâché snuffbox. French, early 19th century

The busts of the celebrated philosophers François-Marie Arouet Voltaire and Jean-Jacques Rousseau, rendered in ivory, have been applied to the lid of a papier-mâché box tinted to resemble maple wood.

A wooden box in the British Museum with similar portraits is said to commemorate the deaths of the two men, both of whom died in 1778 (C. le Corbeiller, *European and American Snuff Boxes 1730–1830*, New York, 1966, no. 690).

D: 3¾" (9.6cm) × H: ¾" (1.9cm) 57.217

HISTORY: Purchased before 1931.

432. VENUS AND CUPID

Ivory statuette. French (Dieppe), Belleteste workshop, late 18th–early 19th century

Venus and her attendant, Cupid, stand amid clouds on an octagonal ground borne on a similarly shaped plinth with curved sides veneered in ivory and ebony. The front of the plinth is carved with an amatory trophy composed of a bow, shield, and quiver of arrows bound with roses and surrounded by branches. Stepping forward, Venus moves to bestow a garland, of which only a fragment remains in her right hand. A mantle, draped over her right arm, covers the join of the right arm with her body. Venus wears fetters on her wrists and ankles, and her hair is bound with pearls. To the right, a small cloud bears the feet of a bird, presumably the remnants of a dove. Cupid, at the left, gazes upward. His wings and quiver are separate attachments, as was his bow, which has been lost. Also missing are a loop of ribbon in Venus' hair, two fingers on her left hand, and loops from the shackles on her ankle and wrists. The reverse is signed: *"Sculpté à Dieppe par Belleteste."*

Works almost identical to this one include a statuette formerly in the Hirth Collection, Munich (no. 1118), which bears the inscription: *"Sculpté à Rome par de Belleteste,"* and another in the Hever Castle Collection (sale, Sotheby's, London, May 6, 1983, lot 346) inscribed: *"Sculpté à [...] Par. Belleteste."* From the late seventeenth century through the early nineteenth century, several generations of the Belleteste family were active as ivory carvers in Dieppe, Versailles, and further afield. Frequently, the family atelier produced a number of versions from the same model.

H (with base): 8¾" (22.3cm) 71.415
H (figure alone): 6³⁄₁₆" (15.6cm)

HISTORY: Purchased before 1931.

BIB.: C. Scherer, *Elfenbeinplastik seit der Renaissance*, Leipzig, 1902, 26–27.

433,434. VOLTAIRE and ROUSSEAU

Ivory portrait busts with wood socles. French (Saint-Claude), late 18th century, workshop of Jean-Claude-François-Joseph Rosset (1706–1786)

Voltaire (cat. no. 433) is represented as an elderly man wearing a wig with curled ends, a ruffled shirt, a coat edged with fur and trimmed with lace frogs, and a mantle twisted around his back and chest. Rousseau (cat. no. 434) is shown in middle age, dressed in a ruffled shirt, vest, and coat with buttons and a mantle similar to that worn by Voltaire. His wig is shorter and curled. Both busts are mounted on ebonized wood socles.

These representations of the two French philosophers, both of whom died in 1778, have been attributed to a member of the Rosset family of Saint-Claude. The town, long famous for its *tabletterie*, or work in rare woods and exotic materials, is situated at the confluence of the Bienne and Tacon rivers in the Jura mountains, fifteen miles from Voltaire's residence at Ferney. Of the principal sculptor in the Rosset family, Jean-Claude-François-Joseph, the marquis de Villette wrote: "Captivated by the good will of the artist, Voltaire received him at Ferney, and I witnessed the ingenuousness with which he removed his periwig while he played chess, and bowed his head" (cited by S. Lami, *Dictionnaire des sculpteurs de l'école française au dix-huitième siècle*, Paris, 1911, II, 304).

Rosset specialized in small-scale sculpture in various mediums and was noted for his representations of Voltaire. In the Nelson-Atkins Museum, Kansas City, there is a marble statuette signed and dated: *"ROSSET à St. Claude 1776."* In 1779, at the Salon de la Correspondance in Paris, Rosset exhibited a relief showing the philosopher seated at the foot of a tree holding a book and sheltering a poor family with his arms.

In 1771 Rosset settled in Paris, where he specialized in busts of Voltaire and other celebrated personages including Rousseau, Montesquieu, and d'Alembert (Tardy, 305). Three of Rosset's four sons followed their father in the profession, and one, Claude-Antoine, is remembered for a statuette of Rousseau exhibited at the Louvre in 1793.

A small ivory bust of Voltaire owned by À la Vieille Russie, Inc., New York, illustrated in *The World of Voltaire* (University of Michigan Museum of Art, Ann Arbor, 1969, no. 5), closely resembles the Walters example except for the delineation of the pupils of the eyes in the former and the blank eyes in the latter.

433. H (with socle): 6¾" (17.2cm); H (bust alone): 5⅜" (13.7cm) 71.364
434. H (with socle): 6¾" (17.2cm); H (bust alone): 5⅜" (13.7cm) 71.365

HISTORY: Acquired before 1931.

435. MORTAR

Ivory. French, second half 19th century

The cylindrical surface of the "Renaissance-revival" mortar is divided into four horizontal bands, each with different "antique" decorative motifs, including acanthus leaves, portraits of emperors, and inhabited vine scrolls.

The central zone of the mortar contains four cartouches showing, in succession, the portraits of four Roman emperors. The profiles may be based on coins depicting Caligula, Claudius, Hadrian, and Constantius II (see J. P. C. Kent, *Roman Coins*, New York, 1978, nos. 165r, 182, 278, 668). A portion of the base has been carved to simulate a break. There is a chip in the rim of the cup.

H: 7¾" (19.8cm) 71.370

HISTORY: Purchased from Jacques Seligmann, Paris, 1912.

436. ARMAND DE BOURBON, PRINCE OF CONTI(?)

Ivory relief on a wood plaque. French, 19th century

The sitter is seen in profile, facing left. He has a markedly aquiline nose and jutting lower jaw. He wears his own hair, shoulder length and gently curled, and has a mustache and chin tuft. In addition to a heavy scalloped lace collar, he wears an embroidered sash. The Order of Saint Esprit is suspended from a ribbon about his neck. The portrait may represent Armand de Bourbon, prince of Conti (1629–1666). Armand was the younger brother of Louis II de Bourbon, known as le Grande Condé, whom the bust was formerly thought to represent.

The ivory has been mounted on an ebonized wood plaque, the back of which is inscribed in ink: "779 trl, 451 TLL and 403 TAL." A paper sticker with the number "7" written in ink also appears on the plaque.

H: 4³⁄₁₆" (10.6cm) 71.427

HISTORY: Purchased in Paris, 1923.

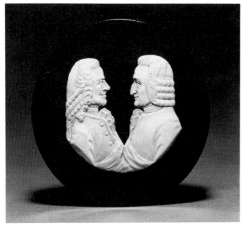

431

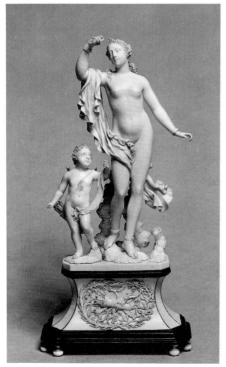

432

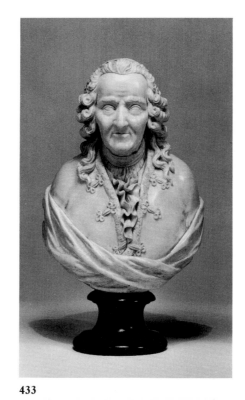

433

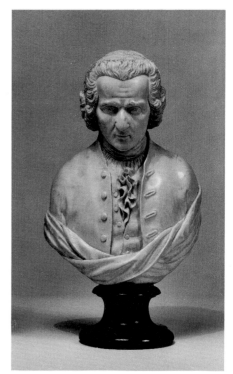

434

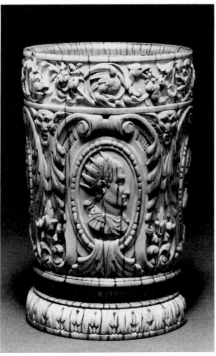

435

436

437. PHYRNE

Ivory statuette. French, second half 19th century

Phyrne stands on an ivory socle mounted on a wooden base. Her elaborately braided coiffure is bound with a ribbon and a strand of graduated pearls. Turning her head, she shields her face with her left forearm. Phyrne ambiguously counteracts this gesture of modesty by raising her right arm over her head to display her voluptuous torso to best advantage.

In the nineteenth century, the famous courtesan was popularized by Jean-Léon Gérôme's masterpiece of 1861, *Phyrne before the Tribunal* (Hamburg, Kunsthalle), illustrating the titillating moment when the orator Hypereides won his client's acquittal by baring her bosom to the appreciative Athenian judges (Athenaeus, *Deipnosophistae* 13.590d–f). Having served as the model for Praxiteles (Pliny, *Natural History* 34.19.70) and Apelles (Athenaeus, *Deipnosophistae* 13.590f–591a) as well, the subject of Phyrne offered artists an occasion for representing an idealized nude. Gérôme's figure frequently served as the prototype for representations of Phyrne in bronze, ivory, and silver. A marble version by Jean-Alexandre-Joseph Falguière belongs to the Maryland Institute College of Art, Baltimore (*The Taste of Maryland*, Walters Art Gallery, May 1984, Baltimore, no. 90). The anonymous Walters ivory differs from Gérôme's composition in the position of the figure's arms.

H: 10¾" (27.4cm) 71.368

HISTORY: Purchased before 1931.

438. THE THREE THEOLOGICAL VIRTUES

Ivory tabernacle. French, 1855–1857. Augustin-Jean Moreau, known after 1865 as Moreau-Vauthier (1831–1893)

Shown in a Gothic architectural setting are statues of the personifications of the three theological Virtues: Charity, leading a child and carrying an infant; Faith, holding a cross and chalice; and Hope, with her anchor. They are placed beneath an elaborate canopy composed of openwork pinnacles, a triforium, and trefoil-drop tracery, and are supported on a tripartite pedestal faced with panels of delicate openwork. The backdrop is represented as a masonry wall bordered by colonnettes and surmounted by a lancet arch.

In reviewing this work at the 1857 Paris Salon, L. N. Barbier, an ivory-turner and professor at Méru, observed:

No one better than he [Moreau-Vauthier] among the workers of ivory, has understood the Gothic; he has given to his monument of the *Three Theological Virtues*, this grace and style which only the sculptors of cathedrals knew. The more one studies this work the more one sees indescribable details, the elegant pilasters, the garlands of ivy that extend furtively along the ledges, the festooned niches more delicate than the finest Venetian lace that serve to shelter the *Three Virtues*, the moldings of the upright members, the exceptional delicacy of the open-work friezes, all these direct the imagination towards the thirteenth century, to Pierre de Montereau, the architect of Ste. Chapelle. (L. N. Barbier, *Esquisse historique de l'ivoirerie*, 70)

Though Moreau-Vauthier had participated with his father, Jean-Louis Moreau, in producing a Renaissance-style ivory casket which was shown at the Exposition Universelle of 1855, the *Theological Virtues* was one of two of the sculptor's first works to be accepted in the Paris Salon; the other was an ivory medallion based on a relief by C. A. A. Gumery, depicting F. C. A. Toussaint, their mutual teacher at the École des Beaux-Arts. The Walters tabernacle illustrates the retention during France's Second Empire of the Gothic style, a form championed by such noted figures as the architects J. B. A. Lassus and E. E. Viollet-le-Duc. In addition, this work may also reflect the sculptor's indebtedness to his father, a *tablettier* (ivory-turner) who is remembered for a neo-Gothic ivory clock damascened with scenes from the life of Saint Louis. The clock was exhibited in 1844 as a project and in 1855 as a completed work (Tardy, 302).

Each Virtue is carved from an individual tusk. The architectural setting is composed of numerous separate pieces of ivory. The composition is mounted in what appears to be the original velvet-lined vitrine. It is signed in the masonry wall at lower left: "A. Moreau. Scu... /1855."

H (of tabernacle): 35" (89.0cm) 71.584

H (of Virtues): 10⅞" (27.6cm)

HISTORY: Exhibited at Paris Salon, 1857, no. 3026; purchased at Tiffany & Company, New York, before 1931.

BIB.: L. N. Barbier, *Esquisse historique de l'ivoirerie*, Paris, 1857, 70–73; A. Valabreque, "L'Ivoire à l'exposition universelle de 1889," *Revue des arts décoratifs*, X, 1889/90, 382, 387.

See also colorplate 89

439. A FLORENTINE LADY

Ivory bust with onyx, silver gilt, pearls. French, c. 1892. Augustin-Jean Moreau, known after 1865 as Moreau-Vauthier (1831–1893)

A young lady is shown in early-seventeenth-century dress. Her hair is worn in short curls and coiled on top of her head, adorned with a strand of pearls. She wears a high-standing lace Medici collar rendered in silver gilt set with pearls. The brocaded fabric of the bodice is suggested by the matte surface of the ivory, carved with alternating bands of foliate and zigzag ribbon motifs. The shoulders are puffed and slashed, with gilt-metal embellishment and pearls, and the sleeves are incised with conjoined fleurs-delys. Her head and neck are of a single section of ivory; the remainder of the bust is composed of five pieces mounted on a core of white onyx. The shaped base is in cream-colored onyx.

Moreau-Vauthier executed another version of this subject, differing in minor details, including the metal mounts. He exhibited this version in 1892 at the Paris Salon (no. 2912) as *Tête florentine, buste ivoire et bronze*.

After it was acquired, the Walters bust came to be identified as a portrait of Marie de' Medici, a frequent subject in mid-nineteenth-century academic art (see carved ivory representations in the Hearn Collection, nos. 71, 75, 81). Although lacking a crown, this image is reminiscent of well-known portraits of the queen of France by Peter Paul Rubens and Frans Pourbus the Younger.

Another work in which Moreau-Vauthier combined ivory with onyx was his *Jeune orientale*, exhibited at the Paris Salon in 1886 (no. 4342).

Signed beneath the figure's left shoulder: A. MOREAU-VAUTHIER.

H: 18" (45.7cm) 71.446

HISTORY: Purchased at Tiffany & Company, New York, Nov. 1, 1898.

See also colorplate 90

440. SEATED INFANT

Ivory statuette with lapis-lazuli socle. French, c. 1880. Augustin-Jean Moreau, known after 1865 as Moreau-Vauthier (1831–1893)

An infant is seated on a drapery sucking his thumb and holding his foot. Children alone or grouped in compositions are recurrent subjects in Moreau-Vauthier's sculpture. Examples include *Un enfant*, Salon of 1861 (no. 3504); *Portraits d'enfant*, Salon of 1874 (nos. 3058–59); and the putti supporting a sphere on the base of *La fortune*, Salon of 1881 (no. 4141).

A rim of silver-gilt formerly encircled the base of the statuette. The socle is of lapis lazuli.

Signed around the base: A. MOREAU-VAUTHIER.

H: 4¼" (10.4cm) 71.319

HISTORY: Acquired from the sculptor's widow between 1893 and 1895.

441. A NEREID

Ivory statuette with lapis-lazuli socle. French, c. 1877. Augustin-Jean Moreau, known after 1865 as Moreau-Vauthier (1831-1893)

A female nude is seated on a drapery-covered conch shell borne on a wave. Her head is wreathed with rushes.

In reviewing the 1877 Salon, Charles Timball made the following observations regarding the marble version of this statue:

One can be reproachful without being severe with the beautiful Triton, regarding some irregularities in her features. The face, one can more readily encounter on our highways and byways than in the bottoms of grottoes of the Aegean. But how can we not pardon the whimsical countenance of a goddess who shows us a back so well modelled, arms of such beautiful form terminated by hands which are vital to the tips of her fingernails. (C. Timball, "La sculpture au Salon," *Gazette des beaux-arts*, II, Paris, 1877, part 2, 34)

When acquired, the statuette had a silver rim around its lapis-lazuli socle. The root cavity of the tusk penetrates the bottom of the ivory.

It is signed on the wave: A. MOREAU-VAUTHIER.

H: 9" (23.0cm) 71.425

HISTORY: Acquired from the sculptor's widow between 1893 and 1895.

437

437

440

438

439

441

442. BUST OF BACCHANTE

Ivory with green marble socle. French, c. 1891.
Augustin-Jean Moreau, known after 1865 as
Moreau-Vauthier (1831–1893)

The laughing bacchante turns her head to the left. She wears grape leaves in her hair, which is coiled in back and falls in tresses over her shoulders. When acquired, the edge of the base of the ivory was encircled by a silver band, now lost.

Stylistically, the Walters bust recalls the spirited bacchantes of the eighteenth-century sculptor Claude-Michel Clodion. Moreau-Vauthier exhibited an ivory bust of a bacchante at the Paris Salon of 1891 (no. 2771); a marble version was shown in 1893 (no. 3218); and a second ivory rendition was shown at the Exposition de l'Ivoire, Musée Galliera, Paris, June–Oct. 1903 (L. Roger-Miles, *Rapport général*, Paris, 1904).

It is signed on the right shoulder: A. MOREAU-VAUTHIER.

H: 7⅞" (19.9cm) 71.426

HISTORY: Probably that exhibited at the Paris Salon, 1891, no. 2771; purchased from Tiffany & Company, New York, before 1931.

443. NUDE WITH BUTTERFLY

Ivory statuette with gray marble base. French, c. 1896. Clovis Delacour (active from 1887 to 1903)

A nude woman, perched on a drapery-covered rock, raises her hand in surprise as a butterfly alights upon her shoulder. Rushes and other vegetation surround the base of the rock.

The subject may be Psyche, the personification of the soul in Greek mythology, who is frequently represented with the butterfly as her attribute, as in Jacques-Louis David's painting of 1817, *Cupid and Psyche* (Cleveland Museum of Art).

Clovis Delacour, a follower of Moreau-Vauthier from Châtillon-sur-Seine, submitted mythological subjects to the salons of the Société des Artistes Français from 1887 to 1891 and to the exhibitions of the Royal Academy, London, from 1896 to 1903. The Walters statuette is encircled at its base by a silver-gilt rim and is mounted on a grayish-green marble socle.

It is signed on base: "C. Delacour."

H: 9⅜" (23.8cm) 71.352

HISTORY: On Oct. 10, 1895, Henry Walters and George A. Lucas placed an order with Delacour for a plaque and a "Bathing figure seated," for 2500 to 2700 francs. On Sept. 12, 1896, Lucas settled the account for *Baigneuse au papillon* for 2700 francs.

BIB.: L. Randall, *The Diary of George A. Lucas: An American Art Agent in Paris, 1857–1909*, 2 vols., Princeton, 1979, II, 184, 833.

444. AMPHITRITE

Statuette in ivory with silver gilt, pearls, coral, and gold. French, 1889–1900. Christofle & Cie.: designed by Marius-Jean-Antonin Mercié; carved by Émile-Philippe Scailliet (1846–1911)

The Nereid Amphitrite stands on a silver-gilt socle decorated with aquatic motifs, including seashells, seaweed, and two Baroque pearls. The metal base is attached to a faceted green jasper plinth, the lower portion of which is graduated in two tiers. The angle of each level is bound by a silver-gilt band, the lower, thicker one being ornamented with a seaweed-and-scallop pattern. Four silver-gilt dolphins swim down the beveled corners of the plinth. Amphitrite's right arm is raised to hold aloft a piece of rose coral. Her trident is an appropriate attribute for the wife of Poseidon and mother of Triton. She wears a diadem ornamented with fish and a shell, a gold banderole set with a Baroque pearl below her breasts, and a gold armlet on her left arm. A gold ribbon encircles her right arm at the elbow and flows around her shoulders and behind her back. Her hair is tinted; her nipples may also have been tinted. The encircling ribbon and gold bands mask the joints between separate pieces of ivory.

Under the rubric of the house of Christofle, the *Amphitrite* was designed in 1878 by Marius-Jean-Antonin Mercié and cast in silver as a table centerpiece for the duke of Santonia. Mercié, a leading sculptor of the Second Empire, won the Grand Prix de Rome in 1868 (Bouilhet, *L'orfèvrerie française aux XVIIIᵉ et XIXᵉ siècles*, III, Paris, 1912, 143–144, 147).

Ivory versions of the *Amphitrite* were carved by Émile-Philippe Scailliet (1846–1911), a student of Moreau-Vauthier who exhibited regularly at the Salon from 1866 to 1910, receiving an Honorable Mention in 1887. The version illustrated in Bouilhet (III, 251; cf. 250) was exhibited at the 1889 Exposition Universelle in Paris; the Walters version was shown at the Exposition Universelle of 1900.

The signature "Ant. Mercié" is engraved on the socle.

H (with base): 27" (68.7cm) 71.450

HISTORY: Purchased from Christofle & Cie., Paris, 1900.

BIB.: Letter from Charles Christofle to Henry Walters, Feb. 23, 1900, in the Walters Art Gallery.

See also colorplate 91

445. MYSTERIOUS AND VEILED NATURE REVEALS HERSELF BEFORE SCIENCE

Statuette in ivory, gilded and oxidized silver, and malachite. French, after 1899. Louis-Ernest Barrias (1841–1905)

Mysterious and Veiled Nature Reveals Herself before Science demonstrates Barrias' sensitivity to the role of color and texture in sculpture. Standing with her weight on her right leg, the figure is draped in a gilded garment that extends from a point just beneath her breasts to her feet. With head bowed, she raises both arms to shoulder level to grasp the edges of a long silver veil that envelops her head and shoulders. The veil flows over her back and is secured in a knot at her waist. The rippling pattern of drapery folds is enlivened further by minute chasing over the surface; coloristic effects are introduced by burnishing in areas of shadow. A rosy tint adds a touch of naturalism to the ivory toes, face, and arms of *Nature*. Details such as the bracelets on her upper arms (one of which is bejeweled) and the malachite scarab at the top of her gilded garment enhance the preciousness of the image.

In the Walters reduction, a separation between flesh, hair, drapery, and jewelry is maintained. The distinction was more pronounced in Barrias' monumental polychrome sculpture that served as the model for the Walters piece. Exhibited at the Salon of 1899 (no. 3186), the larger version was draped in red-veined onyx and veiled in golden onyx, added color highlighted the flesh, and a malachite scarab and lapis-lazuli belt further enriched the chromatic scheme. Critical reaction to this extraordinary image was mixed: while some critics deplored the revival of polychromy as decadent, all agreed that in *Nature* Barrias had created an effective and sensitive fusion of materials.

Earlier in his career Barrias had produced a nude version of *Nature* (445a), which was acquired by the Faculté de Médecine, Bordeaux, after its exhibition at the Salon of 1893 (no. 2543). In this work, the nude, carved in white marble, removes her long veil with an elevated and extended right arm. Rather than encircling her body, the veil echoes the *contrapposto* pose of the figure.

Barrias exhibited a final rendition of the subject at the Salon of 1902 (no. 2229); this version was purchased by the École de Médecine in Paris. Draped and veiled in a manner similar to the large polychrome sculpture, this statue of *Nature* was also carved in white marble. A modern replica in marble (c. 1933) adorns the entrance to the Montreal Neurological Institute.

Barrias' return to a monochromatic figure was motivated by contemporary attitudes toward polychromy. Although the critics cited antique examples in support of polychrome sculpture, at the turn of the century polychromy was generally deemed more suitable for decorative objects. The decorative intent of the Walters reduction is emphasized in the careful chasing of the metallic surface and minute details of color and jewelry.

The firm of Susse Frères issued numerous editions of the partially draped figure. These were produced in bronze with polychromy, bronze and ivory, and bronze and marble, and ranged in height from eight inches to forty-eight inches (23.0cm to 122.0cm). Susse Frères issued one edition of the earlier, nude version in bronze and gilt bronze, but this proved less successful. The editions are discussed in Berman, IV, 1155, no. 4616; III, 375, no. 1387.

Signed on left side of base: "E. Barrias."

Foundry mark: "Susse Frères éditeurs, Paris, P."

445a. Louis-Ernest Barrias, *La Nature mystérieuse et voilée se dévoilant devant la science* (1893), marble, Faculté de Médecine de Bordeaux, Bordeaux, France.

H: 17" (43.1cm) 71.444

HISTORY: Purchased from Susse Frères, Paris, 1900.

See also colorplate 93

442

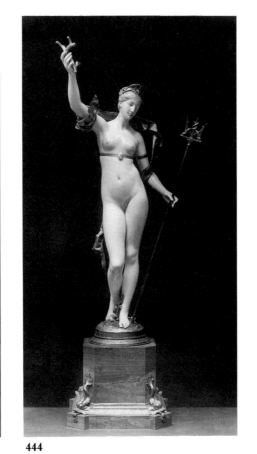

444

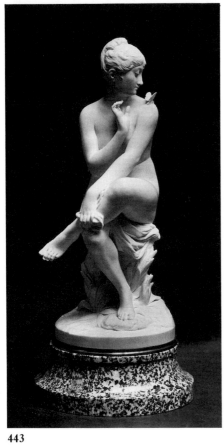

443

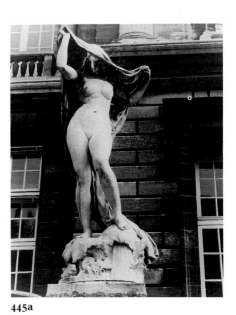

445

445a

446. THE YOUNG GIRL OF BOU-SAADA

Ivory, silver, wood, mother-of-pearl, turquoise. French, after 1890. Louis-Ernest Barrias (1841–1905)

Barrias' skill at adapting an image for reproduction in a wide range of materials was noted frequently by contemporary critics. This ability is particularly apparent in *The Young Girl of Bou-Saada*, in which the splendor of physical materials reinforces the richness of the Oriental subject. The model sits with crossed legs on a base of wood and inlaid mother-of-pearl which is partially covered by a simulated Oriental carpet. She holds small bouquets of flowers in each hand; her left arm rests on her knee, while her right arm extends outward and slightly upward. Her hair falls in massive braids on either side of her face.

Earlier in his career Barrias represented the seated pose of *The Young Girl of Bou-Saada* in a markedly different guise. Using a model that he had observed during a visit to Greece, the sculptor began *The Young Girl of Megara* in 1868 (cited by G. Lafenestre in "Ernest Barrias 1841–1905," *La revue de l'art ancien et moderne*, XXIII, 1908, 332). In Rome, Barrias completed a marble version of this figure, submitting it to the Paris Salon of 1870 (no. 4261), where it earned a gold medal. Clearly the ancestor of *The Young Girl of Bou-Saada*, *The Young Girl of Megara* differs in several respects and shows a nude young girl spinning.

In 1890, Barrias submitted a wax model for *The Young Girl of Bou-Saada* to the Salon (no. 3490). For the first time, the more contained pose, flowers, and drapery established the appearance of the flower girl. This transformation from classical overtones to Orientalism is explained fully by the destination of the finished bronze, which was placed on the tomb of the Orientalist painter Gustave-Achille Guillaumet. He died in 1887 and was buried in Montmartre Cemetery, having spent much of his life in Bou-Saada, specializing in local genre scenes and landscapes. The Algerian flower girl, with her air of graceful melancholy, was an appropriate tribute to this artist. In the visual richness of the later image, Barrias created a work that lent itself to the splendid synthesis of exotic materials in the Walters reduction.

Susse Frères issued several editions of this subject, varying in size and patina. The head alone appears in *Long Braids* (Berman, III, 652, no. 2415).

Signed on carpet: "E. Barrias."

Foundry marks on carpet: "Susse Fres edrs. Paris / Copyright by Susse Fres."

H: 12¼″ (31.1cm) 71.430

HISTORY: Purchased from Susse Frères, Paris, Oct. 27, 1900, for 4,000 francs.

See also colorplate 92

447. PENDANT AND NECKLACE

Ivory, gold, enamel, opals. French, c. 1902. René Lalique (1860–1945)

La source, a partially draped figure holding an urn, is carved of ivory. She stands on an orange Mexican-opal base, enframed by a bower of wisteria in gold which is enameled in blue, green, and opalescent white, set with two cabochon opals at the top. The pendant is suspended from a chain composed of blue-enameled elongated links alternating with gold rings. Lalique's drawings showing variants of this design are illustrated by S. Barten in *René Lalique, Schmuck und Objets d'art, 1890–1910*, Munich, 1977, 330, nos. 679.1, 679.2.

Noted for the manner in which he combined precious with nonprecious materials to create highly imaginative works transcending traditional concepts of jewelry, Lalique exploited ivory as a medium as early as 1893–1894, employing it in a bookbinding in the Gulbenkian Museum, Lisbon (Barten, no. 1756). Usually he used ivory for reliefs inserted in pendants and brooches.

Marked on lower edge: LALIQUE.

Pendant. H: 3⅛″ (7.9cm) 57.941
Chain. L: 22″ (55.9cm)

HISTORY: Exhibited at the St. Louis World's Fair, 1904; acquired at the fair (Objets et bijoux, no. 27 in Département D, Manufactures) as "No. 53 Pendant," for $600.

BIB.: *WAG Jewelry*, no. 706; E. Sedeyn, "À travers les expositions," *L'art décoratif*, 1903, IX, 184; M. P. Verneuil, "Les objets d'art à la Société des Artistes Français," *Art et décoration*, XIV, 1903, 224; H. Vollmar, "René Lalique," *Deutsche Kunst und Dekoration*, XIII, 1903–1904, 164, 172; H. Vever, *La bijouterie française au XIXᵉ siècle*, III, Paris, 1906–1908, 739; S. Barten, *René Lalique, Schmuck und Objets d'art*, Munich, 1977, 330, no. 678.

See also colorplate 94

448. ORCHID COMB

Ivory, horn, enamel, gold, diamond brilliants. French, c. 1903–1904. René Lalique (1860–1945)

This work, shown at the 1904 St. Louis World's Fair, exemplifies Lalique's practice of producing dramatic tours de force for such occasions. The blossom is rendered from a single piece of ivory set on a gold stem striped with brown enamel. Three leaves extending from the base of the blossom are of *plique-à-jour* enamel graduated in hue from peach to pale olive. The central vein of each leaf begins with gray enamel and is followed by graduated diamond brilliants. The stem is attached with a gold hinge to the three-tined horn comb.

Another example of Lalique's use of the orchid blossom occurs in the cattleya diadem (current location unknown), listed by S. Barten in *René Lalique, Schmuck und Objets d'art*, Munich, 1977, 175, nos. 30.1, 30.2. Equally exotic is the Venus's-flytrap diadem, also executed in ivory, in the Gulbenkian Museum, Lisbon (Barten, no. 29).

Marked on upper edge of right leaf: LALIQUE.

H: 5¼″ (13.3cm) 57.936
L (including comb): 7″ (17.8cm)

HISTORY: Exhibited at the St. Louis World's Fair, 1904; acquired at the fair (Objets et bijoux, no. 27 in Département D, Manufactures) as "No. 1, Diadem," for $1,000.

BIB.: *WAG Jewelry*, no. 708.

See also colorplate 95

449. PRIMING FLASK

Staghorn. German (Bavaria), dated 1763

The small curved section of horn is polished to imitate ivory. One side is engraved with a classical bust and the other with the arms of Fradel (Brabant or Holland), impaled with those of Frays or Grubel of Bavaria, and the date "1763." The remainder of the flask is decorated with leaf scrolls, and the spout with a pine-cone pattern. The base shows a mountain landscape. All of the engraved lines have been blackened.

The suspension ring and spring-stopper are iron.

L: 6″ (15.2cm) 51.574

HISTORY: Collection of Karl Thewalt, Cologne (sale, Nov. 14, 1903, lot 1743); Henry G. Keasbey, New York (sale, American Art Association, New York, Dec. 5, 1924, lot 37); purchased at the sale.

See also figure 7

450. THE CHRIST CHILD

Ivory statuette with modeled composition and wood. Transalpine, 18th century

The Christ Child wears a red robe and stands on a green mound with his arms raised and his fingers slightly extended. The partially gilded gray and brown plinth is carved with symmetrically placed rocaille scrolls.

On the basis of the facial type and the detailed rendering of the hair curls, traits that can be traced ultimately to the style established in Munich by Christoph Angermair in the seventeenth century, a Transalpine origin has been assigned to this piece.

A paper label on the base reads: POLYCHROME IVORY AND WOOD/CHRIST CHILD? XVITH CENTURY./GRUEL COLLECTION.

H (with base): 8⅞″ (22.5cm) 71.465
H (figure alone): 5⅝″ (14.3cm)

HISTORY: Acquired by Henry Walters from the Gruel Collection, before 1931.

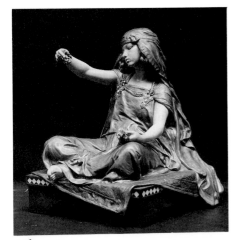

446

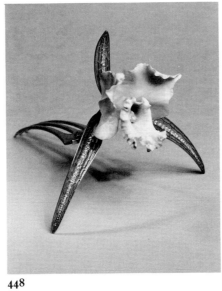

448

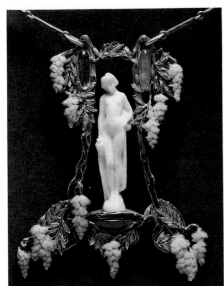

447

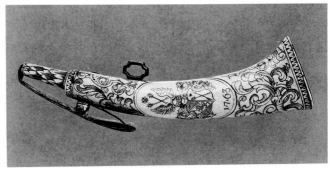

449

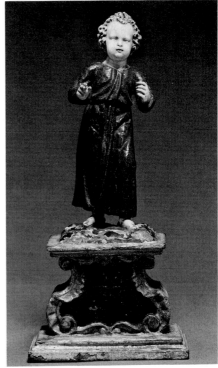

450

451. BEAKER

Ivory. German, second half 19th century

The German neo-Gothic style of the mid-nineteenth century is illustrated by the decoration of this vessel, based on the designs of Ludwig Foltz (1809–1867) for the Mettlach Cathedral Anniversary Beaker of 1845. In particular, the Walters ivory follows a Rhenish stoneware rendition of the composition catalogued by Arnold Wolff, "Der Mettlacher Dombecher von 1845 und seine Nachfolger," *Kölner Domblatt, Jahrbuch des Zentral-Domsbauvereins*, Cologne, 1970, 29–52, figs. 6–7, type 2:11.

Beneath a Gothic arcade are three groups: the figure of Germania holding a model of the cathedral, a stonemason drinking from a beaker, and the Three Kings following the star. Above are the escutcheons of the city, the bishopric of Cologne, and the masons' guild. A grapevine is carved around the base. A thin ivory disc, now detached, constitutes the base of the beaker.

H: 7⅛" (18.0 cm) × D: 3½" (8.8cm)
71.1148

HISTORY: Bequest of Calvert J. Cahn, 1968.

452. BROOCH

Ivory, partially tinted. Swiss(?), c. 1850

Carved ivory brooches showing stag scenes have been associated with the tourist trade of the 1840s and 1850s at Dieppe, in France; in the Odenwald region of Germany; and in Switzerland. In the earliest examples, the scenes are framed by rococo scrolls, whereas in later examples they are surrounded by intertwined roots and branches.

H: 1⁹⁄₁₆" (4.0cm) 71.1160

HISTORY: Gift of Mrs. Cyril W. Keene, 1977.

453a,b. HUNTING SCENES

Ivory mortar and pestle. German(?), late 19th century

The foot of the mortar (cat. no. 453a) has been turned, and its bowl is carved with a continuous landscape depicting a hunt. A pack of dogs attacks one boar, while another boar is pursued by an archer and a mounted spearman accompanied by dogs.

The handle of the pestle (cat. no. 453b) is decorated with raised designs on a pounced and stained ground. Above, pseudo coats of arms, from which bows are suspended, alternate with martial trophies; below, a zig-zag ribbon enlivens the surface.

An old label reads: "112."

Mortar. H: 5⅞" (15.0cm) × D: 3" (7.8cm)
71.380a,b
Pestle. L: 8⅛" (20.8cm)

HISTORY: Purchased from Ongania, Venice, 1899.

454. BACCHANALIA

Ivory tankard. German(?), late 19th century

This extraordinary vessel, carved entirely of ivory, recalls in form and decoration seventeenth-century German and Flemish prototypes.

Encircling the drum of the Walters tankard is a bacchanalia including a nymph with a putto on her knee, a youth playing cymbals, two bacchantes adorning a herm with garlands of flowers, a woman (possibly Diana) carrying a bow and arrows, an attendant, children cavorting with a goat, and a satyr climbing an altar. A Bacchic thyrsus rests on the ground beside the herm.

The lid is composed of several sections pinned together. A child playing a tambourine and a seated youthful satyr blowing a flute form the finial. Below are friezes of foliage, scrollwork interrupted by shields, a cupid's head, and a rim with gadrooned carving. At the base of the tankard are a band of scallop shells carved in shallow relief and four scrolled feet attached by pegs and carved with alternating Pan and Silenus masks. The three-part scrolled handle is adorned with a satyr's head and a putto swathed in a billowing drapery.

The conglomeration of decorative motifs and the coquettish character of the participants in the bacchanalia leave little doubt as to the late-nineteenth-century date of this piece. Similar to this tankard are two colossal tankards in the George A. Hearn Collection, one decorated with the Triumph of Neptune (no. 171) and the other with the Festival of Flora, or the Abundance of the Earth (no. 172). A bacchanal appears on a related tankard, perhaps by the same hand as catalogue no. 454, sold at Sotheby's, New York, June 16, 1984, lot 184.

H: 13¾" (34.9cm) 71.1131

HISTORY: Gift of Dr. Ronald T. Abercrombie, 1955.

455. THREE GRACES AND CUPID

Ivory relief. German or French, late 19th century

The Three Graces form a compact group of robust nudes on an ivory plinth strewn with flowers. The figure on the right holding a garland turns her head sharply to her left and downward, and her wavy hair cascades over her shoulder. The central figure stands frontally and looks over her right shoulder at the lively Cupid perched above. She covers her breast with her left hand, which is adorned with a garland; her right hand grasps the hand of the third Grace. Perched above the Graces, Cupid clutches an arrow and the remnants of a torch. The front of the plinth, the toes from the right foot of the central figure, and the left foot of the right-hand figure are lost.

H: 5⁵⁄₁₆" (13.4cm) 71.397

HISTORY: Purchased before 1931.

456. CRUCIFIX ON GOTHIC REVIVAL BINDING

Ivory, green morocco leather, gilt bronze, colored pastes. German, late 19th century

A fourteenth-century-style ivory figure of Christ with a circular nimbus is mounted on a Cross in the center of an openwork gilt-bronze plaque. The Cross and the border panels of the plaque are engraved with vine decoration. Quadrilobe plates depicting symbols of the Evangelists with scrolls bearing their names have been pinned to the terminals of the Cross, and large cabochon pastes in green, purple, red, and yellow have been mounted on the corners of the plaque. The interstices between the Cross and border panels are marked by fretwork and fruit-bearing vines. A diaper pattern is inlaid and gilded on the dark-green morocco binding.

Stamped at the base of the front turn-in is "L. Stephanus Buchbinder"; on the back turn-in is: "Franckfurt a.M." Within the binding is a Flemish Book of Hours (W.184, c. 1470).

Book. H: 4⅞" (12.0cm) × W: 3¾" (9.5cm)
W.184
Crucifix. H: 2¼" (5.9cm)

HISTORY: Purchased at Homburg, Aug. 1891, by Peter Marié; Marié sale, New York, 1903, no. 573, to George Richmond, New York; purchased from George Richmond after 1903.

BIB.: *Catalogue of an Exhibition of Illuminated and Painted Manuscripts*, Grolier Club, New York, 1892, no. 77.

457. VIRGIN AND CHILD

Ivory relief. South Italian, Naples(?), 18th century

In this piece, the Madonna balances the Christ Child on her knee as she extracts an apple from a basket of fruit at her feet. At the left, an angel also presents a fruit.

This relief has been associated with a south Italian, late Baroque tradition of miniature ivory carving represented by such intricate compositions as the Last Judgment in the Galleria Nazionale, Palermo (*Civiltà del '700 a Napoli, 1734–1799*, Florence, Dec. 1979–Oct. 1980, II, no. 542), and the Immaculate Conception and Assumption of the Virgin in the Victoria and Albert Museum, London (Longhurst, A21- and 22-1926). A more modest example of work in this same tradition is the small relief of the Adoration of the Shepherds in the Vatican Museum (Morey, no. A 148).

Except for the angel's wing, which is fastened by a dowel, this composition was carved from a single piece. An empty dowel-hole on the angel's left shoulder indicates that there was another wing, now lost.

H: 1⅝" (4.2cm) 71.585

HISTORY: Purchased with the Massarenti Collection, Rome, 1902.

BIB.: Massarenti Catalogue, 118–119, no. 480.

451

452

453

454

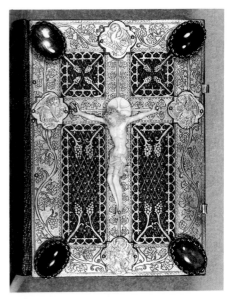

456

455

457

458. MADONNA ADORING THE CHILD

Ivory relief on red velvet ground in a turned tortoiseshell frame with copper-gilt mounts. Italy (Reggio Emilia?), 18th century

The Madonna, seated amid clouds, clasps her hands as she adores the Infant Christ. Her feet rest on a four-winged cherubim's head.

The composition is based on the popular devotional image, the miraculous Madonna della Ghiara. A drawing, dated 1565, based upon an earlier image of the Madonna, and a painting by Lelio Orsi are in the Tempio della Madonna della Ghiara in Reggio Emilia. The earlier image was repainted in 1593 according to Orsi's composition, to which the ivory carver has added a cherubim. Another example of this composition in ivory belongs to the Metropolitan Museum of Art, New York (inv. no. 1976.422.5); a cruder version, sold at Sotheby's, New York, Dec. 18, 1978, lot 157, was described as a Flemish seventeenth-century pendant.

This piece belongs to a group of provincial, late Baroque ivories, of which other examples are to be seen in the Museo d'Arti Applicate, Milan (Zastrow, nos. 158–162). Zastrow suggests (143) that such reliefs were intended to be applied to the bases of crucifixes.

The Walters ivory was previously exhibited as *Saint Clara in Ecstasy*.

A paper label reads: "182."

H (of ivory): 2⁷⁄₁₆" (6.3cm) × W: 1⅝" (4.3cm) 71.372
H (with frame): 3⅞" (9.9cm) × W: 3⅜" (8.6cm)

HISTORY: Purchased before 1931.

BIB.: *Un santuario e una città. Manifestazioni celebrative del 3° centenario dell' Incoronazione della Madonna della Ghiara, 1674–1974*, exh. cat., Reggio Emilia, 1974 (fig. 79); E. Monducci and V. Nironi, *Arte e storia nelle chiese reggiane scomparse*, Reggio Emilia, 1976 (figs. 54, 90, 95, 108, 112).

459. SAINT BRUNO(?)

Ivory statuette. South Italian (Naples?), late 18th–early 19th century

The tonsured monk is represented kneeling. His cowl is thrown back, and his left arm is raised to cover his heart. A rosary and a crucifix hang at his side. The figure wears the distinctive habit of the Carthusians and may represent Saint Bruno, the founder of that strict order. Italian representations of this saint, who was canonized only in 1623, are fairly rare (L. Réau, *Iconographie de l'art chrétien*, III, Paris, 1955, 249–252). The south Italian origin may relate to the fact that when Bruno left the service of Pope Urban II in 1090, he established his second charterhouse at La Torre, in Calabria, where he died. Ivory is an especially appropriate medium for representing the white robes of the Carthusians.

The saint's right arm, which was a separate piece, is missing.

H: 4" (10.1cm) 71.359

HISTORY: Purchased before 1931.

460a,b. SAINT BRUNO and SAINT DOMINIC

Ivory statuettes. South Italian (Naples?), late 18th–early 19th century

The standing figure of Saint Bruno (cat. no. 460a) is shown wearing the Carthusian habit. He holds a book and glances in the direction of his missing left hand, which probably originally held an object of contemplation. His rosary hangs at his side, and a portion of the band of his habit is broken on the right. Sculptured representations of this saint are listed in L. Réau, *Iconographie de l'art chrétien*, III, Paris, 1955, I, 250–252. In addition, the ivory carver Jean-Claude-François-Joseph Rosset carved a Saint Bruno in the 1760s (Tardy, 305).

Saint Dominic (cat. no. 460b), the mate to Saint Bruno, is also formed of pieces of ivory pinned together. Saint Dominic's lower left arm and hand are carved separately and inserted. His right hand is missing and his left has lost all its fingers.

Saint Bruno. H: 6⅝" (16.9cm) 71.334
Saint Dominic. H: 6¾" (17.1cm) 71.376
HISTORY: Purchased before 1931.

461. CRUCIFIX

Ivory. Italian, early 18th century

The body of Christ is mounted by three nails to a modern Cross. His head is turned to the right and tilted backward. Christ is shown at the moment of death; his mouth is gaping, and his eyes are directed upward, with the pupils retracted. The body is subtly rendered, with particular attention given to the neck tendons and the muscular and skeletal structure of the limbs. A loincloth, held in position by a cord, is knotted at his right hip. The knot and both arms are carved separately. On the back of the skull is a drilled hole that may have been used for fastening a halo. An early-eighteenth-century date is assigned to this work on the basis of the careful, restrained rendering of the subject.

H: 13¾" (34.5cm) 71.421
HISTORY: Acquired before 1931.

462. SAINT FILIPPO NERI

Ivory relief. Italian, first half 18th century

The oval medallion is carved with a half-length representation of Saint Filippo Neri (1515–1595), gazing heavenward in ecstasy. The body is shown in three-quarter view, with the head turned sharply to the right, emphasizing the distinctive profile. The saint is balding and wears a full beard. His hands are crossed over his chest. A typical gesture of devotion, this pose may refer specifically to the "miraculous palpitation of the heart" experienced by Saint Filippo Neri in 1544 (P. G. Bacci, *The Life of Saint Philip Neri*, 2 vols., London, 1847, I, 21–28). He wears a clerical robe with short, full sleeves over a loose shirt with lace at the cuffs. His head is surrounded by an aureola, the rays of light indicated by lines engraved into the surface.

On the back of the plaque there is a paper label printed with the identification: SAINT / XVIII CENTURY / GRUEL COLLECTION, together with the penciled number "73."

H: 4½" (11.4cm) × W: 3½" (8.8cm)
71.463

HISTORY: Collection of Léon Gruel, Paris; purchased in Paris, 1912.

463. PORTRAIT OF A MAN

Ivory relief. Italian, 1755. Andrea Pozzi, Rome

The subject, a bewigged young man, is shown bust-length, in three-quarter view, wearing a cravat, buttoned coat, and mantle.

Inscribed on the bottom side of the bust is: "And. Pozzi F.ᶜ," and below: "C. H. W. Roma 1755."

The initials C. H. W. were formerly identified as those of the British diplomat and satirical writer Sir Charles Hanbury Williams (1708–1759). However, the ivory image bears little resemblance to the known portraits of Williams, who was serving in St. Petersburg at the time the sculpture was made (J. Kerslake, *Early Georgian Portraits*, National Portrait Gallery, I, Oxford, 1977, 310–311; II, pls. 889–891).

Andrea Pozzi (Pozzo), an ivory carver who worked for Charles III of Spain, is represented in the Grünes Gewölbe, Dresden, and the Museo Nacional de Artes Decorativas, Madrid.

The reverse bears a paper sticker: IVORY MEDALLION, PORTRAIT OF / SIR CHARLES HANBURY WILLIAMS /: 1709–1759. / SIGNED,: AND. POZZI FE, ROMA 1755.; another oval paper sticker is inscribed: "5."

H: 4⅛" (10.5cm) × W: 2¼" (8.2cm)
71.371

HISTORY: Collection of Jeffrey Whitehead (sale, Christie's, London, Dec. 10, 1910, lot 88); purchased from George R. Harding, London, Apr. 26, 1911.

BIB.: M. C. Ross, "A Portrait Ivory by Andrea Pozzi," *Burlington Magazine*, LXXI, 283; *Civiltà del '700 a Napoli, 1734–1799*, Florence, Dec. 1979–Oct. 1980, II, 264.

458

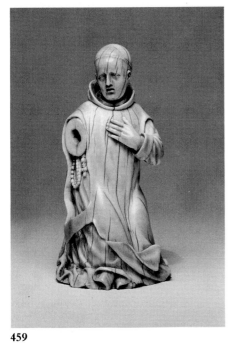

459

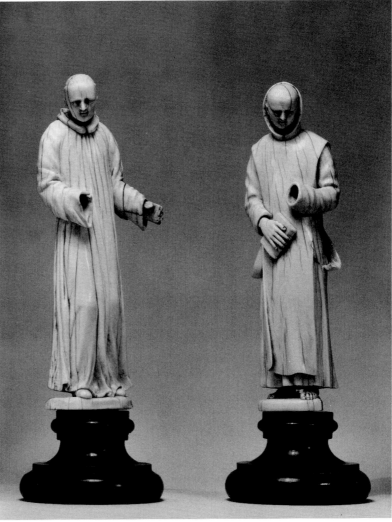

460

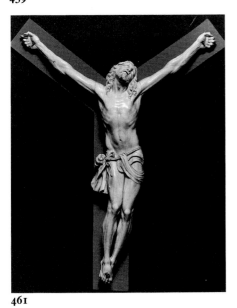

461

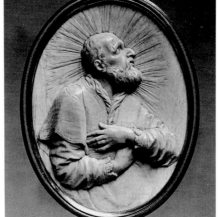

462

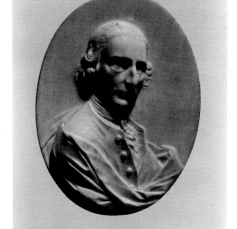

463

464. SAINT NICHOLAS OF BARI

Polychromed wood and ivory statuette. Italian, late 18th century

Saint Nicholas, the mid-fourth-century Bishop of Myra who was buried at Bari, is shown in his customary role as protector of children. The saint is of polychromed wood, with head and hands of ivory. He is portrayed holding an ivory cross and standing beside a praying child carved entirely of ivory. The wooden base rests on four depressed, conical, ivory feet. A hole drilled in the center of the base suggests that it was adapted from another work.

The top member of the ivory cross has been lost.

The base reads: SAINT NICHOLAS / POLYCHROME IVORY & WOOD / XVIITH CENTURY / GRUEL COLLECTION.

H (with base): 7½" (19.1cm)　71.350
H (of figure): 6⅛" (15.6cm)

HISTORY: Collection of Léon Gruel, Paris; purchased before 1931.

465. ORESTES AND PYLADES WITH IPHIGENIA IN TAURIS

Ivory tankard. Italian(?), first third 19th century

Ten figures in various poses cover almost the entire vertical surface of the tankard. They are carved in deep relief, replicating a Roman sarcophagus (465b) probably acquired by Domenico Grimani in Rome and installed in the Grimani Palace at Santa Maria Formosa, Venice, during the first half of the sixteenth century. The sarcophagus, now in the Schlossmuseum, Weimar (inv. no. G1744), depicts scenes from Euripides' *Iphigenia in Tauris* (Carl Robert, *Die Antiken Sarkophag-reliefs*, Berlin, 1890, Band 2, 183–184, no. 172). In the narrative shown on the sarcophagus, Orestes and his companion Pylades, their arms bound, have been brought to the temple of Artemis where they encounter the priestess, who stands to the right of the altar. The discovery of her identity as Orestes' sister, Iphigenia, is depicted in the scene on the left. The scene on the right represents the struggle to escape from Tauris.

While copying the central episode, the Neoclassical carver has modified other elements of the composition, distorting the narrative and inventing details to fill lacunae on the left and right. Orestes points into the urn at his feet and the nude figure with a scabbard is shown holding a small bag rather than a sword, as had been intended by the Roman sculptor. The scene on the extreme right of the sarcophagus, in which Orestes assists Iphigenia into his galley, does not appear in the ivory.

The story of Iphigenia enjoyed a revival among Neoclassical artists (Klaus Parlasca, "Iphigeneia in Tauris: Ein Beitrag zu Goethe, W. Tischbein und B. West," *Festschrift für Frank Brommer*, eds. U. Hockman and A. Kruk, Mainz, 1977, 231–236; Christian Lenz, *Tischbein: Goethe in der Campagna di Roma*, Frankfurt, 1979). At this time, the Weimar sarcophagus was described by A. L. Millin (*L'Orestéide, ou description de deux bas-reliefs du Palais Grimani à Venise [. . .]*, Paris, 1817) and, during the dispersal of the Grimani Collection, it was featured in the catalogue of the Venetian dealer Antonio Sanquirico (*Monumenti del Museo Grimani pubblicati nell'anno 1831*, Venice, 1831), from whom it was acquired by archduke Carl Alexander von Sachsen-Weimar during his Italian sojourn of 1834–1835 (Marilyn Perry, "Antonio Sanquirico, Art Merchant of Venice," *Labyrinthos* 1, 1/2, 1982, 71–73). Its Italian provenance suggests that the tankard was probably carved in Italy; the deep relief-carving suggests that it was modeled on the sarcophagus itself rather than on one of the linear engravings published by Millin (pl. 4) or Sanquirico (tav. 26). The tankard was sold in 1880 as a sixteenth-century work. Its cover, feet, and handle are missing.

H: 7½" (19.0cm) × D: 4½" (11.7cm)　71.348

HISTORY: Collection of Count Girolamo Possenti, Fabriano (sale, Raphael Dura, Florence, Apr. 1, 1880, lot 125, ill. misnumbered as 124); purchased from Ongania, Venice, before 1931.

465a. Drawing after Walters catalogue no. 465 (by Linda Sirkis).

465b. Roman sarcophagus: *Iphigenia in Tauris*, marble, second century A.D. H: 24⅞" (63.0cm) × L: 81⅞" (208.0cm); Schlossmuseum, Weimar.

466. VIRGIN AND CHILD

Ivory statuette. Portuguese(?), 17th century(?)

The Virgin, who is shown standing, holds the Christ Child in her right arm. Although her head and shoulders are turned slightly to her right, the figure appears flat and stylized. Her bulbous crown is a separate piece. The Virgin's left hand is missing. Christ's head and left hand are restorations; his right hand appears to have been restored to conceal a hole which may have held a crucifix. In style, the Virgin resembles the figure of Mary in a seventeenth-century Portuguese ivory Visitation in the British Museum (Dalton, no. 544).

On the wooden base is a printed tag: VIRGIN AND CHILD / XVIITH CENTURY / GRUEL COLLECTION, and the penciled notation: "No. 54."

H: 6¼" (15.8cm)　71.404

HISTORY: Collection of Léon Gruel, Paris; purchased in Paris before 1931.

467. PASSION OF CHRIST

Ivory container. West Africa (Benin), late 16th century

The container is carved with the Passion of Christ in seven scenes divided by spiral moldings. The figures are clothed in garments with highly stylized patterns, suggesting European textiles. Included are the Arrest of Christ, the Mocking of Christ, Way to Calvary, Nailing Christ to the Cross, Crucifixion between Holy Women, Deposition, and Lamentation. The inscription IHS appears in both the Nailing and Crucifixion scenes, and the lower part of the same inscription appears in the Deposition, suggesting that the top of the container has been cut. The base is carved with a quadruple interlace of a type found on Benin utensils and bowls.

Similar pieces of African workmanship showing Portuguese influence were made by the Sherbro of Sierra Leone and other peoples. A saltcellar of Benin origin with a stylization of European costumes similar to that in the Walters piece is in the National Museum, Copenhagen (*Die Kunst von Schwarz-Afrika*, Zurich, 1970, 156, fig. K-7).

H: 3⅛" (8.0cm) × D: 4⅛" (10.5cm)　71.108

HISTORY: Purchased before 1931.

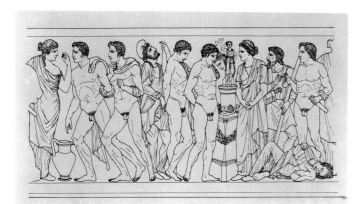

465a

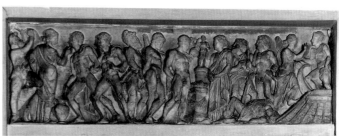

465b

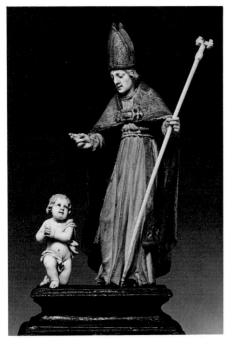

464

466

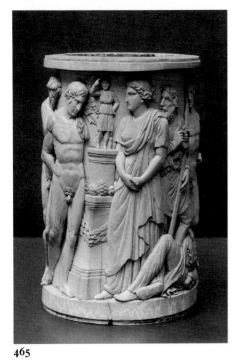

465

467

468. THE GOOD SHEPHERD

Ivory statuette. Indo-Portuguese, 17th–18th century

The statuette is carved in two segments. Above, the youthful Christ is seated asleep with his head resting on his hand, his eyes closed, and his legs crossed. He wears a tunic and sandals and carries a costrel, or drinking vessel, and wallet at his side. On one knee is a lamb.

The lower section, the rockery, is divided into a number of tiers. At the summit is Christ's seat, flanked by lambs. Below, water issues from a fountain, possibly the Fountain of Life, set off by a pair of flowering plants. Birds and sheep drink from its basin. More sheep are perched among the rocks. In a cave at the bottom, a reclining Mary Magdalen, with her cross and skull, reads the Scriptures. Lions crouch in lateral chambers. The reverse of the lower section is scored with crisscross lines.

Indo-Portuguese ivories of the Good Shepherd are to be found in many collections. Among those most closely related to the Walters carving is an example in the Ferment Collection (Tardy, 1977, 229). Another example is in the Museo Cristiano of the Vatican Library (Morey, no. A 123, cf. D. D. Egbert in "Baroque Ivories in the Museo Cristiano of the Vatican Library," *Art Studies*, VIII, 2, Cambridge, 1931, 40–42). This work differs principally in that a lamb is mounted on Christ's right shoulder. Numerous variations occur within these representations; in some, Christ is raised on a sphere (Victoria and Albert Museum, Longhurst, II, no. A38-1921); in others, the water flows from a leonine mask rather than from a vertical fountain (British Museum, Dalton, no. 556). Occasionally, the Magdalen is crouching rather than reclining. In a particularly elaborate example in the Musée de Commercy, France (Tardy, 50), figures of saints and of God the Father have been added, and a Nativity scene has been substituted for the depiction of Mary Magdalen. In a few examples, an ivory plaque showing God the Father has been mounted above the Good Shepherd's head (Victoria and Albert Museum, Longhurst, II, no. A38-1921, and Milan, Zastrow, no. 107). Occasionally, as in an example in the Victoria and Albert Museum (Tardy, 1977, no. 231), the image is surrounded by an aureola of radiating palm fronds.

The various interpretations and explanations of this subject remain inconclusive. O. M. Dalton cites Eusebius, *De vita Constantini*, III, chap. 49, in noting that pagan statues over fountains in Constantinople were replaced in early Christian times with representations of the Good Shepherd and Daniel, whereas Josef Strzygowski (*Origin of Christian Church Art*, trans. O. M. Dalton and H. J. Braunholtz, Oxford, 1923, 122–158) identifies the seated and reclining figures with Yima, the Good Shepherd of Magdean mythology. Egbert (41–42) notes the similarities between the iconography of the recumbent Magdalen in the Indo-Portuguese ivories and that in a painting in the Prado by the sixteenth-century Andalusian Gaspar Becerra, and observes that the presence of

the lions in the side caves in the ivories is the result of a confusion between the life of Mary Magdalen and that of Saint Mary of Egypt, the lions being associated with the latter (cf. H. M. Garth, *Saint Mary Magdalene in Medieval Literature*, Baltimore, 1950, 24–25).

Good Shepherd rockeries traditionally have been identified as works of Indian craftsmen in Goa, the former capital of Portugal's eastern empire. Luis Keil suggests, instead, that they were produced near Dominican missions along India's Coromandel Coast (*Alguns Exemplos da Influencia Portuguesa em Obras de Arte Indianas do Século XVI*, cited by M. McCully in "The Indo-Portuguese Ivory Crucifix in the Yale University Art Gallery," *Yale University Art Bulletin*, XXXIV, Nov. 1972, 6, n. 10). At present, there is insufficient evidence to sustain the sixteenth- and early-seventeenth-century dates usually attributed to all these works.

When acquired, the Walters ivory was mounted on an ebonized base decorated with ivory festoons. Unlike so many other examples of Good Shepherd ivories, which bear evidence of red and green polychromy, there are no traces of color on this piece. Similarly, if the Walters Good Shepherd originally carried a sheep on the right shoulder, as seen in most other examples, the animal has been removed without a trace.

H: 6⅞" (17.4cm) 71.324

HISTORY: Purchased with the Massarenti Collection, Rome, 1902.

BIB.: Massarenti Catalogue, II, no. 482.

See also colorplate 96

469. THE VIRGIN OF THE IMMACULATE CONCEPTION

Ivory statuette with traces of gilding and polychromy. Indo-Portuguese, 17th century

The Virgin is crowned and stands on a crescent moon which, in turn, is supported by a square, stepped plinth with a lotus-blossom top. The artist's Asian origin is reflected in the treatment of the Virgin's mantle, which resembles an Indian sari in the manner in which the fabric falls in elegant, stylized folds, and the treatment of her earlobes, which are elongated in the tradition of Indian sculpture. Traces of gilding are apparent in the Virgin's hair, which falls in waves down her back; in the collar of her dress; and on the plinth. In addition, her mantle was formerly adorned with stars, several of which remain visible on the back. The Virgin's lips were tinted red and the pupils of her eyes black.

Apart from the hands, which have been carved separately, the statuette is carved from one piece of ivory. Losses include six of the eight fleurons of the Virgin's crown and chips from the corner of the plinth.

A paper label reads: "7."

H: 10⅛" (25.7cm) 71.341

HISTORY: Purchased with the Massarenti Collection, Rome, 1902.

BIB.: Massarenti Catalogue, II, no. 478 (identified as a Florentine work of the fifteenth century).

See also colorplate 98

470. THE VIRGIN OF THE IMMACULATE CONCEPTION

Ivory statuette with traces of gilding. Indo-Portuguese, c. 1700

The Virgin kneels on a crescent moon with her hands in an attitude of prayer. Her head is uncovered, and her hair falls down her back and in tresses over her shoulders. In rendering the folds of the garments, little concession has been made to anatomy.

A similar statuette of the Immaculate Conception in the Museo Cristiano of the Vatican Library has been discussed by Donald Drew Egbert ("Baroque Ivories in the Museo Cristiano of the Vatican Library," *Art Studies*, VIII, 2, Cambridge, 1931, 37–38). He rather unconvincingly assigns it to the Balearic Islands in the seventeenth century.

A square paper label with blue borders on the under surface of the statuette is inscribed in ink: "123."

H: 5⅛" (13.2cm) 71.407

HISTORY: Purchased before 1931.

471. THE VIRGIN OF THE IMMACULATE CONCEPTION

Ivory statuette. Indo-Portuguese, 19th century

The Virgin, her arms stiffly crossed, stands on a crescent moon. She wears a robe with deeply incised folds and a mantle gathered above the knee in a stylized pattern. Both garments are bordered with a design of small circles enclosing dots.

The figure has been mounted on a two-tiered base. The upper section, composed of the globe, is ornamented with a winged seraph's head, and the lower, of a trunk with a scallop shell flanked by two columns. There is little continuity between the carving of the two sections. Traces of gilding are visible in the Virgin's hair. Her lips and eyes and those of the seraph bear traces of polychromy.

Two other ivories can be associated with the Walters Virgin. In the British Museum (Dalton, no. 456) there is a Virgin of the Immaculate Conception with the carving in the drapery employing the same circle-and-dot motif; in a statuette of the same subject formerly in the Hearn Collection (no. 28), the figure is almost identical to that of the Walters piece, though the base of the statuette resembles the British Museum example.

H (with base): 10¼" (26.6cm) 71.342
H (figure alone): 7⁷⁄₁₆" (18.8cm)

HISTORY: Purchased before 1931.

468

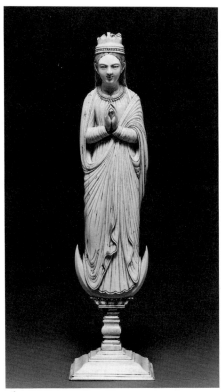

469

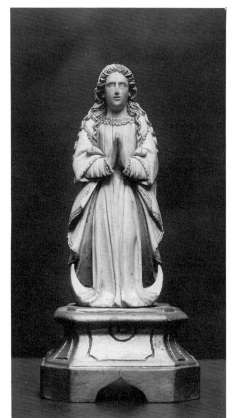

470

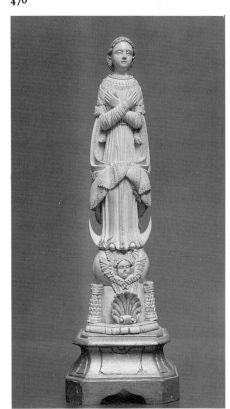

471

472. FIGURE FROM A CRUCIFIX

Ivory, black color on hair and beard. Spanish, 18th century

The naïve treatment of this crucifix suggests a provincial, perhaps Philippine, origin. Disregard for anatomical exactitude is apparent in the rendering of the attenuated torso and the bowed legs. The spindly arms have been carved separately and attached. The cloth falls in schematized folds around the loins. A comparably abstracted treatment of the subject is seen in a large seventeenth-century Spanish crucifix in the Museo d'Arti Applicate, Milan (Zastrow, no. 131).

The Walters crucifix has suffered damage most notably in the hands; three fingers have been broken on the figure's right hand and all five on the left. A large hole drilled in the head may have contained a dowel for attaching a halo. Also, although no traces survive other than the tinting of the hair, the figure originally may have been polychromed.

H: 11⁄₁₆" (28.1cm) 71.492

HISTORY: Acquired before 1931.

473. THE ARCHANGEL MICHAEL

Gilt and polychromed ivory statue; gray marble base. Hispano-Philippine, 17th century

The Archangel Michael at the Day of Judgment stands on a prostrate demon and holds a flaming sword raised in his right hand. He is represented winged, wearing a tunic with short sleeves, a breastplate, a scarf draped over his shoulder and gathered on his hip, a *lorica*, and buskins adorned with winged cherub heads. The demon has wings and a serpentine tail; its head, arms, and torso are human. It grimaces in pain, exposing its teeth.

Limited use has been made of gilding, now dark brown for the most part, and of polychromy. The Archangel's eyebrows and pupils are brown, his lips red, and his long hair gilded. The wing feathers are delineated in gilding, as are the scroll motifs of the tunic and *lorica* and the stripes, zigzag lines, rosettes, and scrolls which adorn the scarf and buskins. A red sun and gold moon and stars adorn the breastplate. His collar is bordered with ovals and lozenges in red and black on a gold band, and a raised faceted gem is represented in its center. The demon's hair is black, its eyebrows and pupils are dark brown, and its lips and a wound in its abdomen are red.

A number of pieces of ivory have been employed in creating this statue. The Archangel's head and torso are carved from a single tusk, the arms are in two segments, and the legs each of a single piece. Separate sections have been doweled to the torso to constitute the *lorica* skirt. Each wing is formed by three sheets of ivory held together by cross-members. The head and torso of the demon are carved from a single, solid tusk, with separate pieces for the tail and limbs.

Numerous, often crude, repairs have been made to the statue, which has experienced breaks and losses. Among the losses are the Archangel's scales for weighing souls and the demon's right arm and wing, as well as a peg intended to fit in a hole drilled into the demon's head.

The statue of the Archangel is held upright by two iron rods that extend from holes in the soles of his feet through the demon's torso into a gray marble base carved with a depiction of Hell. Amid the flames are two satyrs, one of which has lost its head. The marble base, which differs stylistically from the rest of the piece, appears to have been carved by a European artist.

Incised and painted in the scalloped hem of the Archangel's skirt is the inscription: SARA BADOS BARBOVTAN SIRARE PERIOVAM CEQVATO PERIOVAM 1303. It has not been translated. Comparable examples are illustrated on the cover of *Marfiles Hispano-Filipinos en las Collecciónes Particulares*, Instituto de Cultura Hispánica, Madrid, Oct.–Dec. 1972, and in *Westeuropäische Elfenbeinarbeiten aus der Ermitage Leningrad, XV–XIX Jahrhundert*, Kunstgewerbemuseum, Berlin, 1974, no. 134.

H (with base): 46½" (118.2cm) 71.490
H (of figures): 39½" (103.0cm)

HISTORY: Purchased from Ongania, Venice, in the early twentieth century.

474. VIRGIN AND CHILD

Ivory statuette, partially polychromed. Hispano-Philippine, 17th century

The Virgin holds the Infant erect. He raises his right hand in blessing and holds an orb in his left. In pose and facial features, this typical Hispano-Philippine statuette exhibits similarities to Chinese renderings of the deity Kuan Yin, a feature discussed by M. E. Marcos in "Virgenes de Marfil Hispano-filipinas," *Archivo Español de Arte*, XLIII, no. 160, 1967, 341.

Bordering the hem of the Virgin's mantle is a double band of gold and a pattern of alternate lozenges and ovals, with dots colored blue and red. Both figures have black hair and similar belts in blue and red. The fold of drapery over the Virgin's left elbow has been carved separately and applied with two pins.

The base is drilled with two holes in which pegs would have been inserted to attach the statuette to a lower member, presumably a support of angels and clouds.

H: 5½" (14.0cm) 71.358

HISTORY: Purchased before 1931.

475. MADONNA AND CHILD

Ivory, polychromy, and gilding. Hispano-Philippine, 17th–18th century

The Virgin carries the Christ Child erect in her arms and holds a rosary in her right hand. Christ raises one hand in blessing and carries the orb in the other. Supporting the figures are cherub heads in clouds. The statuette has been conceived frontally, with little attempt to depict the contours in profile.

The statue is richly gilded and colorfully polychromed. Mary's hair is brown and her crimson-lined mantle is decorated with crude floral and foliate motifs in blue and gold. Jesus' hair is golden and his garments are flecked with gold. The angels' wings are blue and their hair black.

The statuette is carved from a hollow tusk. Two peg holes have been cut on either side of the base for attachment to a plinth. A section of the rosary is missing. It has been suggested that the polychrome decoration, which does not conform exactly to other examples of Hispano-Philippine ivories, is not contemporaneous with the carving.

A paper label reads: IVORY POLYCHROME / VIRGIN- / XVIIITH CENTURY; another label reads: "115."

H: 9¼" (23.5cm) 71.322

HISTORY: Purchased before 1931.

476. INFANT CHRIST

Ivory statuette with polychromy. Hispano-Philippine, 17th century

The nude Infant Christ stands on a cylindrical ivory base. His right hand is raised in benediction, and he holds a cruciform staff. The forms are smoothly rounded and generally lack detail. The Child's eyes and eyebrows are painted, and his hair is gilt. The crucifix is carved separately, as are his arms and the top of his head. He is missing the middle finger from his right hand and the forefinger from his left.

The Infant Christ was a favorite devotional image in Spain throughout the seventeenth and eighteenth centuries and was especially popular in Andalusia. Appealing to sentimental piety, these images were frequently found in convents, where they were costumed by nuns (cf. M. Gómez Moreno, *The Golden Age of Spanish Sculpture*, London, 1964, nos. 79 and 80). The motif spread throughout the Iberian peninsula and to the colonies of the Iberian nations. A similar statuette, identified as "Portuguese Goa, end 17th c.," was in the possession of the Boston dealer Bernheimer in 1963 (*Antiques*, LXXXIV, no. 6, 640).

The number "58" has been written in pencil on the top of the base; a printed tag under the base reads: ST. JOHN BAPTIST / XVII THE CENTURY / GRUEL COLLECTION.

H: 6⅞" (17.4cm) 71.392

HISTORY: Purchased from Léon Gruel before 1931.

477. THE INFANT JESUS

Gilt and polychromed ivory statuette. Hispano-Philippine, 17th century

The Infant lies on his right side with his eyes closed. The hair is gilded, the eyebrows colored brown, and the lips red. A similar, though more naturalistic, figure is in the British Museum (Dalton, no. 553). The left foot has been repaired.

L: 8½" (21.7cm) 71.405

HISTORY: Acquired before 1931.

472

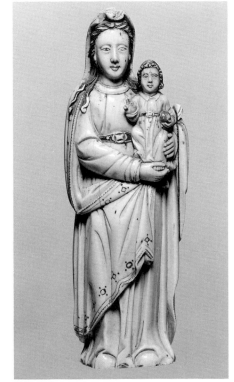

474

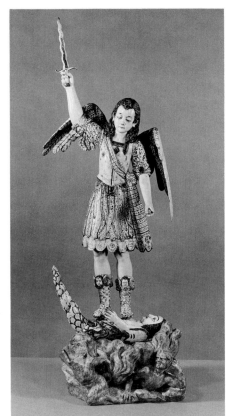

473

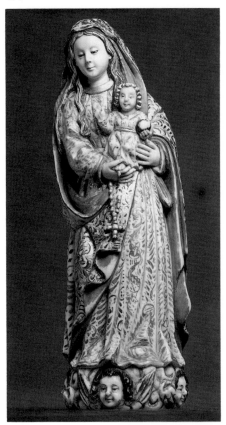

475

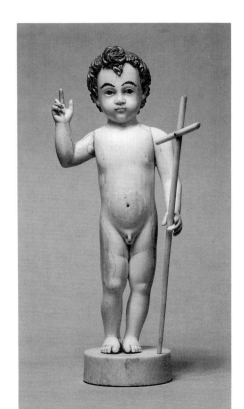

476

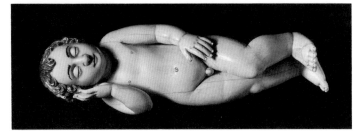

477

478. THE INFANT JESUS

Ivory statuette with polychromy and glass inlay. Hispano-Philippine, 18th century

The nude, bald Infant is shown on his back with his right arm resting over his chest and his left at his side. The sculptor has striven for verisimilitude in the rendering of the folds of the flesh and in the use of inset glass eyes. The lips have been painted red, and traces of pink are still visible in the wrinkles on the back.

Such figures are presumed to have been used in crèches. The space between the arms and the torso suggests that a costume may have been added. The figure's right index finger and the large toe of his left foot have been repaired. A plug has been set in the Child's head and a hole drilled in the right foot. Tardy (1977, 233, 238) illustrates several similar statuettes of the Infant Jesus, identifying them as Indo-Portuguese.

L: 9½" (24.2cm) 71.406

HISTORY: Acquired before 1931.

479,480. SAINT FRANCIS OF ASSISI and SAINT FRANCIS XAVIER

Ivory heads. Hispano-Philippine, 17th century

The two heads appear to be by the same hand. The necks are elongated and tapered, intended to serve as pegs for insertion into a torso. Saint Francis of Assisi (cat. no. 479) has a narrow face with sunken cheeks. He wears a tonsure with the remaining fringe of hair carved in parallel lines. Saint Francis Xavier (cat. no. 480), the Jesuit Apostle to the East, is represented as intense and rather gaunt. His brow is furrowed and his cheeks are lined. Both of Saint Francis Xavier's ears are damaged. The tops of both heads have been drilled to support halos. The heads, formerly described as "French colonial," were thought to have been made at Pondicherry, India.

Saint Francis of Assisi. H: 2⅞" (7.4cm) 71.389
Saint Francis Xavier. H: 2⅞" (7.4cm) 71.390

HISTORY: Purchased from Léon Gruel, Paris, before 1931.

481. SAINT

Ivory head with silver mount. Hispano-Philippine, 18th century

The saint has a bland expression and wears a pronounced tonsure. Apparently balding, he has an incomplete circle of hair; only a forelock remains in the center of his forehead. The long neck suggests that the head may have been intended for insertion into a torso, as in catalogue nos. 479 and 480. The mouth has been painted, and there is a small hole in the head for a nimbus. The neck was drilled at a later date and cut to form a whistle, which can be hung by means of the silver acanthus-leaf mount inserted into the crown of the head.

H: 1½" (3.8cm) 71.412

HISTORY: Purchased from Léon Gruel, Paris, before 1931.

482. SCENES OF AFRICAN LIFE

Ivory tusk. Congolese (Loango), 1850–1860

The tusk is carved in high relief with a procession of figures in a rising spiral. It is thought to have been carved by the Vili people of Loango for the French traders who dominated the area.

The scenes, which read from the bottom, show a war between two black peoples, in which the defeated are roped and led away; a sailor woodworking; coconuts being picked; a trader selling gin; prisoners being led off for sale as slaves; a European lighting his cigar; fishermen carrying large fish; a procession of dignitaries; the execution of criminals; goods and ivory being brought for sale; another procession of dignitaries, who salute a European in a wicker chair; the preparing of a pig and other food for a banquet; a procession; the arrest of a wrongdoer; a procession; and an execution. The top is carved with a gorilla eating a banana and scratching his side.

The costumes suggest a mid-century date, and the blacks in the processions are shown in printed European cotton textiles. There are many distinctions in rank among the blacks, as indicated by their costume, hats, and jewelry, and by specific symbols, for example, an umbrella.

Other similar tusks are known, the earliest of which was purchased between 1839 and 1867 by the French admiral Fleuriot de Langle. A related tusk is in the Musée de l'Homme, Paris (Tardy, 1977, 422, no. 1), and there is one each in Leiden and Tervuren (Tardy, 1977, 421, nos. 2, 4).

L: 44½" (113.0cm) 71.586

HISTORY: Purchased from Tiffany & Company, New York, c. 1910.

478

479

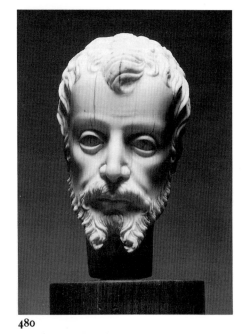

480

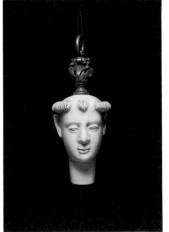

481

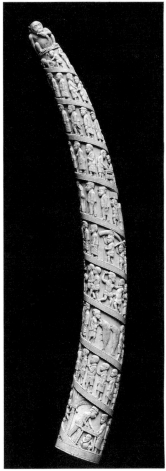

482

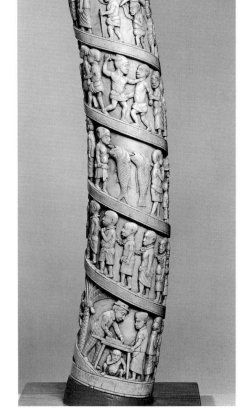

482

483. PSEUDO-GOTHIC TRIPTYCH

Carved bone and ivory on wood. Spanish, probably 1890s. Ascribed to Francisco Pallas y Puig (1859–1926)

The Glorification of the Virgin occupies the central portion of this triptych. She holds the Christ Child on her left arm and is surrounded by six music-making angels. Below are two scenes, representing the Presentation in the Temple on the left and the Marriage of the Virgin on the right. Separating these is a statuette of Saint Peter standing under an architectural canopy. The margins are occupied by full-length figures of eight Apostles, including Saint Peter, shown again at the lower left. In the lower margin, three angels playing musical instruments are seated amid decorative vinework.

Each wing of the triptych is divided into three sections. The upper portions are occupied by royal portrait busts of Ferdinand and Isabella, in quatrefoils identified by their coats of arms. Beneath the busts are pairs of narrative scenes. On the left, the Assumption of the Virgin appears above the Nativity. On the right, the Annunciation is shown beneath a scene which may represent Christ Taking Leave of His Mother. Included within the border of floral tracery surrounding the historiated section of each wing are pairs of Renaissance-style portrait busts set in quatrefoils; the borders of the wings are interrupted at top and bottom by heraldic shields. Extending across the base of all three panels is the inlaid ivory inscription: SIT NOMEN VIRG. MARIAE BENEDICTUM IN SAECULA (*May the name of the Virgin Mary be blessed through the centuries*) in a gothic script. Located under ornate Gothic canopies, the figures are carved in relief on thin, narrow bone plaques mounted on wooden supports. The figures retain traces of gilding and polychromy, and the smooth backgrounds are colored blue. Each of the three sections is surrounded by a wooden frame decorated in marquetry of inlaid wood and ivory, an Arabic style frequently used in Spain and north Italy during the fourteenth and fifteenth centuries. Adolph Goldschmidt ascribes this triptych and several similar works to Francisco Pallas y Puig, a Valencian sculptor identified by Manuel Gómez Moreno as the nineteenth-century source for various modern works in the Romanesque and Mozarabic styles ("Los Marfiles Cordobeses y sus Derivaciones," *Archivo Español de Arte y Arqueología*, IX [1927], 233 ff.). Henry Walters, who is quoted by Goldschmidt (49), generously considered this and two related triptychs (71.150 and 71.151) as "compositions . . . in the style of the fifteenth century" rather than intentional forgeries; Goldschmidt, too, follows Gómez Moreno in describing Pallas y Puig as an artist "who tries to express his own ideas" using an earlier style rather than as a forger "attempting to falsify by slavishly imitating earlier objects" (49). Otto Kurz is less charitable, branding the sculptor a forger (*Fakes*, New York, 1967, 173–174).

H: 23⅞" (60.6cm) × W: 26" (66.1cm)
71.149

HISTORY: Purchased c. 1895.

BIB.: A. Goldschmidt, "Pseudo-Gothic Spanish Ivory Triptychs of the Nineteenth Century," *JWAG*, VI, 1943, 49–59, no. 1.

484. SIR ISAAC NEWTON

Ivory relief. English, first half 18th century. Attributed to Alexander van der Hagen (d. 1775)

The bust of Sir Isaac Newton is carved in high relief. His right shoulder and chest are swathed in heavy drapery, partially covering the shirt and coat, which are open at the neck. The subject's hair is parted in the center and curls behind his ears. He is portrayed with a heavy, square jaw, wide-set eyes, and scowling eyebrows which give him a forbidding expression. The relief is based upon John Michael Rysbrack's bust of Newton known as the "Conduitt" bust, of which there are at least six replicas (M. I. Webb, *Michael Rysbrack, Sculptor*, London, 1954, 221–222). Stylistically, the carving is similar to that of Alexander van der Hagen, who worked for Rysbrack and is known to have copied his master's bust in ivory (H. Walpole, *Anecdotes of Painting in England*, Strawberry Hill, IV, 1771, 98; G. Vertue, *Walpole Society*, vol. 22, 135).

On the reverse, in ink, the name "Newton" is written in large black script.

Virtually identical to the Walters piece is an ivory belonging to the Victoria and Albert Museum, London (Longhurst, no. A.112-1929). A version in pear wood was sold at Christie's, London, June 5, 1930; a boxwood version, sold at Sotheby's, London, Nov. 16, 1972, lot 88, is now at the Yale Center for British Art, New Haven.

Oval. H: 5¼" (13.5cm) × W: 4¹⁄₁₆" (10.3cm)
71.424

HISTORY: Purchased before 1931.

485. ALEXANDER POPE

Ivory relief. English, first half 18th century. Attributed to Alexander van der Hagen (d. 1775)

The togate poet appears in profile, facing right. His exaggerated, square jaw and the heavy folds of drapery are comparable in style to the portrait of Sir Isaac Newton (cat. no. 484). Unlike most of van der Hagen's works, the portrait is not derived from a Rysbrack bust but appears to be a profile view of Roubiliac's 1741 bust of Pope (K. Esdail, *The Life and Work of François Roubiliac*, London, 1928, pl. 8).

An almost identical ivory belongs to the Victoria and Albert Museum, London (Longhurst, no. A.44-1931).

On the reverse, in large, black script, is the inscription: POPE / AUT^r. ANG.¹ In brown ink, partly effaced by scratches and the later inscription, is another inscription: A^r / POPE / AUTEUR ANGLAIS.

H: 5³⁄₁₆" (13.5cm) × W: 4¹⁄₁₆" (10.3cm)
71.428

HISTORY: Purchased before 1931.

See also colorplate 97

486. PUGILIST

Ivory statuette, mounted with gold on a carnelian base. English, c. 1800

The pugilist stands with his bare fists raised in a sparring position. Supported by a wide waistband, his tight breeches extend to mid-calf and have a "two-button fall-down"; his upper torso is bare. The ivory socle on which he stands is fitted into a gold mount. The mount is attached to an uncarved carnelian seal that serves as a plinth for the diminutive statuette.

Among the contemporaneous representations of pugilists in similar costume and postures is a group sculpture in ivory showing Tom Cribb and Tom Molyneaux carved in the first quarter of the nineteenth century (Sotheby's, New York, Apr. 20–24, 1983, lot 692).

H: 1½" (3.8cm) 71.648

HISTORY: Purchased before 1931.

487. AMERICAN EAGLE

Sperm-whale tooth. American, late 19th century

Although formerly thought to have been carved by a sailor on a New Bedford whaler, this whale-tooth ornament falls outside the traditions of New England scrimshaw. The sculptor has treated the subject with remarkable realism, thus permitting ornithologists to identify the model as a bald eagle. The only inaccuracy in the rendition is the nostrils, which open through the beak rather than through the cere, the soft tissue at the base of the bill.

Labeled: "162"; remnants of a paper label marked: "G III."

L: 7⅛" (18.1cm) 71.399

HISTORY: Purchased from Tiffany & Company, New York, early in the twentieth century.

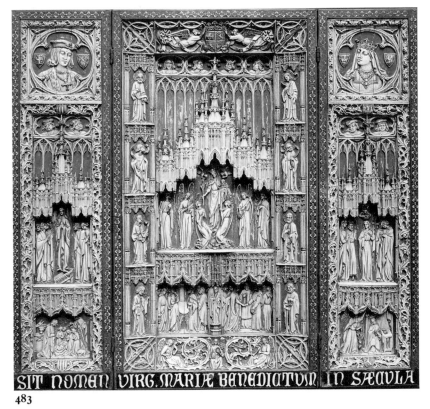

SIT NOMEN VIRG. MARIÆ BENEDICTVM IN SÆCVLA

483

484

485

486

487

488. ROYAL PORTRAITS

Mammoth ivory carved pokal. *Russian (Kholmogory School), second half of the 18th century. Attributed to Master AD*

The slightly tapered cup is supported on a foliate-covered knob which rests on the head and spear of a soldier in fanciful armor who also holds a shield. Serving as the cup's stem, the soldier stands on a grooved and carved cylindrical socle, which rises from the center of the base. The base is surrounded by a decorated border and divided into three equal segments by ribs. Each segment features a double-headed imperial eagle surrounded by rococo floral ornamentation carved in bas-relief. Narrow carved ribs divide the surface of the cup into three vertical panels, each containing a three-quarter-length portrait beneath a tasseled drapery. On a closely related cup bearing the monogram of the master AD, the portraits are identified as Catherine the Great, the Empress Elizabeth, and Peter III. The likenesses of Catherine and Peter are based on engravings by I. Shotenghin after portraits painted in 1748 by G. Kh. Grot; the image of Elizabeth is based on the 1746 portrait by Louis Caravague (d. 1754), engraved by I. A. Sokolov (I. N. Ukhanova, *North-Russian Carved Bone of the Eighteenth to the Beginning of the Nineteenth Century* [in Russian, typescript in Walters Art Gallery Library], Leningrad, 1969, 48, no. 50).

In the Walters *pokal* Catherine is seated in three-quarter view, with her head turned to her right. She wears a crown, an elaborate gown, a sash, and a medallion, perhaps the star of the Order of Saint Catherine the Great Martyr. She gestures with both hands toward a scepter and orb resting on the edge of a table in the lower-right foreground. In the panel to her right, Peter III stands in three-quarter view with his right arm extended to grasp a baton. He holds a sword in his left hand. He is decorated with the Order of Saint Andrew and a sash with the badge of that order. The third panel depicts Elizabeth wearing a dress with a very full skirt and a tight bodice that reveals her shoulders. She wears the Order of Saint Catherine the Great Martyr over her heart and a sash tied in a bow at her left, from which the badge of that order is suspended. The curving border of the cup beneath the portrait panels is ornamented with military trophies, including cannons, flags, pikes, and swords.

The fitted cover of the vessel forms a shallow dome which is surmounted by a crown encircling a central finial. The sloping surface of the cover is divided by floriated ribs into three panels in which the ornamentation is carved over a background surface, imitating ashlar masonry. In one panel, flowering branches surround a medallion with a half-length female portrait carved to imitate a miniature suspended from a chain. In the panel to the right, Apollo is depicted in pursuit of Daphne. The specific meaning of the third panel, which combines images from emblem books, remains obscure, although the juxtaposition of the devices suggests an amatory significance: on the right, Cupid is standing in a garden holding his bow and a shield emblazoned with three hearts; from clouds in the upper left, a hand of God extends, pouring water from a pitcher to irrigate a plant growing from a two-handled pot; on the right, an eagle is balanced on a globe.

L. Sviontkovsky-Voronovoi suggests that much eighteenth-century Russian allegorical imagery depends upon the book *Symbola et Emblemata Selecta* (Amsterdam, 1705), printed by order of Peter the Great (L. Sviontkovsky-Voronovoi, *Carved Bone from the Collection of P. Schukin in the Russian Historical Museum* [in Russian], Moscow, 1923, 11; cf. A. Henkle and A. Schone, *Emblemata*, Stuttgart, 1967, cols. 297, 760–761, and J. Landwehr, *Emblem Books in the Low Countries 1554–1949*, Utrecht, 1970, 652). The shallow relief in the Walters cup, typical of Archangel work, is similar to the openwork technique seen on two cups from the P. Schukin Collection in the Russian Historical Museum, Moscow (Sviontkovsky-Voronovoi, 39, 87). A more closely related cup, from the de Koenigsberg Collection, was sold at the Sotheby Parke-Bernet Galleries, New York, Apr. 8, 1939, lot 21.

There is a crack through the rim of the cover, and the top of the finial and one fleuron from the crown are missing.

Inside the cover is a paper tag, printed: IMPORTED FROM FRANCE. Beneath the base, there is another tag printed with the same words and two old tags; one, with a red border, is marked "M 149" in pencil and the other, with a gold border, is marked "19" in red ink.

H: 12⅛" (30.7cm) 71.477a,b

HISTORY: Said to come from the Mouravier-Apostol Collection; purchased from Polovtsoff, Paris, 1930.

BIB.: P. Verdier, *Russian Art*, Baltimore, 1959, 42; R. Randall, "Russian Arts Installed," *BWAG*, XXVIII, 1976, no. 4.

See also colorplate 100

489,490. WARRIORS, LIONS, AND EAGLES

Mammoth ivory combs. North Russian(?), 18th century

Each comb is designed on the same pattern: a single row of teeth surmounted by a bilaterally symmetrical row of carved figures. (For related examples, see L. Sviontkovsky-Voronovoi, *Carved Bone from the Collection of P. Schukin in the Russian Historical Museum* [in Russian], Moscow, 1923, nos. 46, 64, 74). On both, warriors and lions flank opposed heads of eagles, which support a heraldic crown. In catalogue no. 489, the armored figures hold swords, and the text of Psalms 21:22 (Septuagint numbering, corresponding to Psalms 22:21 in the Russian and King James versions) has been inscribed in Russian Church Slavonic beneath the figures. The Slavonic inscription on one side translates: "Save me from the lion's mouth"; that on the other completes the passage: "From the horns of unicorns is my tranquility." Appropriately, on one side is a lion in a cartouche, on the other, a unicorn. In catalogue no. 490 the lion, unicorn, and inscriptions are replaced by rondels cut into the surface; these may have been intended to hold additional ornamentation.

489. H: 2¾" (7.0cm) × W: 5¼" (13.4cm) 71.459

HISTORY: Purchased in Paris before 1931.

BIB.: *Hair*, June 20–Aug. 7, 1980, Cooper-Hewitt Museum, New York; P. Verdier, *Russian Art*, Baltimore, 1959, 40; T. Rice, *A Concise History of Russian Art*, New York, 1963, 96, no. 73.

490. H: 2⅞" (7.3cm) × W: 4½" (11.4cm) 71.460

HISTORY: Purchased in Paris before 1931.

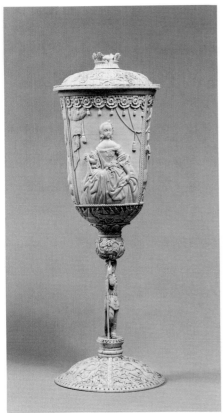

488

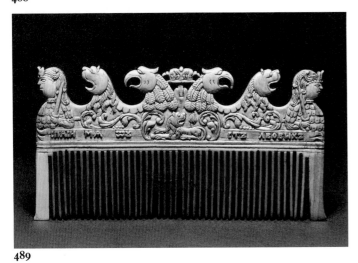

489

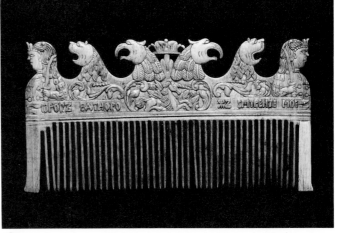

489

490

491. ANIMALS AND DECORATION

Wood desk sheathed with carved and engraved walrus ivory and bone. Russian (Kholmogory School), early 19th century

This seven-drawer miniature writing desk is known as a *teremok* (small tower) cabinet. Flat walrus-ivory and bone plaques, some of which have been stained moss green, are affixed by nails to the cabinet's front and sides, and to the fronts of the three interior drawers. Their surface is busily decorated with circle motifs and colored black (see L. Sviontkovsky-Voronovoi, *Carved Bone from the Collection of P. Schukin in the Russian Historical Museum* [in Russian], Moscow, 1923, ills. 86, 101, 102, 107, 108 for objects with similar decorative motifs). Twelve thicker plaques carved with rocaille floral openwork decoration typical of the mid-eighteenth-century north Russian School have been set over mica sheets on the exterior drawer fronts, sides, and top. The two largest of these plaques are set into the sloping drop-front. They include, on the right, a lion, and on the left a doe and swooping bird, within the stylized floral matrix. Related examples are illustrated in I. N. Ukhanova, *North-Russian Carved Bone of the 18th to the Beginning of the 19th Century*, pls. 13–15. There is a very similar cabinet in the Post Collection at Hillwood, Washington, D.C. (K. V. Taylor, "Russian Ivories at Hillwood, Washington, D.C.," *Antiques*, XCIX, no. 6, 1358–63, fig. 8). Several of the plaques are chipped or cracked.

On the back on a paper tag is written: "130"; engraved on the bottom of the left front foot is the date "1812."

H: 11¾" (29.5cm) × W: 8" (25.0cm) × D: 4½" (11.0cm) 71.429

HISTORY: Purchased in Scandinavia before 1931.

BIB.: P. Verdier, *Russian Art*, Baltimore, 1959, 41; T. Rice, *A Concise History of Russian Art*, New York, 1963, 79, pl. 60.

See also colorplate 99

492. IMPERIAL EAGLE AND ORNAMENT

Cow horn comb. Austrian, 1778

The teeth on each side of this comb vary in number and thickness. At the top of the pierced central triangular area a double-headed eagle holding a scepter and sword is delineated under the triple-lobed crown, surmounted by an orb and cross of the Holy Roman Empire. Beneath the eagle is the name "Michael Bauer," set amid the scroll foliage between a towered gateway on the right and what appears to be a gate and cross on the left. Pentagonal pierced zones occupy each corner. The date "1778" is carved in the top zone, the initials "IL" in the left corner, and "BS" together with "IK" at the right. The central section has been colored green and red, with a slight tinge of gold on the imperial crown and gateway.

H: 7⅜" (18.3cm) × extreme w (at bottom): 8⅜" (21.4cm) 71.411

HISTORY: Purchased in Trondjheim, Norway, c. 1900.

BIB.: *Hair*, June 20–Aug. 7, 1980. Cooper-Hewitt Museum, New York.

493. ESKIMO SLED

Mammoth ivory paperweight. Siberian (Tobolsk), late 19th century

Recessed in the trapezoidal paperweight is an Eskimo genre scene in bas-relief. On the left, a woman and child sit on a sled drawn by three reindeer. Like the rest of his family, the man standing on the right is bundled in furs. He holds a long pike in his left hand and a lead for his sled in his right. The Arctic horizon is indicated by a continuous row of pines in the background.

H: 3½" (9.1cm) × W: 7¼" (18.5cm) 71.400

HISTORY: Purchased at Tiffany & Company, New York, before 1931.

BIB.: G. Kunz, *Ivory and Elephant*, New York, 1916, 127–128; S. Etsujirō, *Zō* [Elephants] (in Japanese), II, ill. following 1600.

See also figure 1

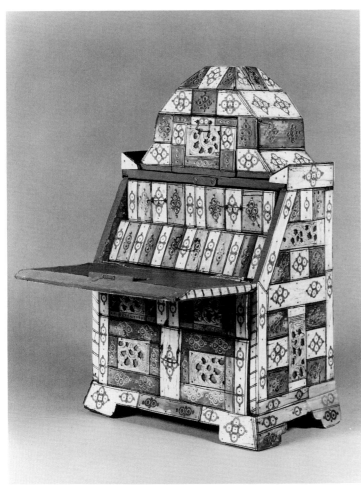

491

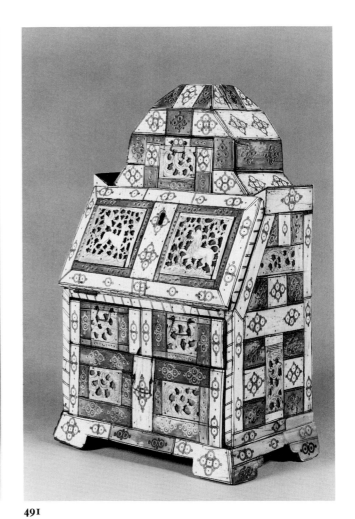

491

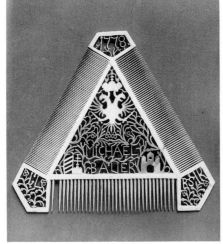

492

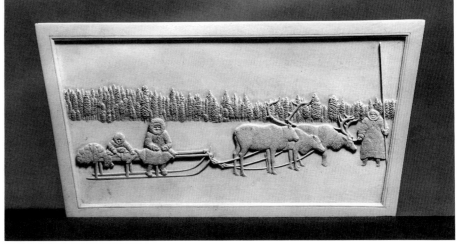

493

CONCORDANCE

In the present catalogue, the ivories are numbered in date order from ancient Egypt to the early twentieth century. The concordance will allow those using earlier publications or other references to the Walters Art Gallery collection to ascertain the catalogue number from the Gallery's accession numbers, which are listed here sequentially.

Accession	Cat.	Accession	Cat.	Accession	Cat.	Accession	Cat.	Accession	Cat.	Accession	Cat.
W.8	248	71.32	147	71.84	363	71.158	182	71.231	286	71.285	268
W.106	314	71.33	173	71.86	263	71.159	184	71.232	287	71.286	277
W.184	456	71.34	137	71.88	274	71.160	187	71.233	282	71.287	275
51.574	449	71.35	6	71.90	278	71.161	186	71.234	247	71.289	252
51.1338	392	71.36	5	71.92	354	71.162	186	71.235	262	71.291	198
52.101	242	71.40	135	71.93	358	71.163	283	71.236	264	71.292	196
57.118a,b	425	71.41	126	71.95	321	71.167	333	71.237	280	71.293	193
57.216a,b	429	71.42	165	71.97	330	71.168	327	71.239	261	71.294	195
57.217	431	71.43	121	71.98	356	71.169	322	71.240	269	71.295	201
57.936	448	71.44	168	71.101	351	71.170	323	71.241	281	71.296	202
57.941	447	71.45	71	71.102	306	71.171	352	71.242	355	71.297	180
57.1231	373	71.46	161	71.107	348	71.174	265	71.243	271	71.298	200
65.23	372	71.47	144	71.108	467	71.175	290a	71.244	190	71.300	260
71.2	104	71.48	227	71.109	279	71.176	290b	71.245	342	71.302	76
71.3	122	71.49	155	71.113	183	71.177	308	71.246	284	71.303	246
71.6	152	71.50	244	71.115	199	71.178	298	71.247	302	71.304	181
71.7	149	71.51	124	71.116	78	71.179	299	71.248	291	71.305	197
71.11	84	71.52	157	71.122	289	71.182	309	71.249	316	71.306	234
71.12	83	71.54	116	71.124	288	71.183	319	71.250	307	71.307	225
71.13	14	71.55	156	71.126	295	71.185	343	71.251	359	71.308	230
71.14	151	71.56	142	71.128	276	71.188	285	71.254	206	71.309	229
71.15	125	71.57	128	71.135	192	71.190	350	71.255	213	71.310	232
71.16	93	71.58	228	71.136	212	71.191	296	71.256	216	71.311	226
71.17	139	71.59	72	71.137	203	71.192	341	71.257	208	71.312	231
71.18	64	71.60	164	71.138	204	71.193	328	71.258	209	71.313	233
71.19	140	71.61	136	71.139	249	71.194	311	71.259	210	71.314	235
71.20	167	71.62	175	71.140	250	71.196	326	71.260	214	71.318	408
71.21	138	71.63	91	71.141	256	71.197	338	71.261	215	71.319	440
71.23	119	71.64	170a,b	71.142	245	71.200	305	71.262	171	71.321	370
71.24	123	71.65	194	71.144	257	71.201	310	71.264	324	71.322	475
71.25	134	71.66	191	71.145	254	71.202	364	71.265	332	71.324	468
71.26	141	71.67	185	71.146	258	71.203	315	71.266	365	71.325	394
71.27	130	71.68	188	71.149	483	71.204	357	71.267	337	71.326	367
71.28	127	71.74	267	71.153	273	71.206	335	71.268	331	71.328	417
71.29	88	71.75	366	71.156	313	71.207	334	71.269	345	71.329	400
71.31	52	71.78	346	71.157	266	71.208	300	71.272	312	71.330	401
						71.210	317	71.273	304	71.332	369
						71.211	293	71.274	325	71.334	460a
						71.213	294	71.275	329	71.339	379
						71.214	301	71.276	297	71.341	469
						71.215	349	71.277	303	71.342	471
						71.216	360	71.279	336	71.343	426
						71.217	361	71.280	318	71.344	427
						71.218	362	71.281	347	71.345a,b	428a,b
						71.219	292	71.282	353	71.346	416
						71.220	253	71.283	339	71.347	430
						71.221	255	71.284	320	71.348	465

71.349	406	71.416	374	71.491	272	71.540	53	71.616	61	71.1123	158
71.350	464	71.417	383	71.492	472	71.541	34	71.617	106	71.1124	97
71.351	371	71.418	240	71.493	60	71.542	30	71.618	105	71.1126	65
71.352	443	71.419	241	71.495	58	71.555	29	71.619	92	71.1127	143
71.353	424	71.421	461	71.496	66	71.556	44	71.620	118	71.1128	178
71.355	399	71.424	484	71.497	66	71.557	79	71.622	21	71.1129	178
71.356	385	71.425	441	71.498	66	71.558	70	71.623	20	71.1130	117
71.358	474	71.426	442	71.499	75	71.561	236	71.624	68	71.1131	454
71.359	459	71.427	436	71.500	77b	71.562	221	71.625	107	71.1134	391
71.360	380	71.428	485	71.501	77a	71.563	220	71.627	102	71.1136	397
71.362	396	71.429	491	71.502	10	71.564	222	71.628	109	71.1144	176
71.363	407	71.430	446	71.503	31	71.565	223	71.629	101	71.1148	451
71.364	433	71.435	375	71.504	16	71.566	219	71.630	113	71.1149	51
71.365	434	71.436	378	71.505	3	71.567	224	71.631	111	71.1154	403
71.366	415	71.443	422	71.506	9	71.570	243	71.632	112	71.1156	340
71.367	415	71.444	445, 445a	71.507	17	71.571	238	71.633	108	71.1157	259
71.368	437			71.508	35	71.580	237	71.634	110	71.1160	452
71.370	435	71.445	381	71.509	8	71.581	48	71.635	99	71.1162	270
71.371	463	71.446	439	71.510	47	71.583	40	71.636	100	71.1163	386
71.372	458	71.449	421	71.511	38	71.584	438	71.637	98	72.18	239
71.374	395	71.450	444	71.512	25	71.585	457	71.639	69	86.10	418
71.375	402	71.459	489	71.513	37	71.586	482	71.640	50		
71.376	460b	71.460	490	71.514	45	71.587	189	71.641a	33		
71.377	405	71.461	368	71.515	36	71.590	115	71.648	486		
71.380a,b	453a,b	71.463	462	71.517	2	71.591	85	71.1090	56		
71.388	376	71.464	393	71.518	54	71.592	86	71.1097	148		
71.389	479	71.465	450	71.519a,b	32	71.593	90	71.1098	129		
71.390	480	71.466	411	71.520	41	71.594	87	71.1099	120		
71.391	398	71.467	412	71.521	7	71.595	67	71.1100	154		
71.392	476	71.468	409	71.522	4	71.596	89	71.1101	179		
71.393	377	71.469	410	71.532	22	71.597	131	71.1102	95		
71.395	419	71.470	384	71.524	23	71.598	80	71.1103	59		
71.397	455	71.471	382	71.525	43	71.599	133	71.1104	160		
71.399	487	71.476	387	71.526	42	71.600	73	71.1105	172		
71.400	493	71.477a,b	488	71.527	24	71.601	74	71.1107	217a		
71.401	388	71.478	177	71.528	18	71.602	103	71.1108	217b		
71.402	404	71.479	94	71.529	49	71.603	163	71.1110	150		
71.404	466	71.480	420	71.530	19	71.604	26	71.1112	114		
71.405	477	71.481	413	71.531	14	71.605	28	71.1113	159		
71.406	478	71.482	414	71.532	12	71.606	81	71.1114	218		
71.407	470	71.483	251	71.533	15	71.607	27	71.1115	153		
71.410	423	71.484	344	71.534	13	71.608	63	71.1116	217c		
71.411	492	71.485	205	71.535	1	71.609	62	71.1117	169		
71.412	481	71.486	207	71.536	39	71.611	132	71.1118	174		
71.413	389	71.488	211	71.537	11	71.612	162	71.1119	145		
71.414	390	71.489	57	71.538	46b	71.613	55	71.1120	166		
71.415	432	71.490	473	71.539	46a	71.615	82	71.1122	96		

BIBLIOGRAPHY

LIST OF ABBREVIATED TITLES
USED IN THE TEXT AND NOTES

Age of Spirituality — *Age of Spirituality*, ed. Kurt Weitzmann, Metropolitan Museum, New York, 19 Nov. 1977–12 Feb. 1978.

Avril, *Le temps des croisades* — Avril, François; Barral i Altet, Xavier; and Gaborit-Chopin, Danielle, *Le temps des croisades*, Paris, 1982.

Barnett, *Nimrud Ivories* — Barnett, Richard, *A Catalogue of the Nimrud Ivories with other Examples of Ancient Near Eastern Ivories in the British Museum*, 2nd ed., London, 1975.

Beckwith, *Coptic Sculpture* — Beckwith, John, *Coptic Sculpture, 300–1300*, London, 1963.

Berliner — Berliner, Rudolf, *Die Bildwerke des Bayerisches Nationalmuseums, IV, Die Bildwerke in Elfenbein Knochen, Hirsch- und Steinbockhorn mit einem Abhange: Elfenbeinarbeiten der Staatliche Schlossmuseum in Bayern*, Munich, 1926.

Bookbinding — *The History of Bookbinding*, ed. Dorothy Miner, Baltimore Museum of Art, Baltimore, Nov. 1957–Jan. 1958.

Byzantine Art — *Early Christian and Byzantine Art*, ed. Dorothy Miner, Walters Art Gallery and Baltimore Museum of Art, Baltimore, 25 April–22 June 1947.

Capart, *Primitive Art in Egypt* — Capart, Jean, *Primitive Art in Egypt*, London, 1905.

Cott — Cott, Perry B., *Siculo-Arabic Ivories*, Princeton, 1939.

Court Style — *Transformations of the Court Style*, ed. Dorothy Gillerman, Rhode Island School of Design, Providence, 2–27 Feb. 1977.

Dalton — Dalton, O. M., *Catalogue of the Ivory Carvings of the Christian Era . . . in the British Museum*, London, 1909.

Delbrueck — Delbrueck, Richard, *Die Consulardiptychen*, Berlin, 1929.

Emery, *Archaic Egypt* — Emery, Walter B., *Archaic Egypt*, Baltimore, 1961.

Gaborit-Chopin — Gaborit-Chopin, Danielle, *Ivoires du moyen age*, Fribourg, 1978.

Gauthier — Gauthier, Marie-Madeleine, *Emaux limousins champlevés des XIIe, XIIIe et XIVe siècles*, Paris, 1950.

Goldschmidt — Goldschmidt, Adolph, *Die Elfenbeinskulpturen aus der Zeit der Karolingischen und Sachsischen Kaiser, VIII–XI Jahrhundert*, vol. 1–2, Berlin, 1914–1918; *Die Elfenbeinskulpturen aus der Romanischen Zeit, XI–XIII Jahrhundert*, vols. 3–4, Berlin 1923–1926.

Goldschmidt and Weitzmann — Goldschmidt, Adolph, and Weitzmann, Kurt, *Die Byzantinischen Elfenbeinskulpturen*, 2 vols., Berlin, 1930–1936.

Graeven — Graeven, Hans, *Elfenbeinwerke in Italien, 2, Frühchristliche und mittelalterliche Elfenbeinwerke in Photographischer Nachbildung*, Rome, 1900.

Hearn Collection — *The George A. Hearn Collection of Carved Ivories*, New York, 1908.

Images of Love and Death — *Images of Love and Death in Renaissance and Late Medieval Art*, ed. W. R. Levin, University of Michigan, Ann Arbor, Nov. 1975–Jan. 1976.

International Style — *The International Style: The Arts of Europe around 1400*, ed. Philippe Verdier, Walters Art Gallery, Baltimore, 23 Oct.–2 Dec. 1962.

Kanzler — Kanzler, Rodolfo, *Gli avori dei musei profano e sacro della Biblioteca Vaticana*, Rome, 1903.

Koechlin — Koechlin, Raymond, *Les ivoires gothiques français*, 3 vols., Paris, 1924.

Kofler — Schnitzler, Hermann; Volbach, Fritz; and Bloch, Peter, *Skulpturen, Elfenbein, Perlmutter, Stein, Holz Europäisches Mittelalter, Sammlung E. und M. Kofler-Truniger, I*, Lucerne, 1964.

Kühnel — Kühnel, Ernst, *Die Islamischen Elfenbein-skulpturen*, Berlin, 1971.

Leeuwenberg — Leeuwenberg, Jaap, *Beeldhouwkunst in het Rijksmuseum*, The Hague, 1973.

Les fastes du gothique — *Les fastes du gothique: le siècle de Charles V.*, ed. Françoise Baron, Grand Palais, Paris, 9 Oct. 1981–1 Feb. 1982.

Loomis — Loomis, Roger Sherman, *Arthurian Legends in Medieval Art*, London, 1938.

Longhurst — Longhurst, Margaret, *Catalog of Carvings in Ivory, Victoria and Albert Museum*, London, 1, 1927; 2, 1929.

MacGregor Collection — *Catalog of the MacGregor Collection of Egyptian Antiquities*, Sotheby, Wilkinson, and Hodge, London, 26–30 June, 3–6 July 1922.

Marangou — Marangou, Lila, *Bone Carvings from Egypt*, Tübingen, 1979.

Massarenti Catalogue — *Catalogue du musée de peinture, sculpture et archéologie au palais Accoramboni*, Rome, 1897.

Morey — Morey, C. R., *Gli oggetti di avorio e di osso del Museo Vaticano*, Vatican City, 1936.

Morey, "Italian Gothic" — Morey, C. R., "Italian Gothic Ivories," *Medieval Studies in Memory of A. Kingsley Porter*, Cambridge, Mass., 1939, I.

Pagan and Christian Egypt — *Pagan and Christian Egypt*, ed. J. D. Cooney, Brooklyn Museum, 23 Jan.–9 Mar. 1941.

Philippovitch — Philippovitch, Eugen V., *Elfenbein*, Braunschweig, 1961.

PKG 13 — Mellink, Machteld, and Filip, Jan, *Frühe Stufen der Kunst*, Propyläen Kunstgeschichte, 13, Berlin, 1974.

PKG 15 — Vandersleyen, Claude, *Das alten Ägypten*, Propyläen Kunstgeschichte, 15, Berlin, 1975.

Randall, *Ivories* — Randall, Richard H., Jr., *Medieval Ivories*, Baltimore, 1969.

Scepter I — Hayes, William C., *The Scepter of Egypt, A Background for the Study of Egyptian Antiquities in the Metropolitan Museum of Art, Part I, From the Earliest Times to the End of the Middle Kingdom*, Cambridge, Mass., 1955.

Scherer — Scherer, Christian, *Die Braunschweiger Elfenbeinsammlung*, Leipzig, 1931.

Schiller — Schiller, Gertrud, *Ikonographie der Christlichen Kunst*, 5 vols., Gütersloh, 1966–1980.

Smith, *AAE* — Smith, W. Stevenson, *The Art and Architecture of Ancient Egypt*, Baltimore, 1958.

Steindorff — Steindorff, George, *Catalogue of the Egyptian Sculpture in the Walters Art Gallery*, Baltimore, 1946.

Tardy — Tardy, *Les ivoires*, Paris, 1966.

Tardy, 1977 — Tardy, *Les ivoires*, 2nd edition, 2 vols, Paris, 1977.

Theuerkauff, *Bossuit* — Theuerkauff, Christian, "Zu Francis van Bossuit, Beeldsnyder in yvoor," *Wallraf-Richartz Jahrbuch*, 37, 1975, pp. 119–182.

Theuerkauff, *Helfenbein* — Theuerkauff, Christian, "Kunststückhe von Helfenbein zum Werk der Gebrüder Stainhart" *Alte und Moderne Kunst*, 124/125, 1972, pp. 22–32.

Ucko — Ucko, Peter, "Anthropomorphic Ivory Figurines from Egypt," *Journal of the Royal Anthropological Institute*, London, 95, 1965, pp. 214–240.

Vandier, *Manuel, I* — Vandier, Jacques, *Manuel d'archéologie égyptienne, les époques de formation, la préhistoire*, I, Paris, 1952.

Vandier, *Manuel, III* — Vandier, Jacques, *Manuel d'archéologie égyptienne, les grandes époques, la statuaire*, III, 2 vols., Paris, 1952.

Vandier, d'Abbadie — Vandier, d'Abbadie, Joë, *Catalogue des objets de toilette égyptiens*, Paris, 1972.

Verdier, *Art International* — Verdier, Philippe, "Les ivoires de Walters Art Gallery," *Art International*, 7, 1963, no. 3, pp. 28–32; no. 4, pp. 28–36.

Volbach — Volbach, Wolfgang Friedrich, *Die Bildwerke des Deutschen Museums, Die Elfenbeinbildwerke*, Berlin, 1926.

Volbach, *Spätantike* — Volbach, Wolfgang Friedrich, *Elfenbeinarbeiten der Spätantike und des frühen Mittelalters*, Mainz, 1952.

WAG Jewelry — *Jewelry—Ancient to Modern*, ed. Ann Garside, Walters Art Gallery, Baltimore, 15 Oct. 1979–15 Jan. 1980.

The Waning of the Middle Ages — *The Waning of the Middle Ages*, ed. J. L. Schrader, University of Kansas, Lawrence, 1 Nov.–1 Dec. 1969.

Weitzmann, *Ivories and Steatites* Weitzmann, Kurt, *Catalogue of the Byzantine and Early Mediaeval Antiquities in the Dumbarton Oaks Collection, 3, Ivories and Steatites*, Washington, D.C., 1972.

Wessel, *Christentum am Nil* Wessel, Klaus, *Christentum am Nil*, Recklinghausen, 1964.

Westwood, *Ivories* Westwood, J. O., *A Descriptive Catalog of the Fictile Ivories in the South Kensington Museum*, London, 1876.

Wulff Wulff, Oskar, *Altchristliche und mittelalterliche Byzantinische und Italienische Bildwerke*, 2 vols., Berlin, 1909.

Zastrow Zastrow, Oleg, *Museo d'arti applicate, Gli avori*, Milan, 1978.

PERIODICALS

AA *Archäologischer Anzeiger*

AJA *American Journal of Archeology*

AM *Athenische Mitteilungen*

BCH *Bulletin de correspondance hellénique*

BMMA *Bulletin of the Metropolitan Museum of Art*

BWAG *Bulletin of the Walters Art Gallery*

JHS *Journal of Hellenic Studies*

JMMA *Metropolitan Museum of Art Journal*

JRS *Journal of Roman Studies*

JWAG *Journal of the Walters Art Gallery*

RM *Römische Mitteilungen*

WAG *Walters Art Gallery*

INDEX